The First Book of
Fashion

Bloomsbury Academic

An imprint of Bloomsbury Publishing Plc

50 Bedford Square 1385 Broadway
London New York
WC1B 3DP NY 10018
UK USA

www.bloomsbury.com

BLOOMSBURY and the Diana logo are trademarks of Bloomsbury Publishing Plc

First published 2015

British Library Cataloguing-in-Publication Data
A catalogue record for this book is available from the British Library.

ISBN: HB: 978-0-8578-5768-2
 ePDF: 978-1-4742-4989-8
 ePub: 978-1-4742-4990-4

Library of Congress Cataloging-in-Publication Data
Schwarz, Matthäus, 1497-approximately 1574.
[Trachtenbuch. English]
The first book of fashion : the book of clothes of Matthäus and Veit Konrad Schwarz
of Augsburg / edited by Ulinka Rublack, Maria Hayward and Jenny Tiramani.
pages cm
Includes bibliographical references and index.
ISBN 978-0-85785-768-2 (hardcover) — ISBN 978-1-4742-4989-8 (ePDF) —
ISBN 978-1-4742-4990-4 (ePub) 1. Fashion—Germany—Early works to 1800.
2. Costume—Germany—Early works to 1800. 3. Clothing and dress—Germany—
Early works to 1800. I. Schwarz, Veit Konrad, 1541-1587. II. Rublack, Ulinka,
editor. III. Hayward, Maria, editor. IV. Tiramani, Jenny, editor. V. Title.
GT905.S3513 2015
391.00943—dc23
2015005570

Designed by Luke Herriott
Typeset by Lachina
Printed and bound in China

The First Book of
Fashion

*The Book of Clothes of
Matthäus & Veit Konrad
Schwarz of Augsburg*

Edited by

Ulinka Rublack and

Maria Hayward

Bloomsbury Academic
An imprint of Bloomsbury Publishing Plc

B L O O M S B U R Y
LONDON · NEW DELHI · NEW YORK · SYDNEY

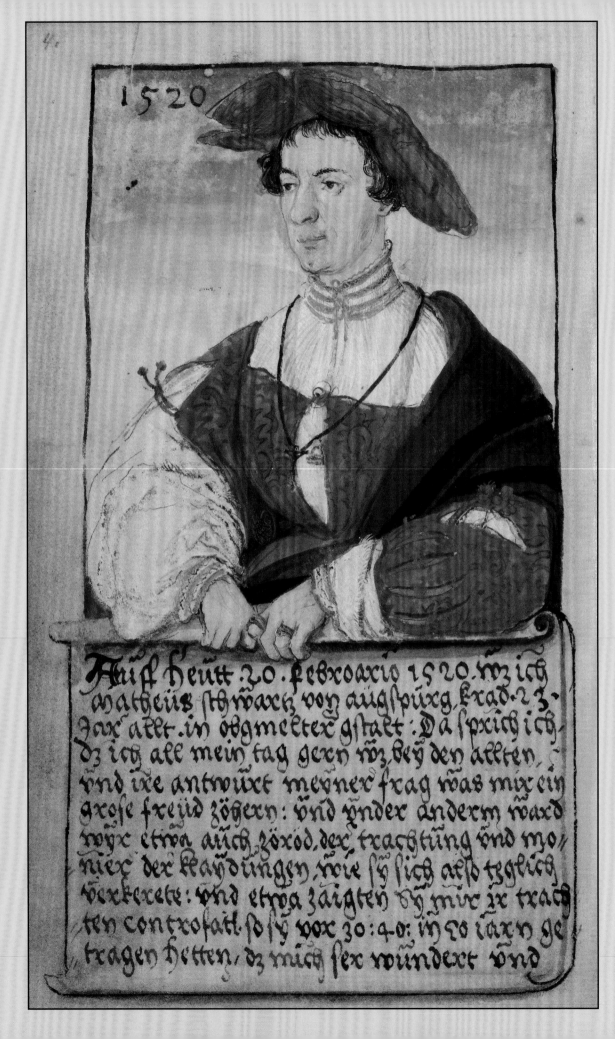

4.

1520

Auff heütt 20. febroario 1520. v23 ich
matheüs schwarcz von augspürg. krad 23.
Jar allt. in obgmellter gstalt: Da spxich ich
dz ich all mein tag gern vor beÿ den allten,
vnd ire antwurt meyner frag was mir ein
grose freüd zöhern: vnd ÿnder anderm ward
voyr etwa auch zörod der trachtüng vnd mo//
nier der klaÿdungen voie sÿ sich als tgglich
verkerete: vnd etwa zaigten dÿ mir ir trach
ten controfatl so sÿ vor 30: 4.o: in 50 iarn ge
tragen hetten, dz mich ser wündert vnd

Table of Contents

✤ List of Illustrations

Preface

The Herzog Anton Ulrich-Museum in Braunschweig (Brunswick), Art Museum of the State of Lower Saxony, is one of the oldest museums worldwide. It was founded at about the same time as the British Museum in London. Duke Carl I of Braunschweig-Wolfenbüttel (1713–1780) established the museum in so-called Burg Dankwarderode in 1753. It was founded as a universal museum called "Kunst- und Naturalienkabinett" and the first visitors came in 1754. The collection of natural history was transferred to today's Naturhistorisches Museum in Braunschweig later, in 1877. Today the Herzog Anton Ulrich-Museum contains valuable works of art which date back several millennia. The collections are based on those of the Dukes of Braunschweig and Lüneburg from the house of Wolfenbüttel. Duke Anton Ulrich (1633–1714) is considered to be the founder of the collection. He brought together the works of art in his castle in Salzdahlum near Braunschweig, although the first items of the collection had already been in Wolfenbüttel castle during the Renaissance period. As early as 1578 there existed visitor rules and regulations for the castle. Before 1589, at the time of the death of Duke Julius, an inventory for the cabinet of curiosities existed. Since that time, the collections were extended systematically.

During the time of Duke August the Younger (1580–1666) special efforts were made to acquire books and graphic art. They provided the basis for today's Herzog August Bibliothek in Wolfenbüttel. August the Younger continued to expand the collection for 30 years. The Augsburg agent Philipp Hainhofer (1578–1647) supplied Duke August with rarities, such as the precious *Kunstkammer* cabinets or ethnographic objects. Therefore, it is not surprising that today's Herzog Anton Ulrich-Museum houses a great number of art works which originated in Augsburg, such as Renaissance and Baroque paintings, graphic sheets, elaborate clocks, an ivory cassette with Augsburg enamelling, a baroque narwhal tooth reliquary and many other works of art. In the Holy Roman Empire of the German Nation, Augsburg was regarded as the center for the manufacturing of luxury products, which were designed as gifts or for domestic display.

A sense of this wealth and opulence is reflected in the Book of Fashion of Matthäus Schwarz. It is kept in the Prints and Drawings Cabinet in the Herzog Anton Ulrich-Museum. Matthäus Schwarz was chief accountant to Jakob Fugger the Rich, who was a member of a famous merchant family. Due to their wealth, this family was considered to be as important as royalty. Over decades, Matthäus Schwarz had himself portrayed in varying garments as a documentation of himself at varying stages in his life. The portrayal of the accountant in Jakob Fugger's accounting office is an early highlight. In this office the drawers for business correspondence refer to a wide spanning trading network of the merchants via Antwerp to Lisbon. This picture is one of the most popular works in the Herzog Anton Ulrich-Museum, often requested for reproduction in textbooks and other academic books. The current publication—for which the museum would like to thank the publishers and the authors most sincerely—explores how Augsburg's cultural history forms the background to Matthäus and Veit Konrad Schwarz's unique books of fashion and helped to shape Matthäus Schwarz's marked desire for self-representation.

Prof. Dr. Jochen Luckhardt
Director
Herzog Anton Ulrich-Museum Braunschweig, October 2014

HERZOG
ANTON ULRICH
MUSEUM

The First Book of Fashion

Ulinka Rublack

❧ Renaissance culture and fashion

Painting, architecture, and sculpture often dominate our sense of the Renaissance. Yet this cultural movement became visible to many through a new world of fashion fueled by a passion for innovative ideas in dialogue with classical traditions. In daily life, dress possessed immediate visual appeal and increasingly offered choice. Clothes were immensely colorful as well as multi-textured, which made them attractive to look at and touch. New materials, cutting, and sewing techniques transformed tailoring. Shrewd merchants created wider markets for innovations and chic accessories. Art depicted humans on an unprecedented scale, paying tribute to real world experiences. Mirrors enticed more people into trying to imagine what they looked like. Dress could be as arresting as a face.

This new approach to consumption and aesthetic appreciation depended on the assemblage of a wide range of goods. Detachable parts of armor or garments, jewelry, caps, bonnets, purses, feathers, hairpieces, or even shoes animated appearances. They are central to an appreciation of this period's visual interests: forged by courts, the church, and other wealthy patrons as much as by people in cities ranging from Venice, Paris, and London to Augsburg, Nuremberg, and Prague. Citizens used streets to publicly display their clothing and express their feelings as well as different values. Laws left scope for all social classes to own fashionable items. Secondhand markets helped to circulate more valuable materials. Imitations were readily available. A passion for fashion became a broad social phenomenon, and dress was more deeply embedded in how people felt about themselves and others (Figure 1.1).

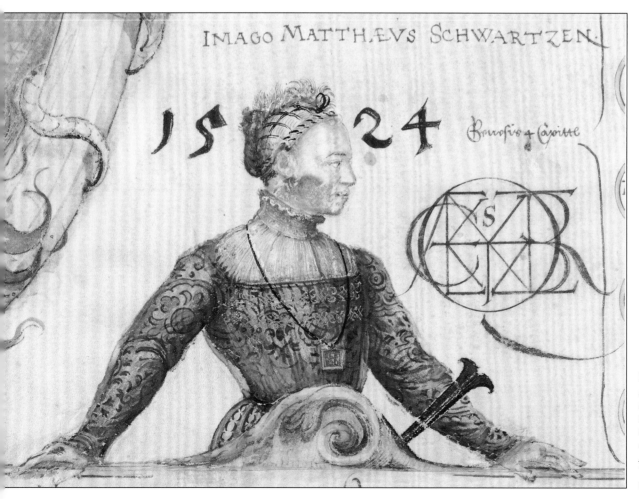

Figure 1.1. *Narziß Renner, Portrait of Schwarz in the genealogy of Christ, 1524, 1553, copy.* © Herzog August Bibliothek Wolfenbüttel: Cod. Guelf. 112 Aug. 2°.

Sebastian Brant, author of the bestselling *Ship of Fools* (1492), humorously lamented

Of Innovations:

An erstwhile quite disgraceful thing
Now has a plain, familiar ring:
An honour 'twas a beard to grow,
Effeminate dandies now say no!
Smear apish grease on face and hair
And leave the neck entirely bare,
. . .
Vile sulphur, resin curl their hair,
An egg white's added too with care,
. . .
Their number (of lice) now would wax untold,
Since modern clothes have many a fold,
Coat, bodice, slipper, also skirts,
Boots, hose, and shoes and even shirts
. . .
Shame German nation, be decried!
What nature would conceal and hide,
You bare it, make a public show,
'Twill lead to evil, lead to woe,
And then grow worse and harm your name.

But there was nothing to stop the tide.

Matthäus Schwarz and The First Book of Fashion

There can be no better guide to this fascination with dress, distinctiveness, and self-observing display among Renaissance citizens than Matthäus Schwarz of Augsburg (Figure 1.2).

Schwarz was born on the 20th of February 1497, as son of a wine merchant and innkeeper. In 1520, at twenty-three years old, he secured his permanent position as head accountant for the Fugger merchant firm and started a unique project: his little "book of clothes"—*Klaidungsbüchlein*. This was an exquisitely illuminated manuscript, each page measuring 16 × 10 centimeters. Schwarz closely worked together with Narziss Renner, a nineteen-year-old local artist, who immersed himself in the project to produce portraits with rich tempera colors on parchment. Schwarz and Renner's cooperation led to a final flowering of this art.[1]

Schwarz's interest in dress similarly reveals his fascination with innovation and tradition. It dated back to his early teenage years, when he had talked to older people about the clothes

they were wearing, studied their depictions, and observed that clothes and "manners" now seemed to "change day-by-day." In response to this sense of accelerated change, he had begun to regularly record his clothes through drawings. In the book of clothes, Schwarz noted the date and particular features of each outfit, as well as some circumstances of his private life or political events. His attention to precision ("23 November 1523, aged 26 ¾ and 1 day," reads a typical entry) underlined his acute sense of the passing of time.

Renner and Schwarz collaborated for sixteen years. Afterward, the project continued with other artists until 1560. At age sixty-three, after forty years of time and investment, Schwarz had accumulated seventy-five parchment sheets with 137 images of himself. Until the age of photography, nobody created a similar sequential record. Schwarz had compiled the world's *First Book of Fashion*—a chronicle that recorded ambitious, innovative dress as historical artifacts and also chronicled personal and social change.

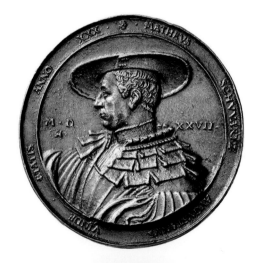

Figure 1.2. *Friedrich Hagenauer, Medal of Matthäus Schwarz, 1527. Image courtesy of Nomos AG, Zurich, Auction 5, Lot 6, 2011.*

1. Ulrich Merkl, *Buchmalerei in Bayern in der ersten Hälfte des 16. Jahrhunderts: Spätblüte und Endzeit einer Gattung* (Regensburg: Schnell + Steiner, 1999).

The manuscript is full of further astonishing firsts. It contains, for example, the first secular nude drawing after those by Albrecht Dürer, as well as the first image of a man recovering from severe illness. Schwarz, in short, must be seen as an exceptionally creative northern Renaissance man. He recasts our sense of what it meant to experience and shape this period by placing dress that was worn and displayed everyday at the heart of Renaissance visual interests.

Augsburg and its role

Augsburg, Schwarz's hometown, was a large south-German city of about 30,000 inhabitants. It was one of Germany's proud Imperial towns directly subject to the Habsburg Emperor rather than a territorial prince and overlord. At the beginning of the sixteenth century, the city teemed with trade and a taste for ingenious ideas as much as for history. Recently excavated Roman antiquities brought the classical past to life. Exciting images and artifacts marked this town: it is almost impossible for us nowadays to imagine the many brightly colored private houses, civic buildings, and guild houses in its center decorated with historical, mythical, or realistic scenes, as well as the bustle of open craft workshops and market stalls with their wares.[2] Augsburg's newly rebuilt churches, elegant arcades, towers, town houses, and interiors painted in fashionable purple or blue created a perfect contemporary backdrop for some of Schwarz's depictions of clothing.

Augsburg was a political, financial, economic, and artistic center and attracted discerning clientele. Emperors and their international entourage repeatedly resided in Augsburg for months, strengthening the craft market not just through trade, but also by spurring on a mutual transfer of tastes and skills. After they had left, Dr. Conrad Peutinger, a high-ranking humanist championing global merchant trade, corresponded on behalf of collectors to arrange commissions for local craftspeople.[3] Matthäus Lang (1469–1540), the wealthy cardinal and international statesman, rode to Augsburg to shop for armor, as well as much of what he needed for his castle nearby.

Matthäus Schwarz's own family was connected to the extraordinary creative talent and energy that pulsed through their town. His father commissioned Holbein the Elder (born c. 1465 in Augsburg) to paint a panel depicting him with his three successive wives and their unusually large family for the local

church dedicated to his patron saint Ulrich (see below). Apart from Holbein, who left the city in 1514/7, this was the city of mature and exceptionally skilled German Renaissance artists, such as Hans Burgkmair (1473–1531), Jörg Breu (c. 1475–1537), and others, who in their thirties produced large scale glorifying print projects for Emperor Maximilian I (crowned 1508). 1517 saw the publication of the *Theuerdank*, a lavish verse epic with 118 exquisite woodcut illustrations and special lettering (Figure 1.3). It told the story of Maximilian's knightly bridal journey in the face of obstacles, such as dangerous chamois hunts, and his plans for a crusade against the infidel. Carried out by the Schönsperger workshop, this was a milestone in German illustrated printing, which, alongside other woodcuts, inspired Schwarz and his artists to copy and develop some of its motifs. Schwarz, in fact, knew Schönsperger's son.

Augsburg was renowned for the quality of such printed books, as well as design, metalwork, painting, and textiles.

Figure 1.3. *A page from Maximilian I's Theuerdank, printed in 1517.* © *Victoria and Albert Museum, London.*

2. For an overview and specific descriptions of murals, see Bruno Bushart, "Kunst und Stadtbild," in *Geschichte der Stadt Augsburg: 2000 Jahre von der Römerzeit bis zur Gegenwart*, ed. Günther Gottlieb et al. (Stuttgart: Theiss Verlag, 1984), 363–85.

3. Erich König, ed., *Konrad Peutingers Briefwechsel* (Munich: Beck, 1923), 126–7, 138. These ranged, for example, from a curious oven designed to breed eggs to conventional silver plates.

The use of different tone blocks achieved multicolored prints. A combination of several woodblocks achieved monumental prints. More ordinary woodcut images popularized a large variety of genres ranging from travel accounts to tales or medical advice. This workforce of illuminists, printers, artists, and woodcutters collaborated with Augsburg's famous metalworkers to advertise some of their designs for luxury objects, such as intricate goblets, dishes, belt buckles, jewelry, and armor, as well as portable clocks, musical instruments, and automata. From 1510, portrait medals emerged in German art and soon the nobility, as well as Augsburg and Nuremberg elites, were commissioning them. Experimentation was everywhere. Three of Matthäus Schwarz's brothers were trained in artistic trades, and the distinguished medalist Hans Schwarz was a cousin.[4]

Realistic portrayals of the physical appearance and clothing featured in the work of several Augsburg artists during Schwarz's time. These include Daniel Hopfer (c. 1470–1536), who decorated armor with exquisite etchings and portrayed mercenary soldiers; the sculptor and medalist Hans Daucher (1486–1538); and the Petrarch Master, who created radically innovative woodcut illustrations by 1520, which were published in 1532. All this work sparked off impulses generated in nearby Nuremberg, where Albrecht Dürer had begun to pioneer monumental portrait woodcuts in startlingly lifelike ways. Dürer provided a new approach, which led away from the style of Maximilian I's influential commissions, to champion different art after the Emperor's death in 1519. In 1522, Dürer's woodcut of Ulrich Varnbüler (43 × 32.6 cm) did not show an idealized man. He characterized his friend's bold personality by emphasizing Varnbüler's unshaven face and his oversized, fashionable cap in "tangible three dimensionality"[5] (Figure 1.4).

This type of portrayal transformed how people conceived of themselves and artistic representation, as they explored "how much art should look like the visible world."[6] These explorations explain why someone like Schwarz was so intent on a series of observed lifelike depictions different from more standardized portrayals of wealthy citizens at the time, which continued to use dress to conservatively and rather repetitively symbolize the rank and honor of family members.[7]

Intense self-observation and a naturalistic observation of others remained important trends. Hans Burgkmair attempted to provide authentic portrayals of non-Europeans beginning in

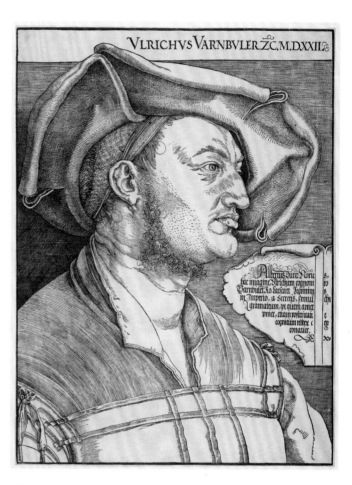

Figure 1.4. *Albrecht Dürer, Woodcut of Ulrich Varnbüler, 1522.* © *The Trustees of the British Museum.*

1508. In 1526, the woodcutter and sculptor Christoph Weiditz (1500–1559) arrived in Augsburg and translated his own interest in lifelike depictions of burghers into medals that he himself called masterpieces. He asked the new Emperor Charles V for his patronage, and on a trip with Charles, he completed an album with costume drawings of people across European society, including newly arrived "Indians" and African slaves in "their manner." Weiditz knew Narziss Renner, and Schwarz would have known Weiditz's astonishing ethnography of global dress or copies of it.[8]

Augsburg thus held an exceptional position as an international center of artistic experiment during these years. Visual and collecting practices created a person's (or an institution's) outlook and memory. This culture also influenced Augsburg's major craft: the textile trade. In 1536, its weavers'

4. August Fink, *Die Schwarzschen Trachtenbücher* (Berlin: Deutscher Verein für Kunstwissenschaften, 1963), 12.

5. Jeffrey Chipps Smith, *Dürer* (London: Phaidon, 2012), 345.

6. Jeanne Nuechterlein, *Translating Nature into Art: Holbein, the Reformation, and Renaissance Rhetoric* (Philadelphia: Pennsylvania University Press, 2011), 9.

7. Cat., *Bürgermacht und Bücherpracht: Augsburger Ehren- und Familienbücher der Renaissance*, ed. Christoph Emmendörffer and Helmut Zäh (Augsburg: Maximiliansmuseum, 2011).

8. Christoph Weiditz, *Authentic Everyday Dress of the Renaissance: All 154 Plates from the Trachtenbuch*, ed. Theodor Hampe (Berlin: de Gruyter, 1927); I discuss this in *Dressing Up: Cultural Identity in Renaissance Europe* (Oxford: Oxford University Press, 2010), 187–99, and many copies of Weiditz and other manuscripts of this type circulated before and after there existed printed costume books.

guild numbered 1,451 members. Day after day, these weavers busily turned enormous quantities of imported cotton and linen thread, spun by women, into durable fustian fabrics. Much of this work paid relatively poorly, but the weavers proudly decorated their assembly room with elaborate Old Testament scenes, events from the life of Alexander the Great, and with the prince electors of the German states, Jewish prophets, ancient philosophers and other virtuous, heroic men. This underlined the guild's commitment to education and civic ideals to further the good of their community by improving morals and wise government for peace and prosperity.[9] It further signaled that weavers felt confident about their political voice, to rival local patricians and rich burghers.

The Fuggers

One particular Augsburg family, who were descended from a poor weaver (who in 1367 entered Augsburg in search of employment), had become superrich and inconceivably powerful (Figure 1.5). Now commonly dubbed "Medici of the North," the Fuggers by the early sixteenth century were at the height of their financial and political success, after the childless Jakob took over management in 1510. Everyone recognized Jakob Fugger (1459–1525) through his trademark sumptuous gold-threaded cap, which he cleverly paired with modest clothes. Fugger knew how to invest in the burgeoning silver production in the Tyrolean mines and Hungary. Drawing on a network that stretched deep into Transylvania, he also dominated the European market for copper. This allowed him to provide credits to the Habsburg Emperors, popes, and many other powerful families, who returned payments in cash or in rights to mineral resources in their lands. When Maximilian I died in 1519, Fugger, alongside other influential merchants, sent money to each of the German princes able to elect a new Emperor to ensure that the young Habsburg Charles V would be chosen. Fugger's company financed weddings among European ruling houses, diplomatic embassies, and the recruitment of the pope's new Swiss guard; it even collected indulgence money.

In addition to metals, Jakob Fugger traded in silks, damasks and velvet fabrics, cotton, precious stones, spices, and other luxury goods through Venice and the Mediterranean market as well as Antwerp, which took off as gateway to the Atlantic world of global expansion. Intensified trade with Africa and Asia transformed the European supply of luxuries. Anyone working for Fugger "the Rich" was at the nodal point of a deeply contested but thriving moneymaking universe, which achieved unparalleled political control.

After Jakob died in 1526, his nephew Anton took over the firm in a period of marked interest in overseas expansion, which the local Welser merchant family pioneered with agents in Santo Domingo. Anton Fugger soon acquired substantial quarters in which Charles V lodged every time he stayed in

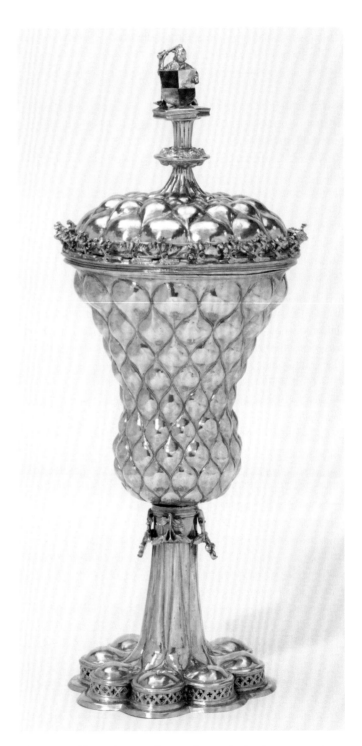

Figure 1.5. Pineapple cup and cover, given to the Augsburg weavers by a member of the Fugger family. © Victoria and Albert Museum, London.

9. The room is preserved in the Bavarian National Museum, Munich.

Augsburg, and where the Italian artist Titian would finish six paintings for him in 1548.[10] The French essayist Michel de Montaigne later judged these the "richest rooms he had ever seen." Marble abounded, Charles' name was chiseled into chimneys, and the imposing Fugger building facades in the center of Augsburg were painted with the Imperial eagle alongside elaborate classical scenes. In 1547, the Fugger's head office was further improved—despite the fact that between 1533 and 1539 the truly enormous sum of over 14,000 florins had already been invested in it.[11]

In this magnificent office, traditionally called the golden writing chamber, Matthäus Schwarz oversaw other accountants and scribes to review all transactions, receive political news from all over Europe, send coded instructions to managers from Lisbon to Antwerp and Kraków, and keep track of New World trade links. Big business in credit, expensive brocades, damasks, silks, and other cloth, gold, silver, copper, jewels, precious faience ceramics, Venetian mirrors, and other artifacts were managed from these rooms, which manifested through their very architecture and interior beauty a new age of material wealth and sophistication for those able to afford it. Schwarz called this "subtle merchandise" (Figure 1.6).

The Fuggers ranked third after the Emperor and the dukes of Saxony in commissioning portrait medals. Schwarz and other employees followed this artistic taste. These medals were given as gifts to friends and associates to form part of their collections. They created aesthetic networks.[12] Some of the most important people of the period ate at the Fugger table, or lodged in its employees' houses, when the Fugger palaces overflowed. In 1548, for instance, Charles V's confessor, Pedro de Soto, lodged at Schwarz's house, for which he had received a substantial long-term loan. Personal loyalty to the Fuggers was vital for its most important employees, who were made to feel part of an extraordinarily hierarchical, patriarchal, and tightly monitored family firm, and they loyally adhered to its Catholicism and support of the Habsburg dynasty. Schwarz recorded Jakob Fugger's patronage and his funeral in 1526, the wedding of Anton Fugger in the following year, and Anton's funeral in 1560 as among the most significant experiences of his adult life.

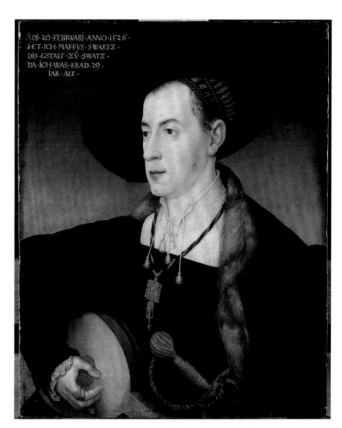

Figure 1.6. Hans Maler, Portrait of Matthäus Schwarz 1526, oil on canvas. Photo © RMN-Grand Palais (musée du Louvre)/Jean-Gilles Berizzi.

Schwarz's youth and artistic projects

Matthäus Schwarz had first entered into the service of Jakob Fugger in October 1516, aged nineteen. He had left school six years before. His father first employed him in his own business, but he then supported Matthäus's keenness to see "foreign countries" by sending his son to live in Italy for two years to learn the language and accounting. Matthäus first stayed in Milan but then moved on to Venice for six months, to be taught bookkeeping. He resided in the German Foundation next to the Rialto Bridge on the Grand Canal, where all the trading was done. Some of the most exciting contemporary art was painted on the walls of this palace, in which the Fuggers had their own lodgings: Giorgione and Titian contributed frescoes for the façade, and Schwarz would have been struck by other contemporary artists whose work he saw.

When he returned to Augsburg, Schwarz immediately started working for "Fugger the Rich" as his main bookkeeper. This key achievement helped restore the family's honor. The traumatic event in its history had been the public execution of Matthäus's paternal grandfather, who had been a man of common descent. Ulrich Schwarz the Elder (born 1422) nonetheless had achieved a political career by representing his

10. Norbert Lieb, *Die Fugger und die Kunst, vol. 2: Im Zeitalter der hohen Renaissance* (Munich, 1958), 155.
11. Lieb, *Fugger und die Kunst*, 180–1.
12. Annette Kranz, "Ein Who's Who der Frühen Neuzeit: Zur gesellschaftlichen Verortung der Porträtmedaille in der deutschen Renaissance," in *Wettstreit in Erz: Porträtmedaillen der deutschen Renaissance*, ed. Walter Cupperi et al. (Munich: Deutscher Kunstverlag, 2013), 42. Schwarz also presented Anton Fugger with a precious silver goblet for his wedding; Lieb, *Fugger und die Kunst*, 87, 375.

fellow carpenters to champion greater political participation for Augsburg's lower guilds. Exceptionally, Ulrich Schwarz the Elder had become Augsburg's mayor. His highborn opponents soon charged him with corruption and managed to have him hanged in 1478. Until he was eleven, Matthäus knew his widowed grandmother, who had seen the executioner sporting her husband's final outfit in the streets of Augsburg as booty—Ulrich had also loved fine clothes. [13]

Matthäus's father therefore commissioned Holbein the Elder to depict his family immediately after his own mother died and hung the panel in the important church of St. Ulrich. This was meant to restore the family's honor. His wives and their thirty-six children stood below Mary and Jesus, who were depicted as successfully pleading with God not to punish the family. Matthäus had fourteen sisters and nine younger and seven older brothers. Twenty of these siblings eventually survived into adulthood. Each child was identified: this was Matthäus's first portrayal. His father, who was named after Ulrich, used the image to rid his exceptionally large lineage of shame and enable it to once more accumulate honor. Matthäus would never question social hierarchies and used his own strategies, some of them sartorial, to rise in recognition.

Ulrich Schwarz the Younger therefore must have been particularly proud of his maturing son's successful employment with the Fugger, but he died in 1519. Matthäus's mother, a Swiss woman called Agnes Staudach, had died long before, when he was five. Matthäus recollected for his book: "In 1502 on the 18th of June when my mother died I learnt the abc from (Master) Schiterer . . . I started to think, but it was as in a dream."

Matthäus's fascination with changing fashions, as we have seen, dated back to his early teenage years, when he had loved talking to old people and registered dress as a significant expression of cultural change. Regular sessions with Narziss Renner began in 1520. Drawing on his memory and previous drawings, Schwarz gave instructions on how to reconstruct thirty-six images of what he had looked like from his birth onward and to mark emotional experiences he remembered as formative. This resulted in a unique sequence of childhood images for his period, in which he frankly admitted to have been morally corrupted by Emperor Maximilian's fool, or he showed himself fed up with school. Schwarz commissioned the following seventy-one images during the high point of his life as the young, dynamic Fugger accountant, in a mere sixteen years, between 1519 and 1535.

At the beginning of this same period, Schwarz began to immerse himself in a number of other ambitious biographical, artistic, historical, and professional projects. He first wrote manuscripts on advanced bookkeeping techniques in 1516 and 1518, and he illustrated his art with actual Fugger accounts from Venice. Arithmetic and accounting at the time were not regarded as mechanical but subtle skills of people with exceptionally fine minds, who could hold and process a tremendous amount of information about weights, currencies, measures, modes of payments, transfer costs, and the quality of goods across different localities with precision. They assessed gains and losses, cause and effect. After 1518, Matthäus made his motto: "Every why has its cause."[14]

Next, Schwarz began keeping a brief diary, which he called "The Course of the World" (*Der Welt Lauf*). He started it in 1519 and frequently mentioned its entries in his book of clothes. Yet he destroyed it before his marriage and thereafter thought of it as chronicling a *Bubenleben*, an ambiguous term that translates as "(bad) boy's life."

1519 also saw the beginning of his long-term collaboration with Narziss Renner. This was clearly exciting for both young men. Renner was allowed access to his world and, it seems, some of the Fuggers' extensive collection of contemporary medals and art. Immediately in 1521, Schwarz commissioned Renner to also complete an unusual prayer book on parchment. Renner was only twenty, but this gave him the chance to make a name for himself and show off all his skill and ambition in a tiny format and traditional genre. The prayer book measured no more than 11.3 × 8.2 centimeters and was richly illuminated with motifs that closely drew on contemporary woodcuts and engravings by leading artists, such as Dürer, Lucas van Leyden, Altdorfer, Burgkmair, and others. Italian and German medals, including one by the Fuggers, also featured. Unusually, an image of Schwarz as devout donor was inserted on thirteen pages; in addition, Schwarz was represented as sole figure on two further pages. One image depicted him in a riding costume. Most strikingly, the prayer book featured interspersed, detailed images of four full-length local male figures Schwarz called "fools." Their dress was minutely observed. A short text described each person, and Schwarz later entered the dates of their death. These men suffered from addiction, speech impediments, and mental problems. Jörg Fugger's charity supported one of them. Schwarz proudly showed and even lent this prayer book to high-ranking Augsburg visitors, as a result of which some pages went

13. There is a specialized literature on this, but for a summary turn to Wolfram Baer, ed., *Augsburger Stadtlexikon: Geschichte, Gesellschaft, Kultur, Recht, Wirtschaft* (Augsburg: Perlach Verlag, 1985), 337.

14. Recently, another reference manuscript for business practices has been ascribed to Fugger, but it has to be born in mind that the very year in which he suffered his stroke was 1548: Ekkehard Westermann and Markus A. Denzel, *Das Kaufmannsnotizbuch des Matthäus Schwarz aus Augsburg von 1548* (Stuttgart: Steiner, 2011).

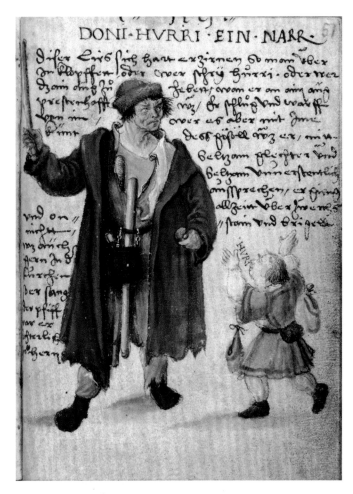

Figure 1.7. *Gebetbuch (prayer book) des Matthäus Schwarz, Bl. 51 recto—Doni Hurri, Staatliche Museen zu Berlin. © bpk/Kupferstichkabinett, SMB/Jörg P. Anders.*

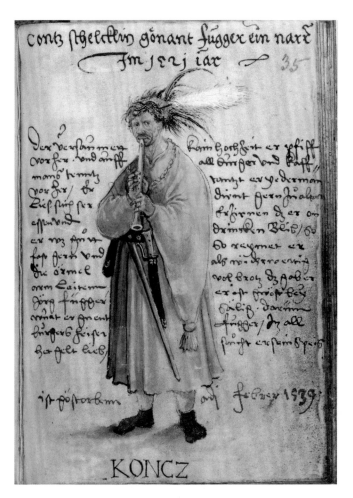

Figure 1.8. *Gebetbuch (prayer book) des Matthäus Schwarz, Bl. 35 recto—Contz Schelcklin named Fugger, Staatliche Museen zu Berlin. © bpk/Kupferstichkabinett, SMB/Jörg P. Anders.*

missing. He and Renner made their mark through unorthodox art and shared a sense of humor[15] (Figures 1.7 and 1.8).

This exhilarating, early collaboration instantly led to a further, historically inspired commission. Schwarz asked Renner to execute an extremely ambitious, large and soon influential parchment painting to depict an imagined garden party. The parchment measured 80 × 93.5 centimeters. It featured thirty couples from local families in dress dating from 1200 to 1522, framed by 202 local coats of arms. This required major historical work, as most of the patrician families at this time had died out. Contemporaries were depicted in a lifelike fashion. In the center of the background, a man fought against death. In the foreground stood "common people," including Renner himself and the four fools, with an indication of their names. At the

very end of the party stood Matthäus, his left arm raised above his shoulders as if to invite his onlookers to join this march of time and manners. This parchment was hung up and sparked off a genre of its own in Augsburg, called the patrician's dance, though it never again included fools and common folk[16] (Figure 1.9).

In 1524, Schwarz worked out Christ's genealogy and got Renner to illustrate it on parchment, not, of course, without forgetting to include a portrait of himself (see Figure 1.1). In addition, Schwarz also commissioned two medals of himself, as well as a panel portrait in oil by Hans Maler, a renowned painter who also worked for the Fuggers and Queen Anne of

15. On the *Gebetbuch*, see Georg Habich and Ruth von Bernuth in the bibliography; special thanks go to Dr. Michael Roth from the Kupferstichkabinett in Berlin, where this small, fragile manuscript is held, for his discussion of it.

16. For a black and white depiction and discussion, see Fink, *Trachtenbücher*, 31; for a large depiction, see Merkl, *Buchmalerei*, Plate 255; for a small color plate, see Cat. *"Kurzweil viel ohn' Maß und Ziel." Alltag und Festtag auf den Augsburger Monatsbildern der Renaissance* (Munich: Hirmer, 1994), Plate 6; the motif of Schwarz in this posture was remembered locally and features on the Pahler-Imhof wedding plate in 1572; Fink, 36. See figure 1.10.

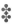

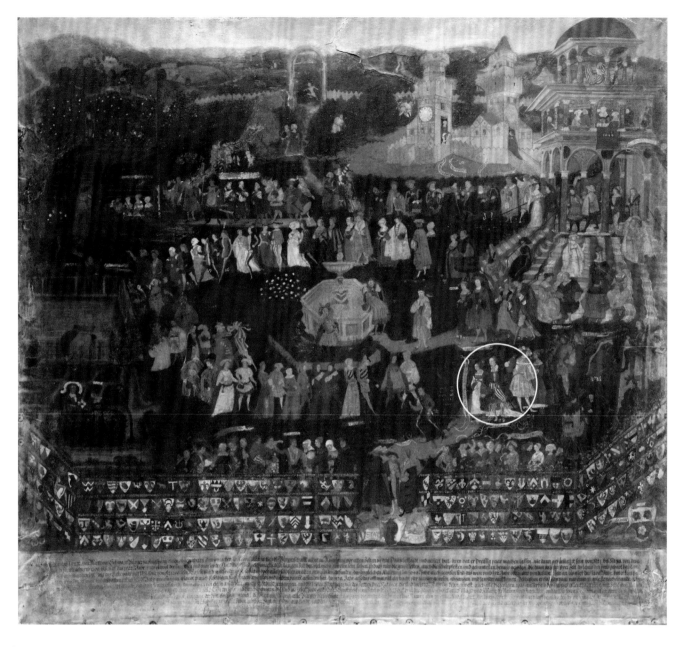

Figure 1.9. *Narziß Renner, Garden-dance in Augsburg, 1522. © Maximiliansmuseum, Augsburg.*

Hungary. This panel was completed in 1526 and now hangs in the Louvre's Northern Renaissance Gallery (see Figure 1.6).

By 1527, at the end of his twenties, Schwarz's projects slowed down. He kept his book of clothes going, but after 1535 he merely added twenty-nine pictures during twenty-five years. In 1541, Schwarz commissioned another panel portrait of himself at forty-five, after he received a diploma of nobility, an *Adelsdiplom*. This painting now hangs in the Thyssen-Bornemisza collection in Madrid (see Figure 1.13). He commissioned a matching portrait of his wife and two further medals in advance of major political events, the Imperial Diets in 1550 and 1551 (see I 133, 134).

The book of clothes ended with him dressed for Anton Fugger's funeral, after a gap of seven years without any images and fourteen years before Schwarz himself died.

Through all these depictions, Schwarz could see himself growing up, maturing, and growing old. Yet, he remarkably succeeded in creating his legacy. A game piece (used for board games) made from limestone, after his 1530 medal, depicted him alongside figures such as Jakob Fugger, Hieronymus Fugger, and Wilhelm IV of Bavaria. A 1572 wedding bowl of the Augsburg Pahler-Imhof family depicted Schwarz as a young, fashionable man leading a dance, as in the 1522 parchment

(Figure 1.10). The Augsburg art agent Philipp Hainhofer included Schwarz's medals as young and old man in a cabinet that he sent to the Duke of Brunswick-Lüneburg in the seventeenth century, alongside medals of Jakob Fugger, Conrad Peutinger, Matthäus Lang, Albrecht Dürer, and various popes. Schwarz was commemorated as one of the men who had defined the tone of their time.[17] This extraordinary achievement lasts until today. Matthäus Schwarz is the only accountant whose portrait hangs on the walls of two international museums.

Schwarz and Renaissance fashion

Seen in isolation, however, both the Louvre and Madrid panels provide a strikingly misleading sense of his wardrobe for most of his life and hence the aesthetic movement he helped to create. Schwarz chose to be depicted in restrained colors for the portraits, to particularly highlight exquisite, innovative jewelry. By contrast, up to his marriage at the mature age of forty-one,

17. Cupperi, ed., *Wettstreit*, 109, Plate 14; Fink, *Trachtenbuch*, 36, Plate 27; Ronald Gobiet, ed., *Der Briefwechsel zwischen Philipp Hainhofer und Herzog August d.J. von Braunschweig Lüneburg* (Munich: Deutscher Kunstverlag, 1984), 852.

Figure 1.10. *Pahler-Imhof Wedding-bowl, Augsburg, 1572, which depicts Matthäus Schwarz leading a dance at the end of the first quarter of the upper right rim.* © *Maximiliansmuseum, Augsburg.*

Schwarz was at the forefront of those commissioning clever, colorful clothes.

Schwarz has been credited as "inventor of the birthday." Unusually for his time, he regularly marked the 20th of February as a special day in his life.[18] This related to his particularly strong belief in the significance of his birth horoscope, but it also served as an excuse to plan a new outfit he could be depicted in. Just after his twenty-sixth birthday, for instance, he wanted to be depicted in a spectacular all-white doublet and hose made from linen and cotton; the doublet, he claimed, had 4,800 small, delicate slashes. Large slashes and short, precise "pinking" had become a hallmark of German tailoring skills at this time, and Schwarz drove this look to extremes. Small black ribbons were used as a girdle, on the sleeves, and as trimmings.

As Maria Hayward sets out in detail below, all of Matthäus Schwarz's outdoor outfits were highly decorative in this way. These came in a wide range of colors. He rarely specified where exactly these fabrics came from, but his references included Italy, Spain, and Flanders. In 1538, he wore a violet gown with broad black velvet trimmings with a white, padded and patterned doublet and hose made from Turkish silk. Schwarz often commented on a construction rather than circumstances in his life. The inscription for a 1540 depiction, for instance, ran: "20. February 1540: a Spanish gown with two velvet borders and silken bands."[19]

He appeared almost proud when tailoring costs were in excess of the money for materials. For contemporaries, such investment in making skills was the benchmark for definitions of a new type of luxury.[20] Luxury of this kind was not necessarily conspicuously wasteful. Much could be reworked and handed on. Some gowns were slightly altered or dyed in different colors over a number of years. Still, discerning customers, such as Schwarz, needed to find superior dyers, tailors, tanners, and furriers whose technical skills were constantly adapting to changing demands. In addition, such demanding consumers had to be prepared to make a long-term effort and invest time, to use all their networks of information as well as diverse agents, exercise constant quality control, and push for the right pieces and prices at the right time. Fine, technically intricate clothing registered as achievement in this world.

Sumptuary legislation hence frequently made rather generous allowances. The 1530 Imperial "Police" Ordinance, for instance, permitted even daughters of peasants and unmarried peasant women to wear hair ribbons of silk. Townswomen were allowed to wear expensive belts with silver decorations, as well as a golden ring and a collar with silk embroidery. Unmarried women were permitted special velvet hair ribbons with silver decorations. Urban craftsmen and commoners were told not to wear gold, silver, pearls, velvet or silk, marten fur, bonnets (*Pirret*), or slashed clothes. They were, by implication, allowed to wear taffeta, other types of fur, decorated ostrich feathers, caps, and so on. Any craftsman elected to the town council was allowed to dress like merchants. Merchants were forbidden velvet, damask, silk satin or silk gowns, silver, pearl, silk, or golden or silver cauls, but they were allowed to wear silk doublets, camlet gowns made of the finest wool, fur from the throat of martens, and golden rings. Their wives received more generous allowances for up to two ells of velvet, sill, silk satin, or damask trimmings. Noblemen were told not to wear any velvet either, and at the most damask or silk of similar quality, which could be trimmed with up to six ells of velvet.[21] In 1548, the next Imperial Ordinances demanded that authorities should issue dress laws appropriate for their territory or otherwise pay significant fines.[22] Yet sixteenth-century sumptuary laws are difficult to identify for many German cities, and Augsburg saw no particular effort to implement sumptuary legislation until 1583. Its first sumptuary ordinance seems to date from 1568, when Schwarz was an old man. Cities were clearly torn between their wish to use dress to regulate expressions of gender as much as rank and the typical Renaissance endorsement that cities were aesthetic communities.[23]

Accessories

To be well dressed in this period therefore could mean to be cultured, and this required not just linen shirts, hose, doublets, and gowns, but also a range of accessories. Matthäus regularly wore jewelry, and these pieces provided most continuity for his appearances, like trademarks: for a long period from the age of seventeen he was not without a crucifix on a long chain, then followed several pieces of golden, pearl, and coral jewelry. He depicted himself more rarely wearing rings, but he

18. Jean Claude Schmitt, *L'invention de l'anniversaire* (Paris: Arkhe, 2008).
19. Fink, *Trachtenbücher*, 167, I 121.
20. Fink, *Trachtenbücher*, 142, I 74.
21. Matthias Weber, *Die Reichspolizeiordnungen von 1530, 1548 und 1577. Historische Einführung und Edition* (Frankfurt-on-Main: Klostermann, 2002), 142–50.
22. Weber, *Die Reichspolizeiordnungen*, 181, 229.
23. See Liselotte Constanze Eisenbart, *Kleiderordnungen der deutschen Städte zwischen 1350 und 1700. Ein Beitrag zur Kulturgeschichte des Bürgertums* (Göttingen: Musterschmidt, 1962), 163–67, which is not meant to be inclusive but nonetheless seems indicative. For Amberger's Augsburg portraits in relation to Imperial sumptuary legislation, see Neithard Bulst, Thomas Lüttenberg, and Andreas Priever, "Abbild oder Wunschbild? Bildnisse des Christoph Ambergers im Spannungsfeld von Rechtsnorm und gesellschaftlichem Anspruch," *Saeculum* 53 (2002): 21–73; for the limited reach of sumptuary legislation in Nuremberg, see the extensive work of Jutta Zander-Seidel, *Textiler Hausrat: Kleidung und Haustextilien in Nürnberg von 1500–1650* (Munich: Deutscher Kunstverlag, 1990). On German sumptuary legislation, see my forthcoming article in Giorgio Riello and Ulinka Rublack, eds., *The Right to Dress: Clothing Practices and Sumptuary Laws in the Early Modern World* (forthcoming).

prominently displayed three rings on the opening page of the book and in a later panel portrait of him in 1542.

Schwarz's armor was highly varied. As his fashion chronicle unfolded, he showed himself able to wield almost the full range of contemporary weapons: swords of differing length, bows and arrows, a rapier, sword, and spear. He also fenced and nearly always carried a long sword at his side. German men carried weapons for aesthetic display as much as to mark wealth and a civic, virile adult masculinity. Violent fighting for honor was frequent even among elite men, although Schwarz carefully kept out of these forms of combat.

Schwarz wore a good, but not excessive, range of shoes and boots, but never remarked on them. Shoes considerably influenced deportment. It is clear that the most commonly worn open shoe with narrow sides, the *Hornschuh*, required care to maintain balance and forced the wearer to tread slowly. They had to be fitted with care to ensure that a man did not slip out of them. Yet they were generously cut, and hence must have seemed a great liberation from narrow, pointed Gothic shoes, which had been in fashion for all of the previous century. Hose could be directly sewn onto shoes to add stability. Once in 1530 Schwarz even preferred comfortable mules outdoors, which Ottomans typically wore, but which were only suitable in dry conditions.[24]

Schwarz's headwear characteristically was a much more important and versatile item. It drew attention to the head as the noblest part of the body and would be used for an eloquent symbolic language of paying respect to and greeting others. Rules defined when to take one's cap or bonnet off, when to raise it or merely touch it, and these could be played with. Schwarz only depicted his hair shoulder-length in Venice but otherwise increasingly short, cut just over his ears, which gave his headwear a better and more stable fit. From 1522 onward, he frequently wore a caul underneath his caps. Headwear was seasonal. In 1524, Matthäus thus wore a warming cap with fur in January, while in May he had proudly obtained a red cap with gold-colored dots, which, as he noted, had belonged either to the duke of Milan (Massimiliano or Franceso II Maria Sforza) or the "Duco de Bari." He sported this cap in an astonishing ensemble with a tight doublet of violet damask woven with a pomegranate pattern edged with two golden borders, violet hose, and a short trunk-hose with yellow panes and red points.[25]

This suggests how much Schwarz enjoyed putting together his ensembles but also that he responded to fashions among Italian or Spanish high aristocrats. Wealthy urban elites in Augsburg or Nuremberg characteristically blurred the boundary between their burgher or patrician descent and noble living, and accessories, such as headwear or gloves, were an important tool

to project a particular identity. By June, two of Schwarz's male friends had noticed his fascination with headwear, so much so that they gave him a cap. A well-located Augsburg friend working in Antwerp gave him a beautiful scarlet bonnet with golden threads, three gold buttons, and a black gemstone set in gold—a sign that the friend clearly accepted his particular love of clothing. Matthäus commented excitedly: "it is scarlet red and from super fine (material) from Valencia in Spain, costs 8 florins and has gold threads, I went to Andre Schregl's wedding like this."[26] Despite the fact that it had been a gift, he knew exactly how much it was worth. Even though he worked as an accountant, this was the only time Schwarz indicated the monetary value of anything he wore, probably to avoid accusations of illegal overspending or recording his reciprocal obligations. Right up to Matthäus's old age headwear documented his interest in exploring the fashionable possibilities within an international market he skillfully accessed to express his sense of life.

The message of many of his clothes up to his wedding was about emotions as much as status. A particular interesting element was Matthäus's open sentimentality, as courtship ideals jarred with his real prospects. Ulrich Schwarz the Elder, his disreputable grandfather, was remembered locally as a man who had foolishly challenged elite power. The Fugger merchants were controversial patrons. Matthäus's own parents had already died and so were unable to arrange a marriage for him. Heart-shaped purses, which he wore in green and red (the colors of hope and desire), seem to reflect a young man's search for love, and green clothes underlined this hopeful quest for luck. His son would later wear padded breeches embroidered with alternating hearts turned right-side up and upside down.

Embroiderers as well as purse makers translated these young men's quest for such surprisingly romanticized love into commodities. Because of its many small craft workshops, Augsburg attracted a large number of young apprentices and journeymen, who lived with their mistress and master in the hope of starting their own business and family in their late twenties. In 1539, almost 2,000 unmarried manservants were counted in 5,066 local households.[27] Their sexual adulthood before marriage was extremely prolonged, and interest in appearance as much as courtship was a key feature of their leisure pursuits. They formed strong bonds among groups of friends, but they also competed intensely with each other. Men's pay was higher than women's, and this too helped to make urban young men drivers of innovative Renaissance fashion. The Frankfurt patrician Bernhard Rohrbach, for instance, began in 1464 to describe the clothing he commissioned together with

24. Fink, *Trachtenbücher*, 156, I 104.
25. Fink, *Trachtenbücher*, 138–9, I 66.

26. Fink, *Trachtenbücher*, 139, I 67.
27. Lyndal Roper, *The Holy Household. Women and Morals in Reformation Augsburg* (Oxford: Oxford University Press, 1989), 34, 51. See also, Table 1.1,

groups of male friends and to include designs for specific parts of his dress or devices. He exhibited a similar interest in new materials, colors, and styles.[28] Now, even sports clothes were carefully considered. Ball games, fencing, as well as shooting, were seen as integral to ideals of elegant, athletic Renaissance men. Matthäus also had special carnival clothes made up, but he excluded them from his record.

Dressing up

As status, romance, and aesthetic pleasure most guided his choice of fashion, Matthäus Schwarz up to the age of thirty-eight recorded particular care in dressing up when he was courting particular women (for a "beautiful person," he once comments); for political and social occasions, as when he twice met Ferdinand of Austria and subsequently attended Ferdinand's wedding to Anne of Hungary; at other weddings; and at male society gatherings.

A high point of his attempt to gain Imperial recognition was 1530, when Charles V returned to Germany after nine years, for the Imperial Diet of Augsburg with his brother Ferdinand. Schwarz recorded no less than six new and highly complicated outfits that he had commissioned for these exceptionally hot summer months—one explicitly to "please Ferdinand." Charles and Ferdinand themselves used this Imperial Diet for an extraordinary attempt to secure the magnificence and power of the Habsburg dynasty, not least through finalizing further deals with the Fugger company. Ferdinand had just convinced Charles that he should promote him as king. The king alongside the Emperor decided whom to ennoble and grant a coat of arms. Matthäus Schwarz therefore decided to please Ferdinand through sartorial magnificence as he aspired to be ennobled (I 102). He looked slimmer at the Diet, and his hair was cut very short, just as this generation of Habsburgs now preferred. He wore yellow—Ferdinand's favorite color to express joy. This is a superb example of the most refined as well as successful bourgeois power-dressing at the time. The outfit has been reconstructed by Jenny Tiramani, and this edition includes patterns for different parts of the garments, which included a fine linen shirt, leather hose, and a doublet made of alternating panes of silk satin and damask.[29]

There is no sense, thus, that dressing up for Schwarz was an art in itself or foolish frippery. He did so to explore fashion but always for specific different social or political occasions, for courtship, social promotion, work, or to meet his peers. Close friends usually belonged to the thirty-nine families exceptionally permitted to enlarge the Augsburg patriciate (*Geschlechter*) in 1538, a closed circle of eight remaining families who socialized in "The Lords' Chamber" (*Herrenstube*), or else belonged to the so called "Merchants' Chamber" (*Kaufherrenstube*).

Wide streets and squares in the center of Augsburg, between the triangle of the Fugger houses, the Perlach square, and Golden Writing Chamber, provided public sites in which men such as Schwarz could effectively show off their wardrobes and armor as they walked about, customarily shook hands, or speeded about in elegant sleighs tellingly decorated with courtship scenes when there was snow. They showed off social belonging—such as to groups of young friends in similar or exactly the same dress (see, for example, I 51)—as well as more individual stylistic preferences. Matthäus Schwarz was one among many, for example, who decided to commission works of art in advance of the Imperial Diet in 1530 to fit into a display of sophisticated civility for an internationally significant event.

The sexual reformation

As the book of clothes progressed up to 1535, Schwarz's social life nonetheless began to look increasingly odd. By now, he had completed 111 images with Renner, on a number of which he showed himself attending weddings of close friends. He was thirty-eight and still a single man. The religious debates, which had gripped Augsburg for over a decade, insisted that sexuality was part of every adult life, but it had to be confined within marriage. As Protestantism gained influence, prostitution was forbidden and premarital sexuality punished. Celibacy was thought to be impossible. This targeted the sanctification of clerical elites as much as the lifestyle of a prolonged male youth, marked by emotional, and often sexual, experimentation, as well as projecting a slim, delicate, more androgynous look, which Schwarz cultivated in such a striking way. Many guilds-people now supported the Protestant idea that only a married man building up his own legitimate lineage was considered a proper adult and entitled to become a master.[30] This married, mature man had a more massive, masculine body.

Hence, Augsburg's more diverse sexual culture was criminalized. In 1532, a whole group of young men was caught for engaging in "florencing"—a verb derived from the city well

28. Fink, Trachtenbücher, 22; Pierre Monnet, *Les Rohrbach de Francfort. Pouvoirs, affaires et parenté à l'aube de la Renaissance allemande* (Geneva: Droz, 1997), 371.

29. The reconstruction was generously financed by Cambridge University and St John's College. Jenny Tiramani explains the reconstruction in the following videos: www.bbc.co.uk/news/magazine-22766029 and www.cam.ac.uk/research/features/the-first-book-of-fashion. For a historical contextualization see my forthcoming articles "Dress as Symbolic Communication: The 1530 Imperial Diet," in *Arrayed in Splendour: Art, Fashion, and Textiles in Medieval and Early Modern Europe*, Christoph Brachmann, ed. (Turnhout: Brepols, 2015) and an article on the reconstruction process for a special issue of the BARD Graduate Center journal edited by Pamela H. Smith, to be published in 2016.

30. See Lyndal Roper, *The Holy Household: Women and Morals in Reformation Augsburg*, (Oxford: Oxford University Press, 1989).

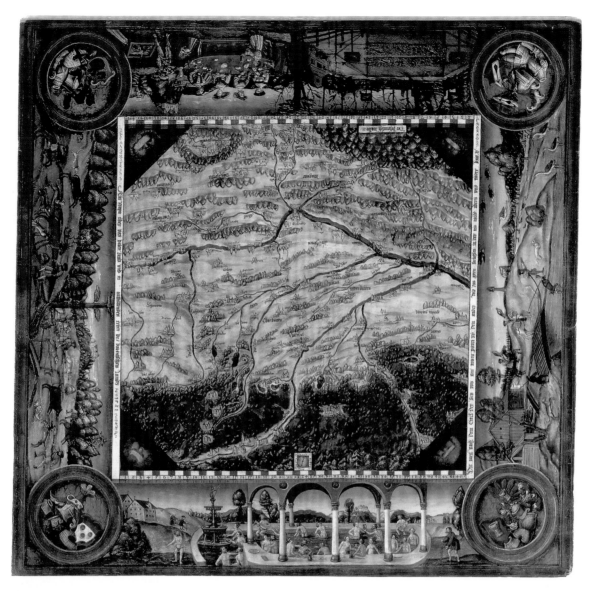

Figure 1.11. *Detail from a table top with a map of Bavaria, Landshut, 1531, just before the implementation of strict sexual regulation in Augsburg. © Bayerisches Nationalmuseum, Munich.*

known as a Renaissance hub of homosexuality. Jakob Miller, a bathhouse attendant, thus confessed to have "fooled around with Berlin the fruit-seller, and Berlin with him, and each florenced the other about three times." This culture of sexual play revolved around male drinking and socializing across social hierarchies in Augsburg's bathhouse. Among others, it involved a member of the Welser family, who was also an active iconoclast, alongside a priest and a honey-cake baker, although no high status person was ever formally questioned by the magistrate.[31]

The civic brothel, which had the sanctioned purpose of providing controlled, affordable heterosexuality for single men,

was closed in that very same year and the trade criminalized. This was a milestone for a city whose female patron saint was the Cyprus princess St. Afra (died 304), who according to legend had arrived as a pagan prostitute in response to a prophecy that she would do great things in Augsburg. After 1532, no public role or redemption was promised to women who engaged in illicit sexuality (Figure 1.11).

Such vigorous fighting about just how the city might purge itself to become "godly" led Augsburg's magistrate to formally introduce Protestantism in July 1534, although it still allowed eight churches to celebrate Catholic mass. In 1537, it abolished all Catholic services. The entire Catholic clergy left town, and a new mayor, whom one critic felt "would make a better military officer," led a council that forbade Catholic holidays, cleaned

31. B. Ann Tlusty, ed., *Augsburg during the Reformation: An Anthology of Sources* (Indianapolis: Hackett, 2012), 121–31.

churches of unsuitable artwork, and pushed through a great "discipline" and "marriage ordinance." This ordinance lauded "holy Matrimony" as the "highest and most necessary bond among humans."[32] All this put pressure on Matthäus Schwarz to get married.

In addition to the empire's "Police" ordinances, there were now recurrent attempts to fight frivolity and excess in drinking, deportment, and entertainment. One mandate in 1541 demanded that "all musicians, waffle sellers, acrobats, and ridiculous, wanton comedians or dancers should stay out of the inns and guildhalls," while everyone was to enjoy no more than four course dinners and be taken to the "fool's house" if drunk, for wasting money.[33] In May 1542, even Schwarz and two of his friends agreed to abstain for one year from the usual custom of drinking to men's health by downing half or a whole glass of alcohol. Matthäus duly celebrated in 1543 by having himself depicted happily raising a large glass of brown beer. (I 123, I 124). Such behavior was typical—ordinances were hard to completely ignore but also impossible to rigorously implement. Still, overall, the town's moral climate noticeably tightened. Carnival masking was prohibited for fear that commoners might parody clerical vestments and cowls.[34]

Soon, Augsburg paid bitterly for offending the Emperor and involving itself in a war. In 1546, the city fought with the Protestant League. In the wake of its defeat, the city was occupied by Imperial troops and severely punished by Charles V, who abolished all its craft guilds, which he saw as leading the resistance against established patrician elites, the Habsburgs and Catholicism. Even so, after the Emperor's own defeat, the 1555 Peace of Augsburg exceptionally conceded that Augsburg would from now on tolerate both Lutheranism and Catholicism.

As a man attached to Catholicism and his city, Schwarz lived through these changes painfully. He would have deeply resented the full introduction of the Reformation in 1537. One year later, he threw away the diary of his youth, recorded the fact on an otherwise empty page in the book of clothes, and decided to marry Barbara Mangold, a Fugger factor's daughter. He began wearing his heart-shaped little purse in black, and they suited his far more restricted color choices of mostly black, brown, or white as a middle-aged man. All this suggests that his view of life had changed—the wedding had not been the exciting match he had hoped for as a young man. It made Matthäus Schwarz respectable, but it did not enable his further social ascent within Augsburg's patriciate (Figure 1.12). He never depicted Barbara

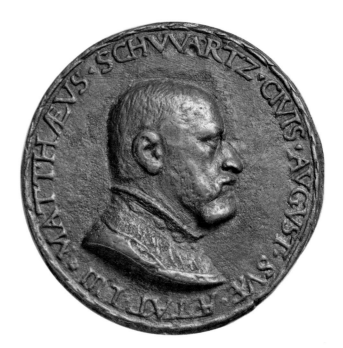

Figure 1.12. *Hans Kels, Medal for Matthäus Schwarz, 1550. © Staatliche Münzsammlungen, Munich.*

in his books of clothes, although he greatly enjoyed displaying his new dress for the wedding.

Marriage and ennoblement

Barbara Mangold was born in 1507 and already thirty-one when she married Matthäus in May 1538—unusually old for a perfectly well-off daughter whose father was still alive. Within the next five years, the couple produced a family of three children. Matthäus Ulrich (named after his father and grandfather) was born in 1539; a further son, Veit Konrad, in 1541; and a daughter, Barbara Agnes (named after her mother and Matthäus's mother) in 1543. Schwarz did not represent himself as an emotionally distant father—the children, rather than his wife, feature as the only other figures besides Jakob Fugger in the book of clothes after his youth. In 1541, moreover, Schwarz returned to the idea of keeping a diary. For the next fourteen years he recorded his children's pranks and other events that marked their youth to aid their own memory (Figure 1.13).

Despite the Reformation and Matthäus's more constrained life as a family man in his forties, this period still offered another high point when he was finally ennobled in 1541 alongside two of his brothers. This meant that they had achieved the highest possible honor for a burgher family. By implication, he could wear the most expensive furs and fabric more easily, although Imperial ordinances mandated against full velvet outfits even

32. Roper, *Holy Household*; for the quote about the mayor, Hans Welser, see Tlusty, *Augsburg*, 29; the ordinance is on 100–104.
33. Tlusty, *Augsburg*, 31.
34. Friedrich Roth, *Augsburgs Reformationsgeschichte*, vol. 4 (Munich: Ackermann, 1911), 310.

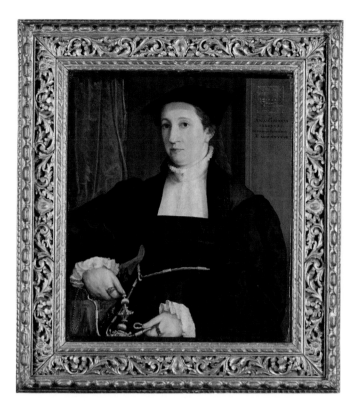

Figure 1.13. *Left: Christoph Amberger, Portrait of Barbara Schwarz, oil on panel. © Christie's Images Limited 2014. Right: Christoph Amberger, Portrait of Matthäus Schwarz, 1542, oil on panel. © 2014. Museo Thyssen-Bornemisza/Scala, Florence.*

for the nobility. After his brothers had died, Matthäus would several times request a formal confirmation of his nobility from the Habsburg, which allowed his oldest son to join a knightly order.[35] Like the Fuggers, Schwarz never used his title. Even so, he instantly depicted his coat of arms in his book and commissioned those portraits of himself and his wife from Christoph Amberger, the best local artist, who at much the same time also portrayed two men of the Fugger family.

Amberger (c. 1505–1562) in his teens had worked with Hans Maler in Schwaz, who executed the Louvre portrait of Matthäus. Having arrived in Augsburg, Amberger married the daughter of his master Leonhart Beck and hence was admitted into the craft of painters in 1530. Ten years later, he increasingly adapted influences from international court painters, such as Holbein, Seisenegger, and Titian to reach the high point of his artistic ability in naturalistically depicting lustrous fabrics, such as silks, as well as jewelry and other symbols of elite belongings, such as gloves. Accordingly, Amberger in the years around 1540 attracted many portrait commissions from local urban elites, especially those who had just been admitted to the exclusive circles of the patriciate

and *Herrenstube*, or felt that they should have been admitted. For Schwarz, Amberger would have been an obvious choice to celebrate his ennoblement and thus the only type of recognition for which he could ever have hoped, given his family's crafts background and his grandfather's execution.[36]

Schwarz used the portraits to record his role as a married civil man of honor and mature refinement by having Amberger depict the couple's jewelry with particular skill. This is particularly clear when we look at Barbara's face, which might well have been done by someone in Amberger's workshop and compare it to the detailed portrayal of the rare and exquisite silk girdle with its tassel. Schwarz himself wore an elegant toothpick in a golden cover decorated with a large pearl, as well as a silver-embossed dagger. The background in the portrait unconventionally depicted turbulent weather over a distant landscape. Matthäus throughout his adult life tried to meet the challenge of exactly measuring hours and minutes. Even so, he did not represent time as something that could be controlled but emphasized that everything was about to change and hence temporality as such—the minutes would tick on and age

35. Fink, *Trachtenbücher*, 15.

36. Annette Kranz, Christoph Amberger, *Bildnismaler zu Augsburg: Städtische Eliten im Spiegel ihrer Porträts* (Stuttgart: Schnell + Steiner, 2004).

would progress. This sense also informed his wife's portrait. The untidy pearl necklace next to Barbara's hands might fall, the wine glass would empty, thunder was about to start. Many contemporaries were interested in astrology. The Fuggers owned a vast collection of horoscopes to see whether their fate corresponded to other people's constellations.[37] Yet the Schwarzes' portraits are unusual to include birth horoscopes to underline a sense that a person's character and fate was ultimately shaped by the stars.

Schwarz suffered a stroke in 1547, which he perceived as divine punishment. He was up in the early hours of the morning, doing his accounting for the firm at five o'clock in the morning. It was the middle of December 1547 and would have been pitch-dark. "God's force" hit him. Aged fifty-two, Schwarz stayed at home for a whole year. This was the very year in which Emperor Charles punished the guilds and reestablished Catholic practices. Patricians defended their right to rule against poor craftspeople of insufficient judgment. Matthäus's grandfather kept being remembered.[38] It was just as well for Matthäus Schwarz not to be seen in the streets.

At this time, prospects for the mighty Fugger firm, too, suddenly appeared bleak. Anton Fugger worried constantly about the future of his business, and he had already withdrawn from Hungarian trade. He considered dissolving the whole company and felt frail and mentally strained. By June 1557, Philip II of Spain, son of Charles V, responded to state bankruptcy with an effort of debt conversion that implied enormous losses for the Fugger firm. Philip soon decided on further measures, which squeezed their economic position even more. These were the greatest financial challenges the Fuggers had faced.

When Anton Fugger died in 1560, Schwarz had worked as his head accountant for thirty-four years. He now was sixty-three years old, a white-haired man dressed in traditional mourning clothes for his master's funeral as an "allegory of winter" (I 137).[39] Schwarz himself compared this image to that of Anton Fugger's wedding to remind himself of happier times. He also decided to end his chronicle of fashion and lived as a well-off man with his family in his house on Augsburg's *Obstmarkt* (fruit market) until 1574, well into his seventies.

Interpreting the *First Book of Fashion*

Over the past two hundred years, Schwarz's unique record has been used and interpreted in different ways. It was widely known in Germany from the eighteenth century onward, but was mostly belittled as the curious record of a fashion fool. During the twentieth century, the image of Schwarz

with "Fugger the Rich" began to be frequently reproduced to illustrate the reach of long-distance trade. There was also noticeable interest in the rare childhood scenes to reconstruct everyday life. Dress historians referred to particular features of the book. August Fink, director of the Herzog Anton Ulrich-Museum in Brunswick, worked for twenty years on a remarkable black-and-white edition with a full commentary. Fink rightly stressed the exceptional value of the manuscript for the history of fashion and explored how Matthäus's dress preferences reflected those of his period.

Cultural historians have frequently referred to Schwarz's project alongside other sources since the 1980s when writing about concepts of personhood, gender, religion, and the life cycle in this period. Two articles provide an interpretation of the manuscript as a whole. Valentin Groebner warned that despite its naturalistic manner, the book of clothes does not lead us into the intimate, private world, or "real" self of a sixteenth century man.[40] Rather, it documented a controlled recording of well-performed social roles, which enabled Schwarz to successfully navigate a complicated urban world that often seemed incalculable. Seen from this perspective, Schwarz thus needs to be grasped in the most literal sense as an expert in self-fashioning: a shrewd bookkeeper, whose self-perception was structured by the merchant world he lived in—that is, a daily practice of accounting, registering, judging trust, manipulating, and being aware of others' manipulations, which was replicated in sartorial management.[41] Gabriele Mentges agrees that by "orienting himself closely to the order of bookkeeping," Schwarz successfully transformed his life into a linear structure and thereby developed a "coherent" sense of "masculine" self-hood.[42]

This, however, makes Schwarz too easily fit a story that sees the Renaissance as the emergence of "economic man," who controls his actions through strategic reasoning to maximize professional achievement and capital gain. In contrast to these views, it can be argued that Schwarz produced no controlled experiment, or "picture chain," similar to a continuous account book registering business figures. His appearances were certainly highly staged and expressed a new kind of self-awareness among urban burghers, as well as an interest in accurately chronicling faces and objects. Yet what makes these images so fascinating is that they are as much about the loss of control as about the ability to control, about the grip of social roles and their limitations for the expression of desire, as well as about mortality. As Ruth Slenczka has recently argued, this is underlined by Schwarz's

37. Kranz, *Amberger*, 322.
38. Chroniken der deutschen Städte, *Hektor Mairs Chronik von 1547–1565*, 126.
39. This is Marina Warner's expression, *London Review of Books*, January 2012, 12.
40. Valentin Groebner, "Inside Out: Clothes, Dissimulation, and the Arts of Accounting in the Autobiography of Matthäus Schwarz, 1496–1574," *Representations* 66 (1999): 101.
41. Groebner, "Inside Out," 115.
42. Gabriele Mentges, "Fashion, Time and the Consumption of a Renaissance Man in Germany: The Costume Book of Matthäus Schwarz of Augsburg, 1496–1564," *Gender & History*, (14/2002): 382–402, esp. 397–9.

care to note down his precise age at every point, as well as his illnesses, which could strike without warning.[43] These more nuanced feelings were supported by his astrological beliefs and most likely related to the limitations his grandfather's execution placed on male family members to achieve high-ranking local marriages, as well as careers in local politics.

This led not just to strategic thinking. It sparked off his passionate aesthetic fascination for perfection in dress in dialogue with the past, as a vanishing moment of creativity and pleasure. Alongside this burgher's struggle for honor, the book's deeply documented creativity and "serial presentation" of fashion remains its most remarkable features.[44] Dress was not just something external. It constituted a sense of the body and a way of life. Hence clothing was already crucial for an *experience of the self in itself*. Schwarz once even precisely notes his waist measurements, as he worried about gaining weight, which to him signaled aging and diminished attractiveness.

A preoccupation with fashion, moreover, built on searching questions about temporality. Since the early fifteenth century, artists keenly studied older works of art to observe "outdated fashions" and integrate accurate historical elements in their work. This responded to a greater awareness of how much dress styles fluctuated. They appeared as part of culture rather than as merely functional. Alarmingly, much of what had been valued in the past could seem misguided and hence suggested that all culture, including art, was a succession of styles that perhaps neither increased sophistication nor achieved timeless beauty. To document fashion hence meant to explore human history, how "the past saw" and how one might be seen. Was there meaning in change? Could anyone transcend being a product of his or her time, laughable to future generations?[45] Fashion made the past and present look arbitrary rather than presenting a linear story of progress or of a memory, which might be controlled.

Schwarz's chronicle of dress hence challenged the outlook of the increasingly fashionable books of honor compiled by elites in Augsburg and Nuremberg at the time. These were designed to cultivate memory as well as actively record achievement by assembling historical evidence through the documentation of honorable marriages, coats of arms, and legitimate children. They provided historical arguments for property claims and further distinctions, were copied and shown to others to document names and connections, origins, rank,

and prestige. We can see them following on from Maximilian I's exceptionally ambitious projects in print to chronicle ancestral achievement as "firmest foundations of both his territory and his talents."[46] The *First Book of Fashion*, by contrast, emerged in the shadow of ancestral failure—a grandfather's execution. This made it far more open in design. It even portrayed Schwarz nude in an un-idealized manner ("I had grown fat and large") and entirely differently from the muscular, lean male nudes his prayer book depicted for Judgment Day.

A patron and his painters

Apart from medals, Schwarz never produced any of his visual or written projects for circulation or print. This meant that he decided who had access to them, could change them, or, in the extreme, as with *The Course of the World*, his diary about his youth, destroy them. The book of clothes seems to have been treated as a private record, which Schwarz shared with selected friends and acquaintances; it was neither, as far as we know, publicly displayed, nor a completely secret book that only he looked at. A codicological analysis suggests that some of its sheets would have been fastened together before it was bound in 1560, which would have made it easier to show them to others. Some of the text even directly addressed others—"You do the same as me!" Schwarz exclaims as he recounts the story of how he was believed to be dead as a toddler, sewn in a shroud to be buried, and then suddenly moved his foot. It was meant to be looked at and read by a selective audience.

This could be just the same for panel portraits or medals. Portrait paintings were not usually hung up on walls but put into chests and selectively displayed to onlookers, so that they would take on much of their meaning from the precise setting in which they were revealed: how long ago paintings had been made, by whom, and to whom they were shown for what purpose. Augsburg's humanist Dr. Conrad Peutinger, for example, told his relative Hans Welser in 1537 that he could be visited at home any time to show him paintings relevant to reconstruct the family's distinguished history: one portrayed a tournament among high-ranking men at the occasion of a relative's wedding, and another panel depicted both his and his wife's genealogy down to the fourth degree.[47] It is likely that portraits were mostly used in such a documentary way to chart family history.

Schwarz wrote the text above most images in his own hand, which can be compared to the hand of the account books he kept for the Fuggers (I 1–108; 140–43).[48] He liked images that were precise, used perspective to the best of his artists' abilities,

43. Ulinka Rublack, *Dressing Up: Cultural Identity in Renaissance Europe* (Oxford: Oxford University Press, 2010), Chapter 2. This aspect of mortality and vanity is particularly emphasized in Ruth Slenczka, "Die Heilsgeschichte des Lebens: Altersinschriften in der nordalpinen Porträtmalerei des 15. und 16. Jahrhunderts," in *Zeitschrift für Kunstgeschichte* 76 (2013), 493–540.

44. Philippe Braunstein, ed., *Un Banquier Mis A Nu: Autobiographie de Matthäus Schwarz, bourgeois d'Augsburg* (Paris: Gallimard, 1992), 107; the same point is stressed by Fink, *Trachtenbücher*, 21.

45. Alexander Nagel and Christopher S. Wood, *Anachronic Renaissance* (New York: Zone Books, 2010), 88–95.

46. Larry Silver, *Marketing Maximilian: The Visual Ideology of a Holy Roman Emperor* (Princeton: Princeton University Press, 2008), 76.

47. Peutinger, *Briefwechsel*, 485.

48. Merkl, *Buchmalerei*, 326.

and included shading effects and costly gilding. Several outline figures were replicated through tracing—a common method at the time, which Lucas Cranach's workshop in Wittenberg used to quickly create multiples. As Fink has convincingly shown, four artists seem to have been involved. The illuminator Narziss Renner executed four-fifths of all images. He had probably been trained locally by his father and, as we have seen, began to work for Schwarz in 1521, at age eighteen or nineteen, when Schwarz himself was twenty-four. Schwarz clearly decided on which details he wanted to be included and frequently added comments as to whether he thought Renner had vividly portrayed him in a lifelike, spontaneous manner (*angesicht recht konterfeit*) or not. Postures, backgrounds, and formats varied over time to make this a lively record, which included several depictions of Schwarz driving a decorated sleigh, for instance. The book of clothes soon became Renner's chief source of income, as he is not known to have worked on any other commission after the age of twenty-three. Tax records show that he therefore remained relatively poor, rather than rising in recognition and pay. This added to the asymmetry in his relation to Schwarz. Renner died after the plague hit Augsburg, in 1536, when Schwarz was thirty-nine. Their collaboration might, in any case, have neared emotional exhaustion in regard to the complicity it required to keep presenting Schwarz as an ever-youthful, handsome bachelor well into his thirties.[49]

Renner had been married since 1525, and presumably had a family to feed. It is extremely likely that his wife Magdalena helped him, as their wedding portrait depicts her holding a brush. A wife's work was common in most trades, and Matthäus would commonly have spoken to a workforce of many female seamstresses and embroiderers' and tailors' wives to discuss his outfits. Women as much as men made business connections—the Renners worked on a printed book of model patterns for seamstresses and embroiderers published in 1533.[50] They increasingly looked for such employment opportunities, as new print media, such as woodcuts and engravings, dominated demand. Some patrons commissioned manuscripts, which included watercolors on paper, but nobody was interested any longer in paying for tempera on parchment. Narziss eventually began to teach school children. It also appears highly likely that Magdalena Renner began to help portray Schwarz for his book more independently while Narziss suffered a long illness (I 93–103) and continued the commission for a short period after he had died (I 113/14).[51]

Narziss Renner's death coincided with Schwarz's identity crisis as he matured, lived through the Reformation, and realized that he would have to marry a woman he did not love. Suddenly, there were longer gaps between images. It seems as if he was at pains to find a suitable end and a suitable illuminator for an increasingly awkward project, which he had embarked on forty years earlier as a young man. At the same time, he aged and his body became bulkier. Schwarz from 1538 to 1546 worked with Christoph Amberger's renowned workshop to commission twelve images (I 115–27), which mirror Amberger's style for panel portraits with its interest in high Italian Renaissance motifs, including those executed for Schwarz and his wife in 1541. Amberger himself was increasingly preoccupied with large projects for the Emperor and others, but may himself have executed images I 121/2. But this was an unusual commission for a workshop that specialized in panel portraiture—no other Amberger illuminations are known. After 1547, one or more artists occasionally took on Schwarz's rarer commissions, which number seven images in total (I 128–34; I 135/36). Jeremias Schemel, the son of a local artist who was just about to become a master himself, ended the project in 1560 (I 137). It seems that he had never worked on parchment before.[52]

The project thus reflected a relationship between patron and painter. This relationship shaped the outcome as in a conversation. It took on different tones with different painters who were let into this, at times, unusually intimate display. And these relationships evolved over time. This context of the production history and its increasingly unusual medium helps to explain why the manuscript and so many of its startling portrayals—such as the two nude paintings—remain unique.

Veit Konrad Schwarz

Except that Schwarz convinced his second son Veit Konrad almost at the end of his own project in December 1560 to attempt a continuation. It followed the same format of providing a prologue and depicting parents, but it featured larger text fields for each image and was larger in size (23.5 × 16 cm). Forty-one images chronicled Veit's life up to 1561, when he was aged twenty. This enabled Matthäus to document what young people had worn since 1540, when he had begun to settle into maturity. Jeremias Schemel worked on this project from January 2 to March 13, 1561. Matthäus left some empty sheets in the book when he bound it, but, as in many other manuscripts, these were never filled, although Schemel could still have taken on further work and Veit repeatedly noted his successful, "diligent" portrayals of dress.

Fashion and his father, Veit Konrad's prologue first reiterated, were foolish. Germans had always imitated other nations. His motivation was to chart changes for those interested

49. For information on Renner, see Merkl, *Buchmalerei*, 50–54; Fink, *Trachtenbücher*, 57.
50. Fink, *Trachtenbücher*, 58.
51. Fink, *Trachtenbücher*, 58–9, with an extensive discussion of the attribution.
52. His best known work on paper is a tournament book and its copies, the 1570 original in the Herzog August Bibliothek Cod. Guelf. 1.6.3. Aug. fol. is digitized online.

in twenty or thirty years' time. Then he became less moralistic to reveal his own creative fascination with dress. He had only included his "nicest" clothes, which had made a favorable impression. Veit loved rivaling anyone in his daringness and love of adventurous, strange clothing. He usually designed all his dress himself and cut slashes on clothes and shoes. This underlines the close involvement of customers with tailors and shoemakers in a Renaissance world "in the making," which helped young people to express their creativity and values through design.

Veit Konrad used his father's diary to reconstruct some childhood scenes and set out what a mischievous, "bad" little boy he had been. Like his father and presumably all boys at the time, Veit Konrad was "breeched" at age five—that is, he received his first pair of hose to emphasize his masculinity and secure control of his bowel movements as he entered school.[53] He spent 1548, the year after which Matthäus had suffered a stroke and rested at home, plagued by illness and away from school. At nine, Veit returned to school, but he continued to be far more interested in play, pranks, and fights than in learning. Three years later, he began as a scribe for the Fuggers, which, as he admitted, had the advantage that he was still thought to be sufficiently immature to understand the secret information he recorded. At thirteen, he left for Italy in 1555. This was four years earlier than Matthäus had gone. Like his father, he stayed in Italy for two years. He replaced his older brother as Fugger scribe in Venice and then entered the firm in Augsburg after his return in 1557.

Veit Konrad now kept a diary, or calendar, to record his life. Courtship clearly preoccupied him as a young adult, but it was deeply frustrating, as he was still too young to marry. At eighteen he was entrusted with the role of leading a bride to her Augsburg wedding for the first time. He hosted a dance for young people in the merchant's chamber together with a friend. For this, he invested a very significant sum of money in his outfit, with the reward that one of Anton Fugger's daughters favored him. This enhanced his reputation, but it still did not lead up to any sustained courtship engagement.

Next, Veit Konrad changed his tailor, as a result of which expenses quickly mounted further still during the same year. He commissioned a fashionable outfit for the Renaissance equivalent of a discotheque—a summer "night-dance" with musicians. "What great fun!" he enthusiastically records. Dancing enthralled him. Even when Anton Fugger died in 1561, and all employees were meant to wear mourning dress for months, Veit Konrad frankly confessed that he had "thrown off" his black clothes on the "17th of February at 2 o'clock."

He needed to get ready for a wedding and dance at the "dance-house." His outfit of choice meant that he would "be seen well." This would be the most expensive ensemble recorded in his book, as he specified the cost of not only the dress but also a diamond and ruby ring.

Still, Veit Konrad only footed half the bill, as he and his three friends had agreed that whichever of them was going to marry first would pay half of the expenses for the outfit of the others. Veit Konrad was certain that he would make a bargain. He was the son of an ennobled citizen whose grandfather had been executed. In all likelihood, his social status was just too odd to allow for a straightforward marriage match that would nonetheless correspond to his expectations. At eighteen, he frankly recorded his exhausted disappointment about mistiming and misplacing his efforts (II 30).[54]

His older brother Matthäus Ulrich, who mostly lived away from Augsburg as an adult, first in service for the Fuggers in Italy and then as knight of the order of St. John in Malta, laughed about Veit Konrad when he returned from Italy and looked at the book of clothes. He entered a rude poem about a woman from Verona whom his "simple-minded" brother had adored, but without understanding that she was mutually interested in him. They had both cried bitterly as Veit Konrad left for Venice (II 18). Veit Konrad remained a single man. Matthäus Ulrich never married either. To Matthäus's mind, the story of his family would have finished with his sons as final male descendants.

Two theories about three copies and fortunes of a manuscript

However, his daughter Barbara Agnes (1543–1589) married in 1573, just one year before Matthäus died. She had children but remained living in her father's house together with her mother and brother Veit Konrad, up to their deaths in 1580/1 (Barbara Mangolt) and 1587/8 (Veit). Matthäus Ulrich had perished in 1570 as knight of the order of St. Stephan in Pisa.[55] Schwarz's daughter therefore outlived her parents and siblings, stayed in the house, preserved the manuscripts and paintings, and passed them on to her daughter, who could not remember her grandfather and sold the manuscripts to the local book collector Jeremias Steiniger. His heirs then sold the Schwarz parchment manuscripts to Duke August the Younger of Brunswick in 1658 for his magnificent library. The duke paid fifty-eight *Thaler*.

According to Fink, Sophie Electress of Hanover, daughter of Princess Elizabeth Stuart and the Elector Palatine, then

53. This is discussed in Heide Wunder, "What made a man a man? Sixteenth- and seventeenth-century findings," in *Gender in Early Modern German History*, Ulinka Rublack, ed. (Cambridge: Cambridge University Press, 2002), 21–48.

54. For an incisive discussion, see Stefan Hanß, "'Tempus fugit': Zeitkonzeptionen in frühneuzeitlichen Selbstzeugnissen" (MA diss., Free University Berlin, 2011), which will soon appear in English as an article.

55. Fink, *Trachtenbücher*, 17.

requested the Schwarz manuscript as a loan in 1704. It is thought that she asked scribe J.B. Knoche, who worked for her court philosopher Leibniz, to make two copies. One of these then remained with her in Hanover, while the other one was sent as gift to her niece Elizabeth Charlotte of Orléans, who resided at the court of Versailles as second wife of Philippe d'Orléans and sister-in-law to Louis XIV.[56]

Philippe Braunstein, however, has recently argued that only the Hanover version is an inferior early eighteenth-century copy, while the Brunswick and Paris manuscripts are similar in quality and production. He argues that both are originals. In Braunstein's view, it is likely that Matthäus made one copy for each of his two sons. Both remained in the Brunswick library until 1806, when, he suggests, one of them was taken to Paris to enrich the Imperial Library alongside other manuscripts and books. The Schwarz manuscript and several others then failed to be part of the reconstitution of these treasures to Brunswick in 1815 and hence remain in Paris to this day.[57]

Yet we have clear evidence that Leibniz's scribe J. B. Knoche made two paper copies of the Brunswick book of clothes for Sophie of Hanover. Her niece Elizabeth Charlotte of Orléans refers to having received a book from her aunt about "him, who has had himself painted in all ages." She added: "custom does much to render dress beautiful or ugly," and, in her next letter to Sophie: "Male fashion is almost as old as the world."[58]

Elizabeth Charlotte of Orléans's possession of the book explains not only why the copy remained in France, but it also explains important derivations from the Brunswick manuscript. The Paris copy undoubtedly is beautifully produced and far superior to the copy for Sophie herself, which remained in Hanover. But it is not another original. Spelling customs had changed (typically *diser* is turned into *dieser*, for instance), perspective drawings of architectural features were mastered in a far more linear style, and there are numerous infelicities in the detail of the dress, which Schwarz himself would never have tolerated if he had commissioned a second copy later in his life, once he knew he had two sons. A good example is the depiction for his birthday in February 1529, which states that his hose

was lined with green velvet (I 93). This color is shown in the Brunswick original but has turned into a golden brown in the Paris copy, while the color of the coat has changed from black to purple.

Therefore only one original of the *First Book of Fashion* by Matthäus Schwarz exists and is in the Herzog Anton Ulrich-Museum in Brunswick. The manuscript is so fragile that it is very rarely shown to scholars, and if it is shown, it is only by two trained curators, who carefully and slowly turn each page. A few childhood scenes are missing, and, as in Fink's edition, we have substituted them with images from the Hanover copy. This edition seeks to help preserve the original for future generations and for the very first time publishes all images in color.

Conclusion

The Schwarz' books provide exceptional insights into the often emotionally troubled lives of young professional adults and men from a crafts background as they struggled to find romance, explore sexuality, tried to achieve social mobility, and yet needed to fit into a society based on still very rigid status hierarchies when it came to decisions about marriages and thus the legitimate social reproduction of privilege. They moreover present an unparalleled opportunity to fully understand the scale and nature of the Renaissance product revolution in dress and its implications, which is insufficiently addressed by current scholarship for those who ranked below traditional aristocratic elites. Renaissance ingenuity, innovation, status claims, and attitudes were to a significant extent generated by and expressed through dress and dress accessories, rather than just through fine art. In this sense, fashion needs to be analyzed as aesthetically integral to the Renaissance movement and as a cultural agent in its own right.

Taken together, the two generations of Schwarz family images provide an astonishing, long-term chronicle of Renaissance fashion, which is precise enough to enable a better sense of how exactly these highly innovative clothes and accessories were made. They portray the cultural and emotional contexts that shaped the wearing of clothes and their wearer. This turns them into an invaluable source for historians, as well as for all those engaged in making historical costume for theatre, film, or reenactment, or for fashion designers taking their inspiration from the past.

56. Fink, *Trachtenbücher*, 9.
57. Braunstein, *Un Banquier*, 144, 113.
58. Eduard Bodemann, *Aus den Briefen der Herzogin Elizabeth Charlotte von Orléans an die Kurfürstin Sophie*, vol. 2 (Hannover: Hahn, 1891), 293, 14.10.17111; 295, 15.11.1711.

Bibliography

Manuscript

Herzog Anton Ulrich-Museum: Hs 27 N. 67a (Matthäus Schwarz) and b (Veit Konrad Schwarz).

Editions

Fink, August. *Die Schwarzschen Trachtenbücher*. Berlin: Deutscher Verein für Kunstwissenschaft, 1963. (All images in black and white.)

Eighteenth-Century Copies

Paris copy (National Library, Manuscrits Allemands Nr. 211) of the original illuminated manuscript by Matthäus Schwarz in *Un Banquier Mis A Nu: Autobiographie de Matthäus Schwarz, bourgeois d'Augsburg*, edited by Philippe Braunstein. Paris: Gallimard, 1992.

Hanover copy of Matthäus Schwarz's manuscript: Wikimedia Commons: *Trachtenbuch des Matthäus Schwarz aus Augsburg*, 1520–1560. PDF.

Selected secondary literature on male renaissance dress

Arnold, Janet. *Patterns of Fashion: The Cut and Construction of Clothing for Men and Women c. 1560–1620*. London: Macmillan, 2008.

Arnold, Janet, Jenny Tiramani, and Santina M. Levey. *Patterns of Fashion: The Cut and Construction of Linen Shirts, Smocks, Neckwear, Headwear and Accessories for Men and Women c. 1540–1660*. London: Macmillan, 2008.

Bailey, Amanda. *Flaunting. Style and the Subversive Male Body in Renaissance England*. Toronto: University of Toronto Press, 2007.

Bäumel, Jutta. "Der Kleider-Nachlaß des Kurfürsten Moritz von Sachsen: Das Inventar von 1533 und die in der Dresdner Rüstkammer überlieferten Originale." *Zeitschrift für historische Waffen-und Kostümkunde* 35 (1993): 65–106.

Belfanti, Carlo Mario, and Fabio Gisuberti. "Clothing and Social Inequality in early modern Europe: Introductory remarks." In *Continuity & Change* 15 (2000): 357–66.

Bernis Madrazo, Carmen. *Trajes y modas en la España de los Reyes Católicos*. 2 vols. Madrid: Instituto Velásquez, 1979.

Blanc, Odile. *Parades et Parures. L'invention du corps de mode à la fin du Moyen Age*. Paris: Éditions Gallimard, 1997.

Borkopp-Restle, Birgit. *Textile Schätze aus Renaissance und Barock*. Munich, 2002.

Bulst, Neithard. "Kleidung als sozialer Konfliktstoff. Probleme kleidergesetzlicher Normierung im sozialen Gefüge." *Saeculum* 44 (1993): 32–46.

Bulst, Neithard. "Zum Problem städtischer und territorialer Kleider-, Aufwands- und Luxusgesetzgebung in Deutschland (13. bis Mitte des 16. Jahrhundert)." *In Renaissance du pouvoir législatif et genèse de l'Etat*, edited by André Gouron and Albert Rigaudière, 29–57. Montpellier: np, 1988.

Cat. *A Well-Fashioned Image: Clothing and Costume in European Art, 1500–1800*. Edited by Elizabeth Rodini and Elissa B. Weaver. Chicago: The David and Alfred Smart Museum of Art, 2002.

Collier Frick, Carol. *Dressing Renaissance Florence: Families, Fortunes, and Fine Clothing*. Baltimore: Johns Hopkins Press, 2002.

Cooper, Tarnya. *Citizen Portrait: Portrait Painting and the Urban Elite of Tudor and Jacobean England and Wales*. New Haven: Yale University Press, 2012.

Currie, Elizabeth. "Prescribing Fashion: Dress, Politics and Gender in Sixteenth-Century Conduct Literature." *Fashion Theory* 4 (2000): 157–78.

Dihle, Helene. "Kostümbilder und Rechnungsbücher der sächsischen Hofschneiderei 1469–1588." *Zeitschrift für historische Kostüm-und Waffenkunde*, 3 (1929): 127–37; 152–56.

Durian-Ress, Saskia. *Schuhe: Vom späten Mittelalter bis zur Gegenwart*. Munich: Hirmer, 1991.

Eisenbart, L. C. *Kleiderordnungen der deutschen Städte zwischen 1350 und 1700. Ein Beitrag zur Kulturgeschichte des deutschen Bürgertums*. Göttingen: Musterschmidt-Verlag, 1962.

Flamand, Christensen S. *Die männliche Kleidung in der süddeutschen Renaissance*. Berlin: Deutscher Kunstverlag, 1934.

Frieling, Kirsten O. *Sehen und gesehen werden: Kleidung an Fürstenhöfen an der Schwelle vom Mittelalter zur Neuzeit (ca. 1450–1530)*. Sigmaringen: Thorbecke, 2013.

Hale, J. R. *Artists and Warfare in the Renaissance*. New Haven: Yale University Press, 1990.

Hautle, Christian, ed. "Das Hofkleiderbuch der bayerischen Herzöge Wilhelm IV, Ludwig und Ernst vom Jahre 1506 bis zum Jahre 1551 beziehungsweise 1608." *Jahrbuch für Münchener Geschichte* 2 (1888): 87–125.

Hayward, Maria. *Dress at the Court of King Henry VIII*. Leeds: Maney, 2007.

Hayward, Maria. *Rich Apparel: Clothing and the Law in Henry VIII's England*. Aldershot: Ashgate, 2009.

Hülsen-Esch, Andrea von. *Gelehrte im Bild. Repräsentation, Darstellung und Wahrnehmung einer sozialen Gruppe im Mittelalter*. Göttingen: Vandenhoeck, 2006.

Hunt, Alan. *Governance of the Consuming Passions. A History of Sumptuary Laws*. Houndmills: Macmillan, 1996.

Huntebrinker, Jan Willem. *"Fromme Knechte" und "Gartteufel." Sölnder als soziale Gruppe im 16. und 17. Jahrhundert*. Constance: Universitätsverlag, 2010.

Jaritz, Gerhard. "Kleidung und Prestige-Konkurrenz. Unterschiedliche Identitäten in der städtischen Gesellschaft unter Normierungszwängen." In *Zwischen Sein und Schein. Kleidung und Identität in der ständischen Gesellschaft*, edited by Neithard Bulst and Robert Jütte. *Saeculum* 44 (1993): 8–31.

Jenkins, David, ed. *The Cambridge History of Western Textiles*, vol. 1. Cambridge: Cambridge University Press, 2003.

Jones, Ann Rosalind, and Peter Stallybrass. *Renaissance Clothing and the Material of Memory*. Cambridge: Cambridge University Press, 2000.

Jones, A. R., and M. Rosenthal. *The Clothing of the Renaissance World: Europe, Asia, Africa the Americas: Cesare Vecellio's Habiti Antichi et Moderni*. London: Thames & Hudson, 2008.

Keupp, Jan. *Die Wahl des Gewandes. Mode, Macht und Möglichkeitssinn in Gesellschaft und Politik des Mittelalters*. Stuttgart: Thorbecke, 2010.

Lüttenberg, Thomas. "Législation symbolique ou contrainte efficace? Les lois vestimentaires dans les villes allemandes au XVIe siècle." In *Vêture & Pouvoir XIIIe–XX siècle*, edited by Christine Aribaud and Sylvie Mouysset, 137–148. Toulouse: Framespa, 2003.

Lüttenberg, Thomas, "The Cod-Piece—A Renaissance Fashion between Sign and Artefact." *The Medieval History Journal* 8 (2005): 49–81.

McCall, Timothy. "Brilliant Bodies: Material Culture and the Adornment of Men in North Italy's Quattrocento Courts." *I Tatti Studies in the Italian Renaissance* 16 (1/2013): 445–90.

Mikhaila, Ninya, and Jane Malcolm Davies. *The Tudor Tailor. Reconstructing Sixteenth-century Dress*. Batsford: Anova Books, 2006.

Mirabella, Bella, ed. *Ornamentalism: The Art of Renaissance Accessories*. Ann Arbor: University of Michigan Press, 2011.

Orsi Landini, Roberta. *Moda a Firenze 1540–1580: Cosimo I de Medici's style*. Florence: Edizione Politstampa, 2011.

Paresys, Isabelle. "Paraître et se vêtir au XVIe siècle: morales vestimentaires." In *Paraître et se vêtir au XVIe siècle. Actes du XIIIe Colloque du Puy-en-Velay*, edited by Marie Viallon, 11–36. Saint Étienne: Publications de L'Université de Saint-Étienne, 2006.

Paresys, Isabelle, and Natacha Coquery. *Se vêtir à la cour en Europe 1400–1815*. Lille: Publications de L'Université, 2011.

Pastoureau, M. *Black: The History of a Color*. Princeton: Princeton University Press, 2008.

Pastoureau, M. *Green: The History of a Color*. Princeton: Princeton University Press, 2014.

Pastoureau, M. *The Devil's Cloth: A History of Stripes and Striped Fabric*, translated by Jody Gladding. New York: Columbia University Press, 2001.

Patterson, Angus. *Fashion and armour in Renaissance Europe: Proud looks and brave attire*. London: V & A, 2009.

Pietsch, Johannes. *Zwei Schauben aus dem Bayerischen Nationalmuseum München. Ein Beitrag zur Kostümforschung*. Munich: Siegl, 2004.

Rangström, Lena. *Modelejon Manligt Mode, 1500–Tal, 1600–Tal, 1700–Tal*. Stockholm: Livrustkammaren, 2002.

Reynolds, Anna. *In Fine Style: the Art of Tudor and Stuart Fashion*. London: Royal Collections, 2013.

Ribeiro, Aileen. "Dress in the Early Modern Period, c.1500–1780." In *The Cambridge History of Textiles*, vol. 1, edited by David Jenkins, 659–90. Cambridge: Cambridge University Press, 2003.

Rogg, Matthias. "'Zerhauen und zerschnitten, nach adelichen Sitten.' Herkunft, Entwicklung und Funktion soldatischer Tracht des 16. Jahrhunderts im Spiegel zeitgenössicher Kunst." In *Krieg und Frieden. Militär und Gesellschaft in der Frühen Neuzeit*, edited by Bernhard R. Kroener and Ralf Pöve, 109–135. Paderborn: Ferdinand Schöningh, 1996.

Rosenthal, Margaret F. "Cultures of Clothing in Later Medieval and Early Modern Europe." *Journal of Medieval and Early Modern Studies* 39:3 (Fall 2009): 459–81.

Rublack, Ulinka. *Dressing Up: Cultural Identity in Renaissance Europe*. Oxford: Oxford University Press, 2010.

Schnitzer, Claudia. *Höfische Maskeraden. Funktion und Ausstattung von Verkleidungsdivertissements an deutschen Höfen der Frühen Neuzeit*. Tübingen: M. Niemeyer Verlag, 1999.

Simon-Muscheid, Katharina. *Die Dinge im Schnittpunkt sozialer Beziehungsnetze. Reden und Objekte im Alltag (Oberrhein, 14. bis 16. Jahrhundert)*. Göttingen: Vandenhoeck, 2004.

Soergel, Philip M. "Baggy Pants and Demons: Andreas Musculus's Condemnation of the Evils of Sixteenth-Century Dress." In *Recht und Verhalten in vormodernen Gesellschaften*, edited by Andrea Bendlage et al., 139–154. Bielefeld: Verlag für Regionalgeschichte, Bielefeld, 2008.

Stallybrass, Peter, and Ann Rosalind Jones. *Renaissance Clothing and the Material of Memory*. Cambridge: Cambridge University Press, 2000.

Vincent, Susan. *Dressing the Elite: Clothes in Early Modern England*. Oxford: Berg, 2003.

Wolter, Gundula. *Die Verpackung des männlichen Geschlechts. Eine illustrierte Kulturgeschichte der Hose*. Marburg: Jonas Verlag, 1991.

Wolter, Gundula. *Teufelshörner und Lustäpfel. Modekritik in Wort und Bild 1150–1620*. Marburg: Jonas Verlag, 2002.

Zander-Seidel, Jutta. *Textiler Hausrat: Kleidung und Haustextilien in Nürnberg von 1500–1650*. Munich: Deutscher Kunstverlag, 1990.

Selected secondary literature on Matthäus or Veit Konrad Schwarz

Bernuth, Ruth von. "'wer jm gutz thett dem rödet er vbel': natürliche Narren im Gebetbuch des Matthäus Schwarz." In *Homo deb ilis: Behinderte—Kranke—Versehrte in der Gesellschaft des Mittelalters*, edited by C. Nolte, 411–30. Korb: Didymos, 2009.

Bulst, Neithard, Thomas Lüttenberg, and Andreas Priever. "Abbild oder Wunschbild? Bildnisse des Christoph Ambergers im Spannungsfeld von Rechtsnorm und gesellschaftlichem Anspruch." *Saeculum* 53 (2002): 21–73.

Groebner, Valentin. "Inside Out: Clothes, Dissimulation, and the Arts of Accounting in the Autobiography of Matthäus Schwarz, 1496–1574." *Representations* 66 (1999): 100–121.

Häberlein, Mark. *The Fuggers of Augsburg: Pursuing Wealth and Honor in Renaissance Germany*. Charlottesville: University of Virginia Press, 2012.

Habich, Georg. *Das Gebetbuch des Matthäus Schwarz*, Sitzungsberichte der Königlich Bayerischen Akademie der Wissenschaften. Munich: G. Franzen, 1910.

Hanß, Stefan. "Bin ich auff diße Welt geborhen worden." Geburtsdatierungen in frühneuzeitlichen Selbstzeugnissen. In *Frühe Neue Zeiten. Zeitwissen zwischen Reformation und Revolution*, edited by Achim Landwehr. Bielefeld: Transcript, 2012.

Hanß, Stefan. "'Tempus fugit': Zeitkonzeptionen in frühneuzeitlichen Selbstzeugnissen." MA diss., Free University Berlin, 2011.

Kranz, Annette. Christoph Amberger. *Bildnismaler zu Augsburg. Städtische Eliten im Spiegel ihrer Porträts*. Regensburg: Schnell & Steiner, 2004.

Lieb, Norbert. *Die Fugger und die Kunst im Zeitalter der Spätgotik und Renaissance*, 2 vols. Munich: Deutscher Kunstverlag, 1952.

Mentges, Gabriele. "Fashion, Time and the Consumption of a Renaissance Man in Germany: The Costume Book of Matthäus Schwarz of Augsburg, 1496–1564." *Gender & History* 14 (2002): 382–402.

Merkl, Ulrich. *Buchmalerei in Bayern in der ersten Hälfte des 16. Jahrhunderts: Spätblüte und Endzeit einer Gattung*. Regensburg: Schnell + Steiner, 1999.

Rublack, Ulinka. *Dressing Up: Cultural Identity in Renaissance Europe*. Oxford: Oxford University Press, 2010.

Schmitt, Jean Claude. *L'invention de l'anniversaire*. Paris: Arkhe, 2008.

Slenczka, Ruth. "Die Heilsgeschichte des Lebens: Altersinschriften in der nordalpinen Porträtmalerei des 15. und 16. Jahrhunderts." In *Zeitschrift für Kunstgeschichte* 76 (2013): 493–540.

Weitnauer, *A. Venezianischer Handel der Fugger. Nach der Musterbuchhaltung des Matthäus Schwarz*. Munich: Dunker & Humblot, 1931.

Westermann, Ekkehard, and Markus A. Denzel. *Das Kaufmannsnotizbuch des Matthäus Schwarz aus Augsburg von 1548*. Stuttgart: Steiner, 2011.

Wunder, Heide. "What made a man a man? Sixteenth- and seventeenth-century findings." In *Gender in Early Modern German History*, edited by Ulinka Rublack, 21–48. Cambridge: Cambridge University Press, 2002.

Zitzlsperger, Philipp. *Dürer's Pelz und das Recht im Bild. Kleiderkunde als Methode der Kunstgeschichte*. Berlin: Akademie Verlag, 2008.

Selected secondary literature and sources on Germany during Schwarz's lifetime

Baer, Wolfram, ed. *Augsburger Stadtlexikon: Geschichte, Gesellschaft, Kultur, Recht, Wirtschaft*. Augsburg: Perlach Verlag, 1985.

Behringer, Wolfgang. "Arena and Pall Mall: Sport in the Early Modern Period." *German History* 27 (2009): 331–57.

Bock, Hartmut. "Kette und Wappenhelme: Zur Unterscheidung zwischen Patriziat und Adel in der Frühen Neuzeit." *Zeitschrift des Historischen Vereins für Schwaben* 97 (2004): 59–120.

Cat. *Bürgermacht und Bücherpracht: Augsburger Ehren- und Familienbücher der Renaissance*. Edited by Christoph Emmendörffer and Helmut Zäh. Augsburg: Maximiliansmuseum, 2011.

Cat. "Kurzweil viel ohn' Maß und Ziel." *Alltag und Festtag auf den Augsburger Monatsbildern der Renaissance*. Munich: Hirmer, 1994.

Cat. *Welt im Umbruch. Augsburg zwischen Renaissance und Barock*, 2 vols. Augsburg: Augsburger Druck- und Verlagshaus, 1980.

Chipps Smith, Jeffrey, ed. *New Perspectives on the Art of Renaissance Nuremberg. Five Essays*. Texas: The Archer M. Huntington Art Gallery, 1985.

Chipps Smith, Jeffrey. *Dürer*. London: Phaidon, 2012.

Clasen, Claus-Peter. *Textilherstellung in Augsburg in der frühen Neuzeit*. Augsburg: B. Wissner, 1995.

Cuneo, Pia. *Art and Politics in Early Modern Germany. Jörg Breu the Elder and the Fashioning of Political Identity ca. 1475–1536*. Leiden: Brill, 1998.

Cupperi, Walter, et al., eds. *Wettstreit in Erz: Porträtmedaillen der deutschen Renaissance*. Munich: Deutscher Kunstverlag, 2013.

Eser, Thomas. *Hans Daucher: Augsburger Kleinplastik der Renaissance*. Munich: Deutscher Kunstverlag, 1996.

Friedrichs, Christopher R. "German Social Structure, 1300–1600." In *Germany: A New Social and Economic History, 1450–1630*, edited by Bob Scribner, 233–258. London: Arnold, 1996.

Gottlieb, Günther, ed. *Geschichte der Stadt Augsburg: 2000 Jahre von der Römerzeit bis zur Gegenwart*. Stuttgart: Theiss Verlag, 1984.

Häberlein, Mark. *Die Fugger. Geschichte einer Augsburger Familie (1367–1650)*. Stuttgart: Kohlhammer, 2006; translated as *The Fuggers of Augsburg: Pursuing Wealth and Honor in Renaissance Germany*, Charlottesville: University of Virginia Press, 2012.

Johnson, Christine R. *The German Discovery of the World. Renaissance Encounters with the Strange and Marvellous*. Charlottesville: University of Virginia Press, 2008.

Lundin, Matthew. *Paper Memory: A Sixteenth-Century Townsman Writes His World*. Harvard: Harvard University Press, 2012.

Mair, Paul Hector. *Geschlechter Buch: darinn der loblichen Kaiserliche Reichs Statt Augspurg so vor fünffhundert vnd mehr Jahren hero, dasselbst gewonet, vnd biss auff acht abgestorben, auch deren so an der Abgestorbnen stat eingenommen vnd erhöhet worden seyn*. Frankfurt-on-Main: S. Feyerabend, 1580.

Mair, Paul Hector. *Zwei Chroniken des Augsburger Ratsdieners Paul Hector Mair von 1548 bis 1564*. Die Chroniken der deutschen Städte. Munich: Königliche Akademie der Wissenschaften, 1917.

Monnet, Pierre. *Les Rohrbach de Francfort. Pouvoirs, affaires et parenté à l'aube de la Renaissance allemande*. Geneva: Droz, 1997.

Morrall, Andrew. *Jörg Breu the Elder. Art, Culture and Belief in Reformation Augsburg*. Aldershot: Ashgate, 2002.

Moxey, Keith. *Peasants, Warriors and Wives: Popular Imagery in the Reformation*. Chicago: University of Chicago Press, 1989.

Nagel, Alexander, and Christopher S. Wood. *Anachronic Renaissance*. New York: Zone Books, 2010.

Nuechterlein, Jeanne. *Translating Nature into Art: Holbein, the Reformation, and Renaissance Rhetoric*. Philadelphia: Pennsylvania University Press, 2011.

Puff, Helmut. *Sodomy in Reformation Germany and Switzerland, 1400–1600*. Chicago: University of Chicago Press, 2012.

Rogge, Jörg. *Für den gemeinen Nutzen. Politisches Handeln und Politikverständnis von Rat und Bürgerschaft in Augsburg im Spätmittlelalter*. Tübingen: M. Niemeyer Verlag, 1996.

Roper, Lyndal. "'Going to Church and Street': Weddings in Reformation Augsburg." *Past & Present* 106 (1985): 62–101.

Roper, Lyndal. *Oedipus & the Devil. Witchcraft, Sexuality and Religion in Early Modern Europe*. London: Routledge, 1994.

Roper, Lyndal. *The Holy Household. Women and Morals in Reformation Augsburg*. Oxford: Oxford University Press, 1989.

Rublack, Ulinka. *Dressing Up: Cultural Identity in Renaissance Europe*. Oxford: Oxford University Press, 2010.

Scott, Tom. *Society and Economy in Germany, 1300–1600*. Houndsmill: Palgrave, 2002.

Scribner, R. W. *Religion and Culture in Germany (1400–1800)*, edited by Lyndal Roper. Leiden: Brill, 2001.

Silver, Larry. *Marketing Maximilian: The Visual Ideology of a Holy Roman Emperor*. Princeton: Princeton University Press, 2008.

Stuart, Kathy. *Defiled Trades and Social Outcasts: Honor and Ritual Pollution in Early Modern Germany*. Cambridge: Cambridge University Press, 1999.

Tlusty, B. Ann, *Bacchus and Civic Order: the Culture of Drink in Early Modern Germany*, Charlottesville: University of Virginia Press 2001.

Tlusty, B. Ann. *The Martial Ethics in Early Modern Germany: Civic Duty and the Right of Arms*. Houndsmill: Macmillan, 2011.

Tlusty, B. Ann, ed. *Augsburg during the Reformation: An Anthology of Sources*. Indianapolis: Hackett, 2012.

Weber, Matthias, ed. *Die Reichspolizeiordnungen von 1530, 1548 und 1577. Historische Einführung und Edition*. Frankfurt-on-Main: Klostermann, 2002.

Wood, Christopher S. *Forgery, Replica, Fiction: Temporalities of German Renaissance Art*. Chicago: University of Chicago Press, 2008.

Fashionable Masculinity: The Clothing of Matthäus and Veit Konrad Schwarz

Maria Hayward

✣ Introduction

aximilian I (1459–1519), Holy Roman Emperor, stated in the semiautobiographical *Weißkunig* that a man "who leaves no memorial in his life will not be remembered when he dies and [he] will be forgotten with the death knell."[1] He was not alone in thinking this, and Matthäus and Veit Konrad Schwarz took the sentiment to heart. Their visual clothing diaries act as small but very significant memorials for these two sixteenth-century Augsburg men, who were linked by family ties. This essay considers this clothing legacy left by Matthäus and Veit, and it has four main aims that are reflected in the structure. The first section provides an analysis of the garments and accessories presented in the individual illustrations as they relate to the body of the wearer, working down the body from head to toe.[2] The second explores the range of textiles, colors, and decorative techniques available to Matthäus and Veit and what their choices indicate about their taste, status, and social lives. The third considers what these clothes reveal about how two men created their wardrobes from early childhood, through adolescence, and then on into adult life. The fourth seeks to locate their clothes within the wider context of trends in southern Germany and considers how far Matthäus and Veit Konrad Schwarz were influenced by foreign fashions. Finally, inserted among this exploration of masculine taste and fashion, is a brief analysis of the clothes worn by the few women who appear in the books.

The composition of two fashionable male citizens' wardrobes in Augsburg: Clothes and accessories in detail

With a few exceptions, the illustrations present Matthäus and Veit in full-length miniature portraits, which provide the viewer with a head-to-toe impression of their appearance. The images are predominantly portrait in format too, as this layout is best suited to the depiction of a single standing figure, but in a few cases, where the scene demands it, the pages are landscape.[3] As such, the illustrations are the primary record of how clothing and accessories were combined to create a particular type of

appearance for a specific event or activity. In contrast, the small commentaries, which are occasionally supplemented with marginal notes providing specific details about fabrics or furs, are short, and they often concentrate on the event as much as on the clothing.[4] In part this was because prior to his marriage Matthäus recorded further details, including those relating to his clothes in *The Course Book of the World*, so there was less need to record these details in *The Book of Fashion*. However, as Matthäus notes, he destroyed this book, and this information is now lost.

The illustrations record a variety of different poses, providing the reader with front, three-quarter, side,[5] and back views of both men.[6] The number of back views may reflect the interest artists, such as Dürer and Hans Holbein the Younger, were taking in recording all aspects of their sitters.[7] Back views also had the virtue of showing the clothes from a different angle, which would have been of interest to Matthäus because the look of the clothes on the body was so important to him.

While a key aim of the books was to record the ensembles of Matthäus and Veit, this does not mean that interpreting the various layers of clothing from the illustrations is always straightforward. When either man wore a gown or cloak, there can be challenges for the researcher in deciding whether these garments were worn over a doublet, doublet and jerkin, or a doublet and placard. Equally, Matthäus's clothing was sometimes depicted as being asymmetric in nature, as in illustration I 75, but whether this was how he really wore his gown—or it was shown like this to display the sleeve of the doublet—is open to question. Veit certainly chose to laugh at the fashions worn by his father, which he described as "more and more foolish and there is still no end to the strange modes of dress until nowadays."[8] Foolish or not, the demands placed by these changing fashions on the sixteenth-century male consumer in Augsburg have been described as the "commodification of appearance."[9] The following

1. T. DaCosta Kaufmann, *Court, Cloister and City: The Art and Culture of Central Europe 1450–1800* (London: Weidenfeld and Nicolson, 1995), 70.
2. S. Vincent, *The Anatomy of Fashion: Dressing the Body from the Renaissance to Today* (London: Berg, 2009). It is also similar to the approach in the *Visual History of Fashion* series (London: Batsford), with volumes by Margaret Scott, Jane Ashelford, Valerie Cumming, Aileen Ribeiro, Vanda Foster, and Penelope Byrde.
3. I 57, I 58, I 130, and I 132.
4. Compare with Holbein's notes to identify the fabrics and colors on his preparatory sketches, see J. Roberts, *Holbein and the Court of Henry VIII: Drawings and Miniatures from the Royal Library Windsor Castle* (Edinburgh: National Galleries of Scotland, 1993), 16–17.
5. I 12, I 14, I 16, I 20–21, I 28, I 32, I 37, I 51, I 57, I 101, I 106, I 108, I 117–19, I 127, I 135; II 15, II 20, II 24, II 29, II 38, and II 40.
6. I 94, I 110, I 113; II 10, II 11, II 12, and II 28.
7. For example, Hans Holbein the Younger, *John Poyntz*, pink prepared paper, black and colored chalks, 29.5 × 23.3 centimeters, RL 12233. In this sketch Poyntz is depicted in a three-quarters back view.
8. Frontispiece, book 2.
9. U. Rublack, *Dressing Up: Cultural Identity in Renaissance Europe* (Oxford University Press, Oxford, 2010), 279. For a very detailed overview of male clothing in southern Germany, see J. Zander-Seidel, *Textiler Hausrat: Kleidung und Haustextilien in Nürnberg von 1500–1650* (Munich: Deutscher Kunstverlag, 1990), 158–243.

section explores each category of clothing and accessories worn by Matthäus and Veit, and it considers how far they bought into male fashions.

Headwear/hair: Matthäus and Veit were usually depicted wearing some form of headwear, indicating the significance of hats and hat etiquette to men in sixteenth-century Augsburg. The bonnet, which could be made of velvet, wool, felt, or felted knitting, was the most popular head covering, and it was popular from the 1490s to the 1560s, with subtle and not-so-subtle variations to the brim and shape of the crown. Most usually black, indeed Veit only wore black bonnets, they could be brightly colored. Matthäus owned examples in blue,[10] gray,[11] red,[12] and white,[13] which could be selected to either complement or coordinate with the rest of the clothing being worn. Bonnets were decorated in a variety of ways and worn either at a rakish angle or flat on the head, making them ideal expressions of individuality.[14] By the mid-sixteenth century, hats with tall crowns and fairly narrow brims had started to appear as an alternative to the bonnet. Hats of this type were considered an Italian fashion.[15] Matthäus was only depicted in a hat of this type in 1560 at the end of his book.[16] Veit wore hats of this style slightly more frequently. Occasionally, several other types of distinctive headwear did feature, including a black cap with the padded roll brim worn by Veit as a young boy,[17] thrummed hats and caps,[18] as well as fur hats[19] and fur-lined bonnets.[20]

Men and boys often kept their heads covered indoors, and there was a separate range of headwear for the domestic sphere. Matthäus wore a variety of fancy cauls, which were probably made from sprang, knitting, looping, and knotting.[21] They were often black, black with metal thread decoration, or made exclusively from metal thread. These cauls were usually worn on the back of his head, covering most or all of his hair. On occasion Matthäus wore them outside in tandem with a bonnet. In contrast, Veit, when young wore a small black coif indoors.[22] While the caul and the coif were more fashionable indoor wear, Matthäus adopted a nightcap while he was convalescing.[23] They were primarily intended to keep the head warm, and they were not usually worn when sleeping. This was a type of head covering associated with the bedroom and other private spaces within the home.

Hair, both on the head and facial hair, was highly significant as a sign of early modern masculinity.[24] Matthäus had two main hair styles during the course of his life, starting with a fringe and a short bob that came to just below his ears. At some points, his hair gets longer, such as the shoulder-length style he had when he was in Italy,[25] while at other times, such as in the naked portrait, in addition to the basic bob, the hair on the back of his neck was shaped into three curling tendrils.[26] However, from the summer of 1527, Matthäus had his hair cut short and close to his head.[27] He retained this style until July 1550 when he reverted to the bob, which he appeared to keep until the end of his life. The illustrations also charted his hair starting to go gray, in tandem with a hint of it receding at the temples. In contrast, Veit's hair is very consistent, both with his youth and with current fashions, and he was always depicted with short hair—a style he retained to the end of his book—and always clean shaven. If Veit had continued with his book longer, it would have been interesting to see whether he would have grown a beard, as they became part of Spanish fashionable dress, especially when trimmed into a neat point, thus a beard would have been in keeping with the rest of his appearance.[28] In contrast, his father briefly adopted a beard and moustache from March to June 1523[29] and then did so permanently from 1535.[30] This beard—long with the moustache—was a clear sign of Matthäus's increased maturity and a demonstration of his masculinity. Both were allowed to become rather unkempt while he was ill and indoors, indicating that during convalescence, keeping his hair trimmed was of less importance than when he was out and about in public. However, to mark his return to full health, Matthäus's beard and moustache were once again carefully managed.

Body garments: Men could wear various layers of clothing depending on their activity, the time of day, and the season, but in general the number of layers they wore was linked to their wealth, social status, and age. All men, apart from those with very limited means, would have worn a shirt as the layer closest to the skin. Over this they would have had a doublet, or a jerkin and doublet, worn with a pair of hose. In addition, they could add another layer in the form of a gown, riding coat, or cloak.

Gowns could function as a sign of age, or more specifically, they were usually associated with older men as indicated by

10. I 23.
11. I 17 and I 55.
12. I 19, I 22, I 24, I 30, I 42, I 46, I 48, I 57, I 66–67, I 73, I 86–87, and I 91.
13. For example, a large oval broach pinned to the brim of his hat in I 15.
14. I 24.
15. F. Boucher, A *History of Costume in the West* (London: Thames and Hudson, 1966), 238.
16. I 137.
17. II 6.
18. I 4, II 12, II 15, and II 28.
19. II 38.
20. For example, I 65.
21. See Albrecht Dürer, *Junges Mädchen mit besticktem Haarband*, 1515, illustrated in Zander-Seidel, *Textiler Hausrat*, 141, fig. 132.
22. II 14. In 1553 and 1554 when he was aged twelve and thirteen.
23. I 130–31.

24. W. Fisher, "The Renaissance beard: Masculinity in early modern England," *Renaissance Quarterly* 51.1 (2001): 155–87.
25. I 25–26.
26. I 79.
27. I 88.
28. Boucher, *History of Costume*, 235.
29. I 61–62.
30. I 108 to I 37.

the picture of Ulrich, Matthäus's father.[31] His ankle-length, fur-trimmed and lined gown would have stressed his position as head of his household, while also acknowledging that he was a man of some wealth and status. In contrast, Matthäus was first depicted wearing a gown in 1509 at age twelve[32] and Veit in 1547 at age five.[33] In both instances, the gown served to give them a degree of importance, so for Matthäus it was when he started to represent the family business and for Veit at the point when he first wore adult male dress. However, the gown lost its appeal quite quickly for both of them. Matthäus did not wear a gown consistently in his twenties or early thirties, indicating that this was a conscious choice.[34] Opting to go out without a gown was one way in which he could stress his youth, while also allowing him to display his ornate doublets and hoses to their best advantage. The latter also suggests that it was not essential to wear a gown in order to be properly dressed for certain activities. However, Matthäus usually wore a gown for more formal occasions, such as when he was at work[35] or when attending the Imperial Diet.[36]

The gown was one of the most important garments in the male wardrobe in the first half of the sixteenth century. It was often the outermost layer worn, and as a consequence, it was frequently an opulent garment lined or trimmed with fur and decorated with guards.[37] It was a relatively unfitted garment that could vary in length from mid-thigh, knee, mid-calf, or ankle length. It often had a collar and sleeves, which could be very complex in their construction. A number of gowns with complex hanging sleeves of this type can be seen in Matthäus's book.[38] Particularly distinctive was the reversible red and green gown that he wore in September and October 1525.[39] Matthäus also identified two specific types of gown—the short gown[40] and the lined gown.[41] In contrast, Veit very rarely wore a gown. As noted above, he wore one to mark his breeching[42] and then only on two other occasions.[43] Namely the wedding of

Mattheus Schalleer and Eva Scharerin on July 17, 1560, and a dark brown wool fur-lined gown in the winter of 1560–61. The reasons he did not wear a gown were partially the same as his father at the same age but also reflect that the gown had been replaced by the cloak as the most fashionable outer garment.

While very simple in cut, the cloak offered the wearer a choice of lengths (hip, mid-thigh, knee, or longer), the way they could be worn (either on both shoulders or on just one shoulder), whether they had a collar, and whether they had sleeves (although the latter was not common). Matthäus wore several small cloaks, which were usually draped over his left shoulder[44] and a slightly longer cloak worn on both.[45] They were worn between February 1522 and November 1523, suggesting that they were a short-lived trend in his wardrobe. They were very different in terms of cut from the long cloaks he wore for mourning and the ten examples worn by Veit between 1550 and 1561.[46] These were fairly uniform in their appearance, being mostly hip length, sleeveless, with a variety of different styles of collar, and worn on both shoulders.

During the course of his life, Matthäus owned a variety of riding coats.[47] They came in a range of lengths, from short coats reaching the hips to longer garments coming to his knees. They usually had sleeves, and they were generally more fitted than a gown. Indeed on occasion they had a waist seam, and they often had heavily pleated skirts. No coats of this style appeared in Veit's book. In contrast, both men owned jerkins. These were usually sleeveless, but they could sometimes have short or full-length sleeves, and while the early examples had no skirts, those worn by Veit had short skirts. Matthäus wore a jerkin relatively infrequently, with nine being recorded in his clothing book.[48] Veit wore jerkins much more frequently (ten in the twenty-two images produced between 1556 and 1561) and in a variety of styles.[49] They frequently appear to have been made in tandem with the doublet that they were worn with.

A staple item in the male wardrobe was the doublet, and a wide variety of styles were recorded in the clothing books.[50] The neckline could vary from being low and wide, sitting on the wearer's shoulders, to high and finished, with a small upright collar close under the wearer's chin. Those with low necklines could fasten down the center-front or be side fastening. The doublet could finish at the wearer's natural waist, or it could have a waist seam, sometimes dropping a little at the center-front, and then skirts below. Most of the doublets worn by

31. Frontispiece, book 1.
32. I 9.
33. II 10.
34. Matthäus wore a gown in twenty-two of the thirty-five illustrations (I 6 to I 40) dating between September 1, 1505 (aged eight), to November 28, 1519 (aged twenty-four). He wore a gown in seventeen of the sixty-four illustrations (I 41 to I 103) dating from 1519/1520, when he was twenty-three/twenty-four, to July 2, 1530, when he was thirty-three. He wore a gown in twenty-six of the thirty-four illustrations (I 104 to I 137) from September 2, 1530 (aged thirty-three), to September 16, 1560 (aged sixty-three).
35. I 28.
36. I 122.
37. As such, wearing a gown was often linked to social status as in the image of "Tod und Herzog" (death and the duke) and "Tod und Graf" (death and the count). See J. Tripps, *Den Würmern wirst Du Wildbret sein: Der Berner Totentanz des Niklaus Manuel in den Aquarellkopien von Albrecht Kauw (1649)* (Bern: Verlag Bernisches Historisches Museum, 2005), 58–59.
38. For example, I 86, I 93, I 106, I 108–09, and I 116.
39. I 74–75.
40. I 117, I 118, and II 26.
41. I 36.
42. II 10.
43. II 32 and II 38.

44. I 51, I 60, and I 64.
45. I 58.
46. See II 15–16, II 23–25, II 28, II 30, II 33, II 36, and II 39.
47. I 20–21, I 41, I 45, I 76, I 101, and I 119.
48. See I 44, I 52, I 90, I 110, I 113–15, I 122, and I 123.
49. II 20, II 22–26, II 30. II 33, II 36 and II 41.
50. I 15, I 17, I 19, I 21, I 24–25, I 27, I 30–32, I 35, I 46, I 48–49, I 51–56, I 58–65, I 71, I 73–74, I 78, I 81–86, I 88–93, I 95, I 97–100, I 102–05, I 108–09, I 116, I 120, I 124; II 13, II 27, and II 31–II 35. These are the occasions when they specifically mention the doublet in their commentary.

Matthäus extended as far as his natural waistline, helping to display his fancy hose to very good affect. In several instances the doublet was pointed to the hose. Between 1512 and 1560 Matthäus wore nine different types of doublet.[51] Some of these doublets, which had cut away fronts, were worn with a placard that could provide warmth or a point of contrast, if they were made from a different color to the doublet.[52] In contrast, Veit wore just one main type of doublet with a fitted body, fitted sleeves, and with some padding on both fronts, creating a slight peasecod belly. The doublets also had small collars, small skirts, and were close buttoned down the front.

Linens: The white linen shirt was a very important part of male dress (Figure 2.1).[53] They were soft against the wearer's skin, providing comfort, while keeping the doublet clean by protecting it from being against the skin and absorbing sweat and grease. As such, shirts were closely linked to ideas of health and cleanliness, which meant that men needed to be able to change their shirts regularly and have them laundered. For married men, shirts were a part of the domestic economy and they symbolized the wife's role within the home. An ordinance of 1550 passed in Augsburg that specified the gifts given by a bride to her husband should be two shirts, six handkerchiefs, and two towels.[54]

A boy's shirt embroidered in silver gilt thread and purple silk (c. 1550–60) and a plain shirt with a simple neckband dating from 1567, demonstrate how embroidered shirts could add to the decorative impact of a man's outfit, while a plain shirt could suggest simplicity or enhance the appearance of the other items being worn.[55] Indeed the range of decoration included blackwork, metal thread embroidery, and Italian shirring. It was usually concentrated around the neckband, the wristbands, or down the center-front. The cut of the doublet and the range of layers being worn would influence how much of the shirt, and embroidery, was visible, and the illustrations in Matthäus's book reveal the variety of types that were available in the 1510s to 1530s. Indeed some of the illustrations were primarily designed to show off his shirts in great detail: three in June 1524[56] and

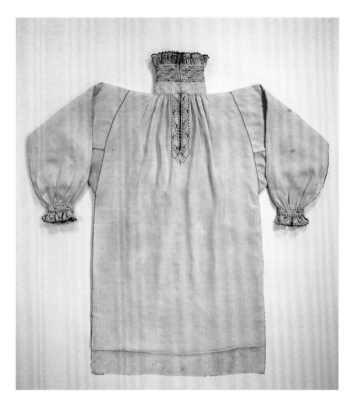

Figure 2.1. *Shirt, Inv. T 1404, Bavarian National Museum. © Bayerisches Nationalmuseum, Munich. Photographer: Walter Haberland.*

four in September 1526.[57] These and the other images reveal the great variety of shirt styles that Matthäus owned in terms of the sleeves, the neck, whether they were front or side opening, and the decoration.[58]

The shirt styles Matthäus wore during his youth were partially linked to the cut of the doublet. When doublets had low necklines, or they might be left open at the front, or not worn at all, then much greater emphasis was placed on the body and sleeves of the shirt, showing off its whiteness and also the fineness of the fabric. In contrast, the emphasis was placed on the neckline and wrists with doublets, with small, stand collars that were buttoned down the center-front and with close-fitting sleeves. All of the shirts were very high quality yet still represented good value for money by using fine local linen and the skills of a seamstress.[59]

Much less variety was evident in the shirts worn by Veit, partly because most of his shirts were concealed by his doublet.[60] Decoration was limited to little frills on the neckbands of his shirts and narrow ruffles on the wristbands (although in comparison to Matthäus, the neck ruffles were getting bigger, with the edging

51. These are (1) very full sleeves, low neckline, center-front opening (e.g., I 15); (2) very full sleeves, low neckline, side opening (e.g., I 17); (3) very full sleeves, high neckline, cut away at the front, fastening at the waist (e.g., I 19); (4) very full, two-part sleeves, low neckline, side opening (e.g., I 28); (5) fitted sleeves, low neckline, side opening (e.g., I 67); (6) very full, ruched sleeves, high neckline, ruched body (e.g., 73); (7) very full slashed sleeves, square neckline (e.g., I 89); (8) very full, paned sleeves, low neckline, paned body (e.g., I 102); and (9) more fitted sleeves, center-front fastening, small collar (e.g., 120).
52. For example, I 54, I 56, and I 62–63.
53. See J. Arnold, S. Levey, and J. Tiramani, *Patterns of Fashion 4: The Cut and Construction of Linen Shirts, Smocks, Neckwear, Headwear and Accessories for Men and Women c. 1540–1660* (London: Macmillan, 2008).
54. L. Roper, *The Holy Household: Women and Morals in Reformation Augsburg* (Oxford: Clarendon Press, 1989), 135.
55. See the collections of the Bayerisches Nationalmuseum, Munich and Uppsala cathedral.
56. I 68–70.

57. I 81–84. Also compare with the very fine shirt in the portrait of Charles V, c. 1519, see Anonymous, *Charles V*, c.1519, oil on panel, Royal Collection, RCIN 403439.
58. For example, opening on left in I 82, and on right in I 83.
59. With many thanks to Jenny Tiramani for discussing this point with me.
60. For the cut of shirts of this type see D. K. Burnham, *Cut my Cote* (Toronto: Royal Ontario Museum, 1973), 14–15.

ruffle a little wider and formed into a more discernible s-shape). His shirts acted as a point of contrast with the black doublets and black cloaks that he favored. Veit could draw the viewer's eye to his shirt by leaving the bandstrings hanging down, the number of bandstrings on the collar, and the size of the small knotted tassels at the ends of the bandstrings. Most notably, Veit was never depicted without his doublet or jerkin, unlike his father; the closest he came to this was the image of him playing a ballgame with his shirt sleeves rolled up.[61] This is possibly because the shirts were less flamboyant, and all the detail and decoration was concentrated on the neck and wristbands, which were the only elements visible when the doublet was worn. It might also suggest dress was becoming more formal and appearing in just hose and doublet suggested a level of undress that Veit did not wish to depict in his clothing book.

Hose: Hose accentuated the lower body, and they underwent significant changes in terms of style and construction during Matthäus and Veit's lifetimes. In his youth Matthäus wore tight fitting plain hose, which were fully or partially covered by his coat or the skirts of his doublet. They were usually a single color[62] (similar to those worn by the grave digger and cowherd), but in two instances they were striped vertically.[63] Matthäus wore several different styles of hose in parallel in the 1510s, 1520s, and 1530s: these included tight fitting hose that accentuated the legs with a codpiece;[64] tight fitting hose slashed on the hips, thighs, and in some instances on the calves, either symmetrically or asymmetrically to reveal the lining, with a codpiece;[65] tight fitting hose with over-hose that came to his knees with a codpiece;[66] and tight fitting hose with very short over-hose or trunk hose with a codpiece.[67] By August 1539 Matthäus wore trunk hose, and after this point this was the only style that he was depicted in, as was Veit.

Matthäus's trunk hose were quite long, often coming to just above his knees, with the panes running from the waistband to the lower band with a lining. In contrast, Veit's trunk hose were much shorter, so revealing more of his thighs. They also had a much more distinctive, round shape, which was achieved with the liberal addition of padding. On March 13, 1561, Veit noted that his trunk hose "weighed 30 Augsburg pounds" because they were "filled with cloth and padded" to make them "round."[68]

Equally, while the panes of Matthäus's trunk hose were often plain, Veit's were usually patterned, either with applied passementerie or pinked.

Three pairs of sixteenth-century German hose demonstrate the potential of the various materials: a pair of plain yellow leather hose with yellow velvet trunk hose owned by elector Moritz of Saxony,[69] a pair of knitted yellow hose (c. 1552–55) also owned by Moritz,[70] and a pair of linen hose (c. 1490–1529) found at Kloster Alpirsbach.[71]

Gregorius Wagner observed pointedly that the codpiece attracted attention "as if there was sweet honeycomb inside."[72] Whether this was true, the codpiece was an essential part of the hose worn by both father and son, although the style of the codpiece that they favored changed over time. When Matthäus first wears a codpiece, it is of the round, spherical type.[73] Once he starts to wear hose with a codpiece regularly in 1513, he continues to wear this style until 1539.[74] During the first half of the sixteenth century, the codpiece is an overt display of masculinity, and in order to function in this way, it needs to be visible. The style of doublet, which had no skirts and was being worn in the 1510s, 1520s, and 1530s, just served to ensure that the codpiece was on display. During this time span, Matthäus wore the bag-style codpiece just once.[75] During the 1540s he was depicted wearing a gown that concealed what style of codpiece he had, but by 1543 he had made the transition to the upturned codpiece.[76] Veit favored this style with the only variable being the size.

61. II 20.
62. I 7–12.
63. I 4–I 5.
64. For example, I 15, I 17, I 22, I 28–31, I 36, and I 52.
65. For example, I 19, I 27, I 32, I 35, I 37, I 42–44, I 47–49, I 51, I 53, I 55, I 57–62, I 64, and I 72–75.
66. For example, I 68, I 70, I 81–84, and I 90.
67. For example, I 67, I 69, I 93, I 96, I 106, and I 111. For a comparable range of types of hose, see the images of "Tod und Herzog" (death and the duke), "Tod und Graf" (death and the count), "Tod und Burger" (death and the burger), and "Tod und Kaufmann" (death and the businessman), in Tripps, *Den Würmern*, 58–59, 74–75.
68. II 41.

69. B. Niekamp and A. Jucker, *Das Prunkkleid des Kurfürsten Moritz von Sachsen (1521–1553) in der Dresdner Rüstkammer: Dokumentation, Restaurierung, Konservierung* (Riggisberg: Abegg-Stiftung, 2008), figs. 63, 69, 82, 87. Moritz died in 1553 and an inventory was taken of his clothes, see J. Bäumel, "Der Kleider-Nachlass des Kurfürsten Moritz von Sachsen. Das Inventar Originale," *Waffen- und Kostümkunde* 35 (1993): 65–106.
70. L. Rangström, ed., *Modelejon Manligt Mode 1500-tal, 1600-tal, 1700-tal/ Lions of Fashion: Male Fashions of the 16th, 17th, 18th Centuries* (Stockholm: Livrustkammaren Bokförlaget Atlantis, 2002), 34–35, 298–99.
71. See A. Stangl and F. T. Lang, *Mönche und Scholaren: Funde aus 900 Jahren Kloster Alpirsbach, 1095–1995* (Karlsruhe: Oberfinanzdirektion, Karlsruhe, 1995), 52.
72. L. Roper, *Oedipus and Devil: Witchcraft, Sexuality and Religion in Early Modern Europe* (London and New York: Routledge, 1994), 46. Large scale codpieces were also carried in guild processions in German cities; Roper, *Oedipus and Devil*, 137. For their significance more widely, see L. Roper, "Blood and codpieces: Masculinity in the early modern German town," in *Oedipus and Devil: Witchcraft, Sexuality and Religion in Early Modern Europe* (London: Taylor and Francis Ltd, 1994); T. Luttenberg, "The cod piece: A renaissance fashion between sign and artifice," *The Medieval History Journal* 8 (2005): 49–81. According to Rabelais "his codpiece … was fashioned on top like unto a triumphant arch, … jagged and pinked and withal bagging and strutting out with blew damask lining, after the manner of his breeches," cited in A. Patterson, *Fashion and Armor in Renaissance Europe: Proud Looks and Brave Attires* (London: V&A Publishing, 2009), 37.
73. I 5. This is in 1504 when he is seven, and it is part of the carnival celebrations.
74. I 17, I 19, I 22, I 27, I 29–33, I 35–36, I 42–44, I 47–50, I 52–54, I 56–63, I 65–70, I 72–75, I 77, I 81–87, I 89–93, I 95–100, I 102–03, I 105, I 107, I 111, I 116, and I 120.
75. I 103. For an example of this style, see Albrecht Dürer, *Ensign-bearer*, c. 1502/3, engraving, 11.6 × 7.1 centimeters. The ensign-bearer is wearing very tight hose with a codpiece of the bag sort, tied to his hose at each corner with points.
76. I 124, I 133, and I 136.

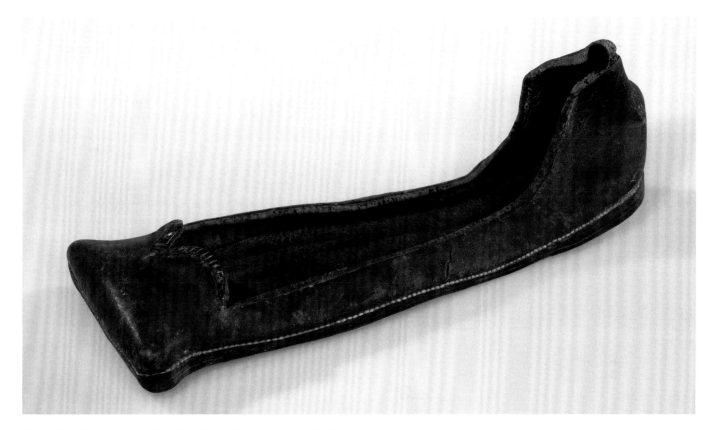

Figure 2.2. *Horn shoe, c.1540. © Bayerisches Nationalmuseum, Munich.*

From 1516 until the mid-1530s, the men often wore garters. While having the practical benefit of helping to reduce wrinkles in the hose if they slipped down a little with wear, they could also be highly decorative. Matthäus either tied his garters below the knee or above and below the knee with the knot positioned to the outside of his knee or positioned centrally above his kneecap. The garters were usually made from lengths of very lightweight fabric, probably a fine silk, and the ends were frequently decorated with fringe of metal thread or a decorative edging worked in metal thread.

Footwear: Matthäus and Veit usually wore shoes (or possibly on occasion footed hose; Figure 2.2).[77] For much of his adolescence and adult life Matthäus preferred shoes that were wide at the front, with slashes on the vamp and quarters.[78] A design for a shoe of this type, which was quite wide at the toe and came up quite high around the heels, was drawn by Albrecht Dürer (c. 1525–26). It was annotated noting that the shoes should have "double soles," how high the leather should come up the back of the heel, that "the ornament on it is to be pressed into the damp leather," and that he wanted "a pair of lasts like these to be made so that the whole sole lies flat."[79] Although by the 1550s, Veit and his father both wore shoes with slightly pointed toes, as neither man mentioned his footwear very often in the commentaries, it is hard to be certain whether the uppers were leather or textile over leather. What is much clearer is that they predominantly wore black shoes—indeed the only one exception was the pair of white shoes worn by Veit in December 1555.[80]

Two other types of footwear were illustrated, and they were specifically mentioned in the text, indicating that they were considered to be unusual. First, there were long boots for riding,[81] or with armor,[82] as well as the indoor boots that Matthäus wore while he was housebound after his stroke.[83] Second, they both wore mules but only very occasionally.[84]

77. J. Swann, *History of Footwear in Norway, Sweden and Finland* (Stockholm: The Royal Academy of Letters, History and Antiquities, 2001), 81–100.
78. For example I 49–57. Also see J. Swann, "English and European Shoes from 1200 to 1520," in *Fashion and Clothing in Late Medieval Europe*, ed. R. C. Schwinges and R. Schorta with K. Oschema (Riggisberg and Basel: Abegg-Stiftung and Schwabe Verlag, 2010), 20.
79. British Museum Sloane, 5218-200; scc M. Scott, *Medieval Dress and Fashion* (London: The British Library, 2009), fig. 114, 184. A shoe made from this document in 1974 was a UK size 7, a European size 41, and a US size 8.5.
80. II 18.
81. I 16, I 20, and I 22.
82. I 125 and I 127.
83. I 130–31.
84. I 104 and II 21.

Accessories: Accessories played an essential role in shaping male identity, and they appeared in inventories and portraits as a marker of status and fashionability.[85] However, there were a surprisingly small number of references to them or depictions of them in either book. The gloves worn by Matthäus and Veit were usually made from brown leather with little or no sign of decoration, with the exception of the slashes on the back of the gloves worn in 1.35. In a few instances, the gloves were held or carried,[86] rather than being worn for a specific function, such as archery,[87] and in one instance there was a suggestion that the gloves were integral with the hanging sleeves of his gown.[88] Bags and purses were equally illusive.[89] The men were most often depicted with them in their early years, particularly associated with their schooling.[90] There were a few specialist bags, such as the hawking bag that Matthäus had in 1516.[91] The lack of purses by the 1550s may indicate that they were keeping small items in the pockets of their trunk hose.

Jewelry: Certain types of jewelry were associated with masculinity in sixteenth-century Augsburg: gold chains, rings, pendants, and hat ornaments, including brooches and aglets. In addition, gold or gilt gem-set buttons cross the divide between jewelry and fastenings.[92] Matthäus was not depicted in his book wearing a gold chain made of large links of the sort seen in the portrait of Philip Graf (c. 1515), suggesting that he did not own one.[93] Instead, he owned several large gold pendants and a silver crucifix that he wore hanging from a silk cord, which was probably a loop-manipulated braid.[94] He wore his crucifix for the first time in 1513 when he was sixteen[95] and wore rings from 1516.[96] His use of pendants was a combination of display, when it was shown off against his white shirt[97] or his doublet,[98] and concealment, when it was tucked inside the neck of his doublet.[99]

Veit wore less jewelry than his father. In part this may reflect his youth, although the items that he did own were of high quality, a mixture of gifts from his father and purchases. He first wore jewelry in Venice in May 1557 when he was fifteen; it was a gift from Signor Gerhardo di Longhi, which encouraged him to buy jewelry for himself.[100] Although his father made a few references to the use of pearls,[101] Veit owned items with some of the most prized gemstones of the period: diamonds,[102] rubies,[103] and turquoise.[104] However, unlike Matthäus, Veit did not wear, or did not openly wear, any devotional jewelry, which hints at the impact of the Reformation in Augsburg society. Instead his jewelry revealed more about his family's position in society—that he owned a signet ring[105] and that his father bought him a watch, which he could use to monitor the passing of the business day.[106]

Weapons: Matthäus and Veit were both right-handed, so they carried their swords on their left hips, and they were often depicted resting their left hands on the hilts. The right to carry arms and having the money to own a variety of swords was one of the key markers of distinction in early modern male society. Matthäus was depicted with a variety of sword types, including the long sword, which would be used with two hands, and the lighter rapier with increasingly ornate hilts. He frequently carried a sword and dagger. In contrast, Veit carried a dagger before he advanced to carrying a rapier, which was his weapon of choice. Like his father, he practiced his skills and was able to receive instruction from a skilled teacher.[107]

The significance placed on owning and carrying a sword ensured that the girdle and hanger became an increasingly important area for male display, as did the scabbard. While this accessory was not depicted in great detail, it is quite surprising that they were not depicted with a matching girdle, hanger, and purse combination more often.[108] Between April 1555 and June 1556, Veit was often shown wearing just a black girdle and hangers with no weapon.[109] As such he was anticipating the time when he would be permitted to carry a sword or dagger.

Both men also emphasized their civic duty by practicing archery in the summer months. Archery competitions provided them with an opportunity to demonstrate their skill to their peers and ensured that they had the most up-to-date bows. Matthäus had a longbow, while Veit used the newer, more stylish crossbow.[110]

85. R. Tittler, "Freemen's gloves and civic authority: The evidence from post-reformation portraiture," *Costume* 40 (2006): 13–20.
86. For example, 1.116.
87. I 35 and I 91.
88. I 15.
89. For their importance and key types in this period, see J. Pietsch, *Taschen: Eine europäische Kulturgeschichte 1500–1930* (Munich: Bayerisches Nationalmuseum, 2013).
90. Inv. No. T.4443; B. Borkopp-Restle, *Textile Schätze aus Renaissance und Barock* (Munich: Bayerisches Nationalmuseum, 2002), 30–31.
91. I 27.
92. See N. Awais-Dean, *Bejewelled: the Male Body and Adornment in Early Modern England* (PhD diss., University of London, 2012).
93. Hans Doring, *Philip Graf and his two sons Reinhard and Otto*, c. 1515, oil on wood panel, 45.5 × 57 centimeters, Schloss Laubach, Karl Georg Graf of Solms-Laubach.
94. See N. Speiser and J. Boutrup, *European Loop Braiding: Investigations and Results: Part 1I: Instructions for Letter Braids in 17th Century Manuscripts* (Leicester: Jennie Parry and the Abegg-Stiftung, 2003).
95. I 17.
96. I 25.
97. For example, I 43, I 68–70, I 73. Or against his white partlet, I 54.
98. For example, I 61–62 and I 72.
99. For example, I 25, I 27, I 32, I 36, and I 59–60.

100. II 23.
101. I 91, I 105.
102. II 23, II 33, and II 39.
103. II 39.
104. II 23.
105. II 39.
106. II 27, II 31; D. Scarisbrick, *Jewellery in Britain, 1066–1837: A Documentary, Social, Literary and Artistic Survey* (Wilby: Michael Hall, 1994), 147.
107. II 41.
108. See examples in T. Capwell ed., *The Noble Art of the Sword: Fashion and Fencing in Renaissance Europe, 1520–1630* (London: Paul Holberton Publishing for the Wallace Collection, 2012), 56–57, 94–95
109. II 16–2II
110. I 33, I 35 and II 29.

As this overview has demonstrated, Matthäus and Veit owned the clothes suitable for men of their age and status. Their wardrobes reflected changing fashionable trends, and they were well aware of the need to combine their doublet and hose with all the necessary accessories, ranging from bonnets to bags and boots, to ensure that they were suitably dressed for all occasions, whether formal or informal and whether linked to work or for more sociable activities. The next section explores what the specific details of their clothes revealed about their taste, their disposable income, and how far their clothing choices were influenced by locally produced textiles.

Exercising choice: Textiles, other materials, color, and decoration in the Schwarz wardrobes

In 1530 new Imperial clothing laws were issued by the Diet of Augsburg "to ensure that each class should be clearly recognized apart."[111] Similar references to clothing appeared in later legislation, such as the 1537 Discipline Ordinance, which stipulated that the citizens of Augsburg should wear clothing appropriate to their rank so that they could "be recognized for whom he or she is."[112] However, it is important to note that no detailed local sumptuary legislation was issued during Matthäus Schwarz's lifetime. These examples stress the local nature of the sumptuary laws in the empire, ensuring that each city had its own clothing identity, as well as aspects of a shared identity with neighboring urban centers, reflecting broader concerns linked to ideas of extravagance and luxury. With the Schwarz family in mind, it is the impact of the laws on the middling sort that is pertinent here and how far these laws acted as a means of defining this particular social group or individuals within this group.

Textiles: Martin Luther complained bitterly that the German people spent a lot on imported luxury goods; the illustration depicting Matthäus at work with Jakob Fugger, indicates how they got access to such items.[113] The labels on the office cabinets reveal that they engaged in trade throughout Europe, with business partners in Innsbruck, Kraków, Lisbon, Nuremberg, Rome, and Venice.[114] A key part of their business was in the textile trade, and this permeated every aspect of life within the Fugger business. For instance, in 1559 Veit recorded that lengths of fabric were given as archery prizes by the Fuggers at an archery contest held during the Imperial Diet. He considered the best prize was five ells of "buschatt" (*Barchent*) or fustian and a piece of checked material of several colors.[115]

The latter suggests that the Fuggers traded in checked fabrics of the sort that Veit was depicted in several years earlier.[116]

The Fuggers had strong business links with Italy, and they traded in textiles, including wool and silk, as well as goldsmiths' work. On a number of occasions Matthäus and Veit recorded that their clothes were made from silk, which was most likely from Italy and possibly part of the Fuggers' stock.[117] Silk fabrics were among the most expensive available in Germany, partly because they were imported and partly because silk fibers were often used to produce complex weaves, such as satins, with a lustrous surface; damask, which often had self-colored complex designs; and velvet, with a decorative pile. This could take the form of continuous cut pile, which resulted in a soft, rich surface, uncut pile, a combination of cut and uncut pile, or a mixture of areas with pile and others without. However, not all silks were expensive. Some lightweight silks, such as taffeta and sarsenet, were more reasonably priced, but they still came in a variety of qualities, which Matthäus noted carefully.[118]

The price of silk damasks was dictated by the quality of the silk, the color the fabric was dyed, and the length of the pattern repeat. When the artists depicted Matthäus and Veit dressed in damask, they usually accentuated the traditional pomegranate or artichoke design, in order to make the viewer aware of what the textile was, and they also accentuated the size of the repeat.[119] However, silk satin[120] and silk velvet[121] played a bigger part in both the wardrobes of father and son, with both fabrics being regularly selected for doublets, gowns, and decorative trimmings for bonnets and other garments. Even so, it is interesting to note that Matthäus Schwarz took pride in his ability to be well dressed even when he was not wearing silk.

The Hanseatic League traded widely in northern Europe, including in London, selling German fustian and linen and buying English cloth for resale in Europe, alongside locally produced fabric. Matthäus and Veit both wore wool, and they usually referred to it as cloth (*tuech*) or wool (*wullin*), but on occasion they provided more information about the origins and quality of the material. In these cases, they generally referred to fabrics that had been produced fairly locally, as suggested by Alpine cloth (*Das tuch barpianisch*), cloth from Mechelen (*gra mechlisch*), and fine wool from Perpignan (*barbia*).

111. A. Hunt, *Governance of the Consuming Passions: A History of Sumptuary Law* (New York: St Martin's Press, 1996), 121. Also see Introduction 1, 12.
112. L. Roper, *The Holy Household: Women and Morals in Reformation Augsburg* (Oxford: Clarendon Press, 1989), 112.
113. Rublack, *Dressing Up*, 107.
114. I 28.
115. In 1559 (II 29).
116. April 1557 (II 22) and July 1558 (II 28).
117. I 17, I 23, I 47, I 85–86, I 94, I 108–09; II 27 and II 35. For Italian silks and silk production, see L. Monnas, *Merchants, Princes and Painters: Silk Fabric in Italian and Northern European Paintings 1300–1550* (New Haven and London: Yale University Press, 2008).
118. I 15, I 19, I 21, I 52, I 56, I 60, I 63, I 65–66, I 67, I 73, I 75, I 78, I 89, I 91, I 93, I 98, I 99, I 100, I 104, I 107, I 120; II 17, II 18, and II 19.
119. I 49, I 52, I 55, I 90, I 97, I 98, I 99, I 102, I 103, I 107; II 31.
120. I 15–17, I 19, I 24, I 27, I 31, I 33, I 35–36, I 46, I 48, I 52–53, I 55–56, I 58–60, I 62, I 64, I 71, I 74, I 85, I 88, I 91, I 93, I 95–96, I 102–03, I 105, I 108–09, I 118; II 23, II 32–36.
121. I 24, I 46, I 50, I 52, I 54–55, I 61–63, I 71–72, I 75, I 85–86, I 88, I 90, I 92–93, I 96, I 105–06, I 110, I 114–16, I 121–22, I 131; II 13, II 32, and II 36.

While wool and silk featured significantly, some of the most frequently mentioned textiles in the wardrobes of Matthäus and Veit were mixed or union clothes. These were textiles where the warp (the vertical threads) was one fiber and the weft (the horizontal threads) another. The virtue of blending fibers in this way was to gain the benefits of both in terms of handling and flexibility, while reducing the cost. On several occasions both men refer to wearing garments made from mixed-fiber fabrics, and their views on them vary, with each seeing the modest prices as an advantage and a disadvantage dependent on the circumstances. Fustians (a linen warp and a cotton weft) and half silks (combining silk with wool or linen) were the two mixed-fiber fabrics most frequently mentioned. While fustians were first produced in Lombardy, by the end of the fourteenth century they were being woven in Augsburg, Basel, Constance, Ravensburg, Regensburg, and Ulm, while also flourishing in Tounai and Genoa, Milan, Naples, and Venice.[122] During the 1520s and 1530s fustians were very popular and a very significant part of the Fuggers' business.[123] As such, by wearing fustian, Matthäus and Veit showed loyalty to company products while also buying fabrics that were readily available in Augsburg.

Half silks (*taffat/daffat*),[124] which might be wool and silk or silk and another animal fiber, and wool and silk mixes (*Burschat*)[125] were a very regular choice with over forty-five references to these textiles in the books of Matthäus and Veit. It is likely these were either plain or twill weave textiles because there are also references to bridges or Brussels satin, a union cloth with a silk warp and woolen weft woven as a satin, which offered the buyer the shiny surface of a full silk satin.[126] Matthäus also wore some camlet in later life, which could be woven from wool, silk, or a combination of the two. As he did not provide any details, it is not possible to know which version he had selected.[127] One other mixed-fiber cloth (*Macheier*) made a brief appearance in the 1550s, which combined linen with other yarns.[128]

The shirts worn by Matthäus and Veit were made from good quality, fine linens with a high thread count. Linens of this sort were woven in Germany, and Westphalia was famous for its linen fabrics.[129] In addition to having a high thread count, the linen needed to be white, as opposed to its natural gray-green color. As a result linen bleachers became an increasingly significant group in sixteenth century Augsburg, and this was reflected in individual craftsmen employing up to five adult male workers.[130] As noted above, shirts formed a very significant part of both men's wardrobes, and Matthäus in particular valued the quality of his shirts as a key part of his appearance.

Other materials: While Matthäus and Veit make relatively few direct references to leather, it played quite a significant part in their appearance. In June 1524 Matthäus described three pairs of over-hose as being made from Prussian leather.[131] He provides no more details, but the illustrations suggest that Prussian leather was high quality, soft, and flexible, making it very suitable for making hose or over-hose from. If the knee length over-hose were cut from one hide, it would need to be from quite a large animal, such as a deer. Deerskin/doeskin was a popular choice for hose, jerkins, shoes, boots, gloves, bags, and purses.[132] It is quite possible that Matthäus had other pairs of leather hose, but he did not specifically mention them. In contrast, in addition to leather hose, or more specifically at least one pair of leather trunk hose,[133] Veit also had a small number of leather body garments, including a leather jerkin.[134] In this, he was in keeping with Nils Sture, who owned a doublet made from a soft, pale gray, suede. The sleeves were cut in one piece, with a short opening fastened with three buttons.[135] Veit used his trips to Italy to buy leather goods because in June 1557 he recorded that he had "brought the leather jerkin and shoes … with me from Venice."[136]

Fur was a marker of wealth and status while also providing welcome warmth in the winter months. The merchants of the Hanseatic League traded extensively in furs and they, like the Fuggers, had strong connections with Venice, the chief European fur market.[137] Like his father Ulrich, Matthäus used fur to line or trim gowns and bonnets, owning seventeen fur-lined gowns,[138] one fur-lined doublet,[139] and five fur-trimmed

122. A. F. Sutton, *The Mercery of London: Trade, Goods and People, 1130–1578* (Aldershot: Ashgate, 2005), 280. J. H. Munro, "The origin of the English 'New Draperies': The resurrection of an old Flemish industry, 1270–1570," in *The New Draperies in the Low Countries and England, 1300–1800*, ed. N. B. Harte (Oxford: Oxford University Press, 1997), 70.

123. Sutton, *The Mercery of London*, 468. H. Kellenbenz, "The fustian industry in the Ulm region in the fifteenth and early sixteenth centuries," in *Cloth and Clothing in Medieval Europe: Essays in Memory of Professor E. M. Carus-Wilson*, ed. N. B. Harte and K. G. Ponting (London: Heinemann Educational Books, 1983), 259–76.

124. I 21, I 25, I 30–31, I 49, I 51, I 63, I 71, I 78, I 86, I 89, I 93, I 97, I 100, I 112–13, I 123–24, I 128–29; II 13, II 15–19, II 22, II 25, II 27, II 29, II 31–32, and II 35. For more on mixed fabrics in Venice, see L. Mola, *The Silk Industry of Renaissance Venice* (Baltimore and London: The Johns Hopkins University Press, 2000), 171–76.

125. I 122, I 35, I 56, I 61, I 65, I 73, I 89, I 105, I 118, I 124, I 134–35; II 13, II 26, and II 29.

126. I 32, II 27, and II 41.

127. I 88, I 114, I 131, and I 136.

128. II 22–23.

129. Sutton, *The Mercery of London*, 280.

130. Roper, *Holy Household*, 34.

131. I 68–70.

132. C. H. Spiers, "Deer skin leathers and their use for costume," *Costume* 7 (1973): 14–23.

133. II 27.

134. II 20.

135. J. Arnold, "Nils Sture's suit," *Costume* 12 (1978): 13–26.

136. II 25.

137. E. Veale, *The English Fur Trade in the Later Middle Ages* (Oxford: Oxford University Press, 1966), 75–77.

138. I 5, I 7, I 30, I 36, I 45, I 50, I 93, I 104, I 108–09, I 112, I 115, I 117–18, I 122, I 129, and I 134.

139. I 92.

bonnets.[140] His book reveals his preference for marten,[141] followed by several colors of Siberian squirrel, including pale gray pelts,[142] gray squirrel,[143] fitch,[144] and curled lamb.[145] In contrast, Veit wore very little fur, suggesting that it was less significant as a mark of wealth, especially for young men. However, it was still prized in cold weather, as indicated by his choice of a tall sable hat and a gown fully lined with fox fur in the winter of 1560–61.[146]

While offering no protection against the cold, feathers also played an important part in the self-presentation of the Schwarz men. In October 1515 Matthäus wore a bright blue bonnet trimmed with large yellow ostrich feathers.[147] He was to periodically select hats decorated with similar large plumes until 1530.[148] After this point he does not wear them again and Veit only does once. These feathers would have been imported because the ostrich was native to Africa, forming part of the trade in luxury goods. As these illustrations demonstrate, while the white primaries and tail feathers were prized, the feathers dyed quite easily and could be purchased in a wide variety of colors; on occasion they could be further embellished with metal spangles.

Color: Color was an important consideration when selecting clothing because it had financial, social, religious, and symbolic implications.[149] As a result, color was often the subject of sixteenth-century sumptuary laws with particular colors or dyestuffs restricted to particular social groups, particular occasions, or particular garments. Therefore it is not surprising that color plays an important part in the appearance of Matthäus and Veit and that there were some distinctive differences in their relationship with it.

Matthäus used color as one of the most important decorative elements in his clothing, as opposed to patterned fabrics or forms of applied decoration, such as embroidery. Although he often wore black, and to a much lesser extent gray and brown, he also favored a wide range of often very bright colors, including yellow, leaf green, pink, orange, purple, and bright blue. In contrast, Veit wore a limited selection of shades, and they were often more muted. His adult clothes were dominated by black, worn alone or in tandem with gray or brown, and these colors were also worn in their own right, as were white and cream. The one strong color he wore was red, and the occasions ranged from the first set of clothes he chose himself and paid for to his carnival costume.[150] As such the books demonstrate a significant percentage of the fashionable shades that were available to men of their status in southern Germany. They also record a shift in what the desirable color palate was, moving from variety and color to a more limited and muted range.

Moving from the colors they selected to how they combined colors within a particular set of clothes, there were again differences. Matthäus often combined colors, as seen in March 1523 when he wore a brown and yellow doublet with gray and yellow hose and a gray, yellow, and white short cloak.[151] On March 13, 1527, he combined a black and white doublet with pink and black hose.[152] However, more frequently he appeared dressed all in one color. For instance on May 2, 1533, he wore a gray gown, gray doublet, and gray hose with a hint of yellow,[153] but on August 4, 1534, he selected a red doublet, placard, and hose.[154] Veit followed the latter model and almost always wore clothes of a single color.

Dressing all in a single color, especially black[155] but also in red[156] and white,[157] was one of the distinctive features of these books. While the individual garments might be made from different fabrics, a unified appearance could be created by selecting items that were all the same color. Black was most frequently used in this way by Matthäus and Veit and by society in general. As Castiglione noted "Therefore me thinke a blacke color hath a better grace in garment than any other, and though not thoroughly blacke, yet darke, and this I meane for his ordinarie apparrell."[158] What made black so suitable was that it was expensive, respectable, acceptable to Catholics and followers of reformed religion alike, and could be understated while also acting as a vehicle to display decoration and jewelry. It was used for mourning but not exclusively so, and as such black was a desirable color to have in a wardrobe. Red was also popular, expensive, and available in a wide range of shades, including crimson[159] and scarlet.[160] The importance attached to bright colors, and red in particular, in contemporary German society is evident in the paintings of Lucas Cranach and the

140. I 4, I 65, I 92, I 119, and I 131.
141. I 50, I 65, I 93, I 104, I 108, I 109, I 118, I 122, I 129, and I 34.
142. I 92, I 112, and I 117.
143. I 119.
144. I 92, I 112, and I 117.
145. I 104.
146. II 38.
147. I 23.
148. I 101. For the other occasions where he wore hats with ostrich feathers, see I 24, I 41, I 48, I 57, I 76, and I 87. There is one instance where ostrich feathers might be used for a fan, see I 3.
149. For a wide-ranging overview of the topic, see S. Kay-Williams, *The Story of Color in Textiles* (London: A & C Black Publishers Ltd, 2013).

150. II 17, II 34, and II 40.
151. I 60.
152. I 87.
153. I 106.
154. I 107.
155. For example, I 26, I 76–77, II 25, II 27, and II 32. For studies on the significance of black see J. Harvey, *Men in Black* (London: Reaktion, 1997); M. Pastoureau, *Black: The History of a Color* (Princeton: Princeton University Press, 2008); and J. Harvey, *Black: The Story of a Color* (London: Reaktion, 2013).
156. For example, I 42, I 52, I 86, I 107, and II 17. For studies on the significance of red, see A. B. Greenfield, *A Perfect Red: Empire, Espionage and the Quest for the Color of Desire* (London: Black Swan, 2011).
157. For example, I 61, I 120, and II 18.
158. Castiglione, *The Courtier*, 116.
159. I 46 and I 52.
160. I 52, I 63, and I 66–67.

demands of the Peasants' Revolt in Germany, in which they demanded to be allowed to wear red.[161]

In addition to the fashionable connotations of a particular shade, color could be used to stress social bonds, and several examples appear in these books: First individuals could wear livery colors to express allegiance (e.g., when Matthäus dressed in the yellow and blue French colors in October 1515)[162] or civic duty (e.g., wearing parti-colored hose as part of the city livery of Augsburg in March 1527).[163] Second, they could dress in a particular color to express group identity, such as the bachelor's group at a wedding party.[164] Third, they could dress in black to pay their respects to a family member or an employer or patron during a set period of mourning that was bound by conventions.[165]

One other aspect of how color could be used needs to be noted. Matthäus often chose garments in the 1520s and 1530s that were parti-colored or striped (vertically, horizontally, and diagonally). This suggests that there did not seem to be any stigma attached to stripes, or if there was, this was part of the appeal of wearing them.[166] As such stripes could either be seen as part of high fashion or evidence of a dissolute and wild nature. According to Pastoureau the latter resulted in the idea of the striped layman, who had little education but who could read, and the striped clergy who were clever, sinful, and vainglorious.[167] In contrast, Veit's wardrobe reveals an absence of stripes, indicating that they had dropped out of fashion. However, he did wear checks on two occasions.[168]

Decorative techniques and fastenings: According to the English poet John Skelton (c. 1460–1529) in *The Manner of the World Nowadays*, there was a fashion for "cutting and jagging."[169] While Skelton undoubtedly made this as a derogatory comment, he recorded the popularity of slashing and pinking as decorative techniques on doublets, hose, and gowns.[170] As Jenny Tiramani's work has admirably demonstrated, both techniques in the hands of a skilled practitioner could produce striking results quickly, with the possibility of endless variety and novelty. Slashing generally referred to longer cuts that could be vertical, horizontal, or on the diagonal, and in the case of Matthäus's wardrobe, slashing was most usually to be found on the sleeves and fronts of doublets and on his hose.[171] However, a full-length portrait of *Duke Henry the pious of Saxony* dating from 1514 reveals almost everything he

was wearing was decorated with slashing,[172] including his hose, doublet, and long gown. Pinking usually referred to small cuts of up to ¼ inch long (6 mm) made using small metal cutters.[173] Surviving examples of pinked fabrics indicate that geometric designs were often popular.[174] Pinking featured more prominently in Veit's wardrobe, with him specifically mentioning it in relation to the decoration of his doublets and hose.[175]

Panes were popular as a means of either making garments (such as trunk hose) or parts of garments (such as hose) from a series of narrow strips or bands.[176] Parts of garments could also be cut in panes, including jerkins. For instance, see the lower section of Matthäus's doublet sleeves in 1520,[177] the upper section of both fronts of Veit's jerkin in summer 1560,[178] or the back, short sleeves, and fronts of his friend's jerkin in 1561.[179]

Narrow strips of fabric, known as guards, were applied to a range of garments as a means of adding decoration. They were often of a contrasting color and weave to the main garment, and they were most frequently found decorating the hems of women's skirts and the front edges, hem, collars, and sleeves of men's gowns.[180] Guards could be applied singly, in pairs, or with added decoration to provide extra interest.[181]

Passementerie of different sorts was used extensively to decorate the clothing of Matthäus and Veit. Cologne was one of the key centers for making passementerie or silkwomen's goods, including silk and metal threads and the range of smallwares made from them, such as braids, buttons, and girdles.[182] Cologne had three guilds for women who were gold spinners, spinners, and silkwomen, although these were in decline by the sixteenth century.[183] There were no comparable guilds in Augsburg, suggesting that Matthäus and Veit would have bought goods brought from Cologne or from further afield, such as Venice.[184] Matthäus had applied bands of broad passementerie

161. J. Laver, *Costume and Fashion: A Concise History* (London: Thames and Hudson, 1969, 2002), 86.

162. I 23.

163. I 87.

164. For example, II 34.

165. I 37–40, I 37.

166. See M. Pastoureau, *The Devil's Cloth: A History of Stripes and Striped Fabric* (New York: Columbia University Press, 2001).

167. Rublack, *Dressing Up*, 103.

168. II 22, II 25.

169. Quoted in A. Ribeiro, *Dress and Morality* (London: B. T. Batsford, 1986), 60.

170. J. Arnold, "Decorative features: Pinking, snipping and slashing," *Costume* 9 (1975): 22–6.

171. For example, I 47, I 50, and I 52.

172. Lucas Cranach, *Duke Henry the pious of Saxony*, 1514, limewood panel transferred to canvas, 184 × 82.5 centimeters, Staatliche Kunstsammlungen, Dresden, Gemäldegalerie, 1906 G.

173. J. Arnold, *Queen Elizabeth's Wardrobe Unlock'd* (Leeds: Maney, 1988), 187, fig. 269.

174. Inv. no. T.4090; Borkopp-Restle, *Textile Schätze*, 56–57. Also see the pinked satin lining of the hanging sleeves of the gown Pfalzgräfin Dorothea Sabina von Neuberg was buried in, Bayerisches Nationalmuseum, Munich: Arnold, *Queen Elizabeth's Wardrobe*, 187, fig. 270.

175. For example, see II 16–17.

176. For example, see II 33–34.

177. I 42.

178. 2.36.

179. II 41.

180. I 116.

181. For example, I 108, I 116.

182. Sutton, *The Mercery of London*, 278. The 1547 inventory taken at the death of Henry VIII included several references to Cologne gold or "Colin" gold. For example, "xij longe garments of Crymsen Satten ruffed and fringed with Colin gold" [8620], while another set of costumes were decorated with "Colin Siluer" [8621].

183. In 1480 Anthony Odyndale was trading in London and he specialized in selling Cologne silk; Sutton, *The Mercery of London*, 279.

184. Roper, *Holy Household*, 47.

to create striped effects on doublets,[185] while z-shaped motifs of passementerie enhanced the sleeves and hem of a gray gown.[186] Veit's doublets and hose often had small geometric designs created with passementerie,[187] but he also used it more boldly, for example, in the frogging effect on his gown.[188]

Passementerie was also used to fasten clothes. Simple silk cords were only depicted a few times, used as a means of lacing up the front of Matthäus's hose, but they were probably used more often than this suggests. Points with metal aglets or tags[189] were the most frequently depicted form of fastening, and they were used in several specific ways: to join doublet and hose[190] and to secure the codpiece.[191] Matthäus even had a phase of actively showing off his points by selecting bright red examples.[192] Silk or thread buttons, often in the form of a Turk's head knot worked around a wooden core, were first depicted as a means of fastening the front-fastening doublets worn by Matthäus, most notably from July 1550.[193] They were also the usual means of fastening the doublets worn by Veit from 1554 to 1561. In both cases the doublets were closed with round/spherical buttons. Just one example of metal buttons, or precious metal buttons, was recorded.[194] However, large buttons did appeared earlier in a decorative role on the sleeves of Matthäus's gowns.[195]

Some decorative techniques were not used very often, and the most notable of these was embroidery. Matthäus made few specific references to embroidery,[196] and there is just one instance of him actually describing the technique when he referred to *niderlendisch arbait*.[197] That said the illustrated record shows more examples, but they are almost exclusively found on Matthäus's shirts, and as a consequence, the embroidery was linked to the use of particular materials, such as black silk and metal thread.[198] Occasionally embroidery was also used to decorate placards.[199] In contrast, Veit's wardrobe recorded even less use of embroidery.

Making/repairing clothes: The clothing books were intended to provide an overview of two wardrobes as they evolved and developed. The emphasis was on new garments worn for particular occasions or at specific times of their lives. As such it is possible to get a sense of when they were either buying

a lot of new clothes or when they felt the need to record these garments. The books are less helpful in terms of considering the details of clothing production. Veit recorded the name of his tailor twice—Jörg Halbritter[200] and Simon Kistler[201]—and on both occasions he went to a master tailor who made him several sets of clothes for significant events. While Matthäus did not mention his tailor, he did make a few references to clothing alterations.[202] One thing neither of them alluded to was whether any of their clothes were made at home. It is possible that their baby clothes, baby linens, and their shirts while they were young were made either by their mothers or the maids. Equally, some of the shirts that Matthäus wore after his marriage may have been made for him by his wife—however if they were, he did not record it.

Civic legislation that sought to regulate clothing often required the tailor to check that their customers were eligible to wear the items they were ordering. The impact of this on tailors is evident from their masterpiece books.[203] The masterpiece book of Jörg Praun of Innsbruck contained patterns for a range of garments that were grouped according to the status of the wearer. Starting with ecclesiastical dress, there were then sections focusing on the clothes of the citizen, the elite, and for tournaments. Most pertinent in this context were the clothes for the citizen, including the ceremonial gown (the *Ehrrock*), the gown (the *Oberrock*), the mantle (the *Janker*), and the cloak (the *Zweickelmantel*).[204] Not surprisingly it was hard for civic authorities to enforce this legislation because neither the tailors nor their customers were willing to comply.

Matthäus and Veit selected a wide range of fabrics for their clothes, but many of them could be linked to the Fuggers' trade in textiles. In terms of color, fabric type, and variety of decoration, Matthäus was either much more adventurous than his son, or their tastes and choices reflect the prevailing trends of the times in which they were buying clothes. The 1510s, 1520s, and 1530s saw more styles being worn in tandem; while in the 1540s and 1550s, the color range was much more subdued. Their use of silk, wool, and mixed-fiber clothes reflected availability in Augsburg and also gave an indication of their social status—men with money to spend on their clothes but not with the much more extensive budgets of men in the nobility.

Female clothing in the Schwarz household

These books also provide a few glimpses of women's clothing from 1497–1500 and 1541–47.[205] While the number of images

185. I 73–74.
186. I 106.
187. For example, I 27, I 32.
188. 2.21.
189. Matthäus specifically mentions points in the commentary to I 53 and I 105.
190. I 65.
191. I 65.
192. I 32–33.
193. I 133.
194. II 25.
195. For example, I 86.
196. I 50, I 72, and I 75.
197. I 85.
198. For example, I 29, I 30, I 42, I 43, I 46, I 50, I 52–55, I 59–60, I 64, I 67–70, I 75, and I 86.
199. I 104.

200. II 31–32.
201. II 33–35.
202. For example, I 62.
203. I. Petrascheck-Heim, "Tailors' masterpiece-books," *Costume* 3 (1969): 6–8.
204. Petrascheck-Heim, "Tailors," 6–8.
205. Zander-Seidel, *Textiler Hausrat*, 48–156. Also see L. Roper, "'Going to Church and Street': Weddings in Reformation Augsburg," *Past and Present* 106 (1985): 62–101. L. Roper, "Discipline and respectability: Prostitution and the

is limited, they provide very useful insights into the clothing of women of different ranks, different ages, and different marital status. First, there are the pictures of the highest status women, who were also wives and mothers, and it is these considerations that make them significant in this context, namely, Agnes, wife of Ulrich Schwarz and mother of Matthäus,[206] and Barbara, wife of Matthäus and mother of Veit.[207] Second, the smallest group depicted female siblings or children, and they demonstrate the importance of family names, with Barbel, Matthäus's sister appearing at the beginning of the first book,[208] and Barbel, Matthäus's daughter close to the end of the same volume.[209] Their appearance is also quite similar, the chief difference being that Matthäus's daughter wore black rather than red, and her gown had a high neckline rather than a low neckline in filled with a partlet. Third, there are the women in service to the Schwarz family, and they were the most interesting group because depictions of household servants and mid wives in this period are rare. While the first two illustrations were of unidentified maids,[210] the other women were named and their roles were given, adding to the value of the depictions: Anna Germennin, described as a salt maker, who possibly earned additional money laying out the dead;[211] the midwife, Frantz Gerttneri;[212] Veit's wet nurse, Barbara Vogel;[213] his maid, Anna;[214] and the maid, Magdalena.[215]

The higher ranking women, namely Agnes and Barbara, whose status derived from their being married to a member of the mercantile elite and their position as mistress of the house, each wore a one- or two-part gown, and in the case of the latter, the skirt and bodice would be made separately. While there was a change in the neckline, from a low neck to a rather higher, more square neck, the near floor length and fullness of the skirt denoted status and a degree of leisure. In contrast, the women in service wore either a two-part gown or a bodice and skirt that were worn together. Several of them took advantage of the skirt and bodice being different colors and fabrics. In general, most had high necks, while skirt length varied, with Magdalena's being hitched up a little to allow her to walk through the Augsburg streets without her skirts getting muddy.

Their clothes also reflect the range of fabrics available to women from these social groups. Agnes and Barbara wore

good quality wool and silk damask, respectively. In general women of higher status had access to fabrics with a woven pattern. For women of lower status, they usually selected plain fabrics but added a small amount of ornament in the form of a guard of a contrasting color just above the hem of their skirt. Matthäus's sister Barbel wore a bright orange/red, possibly madder dyed gown. In tandem with Veit's mother's red skirt, these garments indicate that red was a popular choice among women, especially married women and those from families of some standing. The apron was worn as a symbol of domesticity and service.

Their hair was always long but never depicted loose. Instead it was usually braided, but the braids could be left hanging down or coiled around the head. In addition, their hair was often covered with a small cap or a larger linen coif. This was true of Agnes and Barbara, as mistresses of the house, but it was also true of Anna Germennin, who was an older woman and possibly a widow, the midwife, and the wet nurse. However, young girls, such as Matthäus's sister and daughter, who were both called Barbel, are shown indoors with bare heads, as were some of the young and probably unmarried female servants.

They had access to a smaller range of accessories than their men folk with particular emphasis placed on purses and girdles. For Agnes and Barbara, their accessories marked them out as the woman of the house, and as such they were primarily markers of status; for the other women, such as Magdalena, they reflected the practical aspects of their roles; and for Anna, her girdle served to stress her position within the hierarchy of servants in the Schwarz household.

What their clothes reveal about Matthäus and Veit Konrad

The clothing books provide an overview of the clothes of two men from within the middling sort in Augsburg society. It is telling that Matthäus and Veit felt the need to record their lives through their clothes, but more telling that they were not unique. Other men who documented their lives, albeit in slightly different ways, included Hermann von Weinsberg (1518–98) a councillor in Cologne, who produced a personal chronicle.[216] This trait spread

Reformation in Augsburg," *History Workshop* 19 (1985): 3–28.
206. Frontispiece book 1, I 1.
207. Frontispiece, book 2.
208. I 3.
209. I 130.
210. I 1 and I 6.
211. I 2.
212. II 1.
213. II 2.
214. II 6 and II 8.
215. II 10.

216. K. Stolleis, "Patrician and bourgeois costumes in Cologne in early modern times," in *Kölner Patrizier- und Bürgerkleidung des 17. Jahrhunderts: Die Kostümsammlung Hüpsch im Hessischen Landesmuseum Darmstadt*, 11. This wish for commemoration was not limited to the German middling sort. For instance, between 1579 and 1580 Thomas Smith, customer of the port of London, commissioned nine portraits of his wife and children, including his second surviving son, and namesake, Thomas (c. 1558–1625) who would become a governor of the Muscovy Company. These pictures, painted by Cornelis Ketel, represented Smith's familial pride, which he could have reflected on each time he saw them as they hung in his house, which was located between Philpot Lane and Gracechurch Street. This is the largest set of English family portraits of this type to survive; see K. Hearn, "Merchant-class portraiture in Tudor London: 'Customer' Smith's commission, 1579/80,"

beyond the German speaking lands, as revealed by another "ego" document, the illustrated book produced by Gerardus Henrici of Wyringia, who was from Utrecht.[217] His book covers the period from 1464 to 1501 but most pertinent in this context is the section from 1470 onward when Gerardus was a student in Cologne. During this time he reflected on what was suitable as academic dress and how far he wished to follow the rules relating to the *habitus honestus*. This section will consider clothes and the male life cycle, dress as it links to social status, the development of specific clothes for particular activities, clothes and celebration, and clothes and the daily and seasonal cycle.

Life cycle: The books of Matthäus and Veit Konrad Schwarz contain an invaluable sequence of images that provide a record of how their clothes changed over the course of their lives. In the case of Matthäus, it is a view that ranged from the cradle (February 20, 1497) to the grave (almost),[218] while Veit's book covers a much shorter time span, running from his birth in October 1541 to March 1561. The clothes that they wore make it possible to track change visually but both men were very conscious of the passage of time, as indicated by each illustration including the date and their age expressed in years and months. This sense of time reinforces the value of having both books, which make it possible to compare the clothes of two generations.

Most notably the books emphasized several key phases in their lives and how these were linked to, and expressed by, their clothing. The most significant set of clothing changes took place in the early years of their lives. At birth they were both swaddled.[219] They then made the transition to the coat, a loose fitting garment with long skirts.[220] Signs of their immaturity included wearing an apron, the use of leading strings as they learned to walk, and the hat with a protective roll around the brim to provide some protection when they fell over. Evidence of their increased maturity included wearing more adult-style headwear and having a girdle with a small purse and handkerchief hanging from it.[221] Breeching was a very significant point in a boy's life when he exchanged the clothes of a young child for those of an adult man, namely the doublet and hose. For Matthäus, breeching had evidently taken place by 1504 when he went to the carnival at age "7 years and about two months," while for Veit he was first

shown in doublet and hose "At the end of February 1547" when he was five years and four months.[222]

The next key phase in their lives was their formal education, which took the form of attending various schools. As such this provided a clear link to their social standing—they did not have a tutor at home, as those above them might do; they were not formally apprenticed, as those below them could have been; and they did not go on to university. Their schooling was linked with quite formal clothes—either a doublet with long skirts, which came down over plain, practical hose, or a gown over doublet and hose. More significantly, these clothes were accessorized with a school bag, pen case, and ink bottle, all essential items for the young scholar. Both Matthäus and Veit stressed that their school clothes were chosen by their fathers, and they took great pleasure in depicting themselves once they no longer had to wear school clothes.[223] When their formal schooling had finished, both young men went on to learn the family business, and they did so by actively engaging in the world of work.

Adolescence and the late teenage years see both young men taking control over their wardrobes and buying their own clothes. As a result, they appear much more fashion conscious, while asserting their youthful masculinity with the codpiece and the wish to carry weapons. In Veit's case at least, his father still took an interest in his son's appearance, but at this stage it was by giving him gifts. On New Year's Day 1558, when Veit was sixteen, his father gave him a black doublet and jerkin with a pair of brown trunk hose.[224] Several months later Matthäus gave Veit a watch, indicating that he now saw his son as an adult.[225]

The remaining phases of the life cycle—as an adult in the prime of life followed by the process of aging, ill health, and death—were only partially recorded in Matthäus's book. The vast majority of the illustrations in his book focused on the period when he was at his peak, and they present the viewer with a sense of a man at ease in his various social circles, an environment where for the most part he dressed with his male friends and colleagues in mind.[226] While Matthäus's book did not note his last fourteen years or his actual death, it did depict the events that took place on November 22, 1499: it was thought that he had died at two years and nine months of age, and his body was prepared for burial by stitching it into a shroud.[227]

The importance of the life cycle was emphasized on a very personal level in Matthäus's book because he started the book on his birthday in 1520 with the note "February 20, 1520, I, Matheus Schwartz of Augsburg, had just turned 23." After this

in *Treasures of the Royal Courts: Tudors, Stuarts & the Russian Tsars*, ed. O. Dmitrieva and T. Murdoch (London: V&A Museum, 2013), 37–43.

217. R. C. Schwinges, "Between gown and fashion: A student's clothing in the late fifteenth century," in *Fashion and Clothing in Late Medieval Europe*, ed. R. C. Schwinges and R. Schorta with K. Oschema (Riggisberg and Basel: Abegg-Stiftung and Schwabe Verlag, 2010), 25–35.
218. The book ends on September 16, 1560, and he died in 1574.
219. I 1 and II 1–2.
220. I 3 and II 4–6.
221. II 7 and II 9.

222. I 5 and II 10.
223. I 11 and II 17.
224. II 26.
225. II 27.
226. For example, I 15.
227. I 2.

he was depicted on his birthday, as opposed to other occasions, a further fifteen times, and of these he marked his birthday in 1520, 1535, and 1539 with two illustrations. This suggests that he may have linked buying clothes with celebrating his birthday or that he chose to be depicted in a set of clothes that he felt was worthy of recording on his birthday, which indicates that it was a day to wear new clothes, his best clothes, or his current favorite set of clothes.[228]

Social status: At the start of his book on February 20, 1520, Matthäus Schwarz made no direct reference to his social status, but he may have felt this was unnecessary because it came directly after his coat of arms. In contrast, Veit described his rank very clearly, stressing that he was the "legitimately born son of Matheus Schwartzen, citizen of Augsburg."[229] Beyond their declared position as citizens, father and son used their clothes as a means of asserting their place within the middling ranks of Augsburg society. As the chief accountant of the Fugger company in Augsburg, Matthäus Schwarz was from the mercantile and artisanal ranks of society who aspired to move higher, and he used some of his disposable income to ensure that he looked the part. Indeed, he frequently looked gorgeous, but that was achieved through the use of cut, decoration, and color rather than the most expensive of the fabrics available to him. In contrast Veit's clothes were more conservative in style than his father's, and this is evident in the much more limited range of garments and styles that he wore. In part this may have reflected his temperament, but it also demonstrated his awareness of current fashions, which had also shifted from the flamboyant to the formal and from bright to understated.

Both men used their clothes to demonstrate their social status, and this was reflected by the quantity and quality of their clothes, in tandem with their purchasing patterns. As noted above, the ways in which they might do this also varied according to their age and their place in the life cycle. As members of the middling sort, Matthäus and Veit were just as aware of those above and below them in the social order, as they were of their own social group. Matthäus in particular used expensive fur to stress his status on occasion. For example he ordered two gowns, one of which was lined and trimmed with marten, for the Imperial Diet in October 1547.[230]

Matthäus and Veit were rarely shown with their social superiors. Jakob Fugger (1459–1525) was made a member of the nobility in 1511, and he was succeeded in the business by his nephew Anton Fugger (1493–1560). While clothing was important to both men, this generation of the family both dressed relatively modestly for their rank. In Matthäus's case he was depicted at work with his employer;[231] while in Veit's case, it was less overt, which may in part reflect the advantages that being his father's son conferred on him. At the archery competition sponsored by the Fuggers, several of the men and women of the family were in the background.[232] In both cases the Schwarz men wore similar styles of garment, with the differences being drawn out subtly in terms of color and fabric. However, the social difference between Veit and one of the men of the Fugger family was made clear by the Fugger gentleman wearing a substantial gold chain, long enough to be worn in three loops around his neck and Veit not doing so.

On occasion Matthäus and Veit were depicted with two different groups of men and women from the lower social ranks, and in both instances these were mainly while they were still young. First, they were shown with individuals who were in service to the Schwarz family or who had been employed to undertake a specific task, such as the midwife or grave digger. Second, they met individuals engaged in trade, such as the cowherd or the wine seller.[233] The exceptions to this were Matthäus being driven to work by a groom as he recovered from his stroke[234] and Matthäus with his page Vizli Memminger.[235]

Specialist clothing: Garments for travel and for sporting activities: Both men traveled extensively for their working education, as they learned their trade in different cities, and once they were employed by the Fuggers. They mostly traveled on horseback, and good horsemanship was an essential skill for men of most social groups from the middling sort upward. Matthäus was depicted in riding clothes nine times, and these illustrations revealed variety.[236] In contrast, Veit was only presented riding twice, and on both occasions he wore a short cloak.[237] These short cloaks had the virtue of leaving the arms free while keeping the upper body warm. Matthäus also wore short riding coats, as well as long coats that were split up the back to allow the skirts to cover his thighs. Depending on the season, riding coats were often heavily padded to provide extra warmth.[238]

This period also saw the development of specialist sporting clothes, reflecting the importance of athletic activities to hone the body and develop mental agility, such as fencing,[239] archery,[240] palmier,[241] and sledding.[242] Fencing practice took place all

228. Frontispiece, book 1, I 1 (February 20, 1497), I 42 (February 20, 1520), I 47 (February 20, 1521), I 51 (February 20, 1522), I 90 (February 20, 1528), I 93 (February 20, 1529), I 108–09 (February 20, 1535), I 112 (February 20, 1536), I 113 (February 20, 1538), I 117–18 (February 20, 1539), I 121 (February 20, 1540), I 122 (February 20, 1541), I 135 (February 20, 1552). Also see Introduction 1, 12.
229. Frontispiece, book 2.
230. I 122.
231. I 28.
232. II 29.
233. I 7 and I 12.
234. I 132.
235. I 126.
236. I 14, I 16, I 20, I 23, I 41, I 45, I 76, I 101, and I 119.
237. II 15 and II 24.
238. For example, I 20.
239. I 32 and II 41.
240. I 33, I 35, and II 29.
241. II 20.
242. I 44, I 51, I 57–58, and II 38.

year round, as did palmier—a form of tennis played without a racket—because it was played on indoor courts. Archery was predominantly a summer activity, while driving a sled required the snowy conditions of winter. All of these activities demonstrated the importance of having leisure time, a feature of the lives of the aspirational middling sort, and they all had a social element, involving spectators and competition, with the victor being given a wreath or garland to wear.[243] These activities were also closely linked to conspicuous consumption; they were relatively expensive to engage in because participation required access to specialist clothes and equipment.

Social activities: Significant occasions were often the reason or excuse for new clothes, and three examples will be considered here: weddings, the carnival, and mourning. Starting with weddings and after-weddings, Matthäus and Veit both attended as a guest,[244] and as key participant,[245] but only Matthäus took the central role as the bridegroom.[246] The number of weddings that they attended indicates the importance of marriage to early modern society. The clothes both men wore to these occasions, both in terms of their being their best clothes and in some instances being occasions that required several sets of different, new clothes, demonstrate why the authorities in Augsburg sought to regulate the size and cost of weddings.[247]

The scarlet clothes that Matthäus wore to undertake his role of overseeing the bridal chamber at Anton Fugger's wedding were among the most sumptuous that he would ever own.[248] As such they acknowledged the importance of the marriage, the status of the bride and groom, and Matthäus's relationship to the happy couple. The color would have helped to ensure that he stood out on a day when everyone was dressed in their best. In addition to rich clothes, wedding guests often wore a wreath or garland, either pinned to their hat or bonnet or resting on their hair.[249] The illustrations indicate that these garlands could be made from fresh or silk flowers and leaves or from metal wire. Lucas Cranach's portrait of Sybille of Cleves presented her with her hair loose and a wreath of fresh flowers on her head,[250] while his portrait of Duke Henry the pious of Saxony suggested a wreath of red and white silk flowers.[251]

Carnivals also provided opportunities for socializing and dressing up and post-Reformation such behavior often resulted in criticism of the sort made by Sebastian Franck:

> *Then comes the carnival, the Bacchanalia of the Roman church . . . People dress up in costume and run about the city like fools and madmen playing whatever pranks and games they can think up . . . On such occasions one sees outlandish outfits and strange disguises; women wear men's clothing and men adopt women's dresses.[252]*

Matthäus only provided one direct record of the clothes he wore for a carnival in 1504 when he was seven.[253] He attended as a page to Contz von der Rosen, and he was dressed in a tight-fitting, yellow and black striped doublet and hose. In contrast Veit took part in the carnival on the first Sunday in Lent, which fell during February in 1561. He was dressed in a flamboyant scarlet costume and full face mask, which he had borrowed from Hans Fugger.[254]

The slight rebellious, youthful streak that is evident during the carnival manifested itself on other occasions in Veit's life. For instance in January 1561, when he was nineteen years old, Veit was reluctant to remain in mourning because of the constraints that it was placing on his social life.[255] While the clothes he wore were black, they were sumptuous in terms of the choice of fabric and decoration, and there was nothing about them that could be deemed to be plain, simple, or understated. This formed a marked contrast with the four stages of mourning that Matthäus observed for his father.[256] Each stage of mourning had its own distinct set of clothes, and while not linked to fashion, it does change and it does incorporate elements of the fashionable.[257] In contrast, Matthäus was much less formally dressed when he noted that he was in mourning for his mother on June 18, 1502, but this may have been a reflection of his youth because he was only five years old.[258] Mourning could be a personal act, but it could also be a group commemoration for an employer and patron as happened in 1560 when both father and son wore the long black mourning cloak and tall hat in remembrance of Anton Fugger on September 14, 1560.[259]

Clothes for indoors, outdoors, seasonal change, and various times of day: While it might be unwise to draw very strict correlations between the types of scene that Matthäus and Veit were depicted in, and real locations, they are generally depicted outside. Indeed, after his childhood, Veit was very rarely

243. I 35, II 39.
244. I 17, I 36, I 47, I 49, I 51, I 64, I 67, I 72–73, II 30, and II 32–35.
245. For example, I 86.
246. I 115.
247. For example, a ruling passed in 1575 capped expenditure on wedding rings to 150 gulden for patricians, 75 for merchants, and 3 for everyone else; Hunt, *Governance*, 168; Roper, "Going to Church," 80. Exemptions to the legislation could be purchased, but this was often denied to lower social groups; Roper, "Going to Church," 75.
248. I 86.
249. I 31, I 35, I 49, I 51; II 29 and II 33.
250. Lucas Cranach, *Sybille of Cleves*, Staatliche Kunstsammlungen, Weimar.
251. Lucas Cranach, *Duke Henry the pious of Saxony*, 1514, limewood panel transferred to canvas, 184 × 82.5 centimeters, Staatliche Kunstsammlungen, Dresden, Gemäldegalerie, 1906 G.

252. K. Moxey, *Peasants, Warriors and Wives: Popular Imagery in the Reformation* (Chicago and London: the University of Chicago Press, 1989), 64.
253. I 5.
254. II 40.
255. II 39.
256. I 37–40.
257. For the wider context see the definitive study of mourning: L. Taylor, *Mourning Dress: A Costume and Social History* (London: Allen and Unwin, 1983).
258. I 4.
259. I 137 and II 37.

depicted indoors—the exception being when he was at work,[260] when he was playing palmier in a church cloister,[261] and when he was honing his fencing technique.[262] As such all of the scenes presented him in an environment designed to maximize the potential for his clothes to be seen, while also depicting him as a young man of the world. There were slightly more pictures of Matthäus indoors. Some drew parallels with Veit, being associated with his employment and his sporting activities. Others, such as an illustration from February 20, 1538, provided a change of scene,[263] literally, as he stood in front of his tile-covered stove in his fashionable clothes, but others were linked to the stroke that he suffered in 1547,[264] his convalescence during 1548,[265] and when he is almost back to full health in 1552.[266] In the first two of these, he was depicted in informal clothing, a loose gown that was warm, comfortable, and in a style suited to this family environment.

Augsburg was hot and sunny in the summer but could have snow in the winter months. Perhaps not surprisingly, there were more spring, summer, and autumn scenes than those depicting winter. While winter offered the opportunity for fur-lined gowns[267] and even fur coats and hats,[268] in general, Matthäus, in particular, was depicted decidedly underdressed for the cold weather, possibly because cloaks would cover the more intricate doublet and hose he was wearing.

Equally they were generally depicted during the day, as this was the time most suited to showing off new clothes. However there were a small cluster of nighttime scenes and references to going out at night. In Veit's case these were used as an indication of his growing up, or his wish to be seen as more adult than he was. There were also hints that Augsburg at night was not as safe as it might be, which was why it was necessary to be armed.[269] Night also provided opportunities for doing things one should not, which in Veit's case meant going out in a mask and a borrowed costume to take part in the carnival in February 1561.[270]

Matthäus and Veit wore the clothes that reflected their place in Augsburg society. They were men with disposable income; they chose to spend it on social occasions, which reflected their status, and sporting activities, which indicated that they had leisure time. The scope of their wardrobes demonstrated that they could have new clothes for special events and that they could follow the demands of changing fashions.

Clothing in Augsburg: Local styles, ideas of "German" identity, and the influence of Italian and Spanish fashions

Matthäus and Veit lived in southern Germany in Augsburg, an Imperial free city in Bavaria, north of the Alps. The city was well placed on the main trade route to Italy, it was close to the Alpine passes, and it was on the meeting point of the Wertach and the Lech.[271] The city's wealth was linked to cloth production, the clothing trades, and manufactured goods, and the city was the financial center of southern Germany.[272] For example, Claus Heijder, a merchant from Augsburg, was one of the chief suppliers to Gustav Vasa (1496–1560) who was king of Sweden from 1523.[273] The clothing books demonstrate how Matthäus and Veit made full use of the city's links with the textile trade to shape their wardrobes. More importantly south German visual culture was closely linked to the bourgeois towns. The mercantile elites were predominantly Catholic, while the artisans were generally in favor of religious reform.

In 1520 Luther wrote his epistle *To the Christian Nobility of the German Nation*. The title raises the questions of what the term "German" meant to Luther and his contemporaries, what, if anything, was distinctly German about "German clothing," and how the clothes were perceived elsewhere in Europe. Visual images from the time suggest that the mercenary soldiers, which were very popular in the late fifteenth and the first half of the sixteenth centuries, helped to shape how people perceived German clothing, even though this style was not representative of the nation as a whole. Rather it was a distinctive fashion worn by a specific group in society. A very significant number of these prints were produced in 1530s Nuremburg by southern German and Swiss artists.[274] The Germany mercenary was a symbol of Imperial power, just as the Reisläufer of Switzerland, who were often employed by Francis I of France, played a key role in his struggle against the Ottomans.[275]

From the 1480s onward Swiss and German mercenaries were associated with a specific group of styles: big hats with broad, slashed brims and lots of feathers; short doublets; tight hose, with a shell-shaped codpiece; broad-toed shoes, duck-bill

260. II 14.
261. II 20.
262. II 41.
263. I 113.
264. I 130.
265. I 131.
266. I 135.
267. For example, I 17, I 108–09, and I 118.
268. II 38.
269. See II 28 and II 38.
270. II 40.

271. J. L. Bolton, *The Medieval English Economy 1150–1500* (London: J. M. Dent and Sons Ltd, 1980), 121. From the fourteenth century, a number of cities linked to the textile trade, including Augsburg, Bremen, Breslau, Danzig, Frankfurt, Hamburg, Lubeck, Nuremberg, Rostock, Strasbourg, and Ulm, had a population between 10,000 and 25,000.
272. Moxey, *Peasants*, 11.
273. L. Rangström, "Renaissance lions of the Vasa court," in *Modelejon Manligt Mode 1500-tal, 1600-tal, 1700-tal/Lions of Fashion: Male Fashions of the 16th, 17th, 18th Centuries*, ed. L. Rangström (Stockholm: Livrustkammaren Bokförlaget Atlantis, 2002), 292. He mainly bought armor for Gustav Vasa, but Gustav supplied other luxury items too. Vasa's tailor was also German—Georg Ballinger—and he made clothes for the king in the German style; Rangström, "Renaissance lions," 292.
274. R. Bleckwenn, "Beziehungen zwischen Soldatentracht und ziviler modischer Kleidung zwischen 1500 und 1650," *Waffen und Kostümkunde* 16 (1974): 107–18. Moxey, *Peasants*, 67.
275. Moxey, *Peasants*, 74.

shoes, or *solerets*; brightly colored clothing, which often made use of two colors (parti-colored); and lots of slashing.[276] Their clothes were very asymmetrical, as seen in Urs Graf's *Two Landsknechte, a woman and death*, 1524, and very tight fitting, with very large sleeves, as in Urs Graf's *A Landsknechte, a woman*, 1516. They were also colorful, as revealed in the clothes worn by the executioner who is about to draw his sword and the male figure on the left in *The Martyrdom of Saint Catherine*, 1506, by Lucas Cranach the elder.[277]

Matthäus was depicted dressed in this bright, asymmetrical, striped, and very flamboyant style in May 1521 when he was twenty-four.[278] On this occasion he was in armor so a semi-military style was appropriate, but aspects of this tipped over into his everyday wardrobe from the mid-1510s to the 1530s. In particular he favored the bright colors, big bonnets, short doublets, and slashed polychrome hose, as noted above. While eye-catching, his clothes were not as flamboyant as those depicted in Hans Schäuffelein's woodcut titled *Standard Bearer with Mercenaries*, 1532, which depicted the standard-bearer dressed in slashed doublet and hose, urging on fellow mercenaries in their struggle against Turkish soldiers.[279] This image was familiar in Augsburg because it was used as the frontispiece to Hans Busteter, *Ernstlicher Bericht, wies sich ain frume Obsekayt* (Augsburg, 1532), which encouraged the civic authorities of the city to provide troops in 1532. While he undoubtedly took pleasure in aspects of the Landsknecht style, this type of clothing formed just one distinct strand of Matthäus's wardrobe, and it was offset with other styles.

The wider context of German dress: Matthäus's clothes help to demonstrate the subtle and not so subtle differences between fashionable styles in north and south Germany. The northern towns, cities, and principalities were influenced by the clothing that was popular in Flanders, Burgundy, and Switzerland, along with a fondness for embroidery. One of the leading cities in the north was Cologne, a city whose wealth was linked to her ability to manage trade along the Scheldt and the Rhine.[280] Derich Born (1509/10–c. 1549), a merchant from Cologne, who was painted by Hans Holbein the younger in 1533, provides a very good example of what was fashionable in north Germany.[281] He was dressed in a black fur-lined gown with turned back fur-

lined collar, a black satin doublet with full sleeves, blackwork embroidery on the neckband of his shirt, and a plain black bonnet.

The portrait of Georg Herwart, mayor of Augsburg, which was painted in 1544[282] provided evidence of the *schaube*, a garment not seen in seen in the Schwarz clothing books. The *schaub*, or *chamarre*, may have originated in Germany and can be seen in Albrecht Dürer's *Man in festive costume*, 1515.[283] The *Schaube*, which was rather like a cassock but without sleeves, was often lined with fur, and it was associated with the Lutheran clergy.[284] It was also worn by the city magistrates, the town councillors, and the mayor Augsburg as they processed to the town hall.

Wider horizons—travel to Italy: Italian fashion or rather north Italian fashion was very influential in southern Germany in the early sixteenth century, and this was especially true of Nuremberg and Augsburg.[285] As a result Matthäus and Veit would have been exposed to Italian textiles, passementerie, and clothing styles at home. However, their business lives meant they were exposed to a much wider variety of clothing styles rather than just those to be found in Germany. Travel, chiefly on horseback but occasionally by boat and barge, was essential to their work. More significantly they frequently adopted local fashions while living anywhere for a period of time in order to be accepted as part of that community. As a result, Matthäus and Veit referred to wearing clothing in the Venetian style[286] and the Italian manner.[287] They were also illustrated in these styles with Matthäus wearing the distinctive Venetian clothes in 1516, as his son Veit did in 1556.[288] As a consequence of the Habsburg/Valois wars, Matthäus also experienced French style firsthand.[289] Wearing the fashions of the places that they visited and worked in was not unique to them. For instance, in 1560 Alexander Farnese succeeded Don John of Austria as Governor of the Netherlands and traveled there to take up his post. In order to assert his right to this office and his suitability, he was painted wearing a Dutch cloak with wide guards, hanging sleeves, and a small upright collar.[290]

Spanish fashion: By the late 1530s, Matthäus had moved away from bright colors, short doublets, and slashed hose, and he had adopted styles that reflected the Spanish taste. Indeed he had worn items that could be seen as influenced by Spain in 1516, during his visit to Venice, and in November 1524.[291] The appeal of this style of dress can be attributed to several factors: First, it reflected the personal taste of Charles V, Holy Roman Emperor,

276. Boucher, *A History of Costume*, 248. Scott, *Medieval Dress and Fashion*, 184–85.
277. Lucas Cranach the Elder, *The Martyrdom of Saint Catherine*, central panel, oil on lime, 126 × 139 centimeters, Dresden, Gemäldegalerie. Also compare with the woodcut by Durer, 1497–98; see Albrecht Dürer, *The Martyrdom of Saint Catherine*, 1497–98, woodcut, 38.7 × 28.4 centimeters, British Museum.
278. I 48.
279. Nuremberg, Germanisches Nationalmuseum.
280. M. Scott, *Late Gothic Europe, 1400–1500* (London: Mills and Book Ltd, 1980), 207, 227.
281. Hans Holbein the younger, *Derich Born*, 1533, oil and tempera on oak, 60.3 × 45.1 centimeters, Royal Collection, RCIN 405681; H. Krummacher, "Zu Holbeins Bildnissen Rheinischer Kaufleute," *Wallraf-Richartz Jahrbuch* 25 (1963): 191.

282. The Herwart Book of Honour, Schätze 018, Stadarchiv Augsburg; see Rublack, *Dressing Up*, fig. 72, 135.
283. Albertina, Vienna.
284. Laver, *Costume*, 85. The closest garment is that worn by Contz von der Rosen in I 5.
285. Boucher, *History of Costume*, 246.
286. I 25–26.
287. II 15.
288. II 21–22.
289. I 24.
290. Alonson Sanchez Coello, *Alexander Farnese*, c. 1560, National Gallery, Dublin.
291. I 25 and I 71.

who spent time in Augsburg during the 1530s.[292] Spanish fashion was also influential in Italy, which Matthäus had close business links with, especially after the defeat and capture of Francis I of France at the battle of Pavia in 1525.[293] Second, there was a gradual decline in the influence in southern German fashions in Europe by the mid-sixteenth century, and this was linked to the rise of Spain and reflected in the growing predominance of Spanish style.

So what exactly were the features of Spanish male dress?[294] First, they wore a doublet that was close-fitting to the body, with fitted sleeves, a high collar, short skirts, shoulder wings, and that buttoned down the center-front. As such it was designed to emphasize the wearer's physique and to accentuate the waist; a doublet of this type can be seen in Titian's portrait of Charles V (c. 1530).[295] The doublet was sometimes worn with a jerkin, which was either sleeveless or had short sleeves, and a pair of trunk hose. The width and length of the panes varied, so they could be very short or come to just above the knee; they often had pockets, and they retained the codpiece until the last decades of the sixteenth century. Bombast was used to pad the front of the doublet and the hose. Over these was worn a short cloak, on one or both shoulders, as can be seen in Antonio Moro's painting of Alessandro Farnese (c. 1550)[296] and Francois Clouet's portrait of Charles IX, king of France (c. 1568).[297] Other facets of the Spanish fashion included the growing importance attached to dark colors and black in particular, beards cut into a point, and the use of passementerie.[298] The latter came from Germany and Italy, and its popularity was a direct response to sumptuary laws banning embroidery in Spain in 1515, 1520, 1523, and 1534.[299] Clothes of this type dominate Veit's clothing book, especially once he is able to select his own clothes. When compared to his father, he wears more restrained, understated clothes.

As these examples reveal, Matthäus's clothes reflect a variety of influences and styles. Aspects of his wardrobe were highly distinctive and could be associated with southern Germany and his home city, while others reveal an awareness of, and an interest in, other clothing cultures, including his loyalty to the Habsburgs and Catholicism. His book also records how an individual can favor a variety of fashions during the course of a life. In contrast, Veit's book provides a more focused view of a young man who during the early years of his life was faithful to one main style, which indicates how far aspects of Spanish fashion could permeate European culture.

Conclusions

The clothing books of Matthäus and Veit Konrad Schwarz are an invaluable resource; their significance can be linked to the four areas explored here. First, it is possible to explore in detail how two men dressed in Augsburg from the late 1490s to 1561. As such it is a personal exploration of two upwardly mobile middling males with money to spend and ready access to clothes and accessories. Second, Matthäus wore a wider variety of styles, colors, and types of clothes than his son, which in part may link to differences in their personalities while also demonstrating shifting ideas about color and clothing in sixteenth-century Europe in relation to religious and political values. Third, they both had large enough wardrobes to dress appropriately for work, social occasions, and sporting activities. This reflected their social position, wealth, and their wish to demonstrate an awareness of how a gentleman should behave. Fourth, their clothes revealed the cultural environment they lived in, in Augsburg. At certain times in his life Matthäus wore clothes that were more distinctly German or precisely southern German than Veit. Both men traveled and saw other types of fashion and wore it as a means of gaining acceptance when staying in another city, which was very important when undertaking business. They also wore clothes that owed elements to Spanish style, indicating, in Matthäus's case, an awareness of the need to change with the times as he grew older, while still overtly demonstrating his allegiance to the Habsburgs. Veit's book emulated that of his father because his father wanted him to do it and paid for it. The style of writing suggests that he was rather amused by the whole process, and ultimately he stopped well short of his father's clothing record. However, in the prologue, he recorded how proud he was of inventing his own clothing. He also noted the cost of the clothes and the skill with which they were depicted, indicating their importance to him. In contrast, Matthäus's book indicates that he took more pleasure in his appearance, his clothes, and his book during his youth and his prime. As he grew older Matthäus's interest in the project waned a little, reflected by the gaps between images. The gaps were also linked to the problems that Matthäus had getting a good artist after the death of Renner. However, these points do not detract from the value of these books, which record Matthäus and Veit as true men of fashion.

292. Laver, *Costume*, 88.
293. Boucher, *History of Costume*, 224.
294. The most classic text on this topic is C. Bernis, *Indumentaria Espanola en la época de los Reyes Católicos: Indumentaria Espanola en tiempos de Carlos V* (Madrid: Instituto Diego Velazquez, del Consejo Superior de investigaciones cientificas, 1962). Also see A. Descalzo, "Spanish male costume in the Habsburg period," in *Spanish Fashion at the Courts of Early Modern Europe*, vol. 1, ed. J. L. Colomer and A. Descalzo (Madrid: Centro de Estudios Europa Hispánica, 2014), 15–38.
295. Titian, *Charles V*, c. 1530, Prado, Madrid.
296. Galleria Nazionale, Parma.
297. Kunsthistorisches Museum, Vienna.
298. Boucher, *History of Costume*, 235. Also see J. L. Colomer, "Black and the royal image," in *Spanish Fashion at the Courts of Early Modern Europe*, vol. 1, ed. J. L. Colomer and A. Descalzo (Madrid: Centro de Estudios Europa Hispánica, 2014), 77–112.
299. Boucher, *History of Costume*, 227, 229.

Editorial Notes

Translation and notes

This translation closely follows the original, which is available as a transcription (http://www.bloomsbury.com/uk/the-first-book-of-fashion-9780857857682/). I have attempted to retain the tone of Schwarz's text, with its very abbreviated style, which is not highly literate and colored by south-German dialect, while still ensuring its accessibility. Notes follow Fink's edition (Fink, August. *Die Schwarzschen Trachtenbücher*. Berlin: Deutscher Verein für Kunstwissenschaft, 1963), with some corrections and additions. The numbering of the images likewise follows Fink, as specialists will wish to cross-reference editions. Indications of recto and verso pages have been added. Some missing words or brief explanations are inserted in brackets, while occasional question marks indicate that the meaning of an expression or a transcription as such remains uncertain. UR

Commentary

The commentaries are intended to provide a detailed description of the clothes worn in each illustration. Each one begins with a brief overview to put each set of clothes and accessories in context. The text is then subdivided using headings, with the intention of providing a degree of consistency and order, while also making it possible for readers looking for specific types of information to find it easily. With the exception of the very first entry, which analyzes Matthäus Schwarz's coat of arms, the relevant headings from the following list are used for each image: Clothing overview, Headwear/hair, Armor, Body garments, Linens, Legs (including details of hose, the codpiece, and garters when worn), Footwear, Accessories, Jewelry, Weapons (including the girdle and hanger, the necessary accessories to go with a sword or dagger), and Furnishings (with specific reference to the textiles). Where necessary a few additional headings have been used, including Horse/horse harness and Sleigh/cart. When enough detail is visible, short notes on other figures in the illustrations have also been included. A small amount of gilding has been used to indicate gold or gilding. Where this happens it has been noted.

The commentaries concentrate on the clothes depicted in the illustrations and present the reader with a detailed analysis of what can be seen and deduced. The footnotes provide additional information, including, where possible, notes about surviving examples from Germany, but these have also been supplemented with examples from elsewhere. In addition, some visual sources have been included where specific types of clothing have not survived.

There are two ways of reading the commentaries. Some readers will consult individual entries as required, while others will read blocks of entries or indeed read the whole text from beginning to end. For the former, the entries need to be detailed enough to provide all of the necessary details, while for the latter, there will be a cumulative sense of detail that will include some repetition, which will help to highlight trends and innovations. MH

Glossary

The glossary focuses on the textile and clothing terms used in the text written by Matthäus and Veit Konrad Schwarz. The English term is given first, and where possible, this will be the sixteenth-century English term. This is followed by the sixteenth-century German term, and where appropriate, the modern German word, and finally by a definition. A few additional terms have been included that have been used in the commentaries but that do not appear in the translation/transcription, as such, these may be unfamiliar to the reader. These terms are marked with an asterisk, and they only have the English term and a definition. MH

The First Book of Fashion: Matthäus Schwarz of Augsburg

Matthäus's book is small, measuring just 16 × 10 centimeters, and its compact size gives it a sense of intimacy. It is bound in brown leather with stamped gilt decoration.

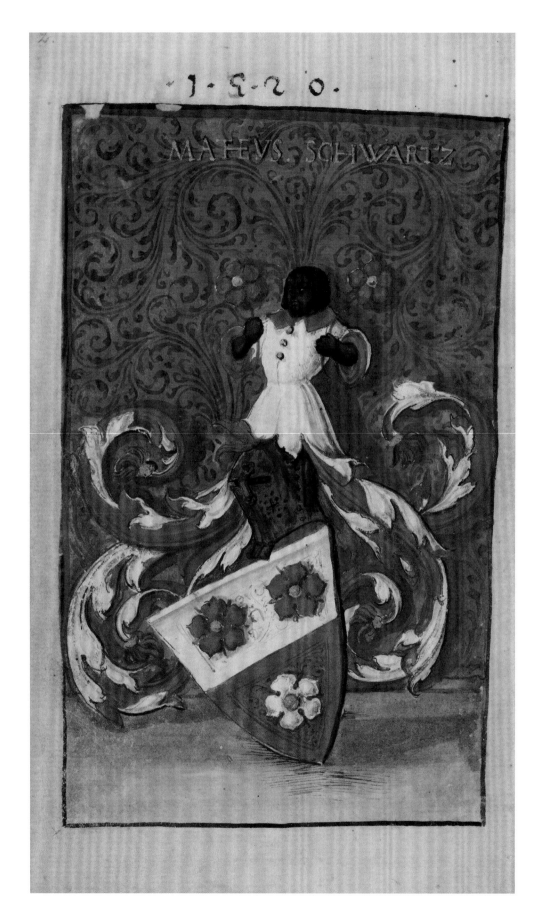

The coat of arms is displayed against a background of bright blue damask, which is intended to look like a wall hanging. Against this is written his name, *MATHEUS SCHWARTZ*, and the date, 1520.[1] It rests at an angle on a stone ledge or windowsill. The combination of his name and his coat of arms asserts his ownership of the book from the outset, while also stressing his role as the patron of the images and owner of the clothes being depicted.

1. Schwarz was ennobled in 1541, which includes his coat of arms at that point (see I 122, dated 20 February, 1542).

1520. Today, 20th February, 1520, I, Matheus Schwartz of Augsburg, was just 23 years old and looked as above. All my days I enjoyed being with old people, and it was a great pleasure for me to hear their replies to my questions. And among other subjects we would also get to talk about clothing and styles of dress, as they change daily. And sometimes they showed me their drawings of costumes they had worn 30, 40, and 50 years ago, which greatly surprised me and seemed a strange thing to me in our time.

This led me to draw mine as well, to see what would come out of it in 5, 10, or more years. This is why I began with today's date to draw them in here, such as the slashes, the colors, etc., and this image is the 42nd, which is when I started. I first had to think back to what happened before, from when I was in my mother's womb up to 1520.

I thought to do this during 1519, while my father was still alive. So I asked him about what I could not remember, which were the times of the years and days, etc., which things happened, up to the 12th image, for I was uncertain about it. Although I did start to remember from the 4th image onward, but it seemed to me as in a dream. But since the 11th image in 1510, I started to describe everything I experienced, and it was much easier for me to say what needed to be drawn.

I have used one manner [of dress] 2 or 3 times, but only inserted it here once, except when it had different slashes or colors. And I thus began with the first dress in my mother's womb, the next in swaddling clothes, etc., and the others are images of my clothes worn in public, but I have omitted carnival clothes, etc.

It has not always gone in the way I wanted, and a special book has been written about this, called "The Course of the World," and in it I have written about many clothes in relation to this little book.

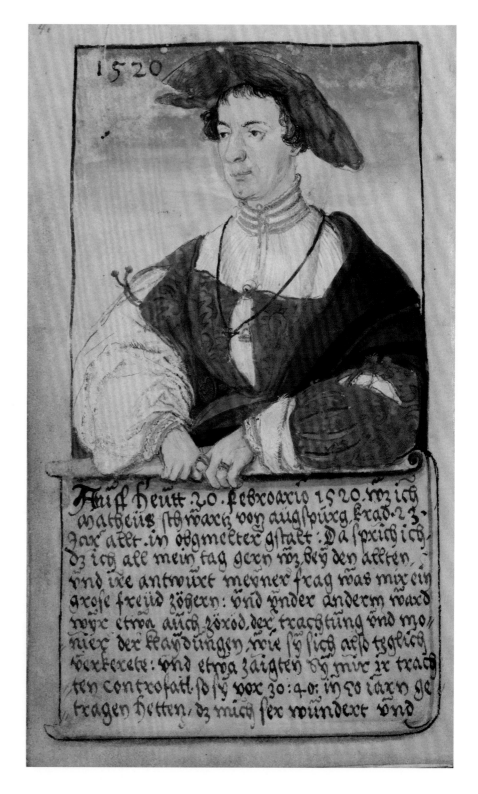

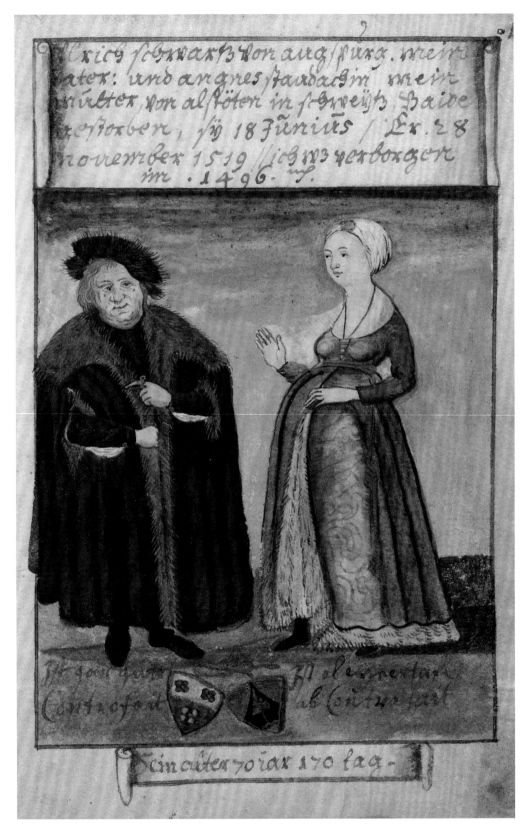

Ulrich Schwartz from Augsburg, my father, and Angnes [Agnes] Staudachin, my mother, from Allstedt in Switzerland. Both have died, she on 18 June, he on 28 November, 1519. I was hidden in 1496. Text below: This is rather well portrayed, it is copied from a panel painting. Aged 70 years and 170 days.

*On 20th February, 1497,
I was born as related in
my book of "The Course of
the World" on the 9th page.
Thus was my first clothing
in the world: in swaddling
clothes.*

Text below: In the first year.

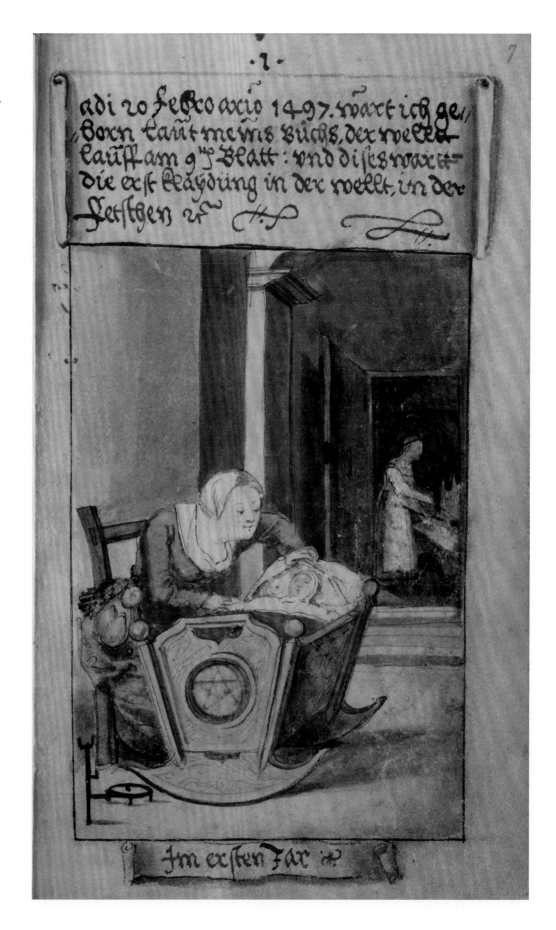

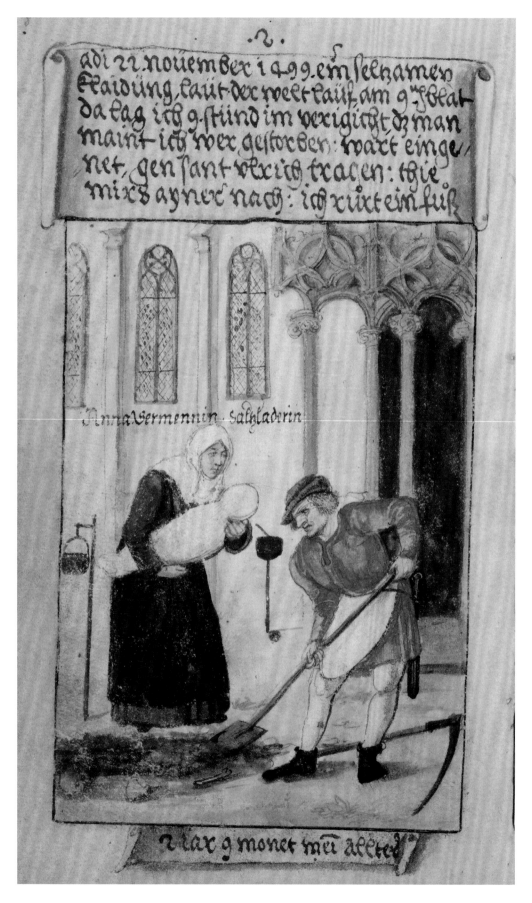

On 22 November, 1499: strange dress, as related in "The Course of the World" on the 9th page. I suffered cramps for nine hours, so that everyone thought I was dead: I was sewn in and carried to Sant Ulrich. Do the same as me: I moved one foot!

Text in the Image: Anna Germennin, salt maker.

Text below: My age 2 years, 9 months.

In August 1500, I suffered badly from chicken pox, as related in my book on page 9 in chapter 4.

Erased: In addition to this illness, I suffered from a bad rash of the French disease.

Text in the Image: Barbel, my sister.

Text below: 3 years, 6 months old.

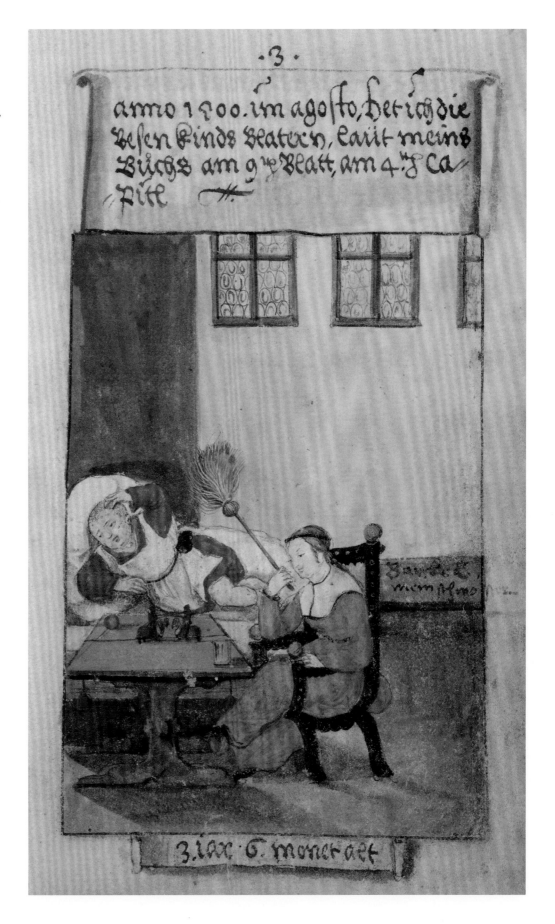

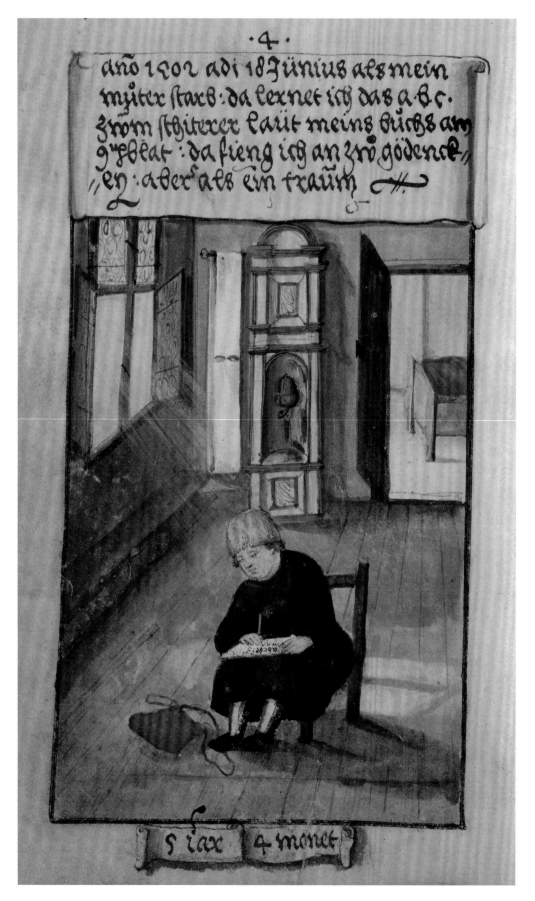

·4·

año 1502 adi 18 Jünius als mein
müter starb · da lernet ich das a·b·c·
from stßiterer laüt meins ßürßs am
g[ʳ]ßlat : da fieng ich an zu gödenck
en · aßer als ein traüm

5 iar 4 monet

On 18th June, 1502, when
my mother died. At the
time, I learnt the abc with
Schiterer, as related in my
book on the 9th page. This is
when I started to think and
remember, but as in a dream.

Text below: 5 years, 4 months.

In 1504 during carnival I was Contz von der Rosen's boy, who at the time was Maximilian I's jester, and he is well portrayed. He didn't draw anything good out of me, as related in "The Course of the World" on the 10th page, 5th chapter, and I had to always follow him, I spent about three weeks with him.

Text below: 7 years and about two months.

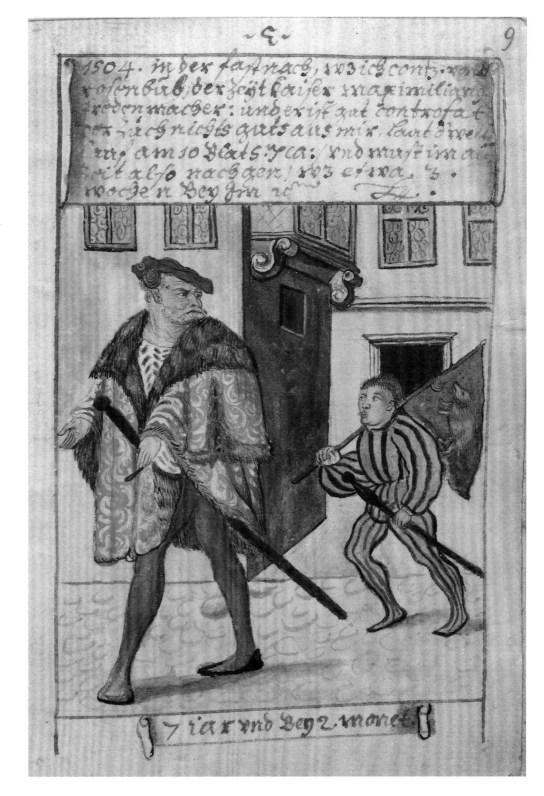

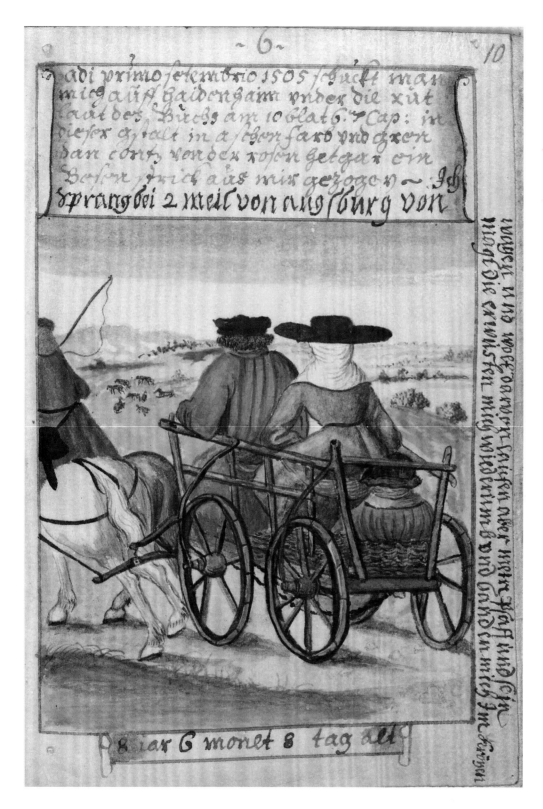

On the first of September 1505, I was sent under the rut to Haidenheim as related in the book on the 10th page, chapter 6, in this manner in ash-color and green; for Contz von der Rosen had turned me into a bad boy. Two miles from Augsburg, I jumped from the cart and wanted to run away, but my priest and his maid got hold of me and tied me to the basket.

Text below: 8 years, 6 months, 8 days old.

In May and June 1506, I ran away from my priest in Haidenhaim, as related in "The Course of the World" page 10 in chapter 6. He beat me too hard. I sang for bread in Hechstot, Gundlfing, Schnaiten, Boley, etc. and made a deal with the herding boys that they would let me herd the cows with them.

Erased from the margin: The reason I ran away from my priest in Haidenhaim was that he hit me in [. . .] manner and almost drowned me in the river Brenz. I then managed to get hold of his dagger and went into his garden during the sermon and chopped all his young cabbages off and afterward pushed the weapon into the ground and ran away.

Text below: 9 years and around 4 months old.

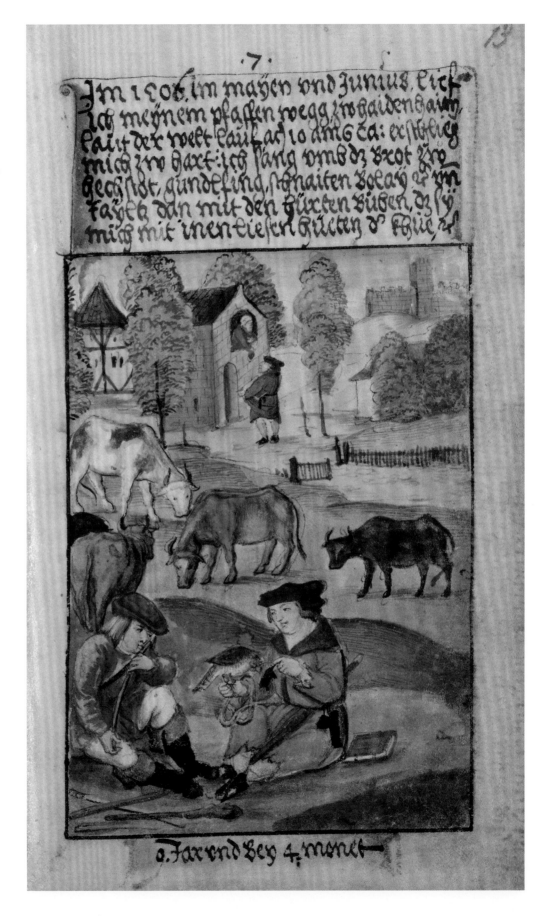

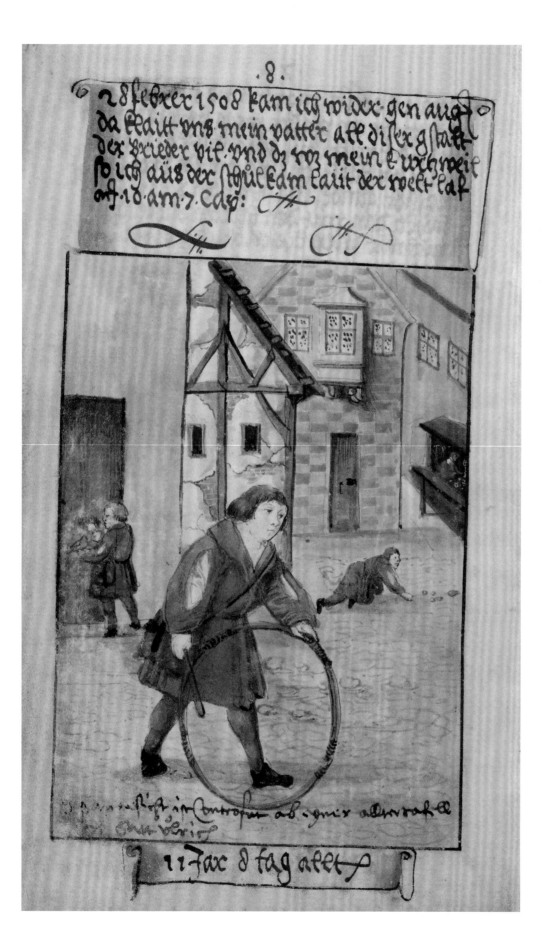

On 28th February, 1508,
I returned to Augsburg.
There my father clothed us
all in this manner, the many
brothers, and this pleased
me during my leisure time
[kurzweil] when I came out
of school, as related in "The
Course of the World" page
10 in chapter 7.

Text in the image: This face is
portrayed from an altar painting in
Sant Ulrich.

Text below: 11 years, 8 days old.

In summer 1509 my father clothed us like this. I was a pupil at St. Moritz and wanted to become a monk in St. Ulrich. I enjoyed looking at altar paintings and carved statues of saints, as related in "The Course of the World," page 10 in chapter 7.

Text in the Image: This face is well captured from an altar painting, which my father commissioned, in which many children are portrayed—not the panel that stands opposite [?].

Erased in the margins: This year there was the great shooting match in Augsburg, and on 7 September, my father's house burnt with everything here, and I found just one carved statue of a saint in the fire.

Text below: 12 years and about 4 months.

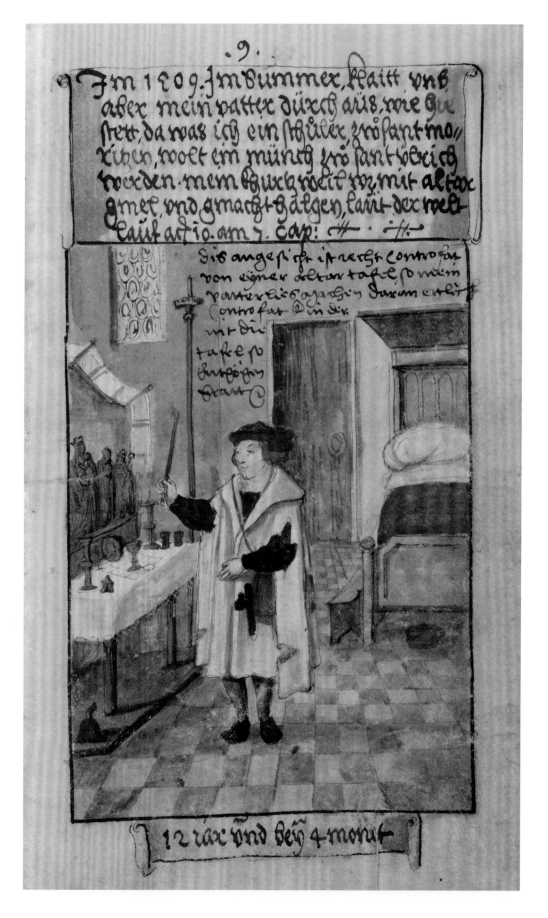

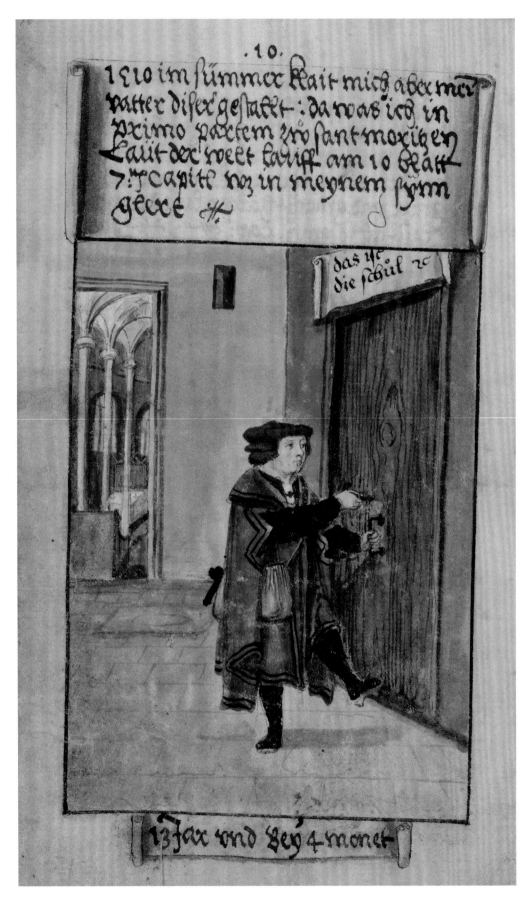

In summer 1510 my father clothed me in this manner. I was in the first part of St. Moritz, as related in "The Course of the World" on page 10 chapter 7, and considered myself learnt.

Text in the Image: This is the school.

Text below: 13 years and about 4 months.

At the end of 1510, I threw away my school bag. My desire was to see foreign lands, and I liked to be dressed in this way.

Text in the Image: This is when I started to keep records, everything had to be described, as related in the book's 9th chapter on page 12.

Text below: 12 years, minus two months.

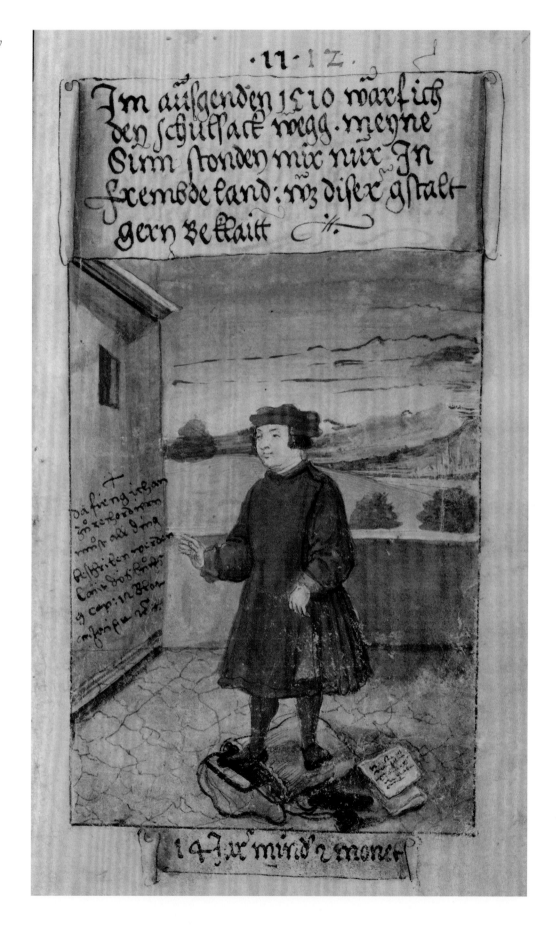

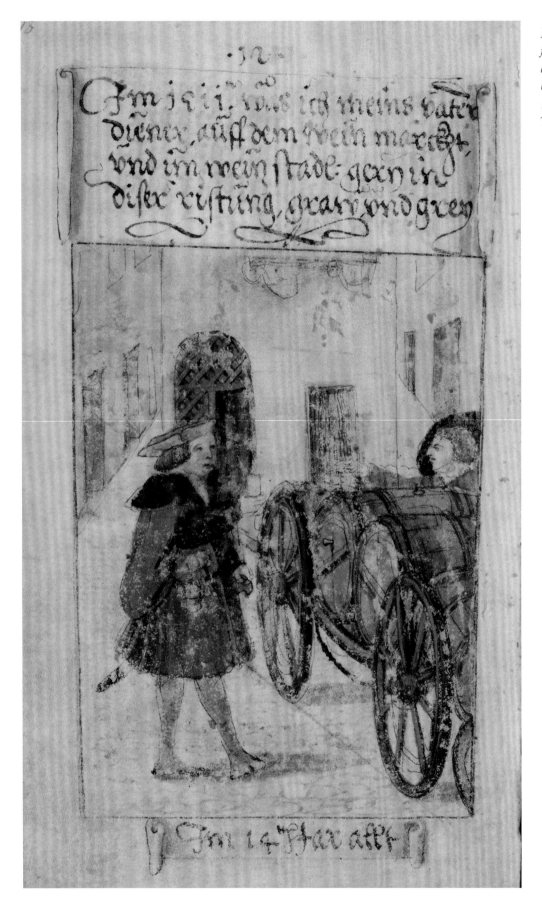

In 1511, I worked for my
father on the wine market
and in the tavern, I liked to
be fitted out in this manner
[Rüstung], gray and green.
Text below: Aged 14.

[This page in the Book of Clothes is blank.]

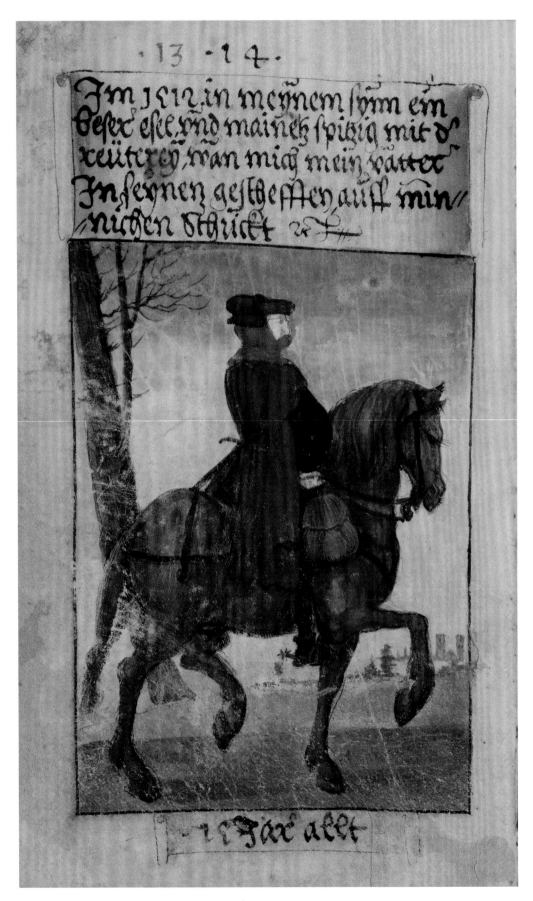

·13 ·14·

Jm 1512, in meynem synn ein
beser esel, vnd maines spißig mit d'
reüterey, wan mich mein vatter
Jn fernen gesthessen auff min/
nichen gschickt 2c·

15 Jar alt

In 1512. In my mind I was a bad ass [ein beser esel], and very keen on horse riding when my father sent me to Munich for his business.

Text below: 15 years old.

In summer 1512, I was flirting in the streets but remained pure. The doublet was silk satin, the hose taffeta. I began to join my peers.

Text below: About 15 ½ years old.

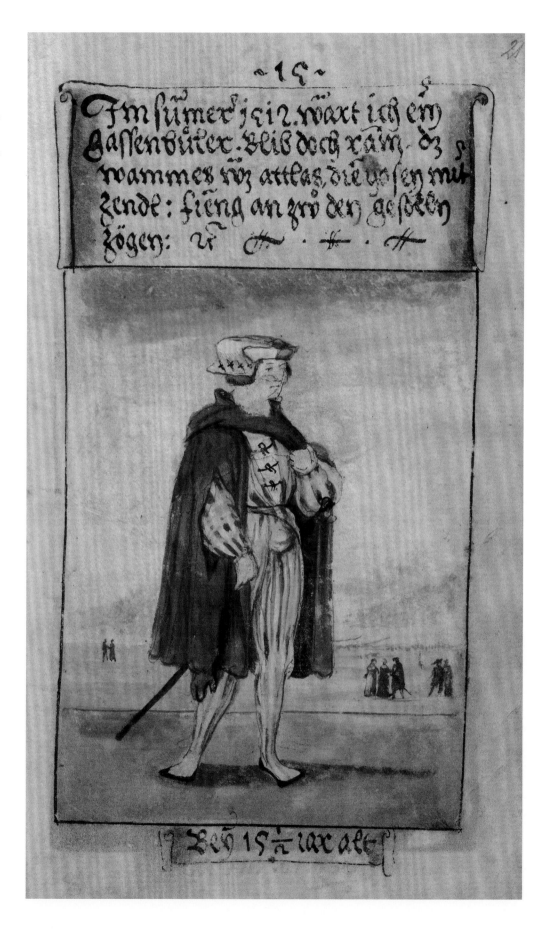

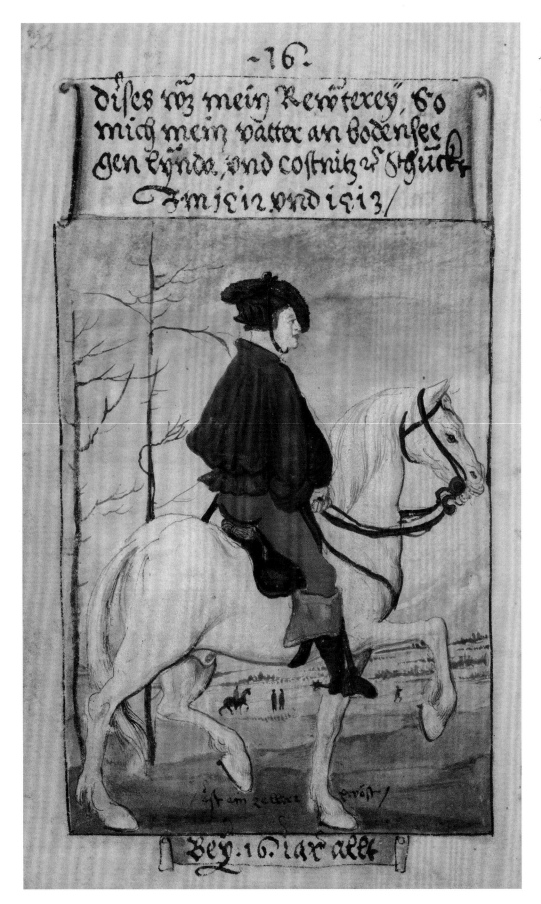

This was me riding as my father sent me to Lake Constance, toward Lynda and Costnitz, etc., in 1512 and 1513.

Text below: Aged 16.

In January 1513 at Lienhart Mair's wedding with my cousin Degerstein. The doublet was silk satin, otherwise exactly as here.

Text in the Image: The face is well portrayed.

Text erased in the margins: In this gown you read [. . .] I fell with many, and many on me [. . .] I had the head pushed into some cow dung, it was useless [. . .]

Text below: 16 years, minus 41 days.

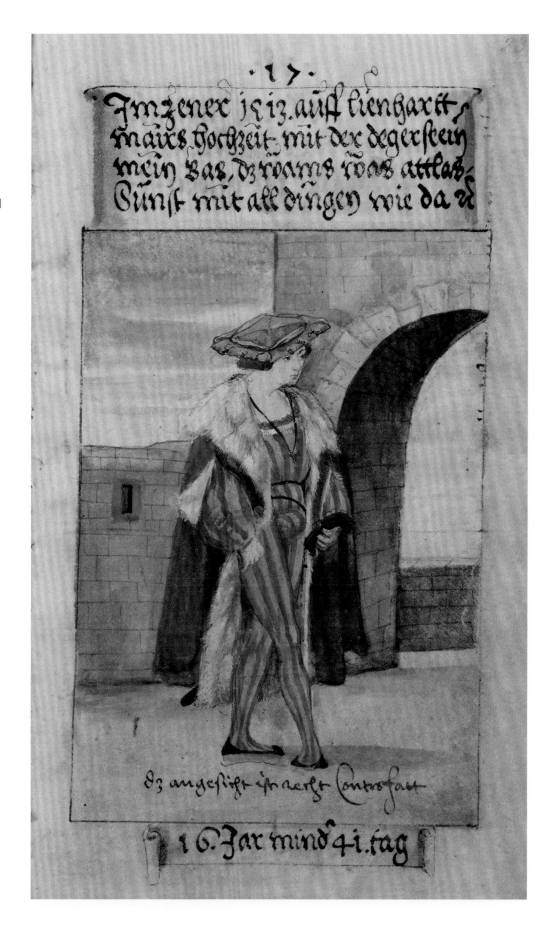

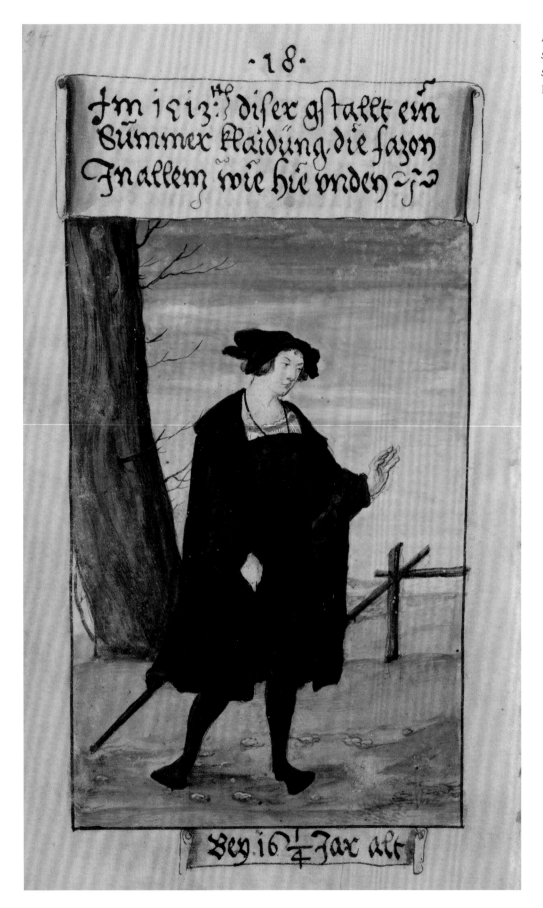

·18·

Jm 1513ᵗʰ diſer gſtalet ein
Summer Klaidung die faſon
Jn allem wie hie vnden

Bey 16¼ Jar alt

In 1513, in this manner:
summer clothes, made in the
style as shown below.
Below the image: Aged 16 ¼.

In March 1514, in this manner. The gown with a border of silk satin, the doublet silk satin, the hose with yellow taffeta. This is when I started to record my clothes.

Erasure at the margins: The gown was lined [...] material [...] I had to [...]

Text below: Aged 17 and 1 month.

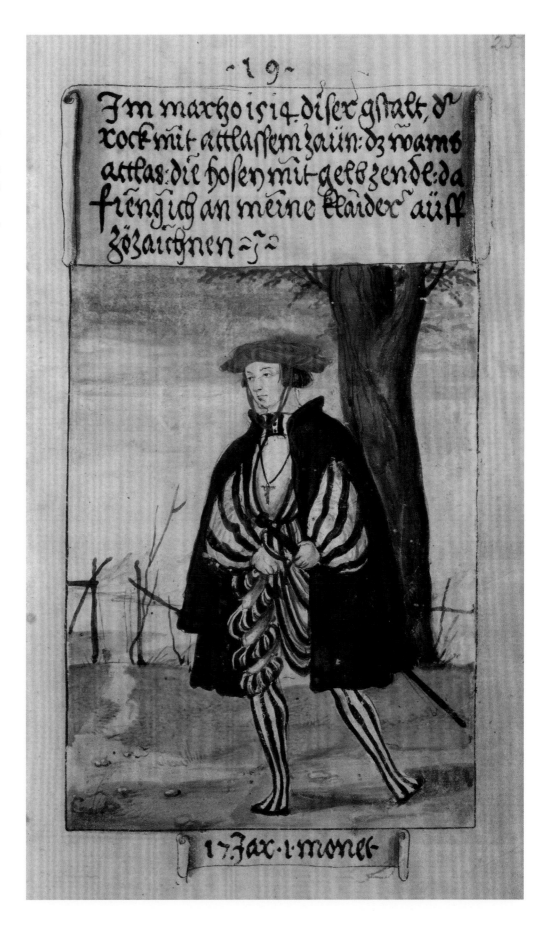

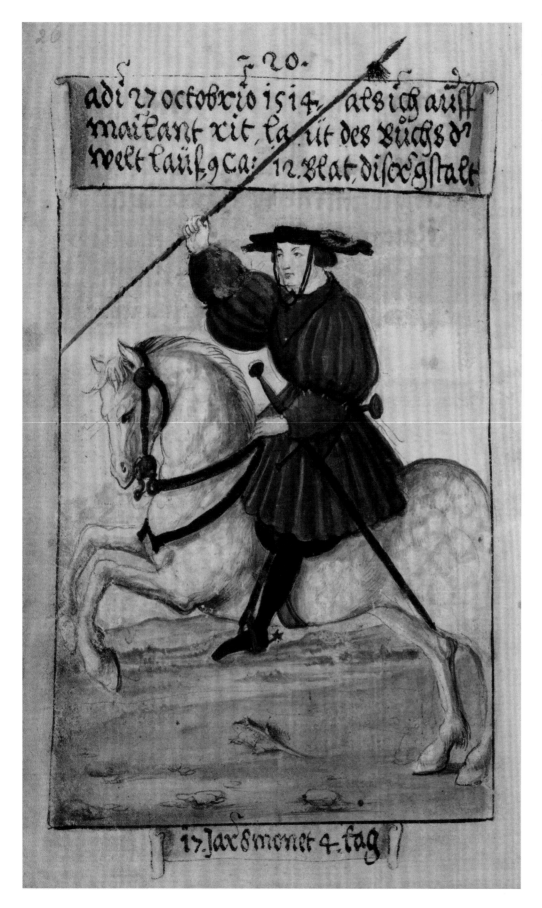

October 27, 1514, in this manner, when I rode toward Milan, as described in the book of "The Course of the World" in chapter 9, page 12.

Text below: Aged 17 years, 8 months, 4 days.

10 April, in Milan, in this manner. The doublet made from a half silk. 1515.

Text below: Aged 18 and 49 days.

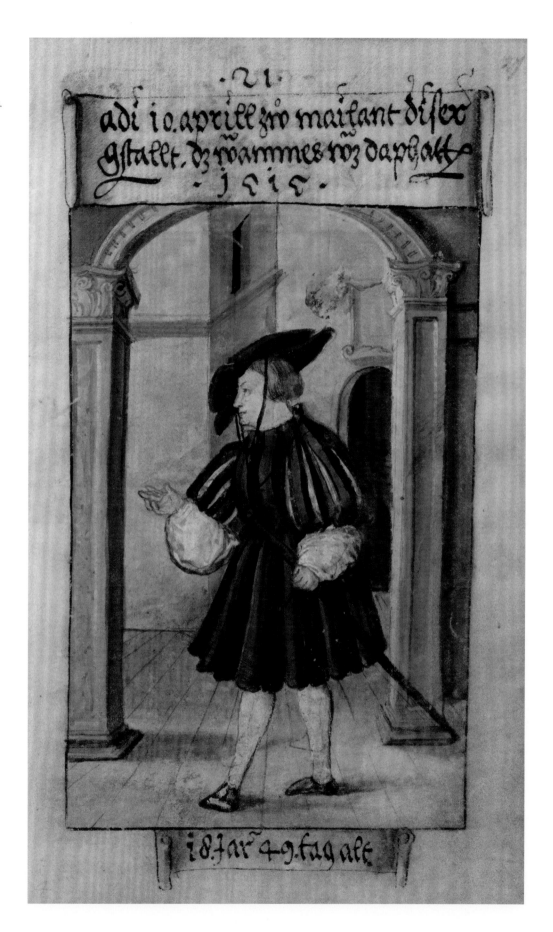

The First Book of Fashion | 75 ❖

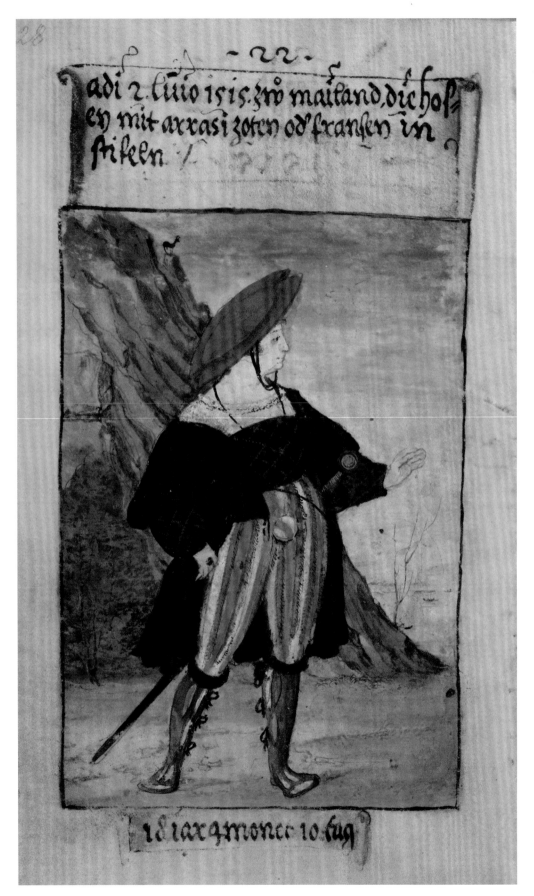

On 2 July, 1515, in Milan, the hose with silk tassels from Arras, in boots. [A further sentence has been erased and is illegible.]
Text below: Aged 18 years, 4 months, 10 days.

October 11, 1515, when Francesco, king of France, rode into Milan after the battle, master Ambrosio Veschunt clad me in this way, not from silk, as is related in every detail in "The Course of the World," 10th chapter, page 10.

In the image: This was an English horse, worth 80 crowns.

Text below: 18 years, 8 months, 9 days.

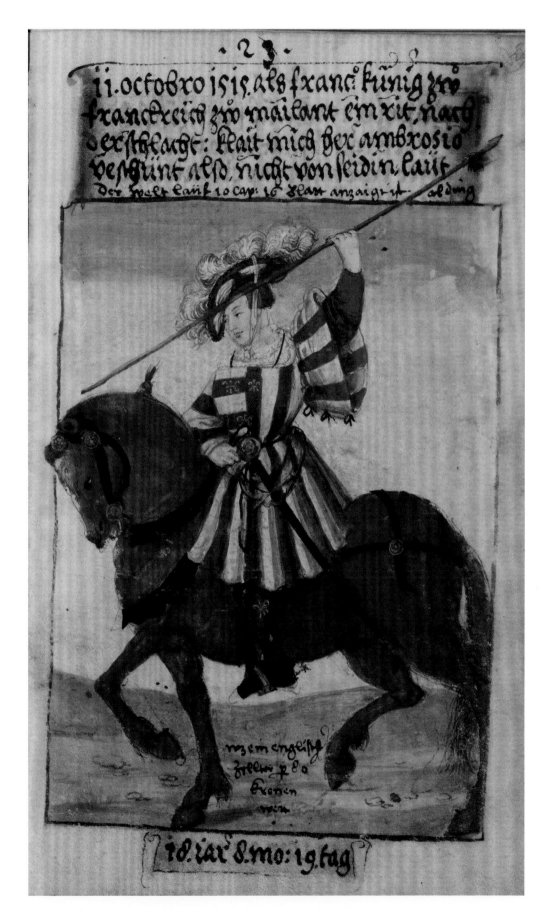

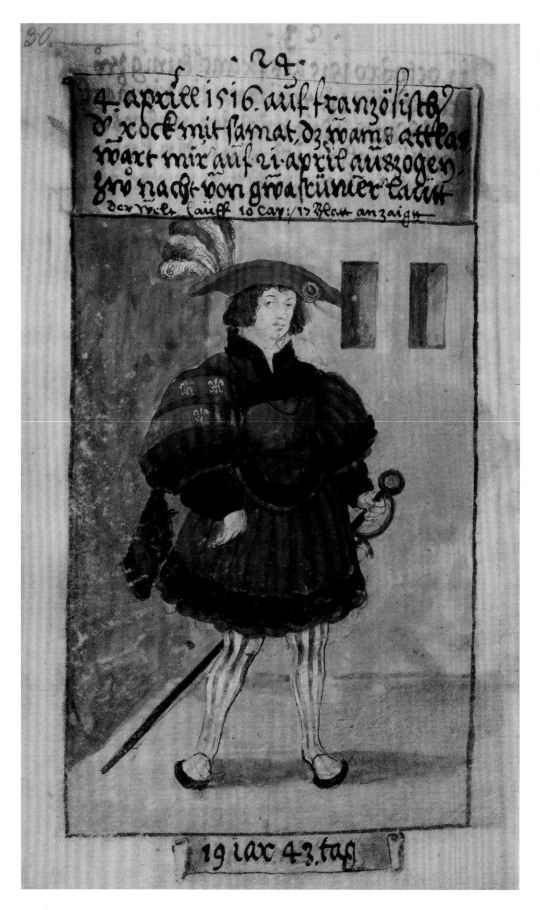

19 iar 43.tag

4 April, 1516, in the French manner. The gown with velvet, the doublet silk satin. This was taken from me on the night of 21st April by Goscoyne men, as related in "The Course of the World," 10th chapter, page 17.

Text below: 19 years, 43 days.

On 2nd June, 1516, in this manner in Milan, but I wore this in Venice; for on 9 June I moved from Milan to Venice, as related in "The Course of the World," page 21 in chapter 15: thus long hair, a Spanish cape, a Genoese bonnet, Lombard gown, the doublet a half silk.

Inside the image: I learnt accounting in a barge like this on the sea. I brought these clothes to Augsburg, and they were made on the 28th April, 1516.

Text below: 19 years, 3 months, 10 days old.

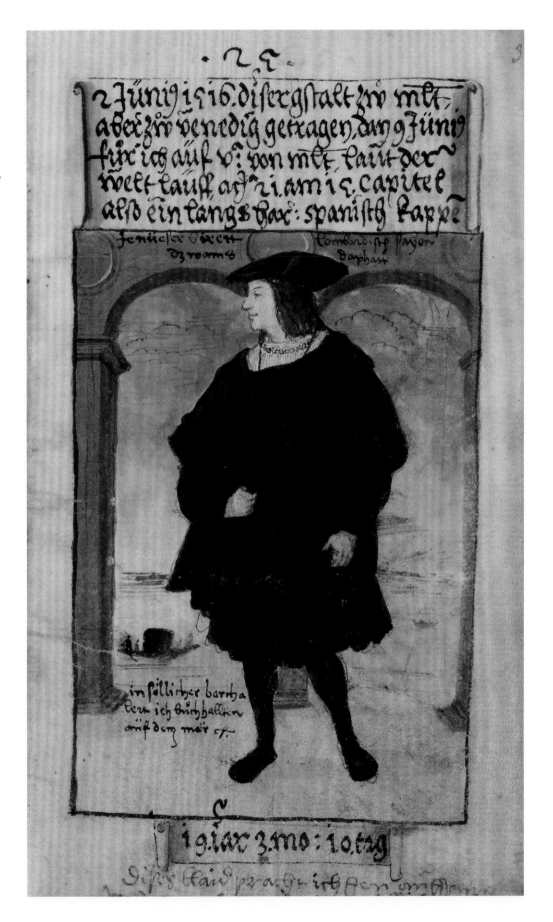

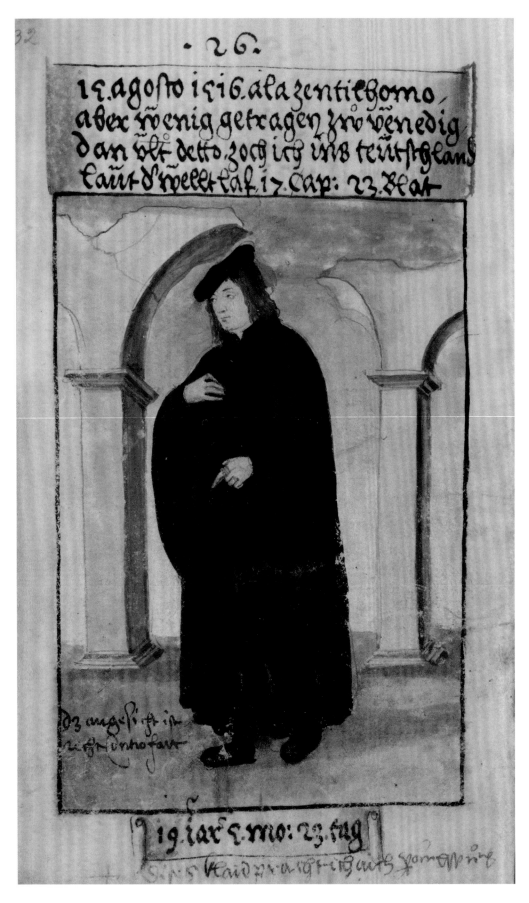

On 15 August, 1516, like a gentilhuomo [gentleman], but I wore this little in Venice, because I returned to Germany, as related in "The Course of the World," chapter 17, page 23.

Inside the image: This outfit I also brought to Augsburg. The face is well portrayed.

Text below: 19 years, 5 months, 23 days.

On October 2, 1516, this was my first outfit back in German style in Augsburg, when I wanted to become a huntsman.

Text below: 19 years, 7 months, 10 days.

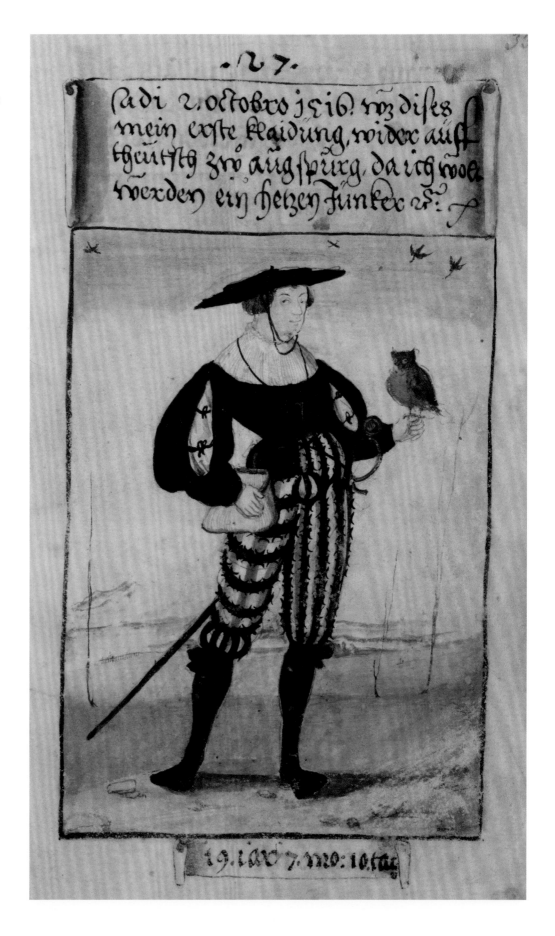

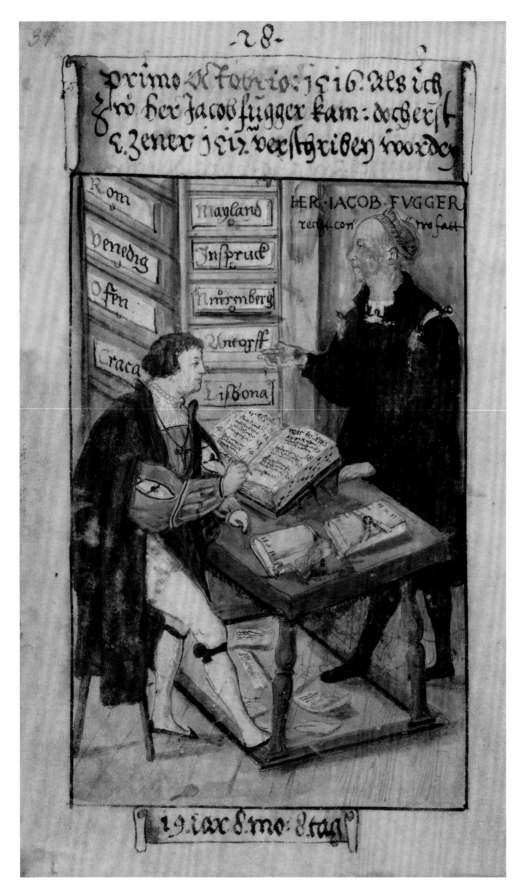

First October 1516, when I came to master Jakob Fugger, but was only contracted on the 9th. [October] Tenth 1517.

Inside the image: Master Jakob Fugger, well portrayed.

Text below: 19 years, 8 months, 6 days.

In summer 1517, in this manner: the doublet made of silk satin, everything else wool. In society with Wolf Breitwyser von Wirtzburg, Jörg Hueber from Munich, only the hose.

Text inside the image: Clay color.

Text below: Aged around 20 ¼ years.

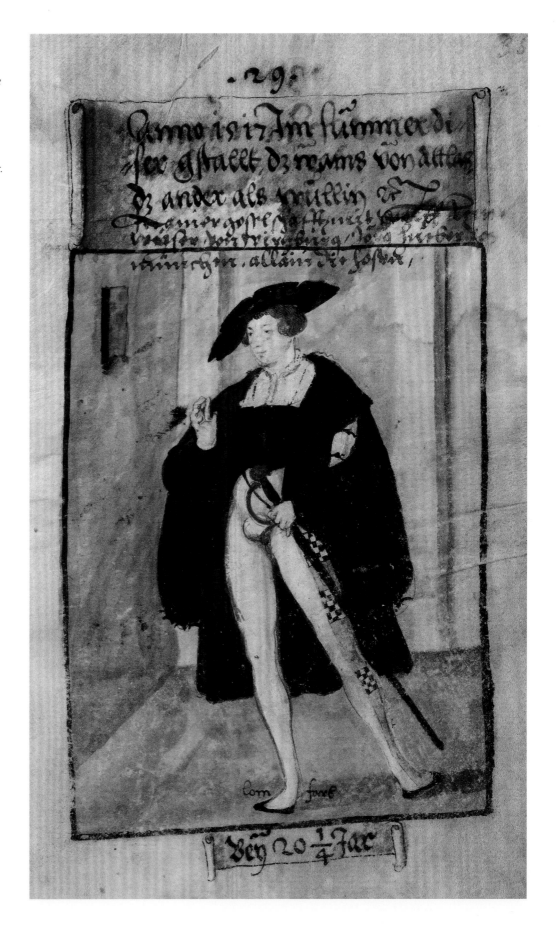

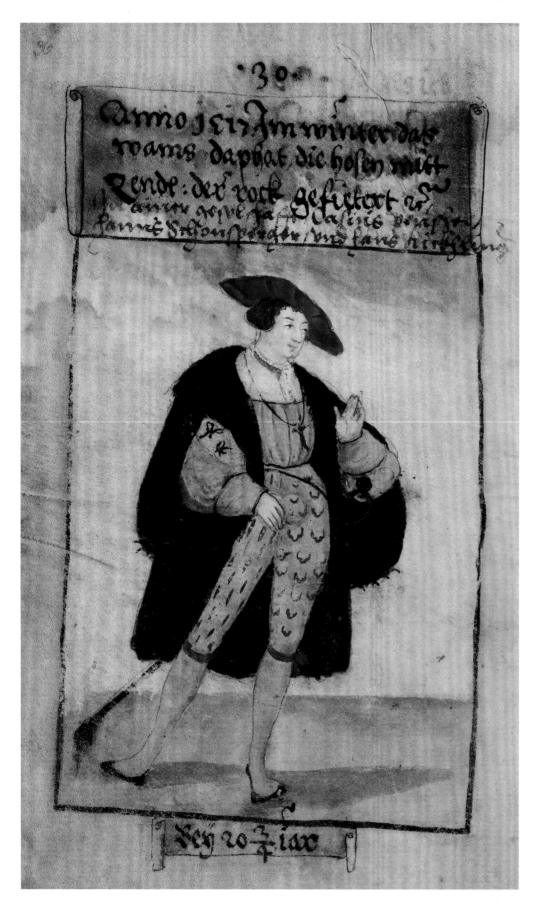

In winter 1517: the doublet a half silk, the hose with taffeta, the gown lined. In society with Casius Peuschel, Hanns Schonsperger, and Hans Kickhlinger.

Below the image: Aged 20 ¾.

In summer 1518, when Emperor Maximilian held a dance at the Augsburg dance house, I was like this: a half silk doublet, a bonnet with taffeta, a golden chain, and a golden wreath, the gown [edged] with silk satin [Atlas].

Below the image: Aged 21.

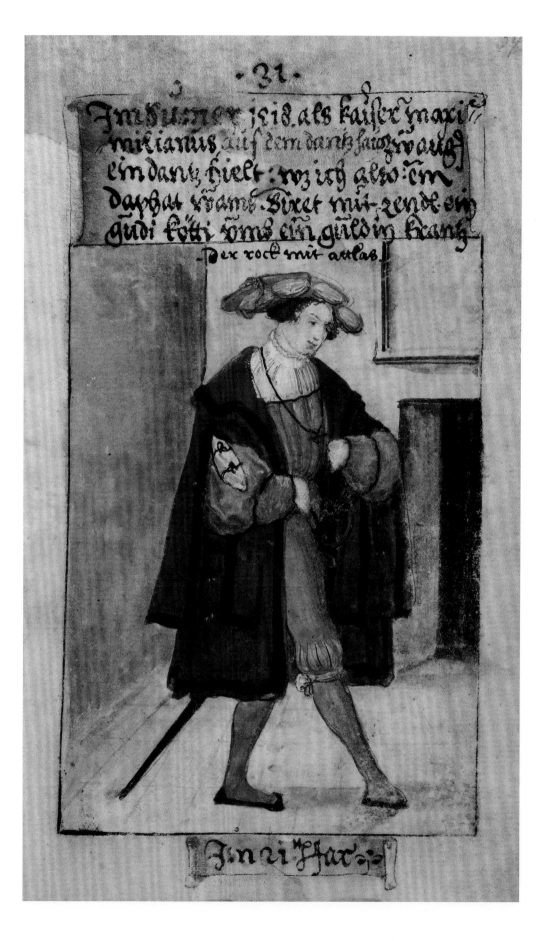

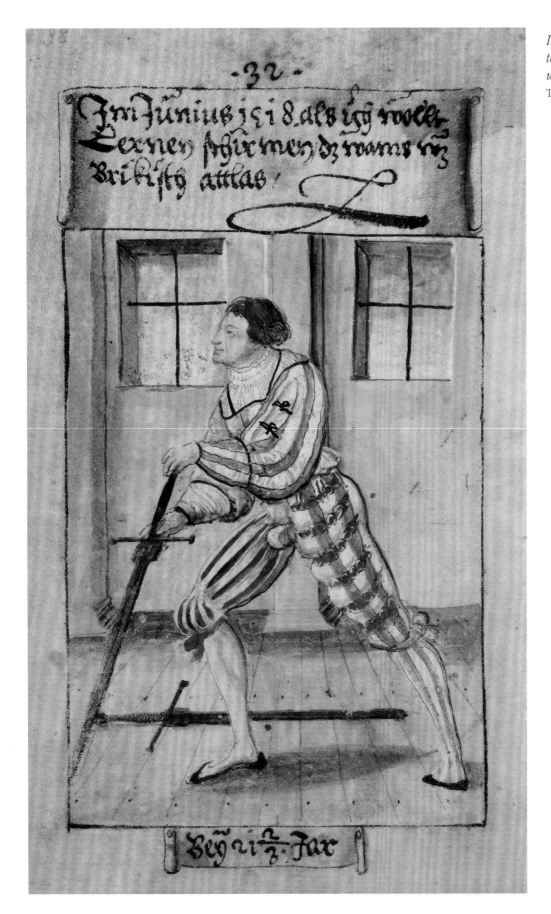

In June 1518, when I wanted to learn fencing. The doublet was silk satin from Bruges.

Text below: Around 21 ⅔ years old.

In August 1518, in this manner: the hose trimmed with silk satin. At this time I greatly enjoyed archery.

Below the image: Around 21 ½ years old.

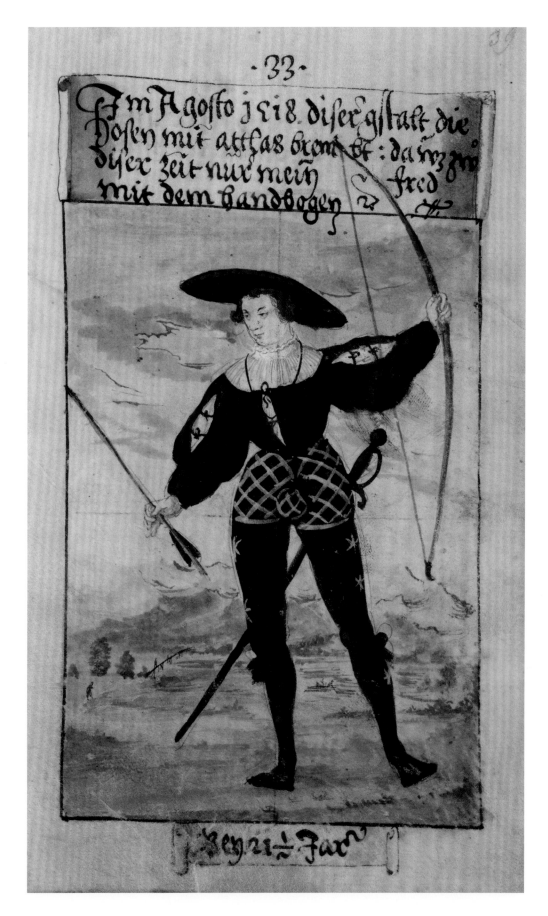

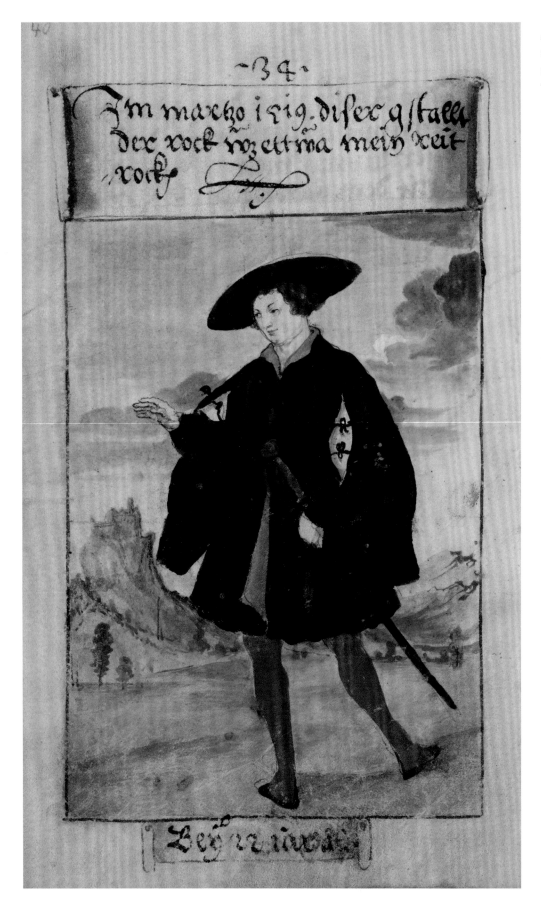

In March 1519, in this manner. The gown was my riding gown.

Text below: Around 22 years old.

On 2nd July, 1519, I had
a shooting match, when
Stofl Hemerlin put the
wreath on me. The doublet
white fustian, the stripes
from silk satin, otherwise
all as below.

Text below: 22 ⅓ years old.

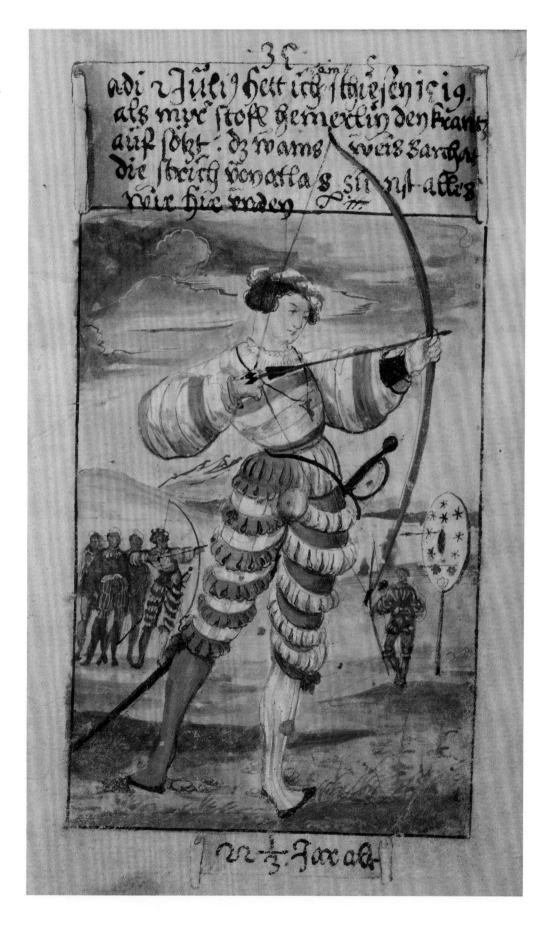

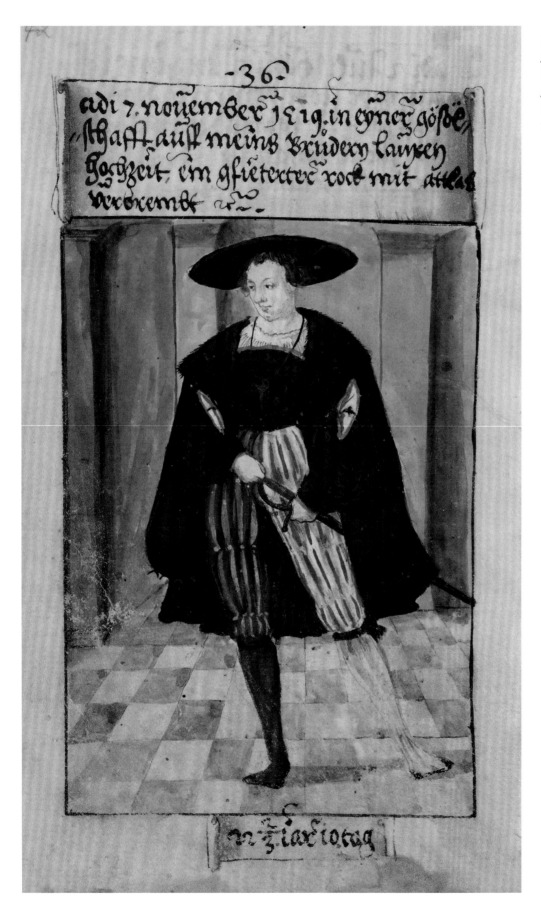

7 November, 1519, in a gathering at my brother Laux's wedding. A lined gown, with silk satin borders.

Text below: 22 ⅔ years, 10 days.

On 28th November, 1519, my father died, and I mourned him in 4 degrees [of mourning] until June 1520: in the gulg, cape, the mantle, and the gown. Nothing of silk.

Text below: 23 to 24 years old.

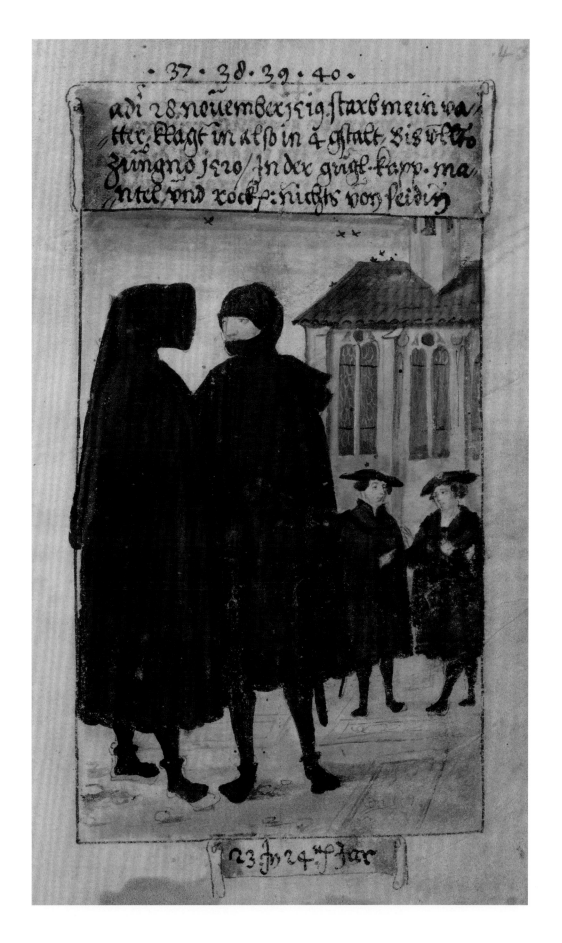

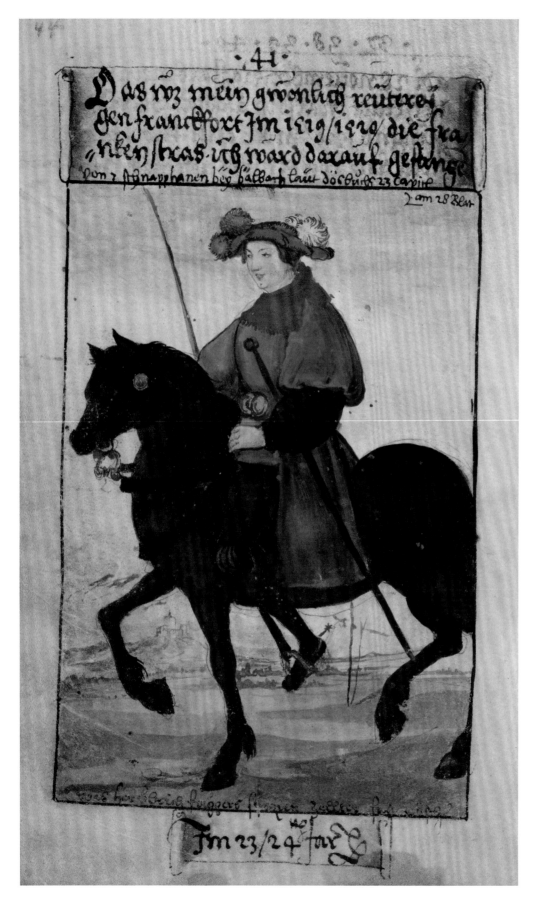

This was my usual ride to
Frankfurt in 1519/1520,
on the Franconian road.
I was caught by 7 robbers
at Bälbach, as in the 23rd
chapter of the book on the
28th page.

Inside the image: [The horse]
was Ulrich Fugger's *Spazierzelter,*
very speedy.

Text below: Aged 23/24.

20 February, 1520. The fool pricked me with a Netherlandish virgin as related in "The Course of the World," 23rd chapter, page 28. Afterward in these clothes.

Inside the image: The face is well captured.

Text below: Just 23 years old.

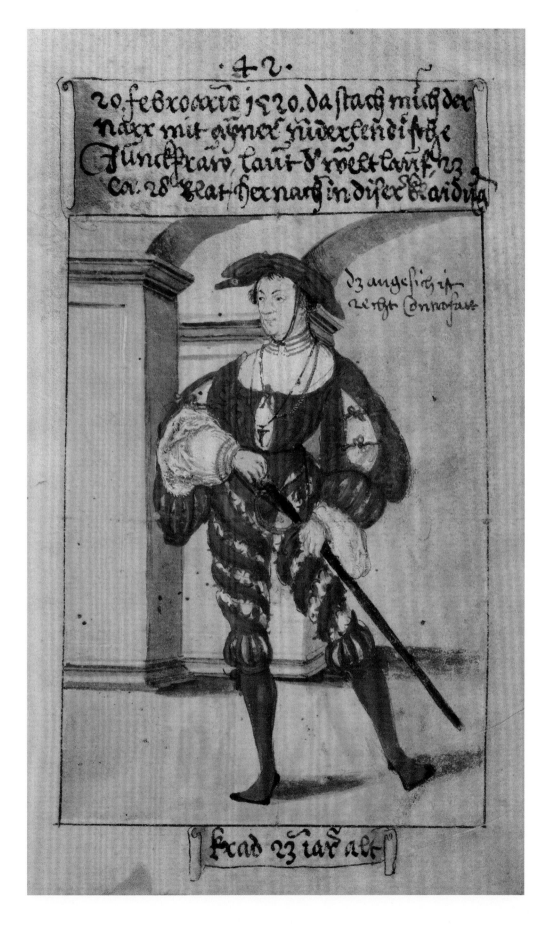

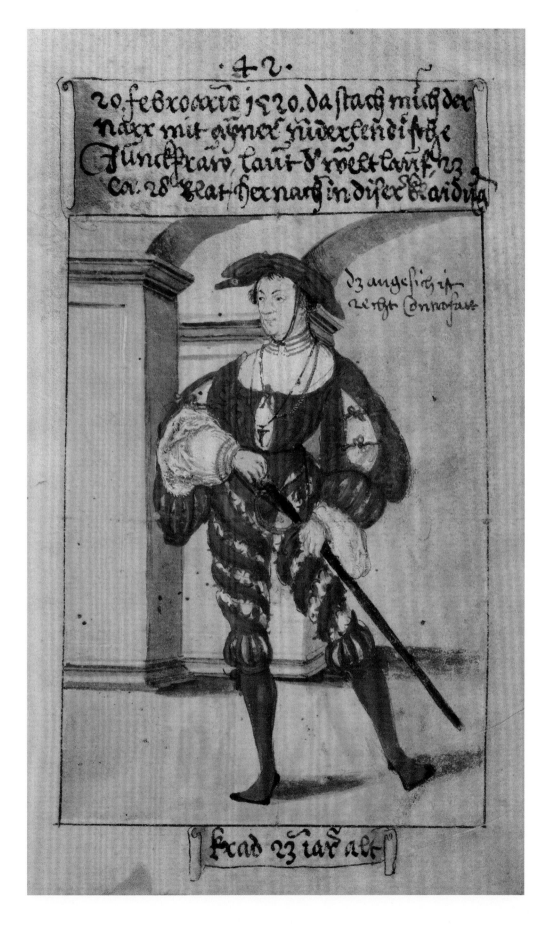 ·42·

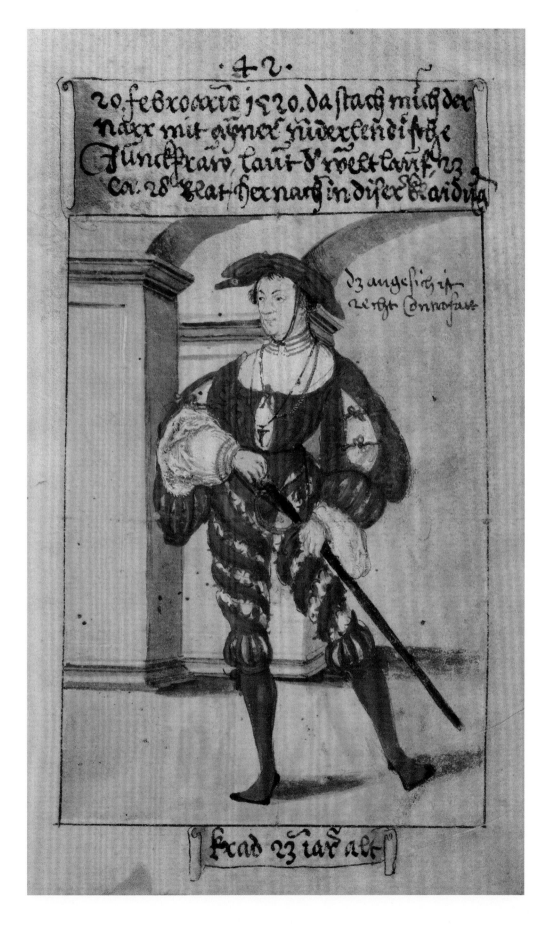 20. febroario 1520. da stach mich der narr mit ayner niderlendische Junckfraw laut der welt lauff im ca. 28 blat hernach in diser klaidung

dz angesicht ist recht connofest

Krad 23 iar alt

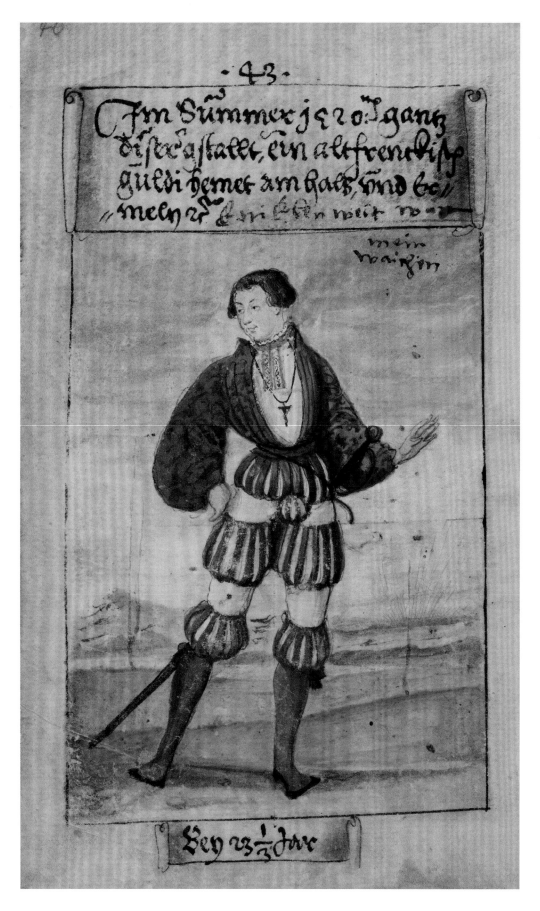

In summer 1520 all like this: a traditional Franconian shirt, golden on the neck and sleeves.
Later addition: My waist had a width of one ell.
Text below: Around 23 ⅓ years old.

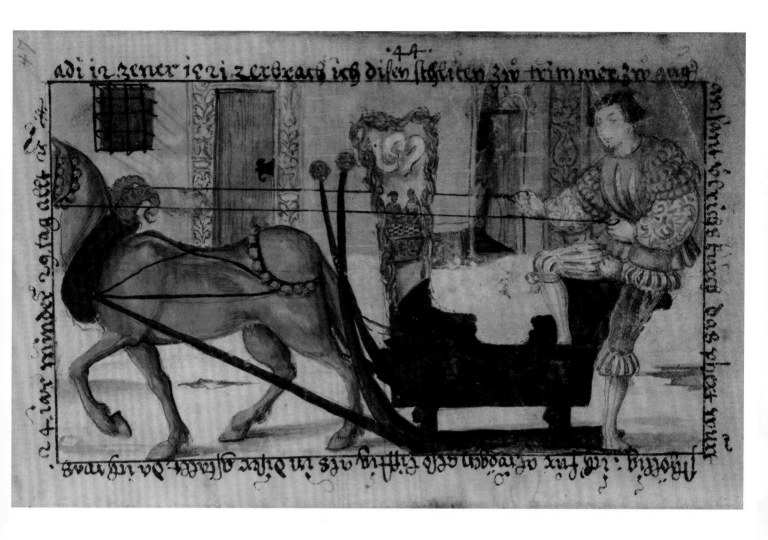

On 12th January, 1521, I broke this sleigh into pieces in Augsburg at St. Ulrich's Church because the horse shied away. I always drove in this manner. I was 24 years, minus 29 days old.

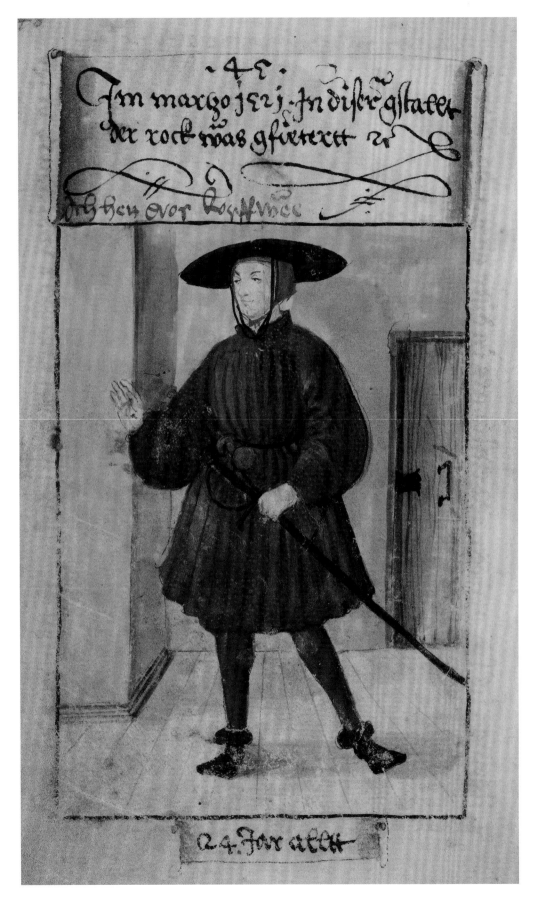

In March 1521, in this manner. The gown was lined.

Later addition: I had a terrible headache.

Text below: 24 years old.

In April 1521. The fabric Barpinian [from Perpignan or as from Perpignan], trimmed with silk satin. The doublet from silk satin, the bonnet with silk satin and crimson velvet. The hose with velvet-rolls in the length.

Text below: 24 years old and two months.

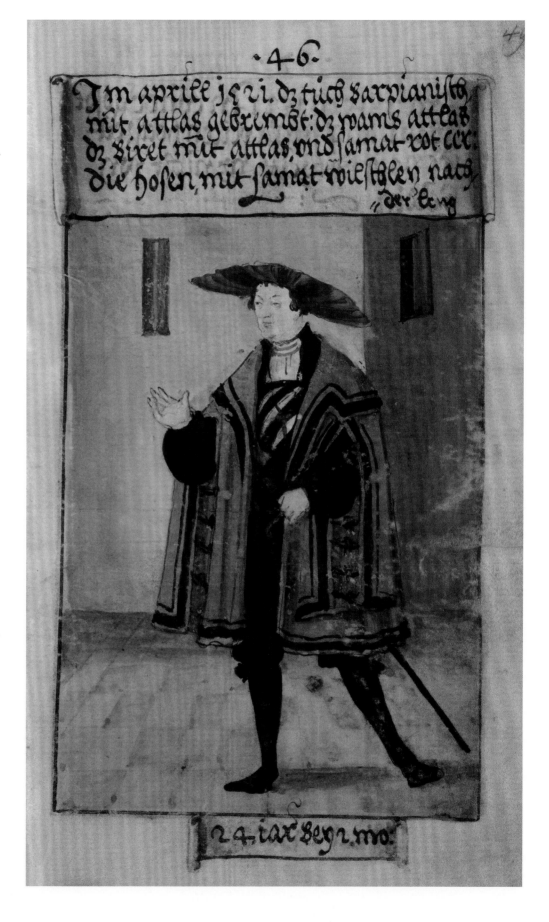

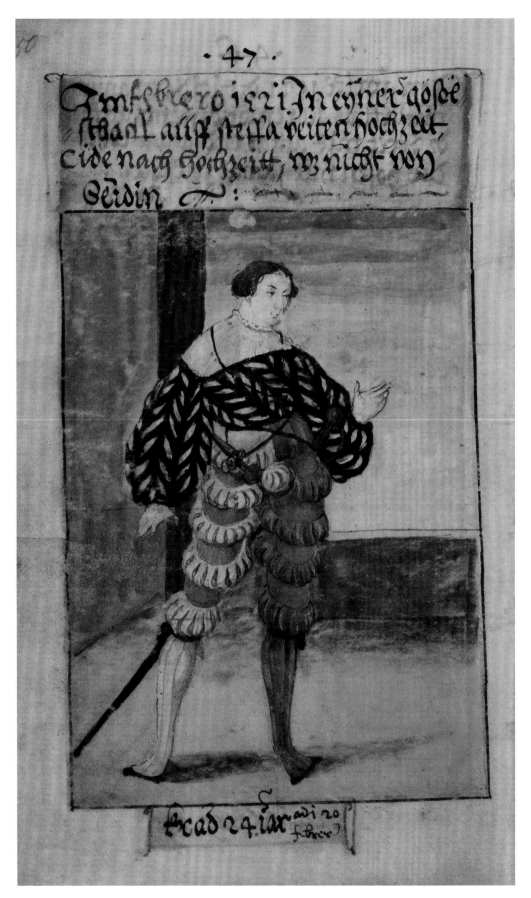

In February 1521, in a gathering at Steffan Veiten's wedding—or rather the after-wedding—it was not from silk.

Text below: Just 24 years old on 20th of February.

10th of May, 1521: the doublet silk satin, otherwise in this manner to walk with others toward His Highness Ferdinand of Austria in Augsburg. There were 5 brothers in one rank, the third [rank], but I carried a spear, otherwise the battle sword to please [?].

Inside the image: The face is well captured.

Text below: 24 years, 2 ½ months.

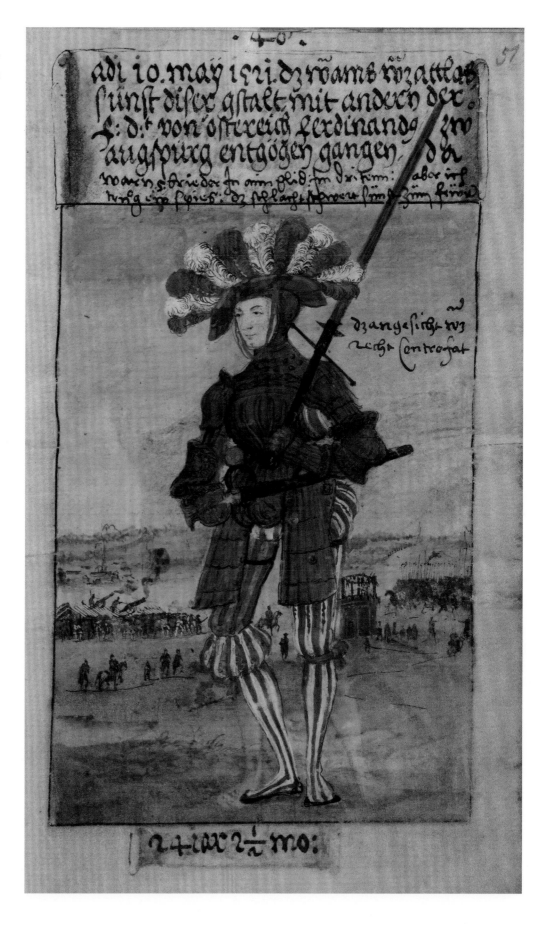

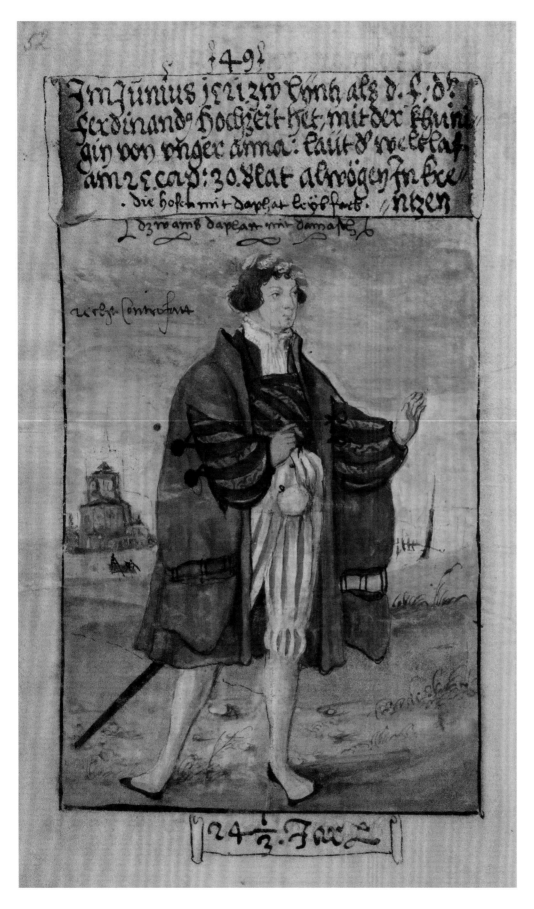

In June 1521 in Linz, when His Highness Ferdinandus held his wedding with Anna, Queen of Hungary, as in "The Course of the World," chapter 29, page 30. At all times with wreaths (for the wedding).

Later addition: The hose of half silk body-colored, the doublet half silk with damask.

Inside the image: Well captured.

Text below: Aged 24 ⅓.

On 2 December, 1521, during the plague in Augsburg. The gown with a velvet trimming, the bonnet embroidered with velvet, the lining of the best marten fur, as in "The Course of the World," 29th chapter, 31st sheet.

Inside the image: The face was well portrayed.

Text below: Aged 24 ¾.

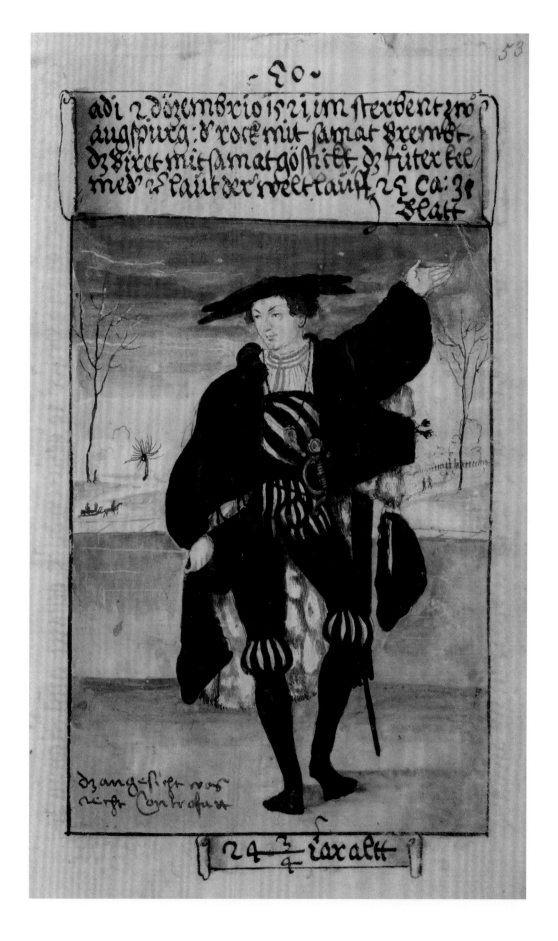

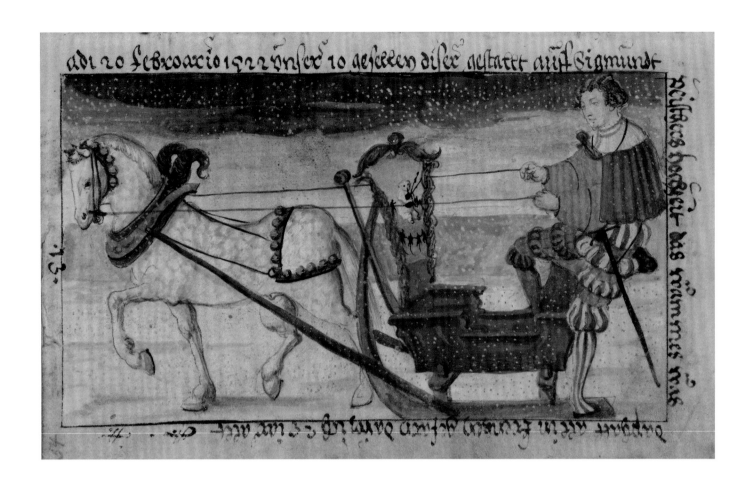

On 20th February, 1522, us 10 comrades looked like this at Sigmund Peitscher's wedding. The doublet was from a half silk, and we all rode wearing wreaths, I was 25 years old.

On 2nd May, 1522, I wore
a thread caul for the first
time. The jerkin was scarlet
red, the doublet green velvet
[and] scarlet red damask;
the hose, green taffeta; the
shirt with golden bands.

Inside the image: The face is
well captured.

Text below: 29 years, 2 ½ months.

In September 1522. The gown with silk satin points, hose, doublet, in a gathering with Wolf Breischuch, Marx Rott, Basti Dietenhaimer. The doublet was made of silk satin, otherwise everything woolen.

Inside the image: The face is well captured.

Text below: 25 years and 7 months.

In September 1522. The doublet made of velvet. A placard in front of the shirt. Inside the image: Golden; velvet. Text below: Aged 25 years and 7 months.

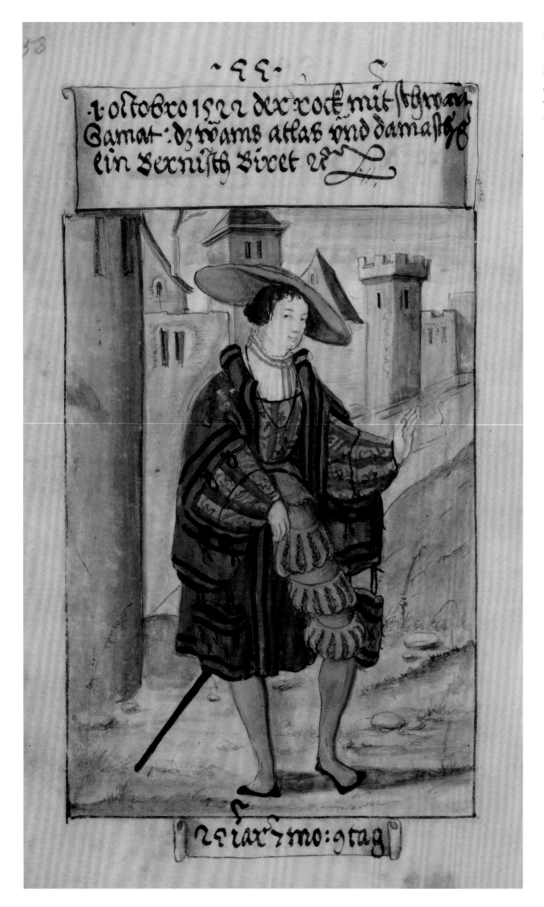

October 1, 1522. The gown [edged] with black velvet, the doublet silk satin and damask, a Bernese bonnet.

Text below: Aged 25 years, 7 months, and 9 days.

In December 1522. The doublet made from a light mix of wool and silk with taffeta edgings, the placard linen, the bands made of silk satin.

Inside the image: The face is well captured.

Text below: Aged 25 and ¾.

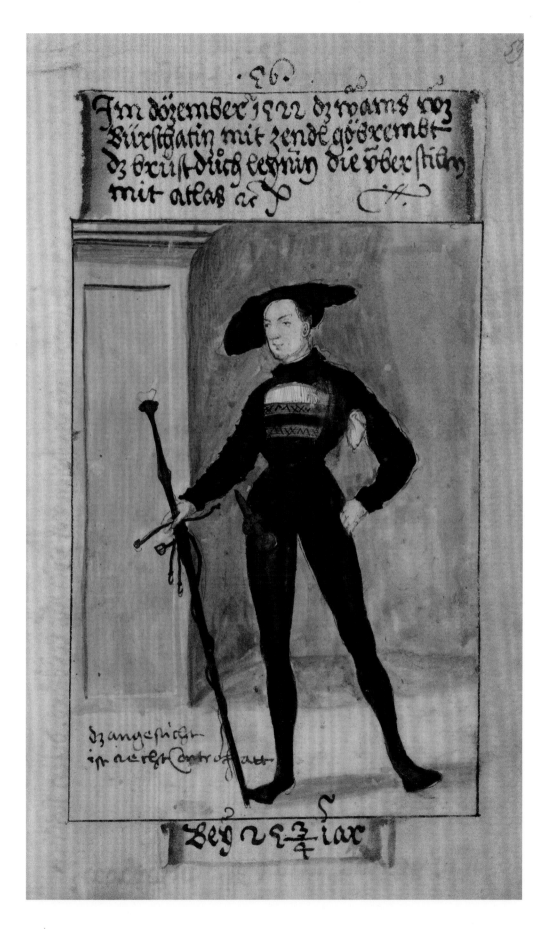

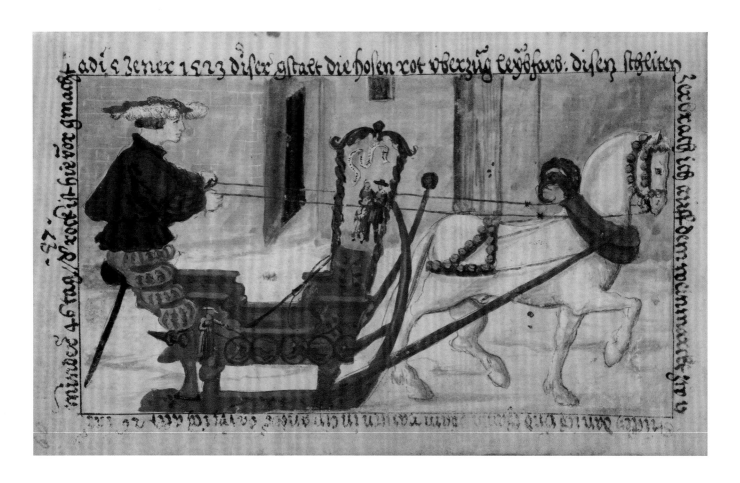

5 January, 1523, in this manner: the hose red, the over-hose flesh-colored. I broke this sleigh into 17 pieces on the wine market, for I and Thama Oham ran into each other, I was 26 years, minus 46 days old. The gown had been made before then.

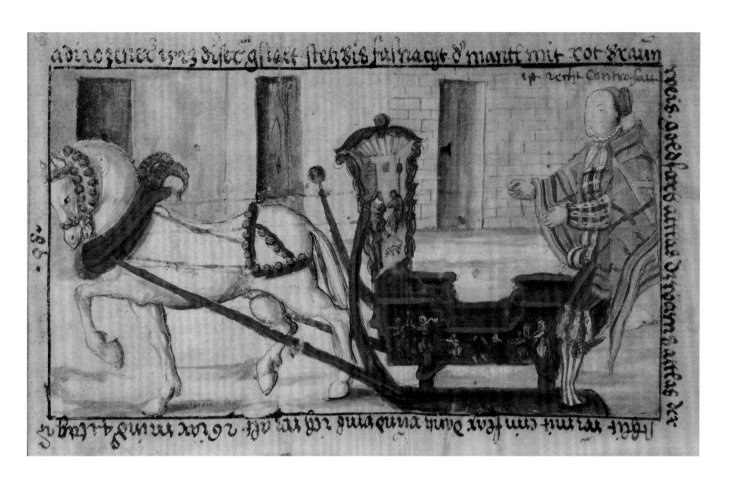

On 10 January, in this manner, until carnival. The cloak with red, brown, white, golden silk satin, the doublet silk satin, the sleigh decorated with a flax-dance all around. I was 26 years, minus 41 days, old.

Inside the image: Well portrayed.

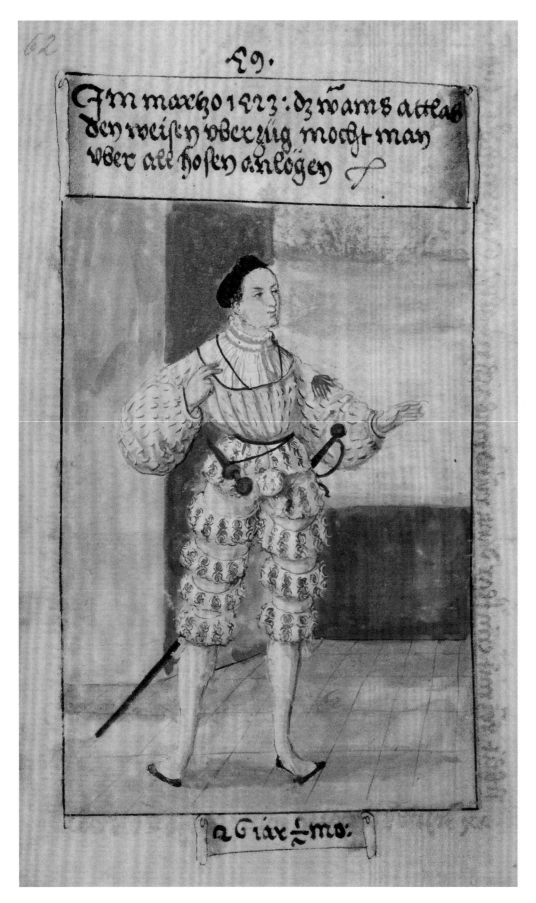

ɔ9.

Jm march 1523: dʒ wams attlas
den weisen vberzug mocht man
vber all hosen anlegen

a biar ½ mo:

*In March 1523. The
doublet of silk satin, the
white over-hose could be
worn with any hose.*
Text below: 26 years and
½ a month.

In March 1523: an evening dress, the short cloak with taffeta, the doublet made from silk satin, the gray over-hose can be fitted over any hose.

Inside the image: Hose with much green [...] small bells all around, with Matheus Herrtz, Andreas Koler, and Wolf Breitwiser.

Text below: 26 years, ½ month.

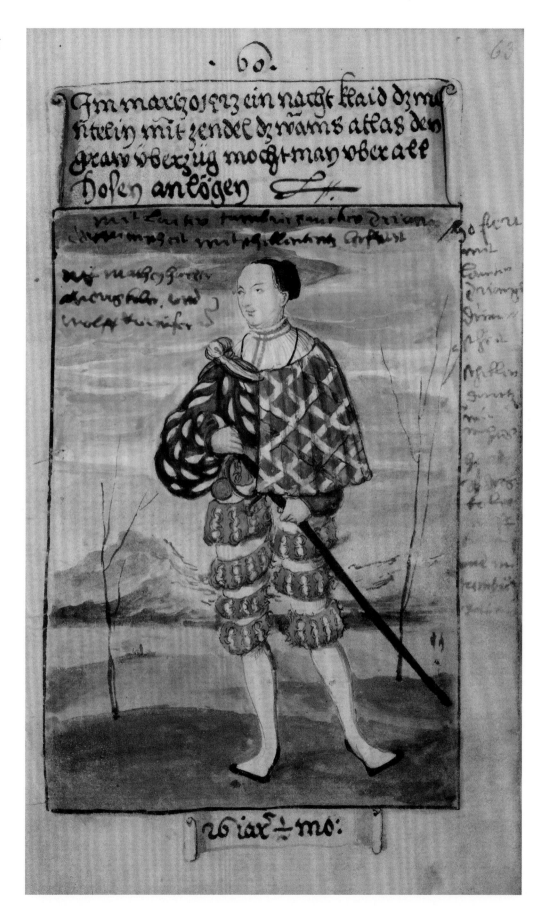

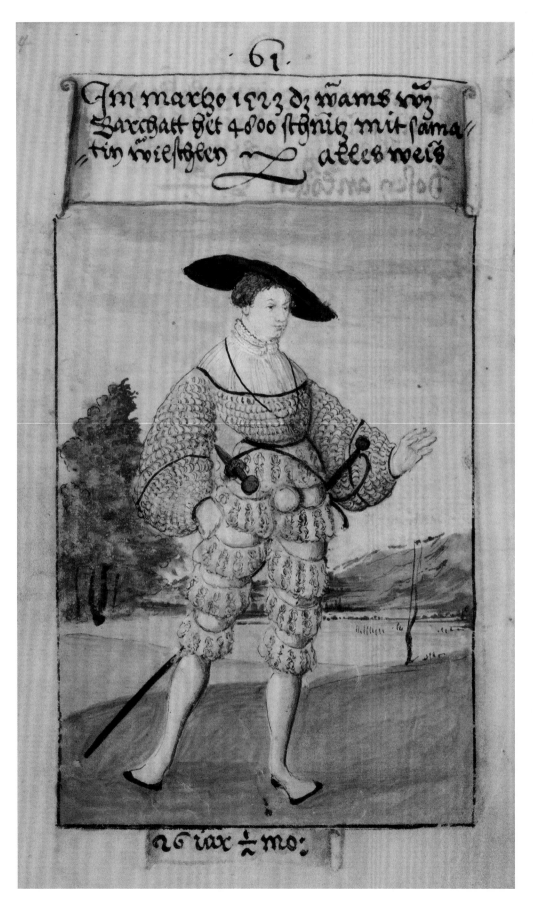

In March 1523. The doublet
of fustian, which has 4,800
slashes with velvet rolls all
in white.

Below the image: 26 years,
½ month.

13th of June, 1523, in Nuremberg, the first beard. The doublet silk satin, the bonnet with velvet, the gown fine wool from Barbia (Perpignan); but the brown velvet trimmings were added later in Augsburg.

Inside the image: The face was well captured.

Text below: Aged 26 years, 3 months, 21 days.

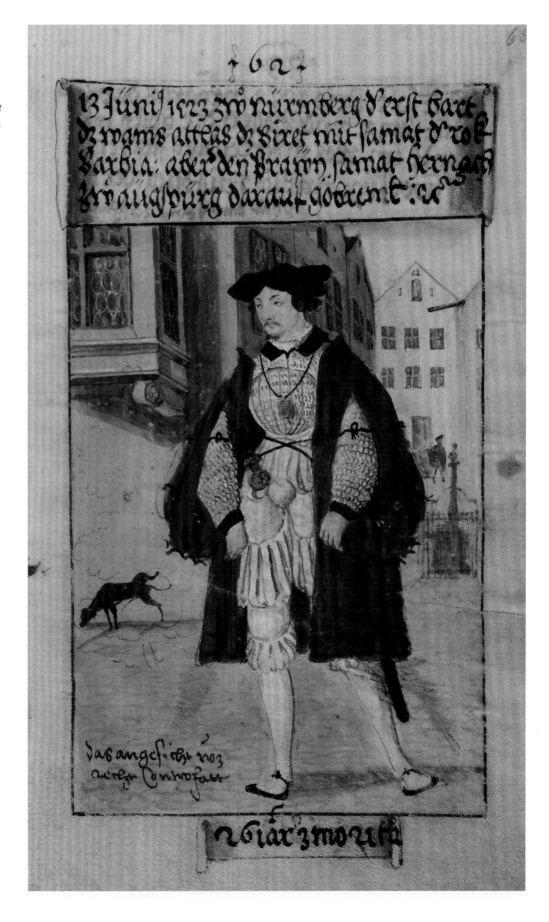

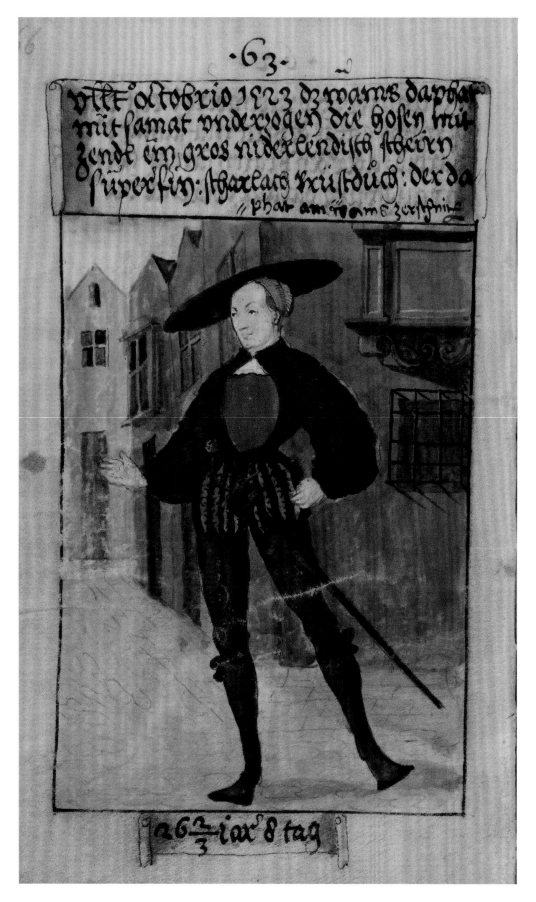

Last day of October 1523.
The doublet from half
silk lined with velvet; the
hose with taffeta; a large,
super-fine bonnet from
the Netherlands; a scarlet
placard; the taffeta pinked
on the doublet.
Text below: Aged 26 and
⅔ years, 8 days.

On 23rd November, 1523, in a social gathering as a group of ten at Marx Schaller's after-wedding. The doublet silk satin, the over-hose can be worn over any hose.

Inside the image: [. . .] but not always.

Text below: 26 ¾ years, 1 day.

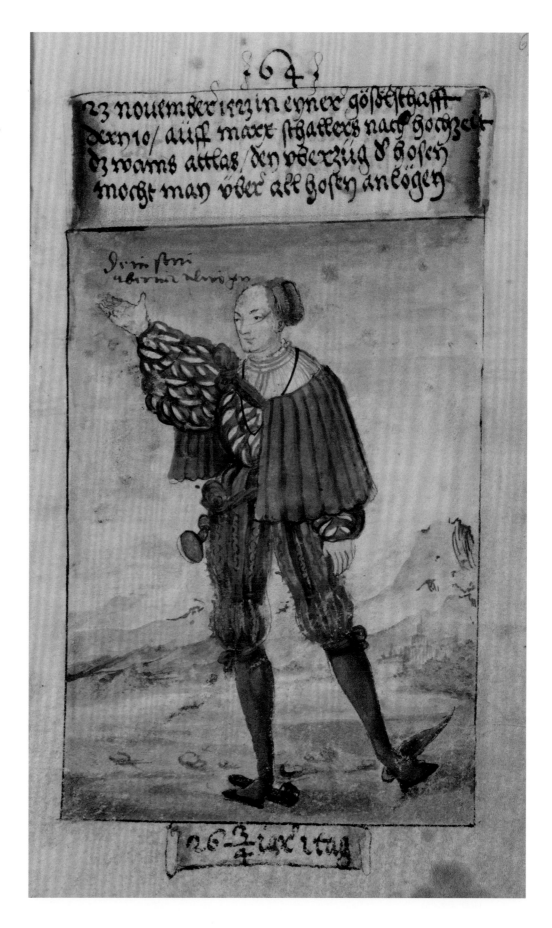

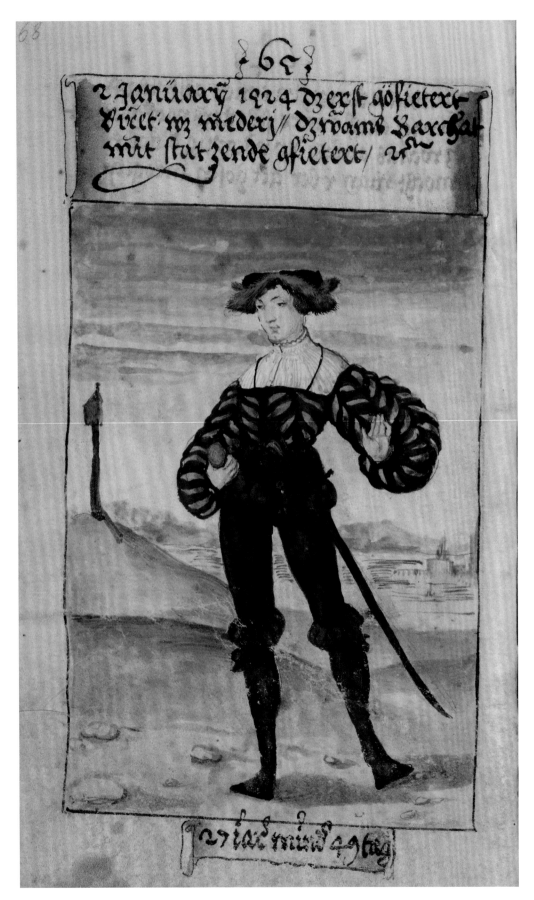

2 January, 1524. The first lined bonnet with marten fur. The doublet light woolen and silk lined with precious taffeta.

Text below: 27 years, minus 49 days.

15th of May, 1524. This cap with the golden aglets belonged to the Duke of Milan [. . .] or the Duke of Bari. Otherwise everything as shown. I learnt lute-playing at this time. The hose was lined with taffeta.

Text below: 27 years, 2 months, 23 days.

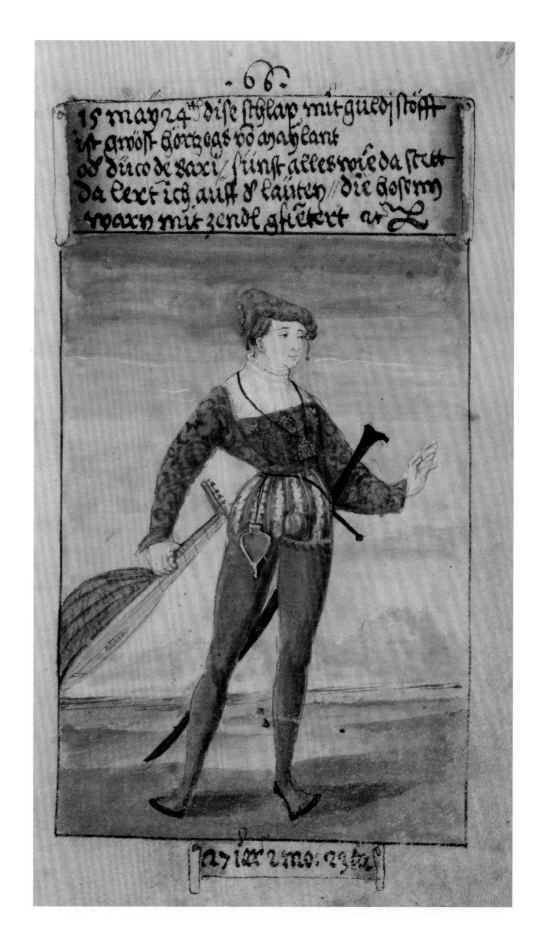

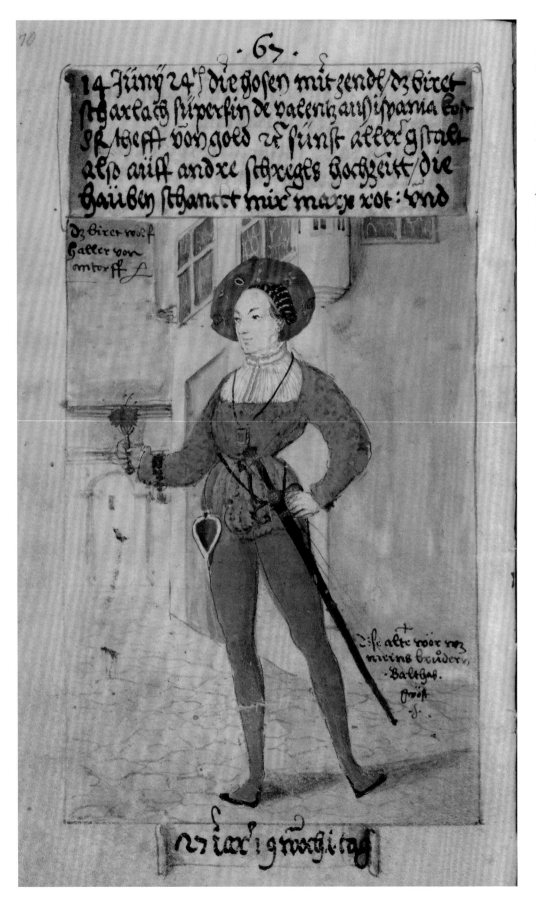

14th June, [15]24. The
hose with taffeta, the bonnet
super-fine scarlet from
Valencia in Spain, costs
8 florins, buttons of gold,
otherwise everything as at
Andre Schregl's wedding.
The caul was a gift from
Marx Rot and the bonnet
from Wolf Haller in Antwerp.
Inside the image: This old
sword used to belong to my
brother Balthas.
Text below: Aged 27 years,
19 weeks, and one day.

In June 1524. Three types of Prussian leather as hose and over-hose, everything as shown, without doublet, but three kinds of shirts. The middle one [has attached to it] an 8 minute hour-glass on the thigh.

Text below: 27 years, 22 weeks.

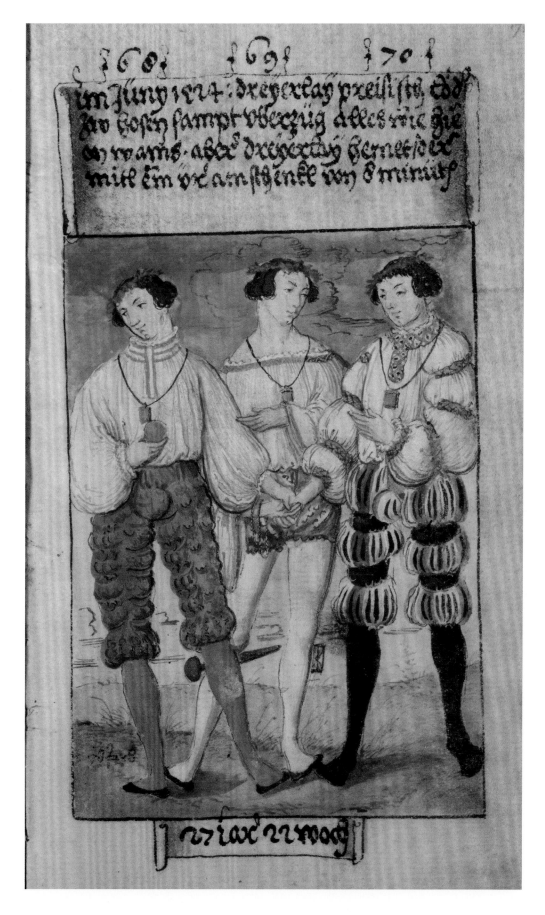

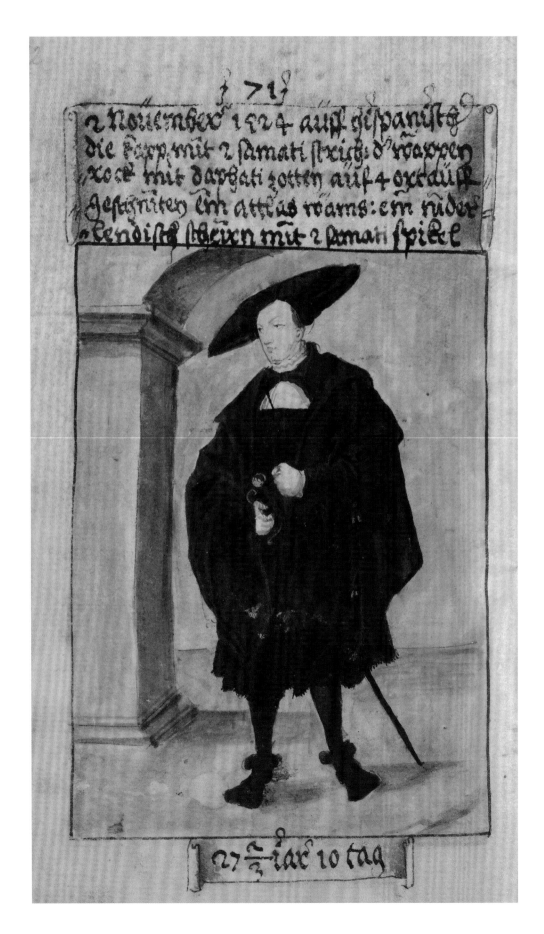

2 November, 1524, in the Spanish manner, the bonnet with two velvet trimmings, the riding gown with silken edgings cut open in four ways [auf 4 ort aufgeschnitten]; a doublet from silk satin, a Netherlandish bonnet with 2 velvet gussets.

Below the image: 27 ⅔ years, 10 days.

30th July, 1525, in Innsbruck, at Laux Schaller's wedding in Schwaz in August. The bonnet embroidered with velvet. This is when I began to be fat and round.

Text below: 28 years, 5 months, 8 days.

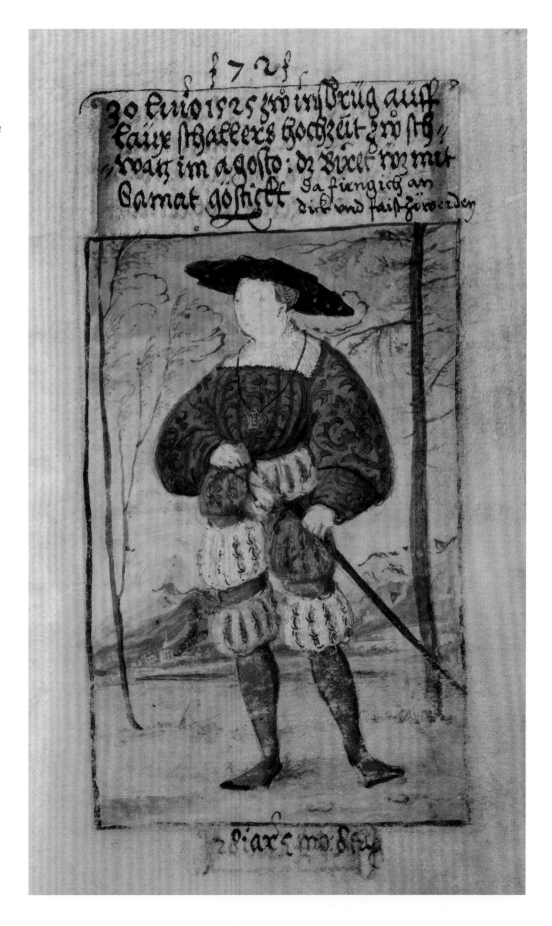

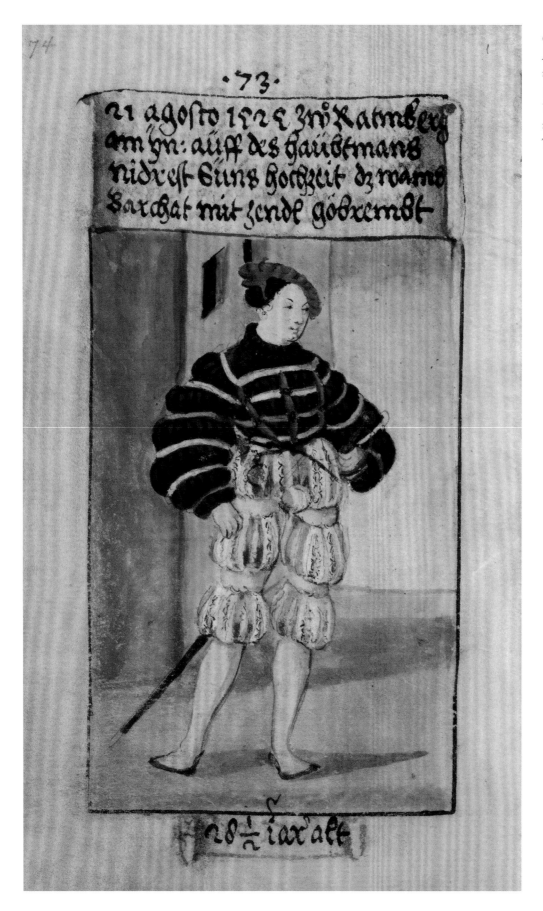

·73·

21 agosto 1525 Jm Ratmberg
am Jn: auff des hauptmans
nidrest Suns hochzeit dz wamb
barchat mit zendl gobrembt

28½ iar alt

On 21 August, 1525, in
Rattenberg-on-Inn at the
wedding of Hauptmann's
(captain) Nidrest's son.
The doublet fustian trimmed
with taffeta.

Text below: Aged 28 ½ years.

September 30, 1525, at Schwaz in a gathering with Jörg Hörman, Hans Rentz, Hans Wiedenman. Everything flesh-colored, the doublet silk satin, the gown was made to be worn on either side, in green as in image 75.

On the margin: These two images number 74 and 75 depict a gown, which could be reversed. We often needed these during the Peasants' War, when we rode to and away from Innsbruck, Schwaz, Hall, Rattenberg, when we had silver and money, and stayed safe. But it cost a lot of wine in the villages, so that we made ourselves good friends, while others remained in the net. Text below: 28 years, 7 months, 8 days.

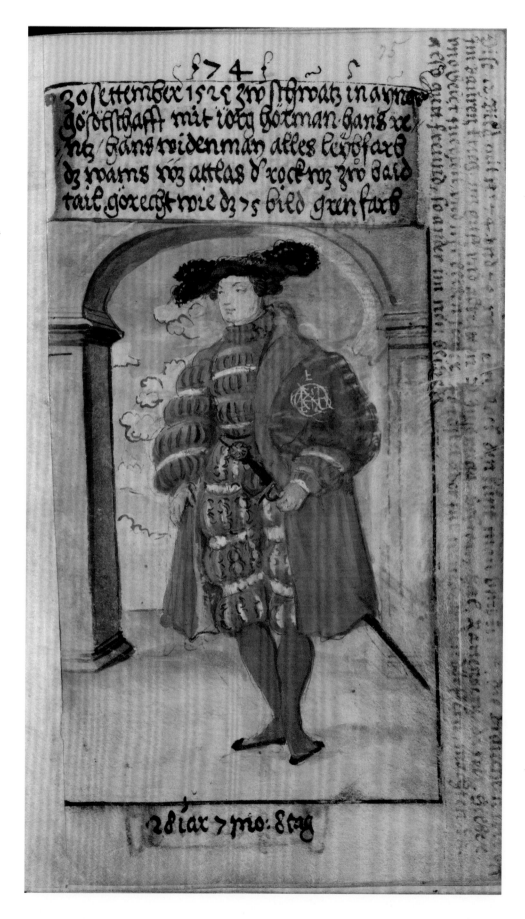

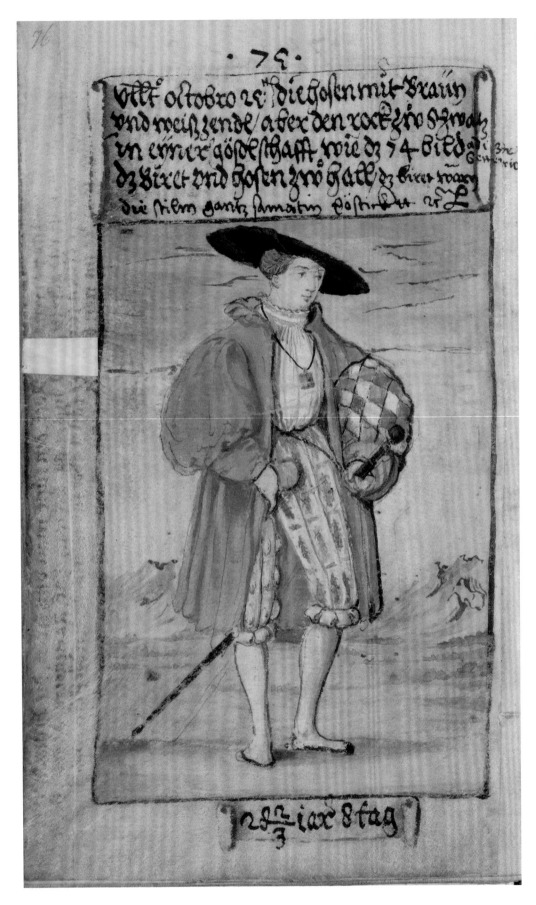

Final day of October
[15]25. The hose with
brown and white taffeta.
But the gown in Schwaz in
a gathering, as in the 74th
image of 30th September,
the bonnet and hose at
Hall. The bonnet had all
the pleats over the brim
embroidered with velvet.
Text below: 28 ½ years, 8 days.

This was my usual outfit [Rüstung] in which I went to go for a walk in Innsbruck, Hall, Schwaz, Rattenberg sometime between July 1525 and 26th April; sometimes I used the [clothes? on the] 75th/74th image, but usually a large brown Netherlandish horse; the riding gown had 40 pleats.

Text below: In the 29th year.

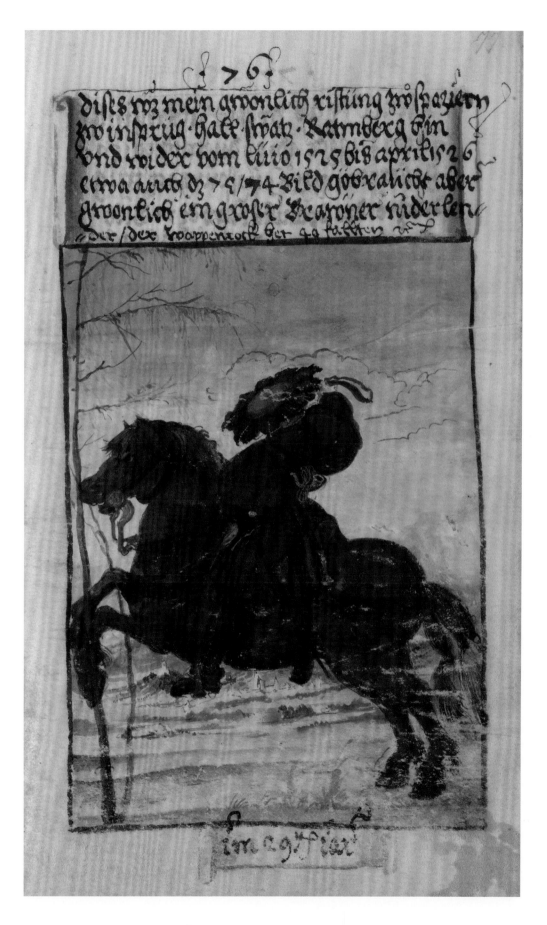

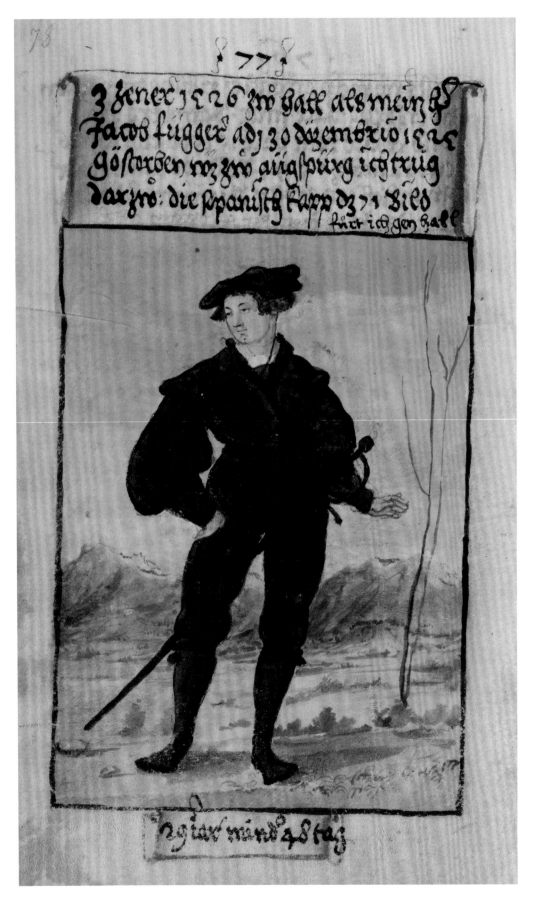

3 January, 1526, in Hall, when my master (Herr) Jakob Fugger had died on 30 December, 1525, in Augsburg. I wore the Spanish cloak with it (the 71st image) and took it to Hall.

Text below: 29 years, minus 48 days.

First of May 1526, this was my usual outfit when I returned to Augsburg. The doublet was half silk, otherwise everything as shown here.

Text below: 29 years, 2 month, 8 days.

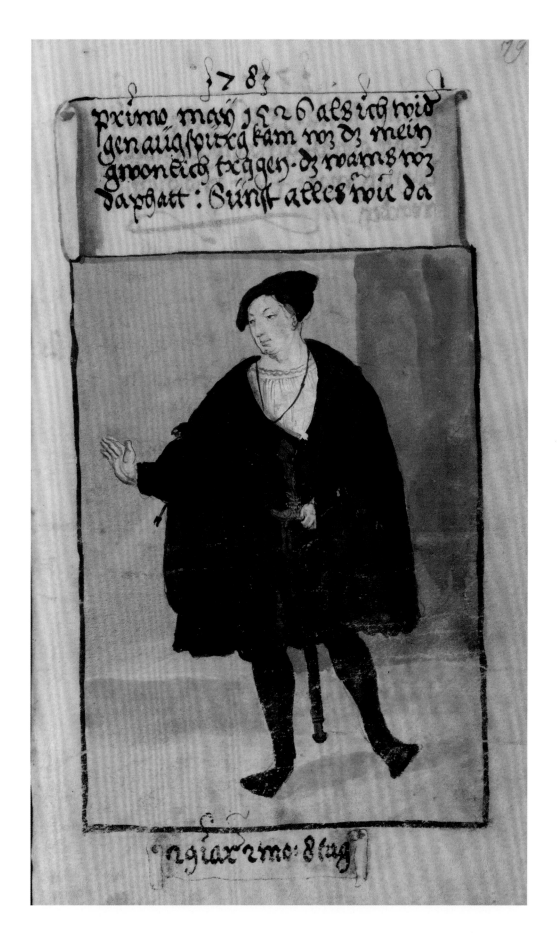

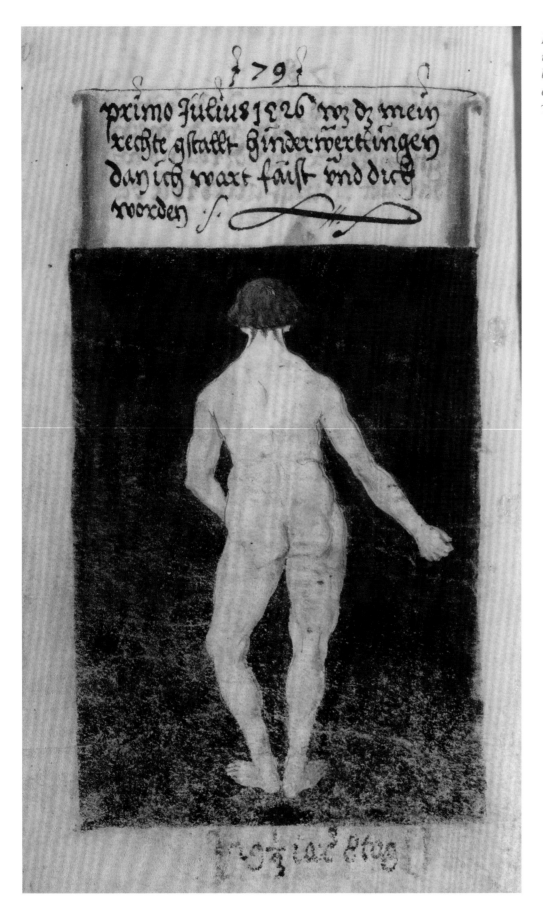

First of July 1526, this was my proper figure from behind, for I had become fat and round.

Text below: 29 ½ years, 8 days.

This was my proper figure straight from the front on the first of July 1526. The face is well captured.

Text below: 29 ½ years, 8 days.

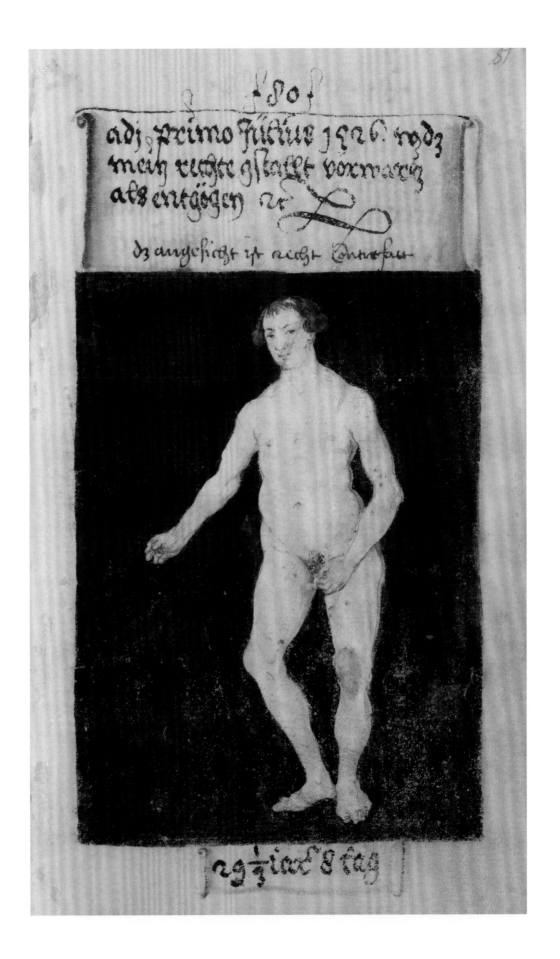

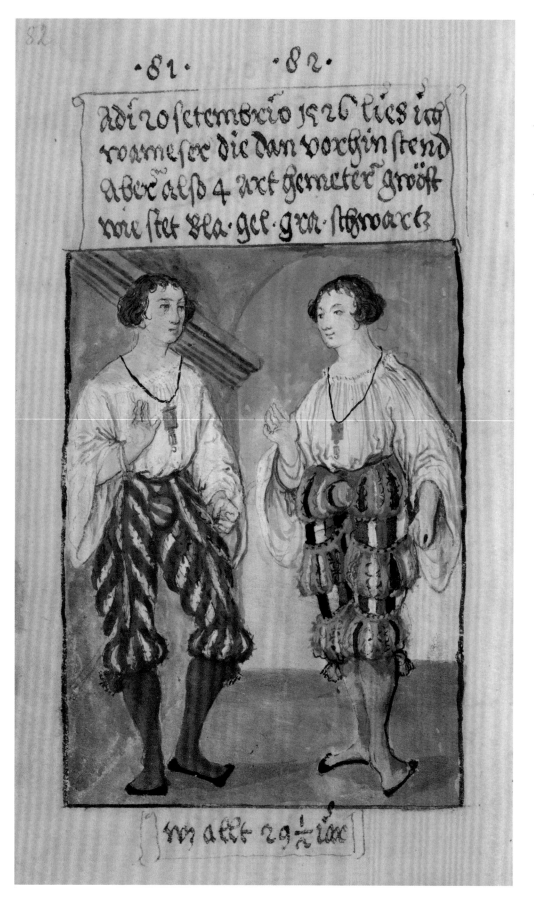

·81· ·82·

adi 20 setembrio 1526 lies ich
roarmesec die dan vorhin stend
aber als 4 ært gemeter gröst
roie stet sla · gel · grn · stwarcz

m alt 29 ½ iac

On 20th September, I had doublets made, which have been previously shown, but there were 4 kinds of shirts with these colors: blue, yellow, gray, black, and also 4 pairs of hose (as seen on images 52, 66, 67, 72) in the colors white, flesh-color, green, brown lining cloth.

Text below: Aged 29 ½ years and 28 days.

· 8 3 · · 8 4 ·

als 4 Saxhosen machen on
die vor dz 52/66/69/72/Bild
vnd die hosen mit forbern
weis· leibfarb· gren· brvn

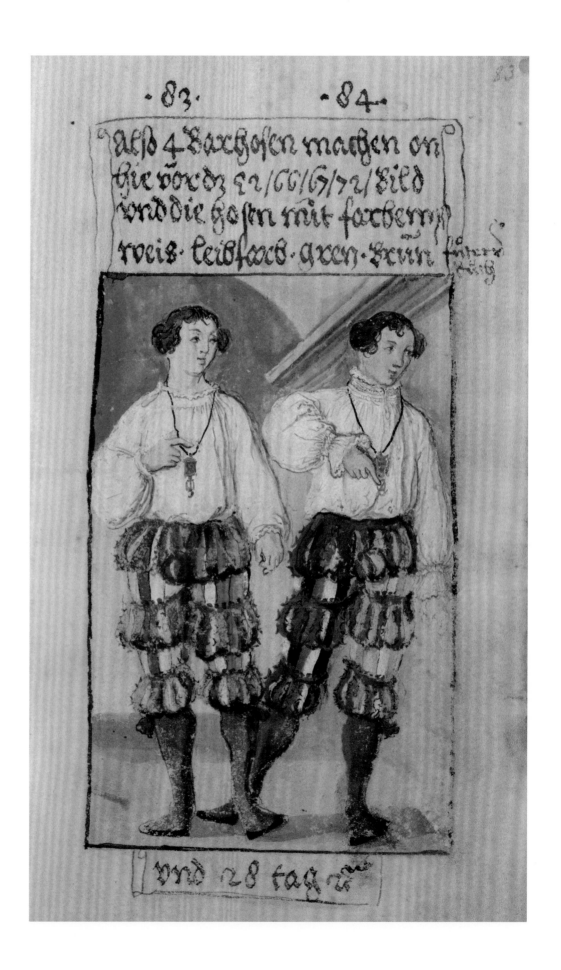

vnd 28 tag ☉

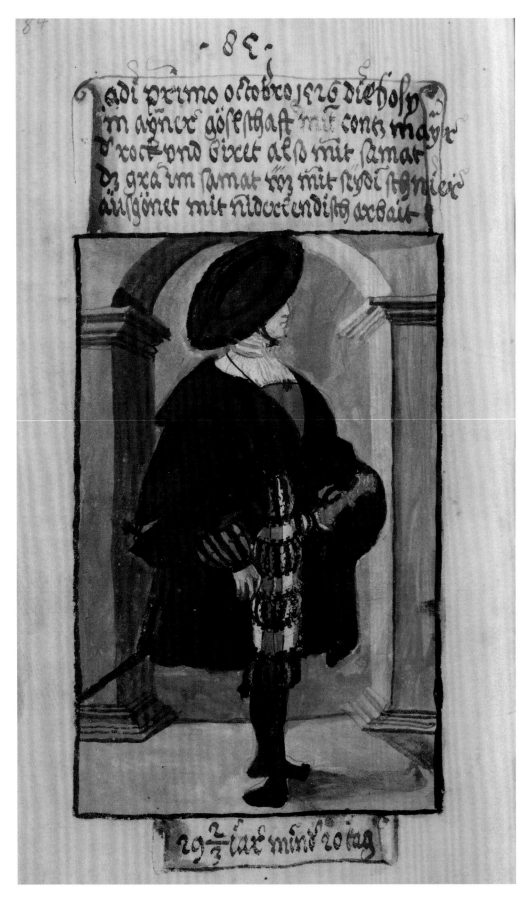

First October 1526: the hose in a social gathering with Contz Mayr, the gown and bonnet in this manner, with velvet; the gray in the velvet was sewn with silk threads with Netherlandish work.

Text below: 29 ⅔ years, minus 20 days.

4 March, 1527, at Herrn Antonio Fugger's wedding. The bonnet with velvet and silk satin, the gown with silk loops, the hose with taffeta-lining and narrow stripes. The doublet half silk. Everything was a gift except for the bonnet.

Text below: I was the man in charge to keep order in the bridal chamber, and Lucas Meiting among the men in the men's chamber [*Manstuben*]. 30 years, 12 days.

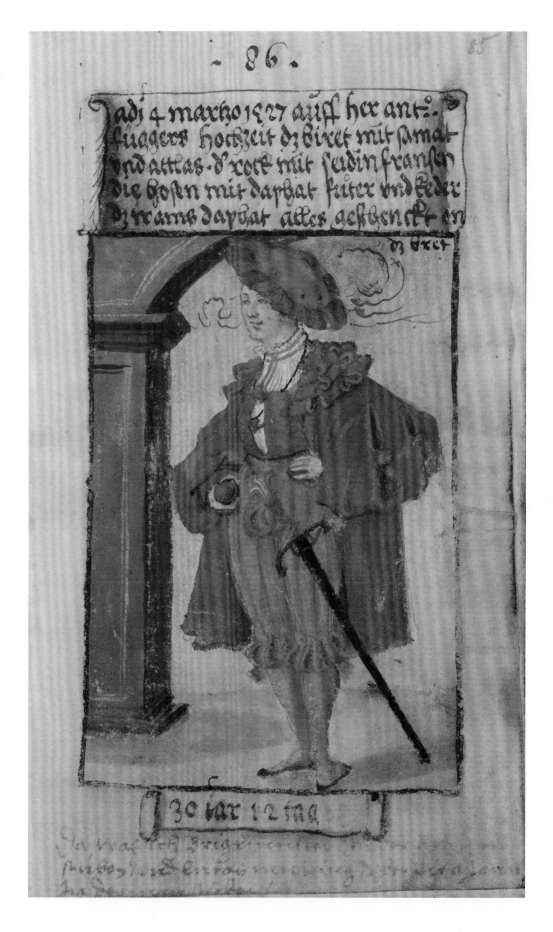

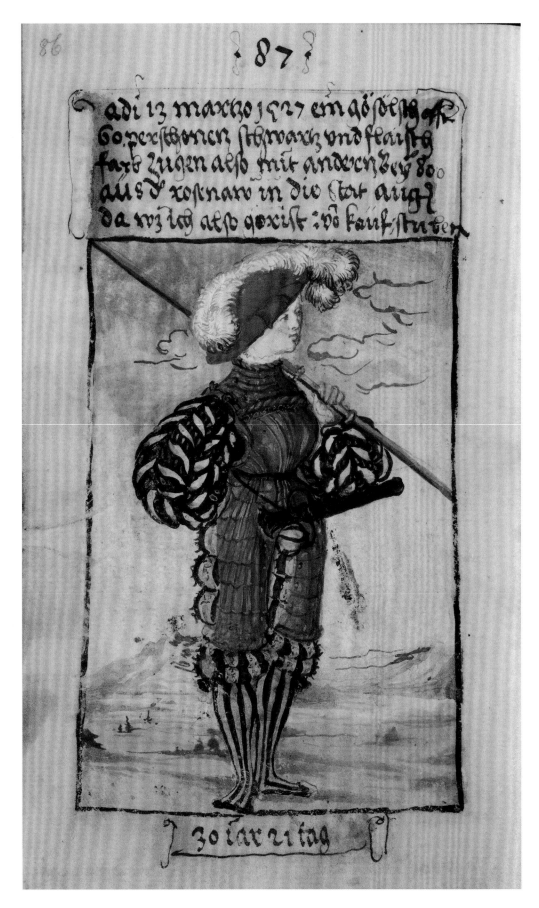

On 13th March a social gathering, 60 people in black and body-color; (we) moved from the Rosenau into the city of Augsburg with around 800 others. There I was fitted out like this by the merchant's chamber.

Text below: 30 years, 21 days.

On 2nd June, 1527, in this manner: the doublet from silk satin, a riding gown from camlet, the bonnet edged with velvet, all of this to please a beautiful person, along with a Spanish gown.
Text below: 30 years, 101 days.

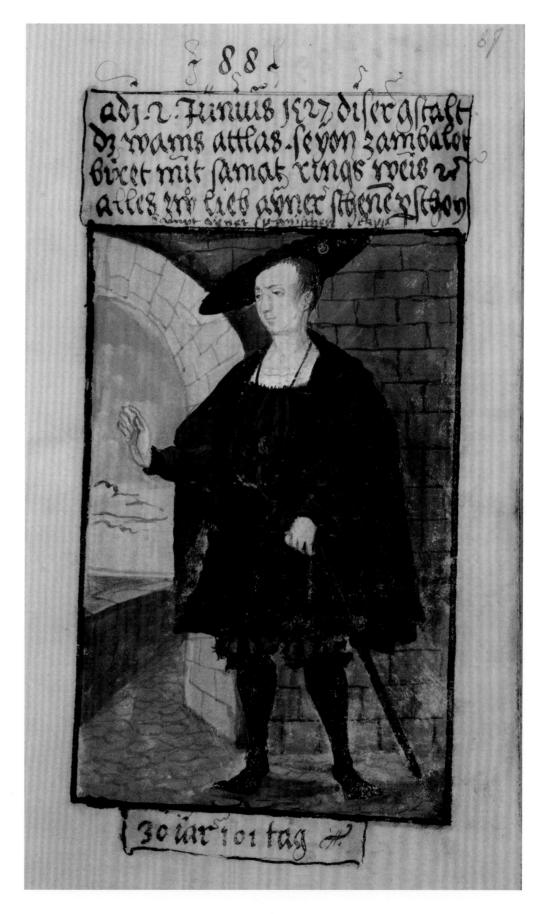

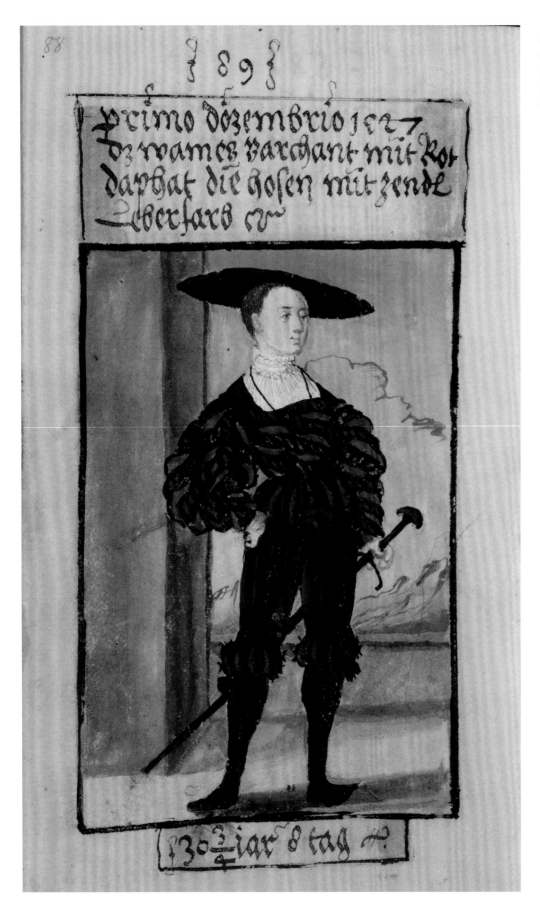

First of December 1527. The doublet from fustian with red half silk, the hose with liver-colored taffeta.

Text below: 30 ¾ years, 8 days.

On 20 February, 1528: gray doublet with red damask, the jerkin black damask with green velvet, lined with red velvet.

Text below: I was 31 years old.

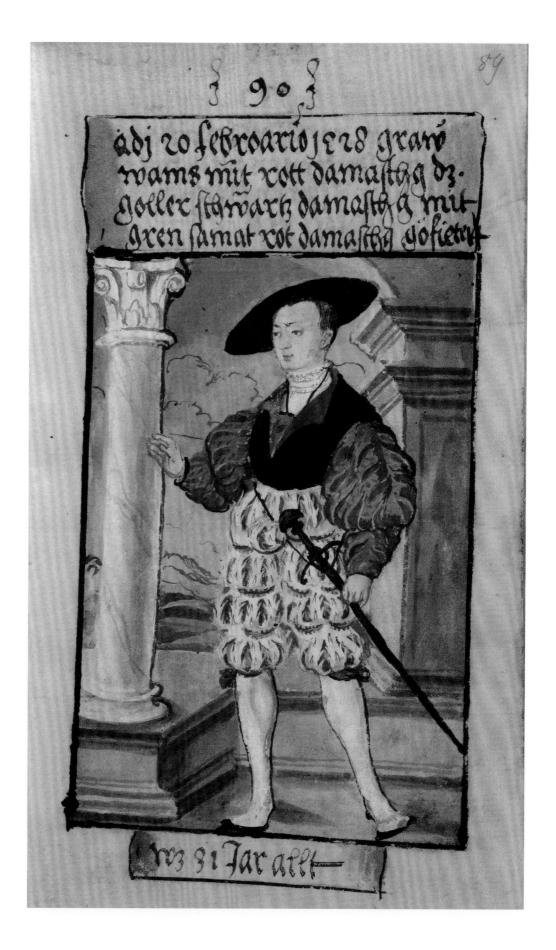

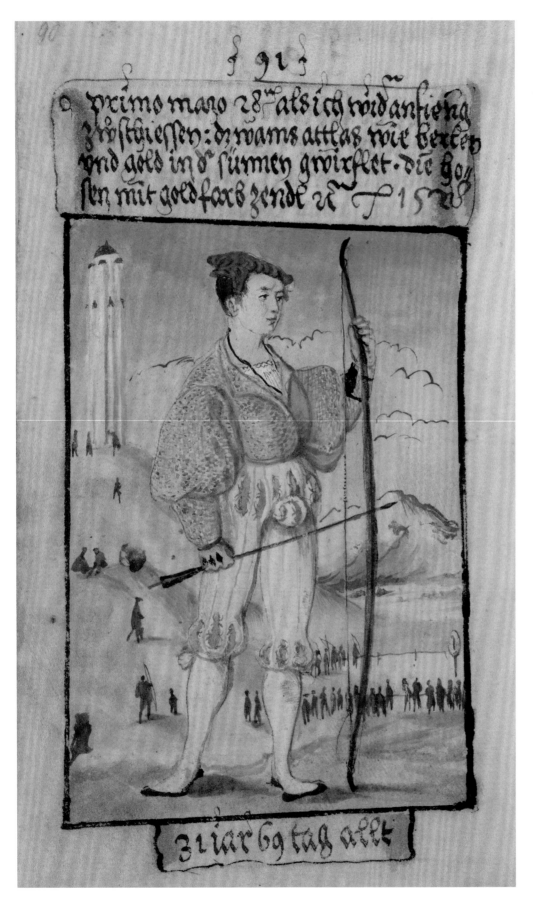

First of May [15]28, when I started shooting again. The doublet of silk satin, like pearls and gold sparkling in the sunlight [perlen und gold in der sunnen gewirfelt], the hose with golden-colored taffeta. 1528.

Text below: Aged 31 years, 69 days.

On 2 December, [15]28: the doublet lined with velvet strips and with Siberian squirrel [Fech], also on the bonnet. Otherwise as shown, nothing from silk. 1528.

Text below: 31 years, 40 weeks, 4 days.

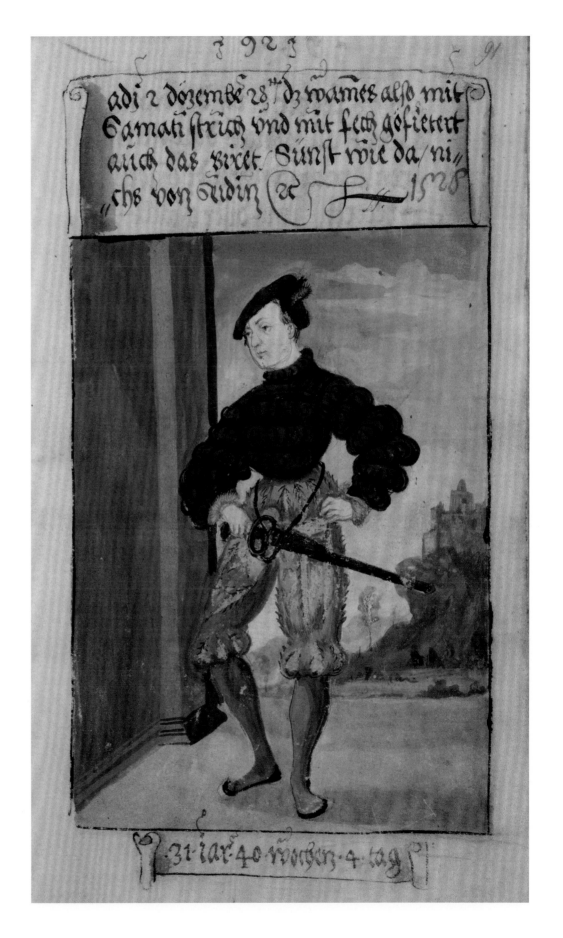

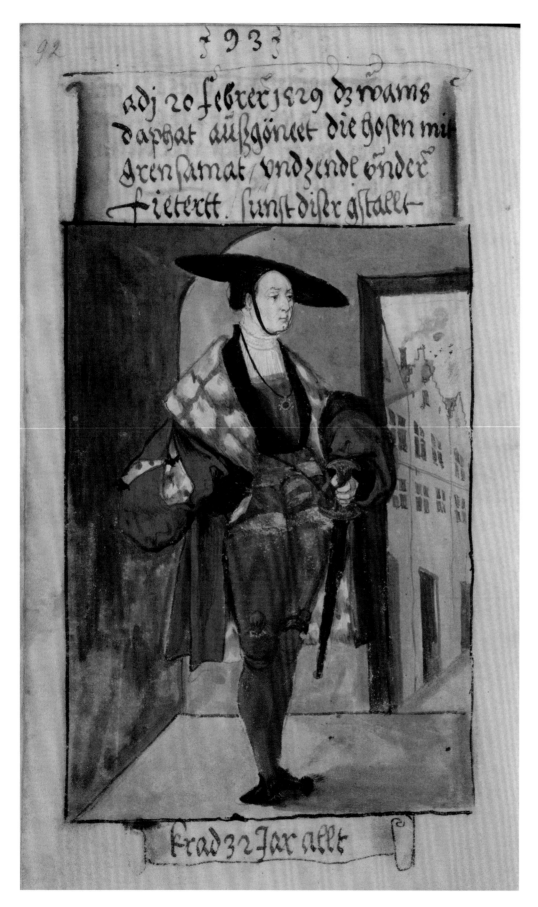

On 20 February, 1529: the doublet sewn with half silk, the hose lined with green velvet and taffeta, otherwise as shown.

Text below: Just 32 years old.

First of August 1529. The Spanish cape trimmed with silk guards [Schnier], the making cost more than the cape.

Text below: 32 years, 5 months, 8 days.

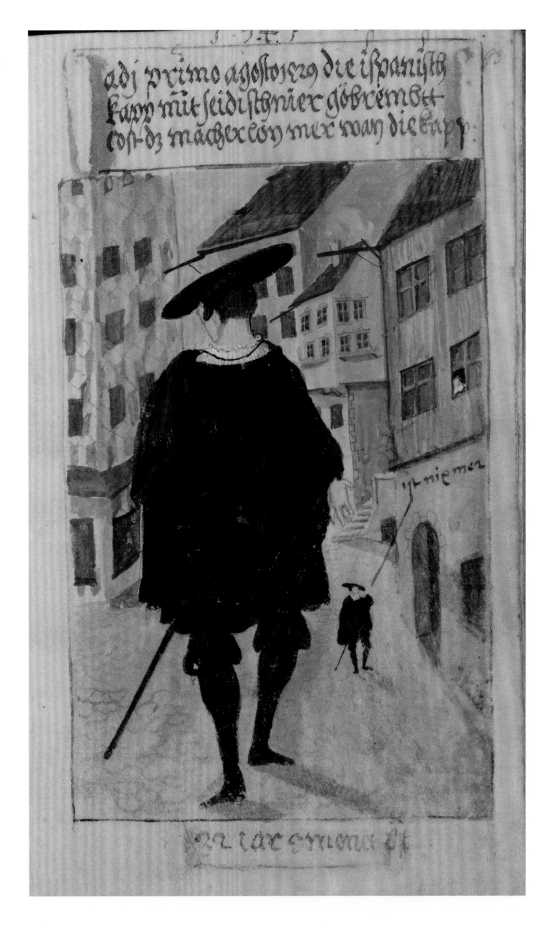

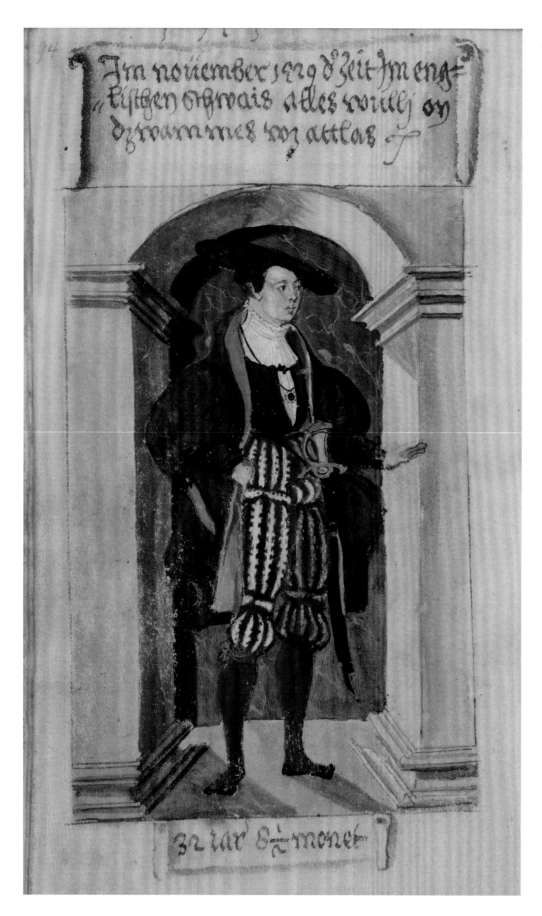

In November 1529, during the English sweat, everything woolen except for the doublet, which was silk satin.

Text below: 32 years, 8 ½ months.

During the same period: hose with silk satin, the gown with velvet.
Text below: 32 years, 8 ½ months.

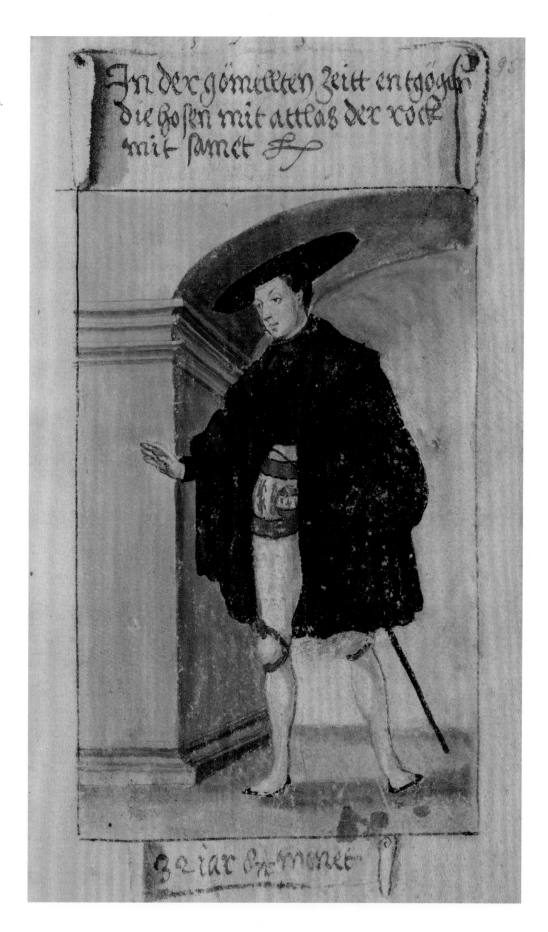

In der gemellten zeitt entgogn
die hosen mit attlas der rock
mit samet

32 iar 8½ monet

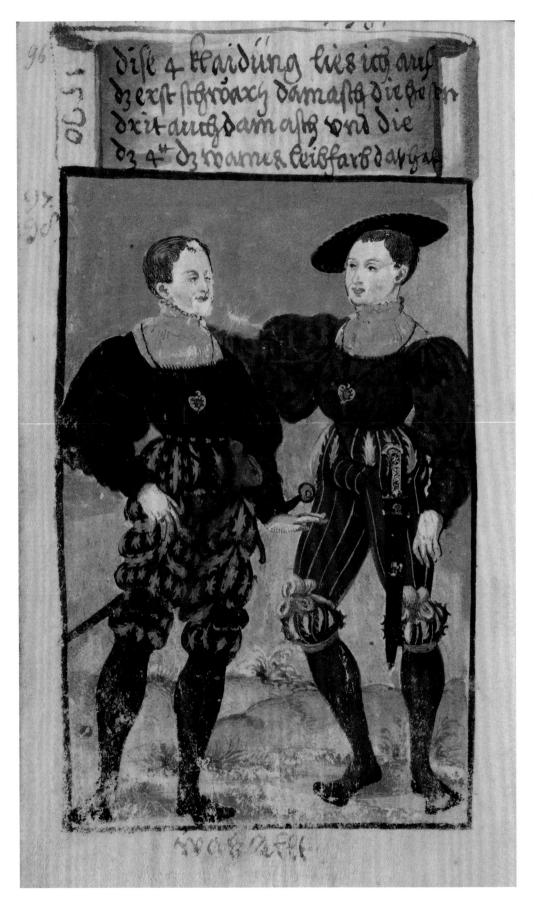

1530. These four garments I had made for the 20th February, 1530: the first black damask, the hose with flesh-colored half silk; the other and third also damask, and the hose with taffeta [Zend], the hose woolen; the 4th the doublet flesh-colored half silk, the hose leather with yellow and golden taffeta [Zendl].

Text below: Aged 33 years.

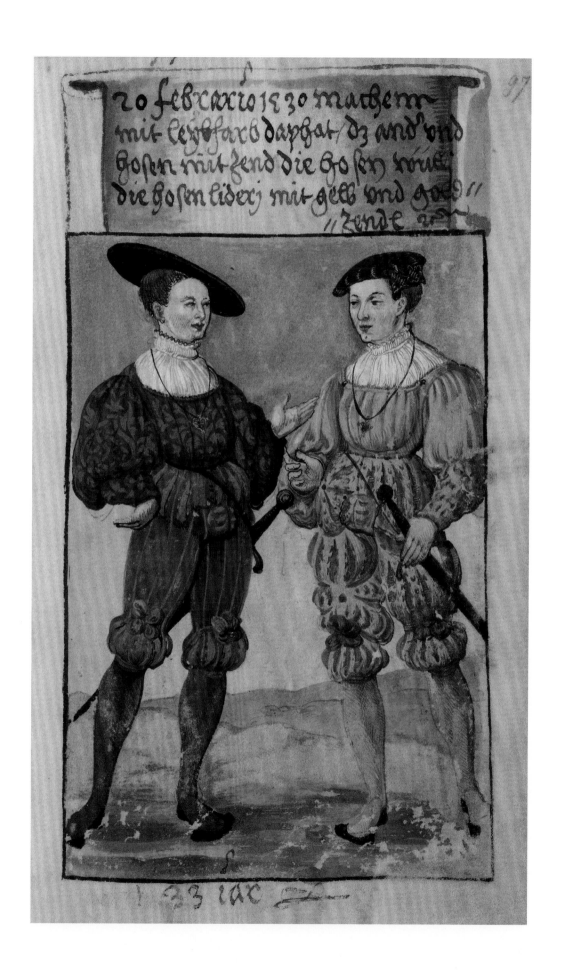

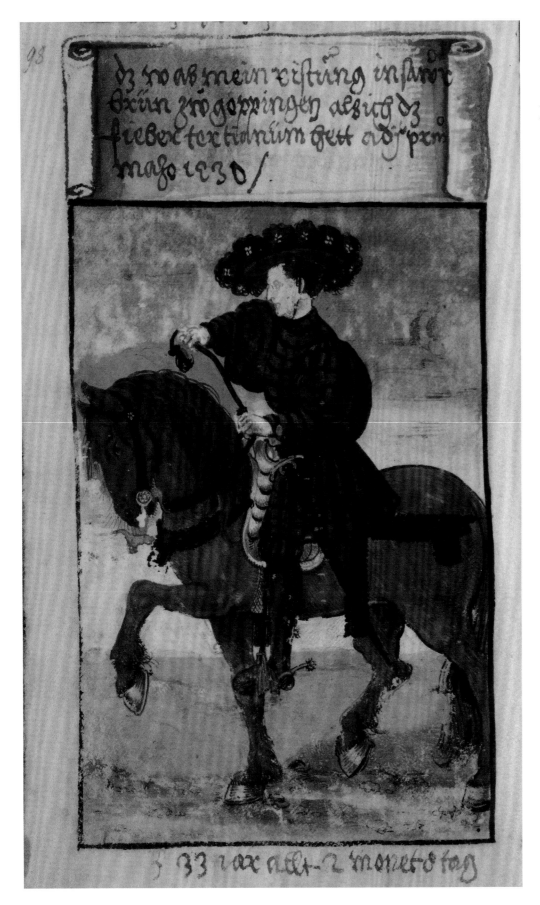

This was my outfit [Rüstung] at the baths at Göppingen, when I suffered tertian fever on the first of May 1530.

Text below: Aged 33, 2 months, 8 days.

1530, to please King Ferdinand during the Imperial Diet, when Emperor Carolus (Charles V) was here. The hose made of leather, the doublet red-brown scarlet silk satin and yellow and golden yellow damask.

Text below: Aged 33 years, 4 months, and 10 days.

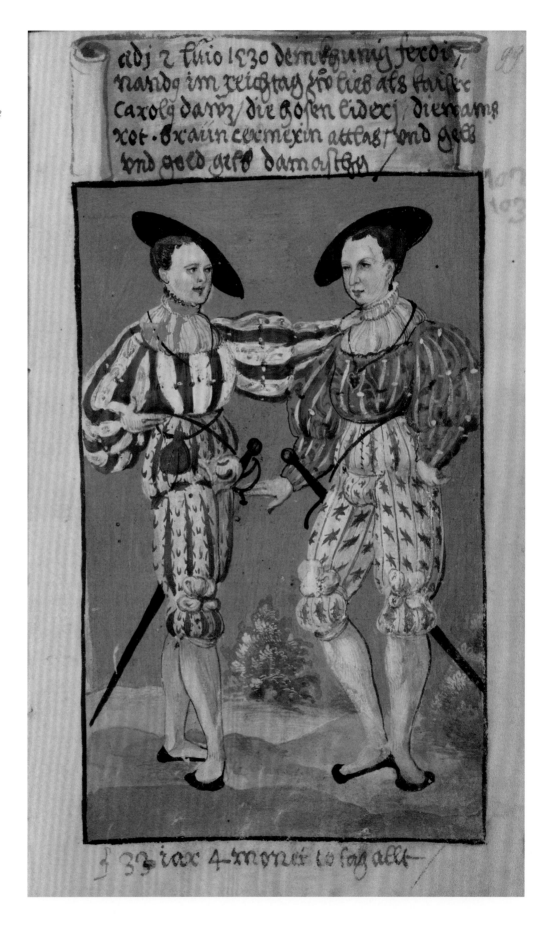

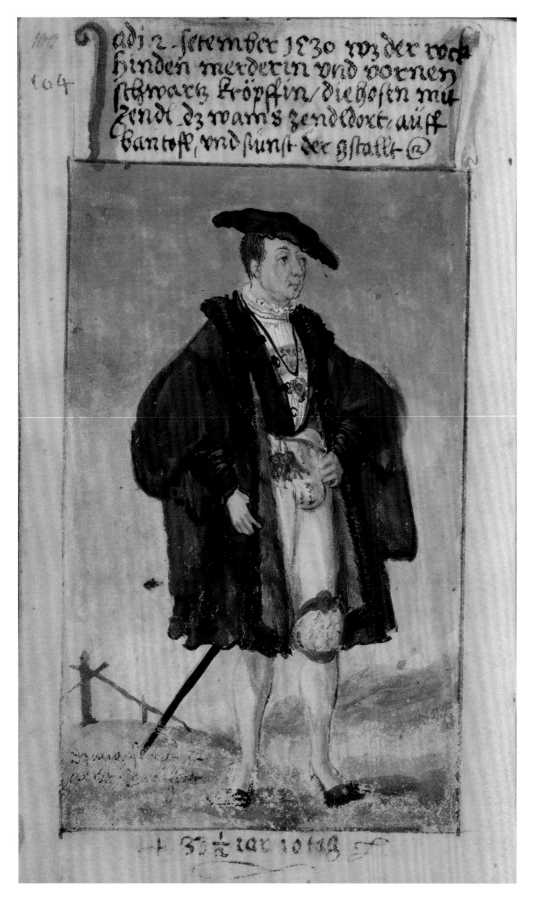

On 2nd September, 1530, the gown was made of marten fur at the back and black curled fur at the front, the hose with taffeta, the doublet of better quality taffeta [zendldort]. On mules, and otherwise as depicted.

Text below: 33 ½ years, 10 days.

Inside the image: The face is well captured.

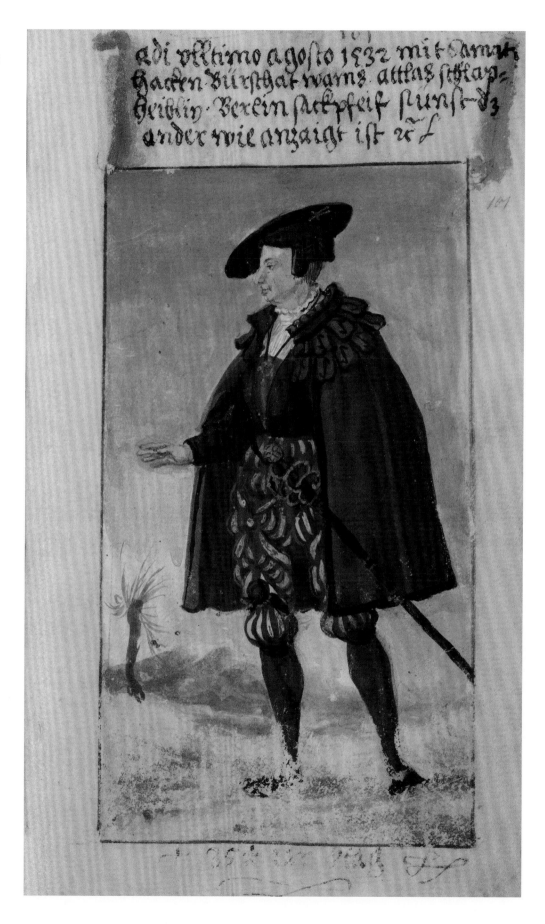

Last day of August 1532, with velvet aglets, a doublet in a light fabric of wool and silk, silk satin bonnet, pearl-Sackpfeif, everything else as shown.

Text below: 35 ½ years, 8 days.

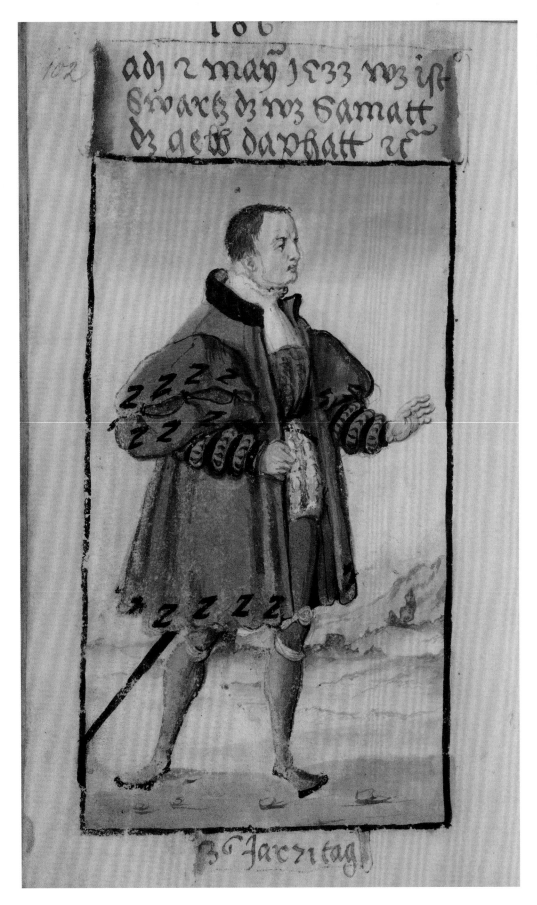

On 4 August, 1534, in this manner, damask and taffeta.

Text below: 37 years, 135 days.

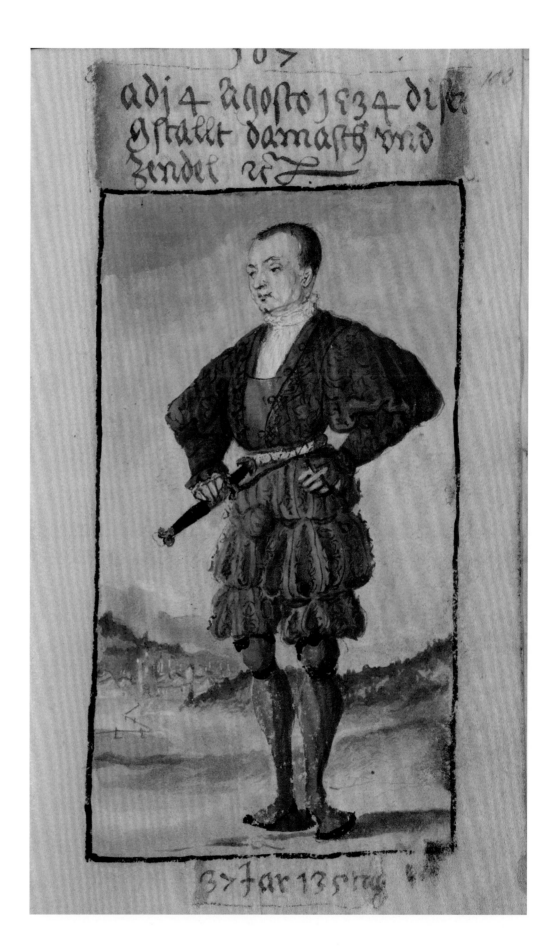

adj 20 febrer 1539 dis 2
Gabt in aller mas wie
Attlas, die rock mit Seidj

38 Jur

On 20 February, 1535,
I wore these 2 clothing
ensembles as shown. The
doublets were silk satin, the
gown had silk passementerie
[Schnier]. That is when I
began to grow a beard, in
1535.

Text below: 38 years old.

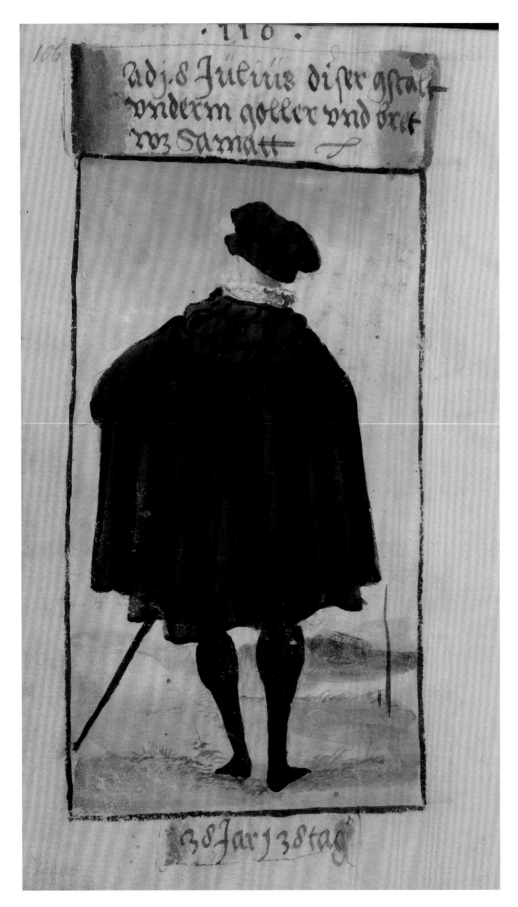

On 8th July in this manner, below the jerkin and bonnet were velvet.

Text below: 38 years, 138 days.

On the 20th August, 1535, when people in Augsburg began to die.

Text below: 38 ½ years old.

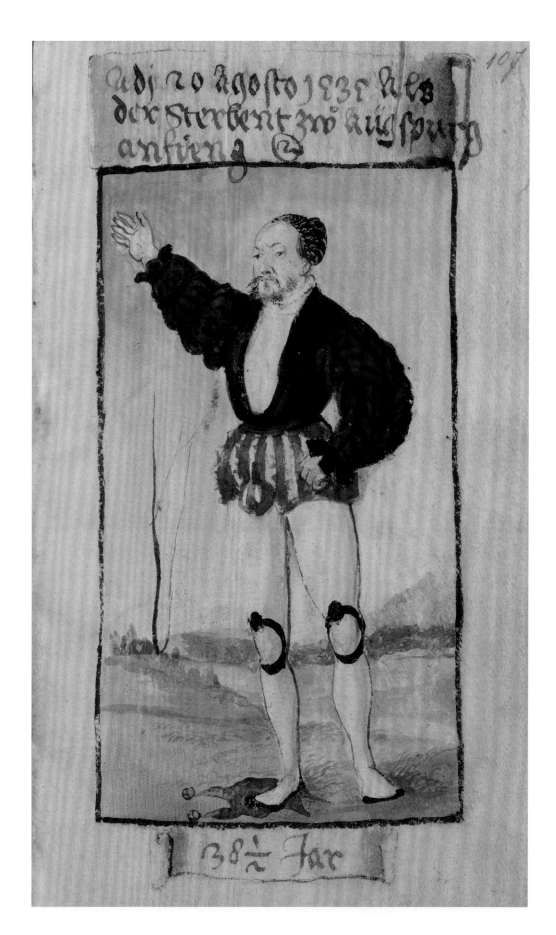

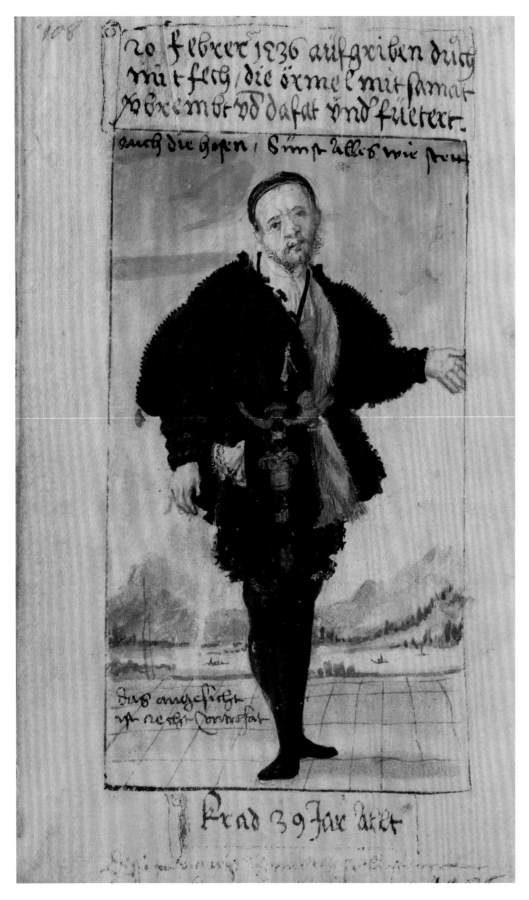

*20 February, 1536, roughed
cloth [aufgriben duch]
with Siberian squirrel fur,
the sleeves trimmed with
velvet and lined with half
silk, like the hose. Otherwise
everything as shown.*

Inside the image: The face is
well captured.

Text below: Just 39 years old.

The marginal note records
Narziss Renner's death.

20th February, 1538, when I decided to take a wife, the gown was made with green trims of half silk.

Text below: I was 41 years old.

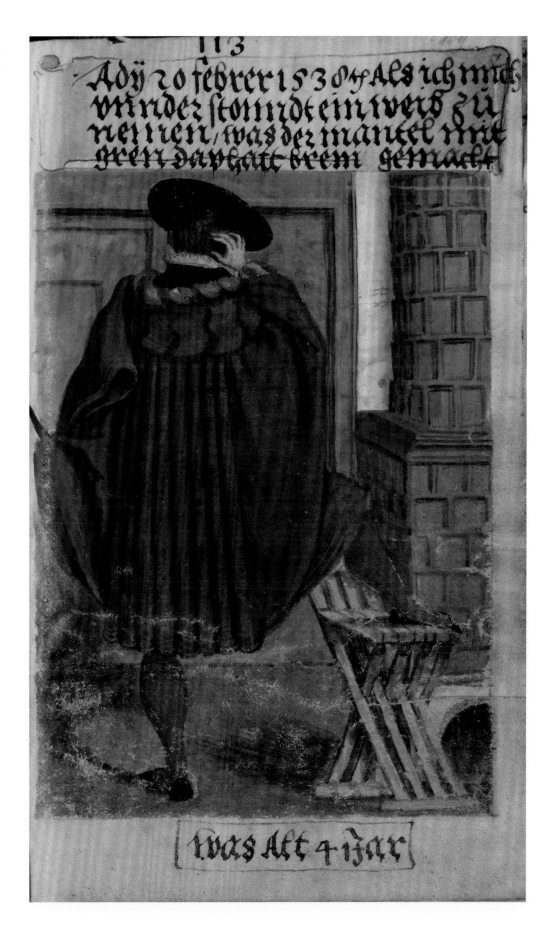

The year 1538. I threw away "The Course of the World," that is to say "The Rake's Life."

On 7 April, I celebrated my engagement. The gown was trimmed with black velvet, the jerkin was sewn with Spanish velvet passementerie.

Below the image: Aged 41 years, 46 days.

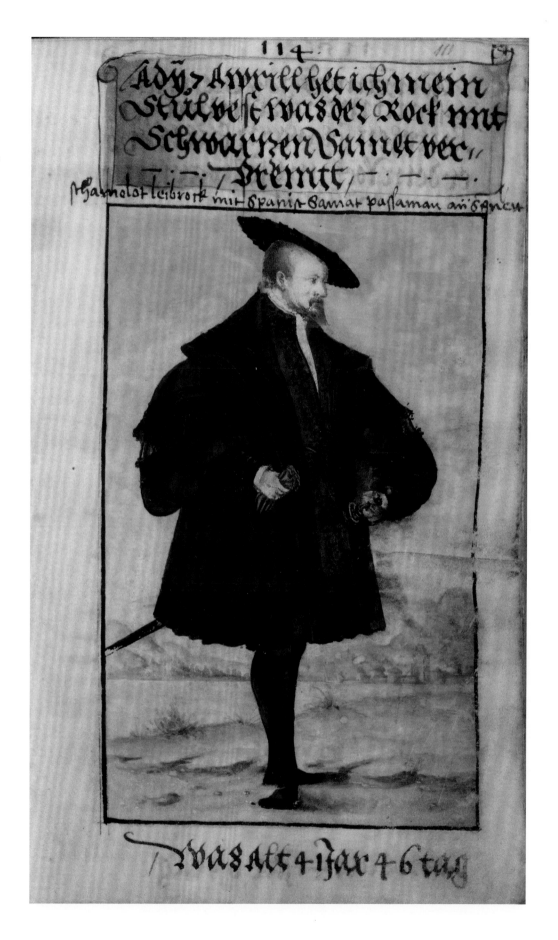

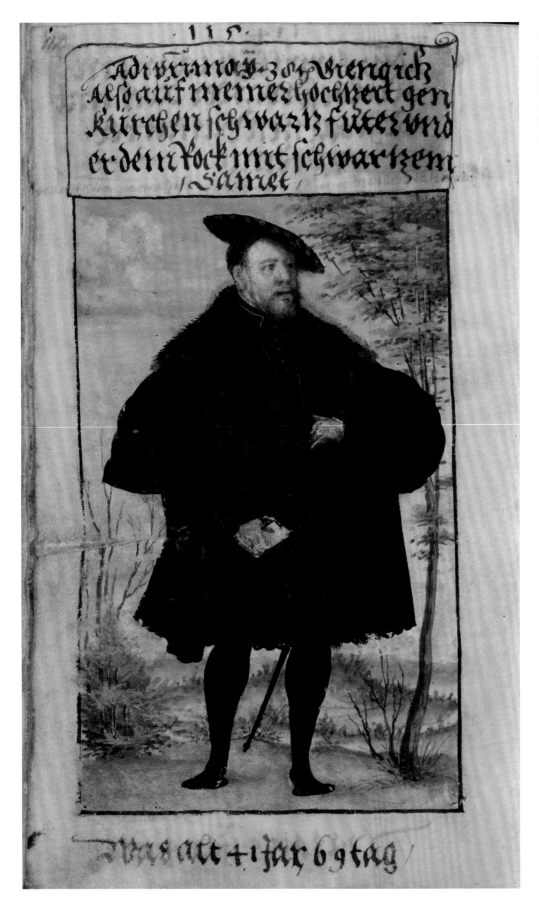

On the first of May 38, I went to my wedding in church like this: black lining below the gown with black velvet.

Text below: I was 41 years and 69 days old.

First of August 1538, in this manner: the gown with black velvet, the doublet white, Turkish quilted silk satin.

Text below: I was aged 41 years, 17 weeks, and 2 days.

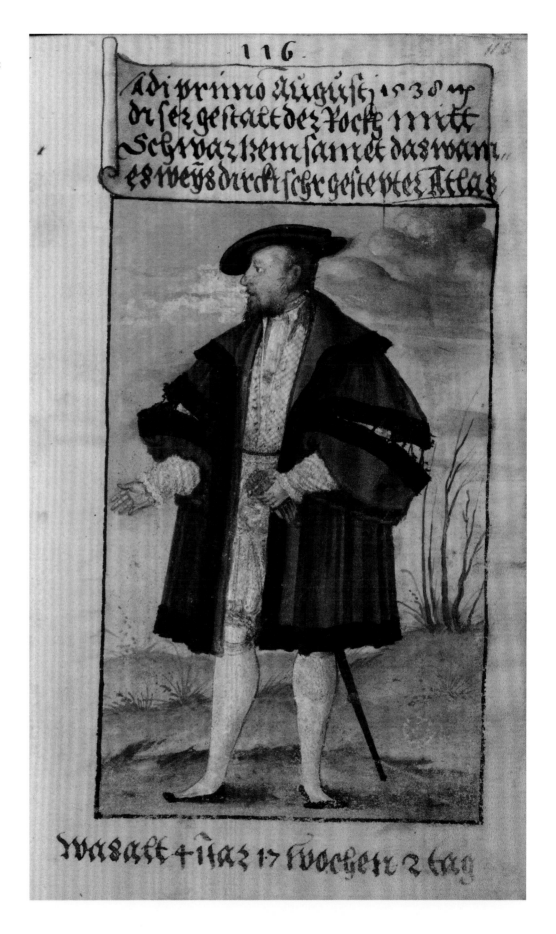

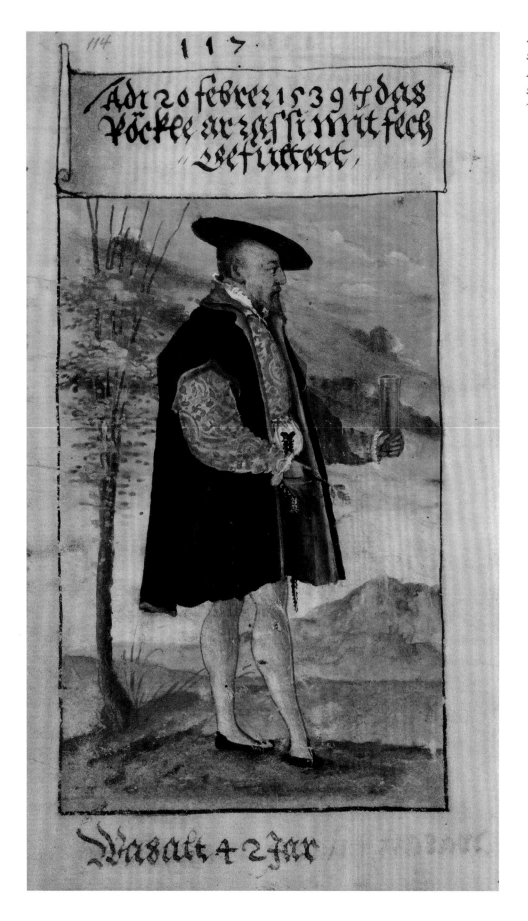

20 February, 1539: the short gown silk from Arras lined with Siberian squirrel fur.

Text below: Aged 42.

20 February, 1539: the short gown from a mixture of wool and silk lined with the best marten fur.

Text below: Aged 42.

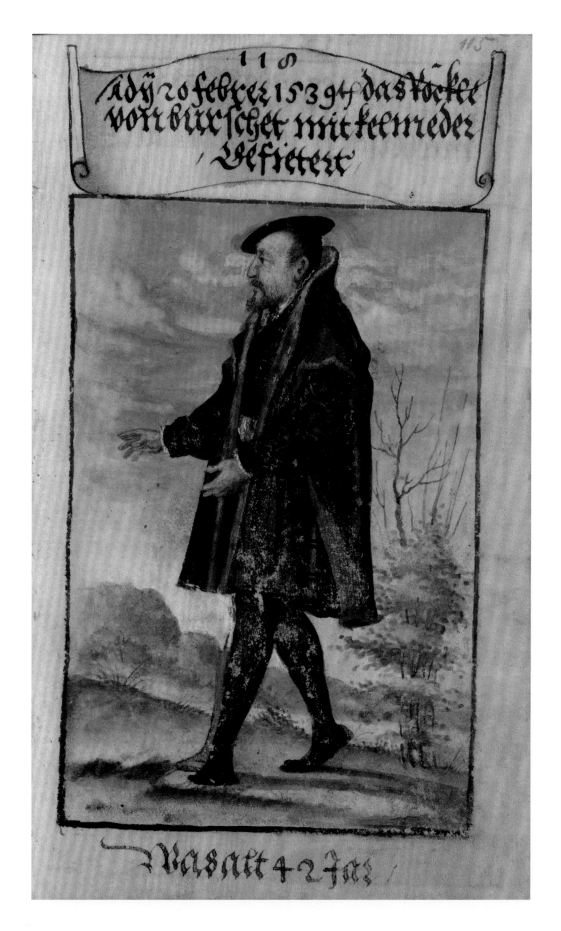

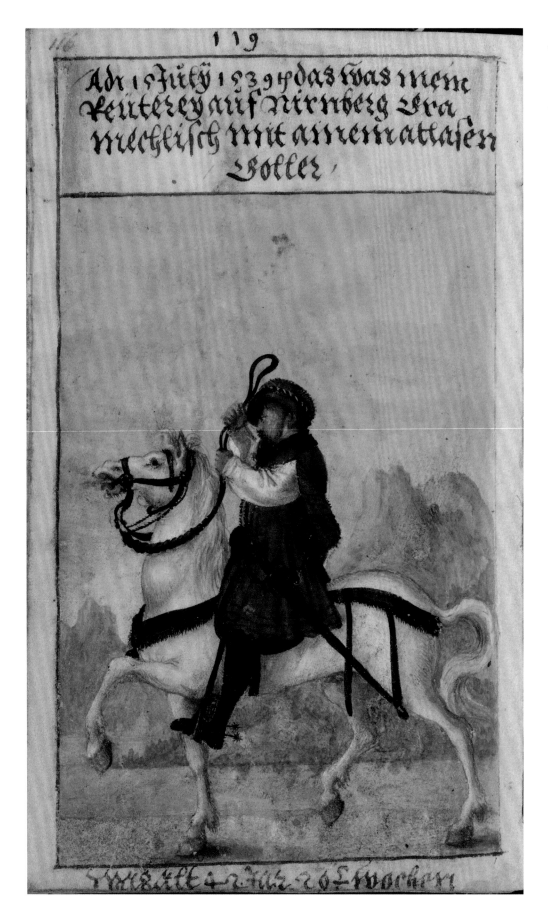

Adr 1 5 July 1 5 3 9 das was mein
Reiterey auf Nirnberg bra
mechlisch mit ainem attlasen
goller

*July 1539. This was how
I rode to Nuremberg with
cloth from Mechelen with a
silk-satin doublet [goller].*
Text below: Aged 42 years,
20 ⁵⁄₇ weeks.

First of August 1539 at Nuremberg: the doublet white half silk and the hose lined with half silk. I also had an identical black outfit made.

Text below: Aged 42 and 23 weeks.

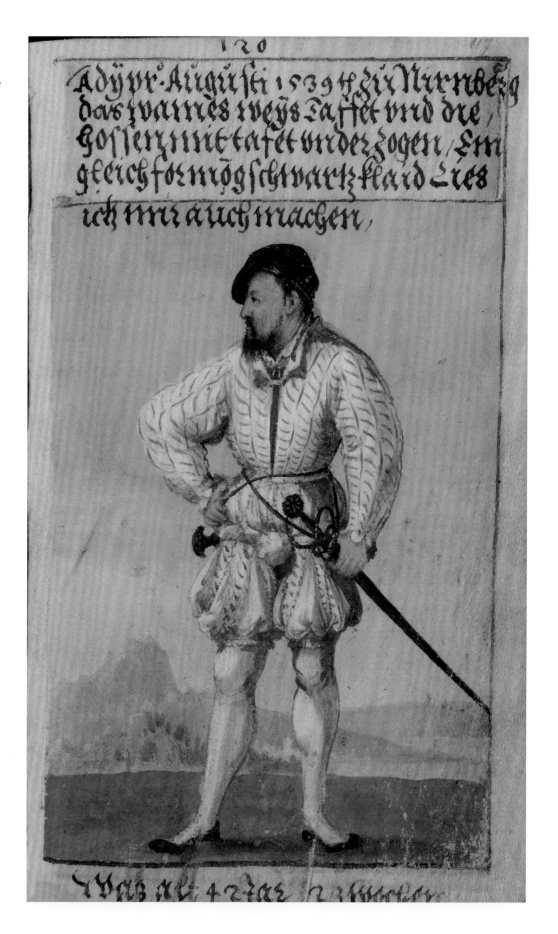

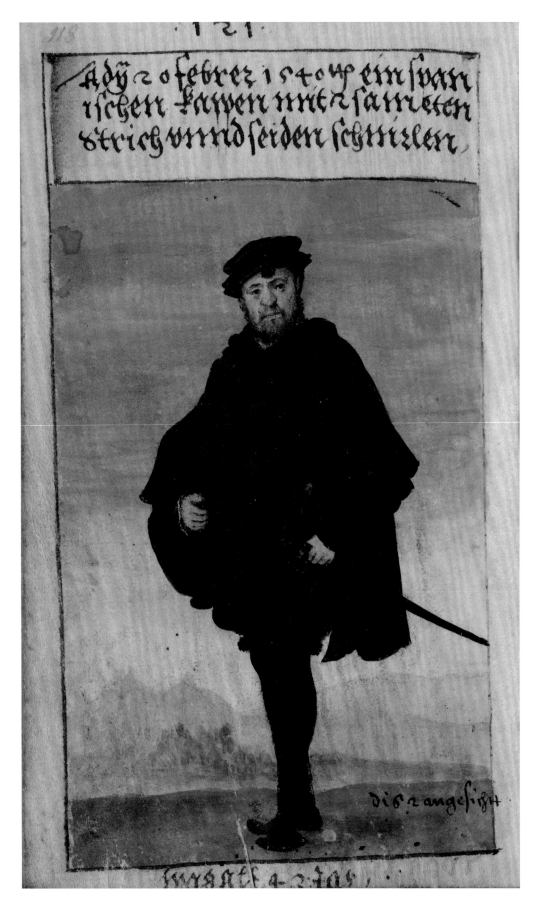

20 February, 1540: a
Spanish gown with 2 velvet
stripes and small silk-ribbons.
Inside the image: These 2
portrayals [angesicht] well
captured.
Text below: Aged 43.

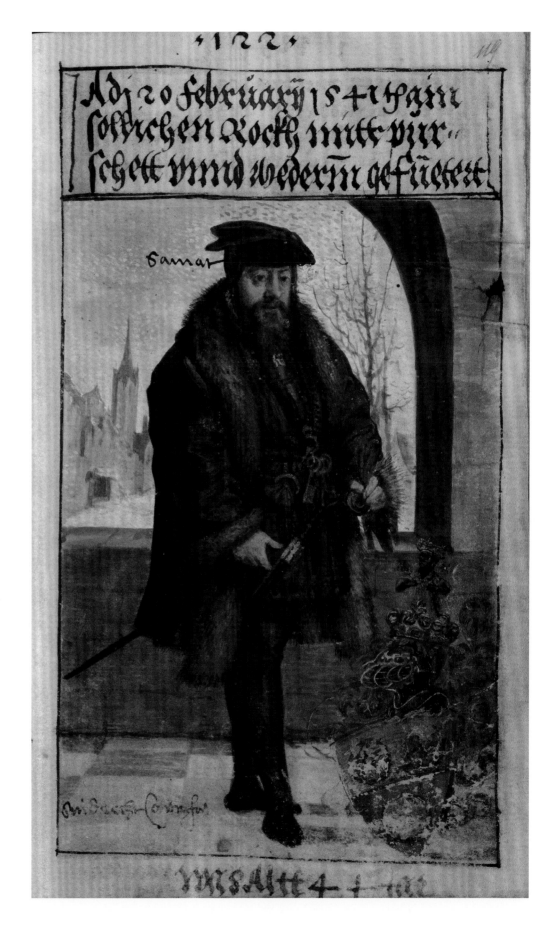

20 February, 1541: this gown lined with light wool and silk and marten fur.

Inside the image: Velvet; well captured.

Text below: Aged 44.

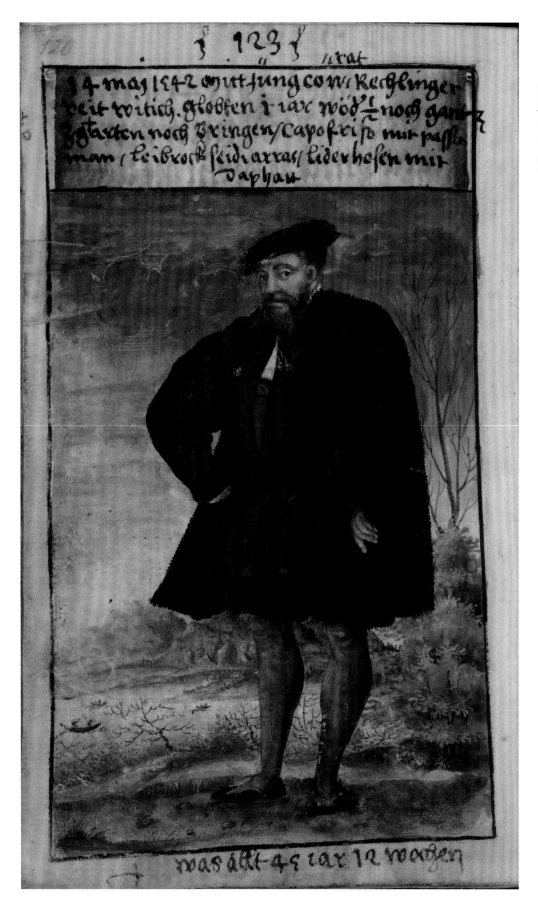

14th May, 1542, with young Conrat Rechlinger (and) Veit Witich. We vowed not to drink a half or a full glass for one year. A Frisian cloak with passementerie, a jerkin with silk from Arras, leather hose with half silk.

Text below: Aged 45 years, 12 weeks.

The vow expired on the 14th of May. The doublet [was made] from light wool and silk, hose with half silk, all with passementerie borders.

Text below: 46 years, 12 weeks.

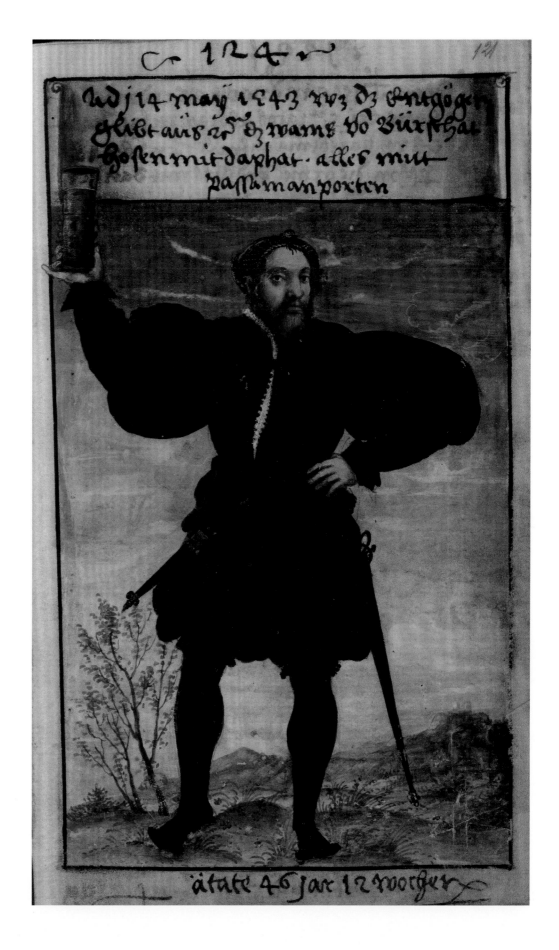

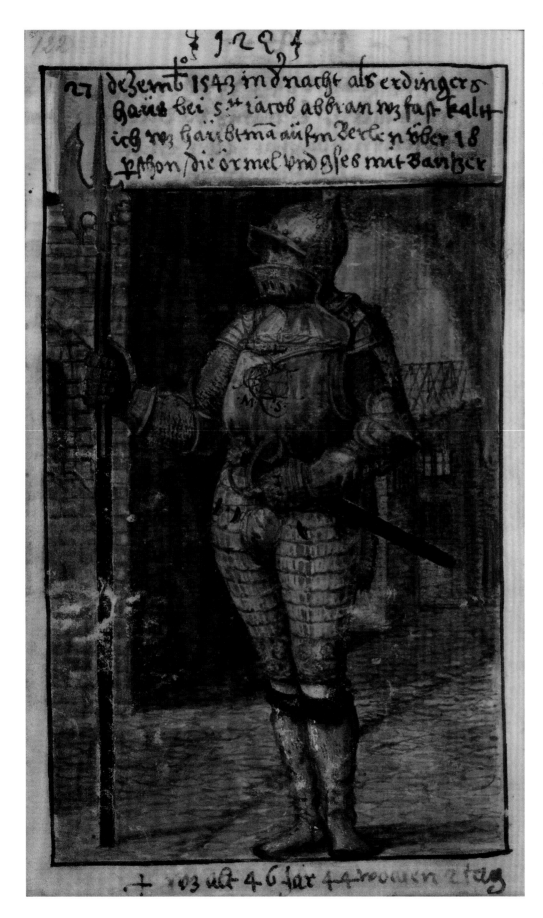

27 December, 1543, at night, when Erdinger's house at St. Jakob burned down, it was very cold. I was a captain in charge of 18 people on the Perlach, the sleeves and rear in armor.

Text below: Aged 46 years, 44 weeks, 2 days.

On 12 August, 1545, this was my armor when we were inspected, around 4,500 [men], except the weavers, on foot and 500 on horses, who stood in the field near the gallows in this order for ¼ hours, 71 people in one rank in this color.

Inside the image: Velvet; half silk; Vizli Memminger.

Text below: I was aged 48 years, 29 weeks.

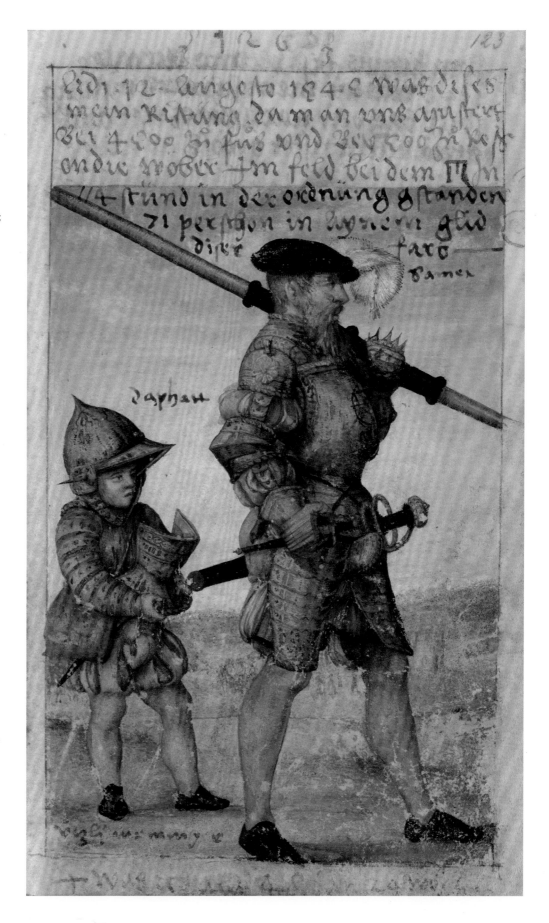

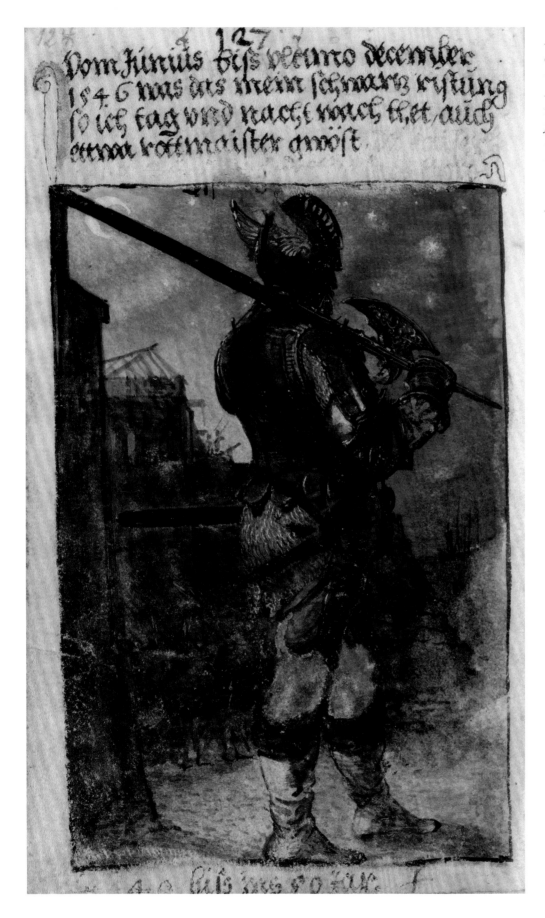

From June up to the final day of December 1546, this was my black armor, when I was on the watch day and night, and was Rott-master for some time [deleted] when Emperor Charles wanted to bag Augsburg [Augsburg wolt in den sack thon].

Text below: 49 to 50 years.

23 July, 1547, when Emperor Charles returned from the war to the Imperial Diet in Augsburg and abolished the guilds on the 3rd of August, 1548.

Inside the image: Half silk.

Text below: Aged 50 ⁵⁄₁₂ years.

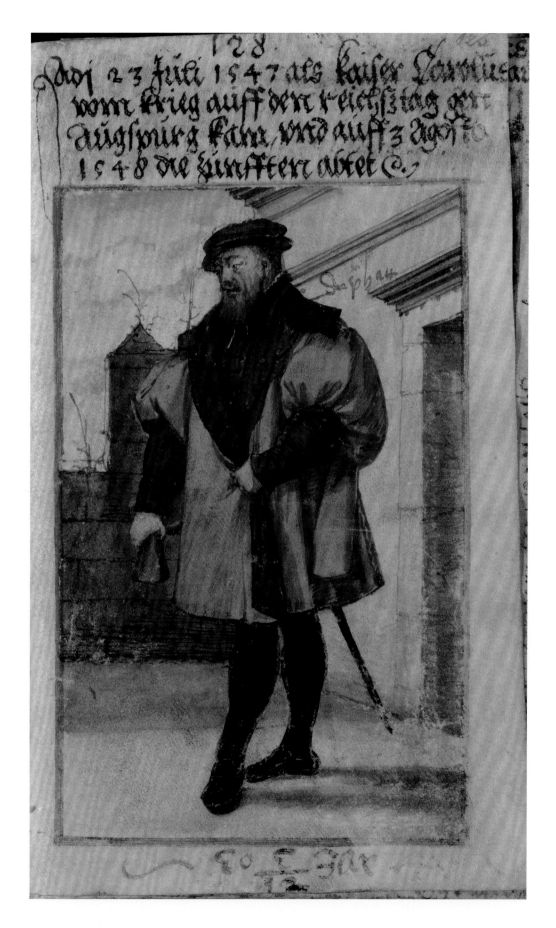

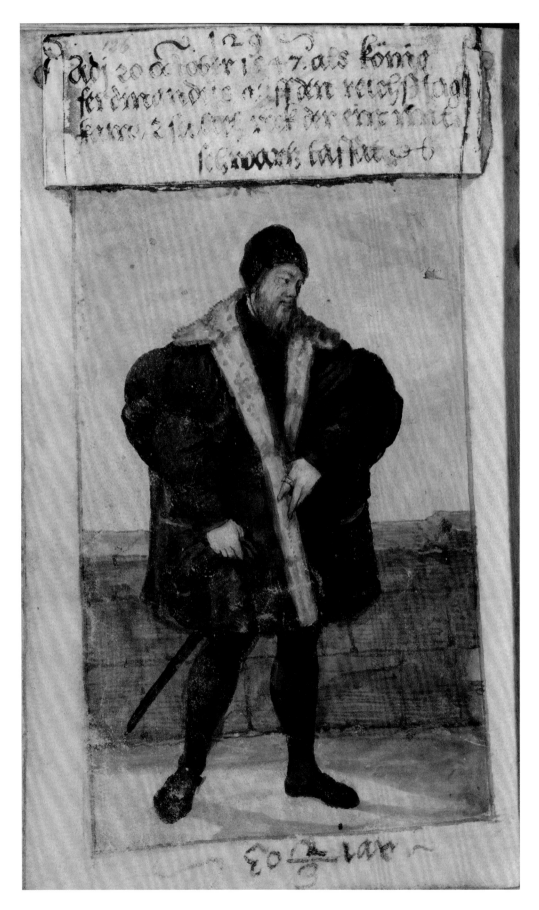

On October 20, 1547, when king Ferdinand came to the Imperial Diet, 2 such gowns, one with black half silk.

Text below: 50 ⅔ years.

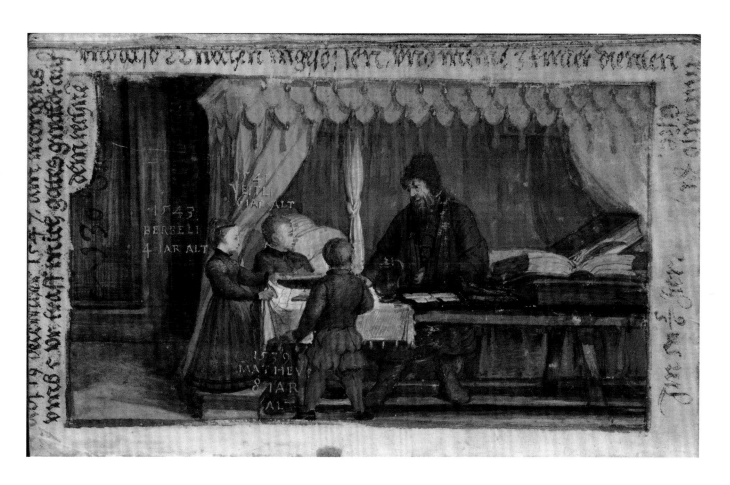

On 19 December, 1547, in the morning at 5 o'clock, God's mightiness hit me [traff mich Gottes gewalt] while I was accounting, and so I remained indoors for 22 weeks, and my three children served me like this at the table.

Inside the image: 1539. Matheus, 8 years old. 1541. Veitli, 6 years old. Berbeli, 4 years old.

Text below: Aged 51 ⅚.

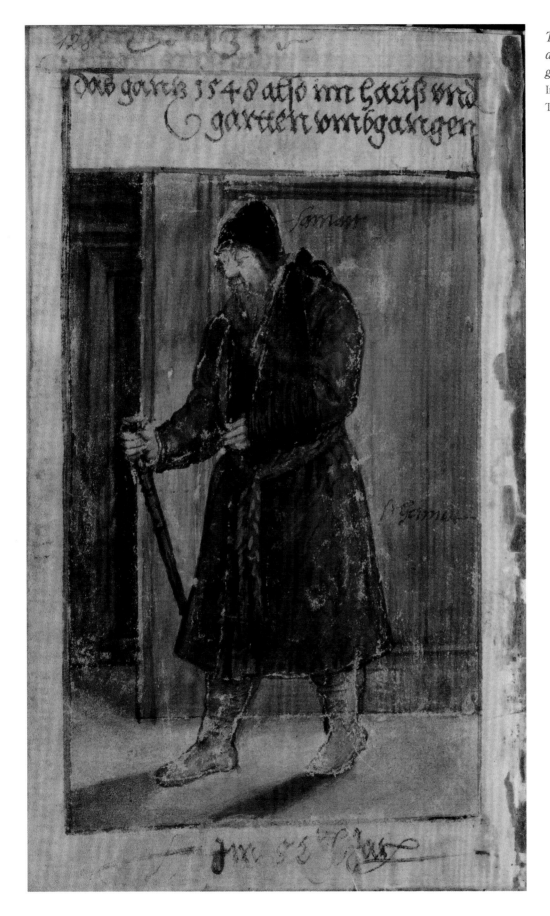

The whole of 1548 I walked around in the house and garden in this manner.

Inside the image: Velvet, Camlet.

Text below: In the 52nd year.

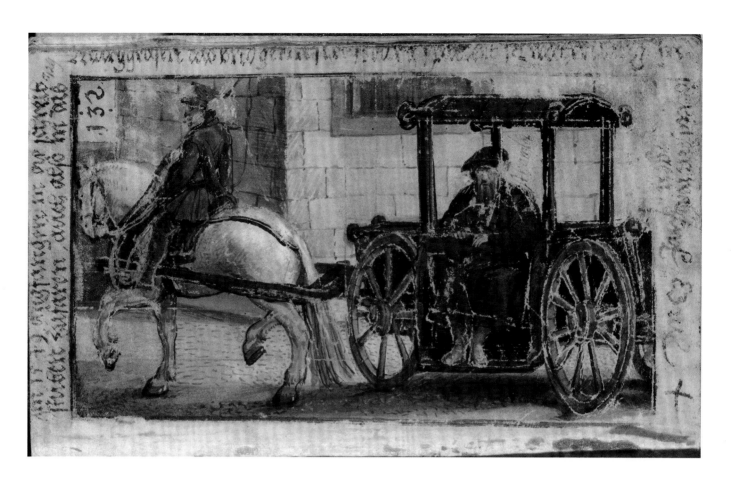

In 1549 I started to drive to the office and likewise to the Margrave-baths [in Baden-Baden, U.R.] and rode [. . .] in such a cart.

Text below: In the 53rd year.

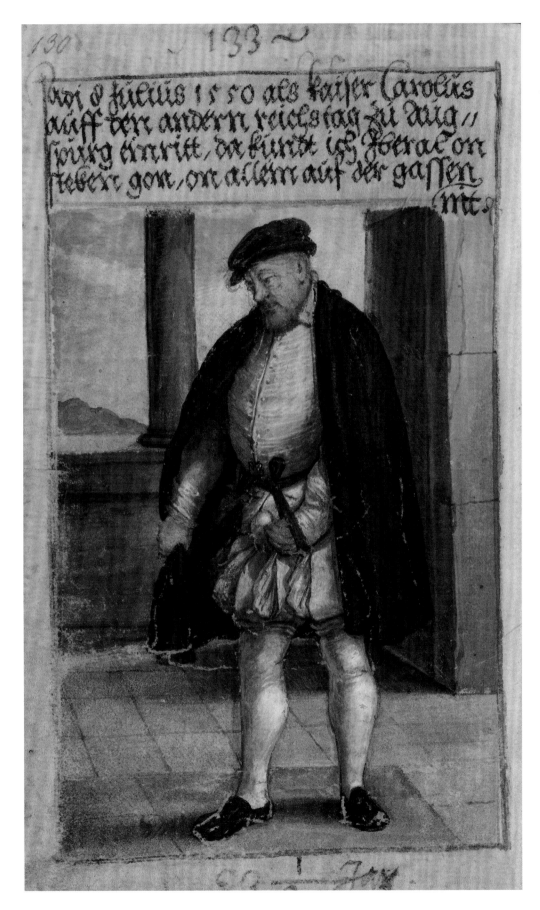

130 133

Am 8 Julius 1550 als kaiser Carolus auff der andern reichstag zu aug// spurg einritt, da kundt ich yberal on stecken gon, on allein auf der gassen rc.

On 8 July, 1550, when Emperor Charles rode to the other Imperial Diet in Augsburg, I was able to walk everywhere without a stick, except for the alleyways.
Text below: 53 ⅓ years.

On October 21, 1551, when
*Emperor Charles rode
from the Imperial Diet to
Innsbruck, and before 26
August, when all the pastors
had to leave the town.*

Inside the image: A mix of light
wool and silk.

Text below: 54 ⅔ years.

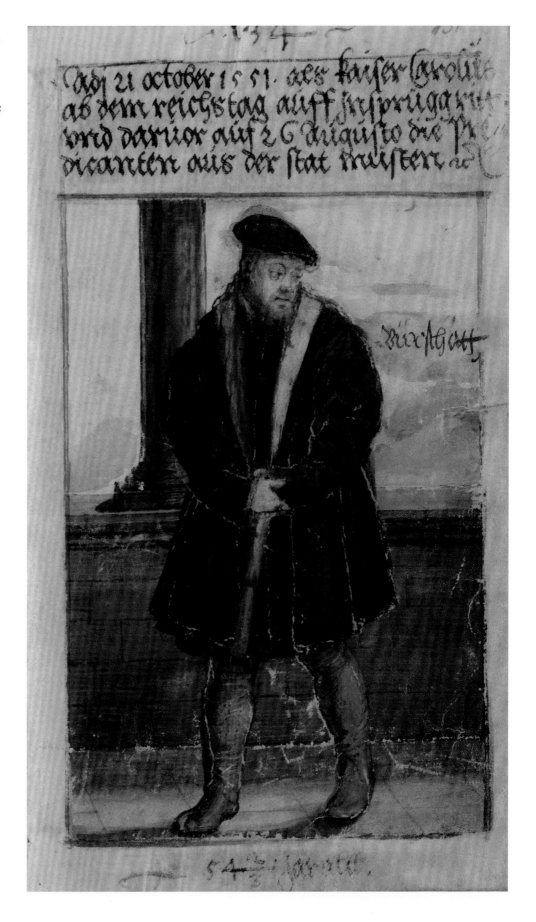

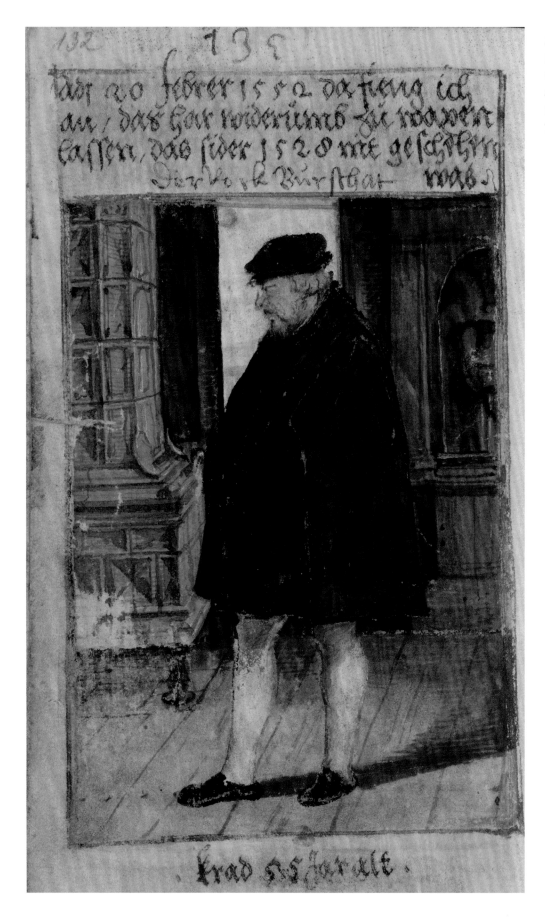

132

?3?

das 20 febrer 1552 da fieng ich
an / das har widerümb zu wachsen
lassen, das sider 1528 nie geschehen
bann Der hohe Bürstbat mab.

frad ns har alt.

20 February, 1552. I began
to let my hair grow again,
which had not happened
since 1528. The gown light
wool and silk.

Text below: Just 55 years old.

On 9 July, 1553, in camlet, fresh and healthy with God's grace, when Duke Moritz of Saxony was shot with three other princes, and Margrave Albrecht of Brandenburg ran away.

Inside the image: Camlet.

Text below: 56 years, 4 ½ months old.

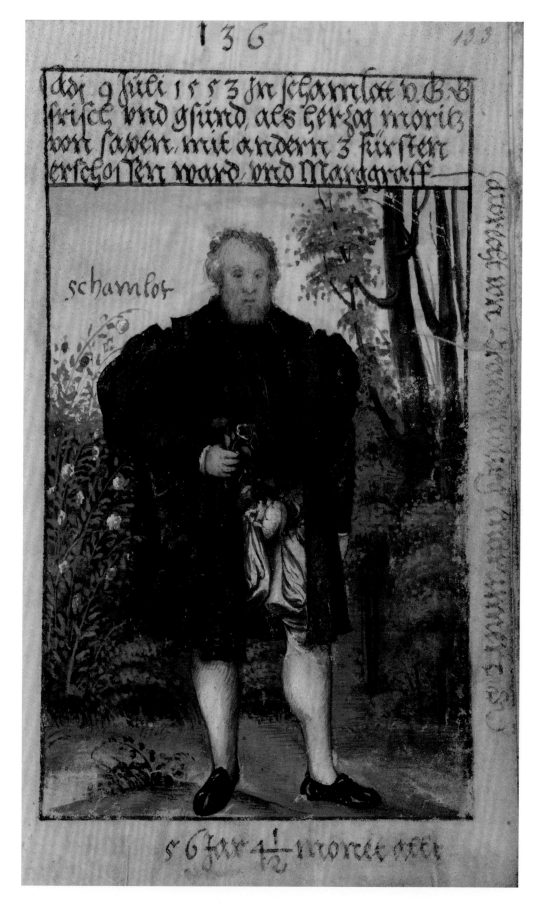

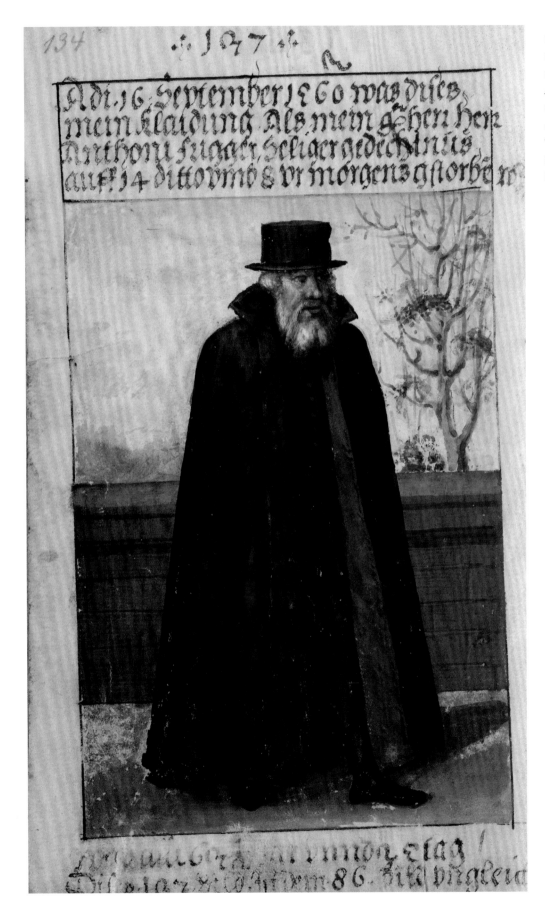

134 ✠ 137 ✠

Adi .16 . September 1560 was dises,
mein klaidung, Als mein gnen Herr
Anthoni fugger, seliger gedechtnüs
auff .14 ditto vmb 8 vr morgens gstorbē rc

... an vnnd etag !
Dise olar rc.Ofildem 86. jst vngleia

On 16th September, 1560, this was my clothing, when my gracious master, Herr Anthoni Fugger in blessed memory died on the 14th at 8 o'clock in the morning. Text below: 63 ½ years and 25 days old. This 137th image is unlike the 86th image.

The Book of Clothes
of Veit Konrad Schwarz,
ca. 1561

Veit's book is bigger than his father's book, measuring 23.5 × 16 centimeters. It is bound in brown leather with gilt stamped and tooled decoration.

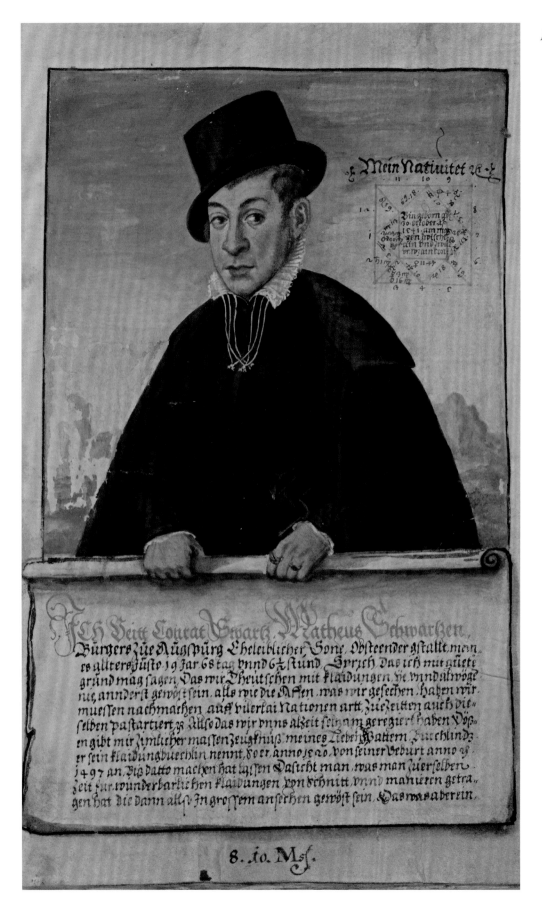

Grosser vnderschid gegen denen die Ime die allten zaigten so y vor 30 40
Jar e o Jaren getragen hetten, also das er verursacht was seine klaider auch
zue controfasen vmb auch er, oder die nachkumenden vber 40 50 oder mer
Jaren zuesechen, was sich ditzeit verkert hab. Dieweill ich dann nun sich
das dieweill ye lennger ye nerrischer, vnnd noch kain aufhören, mit den neuen
gehamen gebreuchen der klaidungen bis dato ist. So hab ich auf dato ange-
fanngen meine klaidungen die Ich vonn kinthait auf getragen hierein In
die buechlin malen zuelassen von farben, vnnd schnitten, wie es dann Im selbst
gröst ist. Ich hab sonnst ain furm aines Barhosens oder annders offtermals ge-
tragen aber doch der billichhait nach nit mir dann ainmal hierein controfa-
lassen zß vnnd doch auch vber 30 40 Jaren zuesechen, was sich sider abermals
verendert hab, erlöb echs nit, so erlöbens doch annder die es gern sechen werden
vnnd seind dise meine klaidungen die furnembsten Kursten vnnd hintesten,
so ich zuerselbenzeit getragen, auch dismals also in guettem ansechen gewöst
Die anndern vnnd schlechten hab ich ausgelassen, dann es mir zuuil weittin
gnomen hett, Sunst cost ain hirset klaid diserzeit meer dann vor Jartzz oder 4 5
hab vergebens auch Im anntanng wie man sicht zue der Jugent ettlich bossenn
machen lassen, als was zuerselbenzeit fur freud vnnder der Jugent gwest ist, Das
hab ich genomen aus ainem buechlin meines Vattern aigen hanndtschrift
da er der kinderbuechlin genannt hat, da dann almein thuen vnnd lassen
inn beschriben ist, was sunst hernach geuolgt ist das hab ich aus frischt gebech-
nus hernach malen lassen, dann mir wol ingedennck sich sollichs eruolgt hat
mir kan sunst kainer kain zue abentheurischen furm ains klaids aufbringe
Dann ye seltzamer klaidung, von schnit, an hosen wammes vnnd tsuch ain
aufbringt, ye lieber ich trag. Ich hab sunst gmeingklich all schnit an hosen
wammes, tetusch vnnd Cappen selbs erdicht, auch mermalls die schuech selbs
erschnitten, vnnd wie dieselben serben sicht man hernach. Also gnueg zu
einganng geredt, forter auf yedem stuck oder gmelt wirt man sein Be-
schaidt finden, darumb vnnderlas ich da vildauon zuschreiben. Datum
Augspurg den anndern tag Jenner Anno 1561 nachmittag vmb zwue er
meines allters zusto, wie am anntang stat, wers nit glaubt der rechnes hin nach

Ende Conrad Schwartz

Omne quare suum quia

Vertrau wiß wem Die Ratt ich dir
Dann der weili zaggisackhzig wer dir

Niemant ausgnomen in der welt
Sein wirt vergosen seer stirbt
Den Buchstaben er dann her las
wo hinder im war Dn geger 1695

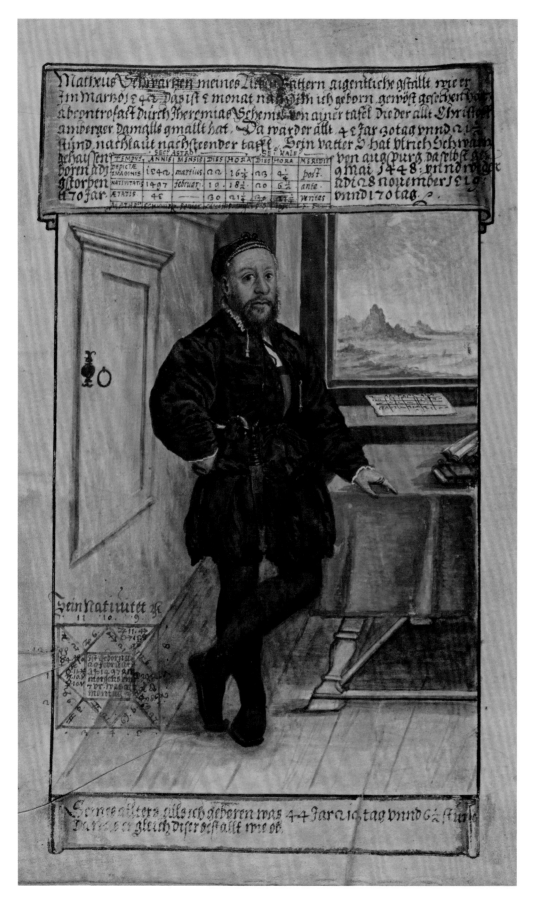

Matheus Schwartzen, my dear father's proper figure, as he looked in March 1542, that is 5 months after I had been born, copied by Jheremias Schemel from a panel that the old Christoff Amberger had painted then. There he was aged 43 years, 30 days, and 21 ½ hours according to this panel. His blessed father's name was Ulrich Schwartz of Augsburg, born there on November 28, 1519, 70 years old and 170 days. [Table to calculate his age in relation to astronomical and common hours.]

Inside the image: His nativity. Is born February 20, anno 1497 at 7 o'clock in the morning; it was a Monday.

House: Sun, 11°, Pisces, Saturn 11°, Pieces, Venus, 10°, Aries

7. House: Moon, 20°, Scales, Jupiter, 11°, Sagittarius, Mars, 15°, Sagittarius

12. House: Mercury, 4°, Pisces

Barbara Mangoltltin, my dear mother's proper figure, as she looked like in August 1542, that is 10 months after I had been born, copied by Jeremias Schemel from a tableau that the old Christoph Amberger had painted. This tableau was only a half-size portrait, but I had it made in this way so that one would also see the length. She was otherwise just 35 years old. Her blessed father was called Annthoni Mangollt, born in Schwäbisch Gmünd, was born there in the year [...] and died in Augsburg on January 12, 1550.

Inside the image: Her nativity. Born on August 21, 1507, in the morning around ½ 5 o'clock; it was a Saturday.

House: Sun, 6°, Virgo, Saturn, 4°, Virgo, Mercury, 15°, Virgo

3. House: Jupiter, 15°, Scales

6. House: Moon, 19°, Aquarius

11. House: Mars, 21°, Cancer

12. House: Venus, 4°, Leo

Text below: When I was born, she was aged 34 years and around 2 months. There she looked like the above.

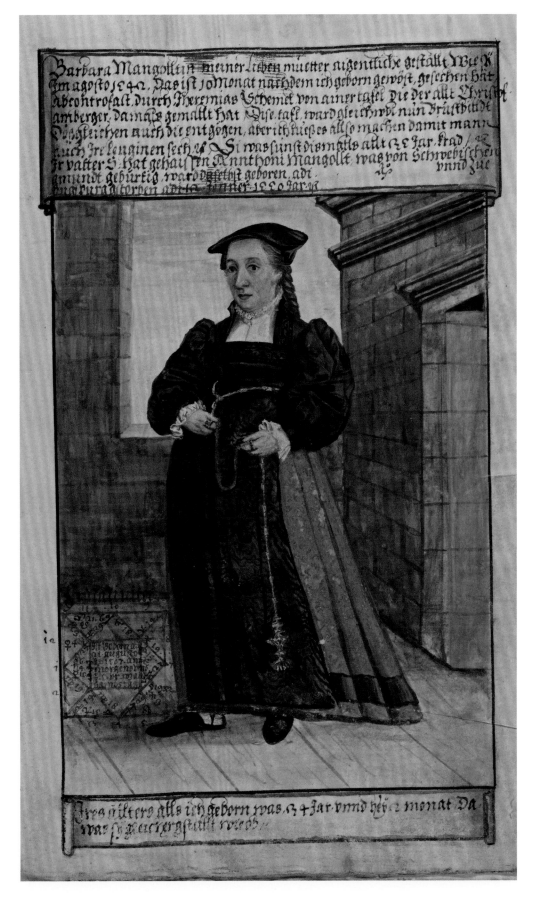

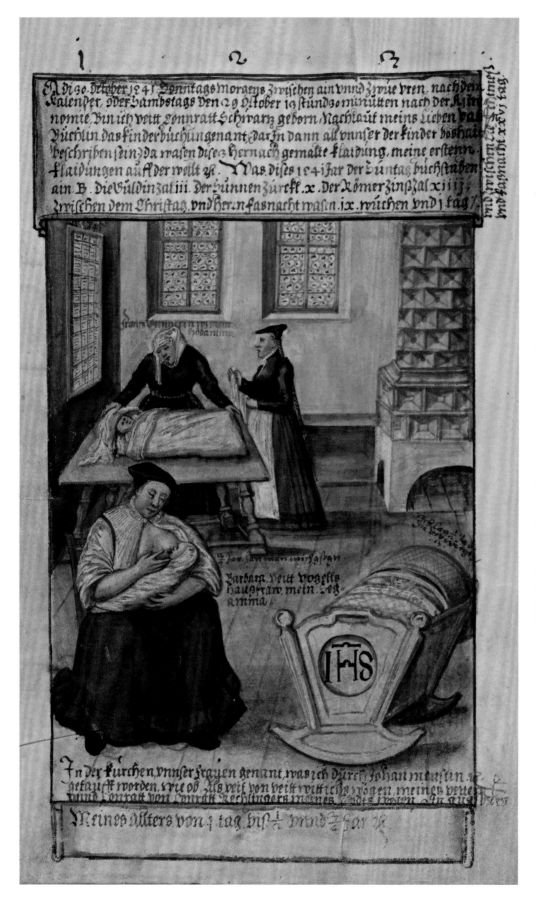

On October 30, 1541, on Sunday morning between one and two o'clock after the calendar or Saturday, October 29, 13 hours, 30 minutes in astronomical terms, I, Veit Conratt Schwartz, was born according to my dear father's book, called "The Children's Book," in which all our children's mischief is described. These clothes below were my first clothes in the world. This 1541st year the Sunday-letter was b, the golden number III, the sun-circle X, the Roman Zins-figure XIIII; there were IX weeks and XXVI days between Christmas and carnival.

Inside the image: Frantz Gerttnerin was my midwife; Barbara, Veit Vogel's wife, my wet nurse. I was breast-fed for ¾ of a year; I lay in a cradle for ½ year.

Text below: I was baptized by Johan Meuslin, in the church called Our Lady, as above, as Veit because of Veit Wittich, my cousin, and Conratt because of Conratt Rechlinger, my godparents [*meines godts wegen?*] in Augsburg. My age ranged from 1 day to ½ and ¾ of a year.

From August 1542 until the 44th year, these were my clothes and things that entertained me. In 1543, aged 1 ¼, I started to walk by myself for the first time on one day, from 2, 3 to [a distance of] 12 shoes wide. Item, aged two, I started to talk clearly and so on. The reason was that I was sat down in the walking chair, because I was full of mischief. If someone carried me, I did not like it; if someone led me or tried to be nice to me in some other way, I did not want it; so one let me drive about and fall in the walking chair, according to "The Children's Book," page 9.

Inside the image: My maid was called Anna.

Text below: My age was 1, 2 up to 3 years.

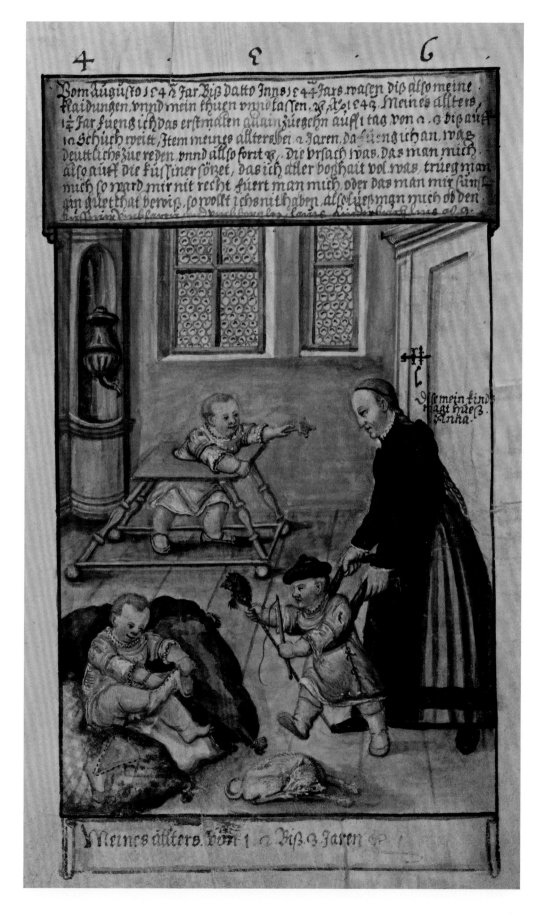

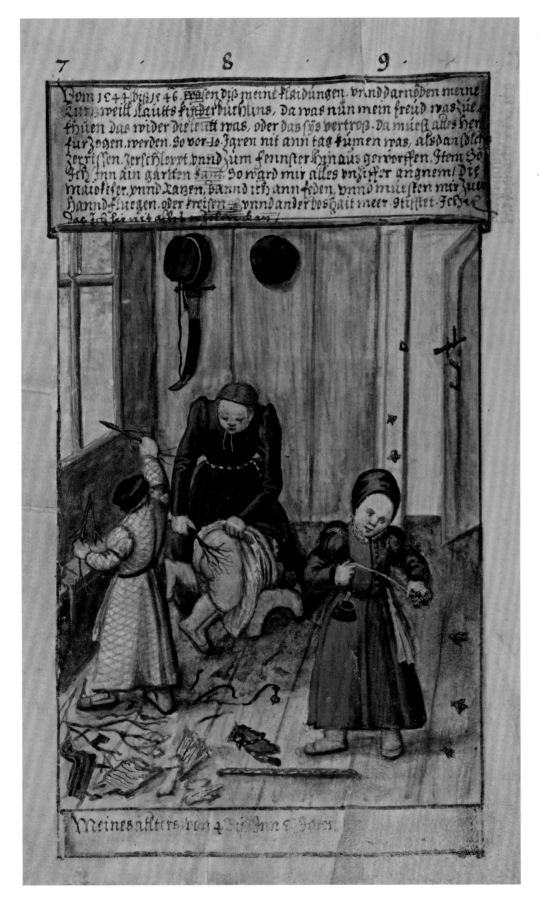

From 1544 to 1546 [these were] my clothes and besides my pursuits as written in "The Children's Book."
It was my pleasure to do something against people or to annoy them. Everything that had not seen daylight for 10 years had to be dragged out, and then it was torn apart, trodden on, and thrown out of the window.
Item: I liked all insects when I came into the garden.
I tied the ladybirds and caterpillars to threads, and they had to fly to or circle around my hand, and I did other bad, naughty things, which I cannot narrate here in full.
Text below: Aged 4 to 5 years.

At the end of February 1547, I had to drag myself to the Latin School, whether I liked it or not. Because I came to see that this was serious and that there was no other choice than that I had to go to school, I showed myself quickly willing and went to Our Lady's at Johannes Busch's school. He then had 110 boys, who were to learn Latin. As I entered I gave everyone pretzels. Thus the teacher, his wife, and also the boys—in sum, everyone—received me with pleasant and kind words. Yes, I got on with my work well for 8 or 14 days; I did not want to miss any school. But after this period, one spoke strangely to me, so that I did not feel happy about school anymore, but I did not show this.

Inside the image: There he went with a heavy heart to school; Magdalena, our maidservant.

Text below: Aged 5 years, 4 months.

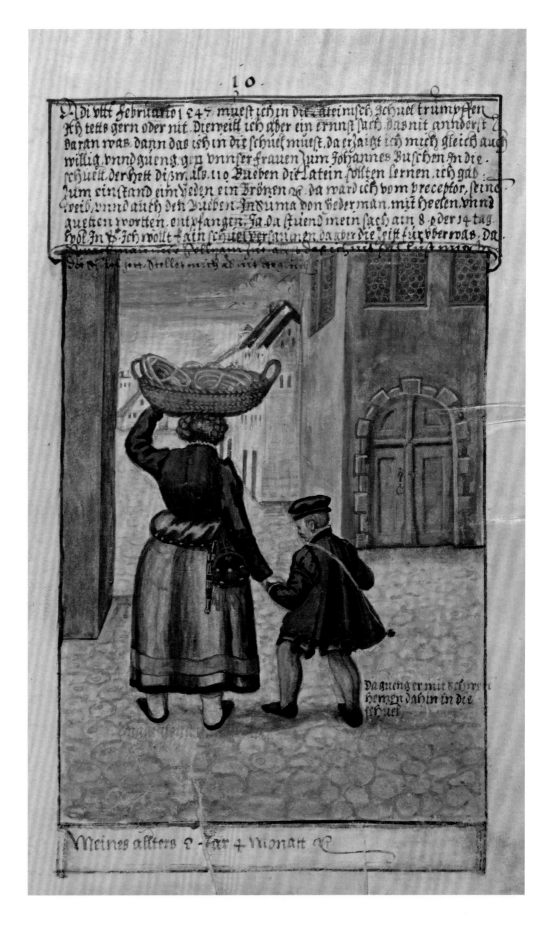

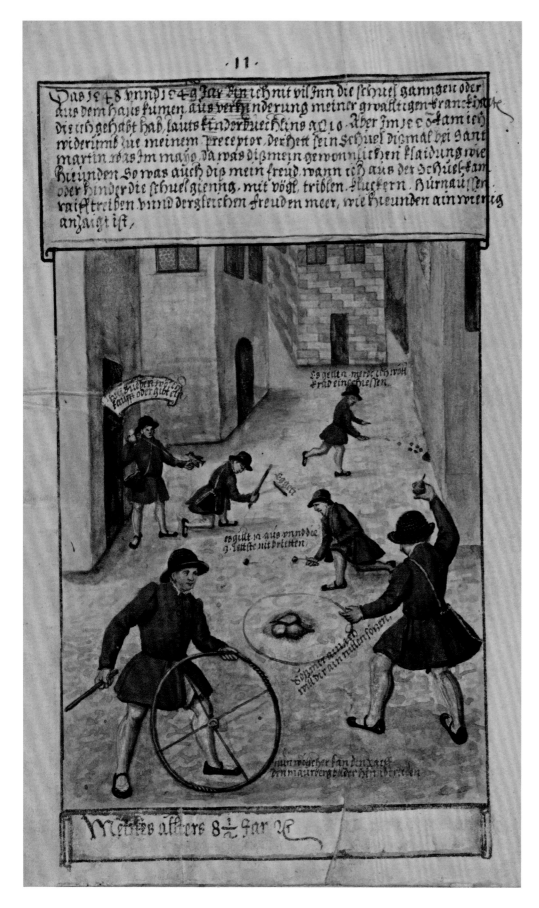

In 1548 and 1549 I did not go to school or out of the house much because I was prevented by my severe illnesses, which I had according to "The Children's Book," page 10. But in 1550 I returned to my teacher. This time he had his school at St Martin's. In May my usual dress was as below. This was my joy when I got out of school or behind the school: with birds, marbles, hoops, and other amusements, as shown partly below.

Inside the image: "Now, who can drive the hoop down the Maurberg?"; "Set me one, I shall set you a loss"; "12 out, and the three last not wide [?]"; "Quick, boys, who buys or gives one?"; *Eggeti!* [meaning unclear]; "There are 2 marbles, I just wanted to shoot one in."
Text below: Aged 8 ½.

In 1551, I went to Johann Burtzell's German school during winter—at the time he lived in the Koller-alley—so that I should learn to read, write, and count. This I did in the worst possible manner, because I had my sense directed to bad things rather than to learning, as I fantasized what I wanted to get on with once school was finished: whether I wanted to pull someone through the snow, snow-ball, ride in the sleigh, or whether I wanted to dare someone to fight, who perhaps had told the schoolteacher or anyone else about my mischievousness. My dress was as shown below.

Inside the image: "Mine, turn the the sled around in a circle, but don't throw me down"; "I am going to pull you hard now"; "I am your master, even if you don't want it"; "Ey, you fool, you have done what the teacher has punished me for."

Text below: Aged 10 years and around 2 months.

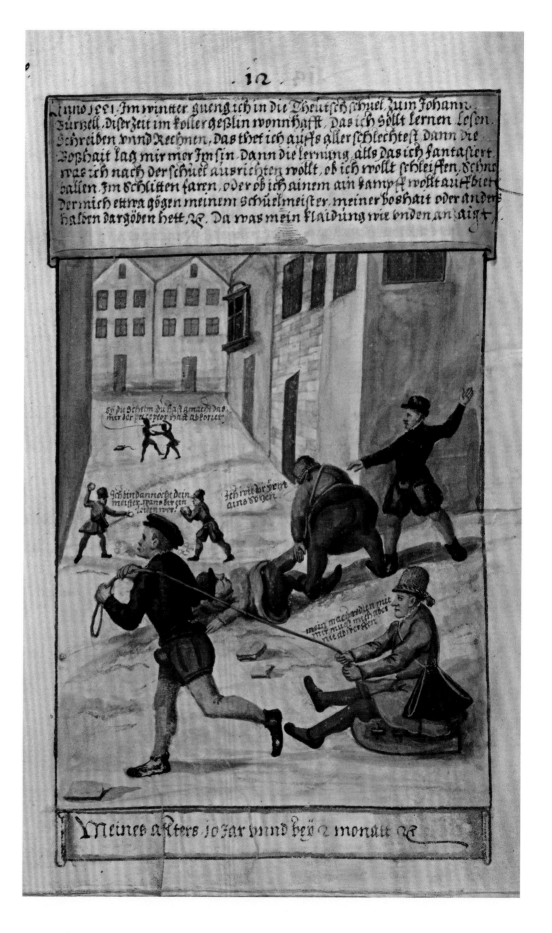

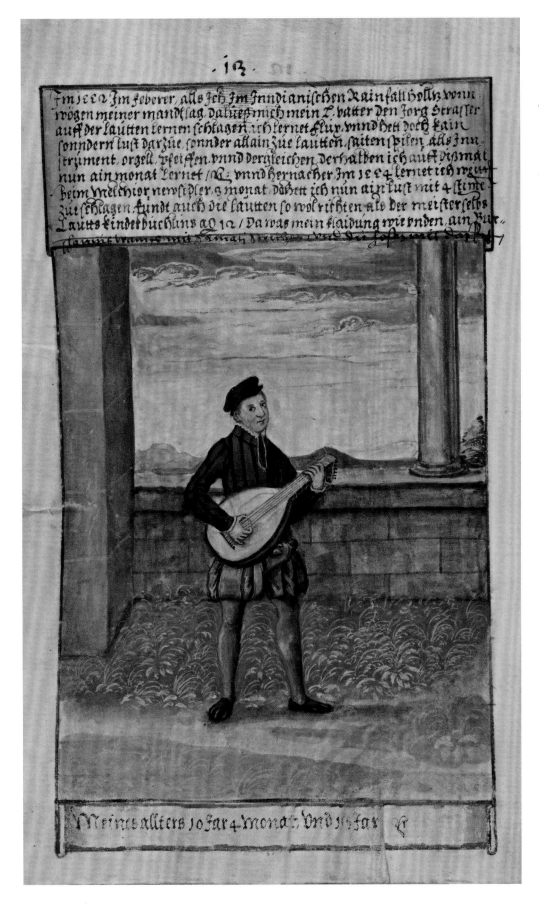

In February 1552, when I was lying in Indian Guajak [?]-wood because of my tonsils. My dear father let Jorg Strasser teach me to play the lute. I quickly learned, and even so had no special pleasure in it, but just to play the lute, string instruments, organ, pipes and so on, which is why I only learned for a month; afterward in 1554, I learned more with Melchior Neudsidler for 3 months. Then I felt pleasure to play with four voices and could tune the lute as well as the master himself, as written in "The Children's Book," page 12. This was my dress as below, a light wool-silk doublet with velvet trimming and hose with a half silk.

Text below: Aged 10 years, 4 months, and 13 years.

In 1553 and 1554 my dear father took me to the writing office because he saw that it could do me no harm. There I had to write all sorts of things regarding the Fuggers' affairs. I probably could be trusted, as the Lords did not need to worry that I would tell other people much about it. Because when I had written two lines, I did not know what the first one had been. It was a foreign language to me. Among other things, I had to copy several tariffs and accountancy matters for Master George Hulderich, also Master Marx, the Fuggers. During this time I really thought that nobody unknown to me should address me with the familiar "Du" anymore, and I was hostile to anyone who did so. Because I imagined being much cleverer, even though I did not understand what was written.

Text below: Aged 12 and 13 years.
Inside the image: I meant it seriously [*ernstlich und spitzig*].

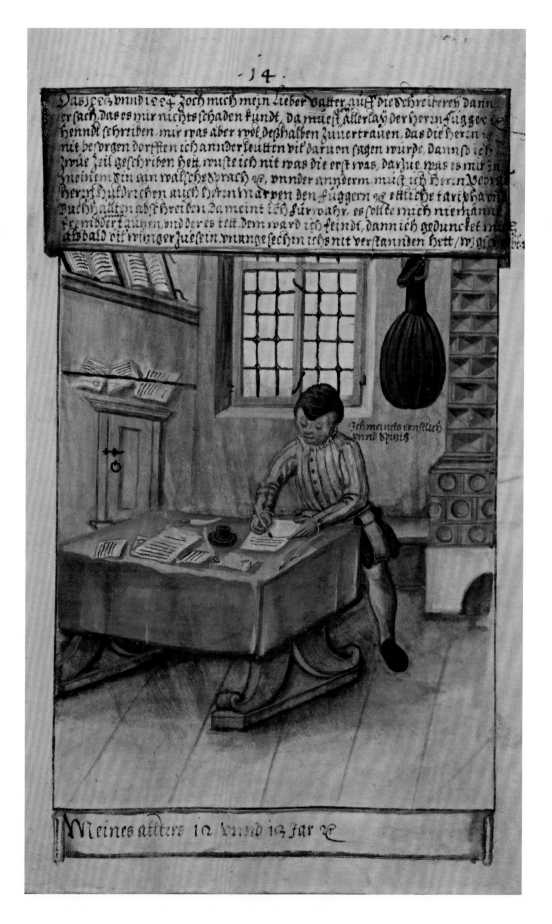

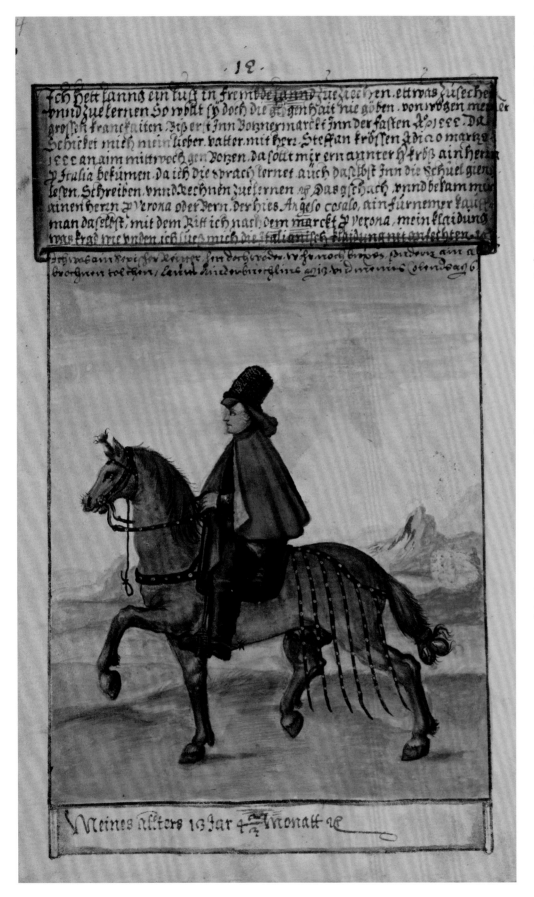

For a long time, I had wanted to move to foreign lands, to see and learn something. But the opportunity never arose because of my serious illnesses, until the Bolzano market during Lent 1550, when my father sent me to Bolzano on Wednesday, March 20, 1550, with Master Steffan Kröss. This said Master Kröß was to find me an Italian master, so that I would learn the language and go to school there to learn reading, writing, and counting. This happened, and I received a master for Verona or Berne whose name was Angelo Cosalo, a distinguished merchant there. With him I rode to the market in Verona. My dress was just as below. I did not allow myself to be taken in by Italian clothing. I was a Saxon horseman, had no weapon or shooting armor, but a broken dagger, as written in "The Children's Book," page 13, and my calendar, page 6.

Text below: Aged 13 years, 4 ⅔ months.

On April 11, 1555, I arrived in Verona with my master Angelo Cosalo, whom Master Steffan Kröß had found for me on March 29 in Bolzano. I had to pay him annually 25 scudi for boarding. I was well treated but did not understand just how nice and kind everyone was. Soon after I came to Verona, I had the dress made depicted below, as it is shown with a half silk, and impressed the whole town. And if I knew a German, I went to see him at home, so that I soon knew my way all over town. This way I soon got acquainted with people. The Italian boys, they now knew me all too well, and for a month or so I did not like to be found alone on the streets because boys pained me too much. I did not suffer it and slapped each of them once or twice in the face. Thus the lads grouped themselves together and wanted to get at me, as happened at times. Their talk was all the time: "The shitty German." I replied: "The magnates are fresh shit!" That was my best Italian according to my calendar.

Text below: On May 6 I started at the business school. Aged 13 and 5 months.

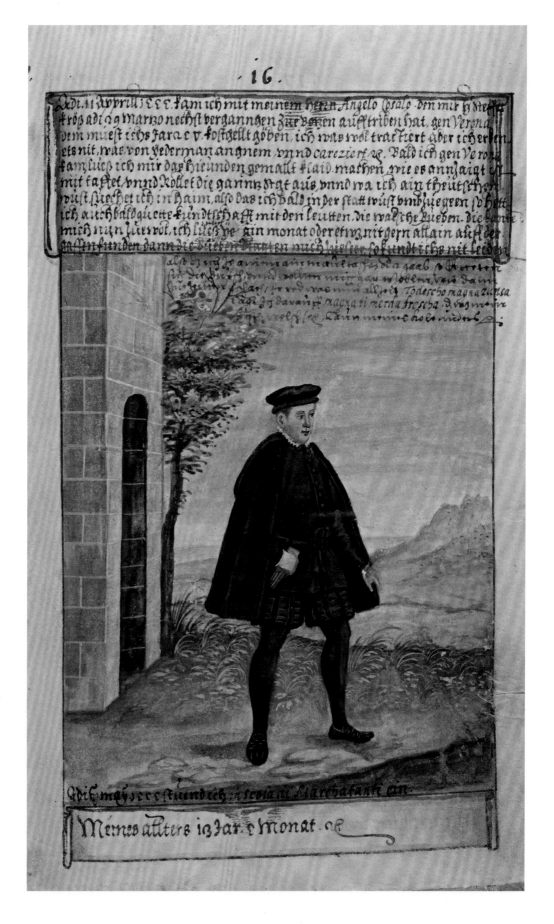

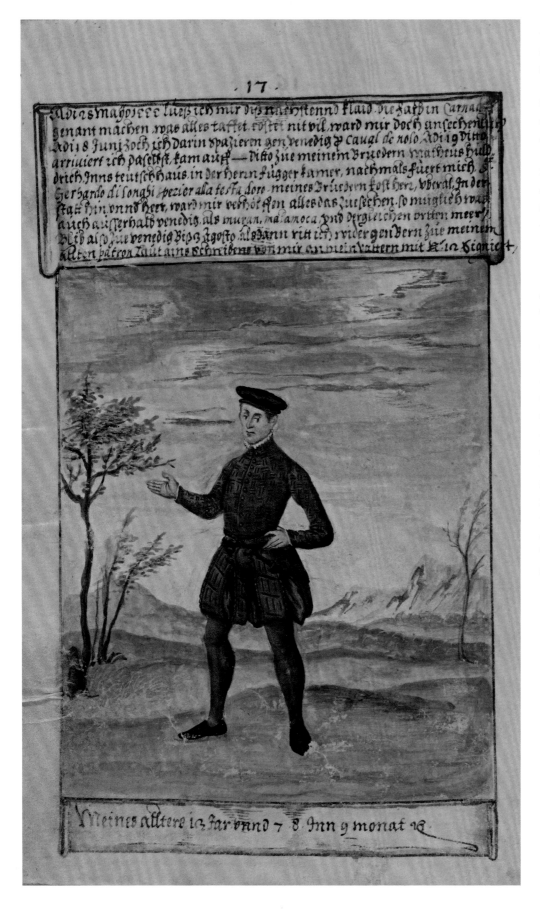

On May 28, 1555, I commissioned the following dress (the color is called "incarnate"): It was all made from a half silk fabric, and did not cost much, but looked good on me. On June 18 I went for my journey to Venice with it, on my hired horse. On the 19th I arrived there ... also at my brother's Matheus Huldrich [Matthäus Ulrich] in the German foundation in the master Fugger's chamber. Afterward Signor Gerhardo di Longhi, frequently at the Golden Head, my brother's boarding master, showed me around everywhere in town. This helped me to see everything one could possibly see, also outside Venice, at Murano, Malamoca, and suchlike places. I thus stayed in Venice until the August 3, then I rode back to Berne to my old patron, as [related] in my letter to my father, signed with No. 12.

Text below: Aged 13 and 7, 8, and 9 months.

In December 1555 my Master Angolo Cosals wife and her daughter Honesta, as well as my Master's brother Bernardin's 5 daughters, almost all of whom were grown up and single, talked me into dressing myself in white for Christmas, everything from a half silk and with the cuts as below. They refused any color; in sum, I would have to wear white to please them; for they said white best suited a young fellow.

Text below: Aged 14 and 2 months. Addition by Veit Konrad's brother: And when I, Matheus Huldrich Schwartz, once walked from Venice to Berne to visit my brother Veitt Conrat, I found that Signora Honesta courted him. But the sheep was so simple-minded that he did not understand. But I am not certain what happened in my absence. But I am well aware that both parties shed a large number of tears both at the time of parting as well as long afterward. Oh how many steps tearful people waste!

> *Oh Lady Honesta,*
> *You turn my head around,*
> *And you against your wish*
> *remain honest.*
> *With God shall be your sheath!*
> *Pray to return it soon!*
> *In the meantime the tail grows.*
> *Ahimé! the feast*
> *without you, Honesta,*
> *makes me sad.*
> *Another turn*
> *and thousand turns again,*
> *Rest with God!*
> *Ahi, he!*

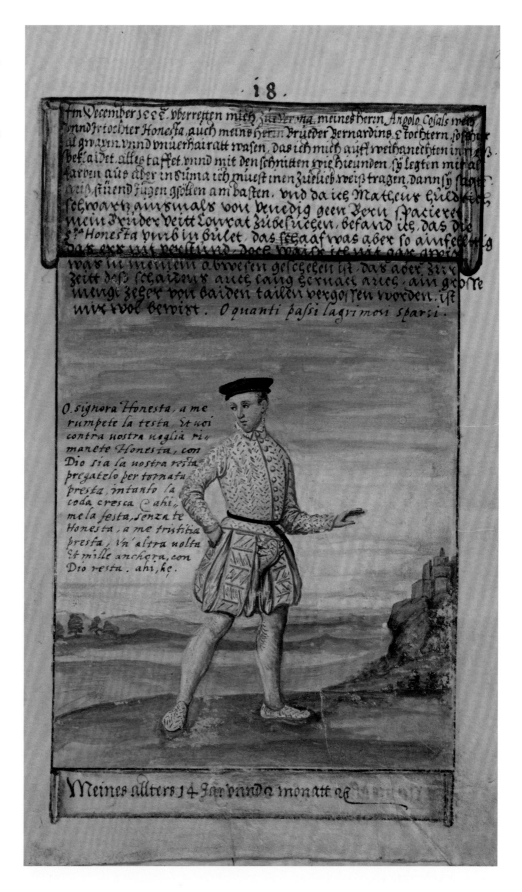

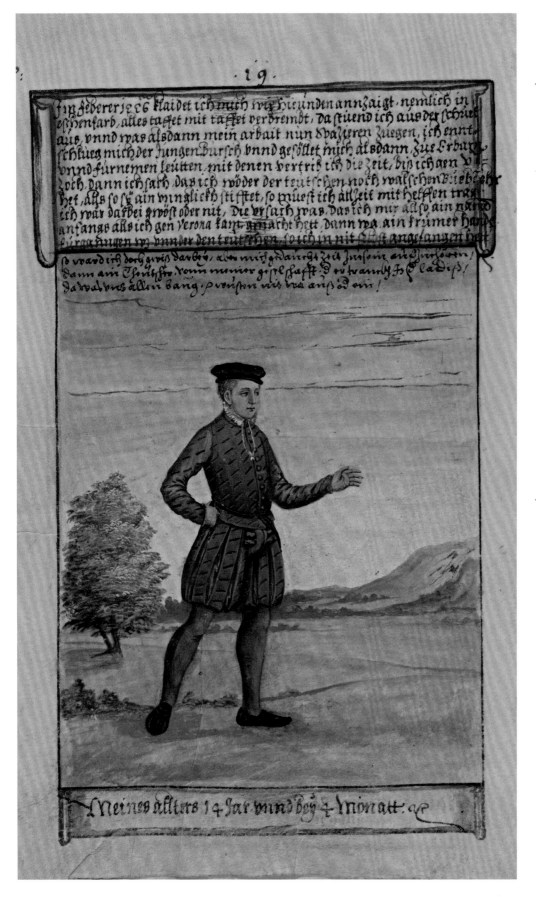

In February 1556 I dressed myself, as shown below, that is in ash-gray, all made from a half silk fabric and trimmed with the same. I finished with school and thus walking about became my work. I got rid of the young lads to associate myself with honorable and distinguished people. I spent my time with them until I went to Venice. Because I saw that I had neither the respect of the German, nor of the Italian boys; thus if someone caused misfortune, I always had to help carry it [the consequences], whether I had been part of it or not. The cause was that I had made a name for myself when I first came to Verona, because there were some bad dealings among the Germans, and although I had not started them, I for sure had taken part in them. But I thought it was time to stop because a German amongst my group of associates drowned in the Adige. This made all of us anxious, and we did not know what to do any more.

Text below: Aged 14 years and around 4 months.

In March 1556 it was my joy to play the ball game. I hit it [the ball] with the Italians either in the cloister of the church, called Duomo, or in Piazza del Potesta. There my dress was as below in the cuts and colors. The hose were otherwise from Rassa [?].

Inside the image: O Mi Rebuco Zuge [?].

Text below: Aged 14 years and 5 months.

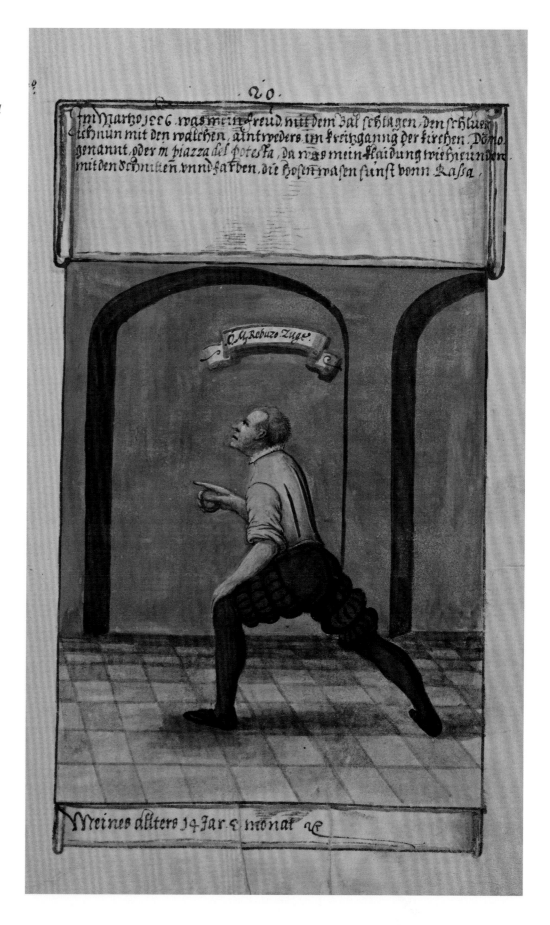

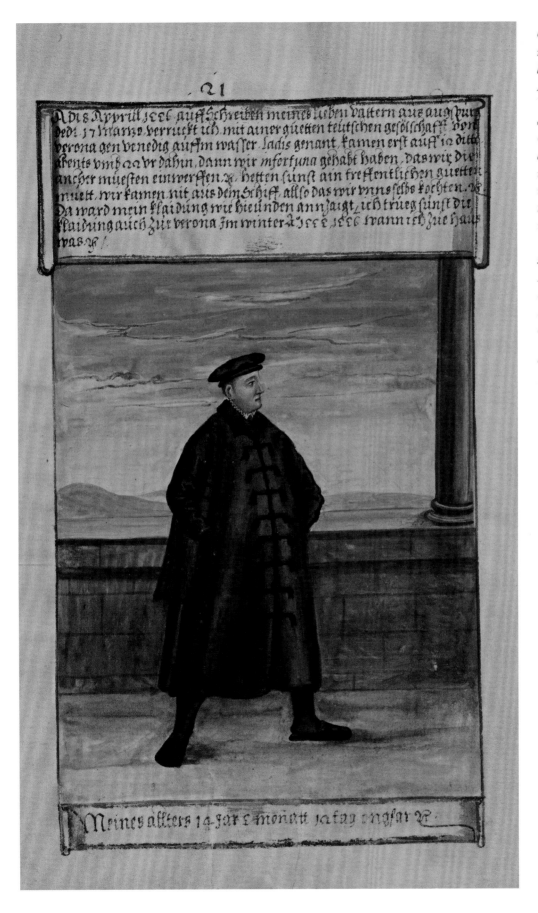

On April 8, 1556, in response to my dear father's letter from Augsburg on March 17, I moved from Verona to Venice on river called Adige, in good German company. We only arrived there on the 12th in the evening because we were unlucky and had to throw the anchor. Otherwise we were in excellent spirit. We did not leave the boat, so we cooked for ourselves. My clothes were as depicted below. I otherwise wore these clothes also in Verona during winter 1555/1556, when I was at home.

Text below: Aged 14 years, 5 months, and around 12 days.

When I came from Verona to Venice on the 12th, as shown opposite, I presented myself in the German house, into the Lord Fugger's chamber, to Signor Sebastian Zäh on April 13, who at the time was His Grace's [Anton Fugger's] servant there. He needed me there for scribal work, on the order of Lord Anntonien Fugger, in the place of my brother, Matheus Huldrich, who rode to Rome, Naples, etc. My clothes during May were as below: The jerkin was from Mochairaro-cotton and the hose with an ash-gray half silk, In the Macharonea manner.

Text below: My age, just as opposite, also 14 years and 7 months.

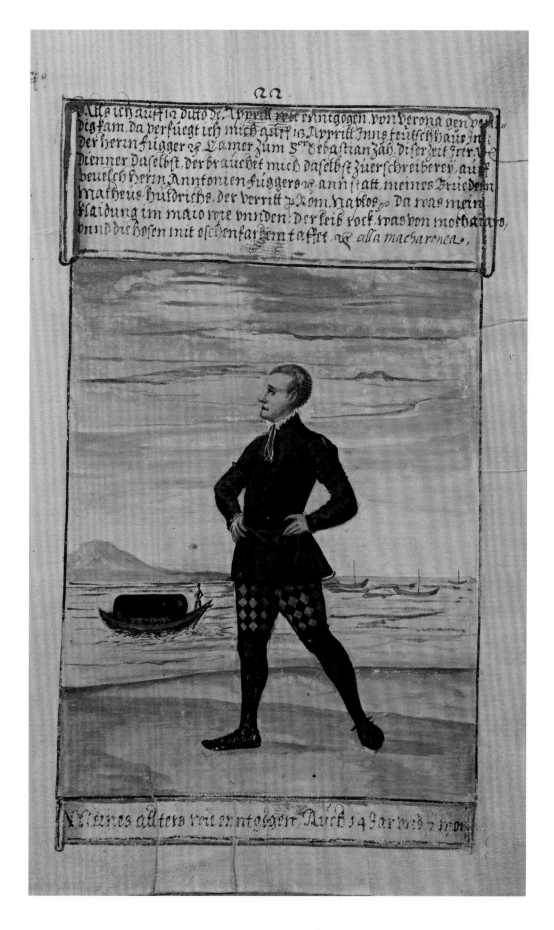

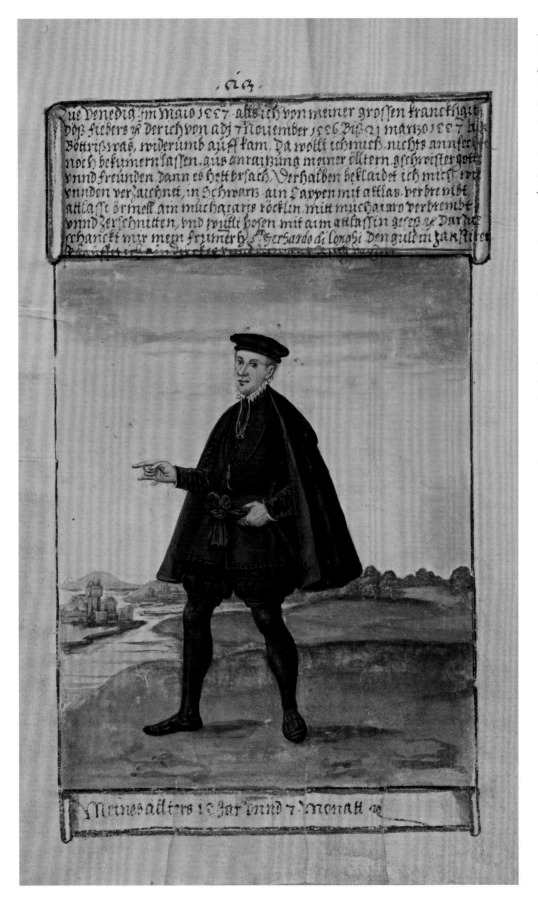

At Venice in May 1557, when I recovered from my great fever, which had kept me unwell [in bed?] from November 7, 1556, until March 21, 1557. So I did not want anything to upset or trouble me when my parents, siblings, God, or friends stirred something up, except when there was a cause for it. Thus I dressed, as is registered below, in black: a cape trimmed with silk satin, silk-satin sleeves on Macheier-cotton, trimmed with Macheier-cotton and slashed, and woolen stockings with silk-satin hose. My pious Lord, Signor Gerhardo di Longhi, gave me the golden toothpick; so I bought a turquoise and diamond-ring to go with it.

Text below: Aged 15 years and 7 months.

On June 7, 1557, I moved
with my guide, Marx
Fischer, from Venice to
Augsburg, and arrived
there on the 20th. I allowed
myself enough time to
thoroughly see every town
I visited. This dapple-gray
horse belongs to Lord
Hanns Jakob Fugger.
Lord Daniel Felix Baron
of Spaur, he asked me to
[come to] Brixen. Because
I belonged to the Fugger, I
should ride there. Perhaps
his Grace saw what kind
of rider I was, as the horse
would return without
harm. I was well served
by this, because my horse
became sick, I let it run
away by itself. My dress
otherwise was fine and
amusing, as is depicted
below, in the Venetian
manner.

Text below: Aged 15 years and
around 8 months.

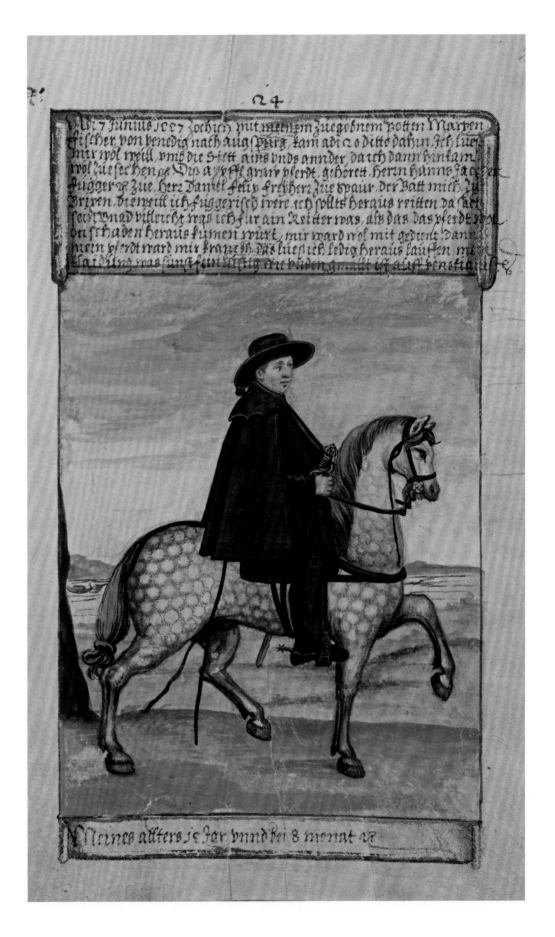

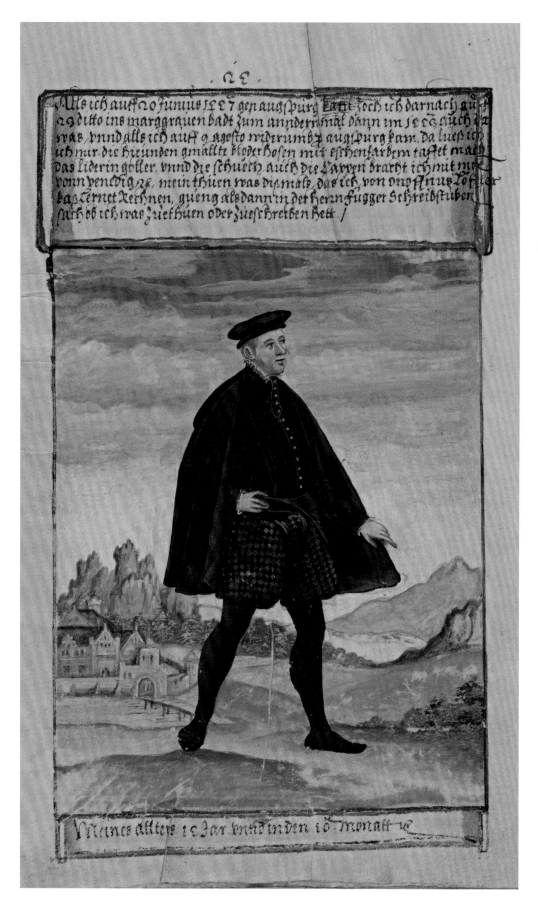

After I came to Augsburg, on the 20th of June, 1557, I once more traveled to the Margraven-bath on the 23rd, where I had also been in 1553. When I returned to Ausgburg on August 9, I had myself made the baggy hose as depicted below with ash-gray taffeta. I brought the leather jerkin and shoes, as well as the cape, with me from Venice. During this time I learned mathematics with Onoffrius Löffler's aunt, and went to master Fugger's writing office and saw whether I received anything to do or write.

Text below: Aged 15 years and in the 10th month.

On January 1, 1558, my
dear father gave me this
clove-colored outfit from a
half silk fabric for the New
Year, quilted and with the
cuts, as below; along with it
[he gave me] a short gown
of light wool and silk.

Below the image: Aged 16 years
and 2 months.

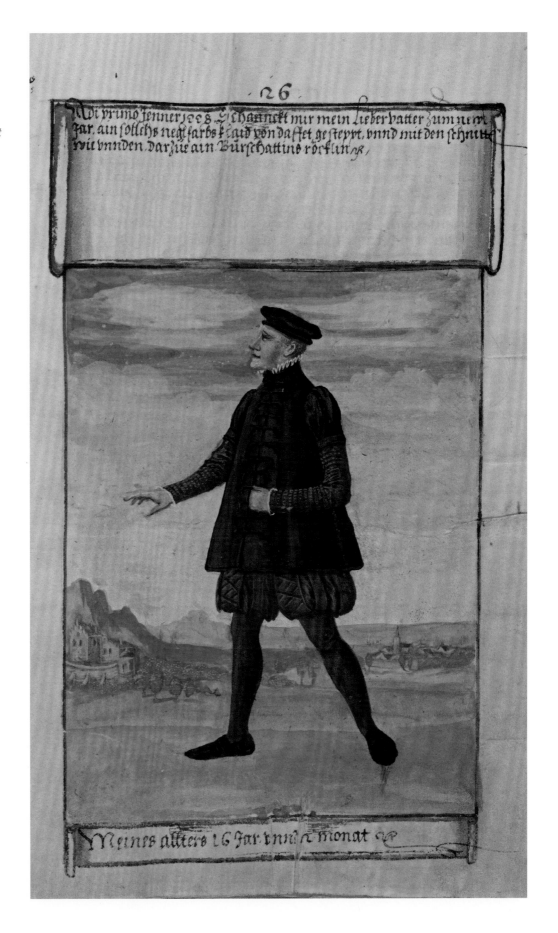

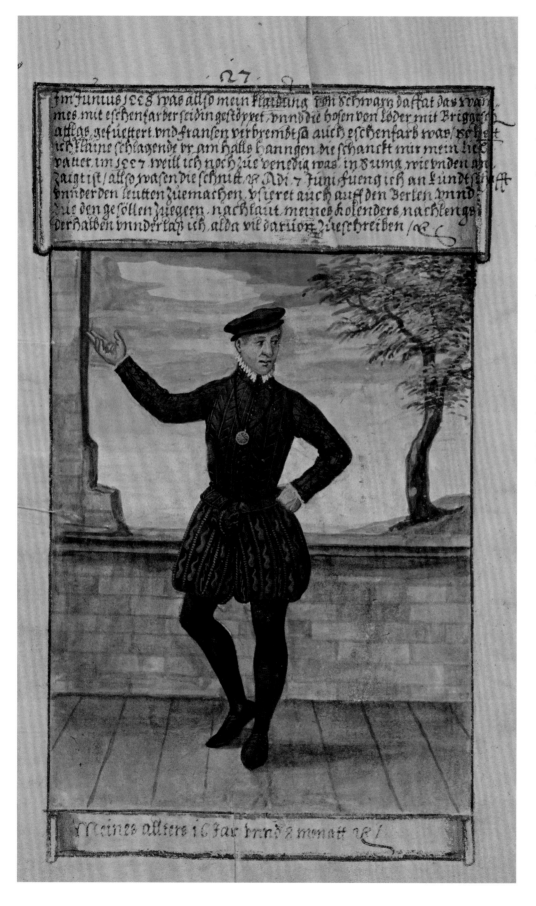

In June 1568, this was my dress: the doublet of black half silk, quilted with ash-gray silk, and the hose of leather lined with satin from Bruges and trimmed with passementerie [fransen], which were likewise ash-gray. I had a small striking watch hanging around the neck, which my dear father gave me in 1557, because I was still in Venice. In sum, as shown below, these were the cuts. On June 7 I started making acquaintances among people, and commonly went up to the Perlen [the Perlach square?] and to the companions [gesöllen], as recorded at length in my calendar, which is why I shall not write much about it here.

Text below: Aged 16 years and 8 months.

In July 1558, I started to swarm about and go for walks with good honorable fellows at night, as recorded in my calendar for this month. My clothes were as below: a black Saxon hat with feathers, a Saxon black woolen cloak lined with green fabric, and a Bohemian knife at the side. Otherwise on the following May 16, I, for the first time, carried a weapon during the night in Augsburg.

Text below: Aged 16 years and around 9 months, also 16 years and around 6 ½ months.

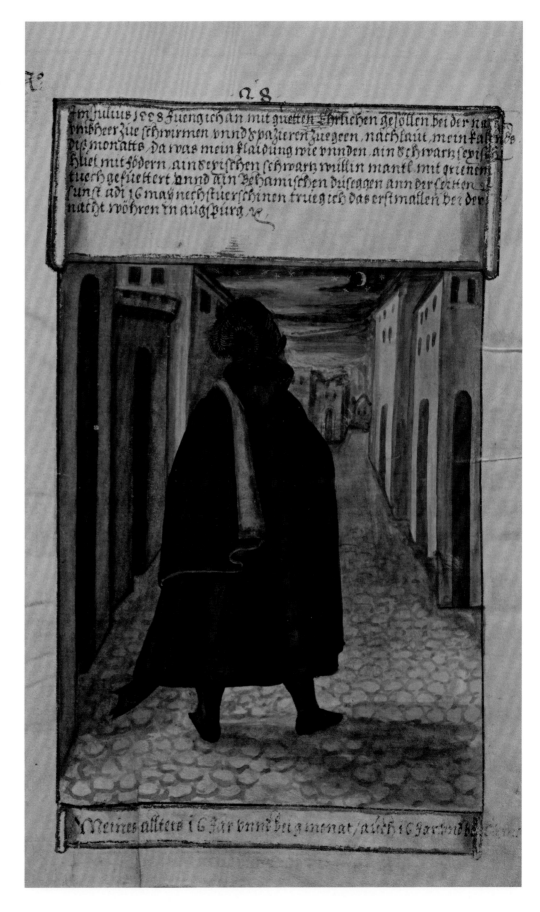

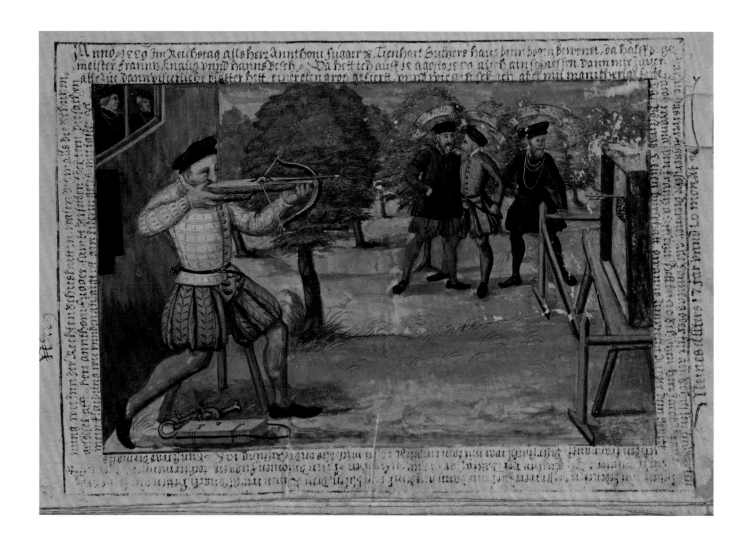

In 1559, during the Imperial Diet, when master Annthoni Fugger lived in Lienhart Sultzer's house at the archway, his Grace helped us Fugger servants have a shooting match every Sunday or feasts in the garden, because they thought it would [be] best for us [to be] at home than outside. We agreed to this and had a fine order, as in the proper shooting hut, and this time the shooting masters were Frantz Knauß and Hanns Besch. On August 15, I also had a shooting match, as Jakob Wegman had pinned the wreath on me, with 20 shooting men. Lord Jakob, Earl of Montfort, as well as Balltasar, Earl of Trautson, the son-in-law of Lord Annthoni Fugger, kept us company. Master Annthoni Fugger, together with his daughters watched everyone, for I had attractive prices [?], [cloth] about an ells length and checkered, but in several colors. The best were 5 ells of fustian, won by Zimprecht Rieger, whom I decorated with the wreath. This thorn [doublet, codpiece?] was stiffened with bone, cost me 12 fl even without the armor. Otherwise my clothes were as shown below, leather hose with half silk.

Text below: Aged 17 years and 10 months.

On January 10, 1560, I first began to wear weapons during daytime. And as I was now invited to distinguished weddings, I was quick to practice my dancing with the pretty single women, as written in my calendar; the planet Venus fully tempted me to also flirt face-to-face [by looking directly into a woman's face], like a donkey [goes after] a bundle of hay. But I never let myself go too far out without a lantern, because I thought, I do not want to court someone to get a child. So it is useless that I fight for the virgins who are to be married, on reflection, as I am not yet marrying; so these same virgins would not wait for me either, and thus [I] would have had effort and work for nothing.

Inside the image: It is truly her. Ecce [Behold].

Text below: My age 18 years and around 2 ½ months.

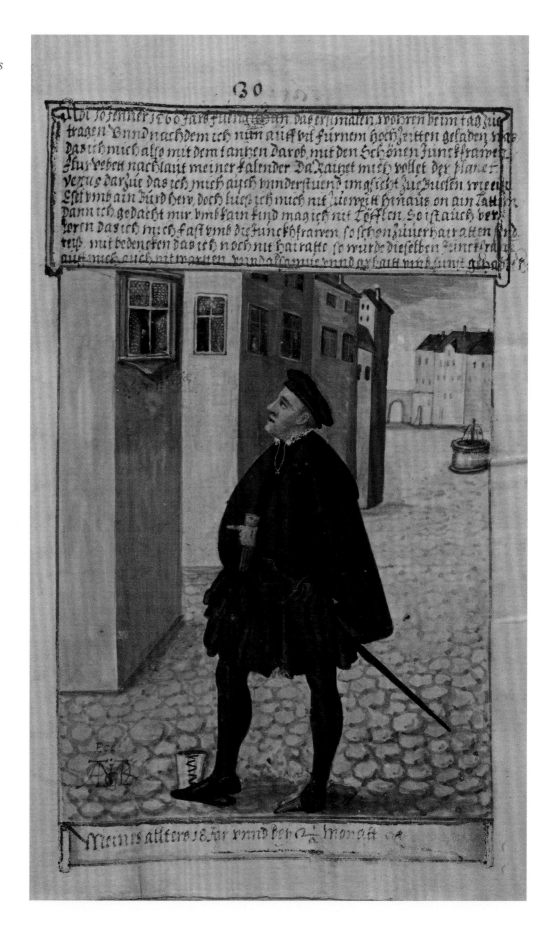

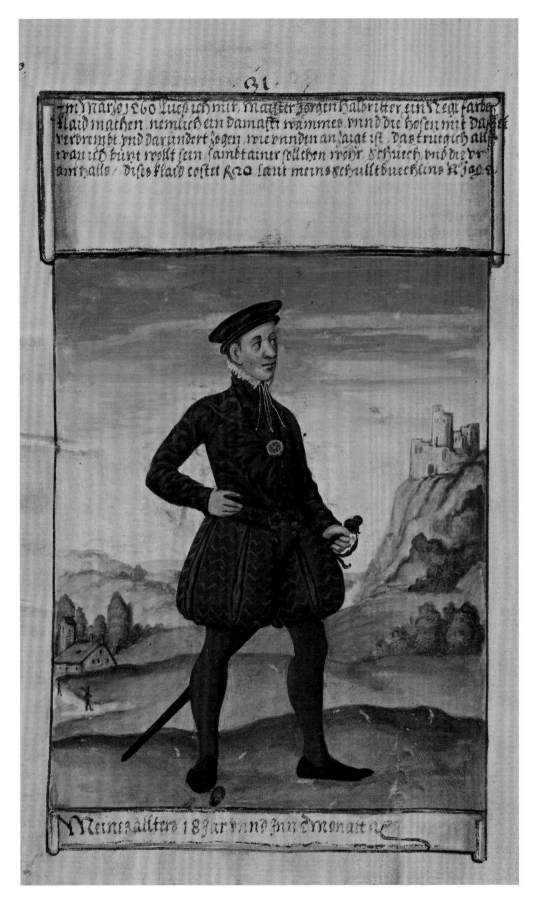

In March 1560 I got master
Jörg Halbritter to make me
a nail-colored dress: that is,
a damask doublet and the
hose trimmed with a half
silk and pulled underneath,
as is shown below. This is
what I wore when I wanted
to be dressed up, together
with such a weapon, shoes,
and the watch around the
neck. The dress cost fl. 20
according to my book of
expenses No. 1, page 5.

Text below: Aged 18 years and
5 months.

On July 17, 1560, I and Hanns Schaller led Mattheus Schaller's bride, Eva Scharerin, from Scharren to St. Anna into church; this was the first time that I led a bride. My dress was as below, a black woolen gown trimmed with velvet, the doublet black silk satin quilted with ash-color, the hose also as the [?] below, lined with good silk satin and with a half silk pulled through it. With the weapons, shoes, bonnet, everything as it is shown. The ribbon was pinned on me by the virgin Judit Mannlich, blessed Herrn Matheus Mannlich's daughter. [This hose and doublet] I had let Halbritter [the tailor] make half a year ago; it cost around 24 fl. I was up to all sorts of things then, as recorded in my calendar.

Text below: My age was 18 years and around 2 ½ months.

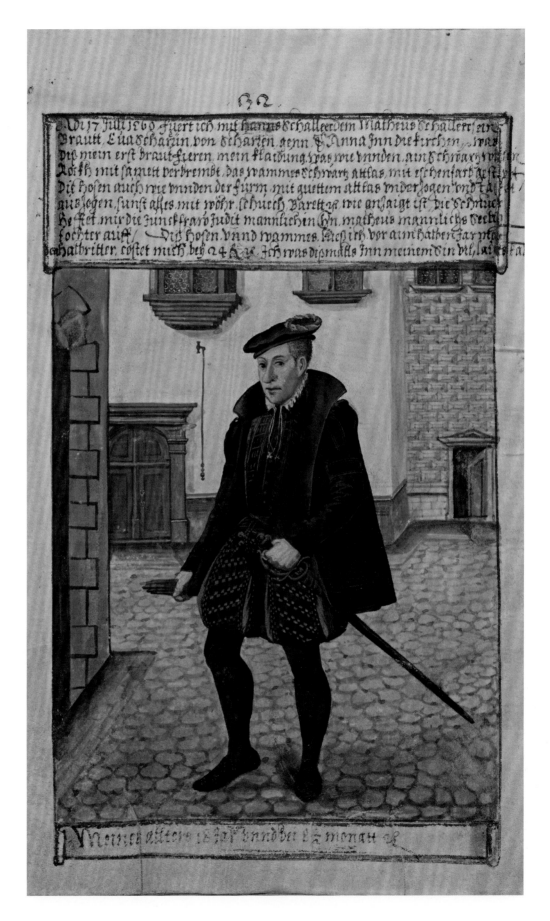

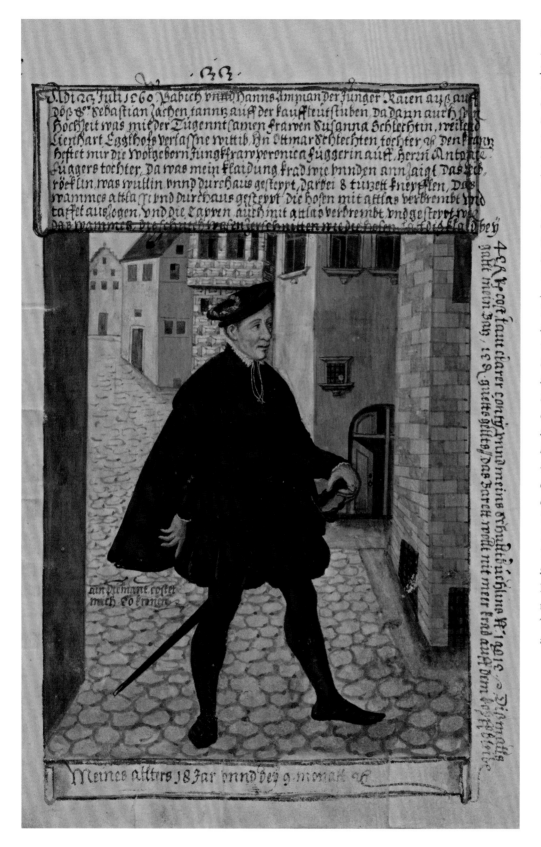

On July 23, 1560, I and Hanns Amman led the youngsters' round-dance at Signor Sebastian Zächen's dance at the merchants' chamber, and this was where his wedding also took place with the virtuous Lady Susanna Schlechtin Weiland Lienhart Egglhof's widow, Herrn *Ottmar Schlechtin's* daughter. The wreath was pinned on me by the well-born virgin Veronica Fuggerin, Lord Anthonie Fugger's daughter. This was my dress then, as shown below. The doublet was woolen and quilted throughout, with 8 dozen small buttons, the hose trimmed with silk satin and quilted like the doublet. The shoes were slashed like the hose. This dress cost around 45 fl. according to a clear account and my book of outgoings No. 1, page 15. This time the Batz valued 15 Pfennig of good coin. The bonnet no longer sat straight on the head.

Inside the image: A diamond cost me 50 crowns.

Text below: My age 18 years and around 9 months.

On this day, July 23, 1560, as is written here, I dressed all in red to please the said bridegroom Sebastian Zäch for the dancing at night, just like him. All silk satin, trimmed with silk satin, pulled under and through, also the doublet quilted throughout and otherwise slashed, as has been diligently depicted below; otherwise my shoes, they were just like this, and this dress cost me around and more than 33 fl. Rhenish coin. Master Simon Kistler has made this, the black and brown dress; these cost around fl 110 according to the book of outgoings book 15. And what good spirit there was and how it all went at the dance is recorded at length in the calendar of this month, which is why I break off here.

Text below: My age, as opposite, 18 years and around 9 months.

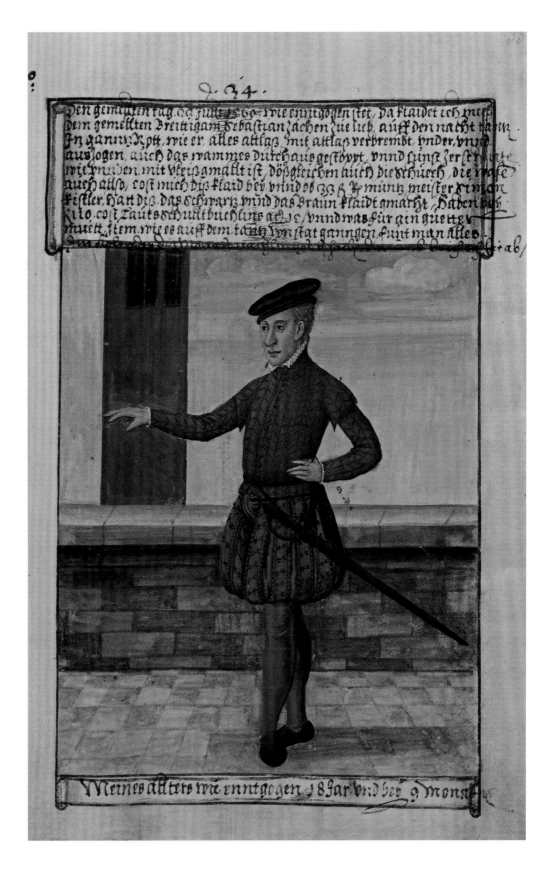

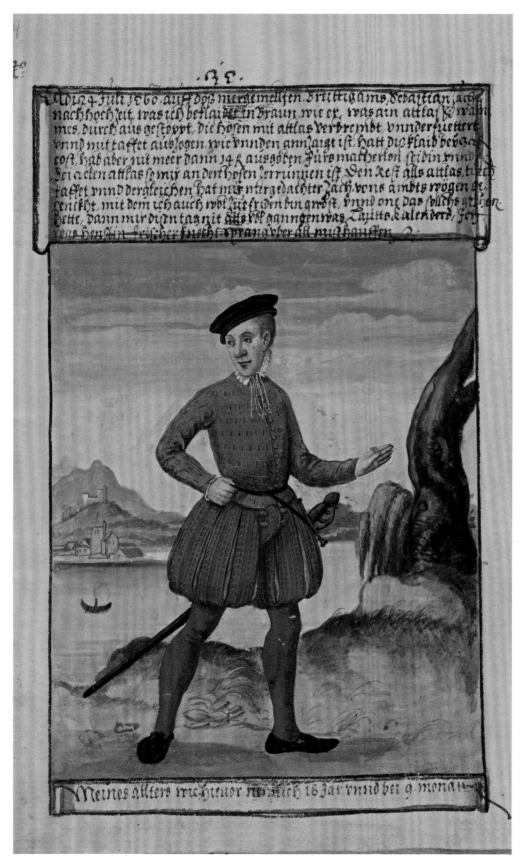

On July 24, 1560, at the aforementioned bridegroom Sebastian Zäch's after-wedding I was dressed in brown, like him. It was a silk-satin doublet, which was quilted throughout; the hose were trimmed with silk satin and with a pulled through half silk, as shown below. This dress cost around 32 fl, but I did not spend more than 14 fl for the making, silk and around 2 ells of silk satin, which vanished away on the hose. The rest, silk satin, cloth, a half silk, and such like, Zäch gave to me on behalf of his office, and I was well satisfied with this and would have done without these [?], for not everything went badly for me those days as recorded in my calendar. I was little Hans, a young man servant [knecht], jumped over all the dung-heaps.

Text below: My age as before, that is 18 years and around 9 months.

From summer until September this was my usual dress to walk the streets [literally: "to tread down the paving"], as shown below, when I walked to the accounts office. The cloak was with silk satin; the jerkin woven white and yellow, and in the middle over the sleeve, a yellow silk-satin trimming like a coxcomb; the hose trimmed with a half silk and pulled through; a velvet purse, in which I kept my keys; otherwise all as below.

Text below: My age ranged from 18 years, 7 months, to 18 years and around 10 ½ months.

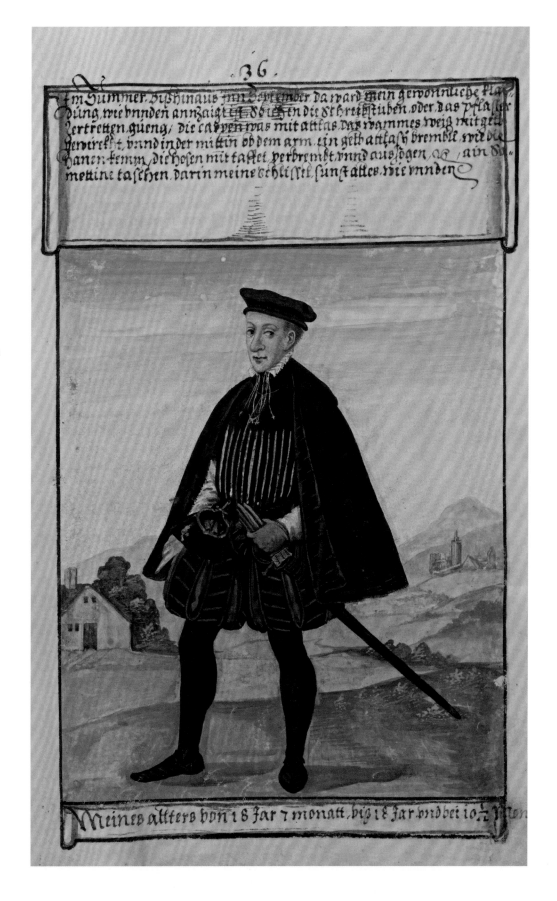

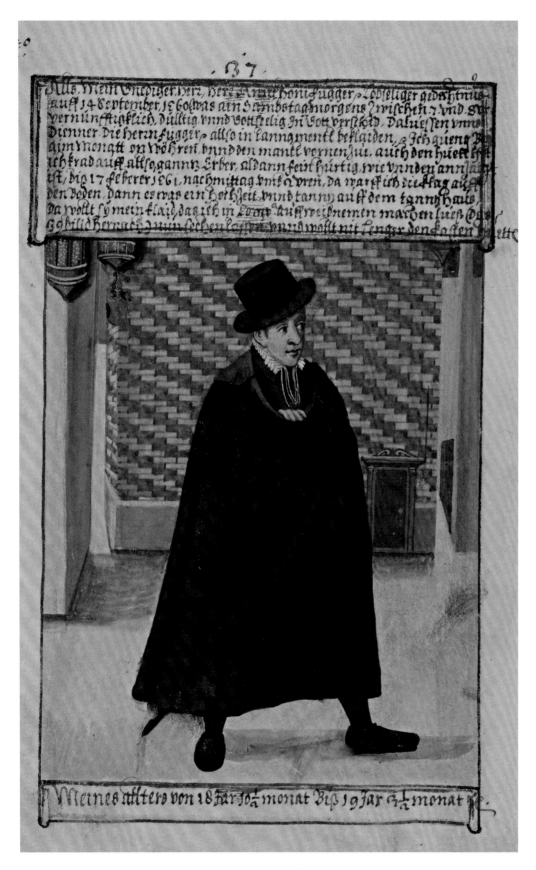

When my gracious Herr, Herr *Annthoni Fugger, in sacred memory passed away on September 14, 1560 (this was a Saturday, in the morning between 7 and 8 o'clock), with in full conscience, patiently and devoted to God, servants of the Fuggers dressed in these long cloaks. I carried no weapons for one month and closed the cloaks in the front, I also wore the hat straight and very honorably, afterward fine and nifty as shown below, until February 17, 1561, at 2 o'clock in the afternoon, when I threw the mourning dress down on the ground, because there was a wedding dance at the dance house; there my dress, which I had made in a group with others to take a wife (the 39th image after this), wanted to show itself and no longer wanted to lie in a chest.*

Text below: Aged 18 years, 10 ½ months to 19 years, 3 ½ months.

This winter, in 1560/61, there was a lot of terrific sleigh riding, as there had not been in many years, so much that I often lost control. This is why the town pipers, sleigh horses, and women's sleighs often had to suffer this month, as recorded in my calendar, without any need to relate it here. My dress was always a sable hat, a clove-colored woolen gown lined with fox fur and the left arm outside the sleeve, for I held my weapon in that hand. The gloves were plated metal, as depicted below. I kept myself on alert, in order to be ready if there was going to be a fight. I always rode [the sleigh] from 9 to 11 or 12 o'clock at night.

Inside the image: "Who passes through this street? Hui."

Text below: Aged 19 to 19 and 3 months.

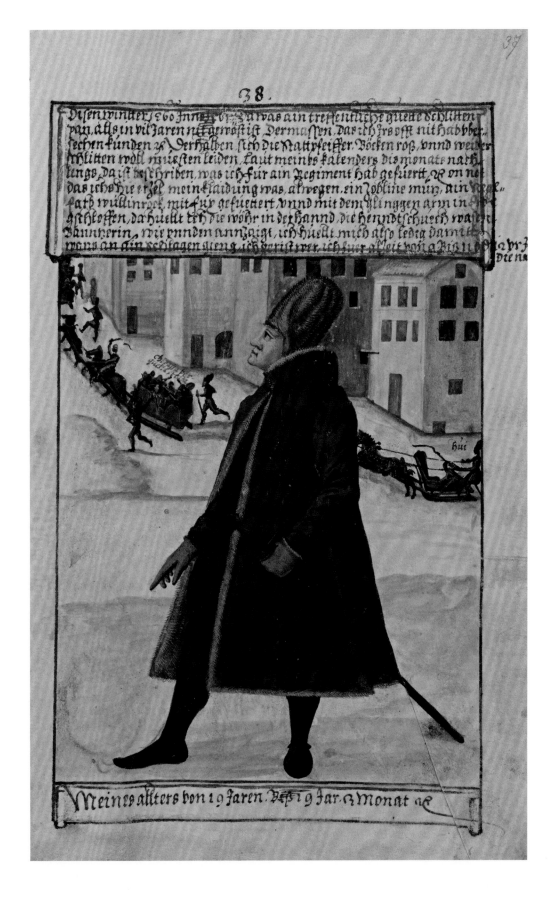

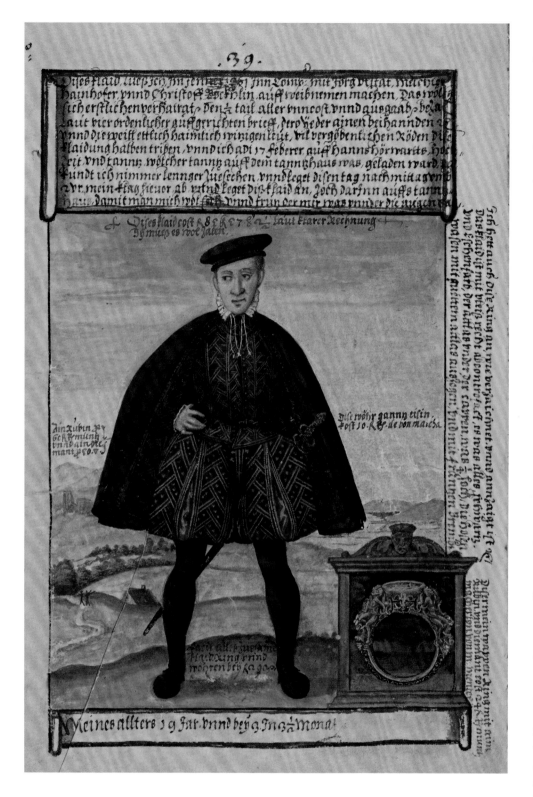

This outfit I had made in January 1561 in the company of Jörg Ulstat, Melchior Hainhofer, and Christoff Böcklin to take a wife, so that whoever was going to marry first had to pay half of all costs and expenses, according to four properly executed letters, of which each of us had one. And because many forthright people [haimlich witzige leut] uselessly talked about these clothes in secret and because on February 17 I was invited to Hans Hörwart's wedding and dance at the dance house, I could not bear this any longer and took off my mourning dress on this day at 2 o'clock in the afternoon and dressed in these clothes, went to the dancing house, so that everyone would see me well, and I would have stood up to those saying anything to my face. I also wore this ring, as it is drawn and depicted. The dress has been well and diligently portrayed. It was all black and ash-gray, the silk satin below the cap was ¼ [?], the hose was lined with good silk satin and trimmed with passementerie.

Inside the image: This dress cost fl 85 kr 57 & 2 ½ according to a clear bill, which they well have to pay. A ruby for 60 fl of Rhenish coin and a diamond for 50 A. This sword, all of iron, cost 10 fl. Rhenish de bon marcha (well made). In sum, all together, dress, ring, and weapons, around fl 290. My signet ring with a ruby and diamond to be made by Master Mentel cost 24 fl Rhenish coin.

Text below: My age 19 years and 3 in 3 ½ months.

On February 23, 1561, I was dressed in this manner at the nightly mummery with Melchior Hainhofer, Matheus Hertz, and Philip Zanngmeister, as shown below. (Herr Hans Fugger lent me the clothing.) Everyone was forbidden to go to the mummery, so we drove to it, had 2 town pipers, and went to many assemblies of single women, where nobody disliked having us. We danced and jumped like calves, because there were belle figlie [beautiful girls] there, who did not displease us. We thought we would conduct ourselves in a way that we would be unrecognized and thought we would extinguish the rhyme that says: four things cannot be hidden, namely love, a cough, fire, or water and pain. But it was all wrong from the beginning, as related in the calendar.

Inside the image: These 5 were our servants; the town pipers; silk satin.

Text below: Aged 19 years and around 3 ¾ months.

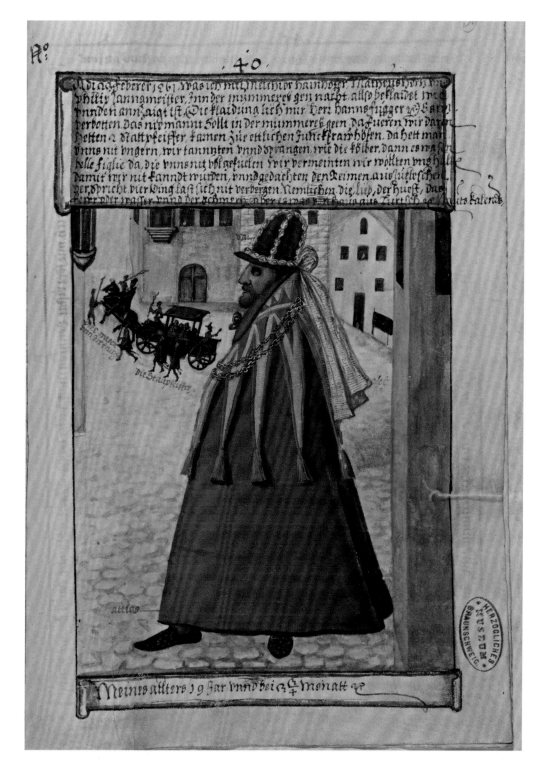

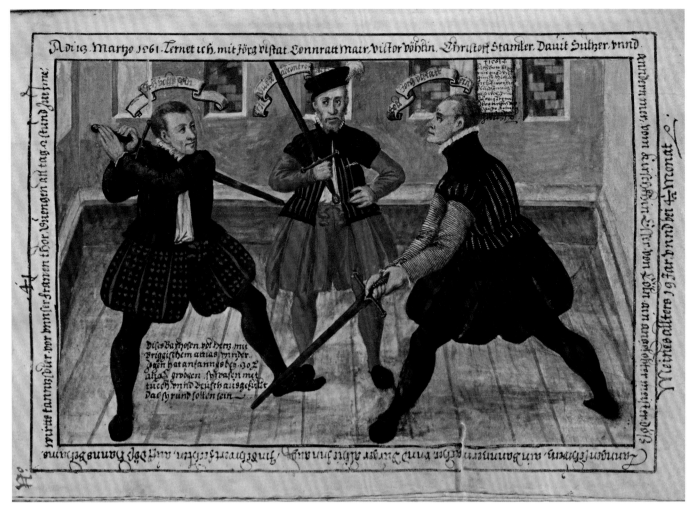

On March 13, 1561, I was taught together with Jörg Ulstat, Connratt Mair, Victor Vöhlin, Christoff Stamler, David Sultzer, and others by the Cherrystone-Eater from Cologne, a vowed master of the Long Sword, an armorer, and citizen here at Augsburg, and the sword fighting was done in Hanns Behams', innkeeper, dance master outside Our Lady's Gate. We went to him for 2 hours every day.

Inside the image: This is meant to be me; this is meant to be Jorg Ulstatt; it is well portrayed; This pair of hose is full of hearts, lined with silk satin from Bruges, it first weighed 30 Augsburg pounds; it was filled with fabric and padded, so that it should be round.

Board on the wall: Oh God, lend me grace and art, That I may learn the free knightly art/duly and well, To use it before the Emperor, kings, and lords [*Herrn*]!

Text below: My age 19 years and around 4 ½ months.

Commentaries

Matthäus's book is small, measuring just 16 × 10 centimeters, and its compact size gives it a sense of intimacy. It is bound in brown leather with stamped gilt decoration.

Heraldic achievement [verso]

The coat of arms is displayed against a background of bright blue damask, which is intended to look like a wall hanging. Against this is written his name, MATHEUS SCHWARTZ, and the date, 1520.[1] It rests at an angle on a stone ledge or windowsill. The combination of his name and his coat of arms asserts his ownership of the book from the outset, while also stressing his role as the patron of the images and owner of the clothes being depicted.

Crest: His crest is a young black boy, which is possibly a punning reference to his surname.[2] His hair is cut in a long bob, which comes to his chin. He also has a very short fringe. He is wearing a white coat with a waist seam and half-length sleeves. The coat has a large, red, downturned collar; a red lining; and wide, turned-back, red cuffs. It is fastened down the center-front from the collar to the waist with three round, gold buttons. The hem is cut in deep points. He holds a five-petaled red flower, probably meant to be a rose, in each hand. These flowers echo those depicted on the shield.

Helm: His dark steel helm has a closed visor, and it is shown in a three-quarter view.

Mantling: The mantling grows out from the hem of the boy's coat. It is red and white, echoing the colors in Matthäus's shield.

Arms: A gules (red) and argent (white/silver) shield is divided in half horizontally. The upper half has a white/silver ground with two red roses with five petals, a gold center, and green leaves. The lower half has a red ground with one white rose with five petals, a gold center, and green leaves.

Gilding: His buttons, the centers of the roses, and decorative rings on the mantling.

Frontispiece and Prologue [verso]

1520. Today, 20th February, 1520, I, Matheus Schwartz of Augsburg, was just 23 years old and looked as above. All my days I enjoyed being with old people, and it was a great pleasure for me to hear their replies to my questions. And among other subjects we would also get to talk about clothing and styles of dress, as they change daily. And sometimes they showed me their drawings of costumes they had worn 30, 40, and 50 years ago, which greatly surprised me and seemed a strange thing to me in our time.

This led me to draw mine as well, to see what would come out of it in 5, 10, or more years. This is why I began with today's date to draw them in here, such as the slashes, the colors, etc., and this image is the 42nd, which is when I started. I first had to think back to what happened before, from when I was in my mother's womb up to 1520.

I thought to do this during 1519, while my father was still alive. So I asked him about what I could not remember, which were the times of the years and days, etc., which things happened, up to the 12th image, for I was uncertain about it. Although I did start to remember from the 4th image onward, but it seemed to me as in a dream. But since the 11th image in 1510, I started to describe everything I experienced, and it was much easier for me to say what needed to be drawn.

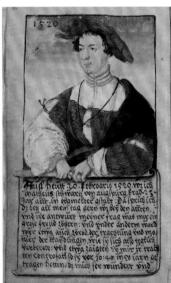

1. Schwarz was ennobled in 1541 (see I 122, dated 20 February, 1542), which includes his coat of arms at that point.
2. However, it is also worth noting that the crest on the Fugger arms was the figure of a black bishop. Indeed it is worth comparing the whole coat of arms with that of the Fuggers; see a carved, painted, and gilded example in the Deutsches Historisches Museum, Berlin; illustrated in *Feste und Bräuche aus Mittelalter und Renaissance: Die Augsburger Monatsbilder* (Berlin: Deutsches Historisches Museum, 2007), 39.

I have used one manner [of dress] 2 or 3 times, but only inserted it here once, except when it had different slashes or colors. And I thus began with the first dress in my mother's womb, the next in swaddling clothes, etc., and the others are images of my clothes worn in public, but I have omitted carnival clothes, etc.

It has not always gone in the way I wanted, and a special book has been written about this, called "The Course of the World," and in it I have written about many clothes in relation to this little book.

Note: Schwarz's entries repeatedly refer to pages of this diary, "The Course of the World" ("*der Weltlauf*"). He destroyed this record before his wedding (see Introduction).

Clothing overview: This half-length image, reminiscent of a full-scale portrait in terms of pose, presents Matthäus as a highly fashionable twenty-three year old man. It should be considered in conjunction with the full-length image, I 42, which shows him without the gown and presents him in doublet and hose.

Headwear/hair: Matthäus wears a bright red bonnet, with a low crown and a wide, slashed brim. The deep slashes come almost to the crown. The bonnet is worn at a slight angle on his head. His slightly wavy hair is cut in a short bob, which leave his earlobes uncovered. He has a very short fringe, and there is a wisp of hair on his chin.

Body garments: He is wearing a mid-brown gown with a broad turned-back collar worn over his left shoulder, but it is not evident on the right. The edge of the collar is decorated with a broad black guard, which is also on the sleeves. Underneath the gown, he is wearing a red damask doublet with quite a large pattern. It has a square neck, which is quite low over his chest, sits on his shoulders, and is higher at the back. The fronts are fastened with one tie at the top and at the waist. In between the fronts are cut away, revealing his shirt. The fronts are probably quilted in vertical rows and lightly padded. The sleeves are full and made in two sections. The upper and lower sections are joined with pairs of red points. The lower section has a series of long vertical slashes, which have blue silk pullings through that are stitched in place. The slashes are held together with pairs of small red silk points. His left arm is inside the doublet sleeve while the right is partially out. The slash higher up on the proper left sleeve is also tied with two red ties, which have little tassels/tufts on each end.

Linens: The shirt is depicted in great detail, suggesting that it is very important to him. The width and volume of the shirt sleeves is made clear, as is the very fine pleating of the linen on his chest. The shirt has a tall neckband edged with a narrow ruffle. It has four rows of gilt metal thread embroidery on the neckband. The sleeves are gathered into a cuff, which is worked with three rows of embroidery, and there are bands of blackwork in between the rows of gold embroidery. The shirt has a front opening, and it fastens with a pair of gilt bandstrings that are tied in a half bow.

Legs: He is wearing matching red hose and they are tight fitting over his hips.

Jewelry: He has four gold rings on his left hand: two of them are plain, and two are set with blue stones, probably sapphires. He wears a silver crucifix[3] on a black silk loop-manipulated silk string or cord around his neck.[4]

Weapons: He is wearing a dagger on his right hip. The flat, round pommel is highly decorative, and the dark gray/blue color suggests either bright steel or blued steel.

Gilding: On the gold/gilt brooch on the brim of his bonnet, the embroidery on his shirt, and the rings.

3. Matthäus is wearing a t-shaped cross or Tau cross with the body of Christ; see D. Scarisbrick, *Jewellery in Britain, 1066–1837: A Documentary, Social, Literary and Artistic Survey* (Wilby: Michael Hall, 1994), 2–33.
4. The under-drawing suggests that the original intention was to show him with a large ring hanging from the cord about his neck.

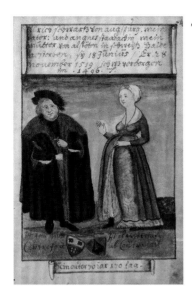

Depiction of the Parents[5] [recto]

Ulrich Schwartz from Augsburg, my father, and Angnes [Agnes] Staudachin, my mother, from Allstedt in Switzerland. Both have died, she on 18 June, he on 28 November, 1519. I was hidden in 1496.

Text below: This is rather well portrayed, it is copied from a panel painting. Aged 70 years and 170 days.

Note: Matthäus's mother died in 1502 (see I 4).

Clothing overview: This is the only picture of his father, and it is a good example of the style worn by older influential men. His mother provides one of the few depictions of clothing worn by women of the bourgeois/mercantile elite.

Headwear/hair: Matthäus's father wears a black bonnet lined and edged with dark brown fur. His hair is graying, and it comes down well below his ears. In contrast his mother has a white linen coif, which covers her hair completely.[6] This style of coif or *Steuchlein* was worn by married women in Germany. The very high hairline suggests that she might have plucked her forehead.

Body garments: Ulrich wears a black wool gown with a dark brown fur lining and a fur cape collar. The fur lining in the sleeves is evident at the slits that his arms pass through. Underneath he is wearing a high-necked black doublet, the neck and sleeves of which are just visible where they are not covered by his gown. Agnes's dark blue gown is made from a watered fabric. It has a low, round neck, a fitted bodice and tight, full-length sleeves. The front of the bodice is open, and the v-shaped gap is joined with a lace. Her gown is open at the front, from the high waist, and each side of the opening is lined with pale gray fur. The same fur has been used to make a broad guard around the hem of her gown.[7] Under her gown she wears a white kirtle.

Linens: The sleeves of Ulrich's shirt are visible where they show through the open seam of his doublet sleeves. The amount of fabric showing suggests the sleeves were quite full but not as opulent as some of the shirts his son will wear. Agnes's shoulders and some of her chest are covered with a partlet made from fine white linen.

Legs: It is likely that Ulrich is wearing black hose, but these are not visible. A glimpse of Agnes's black hose is on offer.

Footwear: They both wear shoes with black uppers, and Ulrich's shoes have rounded toes.

Jewelry: Ulrich has a plain gold ring on the fourth finger of his left hand. Agnes has a gold brooch on her coif. She wears a simple gold girdle, resting above the fullness of her pregnant stomach.[8] It is wrapped around her waist twice, tied in a knot on the left side of her stomach, and then the hanging section is tied in a second decorative knot.

Coats of arms: Two small shields bearing their coats of arms have been placed below their feet.[9]

5. In the Hannover manuscript, the image is not numbered, p. 4.
6. Compare with the linen coif worn by an unidentified woman; see Hans Nrosamer (attributed), *Portrait of a Woman*, c. 1526–27, animal glue or gum on linen canvas, 54.6 × 49.3 centimeters, Royal Collection, RCIN 402867. Also see J. Zander-Seidel, "'Haubendämmerung': Frauenkopfbedeckungen zwischen Spätmittelalter und Früher Neuzeit," in *Fashion and Clothing in Late Medieval Europe*, ed. R. C. Schwinges and R. Schorta with K. Oschema (Riggisberg and Basel: Abegg-Stiftung and Schwabe Verlag, 2010), 37–43.
7. Compare with the glimpse of a similar gown, made of damask and trimmed with a fur guard, in Albrecht Dürer, *Nuremberg woman dressed to go to church*, c. 1500, a drawing on paper, 31.6 × 17.1 centimeters, British Museum.
8. Karen Hearn has identified a similar use of the girdle in emphasize the wearer's pregnancy in late sixteenth- and early seventeenth-century English pregnancy portraits; see K. Hearn, "A fatal fertility? Elizabethan and Jakobean pregnancy portraits," *Costume* 34 (2000): 39–43.
9. Compare with the use of shields of Johann the Stedfast and his wife on the reverse of the diptych, Lucas Cranach the Elder, *Johann the Stedfast and Johann Friedrich the Magnanimous*, 1509, oil on wood, National Gallery, London, 6539; Dunkerton, *Dürer to Veronese*, 17, fig. 23; 19.

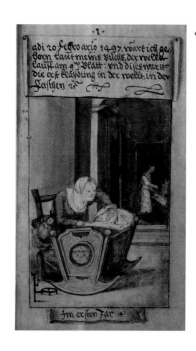

Image I 1 [recto]

On 20th February, 1497, I was born as related in my book of "The Course of the World" on the 9th page. Thus was my first clothing in the world: in swaddling clothes.

Text below: In the first year.

Note: The cradle closely resembles that depicted in Emperor Maximilian I's *White King*. A pentagram was used to ward off evil.

Clothing overview: In this very domestic scene, the clothes of Agnes and her servant make clear the distinctions between married and single women, and of mistress and maid, in late fifteenth-century Augsburg.

Headwear/hair: Agnes wears a white linen coif, very similar to that in the previous illustration, which covers her hair entirely. The maid is bareheaded. Her hair is braided, probably in a single braid, and she is wearing a black band or fillet around her head. Matthäus has a small white linen cap, which frames his face.

Body garments: Agnes is dressed in a blue wool gown with fairly fitted sleeves and a full skirt. The gown has a natural waistline, and the fullness in the skirt can be seen at the back of her waist. The gown has a low neck, cut in a gentle curve, and the front of her bodice is fastened with three little gold/gilt clasps. In the background, her maid wears a brown skirt with a narrow black guard close to the hem and a green, sleeveless bodice, with a suggestion of a small shoulder wing and a fairly low neck. Matthäus is swaddled (*der fetschen*), but it is not visible.

Linens: Agnes has a white linen cloth or partlet that is folded over her breasts. The maid is wearing a full-length white linen apron, which protects her clothes while she is working. She has rolled up the sleeves of her smock, or it has elbow-length sleeves. The illustration is slightly abraded, but it is likely that she is wearing a linen partlet.

Footwear: The maid is wearing black shoes, and the vamps cover the top of her feet.

Accessories: Agnes has a small, yellow/brown, leather bag with a metal closure, hanging from her girdle on her right hip. It has lots of little pockets.[10] Behind it there is a second, smaller, black purse, with a gilt purse frame.

Jewelry: There is a large, triangular gold brooch pinned to the front of Agnes's coif. She has a gold ring on the third finger of her left hand and others on the second and fourth fingers of her right. Her girdle, probably made from black velvet, is decorated with a series of gold/gilt studs.

Furnishings: The crib has a bright red coverlet, white linen sheets, and a white linen pillowbere (or cover) on the pillow.

Gilding: The brooch on his mother's coif, the gilt studs on her belt, and the little clasps on her bodice.

Image I 2 [verso]

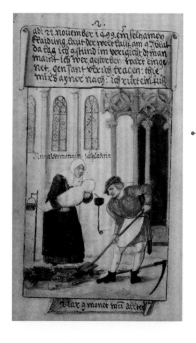

On 22 November, 1499: strange dress, as related in "The Course of the World" on the 9th page. I suffered cramps for nine hours, so that everyone thought I was dead: I was sewn in and carried to Sant Ulrich. Do the same as me: I moved one foot!

Text in the Image: Anna Germennin, salt maker.

Text below: My age 2 years, 9 months.

10. Compare with the bag in Albrecht Dürer, *A Nuremberg housewife*, 1500, Biblioteca Ambrosiana, Milan. Also see the small sixteenth-century leather purse for a woman, in J. Pietsch, *Taschen: Eine europäische Kulturgeschichte 1500–1930* (Munich: Bayerisches Nationalmuseum, 2013), 44, no. 2, and a slightly larger bag to hang from a girdle, 46–47, no. 4.

Note: Corpses were commonly sewn into shrouds, sometimes prematurely. This is an unusual depiction of a gravedigger and local guildswoman.

Clothing overview: The inclusion of a skull and a long bone in the dug soil sets the scene for events in 1499 while also acting as a *memento mori* for Matthäus. The clothes of Anna and the gravedigger also provide a wider view of clothing in Augsburg beyond the Schwarz family.

Headwear/hair: Anna Germennin has a white linen headdress, which drapes her head and extends over her shoulders and chest, covering her hair completely. In contrast, the gravedigger wears a small, russet or possibly a faded madder red bonnet. It has quite a pronounced crown. The brim sticks out at the front, while it is longer and upturned at the sides and back. It is textured, suggesting that it is possibly made of brushed or felted knitting or that it might be thrummed. His gray hair falls down over his ears, while the stubble on his chin is a little browner than his hair.

Body garments: Anna wears a full-length dark gray wool gown, with a loosely gathered skirt; long, fairly fitted, sleeves; and probably a high neck. Over this she is wearing a sleeveless, black overgown (or possibly a full apron) with a low, square neck, which comes to just above ankle height. The clothes are simple, modest, and respectable for a woman who makes her living as a salt maker. In contrast, the gravedigger wears a bright blue body garment that might be a long-skirted doublet or a coat. It has a round neck, with a short neck opening. It is fairly fitted to the body and has long skirts coming to the mid-thigh. Matthäus has been stitched into a white shroud.

Linens: There is a hint of the neck of the gravedigger's shirt, which is likely to be quite simple in cut and materials.

Legs: The gravedigger has plain white or undyed wool hose.

Footwear: Just a hint of Anna's black, round toed shoes, show beneath her skirt. The gravedigger wears ankle-height black shoes, which might be start-ups. They are dyed, not natural brown leather.

Accessories: The gravedigger is wearing a short white apron, and the shape suggests that it is made from leather rather than linen. He is digging with a long handled spade, and there is a scythe or grass hook on the ground.

Weapons: He has a short sword with a broad blade in a black scabbard hanging from a black girdle. The hilt is gilded. It is a rather ornate weapon for a gravedigger, suggesting that grave digging might not be his only occupation.

Gilding: On the hilt of the sword.

Image I 3 [recto]

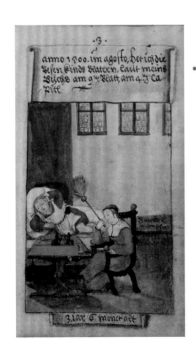

In August 1500, I suffered badly from chicken pox, as related in my book on page 9 in chapter 4.

Erased: In addition to this illness, I suffered from a bad rash of the French disease.

Text in the Image: Barbel, my sister.

Text below: 3 years, 6 months old.

Note: Schwarz plays with tournament figures, which Maximilian I's *White King* depicted as suitable toys for boys.

Clothing overview: This illustration draws out the importance of age and gender in relation to children's clothing. At three years, six months Matthäus still dresses in the clothes worn by young boys, while Barbel is wearing styles very similar to those worn by her mother.

Headwear/hair: Both children are bareheaded. While Matthäus's hair is cut short or has been shaved recently, his sister's light brown hair is long, possibly with a center parting. It is in a braid, with the shorter hair at the sides arranged in two curls.

Body garments: Matthäus wears a red coat, an indication that he has not been breeched yet (made the transition from wearing skirts to adult male clothing). It has fairly fitted, full-length sleeves, a high neck, which has been left undone, allowing it to fall open. The coat has fairly full skirts, which have ridden up over his knees as he lies on the bed. Barbel wears a reddish-orange gown with a low, square neck; fitted, full-length sleeves; a natural waistline; and a fairly full skirt. The edge of the neck and the wrists of her sleeves are trimmed with a narrow black passementerie.

Linens: Matthäus wears a white linen apron over his coat to keep it clean. The sleeveless apron has a bib with a square neck and appears to have a center-back opening. There is a hint of the ruffle edging the neckband of his shirt. Barbel has a white linen partlet infilling the neck and shoulders of her gown. It has a round neck, and there is a suggestion of a little ruffle at the wrists.

Legs: Matthäus's legs are bare, probably as a concession to him having chicken pox.

Footwear: Her black shoes are very indistinct, while his feet are not shown but are probably bare.

Accessories: Matthäus has a black belt or girdle around his waist, from which hangs a small, black purse with a gilt clasp. Barbel has a large fan, possibly made from ostrich feathers, grasses, or rushes, with a long handle, which she is using to keep her brother cool. On the table is a selection of his toys, including two knights on horseback and a ball (or it may be an orange). There is a glass beaker, and two small bells hang from the underside of the table to call the servants.

Jewelry: Barbel has a thin black fillet or circlet around her head, which is possibly made from a loop-manipulated silk cord.[11] She also wears a black girdle, which is rather abraded but is probably similar to that worn by her mother in I 1. She has a gold ring on the little finger of her right hand.

Furnishings: His bed, or possibly a daybed or couch, has a white linen sheet and a mound of pillows with pillowberes. The x-frame chair is covered with a black textile (possibly velvet) or leather, and it is decorated with gilt studs or dome-headed nails.

Gilding: On the pommels and also the decorative studs/nail heads on the chair frame; on the toy knights and her ring.

Image I 4 [verso]

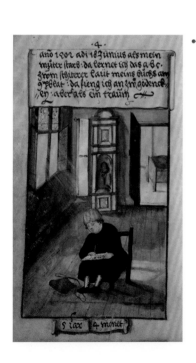

On 18th June, 1502, when my mother died. At the time, I learned the abc with Schiterer, as related in my book on the 9th page. This is when I started to think and remember, but as in a dream.
Text below: 5 years, 4 months.

Clothing overview: His somber clothes, with the exception of his hose, mark the death of his mother. In addition, his activities demonstrate his move toward the male world of education and work. From this point on, he is depicted alone or in male company.

Headwear/hair: Matthäus is wearing a warm gray cap. It might be made from fur, suggested by the vertical lines, or it might be knitted and decorated with thrums. It has a domed crown and no brim, and his hair just showing underneath it.

Body garments: He wears a black wool coat with a round neck. It is fairly fitted in the body with a flat front, suggesting that it is side fastening with the opening on the left shoulder. It has full-length sleeves. The coat comes to just above his ankles. It is likely that he has not been breeched yet.

11. For a young girl with a similar fillet and braids, possibly Dürer's niece, see Albrecht Dürer, *Portrait of a young girl*, 1515, charcoal drawing, 42 × 29 centimeters, Kupferstichkabinett, Berlin; H. Wölfflin, *The Art of Albrecht Dürer*, trans. A. and H. Grieve (London: Phaidon, 1971), 215, fig. 91.

Linens: The undecorated, small collar of his white linen shirt is evident at the neck of his coat.

Legs: He wears very striking hose or short hose/socks with broad red, white, black, and brown vertical stripes. As the coat would probably be floor length when he was standing, very little would be on show. As he has probably not been breeched—5 years, 4 months would be quite early—they are probably socks.

Footwear: He has flat black ankle shoes with fairly rounded toes with a high vamp, which are more practical than fashionable.

Accessories: There is a red bag (probably leather) with a long strap on the floor. He may be wearing a girdle, but it is not shown. He is sitting on a low chair. He has a pen in his right hand, and the letters a, b, c, d, e, f, g, h are written on the paper.

Furnishings: There is a scarlet coverlet on his bed. Next to the small washing place, there is a long length of linen sewn in a loop with two holes hanging from an iron bar. It is probably a towel.

Gilding: None present.

Image I 5[12] [recto]

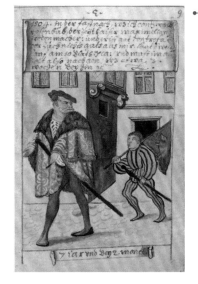

In 1504 during carnival I was Contz von der Rosen's boy, who at the time was Maximilian I's jester, and he is well portrayed. He didn't draw anything good out of me, as related in "The Course of the World" on the 10th page, 5th chapter, and I had to always follow him, I spent about three weeks with him.

Text below: 7 years and about two months.

Note: Kunz von der Rosen was Maximilian I's court jester but also a respected and influential figure. He married Felicitas Gresler of Augsburg in 1506 and previously would have frequently accompanied the Emperor's visits to the city.

Clothing overview: This is the first time that Matthäus is depicted in a tight-fitting doublet and hose of the type worn by adult men. While he does not mention it, he has been breeched, which would be appropriate for his age. It is also the first time he displays his clothes in public. Walking behind the sumptuously dressed Contz von der Rosen as part of the carnival is an appropriate occasion to be seen by many in this striking outfit.[13]

Headwear/hair: Contz von der Rosen[14] wears a bright blue bonnet with an upturned two-part brim over a gilt caul. His gray hair is cut short and his moustache and beard are neatly trimmed. Matthäus is caul, and his hair is cut very short.

Body garments: von der Rosen wears a pale gray damask gown with a large pattern repeat. The gown has wide, elbow-length hanging sleeves, which are fur lined, and the open outer seam has been tied with three pairs of gold points with gold aglets. The gown has a dark brown fur cape collar and what appears to be a full-fur lining. The color suggests that the fur might be sable. While knee length at the front and back, the gown is cut away at the sides. This reveals von der Rosen's legs to the mid-thigh. His white doublet has a low, round neck. It is slashed with vertical rows of short alternating diagonal cuts to reveal a blue fabric below. The

12. In the Hannover manuscript, image no. 5, p. 9. This style of image, with a man and boy, echoes the depiction of Tod und Kriegsmann mit Sohn, image 20 in Tripps, *Den Würmern*, 87; also Niklas Stoer, *Clas Wintergrön mit Sohn Heinz*, published by Niclas Meldemann, Nürnberg, 29.1 × 18.1 centimeters, Ehemais Wien, Sammlungen der Fürsten von Liechtenstein.

13. The style of the scene is reminiscent of Tod und Kriegsmann mit Sohn in J. Tripps, *Den Würmern wirst Du Wildbret sein: Der Berner Totentanz des Niklaus Manuel in den Aquarellkopien von Albrecht Kauw (1649)* (Bern: Verlag Bernisches Historisches Museum, 2005), 87.

14. Compare with Daniel Hopfer's portrait of Contz von der Rosen; see Fink, *Die Schwarzschen Trachtenbücher*, 87, fig. 51.

doublet appears to have wide sleeves, which narrow at the cuff, because part of the left sleeve is visible under the gown. In contrast, Matthäus's very striking doublet has broad vertical yellow and black stripes. It has a high round neck and full sleeves, which were fitted at the wrist. The front of his doublet and the sleeves appear to be slightly padded to give them the rounded shape.

Linens: von der Rosen's shirt has a wide neck, echoing that of his doublet. None of Matthäus's shirt is visible.

Legs: von der Rosen wears bright red, tight-fitting hose, while Matthäus's hose have black and yellow stripes, matching his doublet. He has a round, striped, codpiece.

Footwear: von der Rosen has black shoes, as does Matthäus. Their shoes may be integral with their hose.

Accessories: Matthäus carries a blue, swallow-tailed flag on a staff. It rests on his right shoulder. The flag has a design of an animal, possibly a wild boar. It was probably painted on a lightweight silk.[15]

Jewelry: There is a small gold brooch on the brim of von der Rosen's cap.

Weapons: Matthäus and von der Rosen each wear a sword with black hilt and black scabbard, on the left hip.

Gilding: The brooch, the points, design on the flag.

Image I 6[16] [verso]

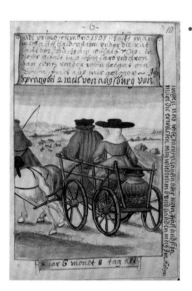

On the first of September 1505, I was sent under the rut to Haidenheim as related in the book on the 10th page, chapter 6, in this manner in ash-color and green; for Contz von der Rosen had turned me into a bad boy. Two miles from Augsburg, I jumped from the cart and wanted to run away, but my priest and his maid got hold of me and tied me to the basket.
Text below: 8 years, 6 months, 8 days old.

Note: It was not unusual for Augsburg boys to be educated by Catholic priests to remove them from their local environment.

Clothing overview: In the following year, at eight Matthäus is sent away in a bid to reform his behavior and he is dressed for travel, as are those traveling with him.

Headwear/hair: The priest wears a large, rather shapeless black bonnet, with a full crown and a modest brim. Below this his rather bushy hair is very evident. In contrast, the maid wears a black hat with a shallow crown and a broad brim. Her hair is not visible. The driver wears a small black cap, which is only partially visible, over a gray hood that covers that back of his neck. Matthäus has a small dark chestnut brown bonnet with a narrow brim.

Body garments: The priest is dressed in a full-length, mid-gray wool gown or cassock, which has some fullness at the back and large, bell-shaped sleeves. The maid wears a pinkish-red gown. This is quite loose fitting in the bodice, with fairly fitted sleeves and a full skirt. The driver is wearing a red, wool, riding coat or gown, which is moderately fitted. Matthäus has a gray gown with a pale green collar.

Linens: The maid wears a voluminous white linen veil under her hat, which covers her head and shoulders and conceals her hair completely.

Accessories: The driver has a long black whip. He also wears a black girdle, and he has a black pouch hanging from it.

15. For a very rare surviving example of this type of painted banner, see the flag of the city of Ghent depicting Agnes van den Bossche, the Maid of Ghent; C. Harbison, *The Art of the Northern Renaissance* (London: George Weidenfeld and Nicolson Ltd, 1995), 65, fig. 38.
16. In the Hannover manuscript, image no. 6, p. 10.

Jewelry: The maid looks to be wearing a black girdle around her waist, which is possibly made from black silk or black leather.

Horses/horse harness: The cart is being pulled by an unmatched pair—a gray and a liver-chestnut. What can be seen of the harness is black. The driver is riding pillion on the right hand horse.

Cart: They are traveling in a rather basic four-wheeled cart with the priest sitting at the front, the maid in the middle, and Matthäus at the back. The sides of the cart are forms of poles lashed together, and there is a narrow band of basketry at the back and partially down the sides.

Gilding: None present.

Image I 7 [recto]

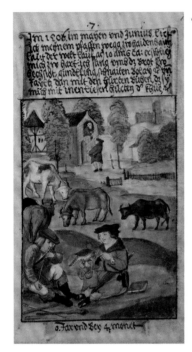

In May and June 1506, I ran away from my priest in Haidenhaim, as related in "The Course of the World" page 10 in chapter 6. He beat me too hard. I sang for bread in Hechstot, Gundlfing, Schnaiten, Boley, etc. and made a deal with the herding boys that they would let me herd the cows with them.

Erased from the margin: The reason I ran away from my priest in Haidenhaim was that he hit me in [. . .] manner and almost drowned me in the river Brenz. I then managed to get hold of his dagger and went into his garden during the sermon and chopped all his young cabbages off and afterward pushed the weapon into the ground and ran away.

Text below: 9 years and around 4 months old.

Clothing overview: He is wearing the same clothes as in the previous image in late spring/early summer 1506, and there is a marked contrast between Matthäus's good quality clothes, which are now in poor condition, and the more robust, well-cared for clothes of the cowherd.

Headwear/hair: Matthäus wears the same dark chestnut brown bonnet seen in I 6. It has a split brim. The back brim is turned down, the front brim is turned up, and the crown is shaped into a point. Matthäus has a short bob, which covers his ears. In contrast, the cowherd has a bright red bonnet with a narrow brim. His blond hair is less groomed and comes down to his collar.

Body garments: Matthäus wears a mid-gray, knee-length, gown with a rich forest green, turned-back wide cape collar. It is a continuous collar with a center-back seam. The green continues down the front as a facing or possibly a lining. The gown is torn as a result of his adventures. The cowherd has a bright blue long-skirted doublet or coat, similar to that worn by the gravedigger in I 2. It has a round neck, fairly fitted sleeves, and the skirts come to his mid-thighs.

Linens: None are visible.

Legs: Matthäus's legs are bare, but the cowherd has white hose. Matthäus's lack of hose is surprising and may be intended to suggest how ragged his appearance has become.

Footwear: Matthäus has black shoes, which are showing signs of wear including holes, while the cowherd has black leather boots, the light brown tops of which are turned down. There is a slash in the outside and inside of the top/cuff.

Accessories: Matthäus is feeding a black mouse or vole to a female sparrow hawk, which sits on his right hand. The yellow cord jesses are looped around his right hand. He has a belt with a pen case and ink pot, probably made from leather or *cuir bouilli* (see I 11 for a closer view). Next to him there is a book with a red binding, and two pairs of clasps keep it closed. He has a cane tucked under his left arm.

Other figures: An older woman in the background is dressed in a bright red gown and a white linen coif; she drops bread out of a window to reward Matthäus for his singing.

Gilding: None present.

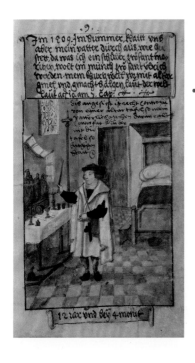

Image I 8 [verso]

On 28th February, 1508, I returned to Augsburg. There my father clothed us all in this manner, the many brothers, and this pleased me during my leisure time [kurzweil] when I came out of school, as related in "The Course of the World" page 10 in chapter 7. Text in the Image: This face is portrayed from an altar painting in Sant Ulrich.

Text below: 11 years, 8 days old.

Note: It was common for siblings to wear the same fabrics and even identical dress. Schwarz does not show his brothers, but, as in all subsequent images with more than one figure of his age, shows different versions of himself.

Clothing overview: Matthäus is in his school clothes but is shown playing games outside school hours.

Headwear/hair: Matthäus is bareheaded and his hair is quite long, covering his ears; he has a pronounced fringe.

Body garment: He has a knee-length gown made from leaf green cloth. It is loose fitting with a turned-back shawl collar. It is front opening, and it is wrapped around his body. The fronts of the gown are flat with extra fullness at the back, falling in folds, rather than set pleats. It has full-length sleeves. The long slit in the sleeve runs from his shoulder to his forearm, revealing either his white doublet underneath or the linen of his shirt, implying he is wearing a sleeveless doublet underneath, pointed to his hose.

Linens: If he is wearing a sleeveless doublet, then the sleeves of his shirt are visible through the slit in the gown's sleeves.

Legs: He wears matching, plain light green hose, which are probably made from cloth cut on the bias.

Footwear: He is wearing flat, black ankle-height shoes.

Accessories: He has a red school bag worn over his shoulder, a larger version of the bag in I 4. He has a black girdle around his waist, from which hangs a black leather pen case and ink pot. He is playing with a hoop and stick in the foreground; he has his hawk on his left wrist in the background on the left, and he is playing marbles on the right (compare II 11).

Other figures: The small figure in the shop on the right is dressed in a bright red doublet with a low neck, a white shirt, and a red bonnet.

Gilding: On the items in the shop in the background. This use of gilt paint suggests this might be a goldsmith, and behind him some tools hang up on the back wall.

Image I 9 [recto]

In summer 1509 my father clothed us like this. I was a pupil at St. Moritz and wanted to become a monk in St. Ulrich. I enjoyed looking at altar paintings and carved statues of saints, as related in "The Course of the World," page 10 in chapter 7.

Text in the Image: This face is well captured from an altar painting, which my father commissioned, in which many children are portrayed—not the panel that stands opposite [?].

Erased in the margins: This year there was the great shooting match in Augsburg, and on 7 September, my father's house burnt with everything here, and I found just one carved statue of a saint in the fire.

Text below: 12 years and about 4 months.

Note: The Moritz-school was the most popular among Augsburg's schools at the time.

Clothing overview: In summer clothes chosen by his father. It is not surprising that a child of his age would have their clothes chosen and bought for them, but it is interesting that

he points this out (as he did in I 8 too). The gown and doublet are more adult in their cut and well suited to his going to the St. Moritz school.

Headwear/hair: Matthäus is wearing a dark red-brown cap of blocked wool felt. The brim is slashed and turned up at the front and down at the back. The crown is formed into a cross shape. His hair is still cut just below his ears.

Body garments: He is wearing a loose-fitting, primrose yellow wool gown, with a wide turn-back collar. It is made from a lot of fabric, which is emphasized by the deep folds of the gown. It has long, hanging sleeves. They have a fancy opening near the top, which his arms pass through, plus a second close to the end of the sleeve. The opening near the top is trefoil-shaped, while the one near the end is a simple horizontal slit. The gown is worn over a black doublet, with a discernible scrolling repeating pattern, suggesting it is possibly a stamped or printed wool (gaufrage). It has a low straight neck and fairly loose-fitting sleeves that narrow at the cuffs.

Linens: Very little of his shirt is evident with the exception of a small ruffle at his wrists.

Hose: He is wearing blue/gray hose that are probably either wool or linen.

Footwear: He has flat, black ankle-height shoes.

Accessories: His red bag hangs from a long strap under his left arm, with his black pen case and ink bottle attached. These are the marks of a schoolboy. There is a small bell on the floor underneath the altar, possibly to call a servant.

Furnishings: His high wooden tester bed has a wooden step up to it. It has a bright red coverlet, white linen sheets, and pillowberes. There is a metal chamber pot, possible latten, underneath it. On the other side of his room, there is a small altar. It is covered with a white linen altar cloth with a long decorative fringe. Draped over the altar is another length of linen with broad gold stripes.

Gilding: On the altar, the white linen over the altar and on the bracket holding the candle.

Image I 10 [verso]

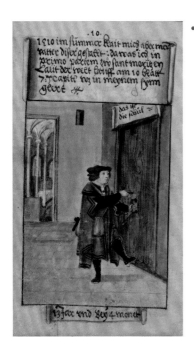

In summer 1510 my father clothed me in this manner. I was in the first part of St. Moritz, as related in "The Course of the World" on page 10 chapter 7, and considered myself learned.

Text in the Image: This is the school.

Text below: 13 years and about 4 months.

Clothing overview: A year later and subtle differences can be seen in his school clothes. While his father still may be choosing his clothes, he is given some variety.[17]

Headwear/hair: Matthäus is wearing a similar style of bonnet to that in I 9, with the same pointed crown and divided brim, but this time it is a redder brown. His hair is a similar length covering his ears.

Body garments: He has a soft smoky blue, mid-calf-length gown with long-hanging sleeves, also similar in cut to that in I 9. The hanging sleeves have two slits to pass his arms through. It has a wide cape collar, which extends over his shoulders. The gown is decorated with two narrow black guards down both fronts, around the edge of the cape collar, the hem, and the sleeve openings. He has a black doublet made from a self-patterned fabric. The doublet has a round neck. It is open at the center–front, and the fronts are secured with a pair of black points/ties in a bow. The sleeves are quite fitted.

Linens: He is wearing a white linen shirt with round neck that echoes the neckline of his doublet.

Legs: He is wearing black hose, which complement his doublet.

Footwear: The black shoes are rather indistinct but probably have ankle-height vamps. The shoe on the right foot appears to have quite a thick, pale-colored sole.

17. Compare with the self-portrait of Dürer at age thirteen; see Albrecht Dürer, *Self-portrait*, 1484, silver point, 27.5 × 19.6 centimeters, Albertina, Vienna; Wölfflin, 22, fig. 1.

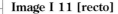

Accessories: He has a brown bag with a gathered top and a long strap. It is much bigger than the previous school bag, suggesting that he has more work to do now. Tied to the back of his bag are his black pen case and ink pot.

Gilding: A little on the altar in the background.

Image I 11 [recto]

At the end of 1510, I threw away my school bag. My desire was to see foreign lands, and I liked to be dressed in this way.

Text in the Image: This is when I started to keep records, everything had to be described, as related in the book's 9th chapter on page 12.

Text below: 12 years, minus two months.

Clothing overview: In late 1510 he leaves school at fourteen and celebrates by discarding the mark of a student—his school bag. He is also free to select his own clothes and takes pleasure in doing this.

Headwear/hair: Matthäus has a bright red bonnet, which has a split brim and pointed crown. The brim is turned up at the front and worn down at the back. His hair has been cut, and it is now just below his ears.

Body garments: He wears a dull mid-gray, knee-length riding coat/gown with a bright green lining. The coat has a round neck trimmed with green. The coat is smooth at the front and fastens at the side on his left shoulder and down the left side. No waist seam is visible at the front. The fabric at the back could be pleated going into a seam at the waist. The pleats are probably stitched in place and lined to make them hold their shape. The full sleeves are drawn in slightly at the wrist, and the end has been turned over, either to shorten them or to form a small cuff. By doing so it reveals the green lining. The green lining is visible where the front has turned back to reveal it.

Linens: There is no sign of his shirt.

Legs: He is wearing bright red hose, which make a striking contrast with the green lining.

Footwear: He has more elegant black shoes, which are quite wide at the front. The vamp only covers his toes, while the quarters come up higher at the heel, and there is a small strap over the top of his foot.[18]

Accessories: He is standing on his discarded school bag (*schulsack*) and his pen case and ink pot are next to it. The bag has a simple drawstring closure and a long strap. Attached to it are his black pen holder and ink pot. Inside the bag is a black-covered book, and next to it there is a sheet of paper and another simpler book or pamphlet.

Gilding: A little on the pen holder and ink pot.

Image I 12[19] [verso]

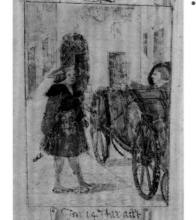

In 1511, I worked for my father on the wine market and in the tavern, I liked to be fitted out in this manner [Rüstung], gray and green.

Text below: Aged 14.

Clothing overview: By 1511 Matthäus has started to represent his father in business matters and uses his clothing to stress this role.

Headwear/hair: Matthäus wears a pale gray bonnet with an upturned brim, which is slashed at the sides. His straight hair is trimmed in a bob. The vintner has a black bonnet with a very wide brim, which is worn diagonally over his right ear. He has wavy, chin-length hair.

18. Goubitz, *Stepping Through Time*, 276, fig. 1a and 1b.
19. This image is in poor condition. The next page is blank.

Body garments: Matthäus has a gray, knee-length gown with a wide black collar. The gown has full sleeves, which hang down, with a long slit through which his arms pass through. The fronts of the gown are quite flat, while it is quite full and gathered in pleats at the back. It is worn over a black or very dark gray doublet with fairly fitted sleeves and a low neck. The vintner has a bright red garment, probably a doublet or a short coat, with full-length sleeves and a round neck.

Linens: Matthäus has a white linen shirt, which can be seen above the neck of the doublet. At best, there is a hint of the collar of the shirt worn by the vintner.

Legs: Matthäus has leaf green hose.

Footwear: His black shoes are not very clear, but they are very wide at the toe and have narrow vamps that just cover his toes.[20]

Accessories: Matthäus holds a green glass beaker in his right hand, suggesting that he is sampling the wine. He has a black belt or girdle worn over his gown. It is worn quite low, so below the waist, at hip level. He has several items tucked into it, including a little brown leather purse.

Weapons: This is the first time that he wears a sword with a broad blade in a black scabbard on his left hip, and his left hand rests on the gilt hilt. There is a dagger in a black scabbard hanging from his girdle.[21]

Cart: There is a four-wheeled cart heavily laden with large wine barrels. Some of the under-drawing on the barrels can be seen, and the perspective on the cart is quite sophisticated.

Gilding: None apparent, but this could reflect the condition of the image.

Image I 13 [blank] [recto]

Image I 14 [verso]

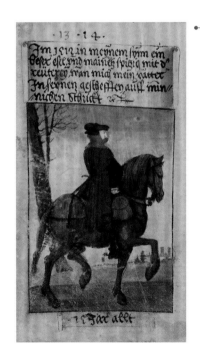

*In 1512. In my mind I was a bad ass [*ein beser esel*], and very keen on horse riding when my father sent me to Munich for his business.*
Text below: 15 years old.

Note: Fink suggests that the expression "being like a bad ass" related to the notion that young adults were unbalanced in their passions. Albrecht Dürer's contemporary woodcuts and engravings popularized the naturalistic depiction of horses.

Clothing overview: As suited to a young man of his age and status, Matthäus has learned to ride, and this gives him much more independence. It also means that he needs clothes for travel.

Headwear/hair: He wears a brown cap with a split brim. The front section is turned straight up, and the back is worn down. The bonnet is worn over a red hood, which covers his chin and extends down onto his shoulders; it might be knitted or made from wool cloth.

Body garments: He wears a brown wool gown or riding coat, which is calf length. The gown is slit up the back to the waist, allowing the material to fall on either side of the horse's body, covering the rider's legs and keeping them dry while in the saddle. The gown is pleated heavily at the back. It has long-hanging sleeves with two openings, and his arms have been put

20. See the parts of a man's welted shoe from an excavation at 10 Downing Street, London, c. 1510, illustrated in J. Swann, "English and European Shoes from 1200 to 1520," in *Fashion and Clothing in Late Medieval Europe*, ed. R. C. Schwinges and R. Schorta with K. Oschema (Riggisberg and Basel: Abegg-Stiftung and Schwabe Verlag, 2010), 20.

21. Compare with the very expensive gilded rapier in the slightly later portrait of a younger Italian boy of higher status, Anonymous, *Portrait of a boy*, c. 1545, National Gallery, London, NG 649, illustrated in Capwell, *Noble Art of the Sword*, 46, fig. 11.

through the upper slit. The gown is worn over a black doublet with quite fitted sleeves. As it is winter, for extra warmth he may be wearing a jerkin that is not visible.

Linens: None of his shirt is visible.

Legs: He has black hose, which match his doublet.

Footwear: His black ankle-height shoes are decorated around the top edge of the vamp with a zigzag series of cuts. They are worn with black rowel spurs with long necks.

Accessories: He has a large red bag, with a flap and an external pocket. There is a hint of a purse frame at the top of the bag.[22] The bag is probably hanging from the pommel of the saddle rather than his girdle. He might be wearing gloves, which would have been the norm when riding.

Weapons: He has a sword in a black scabbard on his left hip.

Horse/horse harness: He is riding a chestnut stallion or gelding, which is trotting with a high-stepping action. It is well trained, and the head position suggests that it is on the bit. The horse has a long mane, and the tail is knotted.[23] The horse has a black bridle without a nose band, a curb bit, and single reins. The straps over the horse's quarters, the stirrups, stirrup leathers, and saddle are all black.[24] The harness is quite simple except for some black pendants on the quarters.

Gilding: None present.

Image I 15 [recto]

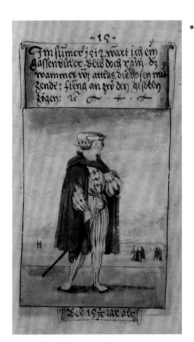

In summer 1512, I was flirting in the streets but remained pure. The doublet was silk satin, the hose taffeta. I began to join my peers.

Text below: About 15 ½ years old.

Clothing overview: When not traveling on family business, Matthäus was out with his young male friends in a very striking doublet and hose designed to attract female attention.

Headwear/hair: He wears a white, close-fitting felted bonnet with a flat crown. It has a split brim, which is turned up at the front and down at the back, where it is decorated with diagonal cuts held with tiny black points tied in half-bows. His hair is quite short, following the line of the bonnet's brim.

Body garments: He has a gray, knee-length gown, which has narrow-hanging sleeves with a long vertical opening. He has placed his right arm through the upper slit in the right sleeve, while the left sleeve has been wrapped around his neck and over his right shoulder. The end of the right sleeve has an integral glove or mitten at the end, which is rather surprising inclusion for a summer gown. The gown has a stand collar, possibly grown-on. Underneath the gown is a front opening white doublet of silk satin, which is decorated with wide gray vertical and horizontal stripes.[25] The fronts of the doublet have been cut back to create a v-shape, and the two sides are kept together with three pairs of black points tied in half bows. There is probably a button or hook and loop at the waist.[26] The doublet has full sleeves that narrow toward the wrists.

Linens: His shirt probably has a fairly high neck. The shirt is visible on his chest, or this might be a white stomacher instead of a shirt.

22. Compare with the bag of a similar style hanging from the girdle of the man in the foreground with his back to the viewer in Albrecht Dürer, *Passion: The Entombment*, 1512, 11.5 × 7.1 centimeters, The Metropolitan Museum of Art, New York; Wölfflin, 193, fig. 83.
23. Compare with Albrecht Dürer, *The small horse*, 1505, engraving, 16.5 × 10.8 centimeters, and Albrecht Dürer, *The large horse*, 1505, engraving, 16.7 × 11.9 centimeters, Victoria and Albert Museum, London.
24. For a horse with harness, including the straps over the rump, see Albrecht Dürer, *St Eustace*, c. 1501, engraving, 35.7 × 26 centimeters, London: British Museum; Wölfflin, 115, fig. 40.
25. Some of the stripes look pink, but this is where the pigment has been abraded rather than the true color.
26. Both types of fastening can be found on surviving doublets.

Legs: He is wearing parti-color white and gray striped hose, probably made from wool. The panes have not been stitched together from above the knee to the hips where they are joined. A green taffeta (*zendl*) lining can be seen behind the panes, and there would have been a foundation layer (possibly fustian) from the waist to the knee behind the panes. With the exception of I 5, this is the first time he is depicted with a codpiece since he reached his teens. It is spherical, striped white and the gray, which makes it very eye-catching.[27]

Footwear: He has black shoes of the cow-mouth shape, which he wears for the first time. The vamp is very low at the front, and the shoe has a very slight heel.

Weapons: Matthäus has a sword in a black scabbard attached to his black girdle with hangers. The sword looks very long but quite narrow and with a long hilt.

Other figures: There are a number of small male and female figures in the background. It is likely that he is the male figure, talking to two women, in the group to his immediate left.

Gilding: None evident.

Image I 16 [verso]

This was me riding as my father sent me to Lake Constance, toward Lynda and Costnitz, etc., in 1512 and 1513.
Text below: Aged 16.

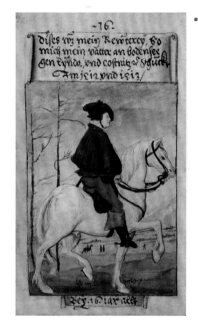

Note: Schwarz was sent to Lindau and Constance, in the Lake Constance region, which borders Switzerland.

Clothing overview: A more flamboyant, if slightly less practical set of traveling clothes than in I 14 that he wore for a period of a year or so. The riding coat may be a cut-down version of the gown worn in I 14, and if it is, it demonstrates the recycling of clothes.

Headwear/hair: Matthäus has a black bonnet, with a slashed brim, which is decorated with thick pile (possibly thrummed) and is worn at an angle over his left ear. The bonnet extends down around his head, and this section is slashed with three diagonal cuts. It is possibly made of felted wool, and it is secured with black ties, which go around his head, under his chin, and the ties are fastened in a bow on the top of his head. His hair is cut short, extending just beyond the line of the bonnet.

Body garments: He wears a chestnut brown, short-sleeved riding coat, and the fullness in the back suggests that it is possibly made from a full or three-quarter circle. The fabric falls in deep flared folds at the back, and it is held in at the waist, possibly with a girdle, to keep his lower-back warm, and then it flares out below for a few inches. It has long sleeves with what appears to be a turned-back cuff. The sleeves are left hanging. There is a grown-on collar at the back. It is worn over a black doublet but only the right sleeve is visible. It looks to be fairly close-fitting, and the collar of the doublet is similar in shape to the collar of the riding coat.

Linens: No body linen visible.

Legs: He wears tight red hose with no obvious decoration.[28]

Footwear: His black leather boots are turned down just below the knee or have a deep cuff of brown leather, and there is a deep split at center-front of the cuff. The boots are worn with long-necked, black rowel spurs.

Accessories: He appears to have bare hands but he would have worn gloves.

Weapons: He has a sword in a black scabbard on his left hip.

27. For much more detail of the round, purely decorative codpiece and the actual front opening of this style of hose, see Anonymous, *Portrait of a man*, 1525, Gemäldegalerie, Kunsthistorisches Museum, Vienna, 887, illustrated in Capwell, *Noble Art of the Sword*, 29, fig. 3. The front opening is secured with Turk's head knot buttons and loops.
28. For a similar pair of plain hose seen from the front, see Tod und Handwerker in Tripps, *Den Würmern wirst Du Wildbret sein*, 83.

Horse/horse harness: He is riding a gray stallion or gelding, which has a full, long mane and loose tail. It moves with an active, high-stepping trot. The horse has a black double bridle, with a curb bit, neck strap, saddle, and stirrups. There are black bosses on the bit. The padded knee roll and the seat of the saddle are just visible. There is something tied up behind the saddle, possibly a small pouch with drawstrings or a length of cord. The horse's shoes have a single stud at the back of the hoof intended to provide more grip so well suited for travel.

Other figures: A few other small figures are present in the background, one of horseback and the other three walking.

Gilding: None present.

Image I 17 [recto]

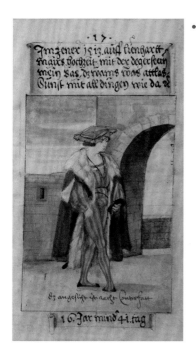

In January 1513 at Lienhart Mair's wedding with my cousin Degerstein. The doublet was silk satin, otherwise exactly as here.

Text in the Image: The face is well portrayed.

Text erased in the margins: In this gown you read [. . .] I fell with many, and many on me [. . .] I had the head pushed into some cow dung, it was useless [. . .]

Text below: 16 years, minus 41 days.

Clothing overview: At 16 Matthäus presents his first set of clothes for attending a wedding, a real opportunity to dress flamboyantly. His clothes are adult, opulent, and also acknowledge it being mid-winter. Even so, his reference to the clothes being ruined reflects his youth.

Headwear/hair: Matthäus has a distinctive, gray, square bonnet with a slashed double thickness brim. There are three slashes on each side of the bonnet and there is a little gray aglet at the top of each slash. It is quartered on the top, to create a little height, and it is worn at a slight angle toward his right ear. He has short hair.

Body garments: A mid-calf length, gray gown with a pale fur lining, which is possibly lynx. It has a large fur turned-back collar and very short sleeves, which are also fur lined. The sleeves come to just below the elbow, but they might be hanging sleeves. His doublet is made from red and yellow striped satin, and the front is cut in one piece, so it is side fastening. It has a low round neck. The right sleeve gives an indication of their fullness and how they end tightly at his wrist.

Linens: He wears a fine linen shirt with a wide neck, which is low over his chest but comes up onto his shoulders. The neckband is decorated with a diagonal design worked in gilt thread. It looks to be a very voluminous shirt. This is suggested by the mass of little folds in the linen at the front of the shirt, and the shape of the doublet sleeves suggests it has very full sleeves too.

Legs: His very close-fitting hose have red and yellow vertical stripes,[29] and the stripes of the doublet and hose line up at the waist. The hose have a round codpiece worn quite low, which is also striped in red and yellow.

Footwear: He has black cow-mouth shoes that are low over the toes, while the quarters come up high around the heel.

Jewelry: This is the first time he wears a crucifix on a black silk cord.[30] The dark color of the crucifix suggests it is silver.

29. Compare with the tight-fitting striped hose worn by the executioner (red, white, and green) and the figure on the far left (red and white), in the central panel of Lucas Cranach the Elder, *The Martyrdom of St Catherine*, 1506, oil on lime panel, 126 × 139 centimeters, Gemäldegalerie, Dresden; Dunkerton, *Dürer to Veronese*, 55, fig. 62. Also see the black and yellow striped hose worn in the scene depicting May, in *Feste und Bräuche*, 102.

30. He will continue to wear it until 1523. For another example of pendants worn on a black cord or ribbon, see Gerlach Flicke, *Sir Peter Carew*, 1549, Collection of the earl of Yarborough, plate 43, Scarisbrick, *Jewellery in Britain*, 109.

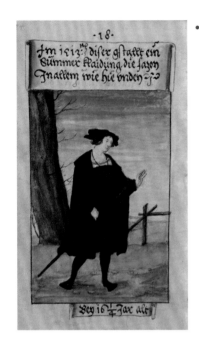

Weapons: He rests his left hand on the curved, black hilt of his sword, which is in a black scabbard. He has a black girdle with hangers.

Gilding: Used to indicate the decorative band on the neck of shirt.

Image I 18[31] [verso]

In 1513, in this manner: summer clothes, made in the style as shown below.
Below the image: Aged 16 ¼.

Clothing overview: Matthäus is all in black for the first time. The differences in the textures and self-colored patterns of the textiles provide a lot of interest in this set of summer clothes.

Headwear/hair: He is wearing a black bonnet with a low, full, quite puffy crown and a wide split brim. It is turned up at the back and slashed at the side. The brim at the front is rather floppy and so accentuates the shape of his face. This style of brim is the reverse of those seen so far. The hat looks to be quite thick, possibly made from felt or felted knitting. His hair has grown a little.

Body garments: He wears a black gown, which comes to just below the knee. It has a wide, cape collar (possibly of a different fabric to the body of the gown) and long, hanging sleeves, with one long vertical slit in the sleeve to allow the arm to pass through. The gown is not made with a lot of fabric, so it hangs down without forming a lot of folds. It is worn open to display the doublet. His black doublet is made from silk damask with a very large pattern repeat, and the motifs are very clear on his left sleeve. It has a wide, straight, low neck, and the front is made from fabric that has been padded, with the padding stitched into place vertically. The stitching lines go right up to the neck, indicating that is has probably been quilted. The sleeves are quite full, but they narrow toward the wrists, although they are quite loose at the wrist itself.

Linens: Matthäus wears a low-necked shirt and the neckline is worked with a thick band of gilt metal thread embroidery. The shirt is not visible at his wrists.

Legs: He has plain black hose, but it is very difficult to see any detail above the knee.

Footwear: The black cow-mouth shoes have low-cut vamps but not much other detail is evident.

Jewelry: His silver crucifix is on a black, probably loop-manipulated cord around his neck.

Weapons: A sword with a black hilt, in a black scabbard, is worn on his left hip with a black girdle and hanger.

Gilding: On the neck of his shirt.

Image I 19 [recto]

In March 1514, in this manner. The gown with a border of silk satin, the doublet silk satin, the hose with yellow taffeta. This is when I started to record my clothes.
Erasure at the margins: The gown was lined [. . .] material [. . .] I had to [. . .]
Text below: Aged 17 and 1 month.

Clothing overview: It is telling that at the point when Matthäus begins to record his clothes as they are made, he is wearing a very fancy pair of hose. The slightly warmer spring weather may explain the increased use of silk.

Headwear/hair: He has a scarlet bonnet with a wide brim, slashed at the center-front and at the sides. There is a double length of scarlet cord under his chin. There is a small

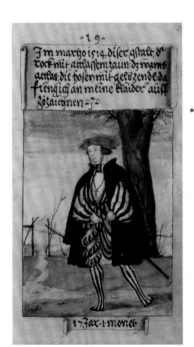

31. Omitted from Braunstein, *Un Banquier Mis a Nu*.

scarlet tuft in center of the bonnet's crown, and the bonnet is worn flat on his head. His hair is cut short in a bob.

Body garments: He wears a black knee-length wool gown. The gown has a small stand collar, which has been folded over and flares out slightly. The gown is worn open at the front, and it has very wide, hanging sleeves with a long slit. The double guard—made of bands of satin of equal width—is crossed with short vertical strips at regular intervals. The guards decorate the end of the hanging sleeves and the hem of the gown. It is worn over a black and white satin doublet with very full sleeves that finish tightly at the wrist. The doublet has vertical stripes on the sleeves and the fronts. The smooth shape of the sleeves suggests that they were made with a very fine layer of padding. The doublet has an upright collar, which is fastened with three black buttons, and the doublet is also fastened at the waist with a lace and pointed to the hose. However, both fronts are cut away between the base of the collar and the waist to reveal an oval section of his white placard and so provide a visual point of contrast with his gown and doublet. His chest is covered with a white placard.

Linens: The shirt probably has a high collar, but it is not visible.

Legs: Matthäus has black and white asymmetrically paned hose. On his left leg, the hose are striped in black and white from the waist to his hip. From his hip to his knee, the hose are paned vertically, and each pane is half black and half white. In between each pane it is possible to see the bright yellow taffeta lining. The position of his gown means that it is not possible to see what happens at the knee. Below the knee, the hose are striped in black and white. On his right leg, the hose are striped black and white from waist to hip. From the hip to the knee, there are three horizontal cuts, allowing the hose to form into four rolls or swags through which the yellow taffeta lining is visible. It is likely that he has a codpiece, but it is not easy to distinguish because of the stripes.

Footwear: He has black cow-mouth shoes, which have low-cut vamps that just cover his toes.

Jewelry: He wears a crucifix on a black silk cord.

Weapons: He has a sword with a round black pommel, and the grip is wrapped with black cord or black wire. It is in a black scabbard and worn hanging from a black girdle and hanger.

Gilding: None present.

Image I 20 [verso]

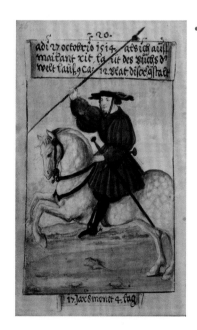

October 27, 1514, in this manner, when I rode toward Milan, as described in the book of "The Course of the World" in chapter 9, page 12.
Text below: Aged 17 years, 8 months, 4 days.

Clothing overview: Matthäus's autumn travel clothes are in a new style for his journey to Milan. This suggests that travel not only brought him into contact with new styles but also provided him with an opportunity to show off his fashionable appearance.

Headwear/hair: He has a black bonnet, which he wears flat on his head. It has a very flat profile and a very wide slashed brim. There are two, very loose, black ties looped under his chin. His ear-length hair is cut in a bob.

Body garments: He is dressed in a riding coat/gown of mid-gray wool.[32] The riding coat has a small upright collar. It has a smooth front and a side fastening. The upper section of the riding coat's sleeves is voluminous with vertical pleats, and the full shape is probably created using a combination of padding and stay-stitching. The lower section of the sleeve from the elbow down is fitted more closely to the arm. The two sections are joined with three pairs of black points with gold aglets, which are tied in a half bow. The riding coat comes in at the waist

32. For a similar style garment, see "Tod und Kaufmann," in Tripps, *Den Würmern wirst Du Wildbret sein*, 75.

and then has full, pleated skirts, which come to his knees. There is a split at the back of the skirts, allowing them to fall on either side of the horse's back.

Linens: His shirt is not visible apart from a tiny ruffle on the edge of the neckband.

Legs: His black hose are visible from the knees down if he is wearing short boots, but hose are not visible if he is wearing long boots.

Footwear: His black ankle or over-knee boots have black rowel spurs.

Weapons: He has a sword in a black scabbard worn on his left hip, a dagger in black scabbard on his right hip, and he holds a spear in his right hand. The lance has a black tassel below the spear head. The sword and dagger both hang from a black girdle and hanger.

Jewelry: There is a gold and black twisted wreath on the brim of his hat. His crucifix is on a black cord around his neck.

Horse/horse harness: He is riding a dapple-gray horse, possibly a mare, which is depicted in a much more active gait than the previous horses he has been riding. The horse has a black bridle with no nose band, round bridle bosses, a curb bit, chest strap, stirrup leathers, and stirrups. The skirts of the saddle are visible below the skirts of his riding coat. He also has a brown girth.

Gilding: The gilt wreath on his bonnet, the aglets on the sleeves of his gown.

Image I 21[33] [recto]

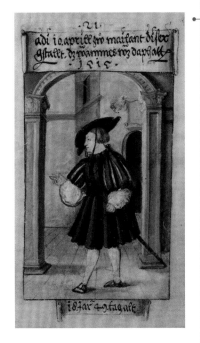

10 April, in Milan, in this manner. The doublet made from a half silk. 1515.
Text below: Aged 18 and 49 days.

Clothing overview: Once in Milan, Matthäus takes an interest in local fashions, and this influenced his choice of summer clothing.

Headwear/hair: He is wearing a black bonnet, with a very broad brim and deep slashes, which is worn angled over his right ear. The black ties of the bonnet loop under his chin, but they are not tightly fastened. The bonnet looks to be quite substantial and might be made from a very thick felt or felted knitting. His hair has grown longer over the six months since I 20.

Body garments: His dark gray and black striped riding gown has a flat front, suggesting that it is side fastening.[34] It has elbow-length, paned sleeves and pleated knee-length skirts. The skirts fall into deep folds, suggesting that they are padded, have a thick inter-lining or there are stay-stitches helping to form the pleats, so giving it this profile. The vertical panes of the sleeves are dark gray with narrow black borders, and they are joined at the shoulder and the elbow. The gown has a round neck, which comes to the base of his neck. There is no collar. Under the gown he is wearing a white half-silk doublet. Not much is visible but the doublet has very full sleeves, which finish tightly at the wrist.

Linens: Just the tiny ruffle edging the neckband of his shirt is visible.

Legs: His white hose, matching the doublet, can be seen from the knee down.

Footwear: He is wearing black shoes, which are quite wide at the toe. The details are not very clear, but the vamp appears to come to the base of his ankle, and they are slashed, making a strong contrast between the black of the shoes and the white of the hose.

Jewelry: His crucifix is on a black cord around his neck.

Weapons: He has a two-handed long sword in a black scabbard, and he rests his left hand on the hilt. While not easy to see in this image, he would be wearing a black girdle and hanger.

Gilding: None present.

33. Omitted from Braunstein, *Un Banquier Mis a Nu*.
34. Compare with the clothing worn by the Swiss Guard—detail from the Raphael, *Mass of Bolsena*, 1511–4, fresco, Apostolic Palace, Vatican City.

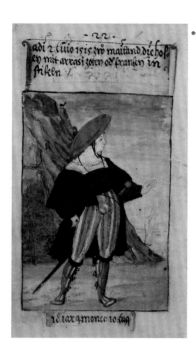

Image I 22[35] [verso]

On 2 July, 1515, in Milan, the hose with silk tassels from Arras, in boots. [A further sentence has been erased and is illegible.]

Text below: Aged 18 years, 4 months, 10 days.

Clothing overview: The gown does not help to show off his doublet and hose to their best. However, spending time in Milan is providing Matthäus with more opportunities to experiment with his appearance.

Headwear/hair: He is wearing a broad red bonnet with a shallow crown and wide brim that is slashed at the center-front and center-back with a deep v. It is worn at a slight angle over his right ear. There is a double black cord or ribbon looped under his chin. His hair is only just visible but looks to be in the usual short bob.

Body garments: His short, knee-length, black gown is worn open at the front, but it could fasten across his chest at waist height if he wanted. A pair of black points with gold aglets hang down from the waist of the right front. It has short, very wide sleeves with inverted pleats. His black doublet has a low square neck, which turns down at the corners, and full sleeves, which finish closely around his wrists. It is side fastening, and it has a smooth, flat front. It is decorated on the chest and sleeves with lengths of applied red passementerie arranged to form a diamond pattern.

Linens: His linen shirt has a wide, round neck. The neckband is edged with a small ruffle and decorated with a double band of blackwork embroidery. A hint of the wrist ruffle is evident on his left wrist.

Legs: He wears striped, tightly fitting hose with a round codpiece. The hose have vertical stripes of white, green, red, and blue. The edges of the stripes appear to have a fringed edge, possibly the silk borders that he refers to. There are black garters tied under his knees.[36]

Footwear: He has brown leather, knee-length boots, which have a horizontal slash over the toes, two vertical slashes on the top of the foot, and rows of vertical slashes on the inside of the calves. The boots fasten up the inside of his leg with three pairs of black points tied in half bows. The stripes of his hose show through the slashes in his boots.

Weapons: He wears a sword on his left hip with a gilt pommel, and the grip is wrapped with gilt wire. It has a black scabbard and is suspended from a black girdle and hanger.

Jewelry: He appears to wear a large dark ring on his right hand. There is a black cord around his neck and his crucifix hangs from it.

Accessories: The black points have gold aglets.

Gilding: The sword pommel and grip, the aglets.

Image I 23 [recto]

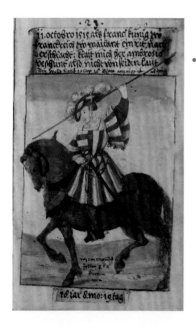

October 11, 1515, when Francesco, king of France, rode into Milan after the battle, master Ambrosio Veschunt clad me in this way, not from silk, as is related in every detail in "The Course of the World," 10th chapter, page 10.

In the image: This was an English horse, worth 80 crowns.

Text below: 18 years, 8 months, 9 days.

Note: This pose is modeled on a woodcut in Maximilian I's *White King* and once more demonstrates how Renner and Schwarz took inspiration from contemporary prints. Francis I

35. Omitted from Braunstein, *Un Banquier Mis a Nu*.
36. While a new style for Matthäus, it had been popular since the early 1500s. See the figure of the executioner who has garters tied under each knee, with the knot to the front, in the central panel of Lucas Cranach the Elder, *The Martyrdom of St Catherine*, 1506, oil on lime panel, 126 × 139 centimeters, Gemäldegalerie, Dresden; Dunkerton, *Dürer to Veronese*, 55, fig. 62.

entered Milan after the Battle of Marignano in September 1515. Schwarz miscalculates his age (eighteen years and seven months).

Clothing overview: Matthäus was still in Milan when Francis I, king of France arrived. He demonstrated his loyalty to the French cause by wearing these clothes. It is significant that he notes that they are not made from silk and they were not his choice. Whether this refers to the style of the garments or the pro-French sentiments, he does not say.

Headwear/hair: He has a bright blue bonnet with a deep, upturned brim that is slashed and laced with a lightweight yellow half silk. The top of the bonnet is decorated with a mass of large yellow ostrich feathers.[37] It is kept on his head with long yellow ties, which are knotted under his chin. His hair is cut in the usual short bob.

Body garments: His wool riding gown is made from wide blue and yellow stripes. It has a low square cut neck, and very wide elbow-length sleeves. The neck is bound with a dark yellow or gilt passementerie. The gown is fairly flat on the chest, suggesting that it has a side opening. The full skirts come to his knees, and there may be some padding and stay-stitching in the skirts, to help them fall in thick folds. The stripes are horizontal on the right sleeve and the right half of his chest, while they are vertical on the left sleeve, the left half of his chest, and on the skirts. The sleeves are made from one rectangle of fabric, which has been left open along the bottom edge but fastened with three pairs of black points with gilt aglets tied in half bows. There are several fleur-de-lis in gold—probably embroidered but possibly painted—on both the blue horizontal and vertical stripes on the chest of his riding gown. He wears a blue doublet under his riding gown, of which just the moderately fitted sleeves are visible.

Linens: He wears a white linen shirt with a wide, round neck, which sits partway down his shoulders. The neckband is decorated with a wide border of gilt thread embroidery.

Legs: His dark blue hose are decorated with a single, gold fleur-de-lis on the left calf.

Footwear: Black ankle-height shoes are worn with black rowel spurs.

Weapons: He holds a spear/lance high in his left hand, and it is decorated with a black tassel. He has a sword in a black scabbard and a gilt chape on his left hip. The hilt contrasts the gilt pommel and the bright iron of the hilt. He has a black girdle and hanger.

Jewelry: There is a black silk cord around his neck. Whatever is hanging from it is concealed because it is tucked inside his riding coat, but it is probably his crucifix.

Horse/horse harness: He is riding a chestnut horse, possibly a mare, with one knot in the mane. He notes the horse's value and that it is English. She is trotting actively, and she is on the bit. All of the tack is black, probably leather covered with velvet, and there are a number of round gilt bosses on the bridle and the rest of the harness. It consists of a bridle, with very broad reins and a curb bit, a chest strap, a crupper, and straps over the haunches. Not much of the saddle is visible apart from the black girth, stirrup leathers, and stirrups.

Gilding: The fleur-de-lis on his riding coat and hose, the embroidery on his shirt, the pommel of his sword, and the bosses on his horse's harness.

Image I 24[38] [verso]

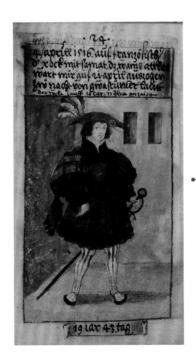

4 April, 1516, in the French manner. The gown with velvet, the doublet silk satin. This was taken from me on the night of 21st April by Goscoyne men, as related in "The Course of the World," 10th chapter, page 17.

Text below: 19 years, 43 days.

37. Compare with the bonnet worn by the captain of the mercenary band in Schön, *A Column of Mercenaries*. He was depicted on horseback and the wide brim of his bonnet was edged with feathers; see Erhard Schön, *A Column of Mercenaries*, c. 1532, woodcut, Herzog Anton Ulrich-Museum, Braunschweig.
38. Omitted from Braunstein, *Un Banquier Mis a Nu*.

Note: The men from Gascony presumably were French soldiers.

Clothing overview: Six months later Matthäus continues to favor the French style while in Milan. What makes it French includes the use of blue and yellow, the specific cut of the riding gown and the inclusion of the fleur-de-lis. However, the fleur-de-lis also appears on the coat of arms of the Fuggers, his employer .

Headwear/hair: His bright red bonnet has a wide standing brim. It is worn flat on his head and it is decorated at the back with six upright, alternating blue and yellow feathers, which are possibly ostrich feathers. His hair is a little longer than before and covers his ears completely.

Body garments: He wears a brown velvet, knee-length, riding gown with a low neck that comes to the base of his neck. The skirts fall in heavy pleats, and they are probably padded and stay-stitched to help create this shape. The pleats are stitched around the dropped waistline at the front and probably into a waistline at natural level at the back. The gown is double breasted, and it is side fastening. It has applied broad guards of black velvet, on the neckline, the sleeves, the dropped waist, and around the hem. The gown has full sleeves, which are made in two sections: the upper very full, padded section with deep pleats, which the arm goes through, and the lower, much narrower section, which is left hanging. On the upper part of the right sleeve, there are two applied guards of blue, which are embroidered or possibly painted with gold fleur-de-lis. Under the riding gown he wears a black silk doublet. The small collar and the lower part of the wide sleeves are visible where they have passed through the slit sleeve of the riding gown. The sleeves are quite full, probably padded, and they narrow at the wrist. The neck of the doublet has been left partially undone.

Linens: His shirt is just visible inside the collar of his doublet, suggesting that it has a small neckband, possibly edged with a ruffle.

Legs: His tightly fitting hose are striped vertically in blue and bright yellow.

Footwear: He is wearing black shoes with a round toe, and the vamps are quite low cut over his toes. There is a narrow strap across the arch of his foot.

Accessories: He has a sword with a black hilt. The pommel is gilded or set with a large orange-colored stone. It is in a black scabbard with a long gilt chape.

Jewelry: There is a large oval brooch, with a central dark stone or cameo set in a gold/gilt mount, pinned to the brim of his hat on the left side. His crucifix is hanging from the usual black cord around his neck.

Gilding: The brooch on his bonnet, the hilt of his sword, the fleur-de-lis on his sleeve.

Image I 25 [recto]

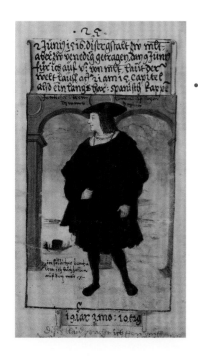

On 2nd June, 1516, in this manner in Milan, but I wore this in Venice; for on 9 June I moved from Milan to Venice, as related in "The Course of the World," page 21 in chapter 15: thus long hair, a Spanish cape, a Genoese bonnet, Lombard gown, the doublet a half silk.

Inside the image: I learned accounting in a barge like this on the sea. I brought these clothes to Augsburg, and they were made on the 28th April, 1516.

Text below: 19 years, 3 months, 10 days old.

Clothing overview: By the summer of 1516, Matthäus has moved to Venice, where he is wearing a mixture of styles, but they are given a degree of unity by all being black.[39]

39. It is reminiscent of Shakespeare's comment in *The Merchant of Venice*: "I think he bought his doublet in Italy, his round hose in France, his bonnet in Germany and his behavior everywhere," (Act 1, scene 2, lines 78–80).

Headwear/hair: His Genoese style black bonnet has no brim at the front and a wide upturned brim at the sides and back. His hair is now much longer, reaching just down to his shoulders.

Body garments: Matthäus is wearing a black Spanish cape[40] that is draped loosely around his shoulders. Underneath this he has a knee-length black Lombard riding gown or sayon with a low neck, which shows off large quantities of his shirt. It has hanging sleeves with a full upper section and a slit for his arms to go through. The opening in the lower part of the sleeve is secured with three pairs of black points with long gold aglets that are tied in half bows. The skirts of the riding gown fall in gentle folds. Finally, he has a black half silk doublet, but only the sleeves are visible. These are moderately full and fit quite loosely around his wrists.

Linens: The white linen shirt has a round neck that comes to the base of his neck. The neckband is embellished with a broad band of blackwork embroidery in a scrolling design, and it is edged with a narrow ruffle. There are lots of fine pleats, suggesting that there is a lot of fabric in the shirt.

Legs: He wears black hose, which are only visible from the knees down. No garters are evident.

Footwear: The black shoes have fairly round toes. The vamps cover the top of his foot with a v-shaped opening at the front, while the quarters fit around his ankle at the back.

Jewelry: The black cord around his neck suggests that he is wearing his crucifix, which is tucked inside his doublet. He has two gold rings on his left hand, on the second and fourth fingers.

Other figures: A figure dressed all in black steers the gondola or small boat in the background to his left, while the passenger, who is possibly female, is dressed in red.

Gilding: His rings, and the aglets on the points.

Image I 26 [verso]

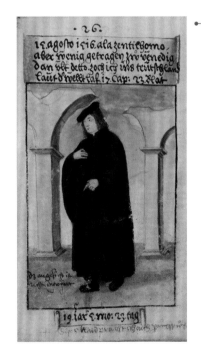

On 15 August, 1516, like a gentilhuomo [gentleman], but I wore this little in Venice, because I returned to Germany, as related in "The Course of the World," chapter 17, page 23.

Inside the image: This outfit I also brought to Augsburg. The face is well portrayed.

Text below: 19 years, 5 months, 23 days.

Clothing overview: The contrast between the variety of styles he experiments with in Milan and the much more formal Venetian style is made quite clear here. Matthäus is dressed in the distinctive style of a Venetian gentleman—namely the black toga with its links to trade, piety, and modesty. Although he did not wear it for long, it indicates his intention of wearing the local fashions and of creating a good impression.[41]

Headwear/hair: He is wearing the black *bareta*, or cap, which is probably made from blocked felt. The *bareta* has no brim and a shaped crown. The Venetians often wore it flat on the head, but Matthäus looks to be wearing his at a slight angle over his right ear. His hair is still shoulder length.

Body garments: Matthäus has a long black wool *toga* or *vesta* with a small collar and very long, voluminous, hanging sleeves in the Venetian style. The gown is closed at the front and falls in deep folds down the center-front. This garment covers the rest of his clothes. This style of clothing was worn by all Venetian men of patrician rank and of the second rank for both winter and summer clothing from the age of twenty-five.[42] As Matthäus is not yet twenty he is

40. He will wear this style again in I 71 (2 November, 1524).
41. Compare with the figures all in black in Titian, *The Presentation of the Virgin in the Temple*, 1539, oil on canvas, Galleria dell'Accademia, Venice.
42. According to a Milanese visitor describing the universality of this style of Venetian man dress: "nobody stirs abroad in any other costume; it is a style certainly very suited to grave persons. They all look like Doctors of Law," J. Harvey, *Men in Black* (London: Reaktion Books Ltd, 1995), 66.

a little early in adopting this style. This may explain why he does not look to be wearing the *becho*, the hood with a very long "tail," which was worn as a stole by the Venetian male elite.[43]

Linens: Very little of his shirt is visible, which is usual in depictions of Venetian men dressed in this manner. However, there is a hint of a very small ruffle at the neck of his *toga* and the wrists of his doublet.

Legs: He has black hose, which are hardly noticeable and were the norm with the *toga*.

Footwear: His black shoes have round toes and plain vamps.

Jewelry: There are two gold rings on the fourth finger of his right hand, possibly set with small stones, and a single gold ring on the second finger of the same hand.

Gilding: Only for his rings.

Image I 27 [recto]

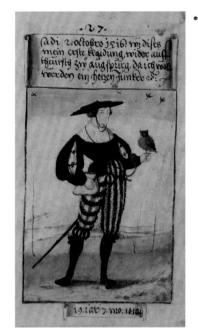

On October 2, 1516, this was my first outfit back in German style in Augsburg, when I wanted to become a huntsman.

Text below: 19 years, 7 months, 10 days.

Note: Hunters began their training by catching birds.

Clothing overview: Almost two months later and Matthäus is proudly wearing Augsburg styles again. While the use of black is central to this doublet and hose, it is the striking contrast with white that makes it so distinctive.

Headwear/hair: His black bonnet has a very wide, deeply slashed folded-over brim that is worn flat on his head, with a double strand of black cord under his chin. His hair has been cut short again, and it forms a marked contrast to the longer style in I 26.

Body garments: A key difference is the lack of a gown, so focusing all of the viewer's attention on his doublet and hose. His black doublet has a low, wide neck that sits on his shoulders. The front of this side-fastening doublet is quilted vertically. The sleeves are very full at the top, but they are more fitted near the wrist. The seam has been left open revealing the sleeve of his shirt. The opening in the doublet sleeves is secured with two pairs of black points, which are tied in half bows. This is the first time he wears this type of sleeves.

Linens: This style of doublet accentuates his linen shirt, which also has very full sleeves. It is probably side fastening and the small neckband is edged with a little ruffle. There is a suggestion of a white zigzag pattern on the neckband, which is possibly Italian shirring.[44]

Legs: His black, white, and gray hose are very distinctive, and they form a marked contrast to those he was wearing while in Venice. On his left leg, the hose have been cut into panes, which run from waist to hip and then from hip to the knee. The edges of the panes have been cut with a series of short cuts, creating a decorative finish. Beneath the panes, the gray and white striped lining is visible. Below the knee, the hose are plain black. On the right leg, the black hose are solid from the waist to the hip. They are then slashed with six horizontal cuts, causing the hose to form a series of rolls from his hip to the knee, and the gray and white striped lining is visible. At his knee, the black is cut in a series of short vertical cuts. The hose are then plain black from below the knee to his toes. The codpiece is black, and the vertical slashes reveal a white lining. He is wearing black garters, which are tied under each knee and are decorated with small gold aglets or gilt fringe.

Footwear: His black shoes are wide at the toes, and they have low-cut vamps.

43. Harvey, *Men in Black*, 66.
44. See the collar in Hans Holbein the Younger, *Derich Born*, 1533, oil on panel, 60.3 × 45.1 centimeters, the Royal Collection.

Accessories: He has a hawk on his left fist in order to go hunting for wild fowl (see I 7). Rather surprisingly he does not have a padded hawking glove of the sort he should be wearing, and the hawk does not have a hood.[45] He is possibly holding the hawk's jesses. There is a pale gray hawking bag hanging from his belt on his right hip with a metal purse frame.[46]

Weapons: His sword has a black and blue hilt, suggesting the use of bluing. It is in a black scabbard and worn with a black girdle and hanger.

Jewelry: He wears his crucifix on a black cord.

Gilding: On the gold aglets/gilt fringe on his garters.

Image I 28 [verso]

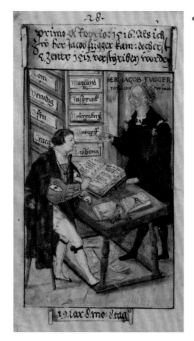

First October 1516, when I came to master Jacob Fugger, but was only contracted on the 9th. [October] Tenth 1517.

Inside the image: Master Jacob Fugger, well portrayed.

Text below: 19 years, 8 months, 6 days.

Note: The image shows the drawers in which Jakob Fugger kept his correspondence with agents in trading cities such as Milan, Innsbruck, Nuremberg, Antwerp, Lisbon, Rome, Venice, Ofen, and Kraków.

Clothing overview: This is one of the rare occasions when he is shown in his work clothes. As he is with his employer, he is wearing good quality, relatively sedate clothes because he is seeking to make a good impression. It also offers a good contrast between the clothing of older and younger men.

Headwear/hair: Jakob Fugger wears a small dull yellow caul, which is edged with a gilt cord and decorated with double rows of gilt cord creating a striped effect. It is positioned on the back of his head.[47] His white hair is receding at the front and cut quite short at the back. In contrast, Matthäus is bareheaded. His hair is cut with a fringe at the front, while at the sides and back it comes to just below his ears.

Body garments: Fugger has a black, knee-length wool gown, and there is a suggestion of a self-colored pattern on the fabric (gaufrage). The gown's long, full sleeves are attached at the shoulder with pairs of black points with gilt aglets. It has a tall collar at back, a square neck at front, where a pair of black points has been left undone. The gown has a flat front, suggesting it is side fastening. Matthäus wears a knee-length brown gown, with long hanging sleeves. His gown is worn open, revealing his clothes underneath. He has a pale gray-blue doublet with a low square neck at the front and a pleated, closed front. It has full sleeves, made in two sections. The upper, fuller part has a long slash on the outside edge, which is tied with two pairs of black points in half knots. The lower section of the sleeve, which is closer fitting, has been slashed vertically, revealing the yellow fabric below. The wrist and the join between the two parts of the sleeve are accentuated with bands of yellow and black passementerie.

Linens: Fugger's shirt has a round neck. In contrast, Matthäus's shirt has a small neckband edged with a ruffle. The full sleeves are visible through the slashes in the upper section of his doublet's sleeves.

45. He should have a glove of the type attributed to Henry VIII made from doe skin, while the hawk would usually have a hood. See the cloth of gold-covered hawk hood and doeskins glove, in the collection of the Ashmolean Museum, Oxford, Starkey, *European Court*, XI.35, 164.

46. For a slightly later and much more opulent example, see the hunting bag of Maximilian I von Bayern, in J. Pietsch, *Taschen: Eine europäische Kulturgeschichte 1500–1930* (Munich: Bayerisches Nationalmuseum, 2013), 66–67, no. 15, also 64–65.

47. Compare with the half-length portrait, Albrecht Dürer, *Jakob Fugger II*, 1518–20, oil on canvas transferred to panel, 69 × 53 centimeters, Staatsgalerie Altdeutsche Meister, Augsburg.

Legs: Fugger has plain black hose, while Matthäus wears white close-fitting hose, which are slashed with two rows of short vertical slashes on the thigh to reveal a gray lining. He has narrow black garters tied below the knee in small half bows, which are embellished with small gold aglets or gilt fringe.

Footwear: Both wear flat black shoes. The vamps of Matthäus's shoes are quite low over his toes, while the quarters are cut high around his heel (see his left foot, which is shown in profile).

Accessories: Matthäus is surrounded by the tools of his trade—a pen and a number of account books, probably bound in leather or vellum, and placed on an angled book rest.

Jewelry: Matthäus wears his crucifix on a black cord.

Gilding: The clasp on the account book, aglets on Fugger's points, aglets/fringe on the end of Matthäus's garters.

Image I 29 [recto]

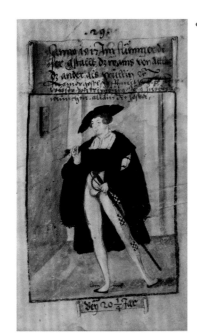

In summer 1517, in this manner: the doublet made of silk satin, everything else wool. In society with Wolf Breitwyser von Wirtzburg, Jörg Hueber from Munich, only the hose.
Text below: Aged around 20 ¼ years.
Text inside the image: Clay color.

Note: Breitweiser was a friend from Würzburg and also depicted on the 1522 image of an Augsburg garden dance (see Introduction I). The meaning of Schwarz's commentary on the hose remains unclear.

Clothing overview: When not at work he spends time with his male friends and associates.

Headwear/hair: His black bonnet has a very wide, folded-over brim, which is deeply slashed, and there is a single black point tied in the half bow on the side. The bonnet is worn at an angle over his right ear. As a result, his hair is visible, and the style has changed very little from the previous image nine months before.

Body garments: Matthäus's black wool gown is mid-calf in length, and it has a wide turned-back collar.[48] It has hanging sleeves with slits that his arms pass through, and the end of the hanging section is cut in a series of decorative, crescent shapes. It is worn with a black satin doublet with a low square neck, a high waistline, and full sleeves. The front is pleated, or quilted, vertically, and it is side-opening. The full sleeves have a long vertical slit and the sides are held together with two pairs of black points tied in half bows.[49]

Linens: His fine linen shirt has a small narrow neckband edged with a little ruffle. It is embroidered in gold metal thread in a thick band around the base of the collar and down the front opening. The full sleeves are visible through the long opening in the sleeve of his doublet.

Legs: His comment suggests that on this occasion his tight-fitting hose are made from wool. There does not seem to be any slashing—rather the striking affect is created just using color. Both legs are parti-colored, with the inside of each leg being pale yellow and the outer half consisting of alternating blocks of black and white squares and then a block of light gray. The hose have a pale yellow, round codpiece.

Footwear: His black shoes have the cow-mouth shaped fronts with low-cut vamps.

Weapons: He wears a sword with black/blued hilt and a black scabbard, which he holds in his left hand. It is worn with a black girdle and hanger.

Jewelry: His crucifix is on a black cord.

Gilding: On his shirt collar and the shirt's front opening.

48. In comparison with the lavish fur collar on his gown in the portrait by Dürer, this gown is slightly more modest—possibly an example of clothes for work.
49. It is similar to the doublet in I 27.

Image I 30[50] [verso]

In winter 1517: the doublet a half silk, the hose with taffeta, the gown lined. In society with Casius Peuschel, Hanns Schonsperger, and Hans Kickhlinger.

Below the image: Aged 20 ¾.

Note: Schönsperger was a son of the Augsburg printer of Emperor Maximilian's landmark publication *Theuerdank* (see Introduction I).

Clothing overview: It is winter, which explains the reference to the gown being fur lined. More interesting is his reference to being in a new group of companions, which indicates that Matthäus is dressing for his male friends, competing with them sartorially.

Headwear/hair: He has a red bonnet with a broad, slashed, double brim, and it is angled toward his left ear. Visually, it works well with his red garters and the red taffeta lining of his hose. He has the same hair style.

Body garments: He wears a knee-length black wool gown lined with black fur and with a broad cape or collar, also of fur. The gown has two-part sleeves. The upper section is full with a deep slit and decorated with curved cutwork, as in I 29. The lower part of the sleeve is quite short. The gown gives him a sense of presence by adding bulk to his appearance and contrasting with the doublet and hose, which accentuate his slim body. He wears a green half-silk doublet with a low neck. It is quilted or pleated vertically on the flat front, which suggests that this is a side-fastening doublet. The full upper section of the voluminous sleeves has a long vertical opening, and this is secured with two pairs of black points tied in a half bow. A black braid or passementerie has been applied to the neck, the wrists, and the join between the two parts of the sleeves.

Linens: Matthäus's shirt is embroidered on the small neckband with gold metal thread in a very thick band. The neckband is also edged with a tiny ruffle. There is some damage to the illustration, but it appears to be embroidered down the front opening.

Legs: The tight-fitting bright green hose are slashed on both thighs to reveal red taffeta underneath. The slashes decorating the right thigh are vertical and arranged in a staggered pattern, while those on the left are U-shaped and divided into three lobes. On both legs, the edges of the cuts have been shaped. The round codpiece is decorated with cuts of the same type as those seen on the left leg. He has narrow red garters tied below each knee with the knot position toward the side/back of his knee. The ends of these garters are decorated with either small gold aglets or gilt fringe.

Footwear: The flat black shoes of the cow-mouth shape have low-cut vamps.

Weapons: He wears a sword with a black hilt in a black scabbard with a black girdle and hanger.

Gilding: On his shirt collar and front opening; also on his garters.

Image I 31 [recto]

In summer 1518, when Emperor Maximilian held a dance at the Augsburg dance house, I was like this: a half silk doublet, a bonnet with taffeta, a golden chain, and a golden wreath, the gown [edged] with silk satin [Atlas].

Below the image: Aged 21.

Note: Maximilian I encouraged elite sociability in Augsburg, and could enter the city at all times through a special gate.

50. Omitted from Braunstein, *Un Banquier Mis a Nu*.

Clothing overview: The imperial dance in summer 1518 provides an opportunity for new clothes not to be missed. He makes more use of silk and half silk, as would suit such an occasion, and the clothes are a little more subdued than those chosen for socializing with his friends.

Headwear/hair: He is wearing a light gray bonnet, with a wide, upturned brim, the edge of which is trimmed with swags of white taffeta that is threaded through slashes in the brim.[51] His hair is still cut in the short bob.

Body garments: Matthäus's dark brown, knee-length wool gown has a wide collar and hanging sleeves, the openings of which are tied with four pairs of black points with gold aglets. The gown is decorated with a broad black guard around the edge of the collar, the hem, down the center-front and on the hanging sleeves. It is worn open to reveal the light gray half-silk doublet underneath. The doublet is quilted vertically on the close front, which probably fastens at the side. The doublet is slightly longer in the body than in previous examples. The two-part sleeves consist of the upper section, which comes to the mid forearm. It is very full, and the outer seam is left open and is secured with two pairs of black points that are tied in half bows. The lower section extended from the mid forearm to the wrist and is quite close-fitting. A black braid or passementerie has been applied to the neck, at the wrists and over the join between the two parts of the sleeves.

Linens: His shirt has a small neckband that is edged with a narrow ruffle and appears to have a front opening.

Legs: He is wearing gray hose, which are close-fitting, except at the knee, where they are slashed with short vertical cuts to reveal dark yellow underneath. Matching gray garters are tied below each knee with the half knot placed to the outside of his leg. The ends of the garters are decorated with either small gold aglets or gilt fringe.

Footwear: His black shoes have cow-mouth toes. They have low-cut vamps, but the quarters are cut high around his heels.

Weapons: His sword has a black hilt, and it is in a black scabbard, possibly with a black chape. It is worn with a black girdle and hanger.

Jewelry: There is a small gold wreath on the right side of the bonnet's brim.[52] He is wearing his crucifix on a black cord. While he refers to a gold necklace, it is not depicted unless it is wrapped around the wreath.

Gilding: The wreath on his bonnet, the aglets on the sleeves of his doublet and gown, also on his garters.

Image I 32 [verso]

In June 1518, when I wanted to learn fencing. The doublet was silk satin from Bruges.
Text below: *Around 21 ⅔ years old.*

Note: Schwarz appears to indicate his victory.

Clothing overview: In the summer of 1518 Matthäus learns to fence. In doing so, he is embodying the view that Castiglione would express in print ten years later that "it is [the courtier's] first duty to know how to handle every kind of weapon, both on foot and on horse."[53]

Headwear/hair: Matthäus is bareheaded, as is suited to this sporting activity, and his hair is now below his ears.

51. For bonnets with a similar style of decoration, see Tod und Burger and Tod und Kaufmann, in Tripps, *Den Würmern wirst Du Wildbret sein*, 75.
52. For another instance of this sort of wreath worn on a man's hat, see *Feste und Bräuche*, 78.
53. Castiglione, *The Book of the Courtier* (1528), 27.

Body garments: He is dressed for fencing.[54] His parti-colored Bridges satin doublet has a low round neck, at the front and back. The left side of the doublet's closed front is striped with white and gray, and the right side is bright yellow. The doublet has large sleeves, which are full at the top but more fitted on the lower forearm.[55] The doublet may be lightly padded. The neck, the cuffs, and the join between the two parts of the sleeves are trimmed with black passementerie, and two pairs of black points secure the open seam on the sleeve. It is joined to the hose with pairs of red points with gilt aglets.[56]

Linens: His shirt has a narrow neckband and a small ruffle, and lots of fine fabric has been gathered into the collar.

Legs: His hose are parti-colored.[57] The left leg is striped vertically in white and gray and slashed horizontally on his thigh, revealing bright blue underneath. Below his knee his hose are striped pale yellow and pale gray. The right leg is yellow slashed vertically on the thigh and knee to reveal the same blue fabric. The round codpiece is striped yellow and gray, combining one color from each leg. Below the knee, the hose are plain bright yellow. He has garters tied under each knee, yellow on the left leg and blue on the right. The ends of the garters are decorated with either small gold aglets or gilt fringe.

Footwear: The black cow-mouth shoes have low-cut vamps and quarters that are cut high around the heel.

Jewelry: He is wearing his crucifix on a black cord.

Weapons: He is holding a two-handed long sword with a black grip, and another is resting on the floor with a grip wrapped with gilt wire.[58]

Gilding: On his garters.

Image I 33 [recto]

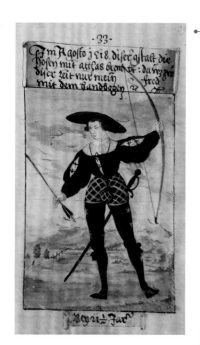

In August 1518, in this manner: the hose trimmed with silk satin. At this time I greatly enjoyed archery.

Below the image: Around 21 ½ years old.

Clothing overview: Later that summer Matthäus also worked on his archery skills, which required regular practice to build up the muscles and the technique to pull back the heavy bow.

Headwear/hair: He is wearing a black bonnet with a very wide brim that is worn at a slight angle. His hair is cut in the usual bob.

Body garments: This is a new style of front opening doublet. The black doublet has a low round neck that sits just below the point of his shoulders. The two fronts are cut away to reveal a narrow oval of his shirt. The doublet is fastened at three places with pairs of dark brown points tied in half bows—at the top of the neck, the center point, and at the waist. The body of the doublet it quite fitted and pleated vertically. The upper section of each sleeve is very full, possibly padded, while the lower section is more fitted, and they are gathered at the wrist. The front seam on each sleeve has been left open, but they are secured with two pairs of black points tied in a half bow.

Linens: His white linen shirt has a narrow neckband edged with a small ruffle. The shirt is heavily pleated, and it has full sleeves.

Legs: Matthäus is wearing tight black hose with a pair of very short black over-hose that extend from the waist to the top of his thighs. They are decorated with applied strips of yellow

54. See J. Arnold, "Two early seventeenth-century fencing doublets," *Waffen-und Kostümkunde* 2 (1979): 107–20.
55. For a similar style of sleeve, see Anonymous, *Portrait of a man*, 1525, Gemäldegalerie, Kunsthistorisches Museum, Vienna, 887, illustrated in Capwell, *Noble Art of the Sword*, 29, fig. 3.
56. This is the last appearance for this style of doublet.
57. For hose, and indeed a whole set of clothes, with a similar degree of flamboyance, see "Tod und der Maler" in Tripps, *Den Würmern wirst Du Wildbret sein*, 99.
58. For a discussion of the differences between the two-handed sword, the long sword, and the estoc, see Capwell, *Noble Art of the Sword*, 18–21. For an example of a German long sword, c. 1525–50, see Wallace Collection A478, Capwell, *Noble Art of the Sword*, 18–19, no. 1.05.

silk satin set on the diagonal to create a lattice, and the codpiece has been decorated in the same manner. A row of five-point yellow stars has been applied down the outside line of each leg of his hose. He has a pair of black garters below his knees. The ends of the garters are decorated with either small gold aglets or gilt fringe.

Footwear: His black shoes have very broad toes.

Accessories: Surprisingly, he does not have a bracer or an archery glove.

Jewelry: He is wearing his crucifix on a black cord.

Weapons: He holds a long bow in his left hand, with horn knocks at each end and an arrow with a general purpose arrowhead and black fletchings in his right. He has a sword with a black hilt, in a black scabbard, on a black sword belt on his left hip.

Gilding: On his garters.

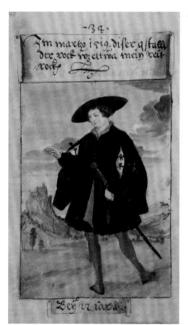

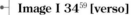

Image I 34[59] [verso]

In March 1519, in this manner. The gown was my riding gown.
Text below: Around 22 years old.

Clothing overview: As a young man learning his career within the Fugger business, the clothes Matthäus wore for travel and while away from Augsburg were important. This riding outfit contrasts with the one he wears later in 1519/20 (see I 41).

Headwear/hair: He has chosen a black bonnet with a broad flat brim worn flat on his head. His hair is cut in a short bob.

Body garments: Matthäus is wearing a black pleated riding gown, which comes to just above his knees. It is worn done up from the turned-back collar to the waist, covering most of the doublet. It has full hanging sleeves with a slit opening to allow his arms to pass through. The upper section is slightly pleated and probably has some padding, and the lower section forms a deep cuff. The hanging sleeves are decorated with pairs of black points tied in half bows. The skirts are probably padded and/or stiffened with a heavy interlining, and the neatly formed pleats are held in place with stay-stitching. The small turned-back collar is lined with bright green, as is the main body of the gown. It is worn over a black doublet. The doublet has full sleeves similar to those in I 33. The front seams of the doublet's sleeves have been left open but they are secured with two pairs of black points finished with gold aglet tied in half bows.

Linens: His white linen shirt has full sleeves, which are visible through the opening in doublet's sleeves. No details of the collar are visible, suggesting that it has a neck that comes to the base of his neck.

Legs: His hose are bright red and tight fitting, with vertical slashes at the knees revealing a green lining. For the first time since October 1516 (I 27) they are worn without garters.

Footwear: His black shoes with cow-mouth toes have vamps that are cut low over the toes.

Jewelry: He is wearing his crucifix on a black cord.

Weapons: A sword with brown hilt and black scabbard with a black girdle and hanger.

Gilding: The aglets on his points.

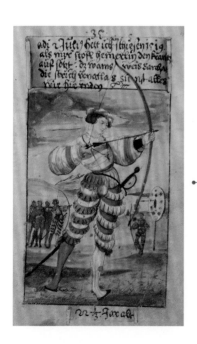

Image I 35 [recto]

On 2nd July, 1519, I had a shooting match, when Stofl Hemerlin put the wreath on me. The doublet white fustian, the stripes from silk satin, otherwise all as below.
Text below: 22 ⅓ years old.

Note: Schwarz once more emphasizes his sporting success.

59. Omitted from Braunstein, *Un Banquier Mis a Nu*.

Clothing overview: Matthäus's flamboyant clothes for a summer archery competition, designed to encourage viewers to admire him as much as his skill. He may well have worn a similar eye-catching style of clothing when practicing archery if I 33 is to be trusted.

Headwear: He has a wreath of twisted red and white fabric on his head as a mark of his success, suggesting that his confidence in his skill is not misplaced. His hair is cut in the usual short bob.

Body garments: The white fustian doublet has a low square neck at the front, revealing some of his shirt. The sleeves sit midway up his shoulders. The doublet has a flat front suggesting it is a side-fastening doublet. It comes to his natural waistline, and it has full sleeves. The doublet is decorated with applied broad, horizontal stripes of yellow and pale gray satin on the body and sleeves, which creates a striking visual effect at relatively low cost.

Linens: Matthäus's shirt has a narrow ruffle attached to the neckband, and the fine linen falls into a number of very fine gathers.

Legs: His hose combine gray, white, and yellow like his doublet but in a more complex way. The hose are parti-colored, with the left leg being striped vertically in white and yellow and the right leg in plain gray. On the left leg, the hose are formed into white and yellow stripes from the waist to the hip. They are then slashed with five horizontal cuts, between the hip and the knee, to form five rolls. Each roll is also slashed with a series of short vertical cuts, creating a "tabbed" effect on each roll. Underneath the slashes, the tight-fitting gray lining is visible. Below the knee the hose are striped white and yellow. On the right leg, the construction is the same, but the coloring is different. A yellow and white striped lining is visible under the slashes on his thigh, and below the knee the hose are plain gray. The hose have a round codpiece in gray, slashed to reveal the yellow lining. He has reverted to wearing garters again, and he has a gray garter tied below each knee. The ends of the garters are decorated with either small gold aglets or gilt fringe.

Footwear: He has black shoes, which are very wide at the toes.

Accessories: He has small black leather bracer on his left forearm, to provide protection from the bowstring for the inside of his forearm and the fabric of his sleeve.[60] He is also wearing pale leather gloves with diamond-shaped slashes on the back of his hands.

Jewelry: His crucifix is worn on a black cord.

Weapons: He is holding a long bow in his left hand and an arrow with a general purpose arrowhead and black fletchings in his right. He has a sword with a black hilt and a black scabbard at his left hip; he wore them with a black girdle and hanger.

Other figures: There are five male figures in the background who are taking part in the competition—the figure preparing to shoot on the left is Schwarz, wearing the same red and white wreath—the other figures also favor bright colors and flamboyant hose.

Gilding: On his garters.

Image I 36[61] [verso]

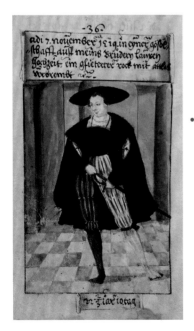

7 November, 1519, in a gathering at my brother Laux's wedding. A lined gown, with silk satin borders.

Text below: 22 ⅔ years, 10 days.

Note: Laux was slightly older than Matthäus. He took over his father's tavern, *The Crown*, and became a guild-master. Laux was ennobled in 1541 and died in 1556.

60. See an early sixteenth-century *cuir bouilli* bracer, British Museum 1922, 1–10, 1; Starkey, *European Court*, XI.37, 166.
61. Omitted from Braunstein, *Un Banquier Mis a Nu*.

Clothing overview: The exuberant hose contrast well with the black doublet and gown in this set of wedding clothes, which involve lots of silk. Matthäus's choice also indicates that black was considered suitable for a wedding, while the use of fur acknowledges that this is a winter celebration.

Headwear/hair: He has a wide-brimmed black bonnet worn flat on his head. The brim is slashed, forming it into a front and back section. His hair is slightly shorter because his ear lobes are just visible.

Body garments: He wore a black, knee-length, wool or wool/silk mix gown with a wide guard of black silk around the hem and hanging sleeves. The gown has a full lining of a rather coarse black fur.[62] The same fur is used on the gown's wide cape collar, which extends over his shoulders, giving him an added sense of width. The gown's hanging sleeves have a large opening, and the end of the sleeves is decorated with a series of curved cuts. The gown is worn over a black damask doublet with a large pattern repeat. The doublet is side fastening, making the most of the damask pattern on the flat front of the doublet. The neck is cut in a slight downward curve, and it is trimmed with red passementerie. The diagonal slits on the sleeves are edged with red, and they are secured with a pair of black points tied in a half bow. The doublet has quite full sleeves, which are probably lightly padded, and they are bound in red at the wrist.

Linens: He has a white linen shirt with a round neckline. The neckband is quite wide, and it is trimmed with a little ruffle edged with a hint of blackwork and gilt thread embroidery.

Legs: Matthäus's hose are brightly colored, ornate, and symmetrical in terms of design but not in terms of color. On his left leg, the hose are bright yellow. They are cut in long, wide, vertical panes, which run from waist to hip, and they are joined at three points with gold aglets (at the hip, mid-thigh, and just above the knee). In addition, each pane has been slashed. As a result, the blue lining can be seen through the cuts in the panes and in the gap between the panes. The round, brown and yellow codpiece is partially obscured by the hilt of his sword. Below the knee the hose are striped vertically in the same yellow and light blue. The construction of the right leg is the same, but the colors are different. Here the hose are dark brown, with the same blue lining to the knee, and plain brown below the knee. He has black garters tied below each knee, and the ends are decorated with small gold aglets or gilt fringe.

Footwear: He has black shoes with wide toes.

Jewelry: He wears a crucifix on a black cord.

Weapons: He has a sword in a black scabbard on his left hip.

Gilding: On the aglets on his hose and the ends of his garters.

Images I 37–40 [recto]

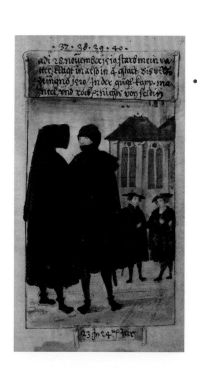

On 28th November, 1519, my father died, and I mourned him in 4 degrees [of mourning] until June 1520: in the gulg, cape, the mantle, and the gown. Nothing of silk.
Text below: 23 to 24 years old.

Clothing overview: These images record the four stages of mourning that Matthäus wore for his father. The sequence serves to emphasize the importance of black as the color of mourning, the formality of mourning worn by a son for his father, and the length of time spent in mourning for a parent.

Headwear/hair: Matthäus had four different styles of mourning headwear. In I 37, the long funnel-shaped hood of his cloak (*gulg*) completely covered his face. In addition, the back section of the hood hangs down at his back as far as his waist. His hood in I 38 is pulled back to frame his head, while the back section is pulled around his face, covering his mouth, so that only his eyes

62. For a gown of this type (but with no fur), see the yellow damask gown with black velvet guards of Moritz of Saxony, Niekamp and Jucker, *Das Prunkkleid des Kurfürsten Moritz von Sachsen*, 98–104, plates 1–7.

and nose are visible. For the third phase of mourning he has adopted a wide, flat black bonnet worn flat on his head (I 39) and finally he selects a flat black bonnet with a wide upturned brim, slashed at the center-front, which is very similar to the bonnet he usually wears (I 40).

Body garments: In each case, apart from I 40, his outer garment covered his doublet. Seen from a three-quarter back view, Matthäus wore a very full, long, mourning cloak in I 37, which came down to his mid-calf. It was intended to cover all of the wearer's clothes, and he keeps his hands inside. Next he wears a black, just below knee-length, cape with a hood (I 38). Again his hands are kept tucked inside. In I 39 Matthäus adopts a black knee-length mantle or gown with a high collar and a black guard placed over the chest and shoulders. The gown is still worn closed, covering his other clothes. His right hand is showing. By I 40 he is wearing a black knee-length gown with a cape collar and hanging sleeves. It has decorative black guards. Both hands are showing.

Linens: Matthäus's shirt is visible in I 39 and I 40 indicating the more relaxed mourning rules by this stage, but in both cases there is only a small amount showing. The shirt has a small neckband edged with a narrow ruffle in I 39. In I 40 the shirt has a round neck. While the illustration is a little rubbed, it looks as though his shirt sleeve can be seen through the opening in the doublet sleeve.

Legs: He is wearing black hose. In each case these are only visible from the knee down.

Footwear: He is wearing ankle-height black shoes, which are quite wide at the toe, with the top of the vamp turned over in I 37 and I 38. In contrast, he has more fashionable black shoes, which are still wide at the toe, in I 39 and I 40.

Jewelry: He has a gold ring on his right hand (I 39) and a gold or gilt brooch worn on the brim of his bonnet (I 40).

Weapons: He is unarmed in I 37, but he carries a sword in a black scabbard in images I 38, I 39, and I 40.

Gilding: His ring and brooch.

Image I 41 [verso]

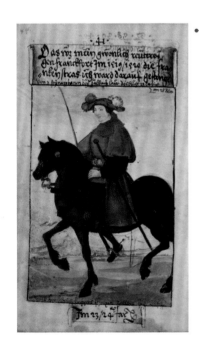

This was my usual ride to Frankfurt in 1519/1520, on the Franconian road. I was caught by 7 robbers at Bälbach, as in the 23rd chapter of the book on the 28th page.
Inside the image: [The horse] was Ulrich Fugger's *Spazierzelter,* very speedy.
Text below: Aged 23/24.

Note: This image is also included in Schwarz's prayer book. It shows that he did not exclusively wear black mourning clothes during the year following his father's death.

Clothing overview: Matthäus is wearing travel clothes again, this time clothes he wore for a year or more. The combination of his clothes, which are quite understated for him but still good quality, and the expensive horse explain why Matthäus is appealing to robbers.

Headwear/hair: He has a dark gray bonnet with a thick, slightly curved, brim, which he is wearing flat on his head. It is trimmed with bunches of gray and white ostrich feathers on the right and left sides, respectively. In addition, he has a red hood, which is turned down around his neck, rather like a scarf, and the edges have been cut in a fringed effect. His hair is cut in a short bob.

Body garments: For the later stages of mourning and when he is away from home traveling, he wears a mid-gray riding coat with very wide sleeves that are gathered into a band just above the elbow. The front of the coat is smooth and fastens at the side. The skirts are cut quite short at the front, but are longer to the side and back. The skirts are not pleated, and the fabric has been cut at the center-back from the waist (or a seam has been left open),

allowing the fabric to fall on either side of the horse's body. In colder weather the skirts could be wrapped over his thighs to keep them warm. Under the coat he is wearing a black doublet. Only the lower part of the fairly full sleeves is visible, and they narrow at the wrists.

Linens: His shirt is not visible.

Legs: He wears tight-fitting black hose. These are slashed at the knee with short vertical slashes, revealing a very striking red fabric.

Footwear: Not much detail can be seen of his black shoes. They are worn with black rowel spurs and black spur leathers.

Accessories: He is carrying a long riding whip in his right hand.

Weapons: He has a sword with a fine blade in a black scabbard with a black chape on his left hip.

Horse/horse harness: He is riding a black horse, possibly a mare, which he describes as a *Spazierzelter*. It is on loan from Ulrich Fugger, which links with Matthäus traveling on company business to Frankfurt. While this horse belongs to a member of the Fugger family, it has quite a simple harness, possibly in response to the fact that he mentions having been robbed. The horse has a black bridle with large gilt metal bosses, a curb bit, and single reins, along with a chest strap, stirrup leathers, and stirrups. Very little of the black saddle can be seen.

Gilding: On the bosses on the bridle.

Image I 42 [recto]

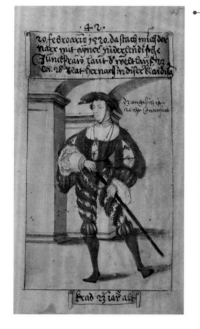

20 February, 1520. The fool pricked me with a Netherlandish virgin as related in "The Course of the World," 23rd chapter, page 28. Afterward in these clothes.

Inside the image: The face is well captured.

Text below: Just 23 years old.

Note: Schwarz had fallen in love with a single woman from the Netherlands. This is one of the images he commissions to commemorate his birthday—Schwarz has therefore been called the "inventor of the birthday" (see Introduction I).

Clothing overview: Matthäus is very striking all in red. This eye-catching outfit of color-coordinating doublet, hose, and bonnet is very well suited for the Valentine's Day celebrations in 1520. It needs to be compared with the frontispiece, where he is depicted wearing a brown gown with the ensemble.

Headwear/hair: The red bonnet has a broad, slashed brim, which is worn at a slight angle over his right ear. The double ties fasten under his chin. His hair has been cut shorter revealing the lower part of his ears.

Body garments: He wears a doublet of bright red damask. It is cut with a very low, square neck, which reveals a lot of the upper part of his shirt. The upper sections of sleeves are very full, the front seam has been left open from the shoulder to the mid-forearm, and it is secured with two pairs of red points with gold aglets tied in half bows on both sleeves. The lower pair of points on the right sleeve has been left undone, allowing his arm to pass through the opening. The lower section of the sleeves forms a more tightly fitting cuff, and the red fabric is slashed vertically to reveal a blue lining. Each slash is secured with a small pair of red points. The fronts of the doublet are secured at the top with a pair of points and at the waist. They are cut away below the top pair of points to reveal the shirt.[63]

Linens: He wears a very opulent linen shirt with a deep neckband edged with a narrow ruffle. It is decorated with four thick bands of gilt metal thread embroidery, and there are three

63. This style of doublet is not seen after this point.

similar bands at the sleeve ends close to his wrists. The shirt has very full sleeves, which are gathered into the wristbands. This fullness is especially evident on the right sleeve.

Legs: The upper sections of the tight-fitting red hose have been slashed diagonally to reveal the blue and yellow vertically striped fabric underneath. A degree of fullness has been created at the knees, which are also slashed vertically and lined with blue and yellow. The hose have a plain red, round codpiece, which is partially obscured by the hilt of his sword. The lower section of the hose below the knees is plain red. Red garters trimmed with gold aglets or gilt fringe are tied under his knees.

Footwear: His black shoes are of the wide cut, and the vamps are low-cut over his toes.

Accessories: A sword in a black scabbard is worn from a black girdle and hanger.

Jewelry: He wears a crucifix on a black silk cord around his neck. In addition he has a long, thick, gold chain with a silver ring set with a dark stone. This is possibly the Valentine's gift from the Netherlandish lady that he mentions.

Gilding: The embroidery on his shirt, his necklace, the aglets on his points and on the garters, the brooch on his bonnet.

Image I 43 [verso]

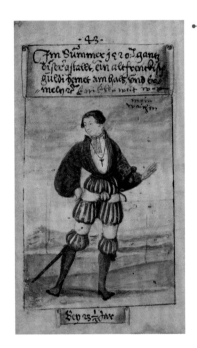

In summer 1520 all like this: a traditional Franconian shirt, golden on the neck and sleeves.
Later addition: My waist had a width of one ell.
Text below: Around 23 ⅓ years old.

Note: The shirt was worn to honor regional customs. Nuremberg women, including crafts-women, presented their grooms with a gold-embroidered shirt.

Clothing overview: Three or four months later Matthäus dresses in summer clothing, which partially explains the lack of a gown. His comment suggests that it was his shirt in tandem with the style of his doublet that was especially fashionable that summer.

Headwear/hair: He is bareheaded, and his hair is still cut short partially revealing his ears.

Body garments: The dark gray damask doublet is cut in a new style. The fronts of the doublet are quilted or possibly pleated vertically. They are left open down the center-front, being fastened only at the waist, revealing a large section of the shirt. It has a small collar and very full sleeves, making him look very wide at the shoulders but very slim at the waist. The sleeves are probably padded to give this full shape, and they are drawn in at the wrist.

Linens: He describes the shirt as being of a traditional, local style of decoration (*ein altfrenckisch guldi hemet*). It has a small neckband edged with a narrow ruffle. The neckband is decorated with a very wide band of gilt metal thread embroidery and four short vertical bands of gilt metal thread embroidery decorating the front opening of the shirt. In between the vertical bands are two wide bands of scrolling red silk embroidery.

Legs: The symmetrical dark gray and white hose are very striking, and they echo the white of his shirt and the gray of the doublet. The gray hose are slashed vertically and horizontally. The pattern of cuts forms three slightly puffed rolls, which extend from his waist to the top of his hips, from the top of the thigh to his mid-thigh, and from above to below the knee. Underneath the gray, the white under-hose are very close-fitting to his thighs. Below the knee, the hose are plain gray. The ball-shaped codpiece is gray, and the white lining shows through the vertical cuts, while the dark gray garters are tied in half bows below the knee. The ends of his garters are decorated with gold aglets or gilt fringe.

Footwear: He has black shoes with wide toes.

Jewelry: He is wearing his crucifix around his neck on a black silk cord.

Weapons: He has a long sword, with a black and blued hilt in a black scabbard, worn on his left hip and suspended from a black girdle and hanger.

Gilding: On the neck of his shirt and on his garters.

Image I 44 [recto, landscape]

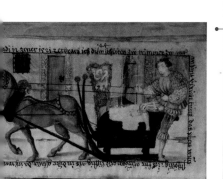

On 12th January, 1521, I broke this sleigh into pieces in Augsburg at St. Ulrich's Church because the horse shied away. I always drove in this manner. I was 24 years, minus 29 days old.

Note: Sleigh-riding was depicted on several woodcuts at the time, but usually warmer clothes were worn.

Clothing overview: Wearing striking, fashionable clothes is evidently more important than being warmly dressed in this January scene. His comment suggests that he spent quite a lot of time driving his sleigh dressed like this in the winter of 1520/1521.

Headwear/hair: He is bareheaded, apart from the gold and green twisted wreath. It might be made from green silk or real foliage twisted with gilt wire. His hair is quite short.

Body garments: He wears a pale mauve/gray jerkin, which is an innovation in his wardrobe. It might be made from leather, wool, or a union cloth. It has a round neck and no collar. There are three long vertical slashes on the chest, and it is side fastening. While his left arm is in the way, it is likely that the jerkin is fitted at the waist and then the short, heavily pleated skirts flare out again. The short, full sleeves are made from four long strips that have been folded lengthwise and then slashed, forming a series of loops. The jerkin is worn over a bright yellow damask doublet with full, padded sleeves, which narrow at the wrist, and a neck that echoes that of the jerkin. In view of the way that it shows through the slashes in the jerkin, the doublet probably fastens at the side.

Linens: His shirt is not visible.

Legs: The pose, with one leg on the body of the sleigh and the other on the runner, shows off his hose and his physique well. The mauve/gray and yellow asymmetrical hose complement the colors of his doublet and jerkin. The hose are probably made from either pieced leather or wool cloth in order to achieve this complex color combination.[64] On his left leg, the yellow hose are cut with a row of vertical cuts and formed into a decorative roll. From waist to hip, the hose are striped in dark and light gray. Just above the knee the hose change to yellow and are slashed over the knee. Below the knee the hose are striped in dark and pale yellow. On the right leg, the yellow hose are close-fitting to his thigh, and they cut in three bands of vertical slashes through which the gray under-hose can be seen. At the knee they are slashed vertically, and there is a little added fullness. Below the knee they are striped in dark and pale yellow. The round, yellow codpiece is slashed to reveal the gray lining on one side and the yellow lining on the other. Yellow garters are tied below each knee, and they are trimmed with gold aglets of gilt fringe.

Footwear: He wears black shoes with wide toes.

Accessories: His long black whip is resting inside the sleigh.

Weapons: He has a dagger behind his left thigh. It has a round, black pommel.

Horse/horse harness: The dark gray horse, possibly a blue-roan, has a black harness for pulling the sleigh, including a bridle, long reins, and a crupper going along the back and under the tail, with the back straps running parallel with it. Large gilt bells decorate the bridle and

64. For a simple pair of leather hose, see the yellow leather hose of Moritz of Saxony, Niekamp and Jucker, *Das Prunkkleid des Kurfürsten Moritz von Sachsen*, 82, 87, figs. 63, 69.

loin straps on the horse's quarters.[65] The horse shoes have a stud for added grip in the snowy/icy conditions.

Sleigh: The black sleigh is painted with a black design in a scrolling, foliate pattern. The end panel has a painting of a man and women playing chess.[66]

Gilding: On the bells on the horse's harness, some details on the painted panel of the sleigh his wreath, and the aglets on his garters.

Image I 45 [verso]

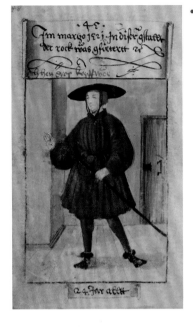

In March 1521, in this manner. The gown was lined.

Later addition: I had a terrible headache.

Text below: 24 years old.

Note: Colors could be linked to medicinal effects at this time, and red cloth was applied to extract pain or heat.

Clothing overview: Matthäus is dressed in clothing suited to spring travel, while also reflecting contemporary views on health. His red wool coif was considered to have medicinal properties, which would have been good for his headache.[67]

Headwear/hair: He is wearing a black bonnet with a very wide brim, which is placed flat on the top of his head. It has two black ties looped loosely under his chin. The brim is slashed and divided into an overlapping front and back section. The bonnet is worn over a bright red coif, which also is tied under his chin in a half bow. It is probably made from wool.

Body garments: He is dressed in a dark gray, wool, knee-length riding gown. The gown is pleated on the chest and down the skirts. It has fairly full sleeves, which would provide good ease of movement while riding without getting in the way. The sleeves are probably padded to give them this full shape. The front of the gown and the skirts are heavily pleated, and the pleats may be held in position with stay-stitches. He describes the gown as being lined, and as the picture is dated March 1521, it could be a fur lining for warmth if spring was late that year. The gown has a small collar, which opens at the front. The cut of the front and the lack of buttons suggest that the riding coat is side fastening. The gown looks to be decorated with a small, spotted pattern.

Linens: His shirt is not visible. There is a hint of white linen coif under the red coif, which extends over the back of his neck.

Legs: His black/very dark gray hose are visible from the knees down only. He does not appear to be wearing any garters.

Footwear: He has black ankle-height shoes, which are rolled over around his ankles. The vamps are slashed, as is the roll at his ankles.

Accessories: At his throat there is a single pair of red points with gold aglets tied in a half bow.

Weapons: He has a sword with a black hilt wrapped with black cord or wire in a black scabbard at his waist, and he rests his left hand on the hilt, as he often does. A dagger with a round, blued pommel is tucked into his black girdle, which the sword is secured to with hangers.

Gilding: The gold aglets.

65. For a similar harness with bells, see *Die Monate Oktober, November*, illustrated in *Feste und Bräuche*, 162.
66. Compare with the young man driving a sleigh with a female passenger, in *Die Monate Oktober, November, Dezember*, oil on canvas, 227.5 × 353 centimeters, Deutsches Historisches Museum, Berlin; illustrated in *Feste und Bräuche*, 167.
67. Andrew Boorde advised the readers of his *First Boke of the Introduction of Knowledge* published in 1547 to "Let your nightcap be of scarlet. . .and in your beed lye not to hote nor to colde but in temperaunce," in C. Willett and P. Cunnington, *Handbook of English Costume in the Sixteenth Century* (London: Faber and Faber Ltd, 1954), 47.

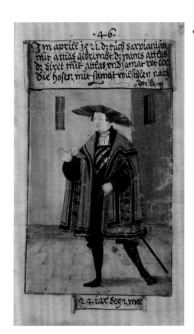

Image I 46 [recto]

In April 1521. The fabric Barpinian [from Perpignan or as from Perpignan], trimmed with silk satin. The doublet from silk satin, the bonnet with silk satin and crimson velvet. The hose with velvet-rolls in the length.

Text below: 24 years old and two months.

Clothing overview: This more formal outfit contrasts with the riding clothes shown in I 45 and suggests that this is what Matthäus wears when working in Augsburg. His bonnet is the most noticeable piece because of the color, but his black doublet and hose are striking, even though they are partially concealed by his gown.

Headwear/hair: He has a crimson bonnet with a very wide brim, which is worn flat on his head.[68] The brim of the bonnet is covered with pleated red velvet and satin, to create a subtle striped effect by contrasting the shine of the satin with the more matte cut pile of the velvet. His hair is cut in the usual short bob.

Body garments: He has a dark gray, knee-length gown made from wool cloth from Perpignan, or in the Perpignan style, with a deep, turned-back cape collar and hanging sleeves with a wide opening. The gown is decorated with a pair of guards (one double the width of the other) made from black silk satin that run down both fronts, around the hem, around the cape collar, and down the long, quite wide, hanging sleeves. The lower section of the openings in the hanging sleeves are secured with four pairs of black points with gold aglets tied in half bows. Matthäus wears a black satin doublet. The doublet has a small grown-on collar, and the fronts are cut away so it only fastens at the bottom. It has wide sleeves, which are probably slightly padded and narrow at the wrist. The doublet is probably worn with a black placard with a low neck, which is slashed diagonally with long slashes. The slashes run from the neck to the waist revealing the shirt.[69]

Linens: The shirt has a small neckband, edged with a narrow ruffle and decorated with three thick rows of gilt metal thread embroidery.

Legs: He has black hose made from long wide panes of black velvet, which are placed very close together, revealing only a very small amount of the black lining. At his knees, the panes are formed into rolls to provide some added fullness to ease movement. If there is a codpiece, it is concealed by the gown and the hilt of his sword. He has black garters tied at the knees.

Footwear: His black shoes are wide at the front, and the vamp is cut low over his toes.

Jewelry: He is wearing his crucifix on a black cord around his neck.

Weapons: He has a sword with a black hilt in a black scabbard worn on his left hip.

Gilding: The aglets on the sleeves of his gown, the embroidered bands on his shirt.

Image I 47 [verso]

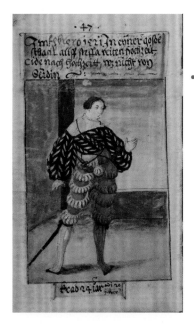

In February 1521, in a gathering at Steffan Veiten's wedding—or rather the after-wedding—it was not from silk.

Text below: Just 24 years old on 20th of February.

Clothing overview: The emphasis that Matthäus places on these being the clothes for an after-wedding suggests the importance of these occasions. It is telling that he notes they are not silk. He may be implying a degree of economy, but it may also suggest that the warmth provided by wool or a half silk might be welcome for a February social occasion.

Headwear/hair: Matthäus is bareheaded, and his hair is cut in a short bob.

68. A similar bonnet is depicted by Holbein in his painting of the Augsburg citizen Weiß in 1523.
69. Compare with the slashes on the placard in Hans Holbein the Younger, *Thomas Boleyn, 1st earl of Wiltshire and Ormonde*, pink prepared paper, black and colored chalks, 40.1 × 29.2 centimeters, Royal Library, RL 12263.

Body garments: He is not wearing a gown, possibly because a gown would diminish the impact of the doublet, and it might get in the way at the wedding. The black wool or union cloth doublet is side fastening, so as not to disrupt the visual effect created by the alternating rows of long diagonal slashes over his chest. The doublet has a white lining, which shows through the cuts and accentuates the pattern. It has a very low neck with a slight downward curve at the front. It sits low on his shoulders, but it might be higher at the back (compare with the doublet in I 42). The sleeves are very full and are probably padded, but they are drawn into a snug-fitting band at his wrist. It is quite high-waisted.

Linens: There is a large amount of fabric in his fine linen shirt, and the shirt is shown off effectively by the very low neck of the doublet. The shirt has a small neckband edged with a narrow ruffle. It probably has very full, big sleeves of the sort seen in I 68.

Legs: He has high-waisted, parti-colored, blue and yellow hose.[70] The left leg is striped in bright blue and a darker blue, while the right leg is bright yellow with a very narrow darker yellow stripe. The hose have five horizontal rows of vertical slashes that have been cut between the waist and the knee. In addition the hose have four horizontal cuts, which make it possible to form the hose into five horizontal rolls. The under-hose, or lining, are green, and they accentuate the slashed decoration. To complete the outfit, the hose have a round, ball-shaped, yellow codpiece decorated with a number of curved vertical cuts. He has black garters tied on the outside of each knee with a half knot.

Footwear: His black shoes are wide at the front, and the vamp is low cut over his toes.

Jewelry: His crucifix is worn on a black cord around his neck.

Weapons: From his black girdle and hangers, he has a sword and dagger suspended. The sword has a dark brown hilt with a black scabbard. The dagger has a round pommel, and it sits on his right hip.

Gilding: None present.

Image I 48 [recto]

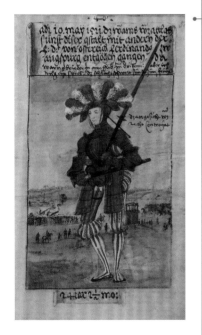

10th of May, 1521: the doublet silk satin, otherwise in this manner to walk with others toward His Highness Ferdinand of Austria in Augsburg. There were 5 brothers in one rank, the third [rank], but I carried a spear, otherwise the battle sword to please [?].

Inside the image: The face is well captured.

Text below: 24 years, 2 ½ months.

Note: Ferdinand of Austria entered Augsburg for the first time after the Diet of Worms and concluded loan agreements with the Fuggers. Schwarz met him in person and began to try to please him sartorially. He instantly followed Ferdinand to his wedding with Anne of Hungary in Linz. Hungary was central to the Fuggers' interests in mining, and the Fuggers financed the wedding with a loan of 170,000 florins.

Clothing overview: Ferdinand's arrival in Augsburg provides Matthäus with an opportunity for a military and sartorial display; this is the first time he is seen in armor. It is worn in tandem with clothes in red and white.

Headwear/hair: He wears a sallet without the visor. Over this he wears a bright red bonnet with a very wide brim, which is similar to that in I 46.[71] It is decorated with very large,

70. Compare with the hose worn in Tod und Graf, in Tripps, *Den Würmern wirst Du Wildbret sein*, 59.

71. Also see the feathered bonnet worn by a young man in Niklaus Manuel Deutsch, *Schweizerkrieger*, 1529, colored chalks on paper, 41.3 × 28 centimeters, Öffentliche Kunstsammlung Basel, Kupferstichkabinett 1927.114; in Tripps, *Den Würmern wirst Du Wildbret sein*, 86, fig. 40.

alternating red and white ostrich feathers, which radiate out from the brim.[72] The shafts of the feathers have been gilded. There is a double red cord looped under his chin, but this is quite loose, suggesting it is as much for display as keeping the bonnet in place.

Body garments: He is in half armor consisting of a breastplate with bevor, shoulder defenses made of articulated plates, arm defenses consisting of vambrace and couter, and gauntlets. The armor is decorated in the fluted or Maximilian style, and bands of decoration can be seen on the gauntlets, couter, and the breastplate.[73] Underneath he is wearing a satin arming doublet. Very little of the doublet is visible apart from small sections of the fairly full sleeves, which are striped red and white.

Linens: His shirt is not visible.

Legs: He is wearing tassets, which provide protection for the thighs, with a codpiece. His red, white, and blue hose complement his armor and arming doublet. Overall the asymmetrical hose are predominantly red and white but with significant blue highlights.[74] The left leg has red and white vertical stripes running from waist to toe. The hose are slashed between the waist and hip to create some fullness, and the blue lining shows through. They are also slashed from hip to just above the knees but fit tightly; blue shows through. From above the knee to the toe, the red and white stripes are solid. On the right leg, there are red and white stripes from waist to hip, and then dark and pale blue stripes (which do not line up) from hip to just below his knee. Below the red and white hose have been slashed (and the edges of the slashes have been cut in a decorative pattern). They are formed into a loose puff, and the blue can be seen underneath. Below the hose are striped red and white. He has red garters tied under his knees in a half bow, and they are decorated with small gilt aglets or possible gilt fringe.

Footwear: The vamps of his black shoes are low cut over his toes, and the quarters are high at the heel.

Weapons: He holds a two-handed long sword in his left hand with a straight cross guard and small lugs. There is a second, shorter sword in his right hand, possibly of the type known as a *Katzbulger* (cat-gutter). The hilt of his dagger can be seen as his waist.

Background figures: There are a lot of figures in the background, mostly on foot, but a few are on horseback. The group of pike men on the left are marching toward the group on the right, which appears to be stationary, and a number of figures in both groups are wearing red.

Gilding: On the vanes of the feathers and the aglets decorating his garters.

Image I 49 [verso]

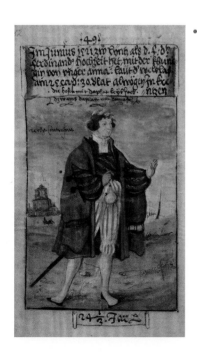

In June 1521 in Linz, when His Highness Ferdinandus held his wedding with Anna, Queen of Hungary, as in "The Course of the World," chapter 29, page 30. At all times with wreaths (for the wedding).

Later addition: The hose of half silk body-colored, the doublet half silk with damask.

Inside the image: Well captured.

Text below: Aged 24 ⅓.

Clothing overview: His choice of clothes for celebrating the very high status wedding of Ferdinand and Anna of Hungary is more formal than when attending the weddings of his friends. Even so, slashing is still the most important form of decoration in Matthäus's wardrobe.

72. A similar type of bonnet with upstanding feathers can be seen in the image of "Tod und Kriegsmann mit Sohn," image 20 in Tripps, *Den Würmern wirst Du Wildbret sein*, 87. Also see Niklaus Manuel Deutsch, *Schweizerkreiger*, 1529, colored chalk on paper, inv. no. 1927.114, Öffentliche Kunstsammlung Basel, Kupferstichkabinett.

73. For example, a full Maximilian armor, c. 1530, Royal Armory, Dresden, 2613 (24681–93), in L. Rangström, ed., *Modelejon Manligt Mode 1500–tal, 1600–tal, 1700–tal/Lions of Fashion: Male Fashions of the 16th, 17th, 18th Centuries* (Stockholm: Livrustkammaren Bokförlaget Atlantis, 2002), 30–31, 297.

74. For a similar pair of hose, this time in blue and yellow and red and white, see "Tod und Jüngling" (Junker), in Tripps, *Den Würmern wirst Du Wildbret sein*, 69.

Headwear/hair: He has a wreath of red and white twisted fabric or cord on his head, and it is decorated with gold cord. His hair has grown longer and sits well below his ears.

Body garments: Matthäus has a mid-gray, knee-length gown that is worn open at the front. It has a standing collar and long hanging sleeves. There is a slit at the top of the sleeves, and these are outlined with black passementerie, which is also formed into two pairs of large Turk's head knots and loops. These are left undone because his arms have been put through the slits in the hanging sleeves. The ends of the sleeves are shaped into points, and the last section is secured with three pairs of black points. The gown is worn over a doublet of a dark brown half silk and gray damask.[75] The doublet has the same style of high, grown-on collar as the gown. The doublet is side fastening, and the flat front is slashed with long diagonal cuts through which a dark gray damask can be seen (also see the doublet in I 46). The sleeves are very full and consist of long, wide vertical panes, which are drawn into a narrow wristband. They are lined with gray damask and probably have some padding to create the full shape.

Linens: His shirt has a very deep neckband, which is trimmed with a small ruffle, and there is a suggestion of lots of fine pleating.

Legs: His bright yellow hose are slashed from waist to hip, hip to the top of the knee, and over the knee, to reveal a bright red or flesh-colored lining or under-hose. He has a round, plain yellow codpiece. He is not wearing garters.

Footwear: His black shoes are wide at the front. The vamps are low cut over his toes, while the quarters are high at the heel.

Accessories: A single black point, one of a number, joins the doublet to the hose and it is tied in a half bow. Another secures the top of his codpiece.

Jewelry: There is a gold chain incorporated into his wreath.

Weapons: He appears to be wearing his sword in a black scabbard, but the hilt is concealed by his gown.

Gilding: On the wreath.

Image I 50 [recto]

On 2 December, 1521, during the plague in Augsburg. The gown with a velvet trimming, the bonnet embroidered with velvet, the lining of the best marten fur, as in "The Course of the World," 29th chapter, 31st sheet.

Inside the image: The face was well portrayed.

Text below: Aged 24 ¾.

Note: The severe plague epidemic began on 25 July and was about to end.

Clothing overview: Although Matthäus is wearing a black bonnet, gown, doublet, hose, and shoes, the impact is alleviated by the contrast provided by the fur, his shirt, and the yellow lining of his hose. How big an audience he has is debatable, as plague would have limited social activity in Augsburg. The fur lining acknowledges the snow on the ground.

Headwear/hair: He has a black bonnet with a very wide, double, velvet-covered, slashed brim that is worn flat on his head. His hair has been cut and now comes part way down his ears.

Body garments: His black gown comes to just below his knees, and it is a complex but close-fitting garment. It has a rolled collar that is decorated with narrow bands of black silk. The rest of the gown is trimmed with a pair of black guards down the fronts, at various points on the sleeves, and probably around the hem. It is fully lined with marten fur (*das futer kelmeder*), which he shows to the viewer. The straight hanging sleeves are made in three

75. Similar in style to the doublet in I 46.

sections, and they have a closed end. The sections are joined together with pairs of black points and decorative buttons and discs of black cord. There is a slit on the underside of the sleeve, and his right arm goes through it. However, the pair of points on the top section of the left hanging sleeve has been undone, revealing the sleeve of his doublet. One of the pairs of points further down has also been undone making it easy to see the three sections. He has a black damask doublet with a low neck cut in a slight downward curve. The front of his side-fastening doublet is decorated with four long, diagonal slashes through which show the white lining. The sleeves are very full and look to have been made from a folded-over loom-width of silk with the minimum of shaping to form the wristband.

Linens: Matthäus wears a shirt with a wide neckband edged with a narrow ruffle. It is decorated with three rows of gilt metal thread embroidery. Rows of embroidery are also worked in gilt thread on either side of the front opening.

Legs: His black hose are tight fitting. They have a series of short of vertical slashes cut between his waist to the top of his thighs and another set over the knees. In both cases a bright yellow lining shows through. The round codpiece is black and slashed to reveal the yellow lining. There are no garters.

Footwear: His black shoes are wide at the front, and the vamps are low cut over his toes.

Jewelry: For the first time he is wearing a rectangular gold pendant on a black cord around his neck. There is a plain gold ring on the fourth finger of his left hand.

Weapons: His sword is in a black scabbard with a black girdle and hanger. The hilt and pommel are gray, suggesting bright steel, and the grip is wrapped with a fine cord or wire.

Gilding: The embroidery on his shirt, the ring, and the rectangular pendant.

Image I 51[76] [verso]

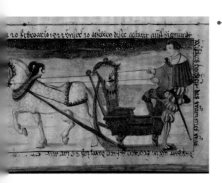

On 20th February, 1522, us 10 comrades looked like this at Sigmund Peitscher's wedding. The doublet was from a half silk, and we all rode wearing wreaths, I was 25 years old.

Note: This documents the importance of group appearances at weddings and shows that Schwarz's tastes were shared by his peers.

Clothing overview: Nearly three months later, it is still snowy, but the cold does not prevent him from wearing lightweight wedding clothes or displaying them while driving his sleigh. Dressed like this, Matthäus and his ten friends would have made a striking impact on the wedding party.

Headwear/hair: He is bareheaded apart from the blue and yellow twisted wreath on his head. His hair has grown a little longer and covers his ears.

Body garments: As he is out driving in the snow, Matthäus is rather under-dressed. He is wearing a very small, short, pleated mauve/gray cloak. It is worn low on his shoulders and comes to his waist. It fastens with blue ties. His orange/red half silk doublet has a very low neck, which sits on the point of his shoulders, and it is equally low at the front and back. The doublet may be quilted on the side-fastening front, and it has very full sleeves that are drawn in at the wrist. The doublet is trimmed with black passementerie.

Linens: His shirt has a small neckband, which is decorated with a narrow ruffle and two rows of gilt metal thread embroidery. There are also two thick bands of embroidery on either side of the front opening of the shirt.

Legs: His hose are asymmetrical and fancy. On his left leg the over-hose are striped vertically in yellow and dark gray/black. They are fitted from waist to hip, and then there are three vertical

76. Omitted from Braunstein, *Un Banquier Mis a Nu*.

bands of slashes that are separated by three horizontal cuts. The hose form into three rolls at the top of his thigh, mid-thigh, and over his knee. They are close-fitting from below the knee. The cut of the hose on the right leg is the same as the left leg, but they are dark mauve/gray. The under-hose are bright red with a vertical, darker red, narrow stripe. The hose have the usual round codpiece, which is half yellow, half dark mauve/gray and red can be seen through the slashes.

Footwear: His black shoes are wide at the front, and the vamps are low cut over his toes.

Jewelry: There is a long black cord around his neck, but whatever is hanging from it is placed inside his doublet.

Weapons: He has a sword with a black hilt in a black scabbard with a black girdle and hanger.

Horse/horse harness: He has a dapple-gray horse/gelding. The black harness, probably black leather, consists of a bridle with long reins; a black, gray, and red collar, which the traces of the sleigh are attached to; and several back straps that link the crupper to the collar. It is decorated with gilt bells on the bridle and the straps on the quarters. The horse shoes have a single stud at the back to provide additional grip in the slippery conditions.

Sleigh: The black sleigh has a red and gray decorative scheme echoed in the horse harness. The end panel is painted with a winter scene, and Matthäus stands at the back to drive.

Gilding: The bells on the harness, the wreath, and on his shirt.

Image I 52 [recto]

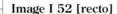

On 2nd May, 1522, I wore a thread caul for the first time. The jerkin was scarlet red, the doublet green velvet [and] scarlet red damask; the hose, green taffeta; the shirt with golden bands.
Inside the image: The face is well captured.
Text below: 29 years, 2 ½ months.

Clothing overview: Dressed all in bright scarlet, Matthäus presents a striking figure. His decision to start wearing a fancy caul at the age of twenty-five makes a link between this accessory and a degree of male maturity.

Headwear/hair: The gilt metal thread caul, possibly made from sprang, is very close-fitting. It is placed on the back of his head, and worn alone like this, it is suited to this indoor wear.[77] Almost all of his hair is tucked underneath.

Body garments: Matthäus is wearing a sleeveless, scarlet damask jerkin, which is fastened at the waist only with the fronts cut to create a v-shape opening. The collar is left undone, and each side turns back. The left half of the collar is scarlet, while the right half is green and they are lined with the same color. It is decorated with two broad vertical guards of green velvet on both fronts. Underneath the jerkin, he has a matching scarlet and green damask doublet. The neck is fairly low cut, and the doublet is side fastening. The sleeves are made in two pieces. The upper, very full section is padded and/or has a heavy interlining to help maintain the shape. It is gathered into the cone-shaped lower section, which fits closely at the wrist.

Linens: The shirt has a small neckband edged with a ruffle. It has a short front opening and both the neckband and the front opening have been decorated with thick bands of gilt metal thread embroidery worked in a diamond pattern.

Legs: His scarlet hose are asymmetrical. They are slashed between his waist and hips, on both thighs, and at the knees to reveal the green taffeta lining or under-hose. The slashes are vertical on the lower body, at the knees, and on the left thigh, and they are horizontal on the right thigh. The edges of the slashes are worked with decorative cuts. In addition, the scarlet hose are slashed around the hips and formed into a small roll, at the level of the round, scarlet

77. Compare with the caul worn by Sir Nicholas Carew, see Hans Holbein the younger, *Sir Nicholas Carew*, c. 1528, oil on panel, 114 × 123 centimeters, collection of the Duke of Buccleuch and Queensbury.

codpiece. It is slashed vertically to reveal the green lining. Red garters are tied under each knee to the outside of his knee.

Footwear: His black shoes are wide at the toe, and the vamps are cut low over his toes.

Jewelry: The black cord hanging around his neck has a large, rectangular, gold pendant, possibly with a pendant pearl.

Weapons: His sword has a two-tone hilt. The pommel and the hand guard are depicted in gray, suggesting bright steel, and the hilt is wrapped with black cord. It is worn on his left hip, and his hand rests just below the hilt. It is in a black scabbard and hanging from a black girdle and hanger.

Gilding: On the collar of his shirt, also the pendant, and the caul.

Image I 53 [verso]

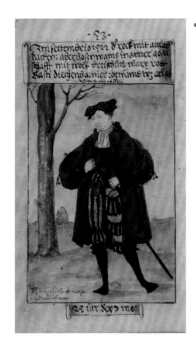

In September 1522. The gown with silk satin points, hose, doublet, in a gathering with Wolf Breischuch, Marx Rott, Basti Dietenhaimer. The doublet was made of silk satin, otherwise everything woolen.

Inside the image: The face is well captured.

Text below: 25 years and 7 months.

Clothing overview: The start of autumn sees Matthäus wearing a gown again, and almost every element of his outfit is heavily decorated.

Headwear/hair: He is wearing a new style of small black bonnet, with a slashed upturned brim. The brim is covered with many pairs of gold aglets.[78] The bonnet is worn over a black caul, with stripes created using gilt metal threads; it is worn toward the back of his head. His hair is almost completely covered by the caul.

Body garments: His mid-brown wool, knee-length, gown has a small grown-on collar and very full three-quarter-length sleeves that come to his mid-forearms. The sleeves are slashed vertically in several places, and the slashes are secured with pairs of black points with gold aglets. The gown is decorated with rows of z-shaped motifs, probably made from black passementerie. These motifs are positioned on the collar, the fronts, the sleeves, and around the hem. Under the gown, he wears a black silk satin doublet. It has a low neck cut with a slight upward curve. It has very full, two-part sleeves. The upper part is padded, while the lower section finishes in a narrow band at the wrist.

Linens: His shirt has a small neckband and a short front opening. The neckband is edged with a ruffle, and it is decorated with three thick rows of gilt metal thread embroidery. Two further rows are worked on either side of the front opening.

Legs: He has selected black wool hose with a red lining that can be seen through the slashes. On the left leg, the black hose are slashed from waist to just below the knee. The slashes are in three blocks, which are separated with horizontal cuts. These allow the hose to form loose rolls. The hose are plain from the knee to toe. The edges of the cuts are jagged to create a curved decorative effect. On the right leg, the hose are cut with three bands of vertical slashes from waist to the hip, from the hip to above the knee, and then over the knee. Each block of slashes are separated by a band of solid fabric. The hose probably have a round, black codpiece, but it is partially obscured by the hilt of his dagger. Black garters are tied below his knees, and they are decorated with small gilt aglets or possible gilt fringe.

Footwear: The black shoes are wide at the front, and the vamps are low over his toes.

Accessories: His sword with a black hilt, along with his dagger, is worn from his black girdle and hanger. The sword is in a plain, black scabbard.

78. See the upturned brim of the bonnet worn by Sir William Palmer, in Gerlach Flicke, att., Sir William Palmer, c. 1546, oil on panel, 101.6 × 62.2 centimeters, Sabin Gallery, Starkey, *European Court*, X.2, 137.

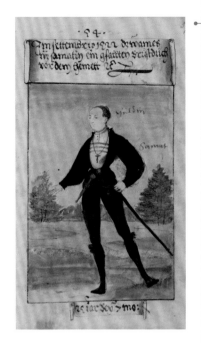

Jewelry: He is wearing his silver crucifix on a black cord, which he has not worn since February 1521 (I 47).

Gilding: The aglets on his bonnet, garters, the sleeves of his gown, and the embroidery on his shirt.

Image I 54 [recto]

In September 1522. The doublet made of velvet. A placard in front of the shirt.

Inside the image: Golden; velvet.

Text below: Aged 25 years and 7 months.

Clothing overview: A contrasting set of autumn clothes being worn in the same month as I 53, this set of black doublet, hose, garters, and shoes are very tight fitting, and the color and cut are intended to accentuate Matthäus's slim waist and well-toned legs. It also demonstrates that a variety of styles was being worn at the same time and could be seen as equally fashionable.

Headwear/hair: He is wearing a close-fitting gilt metal thread caul. It is heavily patterned. It is worn on the back of his head, and it covers almost all of his hair.

Body garments: He has a black velvet doublet with a small grown-on collar that is not intended to fasten. It has a natural waistline and fastens only at the waist. The fronts are cut away to reveal a large amount of his shirt. It has quite wide sleeves that fit at the wrist. A single gilt button fastens the small opening at the wrist on his right doublet sleeve. The front of his chest is covered with a white placard with a downward curve to its top edge. It is decorated with three wide horizontal rows of gold passementerie.

Linens: His shirt is pleated with lots of fine pleats, and it has a small neckband. This is decorated with two thick bands of gilt thread embroidery, and it is edged with a small ruffle. There is also a line of embroidery down the front opening of the shirt and two round gold buttons. These might be made from metal thread wrapped around a wooden core, a Turk's head knot made from metal thread, or a cast metal button.[79]

Legs: Very unusually he is wearing plain, black hose with a round black codpiece. Black garters are tied below his knees, and they are decorated with gilt aglets or gilt fringe.

Footwear: He is wearing a pair of black shoes, which are wide at the front, and the vamps are low cut over his toes.

Jewelry: His crucifix hangs on a black silk cord around his neck.

Weapons: He has a sword in a black scabbard on his left hip and a dagger without a scabbard on his right hip. They are worn with a black girdle and hangers.

Gilding: On his shirt, the caul, his garters, and the button on the wrist opening of his doublet.

Image I 55 [verso]

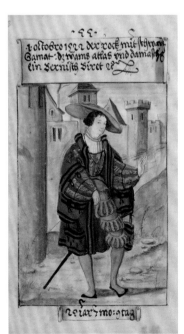

October 1, 1522. The gown [edged] with black velvet, the doublet silk satin and damask, a Bernese bonnet.

Text below: Aged 25 years, 7 months, and 9 days.

Clothing overview: Dressed in shades of gray and contrasting materials, Matthäus is wearing a style with similarities to I 49. His cosmopolitan tastes are reflected in his favoring a Swiss bonnet, which acknowledges the scope of the Fugger network.

79. See Egan, *Material Culture*, 48–50; also B. Read, *Metal Buttons c. 900 BC–c. AD 1700*, second edition (Langport: Portcullis Publishing, 2010), 35–127.

Headwear/hair: He is wearing a very large, pale gray plate-style bonnet worn at a slight angle over his left ear. The big brim has a downward curve. His hair is cut in a short bob, just covering his ears.

Body garments: His dark gray gown is worn open at the front. It has an upright collar and it is decorated with black velvet guards. These run vertically down the collar, and the front edges and horizontally around the hem and on the hanging sleeves. The sleeves are made in two sections: The upper, bigger section has a slit part way down, through which his arms pass. This slit can be closed with two pairs of black loops and buttons. The lower section is completely separate, and it is joined to the main part of the sleeve by a pair of loosely tied black points. Underneath, he is wearing a striped doublet, and the striped effect has been created by piecing the fabric. The dark gray stripes are made from silk satin and the pale gray stripes of damask. The stripes run vertically on the smooth front of the side-fastening doublet, and on the very wide, and probably padded, sleeves. The low neck of the doublet is cut with a slight upward curve and the full sleeves are fitted at the wrist. The doublet's neck, the wrists, and midpoints of his sleeves are edged with black passementerie.

Linens: The neckband of his shirt is edged with a small ruffle, and it is decorated with two rows of gilt metal thread embroidery. Another two rows are worked on either side of the shirt's front opening.

Legs: Matthäus's mid-gray hose match his doublet. As only one leg is fully visible, it is not possible to tell if the hose are symmetrical. On his left leg, the hose are close-fitting from waist to hip, cut in three vertical blocks of slashes at mid-thigh, lower thigh, and at the knee. These are separated by three horizontal cuts. The edges of the vertical cuts are jagged. It is possible to see the matching gray under-hose through the slashes. Below the knee, the hose are plain gray. It is not possible to tell if the hose have a round codpiece because of the position of his right hand, but it is most likely that they do.

Footwear: His black shoes are wide at the front. The vamps are low cut over the toes, and the quarters are high at the back of his heel.

Jewelry: He is wearing his silver crucifix worn on a black cord

Weapons: His sword is in a black scabbard. It hangs on his left hip from a black girdle and hanger.

Gilding: On the collar of his shirt.

Image I 56 [recto]

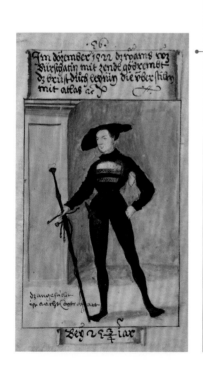

In December 1522. The doublet made from a light mix of wool and silk with taffeta edgings, the placard linen, the bands made of silk satin.

Inside the image: The face is well captured.

Text below: Aged 25 and ¾.

Clothing overview: Almost all in black again, Matthäus is wearing clothes that have a number of things in common with those that he was wearing two months earlier (I 54).

Headwear/hair: He is wearing a very wide brimmed black bonnet. The underside of the brim is covered with silk satin. The back section brim is shaped around the back of his head. Alternatively the bonnet is worn over a small black caul and most of his hair is covered.

Body garments: Matthäus is wearing a very distinctive black doublet made from *Burschat* (a fine, lightweight union cloth of silk and wool). It is close-fitting to the body with tight sleeves that end in turned-back cuffs. It fits at his waist, but extends beyond with small skirts and so overlaps the top of his hose. The fronts of the doublet meet at the neck and the waist (where they are fastened with black buttons), but they are cut away in between, revealing a large oval area of his chest. The doublet is decorated with applied narrow strips of black taffeta, creating

a horizontal striped effect. The same black taffeta has been used to bind the edges of the fronts, the collar, and the skirts. Rather than the stand collar often seen on his doublets, this collar is turned down, and it has a slightly scalloped edge. It is worn with a black placard, which is pleated vertically in lots of very narrow pleats. The placard is decorated with two very broad horizontal bands of gold passementerie, which is worked with a geometric design in black.

Linens: The neckband of his shirt, or its decorative ruffle, is just visible about the neck of his doublet. It is also visible in the chest area between the neck of his doublet and the top of the placard. It may also show in his left underarm, where the seam of the doublet has been left unstitched to allow for some freedom of movement.

Legs: He is wearing tight-fitting, fairly plain, black hose with no garters. The hose are slashed with short, wide vertical cuts around his hips to reveal black fabric underneath. The hose have the usual, round, black codpiece.

Footwear: He has the usual black shoes that are wide at the front and have low-cut vamps.

Weapons: He holds his long sword, with a black hilt, black scabbard, black girdle, and hangers, in his right hand. The girdle and hangers have a black buckle and loops. He is wearing his dagger at an angle by his right hip from another girdle and hanger. The dagger has an ornate, gilded hilt.

Gilding: On his shirt and the hilt of his dagger.

Image I 57[80] [verso, landscape]

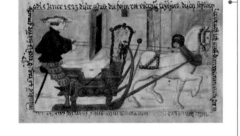

5 January, 1523, in this manner: the hose red, the over-hose flesh-colored. I broke this sleigh into 17 pieces on the wine market, for I and Thama Oham ran into each other, I was 26 years, minus 46 days old. The gown had been made before then.

Note: This documents the speed of men's sleigh-riding. The motifs on the sleigh contrast marital love with passionate desire, which will turn men into fools.

Clothing overview: The short gown is a reworked version of the knee-length gown seen in September 1522 (I 53), suggesting a rapid process of recycling his clothes in just four months to give Matthäus the maximum potential for novelty tempered with the best value for his money.

Headwear/hair: He is wearing a bright red bonnet with a flat crown and fairly wide brim. It is placed flat on his head, and the underside of the brim is embellished all around with large, white ostrich feathers. His hair is cut short.

Body garments: Matthäus is wearing a bright chestnut brown short coat with a small upright collar. It is cut very full in the body but drawn in at the waist, and then the hip-length skirts flare out again. It has wide, elbow-length sleeves, which have a long opening that is secured with one pair of black points. It is decorated with applied, z-shaped motifs of black passementerie. These are placed on the collar, around the opening in the sleeves, and around the hem of the skirts. It is worn over a doublet, only the full sleeves of which are visible. It may be a brown doublet, with its red lining showing through the vertical slashes. Or if the sleeves of the coat are full length, then the sleeves of a red doublet are seen through the slashes.

Linens: Not visible.

Legs: As his hose are seen in profile, it is not possible to tell if they are symmetrical. Based on what is visible of the right leg, the over-hose are bright red. They are slashed vertically, in four bands, from his waist to the hip, over the upper thigh, the mid-thigh, and over the knee. In between the four bands of vertical slashing, there are three horizontal slashes, allowing the

80. Omitted from Braunstein, *Un Banquier Mis a Nu*.

hose to form into four loose rolls. The side view shows the areas of the leather left uncut, in particular across his buttocks. The over-hose have a round, red codpiece that also has vertical slashes. They are worn with red hose of a slightly darker shade.

Footwear: His black shoes are wide at the front, and the vamps are low over his toes.

Accessories: His long black whip is resting inside the sleigh.

Jewelry: There is a wreath on the brim of the bonnet, probably made from gilt wire or possibly something more substantial made by a goldsmith.

Weapons: His sword is in a black scabbard and sits on his left hip. His dagger is in a black sheath attached to his right garter.

Horse/horse harness: He has a gray gelding/stallion in a red harness, decorated with gilt bells on the bridle and on the crupper. The long reins go from the bit of the bridle, via the collar, to his hands. The traces of the sleigh are attached to the collar.

Sleigh: He is driving a coordinating red sleigh with painted decoration on the body of the sleigh and also on the end panel, which depicts a man and a woman.

Gilding: The bells on the harness, the wreath on his bonnet.

Image I 58[81] [recto, landscape]

On 10 January, in this manner, until carnival. The cloak with red, brown, white, golden silk satin, the doublet silk satin, the sleigh decorated with a flax-dance all around. I was 26 years, minus 41 days, old.

Inside the image: Well portrayed.

Note: The sleigh depicts popular dances and had been bought within five days after the accident.

Clothing overview: Driving his sleigh provides Matthäus with the opportunity to show off a new type of garment, a hip-length cloak.

Headwear/hair: He has a gilt metal thread caul worn on the back of his head. His hair is tucked underneath and it is hardly visible.

Body garments: The cloak is bright green and hip length. It is worn on his shoulders and draped over his right arm. It is decorated with stripes of dark gray, red, orange, and white. It has a tall, upright collar, and the fullness suggests that it is made from a full circle. Underneath Matthäus is wearing a doublet of red and white vertically striped and yellow and gray horizontally striped silk satin. It is unlikely that this is a woven fabric—rather the red and white have been pieced, and the gray and yellow bands have been applied on top. Short vertical cuts can be seen on the red and white stripes. It has a low neck and quite full sleeves, which narrow at his wrists.

Linens: His shirt has a high neckband that is edged with a small ruffle in a distinct s-shaped pattern. Two wide rows of gilt metal thread embroidery decorate the neckband, and another two rows are worked on either side of the front opening.

Legs: As in I 58, it is not possible to tell whether the hose are symmetrical. On his left leg, the hose are striped red and white between waist and hip, and then bright blue and pale blue between his hip and just above his knee. They are slashed over his knee, and the edges of the slashes are jagged. From below his knee to his toes, they are striped red and white again. The hose have a prominent, round, red and white striped codpiece.

Footwear: The black shoes are wide at the front, and the vamps are low over his toes.

Weapons: He does not appear to be carrying a sword, but he has a dagger tucked into his left garter.

Horse/horse harness: It is possibly the same gray gelding/stallion as in I 57, but this time in a blue harness, which is almost identical to the red version in the previous image. This

81. Omitted from Braunstein, *Un Banquier Mis a Nu.*

indicates that he soon had a replacement for the red sleigh, which he had destroyed five days earlier.

Sleigh: A matching blue sleigh with a depiction of a flax dance painted on the side and a domestic scene on the end panel.

Gilding: Used for the bells on the horse harness, on his shirt, and on his caul.

Image I 59[82] [verso]

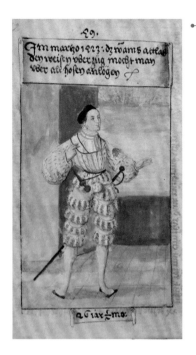

In March 1523. The doublet of silk satin, the white over-hose could be worn with any hose.
Text below: 26 years and ½ a month.

Clothing overview: His bright, striking yellow doublet and hose are well suited to spring. In spite of the fullness of the sleeves and the puffed over-hose, the impression is still of close-fitting clothes intended to emphasize the shape of Matthäus's body.

Headwear/hair: He is wearing a close-fitting black caul that is positioned toward the back of his head. It covers most of his hair.

Body garments: His doublet is made from bright golden yellow silk satin that has a low, round but quite narrow neck, allowing the doublet to sit quite high on his shoulders. The doublet has very full sleeves, which are probably padded, and they fit at the wrists. The front of the doublet is quilted with vertical lines of stitching and is also slightly padded. The yellow satin has been cut with a series of short vertical slashes. The neck and cuffs of the doublet have been edged with black

Linens: The shirt has a high neckband that is edged with a small ruffle, and it is embellished with two rows of gilt metal thread embroidery. In addition, another two bands of embroidery are worked on either side of the shirt's front opening. The shirt is heavily gathered, suggesting it is made from a lot of fine material.

Legs: Matthäus wears plain bright yellow hose with white over-hose that come to his knees. The white over-hose are close-fitting between his waist and his hips. Below his hips, the over-hose are slashed with four blocks of vertical cuts that are separated by four horizontal cuts, allowing the over-hose to form into gentle rolls. In addition, the edges of the vertical slashes are jagged. The over-hose have a large, round white codpiece that is decorated with three pairs of gilt aglets. Yellow garters are tied below his knees in knots. The ends of the garters are trimmed with gold aglets or gold fringe.

Footwear: He is wearing black shoes that have low-cut vamps, while the quarters come up higher around his heels.

Accessories: A bunch of four red points with gold aglets is pinned to his left sleeve. More red points tie the hose to the doublet's lacing band and secure the codpiece.

Jewelry: There is an item tucked inside the neck of his doublet worn on a black cord.

Weapons: His sword has a black hilt, and it is in a black scabbard on his left hip. He has a dagger on right hip. Both hang from a black girdle and hangers worn around his waist.

Gilding: The embroidery on his shirt, the decoration on his garters, the aglets on the points.

Image I 60[83] [recto]

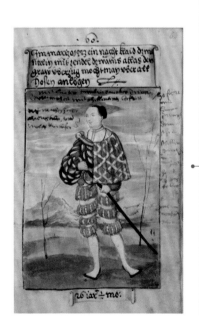

In March 1523: an evening dress, the short cloak with taffeta, the doublet made from silk satin, the gray over-hose can be fitted over any hose.
Inside the image: Hose with much green [...] small bells all around, with Matheus Herrtz, Andreas Koler, and Wolf Breitwiser.
Text below: 26 years, ½ month.

82. Omitted from Braunstein, *Un Banquier Mis a Nu.*
83. Omitted from Braunstein, *Un Banquier Mis a Nu.*

Clothing overview: This is the first time that Matthäus explicitly describes clothes as being worn in the evening, suggesting that he changed his clothes specifically for such events.[84] However, this set of clothes is quite similar in terms of the short cape and fancy hose seen in I 51, while the cut of the doublet resembles the example in I 47. It is a flamboyant outfit to go out in male company.

Headwear/hair: He has a small black caul, striped in black, which is worn on the back of his head. It covers most of his hair, apart from a few strands at the front that have escaped.

Body garments: He has a very short taffeta cloak worn on his left shoulder.[85] It is gray, lightly pleated or gathered and decorated with applied diagonal bands of white, mauve, and yellow silk, forming a diamond-shaped grid. It is secured with gray, yellow, and mauve ties, which are fastened in a knot on his right shoulder. It is worn over a doublet of brown silk satin, with a low, round neck and full sleeves that narrow at the wrist. The doublet is decorated with a series of quite long diagonal slashes on the right sleeve and the front of the doublet, which reveal the pale yellow lining to form a striking effect. What can be seen of the left sleeve suggests that it is not slashed in the same way (or the artist made an error showing it this way). The doublet probably fastens at the side, but the position of the cloak makes it difficult to be certain.

Linens: His shirt has a deep neckband edged with a small ruffle. The neckband is embellished with two rows of gilt metal thread embroidery and another two bands of embroidery are worked on either side of the front opening of the shirt.

Legs: He is wearing pale yellow hose with gray over-hose. The over-hose are close-fitting between his waist and his hip. Below the hip, the over-hose are slashed with four blocks of vertical cuts, which are separated by four horizontal cuts, allowing the upper hose to form into gentle rolls. The edges of the vertical slashes are jagged. It is likely that there is a round, gray codpiece, but it is concealed by the hilt of his sword. He is not wearing garters.

Footwear: The black shoes are very broad at the front. The vamp is low cut over the toes and the quarters come up quite high around the heel.

Jewelry: There is a black cord around his neck, and the piece of jewelry hanging from it is tucked inside the neck of his doublet.

Weapons: His sword rests on his left hip, and the hilt of his dagger can be seen close to his right hand.

Gilding: The embroidery on his shirt

Image I 61 [verso]

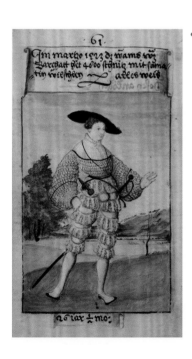

In March 1523. The doublet of fustian, which has 4,800 slashes with velvet rolls all in white.
Below the image: 26 years, ½ month.

Clothing overview: Dressed all in white, this image provides a view of the daywear favored by Matthäus in spring 1523, and it offers a point of comparison with the clothes for going out at night in I 60. While both sets of clothes are very ornate, it is telling that he opts to wear this heavily pinked doublet during the day when more people would be able to admire it in good light.[86]

Headwear/hair: He has a very wide-brimmed black bonnet. The brim has a downward curve. It is worn at a slight angle toward his left ear. His hair is cut in a short bob.

Body garments: His white fustian doublet has a low, wide neck, which just sits on the edge of his shoulders. The very full sleeves are probably padded, and they narrow toward

84. For the changing significance of night and evening, see C. Koslofsky, *Evening's Empire: A History of the Night in Early Modern Europe* (Cambridge: Cambridge University Press, 2011).
85. He wears a similar cloak in I 51 (February 20, 1522).
86. See the detail of pinking and slashing on a yellow satin doublet of Moritz of Saxony, Niekamp and Jucker, *Das Prunkkleid des Kurfürsten Moritz von Sachsen*, 64, fig. 42, and the detail of pinking and slashing on yellow satin, Niekamp and Jucker, *Das Prunkkleid des Kurfürsten Moritz von Sachsen*, 64, fig. 43.

the wrist. The doublet is decorated with lots of very short vertical slashes or pinks, and these are arranged in neat vertical and horizontal rows, forming a scale pattern. The arrangement of the pinked design over the front of the doublet suggests that it fastens at the side. The neck, waistline, sleeve ends, and a midpoint of the sleeves have been trimmed with black passementerie or cord (*Biesen*). The doublet comes to his natural waist.

Linens: His white linen shirt has a small neckband edged with a little ruffle. The neckband is decorated in a whitework technique—possibly Italian shirring. The front opening of the shirt is visible amongst the fine gathers in the linen.

Legs: He has white hose worn with white over-hose, which come to just below his knees. The over-hose are close-fitting between his waist and his hip, but they are decorated here with short slashes. Below the hips, the over-hose are slashed with four blocks of vertical cuts and separated by four horizontal cuts, allowing the upper hose to form into gentle rolls. The edges of the vertical slashes are jagged.[87] The over-hose have a plain round, white codpiece.

Footwear: He is wearing black shoes, which are wide at the front. The vamps are cut low over his toes, while the quarters come up higher around his heels.

Jewelry: There is a large, ornate, gold, rectangular pendant worn on a black cord.[88]

Weapons: He wears a sword and dagger, in a black scabbard and sheath, hanging from a black girdle.

Gilding: The pendant.

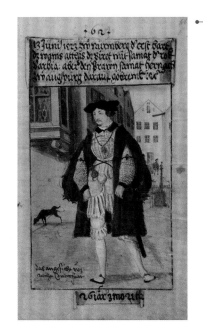

Image I 62 [recto]

13th of June, 1523, in Nuremberg, the first beard. The doublet silk satin, the bonnet with velvet, the gown fine wool from Barbia (Perpignan); but the brown velvet trimmings were added later in Augsburg.

Inside the image: The face was well captured.

Text below: Aged 26 years, 3 months, 21 days.

Clothing overview: Three months later Matthäus buys clothes in Nuremberg, which he wears there. However, very soon after he has some alterations made to the gown in Augsburg. This provides further evidence of where he buys clothes, while also providing evidence of his evolving wardrobe. He also makes a more significant change to his appearance by growing a beard.

Headwear/hair: He wears a black velvet bonnet with a fancy, shaped brim that is worn flat on his head. He has short hair with a neatly trimmed small stiletto-style beard, which he acknowledges as being a first, and a little moustache, which he does not mention.[89]

Body garments: His knee-length gown is made from fine brown wool from Perpignan. It is decorated with a wide and a narrow black[90] velvet guard down the fronts and around the hem. The wide, hanging sleeves are also trimmed with narrow guards at the sleeve opening, down the length of the sleeves, and where the sleeves join the body of the gown. There is a long opening in the front of the sleeve, which is secured with two pairs of black points with gold aglets. Two other pairs of points decorate both sleeves. The ends of the sleeves are cut with a crescent-shaped cut. His white satin doublet has a high, turned-back black collar and deep black cuffs. The doublet fastens at the neck and the waist with a single large white button. The fronts of the doublet are cut away to reveal an oval section of the placard worn underneath

87. The over-hose are similar to those in I 59.
88. This may be the pendant from I 50.
89. For the importance of growing a beard, see W. Fisher, "The Renaissance beard: Masculinity in early modern England," *Renaissance Quarterly* 51.1 (2001): 155–87.
90. Matthäus describes them as brown, but they look black.

(compare with the doublet in I 56). The sleeves are quite full but less so than in I 61. The doublet is decorated with rows of pinks arranged to form a scale pattern. The oval void in the front of the doublet is filled with a white placard that is quilted vertically. It is decorated with lots of small curved cuts.

Linens: Just the small neckband of the shirt is visible. It is edged with a narrow ruffle.

Legs: Matthäus wears ornate white hose. The over-hose are slashed in three vertical bands between his waist and hip, at the mid-thigh, and over the knee. There are also two horizontal slashes, which allow the hose to form into three loose puffs, revealing a large amount of the plain white hose underneath. The over-hose have a plain, white, round codpiece. He does not appear to be wearing any garters.

Footwear: He has black shoes, cut low over his toes. The shoes have narrow straps, which tie in a small bow on the top of his foot.

Jewelry: He has the same large gold pendant worn on a black cord as in I 62.

Weapons: A sword in a black scabbard and a dagger are worn on his right hip from a black girdle with hangers.

Gilding: The pendant, the aglets on the black points.

Image I 63 [verso]

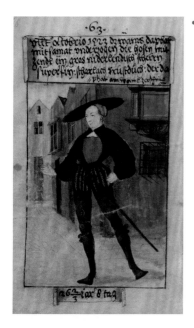

Last day of October 1523. The doublet from half silk lined with velvet; the hose with taffeta; a large, super-fine bonnet from the Netherlands; a scarlet placard; the taffeta pinked on the doublet.
Text below: Aged 26 and ⅔ years, 8 days.

Clothing overview: Matthäus has selected another close-fitting black doublet and hose shown off without a gown, suggesting that he likes this style.

Headwear/hair: His black bonnet has a very wide brim that has a slight downward curve. His description suggests that the very wide, flat style is what is considered to be distinctively Netherlandish. It is made from very high quality wool felt. It is worn at a slight angle on his head and in conjunction with an ornate gold thread caul, which covers almost all of his hair.

Body garments: The black doublet is made from a half silk. It has a small, grown-on collar. It fastens at the collar and the waistband only, either with a button and long loop or a hook and loop. The fronts are cut away to create an oval gap. It has fairly full sleeves, which narrow at the wrist. It comes to his natural waist. The doublet is decorated with a combination of long and short diagonal slashes and pinks, and black velvet shows through the cuts. The shiny black cut pile of the velvet forms a subtle but distinct contrast with the more matte surface of the silk union cloth. Underneath Matthäus has a scarlet placard that infills most of the open front of the doublet. The placard is trimmed with a black passementerie along the top edge.

Linens: Only a small section of the shirt is visible under the doublet and placard. It probably has a small collar, but this is hidden by the doublet's collar.

Legs: He wears plain black hose, in combination with a pair of very short trunk hose, of a type he wears again in I 66. The trunk hose are made from a series of quite wide black panes, which run from the waistband to the band at the top of his thighs. The edges of the panes are cut with a series of short cuts, creating a decorative effect. The trunk hose are lined with bright blue taffeta, and this shows very clearly between the panes. They also have a plain black, round codpiece, and black garters are tied below his knees in half knots.

Footwear: He is wearing a pair of black shoes, which are wide at the front, and the vamps are low cut over the toes.

Weapons: He has a sword with a black and gilt hilt. It is in a black scabbard and worn hanging from a black girdle and hanger.

Gilding: On the caul and the sword hilt.

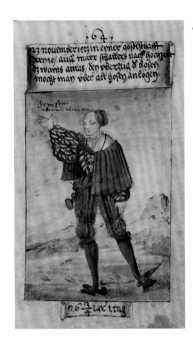

Image I 64 [recto]

On 23rd November, 1523, in a social gathering as a group of ten at Marx Schaller's after-wedding. The doublet silk satin, the over-hose can be worn over any hose.

Inside the image: [. . .] but not always.

Text below: 26 ¾ years, 1 day.

Note: Schwarz stands on a shoe and overshoe as symbols of failed courtship. The same motif recurs in his son's book, whereas Netherlandish paintings, such as van Eyck's Arnolfini Wedding, depict overshoes next to a couple as a symbol of a successful union. This relates to some customs in which a bride gave her groom a shoe before the wedding.

Clothing overview: Another set of clothes for an after-wedding party, which suggest that this style of short cloak was a popular choice for these occasions. The suit of gray cloak, doublet, and hose are smart and would make Matthäus and the other nine men wearing these clothes very distinctive at the celebrations.

Headwear/hair: He wears a gold caul; it covers most of his hair, which must be cut quite short. It is worn on the back of his head and gives the impression that his hair is starting to recede. Over it, worn on the left side of his head, is a green wreath, a reference to his attending the after-wedding. This might be made from real foliage or silk leaves.

Body garments: Matthäus has a very short cloak worn on his left shoulder and off the right. It is gray, pleated, and it comes to his mid-forearm/hips. It falls in heavy folds, suggesting that it is padded or that the folds are held in place with stay tapes. The ties are bright blue, and they are tied in a knot resting on his right shoulder. His doublet of gray satin is a very similar color to his cloak and comes to his waist. The neck is very low, and the full sleeves are drawn in at the wrist. It is decorated in a familiar style with a pattern of diagonal slashes arranged in a zigzag pattern, revealing the white fabric below.

Linens: His shirt has a deep neckband edged with a narrow ruffle. The neckband is decorated with three rows of gilt metal thread embroidery and another three rows are worked down the front opening.

Legs: He is wearing gray hose with bright blue and gray striped over-hose. The latter are slashed down the center of each stripe. The edges of the slashes are jagged. The slashes are arranged in three blocks: from waist to hip, from hip to mid-thigh, and over the knee. The pale gray hose can be seen through the cuts. It is very likely that he has a round, blue and gray codpiece, but it is underneath his cloak. He is wearing garters: gray on the left leg and blue on the right. The ends of the garters are decorated with gold aglets or gilt fringe.

Footwear: He is wearing black shoes, which are low cut over his toes. He is shown standing on two odd shoes: one is a black overshoe (under his right foot), and the other is gray with a long pointed toe (under his left foot).

Jewelry: He has a black cord around his neck, but there is nothing hanging from it.

Weapons: His dagger hangs from a blue sash tied loosely around his waist, and it sits on his right hip.

Gilding: The caul, the embroidery on his shirt, the decoration on his garters.

Image I 65 [verso]

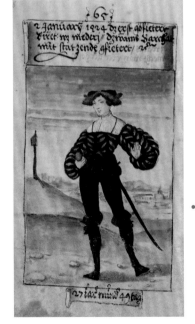

2 January, 1524. The first lined bonnet with marten fur. The doublet light woolen and silk lined with precious taffeta.

Text below: 27 years, minus 49 days.

Note: Schwarz refers to a higher quality of taffeta, called *Statzendl*.

Clothing overview: His fur-lined hat is the only concession to it being winter. Matthäus is mostly in black again and demonstrates his on-going fondness for this style of tight-waisted doublet and fitted hose.

Headwear/hair: He is wearing a black bonnet, with a fairly pronounced crown and a two-part brim that is slashed at the sides. The brim is divided into a front and a back section. The sections overlap, and the brim is shaped into a point at the front. It is trimmed on the underside with marten fur. His hair is cut in a short bob.

Body garments: His black wool doublet is lined with green taffeta, and it is probably side fastening. It has a low square neck, which sits on the points of the shoulders, and it may be cut higher at the back. It has very full sleeves, which narrow at the wrist. The doublet is decorated all over with vertical rows of diagonal slashes arranged in a zigzag pattern, which it is accentuated by the green taffeta showing through the cuts.

Linens: His white linen shirt has a narrow neckband that is edged with a narrow ruffle and embroidered with blackwork. There is more blackwork decorating the front opening.

Legs: His tight black hose are slashed at the hips and knees. At the hips, the slashes have been formed into a narrow roll and possibly padded to form a decorative ridge, which runs around at hip height. Just above his knees, the hose are slashed vertically and folded over to form a series of loops, which hang down over his knees. He has a plain, round, black codpiece. Black garters are tied below his knees with the half knot positioned to the outside of his knee. The ends of his garters are decorated with gold aglets or gilt fringe.

Footwear: His black shoes are wide at the front and the vamps are cut low over his toes.

Accessories: Pairs of bright red points join the doublet to the hose. The red points securing the codpiece have gold aglets that are intended to be eye-catching.

Jewelry: He has a black cord around his neck, but the item hanging from it is hidden from view, tucked inside his doublet.

Weapons: He has a long sword with a black hilt in a black scabbard suspended with a black girdle and hanger. His rests his hand on the hilt of his dagger, which sits on his right hip.

Gilding: The aglets on his codpiece, the decoration on his garters.

Image I 66 [recto]

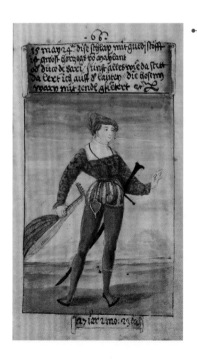

15th of May, 1524. This cap with the golden aglets belonged to the Duke of Milan [. . .] or the Duke of Bari. Otherwise everything as shown. I learned lute-playing at this time. The hose was lined with taffeta.

Text below: 27 years, 2 months, 23 days.

Note: This image underlines the significance of accessories and secondhand items for the diffusion of Renaissance fashion. Matthäus Schwarz was particularly proud of the bright, light-red cap with golden aglets he had purchased from an Italian aristocrat—probably the Duke of Milan—and he left a space in the text to add his name. His uncertainty, however, suggests that Schwarz bought the cap via one of the agents, which the Fuggers employed in Italy. It clearly indicates that there was a high-end consumer demand for secondhand clothes of allegedly noble provenance. Such goods most likely entered the market through auctions. Both Massimiliano and Francesco II (Francesco Maria Sforza) were Milanese dukes interested in fashion. In sporting such a cap and telling people about its former owner, Schwarz as head accountant in full-time employment could link himself to an aristocratic taste and lifestyle.

Clothing overview: Dressed in violet Matthäus presents an athletic figure. His violet doublet and hose provide a strong contrast with the bright red Italian cap, which he had bought secondhand from illustrious owners.

Headwear/hair: His bright red cap is an unusual shape. It has a pleated edge and hanging ties, which end with small tassels that have been left undone. The cap is decorated all over with pairs of gold aglets. It is worn over a metal thread caul, which is worn on the back of his head and covers most of his hair.

Body garments: Matthäus is wearing a violet damask doublet. The fronts of the doublet are cut away, fastening at the waist only. It sits well on the shoulders, and it may be cut higher at the back (as in I 67). The sleeves are fitted, with flared cuffs. The doublet is worn with a placard made from the same damask. Its low neck is decorated with two rows of gilt metal thread embroidery.

Linens: The heavily pleated, white linen shirt has a narrow neckband that is edged with a small ruffle.

Legs: His violet hose complement the doublet, and they are very slim fitting. It is likely that he is wearing a pair of very short trunk hose that are paned. The panes are joined at the waistband and at the bands at the top of his thigh. The edges of the panes have been cut to create a decorative crescent effect. The bright yellow lining can be seen between the panes. The trunk hose have a small, round violet codpiece that has been slashed, and the yellow shows through the cuts. They are worn over a pair of plain violet hose. There are no garters.

Footwear: He is wearing black shoes, which have low-cut vamps and high quarters.

Accessories: Pairs of red points with gold aglets join the doublet and hose at the waist and also secure the codpiece. He holds his lute in his right hand. There is a green, heart-shaped bag trimmed with gold hanging from a length of black cord that is looped over the girdle at his waist.

Jewelry: There are decorative gold pins on the back of his cap. He has a plain gold ring on the fourth finger of his right hand, and he is wearing a large, ornate gold pendant on a black cord.

Weapons: A sword, of the two-handed long sword type, sits of his left hip. It is in a black scabbard and hangs from a black girdle and hangers.

Gilding: His pendent, embroidery, the aglets on his bonnet.

Image I 67 [verso]

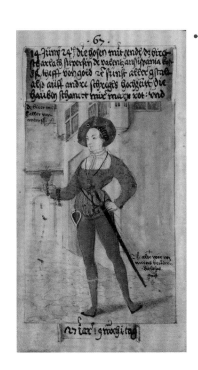

14th June, [15]24. The hose with taffeta, the bonnet super-fine scarlet from Valencia in Spain, costs 8 florins, buttons of gold, otherwise everything as at Andre Schregl's wedding. The caul was a gift from Marx Rot and the bonnet from Wolf Haller in Antwerp.

Inside the image: This old sword used to belong to my brother Balthas.

Text below: Aged 27 years, 19 weeks, and one day.

Note: This is one of several instances where we see the contours of the figure traced through from the previous image to speed up the painting process.

Clothing overview: A month later, Matthäus wears a set of bright green clothes in a very similar style to those in I 66 for a wedding. While he stresses the romance of the occasion, he also emphasizes the importance of gift giving. In addition, it is the first time he mentions the cost of his clothes and accessories.

Headwear/hair: He wears a bright scarlet bonnet with a wide, folded brim that is slashed. One slash is fastened with three gold buttons, while others are left open. The rest of the brim is decorated with pairs of gold aglets. It is made from a thick Spanish wool felt, possibly made from Spanish merino. It is worn at an angle and pulled down over his right ear. It is worn with a black caul decorated with applied stripes of gold passementerie, which almost covers his hair. It is worn on the back of his head.

Body garments: He is wearing a bright green damask doublet. It is cut very low at the front and fastens just at the waist. The doublet is close-fitting, as are the sleeves, and it is worn with a matching placard. The placard has a low neck, and it is decorated with two wide rows of gilt metal work.

Linens: His shirt has a small collar that has been embroidered with a double row of gilt metal thread work. A similar double row decorates the front opening of the shirt.

Legs: The bright green hose and matching trunk hose are very striking. The trunk hose are paned from the waist to the hip. The edges of the paned have been cut with angled cuts, and underneath the orange taffeta shows through. The round, green codpiece is embellished in the same way. There are no garters.

Footwear: He wears black shoes, which have low-cut vamps.

Accessories: There is a small, red, heart-shaped purse hanging from his belt on his right hip. He holds a red carnation in his right hand. Both of which are suited to the wedding. Pairs of red points join the hose to the doublet and secure the codpiece.

Jewelry: He wears a coral bracelet with a blue tassel hanging from it on his right wrist. The underside of the brim of his bonnet has been decorated with a brooch, which looks to be a gem or cameo set in gold. He had a square gold pendant on a black cord.

Weapons: He is carrying a sword on his left hip, with a fairly slender blade. From the 1510s and 1520s, swords of this type were favored by the aristocracy and the urban elite. It is in a black scabbard and with a black girdle and hangers. The stress he places on it having belonged to his brother suggests its family significance and highlights that weapons were often passed on from father to son and from brother to brother.[91]

Gilding: On his bonnet, his shirt, the placard.

Images I 68–70 [recto]

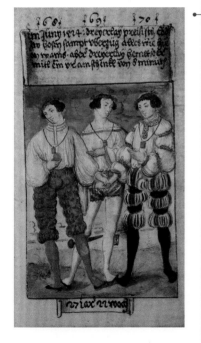

In June 1524. Three types of Prussian leather as hose and over-hose, everything as shown, without doublet, but three kinds of shirts. The middle one [has attached to it] an 8 minute hour-glass on the thigh.
Text below: 27 years, 22 weeks.

Note: This provides a rare glimpse of informal clothes, without a doublet or gown. There is no other known example of the eight minute hour glass as fashionable accessory, although it might also be interpreted as reference to mortality, in which case it may be significant that the orange is a repeated motif from I 3, when Schwarz was severely ill as a child. The scene may recall iconographic models, such as The Three Graces or The Judgment of Paris, but the relationship of the gestures is unique.

Clothing overview: Matthäus does not wear a doublet in any of these images, which is unusual. It suggests that the aim of this image is to show off his fancy shirts, while also indicating informality and a concession to the warmth of summer.

Headwear/hair: In each image he wears a green wreath on his head, which might be made from real foliage or be silk women's work. His hair is just below his ears.

Linens: Matthäus wears three contrasting styles of shirt. In I 68 his shirt has a deep neckband decorated with three bands of metal thread embroidery, a front opening also with embroidery, and very full sleeves. These are gathered into small wristbands that are edged

91. For example, Degen, German, c. 1525–30, Rüstkammer, Staatliche Kunstsammlungen, Dresden, IX 35. See J. C. Von Bloh, "The triumph of the rapier in the Armory of the Prince Electors of Saxony," in *The Noble Art of the Sword: Fashion and Fencing in Renaissance Europe, 1520–1630*, ed. T. Capwell (London: Paul Holberton Publishing for the Wallace Collection, 2012), 204.

with a small ruffle and a single row of metal thread embroidery. The shirt in I 69 has a very wide neck and sits on his shoulders. The sleeves are very full from the shoulder, and they do not narrow at the wrist. The shirt has a thick band of metal thread embroidery around the neck and the wristband. A small ruffle decorates the neckband. The third version, shown in I 70, is the most ornate. This shirt has a high neck and a small neckband edged with a little ruffle. The full sleeves end in a small cuff and narrow ruffle. There is a very thick band of metal thread embroidery around the neckband and down the front opening. There are four more bands of embroidery on both sleeves, which gather in the fullness, creating a series of puffs.

Legs: He stresses that these hose are made of Prussian leather. In I 68 he has dark green over-hose that have been cut in a series of staggered semicircular slashes on his thighs. The leather over the knee has been cut vertically to create some fullness. There is a round codpiece, also in dark green, and the red can be seen through the slashes. They are worn with scarlet hose. In I 69 the over-hose or trunk hose are very short, extending from his waist to the top of his thighs. They are slashed diagonally to create a chevron affect, and it is possible to see the bright yellow hose through the cuts. The trunk hose probably have a round codpiece, but it is hidden behind the clasped hands. Finally in I 70 striped over-hose of white, yellow and dark gray are worn with black hose. The over-hose have been slashed vertically in three bands, between the waist and hip, the mid-thigh, and above the knee. They have also been cut horizontally, forming the over-hose into three puffed bands. The round codpiece is also striped and slashed.

Footwear: He wears black shoes that are quite wide in the toe, and the vamps are low cut.

Accessories: In each case the red points that have been inserted into the waistband of the hose are ready to be tied to the lacing band on the doublet when he puts it on. In I 69 he has an hour glass attached to his right calf.

Jewelry: Each figure wears a quite sizeable, rectangular gold pendant on a black cord

Weapons: In I 68 he has a dagger secured behind his right knee.

Gilding: His jewelry, the embroidery on his shirts.

Image I 71 [verso]

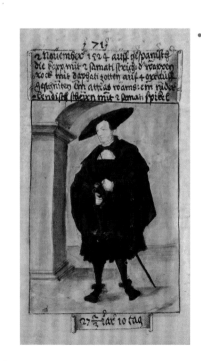

2 November, 1524, in the Spanish manner, the bonnet with two velvet trimmings, the riding gown with silken edgings cut open in four ways [auf 4 ort aufgeschnitten]; a doublet from silk satin, a Netherlandish bonnet with 2 velvet gussets.

Below the image: 27 ⅔ years, 10 days.

Clothing overview: Matthäus is all in black, and the clothes are of a much more formal style than some of his recent black outfits (e.g., I 45, I 50, I 54, and I 56). He identifies them as being in the Spanish style, and he clearly considers that this means more than being dressed all in black.

Headwear/hair: He is wearing a black bonnet with a very broad brim covered in pleated, black velvet. The bonnet extends down around the back of his head and covers most of his hair.

Body garments: His black gown has a large cape collar that turns back over his shoulders and long hanging sleeves. The hanging sleeves have a full upper section, while the opening on the narrow, lower section is joined with three pairs of black points and gold aglets. The long opening in the hanging sleeve is trimmed with fringed half silk edging. The gown is decorated was a narrow double guard down the front of the gown and around the hem, which appears to be cut in points and comes to his mid-thigh. It is worn over a black riding gown that comes to just below his knees. It has a small, downturned collar, and the fronts are cut away to create an oval. It fastens at the collar and the waist. The skirts of the riding gown fall in loose folds, and the hem is trimmed with fringed half silk edging. The riding gown has elbow-length

full sleeves, which can be seen through the sleeves of the gown. Finally Matthäus is wearing a doublet made from black silk satin. It has a low-cut neck, and it is decorated with a small black bow, which is placed at the center. It has full sleeves that are gathered into the more fitted lower section and fits snugly at the wrist. It is this section that can be seen on his forearms.

Linens: Little detail is given, but the shirt has a neckband edged with a narrow ruffle.

Legs: Very little of his hose can be seen but from the knee down, they are plain black.

Footwear: He is wearing closed-ankle shoes that are wide in the toe. The vamps are rolled down around his ankles, forming a thick band.

Accessories: He is wearing short white leather gloves.

Jewelry: The black cord around his neck suggests something is hanging from it—but tucked inside his clothes. He may have a gold ring on his gloved left hand, or it could have bled through from the image on the other side.

Weapons: He has a sword in a black scabbard with a gilt pommel.

Gilding: The aglets on the black points, the sword pommel, and possibly a ring.

Image I 72 [recto]

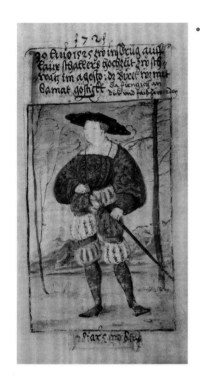

30th July, 1525, in Innsbruck, at Laux Schaller's wedding in Schwaz in August. The bonnet embroidered with velvet. This is when I began to be fat and round.
Text below: 28 years, 5 months, 8 days.

Clothing overview: More wedding clothes but on this occasion they are not used to accentuate his athletic figure. Rather his arms are positioned to conceal a change in his body shape, which takes place in his late twenties and Matthäus sees it as a turning point in his aging. Although he notes the change, it does not result in a change in the style of clothes that he wears.

Headwear/hair: He has a black bonnet with a wide, folded-over brim that is slashed. It is worn flat on his head and over a gilt thread caul made from an open mesh, which covers almost of his hair.

Body garments: Matthäus wears a mid-gray damask doublet with a large pattern repeat. It has a wide, square neck, which is low at the front but higher at the back. The doublet comes to his natural waist, the front of the doublet is smooth, and it is side fastening. It has very full sleeves, which are probably lightly padded to help define their shape. The upper section of the sleeves is gathered into the lower narrow section, and it fits at the wrist. There is a narrow, fringed edging around the neck.

Linens: His white linen shirt is heavily pleated. It has a small neckband, which is finished with a narrow ruffle.

Legs: He is wearing mid-gray hose, with violet, white, and yellow over-hose. Starting at the waist, the over-hose are yellow, then violet, then white on the left leg; they are violet, then white, and then yellow on the right leg. Each color is slashed vertically, and the edges of the cuts are jagged; the gray hose can be seen through the slashes. There is a hint of a round codpiece, but it is not clearly defined.

Footwear: His black shoes have low-cut vamps.

Accessories: Several pairs of red points join his hose to his doublet.

Jewelry: The black cord around his neck has a rectangular ornate gold pendant hanging from it. There is a row of small gold buttons or brooches on the underside of the brim of his bonnet.

Weapons: He rests his right hand on the hilt of his sword and the left on its black scabbard. It is worn with a black girdle and hanger.

Gilding: On his bonnet, the caul, his pendant.

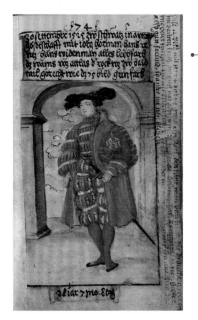

Image I 73[92] [verso]

On 21 August, 1525, in Rattenberg-on-Inn at the wedding of Hauptmann's *(captain) Nidrest's son. The doublet fustian trimmed with taffeta.*

Text below: Aged 28 ½ years.

Clothing overview: Another summer wedding celebrated at Rattenberg-on-Inn with Matthäus wearing another outfit that is striking, although not made from the most expensive materials, as might suit a set of clothes worn on just one occasion.

Headwear/hair: Matthäus is wearing a very small scarlet bonnet with a narrow slashed, brim. The depth and angle of the slashes gives a twisted affect to the brim. The bonnet has short ties that have been left undone, and it is worn over his left ear. It is worn over a black coif, which covers almost all of his hair.

Body garments: The lack of gown shows off his black fustian doublet very well. The relatively sober doublet has a high, round collar, very full sleeves that draw in at the wrist, and it comes to his natural waist. The doublet is gathered vertically on the front and down the sleeves. The gathers have been formed into gentle rolls by the application of narrow horizontal bands of yellow, white, and mauve taffeta, creating a striped effect. In addition, there are three vertical red bands on the chest, which mirror the color of his bonnet. Six pairs of small black points are tied where the red stripes cross the white and mauve stripes on his chest. The doublet is probably side fastening. The neck has been decorated with two lengths of the fustian that have been folded over lengthwise and slashed, creating a tabbed effect.

Linens: His shirt is not visible.

Legs: His bright yellow hose are worn with a pair of over-hose that are striped vertically in yellow, white, and mid-gray. The over-hose are slashed with three blocks of vertical cuts that are arranged in rows from waist to hip, over the mid-thigh, and over the knee. These cuts are separated by two horizontal cuts, so the over-hose form three loose rolls. The edges of the cuts are jagged, and his bright yellow hose show through the slashes. The hose have a round codpiece striped yellow, white, and gray.

Footwear: His black shoes are wide at the front. They have low-cut vamps and high quarters.

Jewelry: There is a gold ring on the fourth finger of his right hand.

Weapons: His left hand rests on his sword hilt. The sword with its black and gilt pommel is in a black scabbard with a gilt chape, and it is worn from a black sword belt and hanger. He has his dagger resting on his right hip.

Gilding: On the chape and the pommel of his sword.

Image I 74 [recto]

September 30, 1525, at Schwaz in a gathering with Jörg Hörman, Hans Rentz, Hans Wiedenman. Everything flesh-colored, the doublet silk satin, the gown was made to be worn on either side, in green as in image 75.

On the margin: These two images number 74 and 75 depict a gown, which could be reversed. We often needed these during the Peasants' War, when we rode to and away from Innsbruck, Schwaz, Hall, Rattenberg, when we had silver and money, and stayed safe. But it cost a lot of wine in the villages, so that we made ourselves good friends, while others remained in the net.

Text below: 28 years, 7 months, 8 days.

Note: This reversible coat seems to have been the dress worn by all Fugger employees in the Tyrol who tried to escape the rebellious peasants and miners. The Tyrol rebels formulated wide-ranging programs for social, economic, and political change during the 1525 Peasants'

92. Omitted from Braunstein, *Un Banquier Mis a Nu*.

War. Schwarz indicates that he and his fellow Fugger employees used wine to bribe those who sheltered them.

Clothing overview: Matthäus discusses his reversible gown and reveals how his clothes contributed to his safety during the Peasants' War. By doing so he shows how the colors and monograms were linked to livery, and how it was necessary to assert or avoid the Fugger connection.

Headwear/hair: His is wearing a dark gray bonnet with a large split brim worn flat on his head. It is decorated with lots of big black ostrich feathers with gilded quills. There is a gilt wreath on the crown of his bonnet, or it may be a gilt hatband. His hair is cut in the usual short bob.

Body garments: He is wearing a reversible, knee-length, very full gown. On this occasion it is worn with the red fabric on the outside and the green as the lining. It has very full sleeves from shoulder to just below the elbow (looking at I 75, it is possible that they are full length and have been pushed up on this occasion to reveal the sleeve of his doublet). Padding and stay-stitching help to create the shape. This section of the left sleeve is blue, and based on the gown in I 75, it is likely that the right sleeve is red. The gown has a small grown-on collar. The blue section of his left sleeve is embroidered (or possibly painted) with the Fugger monogram. A red doublet of satin gathered in vertical folds on the body and sleeves (see I 73). It is decorated with applied, alternating horizontal bands of white and green silk, which cause the satin to form into three puffs on the body and four on the sleeves. The doublet probably fastens at the side. The high neck is decorated with two pieces of fabric that have been folded length-wise and cut vertically, forming a series of little tabs or loops.

Linens: His shirt is not visible at the neck but a hint can be seen at the base of his left doublet sleeve.

Legs: The bright red over-hose are worn with a pair of hose that are striped vertically from the waist to the knee in white, yellow, and green; they are then plain red below the knee. The over-hose are slashed between the waist and the knee, and the vertical cuts are arranged in four rows. In addition there are three horizontal cuts, which cause the over-hose to form into four puffs or rolls. The vertically striped green and yellow under-hose show through the slashes, which have jagged edges. The over-hose probably have a round, red codpiece, but it is partially obscured by the hilt of his sword.

Footwear: The vamps of his black shoes are cut low over his toes.

Weapons: His sword sits on his left hip in a black scabbard, and the hilt is gilt, bright steel and black. It is worn with a black girdle and hanger.

Gilding: The decoration on the left sleeve of his gown, the sword pommel, and the ornaments on his bonnet.

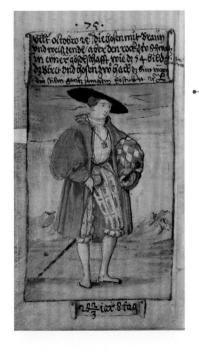

Image I 75 [verso]

Final day of October [15]25. The hose with brown and white taffeta. But the gown in Schwaz in a gathering, as in the 74th image of 30th September, the bonnet and hose at Hall. The bonnet had all the pleats over the brim embroidered with velvet.

Text below: 28 ½ years, 8 days.

Clothing overview: These are his most flamboyant travel clothes, indicating Matthäus's growing importance in the Fuggers' business.

Headwear/hair: He has a black bonnet with a very broad brim that is covered with pleated black velvet.[93] It is placed flat on his head, and it is worn over a gold thread caul, which covers almost all of his hair.

93. Seen in I 23 (1October 11 1515).

Body garments: This time the gown seen in I 74 is shown the other way out, with the light green fabric outermost and with the red as the lining. The gown has very full sleeves from the shoulder to just below the elbow, and here they are shown as being fitted to the wrist. The full section of the left sleeve is made from green, white, and red squares, arranged in alternating rows (red and white and green and white), set on the diagonal, while the whole of the right sleeve, and the lower section of the left, are made of the same green fabric as the rest of the gown. Rather unusually he does not appear to be wearing a doublet. The double thickness gown may mean that a doublet was not always required for warmth.

Linens: The shirt has a neckband edged with a narrow ruffle and decorated with two bands of gold metal thread embroidery along with some blackwork. The shirt is full in the body, and a lot of it is on show.

Legs: His bright yellow hose are slashed with five rows of vertical cuts from waist to just above the knee. The first four sets of slashes are separated by short horizontal cuts, and the hose lie flat to the thigh. The bright blue under-hose show through. The edges of the vertical cuts are jagged. Just above the knee, the last row of slashes has been folded over on themselves to form a tabbed roll. The hose have a matching, round, yellow codpiece.

Footwear: His black shoes have very low-cut vamps, and the quarters come up quite high around the heel.

Jewelry: He has a square gold pendant worn on a black cord.

Weapons: His sword is held firmly in his left hand, and it rests on his left hip. It is in a black scabbard and hangs from a black belt and hanger.

Gilding: On his caul and the pendant.

Image I 76 [recto]

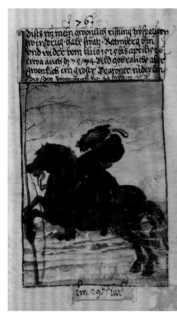

This was my usual outfit [Rüstung] in which I went to go for a walk in Innsbruck, Hall, Schwaz, Rattenberg sometime between July 1525 and 26th April; sometimes I used the [clothes? on the] 75th/74th image, but usually a large brown Netherlandish horse; the riding gown had 40 pleats.
Text below: In the 29th year.

Clothing overview: As Matthäus acknowledges this set of riding clothes is much more practical than those in I 74–I 75, and he wore them for about a year providing a sense of how long he wore clothes and the amount of time he spent traveling.

Headwear/hair: He is wearing a large brimmed dark brown bonnet with a flat crown. The brim is decorated with lots of black ostrich feathers. The veins of the feathers are gilded.

Body garments: He is wearing a black riding gown, and this three-quarter view of the back provides an interesting perspective. The gown has a small collar. It has very full, puffed sleeves, which look to come just below his elbows. They either end at his elbow, allowing the doublet sleeves to be revealed, or continue with a more fitted section that narrows at the wrist. The gown is quite fitted at the back, suggesting that there is a waist seam. The skirts are full and heavily pleated. The pleats are probably padded and held in place with stay-stitching. The skirts are divided at the center-back, allowing the skirts to fall on either side of the horse's back and covering his thighs. The gown is trimmed with narrow black guards. These are most evident on the back of the gown, and their position suggests that the back is cut with two curved seams.

Linens: None are visible.

Legs: Matthäus is wearing black hose, which are slashed with short vertical cuts over his knees revealing the black lining.

Footwear: They are probably black shoes, rather than short boots, with a roll at the ankle, and they are worn with black rowel spurs.

Accessories: He has a silver horn with a long hank of cord hanging on his back.

Jewelry: There is a gilded wreath twisted in a figure eight on the crown. It might be made from gilt wire or be a more substantial piece of goldsmith's work.

Weapons: His long sword hangs at his left in a black scabbard from a black girdle and hanger.

Horse/horse harness: He is riding a feisty looking brown horse, in a dramatic pose. The horse has a black bridle with curb bit and single reins, a chest strap, black saddle, girth, stirrup leathers, stirrups, crupper, and back strap.

Gilding: The wreath on his hat.

Image I 77 [verso]

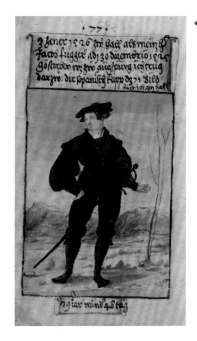

*3 January, 1526, in Hall, when my master (*Herr*) Jakob Fugger had died on 30 December, 1525, in Augsburg. I wore the Spanish cloak with it (the 71st image) and took it to Hall.*
Text below: 29 years, minus 48 days.

Clothing overview: Matthäus is in Hall shortly after Jakob Fugger died. He has put on black for mourning, but it is more ornate than the clothes he wore after his father's death. This might reflect that he is not in Augsburg and so does not need to be in full mourning or that different levels of mourning were required for a parent as opposed to an employer.

Headwear/hair: He is wearing a black bonnet with a full, slightly puffy crown and a small brim that is cut away at the front. At the sides and back, the brim is turned down. His hair is cut short.

Body garments: He is dressed in a black doublet made from a striking fabric with a self-colored, woven pattern. This might be silk damask, stamped wool, or voided velvet. The pattern is large and consists of a stylised foliate and floral design. The doublet fastens down the center-front and is done up from the middle of his chest to his waist. The top buttons have been left undone, allowing the small collar to fall open. The doublet comes to his waist and is without skirts. It has full sleeves that narrow into a fitted section over his forearm. The sleeves have narrow shoulder wings. He notes that he usually wore the black Spanish cloak depicted in I 71 over the doublet, but it is not illustrated here because it would obscure the other garments.

Linens: His white linen shirt has a wide neck and is plain.

Legs: He is wearing rather fancy, close-fitting black hose. These are probably consist of black over-hose that are slashed vertically between his waist and hip, over the thighs, and over his knees, with short horizontal slashes placed between the blocks of vertical cuts. The edges of the slashes have been left plain. The over-hose have a round, black codpiece. The over-hose are worn with plain black hose. He has black garters tied below the knee. The ends of the garters are decorated with black points with gold aglets or gilt fringe.[94]

Footwear: His black shoes have low-cut vamps.

Accessories: His sword is in a black scabbard. It is worn on his left hip with a black girdle and hanger.

Jewelry: He has a black cord around his neck, but what is hanging from it is concealed by his doublet.

Gilding: On his garters.

94. For red silk and silver thread garters tied in a half knot, see Battista Moroni, *The Gentleman in Pink*, 1560, oil on canvas, Palazzo Morosini, Bergamo.

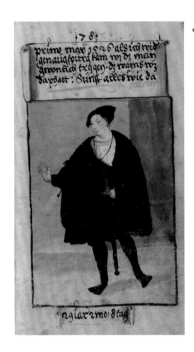

Image I 78[95] [recto]

First of May 1526, this was my usual outfit when I returned to Augsburg. The doublet was half silk, otherwise everything as shown here.

Text below: 29 years, 2 month, 8 days.

Clothing overview: While the mourning he wears for Jakob Fugger may be more ornate that that he wore for his father, Matthäus is still wearing black five months later.

Headwear/hair: He has a small black bonnet with no brim at the front, a small brim at the back, and short earflaps. It is worn over a black coif, and just a little of his hair is showing at the front of the coif.

Body garments: He is wearing a fashionable black knee-length gown. It has a wide cape collar and long, full hanging sleeves. The hanging sleeves are cut in one piece and closed at the bottom. They have a long diagonal slash though which his arms can pass though. On the left sleeve, the slash is closed with three pairs of black points with gold aglets. The points have been embellished with large Turk's head knots on either side of the opening. Two pairs of points have been left undone on the right sleeve. The gown is worn over a black half silk doublet, which is low cut at the front and fastens at the waist. The doublet has very full sleeves, which are gathered into a narrow section close to the wrist.

Linens: Much more of the white linen shirt is visible in this image than in I 40, suggesting that he is close to being out of mourning. The shirt has quite a low neck. The neckband is edged with a double ruffle, and the linen falls in gentle pleats down the front of his shirt.

Legs: He is wearing plain black hose with fancy black over-hose. The black over-hose are slashed from waist to hip, over the upper thigh, the lower thigh, and over the knee. Each band of slashes is separated by horizontal cuts, allowing the over-hose to form into a series of gentle puffs. The vertical cuts have plain edges, and the black hose show through. The over-hose have a round, black codpiece, which is partially concealed by the hilt of his sword.

Footwear: His black shoes have low-cut vamps.

Jewelry: The pendant hanging on the black cord around his neck cannot be seen because it is covered by his doublet.

Weapons: He rests his left hand on the very ornate gilded hilt of his sword. It is in a black scabbard, which is decorated with a self-colored scrolling design and a black chape. It has a black girdle and hanger.

Gilding: On the sword hilt, the aglets.

Image I 79 [verso]

First of July 1526, this was my proper figure from behind, for I had become fat and round.

Text below: 29 ½ years, 8 days.

Clothing overview: With this nude rear view, Matthäus provides the viewer with an insight into how he looks under his clothes. In view of his comments about his weight, it is potentially a surprising decision. However, his age might provide a clue to his motivation because it signaled male maturity and was seen as significant in Germany.[96]

Hair: This picture provides the best view that we have of his hair from the back, showing that he has a full head of hair. It also reveals that in addition to the basic bob, the hair on his

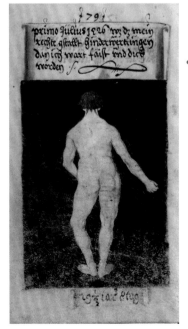

95. Omitted from Braunstein, *Un Banquier Mis a Nu*.
96. S. Foister, *Holbein and England* (New Haven and London: Yale University Press, 2004), 208, citing Westhoff-Krummacher, 1965, 69–71.

neck has been shaped into three strands. Whether this was his usual style or grown in advance of this picture being painted is unknown.

Body: The depiction of his body from the rear reflects an interest in the back view of the nude body seen in a number of contemporary drawings by artists, including Dürer.[97] The view presented here depicts a male body that is some distance from the ideal. While the artist has conveyed a sense of the well developed musculature in his arms and legs, his hips and buttocks shows signs of the good dining he mentions elsewhere. More importantly, if this image is taken as an accurate depiction of his body, then it suggests that later images, which show him with a very small waist (e.g., I 92) and slim thighs (e.g., I 111) are flattering to his body shape. Indeed, he first made negative comments about his weight a year before in July 1525 (I 72) when he observed that "this is when I began to be round and fat."

Stance/gesture: The stance can be compared with other, clothed back views (e.g., I 94, I 111).

Image I 80 [recto]

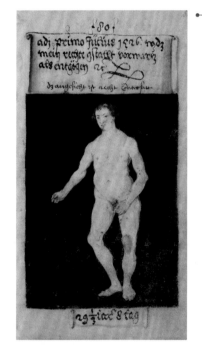

This was my proper figure straight from the front on the first of July 1526. The face is well captured. Text below: 29 ½ years, 8 days.

Note: These startling images have been linked to Schwarz's mourning of Jakob Fugger or a general sense of his mortality as he entered mature adulthood. Some at the time believed that people would rise to heaven or face purgatory with the body they had around this age, and this portrayal has therefore been dubbed by Groebner as Schwarz's purgatory—or paradise—look. It is, however, difficult to be certain, as the purgatory scene in Schwarz's prayer book depicts leaner and more muscular bodies. The lack of any attempt to idealize his appearance and the matter-of-fact text, which only relates to his weight gain, mark this portrayal out. The view from the front and back was used to represent malformed people, and it was also familiar from portrayals of Christ.

Clothing overview: This image draws on views expressed by Castiglione and others that the courtier should be "well built and shapely of limb." While he was not a courtier, Matthäus was of the aspiring middling sort who would be influenced by such ideas.[98]

Hair: His hair is cut in its usual short bob, and the slight curl gives his hair some fullness. He is clean shaven.

Body: His body is shown as being almost hairless and, as such, compares with Dürer's depictions of Adam in his engraving, *Adam and Eve* (1504). The artist who painted this was probably aware of Dürer's views on the ideal proportions of the body and the representation of the perfect human body before the Fall.[99] This can be seen in Dürer's *Die Vier Bücher von Menschlicher Proportion* (Nuremberg, 1528) in which he explored the relationship of the various parts of the body to each other.[100] While the depiction of his body is in proportion, Matthäus is starting to fill out a little at the waist. The slender waist that he recorded as being the width of an ell in the summer of 1520 (I 43) now only remains in the pages of the clothing book. The inclusion of this pair of nude images raises the question of how anyone looking at the book, apart from Schwarz, might have responded and it brings to mind Dürer's engraving *The Bath House* (c. 1496).[101] In this engraving Dürer presents the viewer with a group of nude male figures

97. For example, the back views in Albrecht Dürer, *Two groups from "Rape of the Sabine Women,"* 1495, drawing, 28.3 × 42.3 centimeters, Musée Bonnat, Bayonne.
98. B. Castiglione, *The Book of the Courtier* (1528), 36.
99. In the Kupferstich, Berlin.
100. See E. Panofsky, *Meaning in the Visual Arts* (Chicago: University of Chicago Press, Phoenix edition, 1983), especially "The history of human proportion as a reflection of the history of styles," 55–107.
101. Albrecht Dürer, *The Bath House*, c. 1496, woodcut, 39.3 × 28.5 centimeters, Royal Collection, RCIN 800195; K. Heard and L. Whittaker, *The Northern Renaissance: Dürer to Holbein* (London: Royal Collection Publications, 2011), 81, no. 26.

in a variety of poses. In addition, the depictions are portraits, including his close friend Willibald Pirckheimer (the man on the right drinking), Lucas and Stephan Paumgartner (the two men in the foreground), and Dürer himself standing on the left by the water pump. This suggests that for male audiences this type of depiction was not only acceptable but also a way of stressing ideas about masculinity, and in the case of the bathhouse image, the bonds of friendship.

Images I 81–82[102] [verso]

On 20th September, I had doublets made, which have been previously shown, but there were 4 kinds of shirts with these colors: blue, yellow, gray, black, and also 4 pairs of hose (as seen on images 52, 66, 67, 72) in the colors white, flesh-color, green, brown lining cloth.
Text below: Aged 29 ½ years and 28 days.

Clothing overview: Matthäus marks the end of the mourning period for Jakob Fugger by ordering four pairs of very colorful and exuberant hose (also see I 83–I 84). Worn with just a shirt, his appearance is less formal that usual, but the sleeves of these shirts would not be seen at their best unless worn without a doublet. There is a precedent for him appearing without a doublet in I 68–I 70 (in June 1524).

Headwear/hair: He is bareheaded. His hair is cut in a bob.

Body garments: The doublets that Matthäus plans to wear with these hose are depicted elsewhere: the doublet for I 81 in I 52 and the doublet for I 82 in I 67. This indicates that doublets and hose were often bought separately, rather than together as a suit, and that color rather than style was the unifying factor.

Linens: In I 81 the shirt has a very wide neck, so that it almost slides off one shoulder, and it has very full sleeves. The sleeves come to the mid-forearm and have a very wide opening. The shirt in I 82 has a higher neck. The sleeves look similar to those in I 82, but they are full length, tied at the elbow, and hang down. It is possible to see the ties on the inside of his right sleeve. The sleeve has a side opening on the left shoulder.

Legs: In each case the over-hose are heavily slashed, they have a round, slashed, codpiece, and they are worn with a pair of garters, the same color as his base stocks, tied below the knee and decorated with gold aglets or gilt fringe. In I 81 the over-hose are red. There is a row of long vertical slashes down the center-front of each leg, and on either side the slashes are cut on the diagonal, pointing down toward his knees. The short slashes over his knees are vertical and create additional fullness. All of the cuts are jagged. The over-hose are worn with hose that are striped pale blue, white, and yellow from waist to knee; then below the knee they are plain red. In I 82 the over-hose are a bright sap green. They are slashed vertically in three bands between his waist and hips, over his mid-thighs, and over his knees. There are two horizontal cuts, which allow the slashes to form three loose rolls. The edges of the vertical cuts are jagged. The over-hose are worn with hose that are striped vertically in white, red, and blue on his left leg and black, white, and gray on the right leg. They are striped to the knee and then are plain green below the knee. The hose have dropped to below the level they would be when pointed to the shirt by an inch or two. There is no reference to the hose being leather, so they are probably made from wool.

Footwear: His black shoes have very wide toes, and the quarters come up quite high around the heel.

Jewelry: He wears a rectangular gold pendant with a hanging section and pendant pearl on a black cord around his neck, and he has a gold bracelet. In I 81 it takes the form of a double bangle, and in I 82 it consists of a length of gold chain worn doubled.

Gilding: The pendant hanging, the bracelet, and the decoration on his garters.

102. Omitted from Braunstein, *Un Banquier Mis a Nu*.

Images I 83–84[103] [recto]

Clothing overview: Two more pairs of the same style of over-hose but made in different colors suggest that this is the fashionable cut, and it indicates how Matthäus can create variety in his wardrobe through the use of color, pairing the over-hose with different-colored hose, the style of shirt, and by wearing them with doublets he already has in his possession.

Headwear/hair: He is bareheaded again, focusing the viewer's attention on his shirts and hose. His hair is cut short.

Body garments: The doublets that would usually be worn with these hose are depicted elsewhere: the doublet for I 83 in I 66 and the doublet for I 84 in I 72.

Linens: These two shirts are similar but with important points of difference. In I 83 the shirt has a higher neck, but it is still not a proper collar. The sleeves are fairly full and finish in a cuff at the wrist. The wristband is decorated with a ruffle. The shirt has a side opening on his right shoulder. The shirt in I 84 has a small neckband decorated with whitework/Italian shirring and edged with a narrow ruffle. The sleeves are fairly narrow, and they have a tight cuff beyond, which is a deep ruffle that extends from the wrist to the base of the thumb. It has a center-front opening.[104]

Legs: Matthäus has two more pairs of flamboyant hose of the same style. In each case the over-hose have a round, slashed codpiece, and he has a pair of garters tied below the knee. In I 83 the over-hose are violet-blue. They are slashed vertically in three bands between his waist and hips, over his mid-thighs, and over his knees. There are two horizontal cuts, which allow the slashes to form three loose rolls. The edges of the vertical and horizontal cuts are jagged. The over-hose are worn with hose that are striped vertically in white, red, and green on his left leg and yellow, white and gray on the right leg to the knee; they are plain violet-blue below the knee. In I 84 the over-hose are black, and they are cut in the same style as those in I 83. They are worn with hose that are striped vertically in yellow, white, and pink on the left leg and black, white, and red on his right leg to the knee. Below the knee they are plain black.

Footwear: His black shoes are very wide at the front, and the vamp is low cut over the toes.

Accessories: Pairs of red untied points hang down from the waistbands of both pairs of hose.

Jewelry: He wears a rectangular gold pendant with a hanging section and pendant pearl on a black cord around his neck. The sleeves of these shirts mean that there is little reason to wear a bracelet, as it would be concealed.

Gilding: His pendant and the embroidery on his shirts.

Image I 85[105] [verso]

First October 1526: the hose in a social gathering with Contz Mayr, the gown and bonnet in this manner, with velvet; the gray in the velvet was sewn with silk threads with Netherlandish work.
Text below: 29 ⅔ years, minus 20 days.

Clothing overview: His reference to the hose being "in a social gathering" indicates how Matthäus thinks about his clothes as actively shaping his public image, and he is justified in this opinion. While the red elements in this ensemble are striking, it is the hose that attract the viewer's attention.

103. Omitted from Braunstein, *Un Banquier Mis a Nu*.
104. For a contemporary shirt of a slightly different style with embroidery in violet silk and metal wrapped threads, see T.4104, in B. Borkopp-Restle, *Textile Schätze aus Renaissance und Barock* (Munich: Bayerisches Nationalmuseum, 2002), 22–23.
105. Omitted from Braunstein, *Un Banquier Mis a Nu*.

Headwear/hair: The three-quarters view adopted for this image provides a good angle from which to inspect this black bonnet with a wide brim. It is probably made from felted wool or felted knitting, and the edge of the brim is wrapped with black velvet. The top of the crown has also been decorated with black velvet bands. The bonnet is worn at an angle on his head, covering his right ear, and it is secured with two black ties under his chin to ensure that is stays in place. His hair is not visible.

Body garments: His black[106] velvet gown comes to just below the knee. It has cape collar, which extends over his shoulders, and very full, puffed, two-part, hanging sleeves. The upper and lower sections of the sleeves are joined with pairs of black points. The gown is decorated with pairs of narrow black guards down the fronts, on the sleeves, and around the hem. It is decorated with geometric motifs made from black passementerie. Underneath, the front of his black doublet is cut back to form a v-shape, so that it fastens at the waist only and leaves his chest uncovered. The sleeves are full, but only the lower part is visible where they pass through the slit in the sleeves of the gown. This lower part is made from a number of narrow vertical panes, which reveal the red fabric below. The doublet is worn with a bright red placard that infills the area left uncovered by the doublet, and it provides a strong point of contrast with the black doublet, while complementing the red lining of the doublet sleeves. It is edged with black passementerie, and it is formed into a decorative knot at the center-front.

Linens: His shirt has a high neckband that is edged with a small ruffle and embroidered in gilt metal thread in two thick bands. Two further bands are worked on either side of the front opening of the shirt.

Legs: The main color for his hose is black. The black over-hose have a round, slashed codpiece, and he has a pair of black garters tied below the knee. The hose are slashed vertically in four bands between his waist and hips and over his upper thigh, lower thigh, and his knees. There are three horizontal cuts, which allow the slashes to form four loose rolls. The edges of the vertical and horizontal cuts are jagged. The over-hose are worn with hose that are striped vertically in yellow, blue, and gray on both legs to the knee and then they are black below the knee.

Footwear: His black shoes are wide at the front, and the vamp is low cut over his toes.

Jewelry: There is a black cord around his neck but no indication of whether there is anything hanging from it.

Weapons: His sword had a bright red hilt. It is in a black scabbard.

Gilding: The embroidered bands on his shirt.

Image I 86 [recto]

4 March, 1527, at Herrn Antonio Fugger's wedding. The bonnet with velvet and silk satin, the gown with silk loops, the hose with half silk lining and narrow stripes. The doublet half silk. Everything was a gift except for the bonnet.

Addition below the image: I was the man in charge to keep order in the bridal chamber, and Lucas Meiting among the men in the men's chamber [*Manstuben*].

Text below: 30 years, 12 days.

Note: Schwarz considered this one of his most splendid outfits and referred back to it at the end of his book.

Clothing overview: Matthäus is dressed all in scarlet for his role overseeing the bridal chamber at Anton Fugger's wedding. Undertaking this role emphasizes his importance within the Fuggers' business, and the color ensures everyone present will see him undertaking this

106. Matthäus describes it as gray.

prestigious task. Most important the clothes were given to him, presumably by Anton Fugger, a further mark of Matthäus's esteem.

Headwear/hair: A flamboyant scarlet bonnet with a wide brim worn at an angle on his head and dipping down over his left ear. The brim is decorated with alternating bands of velvet and silk and rows of red buttons. This creates a striking effect that relies on the difference in surface texture and sheen of the two fabrics.[107]

Body garments: He is wearing a knee-length scarlet gown with an ornate, three-layer collar. Each layer is made from one piece of fabric that has been folded in half lengthwise and slashed, giving the impression of a series of tabs or loops. The gown is full in its cut, and the sleeves add to its fullness. The sleeves have an upper part and a lower, hanging sleeve. The upper part is paned, and the panes are joined halfway down with large red buttons. Finally, the hem of the gown is decorated with a trimming in the same color. His scarlet half silk doublet matches the color of the gown. It has a low round neck, and it is short-waisted. It fastens at the front and is secured with large buttons, similar to those on the sleeves of the gown, at the top, the midpoint, and at the waist.

Linens: The scarlet doublet and gown show off his white linen shirt to very good effect. The neck has a small neckband that is edged with a very narrow ruffle. In addition there are two rows of metal thread embroidery around the small neckband and down the front opening. The shirt is made from very fine linen, which forms lots of small pleats over his chest.

Legs: His scarlet hose complete the outfit. The hose are striped, with a fine, darker red stripe, from waist to knee. At the knee the hose are slashed. The edges of the cuts are jagged and folded over to form decorative loops. Below the knees the hose are plain scarlet. The hose have a round, slashed codpiece, and red garters are tied below each knee. The ends of the garters are decorated with gold aglets or gilt fringe.

Footwear: His black shoes have very low-cut vamps.

Jewelry: There is a black cord around his neck, but it is not possible to see what he has on it. He has a gold ring on the third finger of his left hand.

Weapons: The sword with its scarlet hilt matches the rest of his clothes and is offset by the black scabbard (also see I 85). His right hand holds the pommel of his dagger, which sits on his right hip.

Gilding: The embroidery on his shirt, the decoration on his garters.

Image I 87 [verso]

On 13th March a social gathering, 60 people in black and body-color; (we) moved from the Rosenau into the city of Augsburg with around 800 others. There I was fitted out like this by the merchant's chamber.

Text below: 30 years, 21 days.

Note: The Rosenau was a meadow for festivities outside Augsburg.

Clothing overview: Matthäus is in armor for a second time, and he indicates that the hose at least were paid for by the civic authorities of Augsburg, suggesting these parti-colored hose are livery for a city muster.

Headwear/hair: He has a red bonnet[108] with a slightly puffy crown worn at an angle on his head and dipping down over his right ear. It has a wide brim, which has been slashed. The crown has been trimmed with several large, white ostrich feathers, which have been dyed black at the ends and augmented with gilt aglets.

107. He presents a very striking appearance. Compare with Unknown artist, *The Man in Red*, 1540s, Royal Collection.
108. It looks very similar to the bonnet in I 86, just ten days later.

Armor: Matthäus is wearing a breastplate, probably with a back plate, and tassets or thigh defenses. The armor is heavily fluted in the fashionable "puffed and slashed" style. It incorporates elements of decoration designed to replicate current fashions seen in clothing, such as the pleated effect on the breastplate and the puffed effect on the tassets.

Body garments: The breastplate is worn over a flamboyant doublet, which is serving as an arming doublet by providing the foundation that different parts of the armor would be secured to. Similar doublets can be seen in drawings of Landsknecht.[109] Only the very full sleeves of the black and white arming are on display, suggesting it would only be worn with partial armor on the arms or without as depicted here. The sleeves are padded to achieve this very round effect, but they are gathered into a tight-fitting wristband. The black fabric is cut in a chevron pattern consisting of long diagonal cuts to reveal the white fabric underneath. The spaces between the diagonal cuts have been slashed with short horizontal cut for added impact.

Linens: The narrow s-shaped ruffle on the neckband of his shirt is visible above the neck of his breastplate.

Legs: The hose have black and pink/flesh color vertical stripes. While partially obscured by the tassets, they appear to be slashed vertically between the waist and the knee to form three quite full puffs on the thighs and two narrower rolls at the knees. The hose have a round, pink codpiece, striped with black. The hose are worn with black garters tied at the knees, and the ends of the garters are decorated with gold aglets or gilt fringe.

Footwear: Black shoes are cut low over the toes. This might seem rather flimsy footwear for combat, but the Landsknecht are often depicted in this type of shoe.[110]

Weapons: He has a staff weapon resting on his left shoulder, probably either a pike or a halberd, both of which are carried by German infantry at this time. He has a short bladed sword in a black scabbard hanging from a black girdle and hanger. It is probably a *Katzbalger* (cat-gutter).[111]

Gilding: The feathers, the decoration on his garters.

Image I 88 [recto]

On 2nd June, 1527, in this manner: the doublet from silk satin, a riding gown from camlet, the bonnet edged with velvet, all of this to please a beautiful person, along with a Spanish gown.
Text below: 30 years, 101 days.

Clothing overview: By the summer of 1527, Matthäus is back in fashionable clothes, and his choices are influenced by his courtship of an unnamed woman. He has opted for elegant black and away from the more flamboyant styles he favors when in male company.

Headwear/hair: He is wearing a black bonnet with a very wide, flat brim that is worn at a slight angle tipping over his right ear. The brim is edged with twist black velvet. The bonnet reveals that his hair is now cut very short and close to his head.

Body garments: The black Spanish gown comes to just above his knees. It has a wide cape collar, which extends out over his shoulders and full, hanging sleeves. The upper section is full and gathered, while the lower section hangs down. The gown is worn over a black riding gown of camlet, and there is a suggestion of a watered pattern on the fabric. The skirts of the riding gown are heavily pleated and probably are padded and held in position with stay-stitching. The contrast between the fabric on the skirts of the riding gown and the pleated fabric on his chest suggests that the riding gown is sleeveless and cut in a deep-U at the front,

109. For example, Jörg Breu the Elder, Bastl Naschaull, 1525–30, in M. McNealy, ed., *Landsknecht Woodcuts: Kriegsvölker im Zeitalter der Landsknechte* (Marston Gate: Nadel und Faden Press, 2013), 102.
110. For example, Jörg Breu the Elder, *Symon Clappermaul*, 1525–30, in McNealy, *Landsknecht Woodcuts*, 91.
111. Swords of this type can be seen worn at a similar angle across the body in contemporary images of landsknecht; see, for example, Jörg Breu the Elder, Stoffel allweg vol, 1525–30, in McNealy, *Landsknecht Woodcuts*, 105.

revealing the front of his black doublet. It has a low neck and full sleeves, which are quite closely fitted from the mid-forearm to his wrist.

Linens: The white linen shirt has a low round neck, which is edged with a narrow ruffle. The neckband may be decorated with Italian shirring.

Legs: He is wearing black hose, which can only be seen from the knee down, and on this occasion he has chosen hose that draw the viewer's attention to them. They may be very fancy, and we are just seeing the lowest roll of the hose, with the red under-hose showing through the jagged over-hose or plain hose only with slashing at the knee—the latter would be more practical (e.g., I 89). The hose are worn with black garters that are tied below his knees, and the ends are decorated with gold aglets or gilt fringe.

Footwear: He is wearing black shoes with a low vamp, and the quarters are quite high around the heel.

Accessories: There is a length of lightweight, black fabric, possibly a fine silk, tied round his waist to act as a girdle. It is tied in a half bow, and the ends of the fabric has been decorated with gilt thread embroidery or gilt fringe.

Jewelry: There is a round gold brooch pinned to the brim of his bonnet. He has a thick gold ring on the fourth finger of his left hand. Around his neck is the usual black cord from which a pendant is hanging, but it is concealed because it is tucked inside his doublet.

Weapons: He has a sword with a black hilt in a black scabbard, probably worn with a black girdle and hanger.

Gilding: The brooch on his bonnet, the decoration on the ribbon girdle and garters.

Image I 89 [verso]

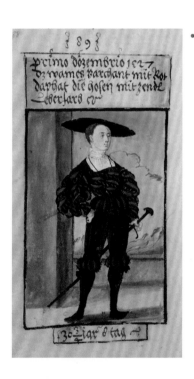

First of December 1527. The doublet from fustian with red half silk, the hose with liver-colored taffeta.

Text below: 30 ¾ years, 8 days.

Clothing overview: Matthäus is wearing a striking doublet and hose, but as he notes, the materials are not the most expensive. He is still favoring these tight styles, even though this picture may present a rather idealized view of how he looked in them.

Headwear/hair: He has a black bonnet with a very wide, flat brim. It is slashed with very short cuts round the edge, and it is worn flat on his head. His hair is still very short and neat.

Body garments: The doublet of black fustian has a high waistline. The black fustian has been slashed with moderately long, diagonal cuts to reveal red half silk placed underneath the fustian. In between the slashes, the black material is cut with a series of smaller diagonal slashes (compare with I 87). The doublet has a square neck, which is low at the front but high at the black. The very full sleeves sit high on his shoulders, narrow on the lower forearm, and tight at the wrist.

Linens: His shirt has a very high neckband edged with a ruffle, and there is a suggestion of some decoration, such as Italian shirring. The shirt is heavily pleated.

Legs: His black hose are slashed vertically from the waist to the hips to reveal the liver-colored (dull red-brown) taffeta lining. From the hip to above the knee, the hose are stripped vertically, black and dark brown. At the knee the hose are slashed to give extra fullness and to show the taffeta lining. Below the knees, the hose are plain black and he has black garters tied under his knees. The edges of the panes, at his hips and his knees, are cut in a decorative scalloped pattern. The hose have a very large, round codpiece, and he has black garters tied below the knees.

Footwear: His black shoes are wide at the front and have narrow vamps.

Jewelry: Around his neck there is the usual black cord from which a pendant is hanging, but it is concealed because it is tucked inside his doublet.

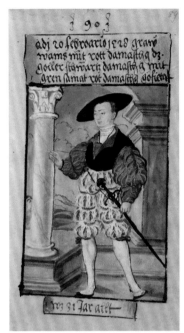

Weapons: Matthäus has a long sword with a black hilt and a black scabbard on his left hip; it is worn hanging from a black girdle and hanger.

Gilding: None present.

Image I 90 [recto]

On 20 February, 1528: gray doublet with red damask, the jerkin black damask with green velvet, lined with red velvet.

Text below: I was 31 years old.

Clothing overview: His clothes for late winter are brightly colored, and Matthäus makes a virtue of mixing colors, textures, and types of decoration.

Headwear/hair: A black bonnet with a fairly wide, flat brim worn at a slight angle on his head. His hair is still short, but it has grown a little at the sides.

Body garments: He is wearing a short-waisted, black sleeveless damask jerkin with no collar. The jerkin is left partially open to show the lining. The proper left front is lined with red velvet, while the proper right front is lined with green velvet. The jerkin is worn over a gray doublet with a red half-silk lining, and both garments have the same high waistline.[112] The doublet is similar in shape and style of decoration to that in I 89. The neck is low cut and the front of the doublet is slashed. It is probably a side-fastening doublet. It has very ornate sleeves with a full upper section, which is probably padded, and a lower, more fitted section that ends tightly at the wrist. The gray fabric is slashed with long cuts, which appear to be horizontal on the left sleeve and vertical on the right. In between the long cuts, the remaining fabric has been decorated with a series of short pinks. The red half silk shows through the slashes and accentuates the decorative effect.

Linens: The shirt has a high neckband edged with a small ruffle, possibly a double ruffle.

Legs: His hose are mid-gray from waist to his knees and then white to the feet. His over-hose are white and slashed vertically and horizontally. There are four rows of vertical slashes, each forming a puffed roll. The horizontal slashes mark the point between each roll. The edges of the panes are jagged, and the panes are decorated with v-shaped slashes. The hose are worn with a large, spherical white codpiece slashed with the gray lining showing through. He has narrow black or dark gray garters tied below his knees.

Footwear: His black shoes are cut low over his toes.

Jewelry: Around his neck there is the usual black cord from which a pendant is hanging. However, it is concealed because it is tucked inside his doublet.

Weapons: Matthäus's sword has a black hilt decorated with gilding. It is in a black scabbard, and hangs from a black girdle and hanger.

Gilding: The hilt of his sword.

Image I 91 [verso]

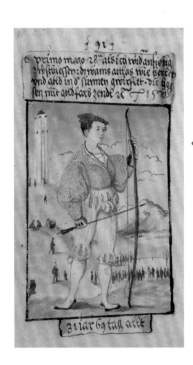

First of May [15]28, when I started shooting again. The doublet of silk satin, like pearls and gold sparkling in the sunlight [perlen und gold in der sunnen gewirfelt], the hose with golden-colored taffeta. 1528.

Text below: Aged 31 years, 69 days.

Note: This image shows the *Luginsland* tower, built in 1514/5.

Clothing overview: Matthäus notes his return to archery in late spring 1528, which suggests that he is not practicing as regularly as he should. Even so he takes the opportunity for this public sporting display to wear clothes that would ensure he got people's attention.

112. It is of the same style as in I 89, which is dated nearly three months earlier (1 December, 1527).

Headwear/hair: He has a very small, flat, red bonnet, with a slashed brim, that is curled under to form a highly decorative effect. It is worn at a slight angle toward his left ear. His hair is still cut quite short, and it is shaped around his ears.

Body garments: He is wearing a very distinctive short orange silk satin doublet with no skirts that ends at the natural waistline. It is probably a shot silk to create the effect of pearls and gold that Matthäus describes. The doublet fastens at the center-front, and both fronts are padded over the chest. The fronts are left undone to the middle of his chest so that they fold back on themselves, revealing that the fronts are lined with the same fabric. From the midpoint, the doublet is fastened down to the waist. The upper section of the sleeves, which comes to below his elbows, is very full, and they are probably padded at the top. The lower section is fitted below the elbow to the wrist.

Linens: The white linen shirt has two rows of black embroidery on the low wide neck. The fabric has been gathered into the neckband, and the linen is heavily gathered below it.

Legs: He has pale yellow fitted hose, with a fine orange stripe from the waist to his knees and then they are plain yellow from below the knee. The hose are slashed from the waist to the hips and at his knees, to provide some fullness and to reveal a golden-orange taffeta lining. The round yellow codpiece is also slashed, revealing the same golden-orange fabric. Around each knee there is a yellow garter tied in a knot on the outside of his knee.

Footwear: His black shoes have low cut vamps, and the quarters come up higher around his heels.

Accessories: He is wearing pale leather archery gloves, which are slashed on the back of his hands.[113] He has a small black leather archery bracer on his left forearm.

Weapons: He holds a long bow with horn knocks in his left hand and an arrow with a general purpose arrowhead and black fletchings in his right. Unusually he does not have a sword or dagger.

Other figures: There are lots of small figures of other men at the archery butts. It is hard to determine any details of their clothing apart from the color. Some of them are dressed in red while others are in black, brown, and blue.

Gilding: None present.

Image I 92 [recto]

On 2 December, [15]28: the doublet lined with velvet strips and with Siberian squirrel [Fech], also on the bonnet. Otherwise as shown, nothing from silk. 1528.

Text below: 31 years, 40 weeks, 4 days.

Clothing overview: Matthäus is wearing a padded, fur-lined doublet and fur-lined bonnet for winter. However, the cost of the fur is offset by the use of cheaper fabrics.

Headwear/hair: He has a very small black bonnet with plain brim, with is slashed and worn at a slight angle. The bonnet has been lined with Siberian squirrel fur, a small amount of which can be seen on the underside of the brim. The back of the bonnet extends down the back of his head and his hair is almost completely covered.

Body garments: Matthäus is wearing a black doublet, with a small collar. The collar has been formed by folding a piece of material in half lengthwise and slashing it to create a tabbed effect.[114] The front has been cut in one piece, suggesting that the doublet is side fastening. It comes to his waist and it has no skirts. The body and sleeves of the doublet have been shaped into a series of puffs with bands of black velvet ribbon. It has been decorated with short vertical cuts in between each band of black ribbon. The doublet has been lined with the fur, and it is visible on the turned-back cuffs of the sleeves. It is a grayer fur than that on his bonnet.

113. These are the same as the gloves in I 35, dated 2 July, 1519.
114. It is similar to the doublet in I 74, dated 30 September, 1525.

Linens: His shirt is not visible.

Legs: The mid-gray hose are quite close-fitting. They are slashed vertically from waist to hip, from hip to mid-thigh, and over the knee. In between the long slashes on his thighs, are two rows of short diagonal cuts. All of the cuts are jagged and they are accentuated by the gray under-hose. The slashes at the knees are formed into gentle rolls. The hose have a round gray codpiece, although it is partially obscured by the hilt of his sword.

Footwear: His black shoes are fairly round at the front. The vamp is low cut over the toes, while the quarters are high at the heel.

Jewelry: There is a gold ring on the fourth finger of his right hand.

Weapons: He has a sword in a black scabbard worn from a black girdle with a black chape and hanger that hangs across his hips.

Gilding: The ring.

Image I 93 [verso]

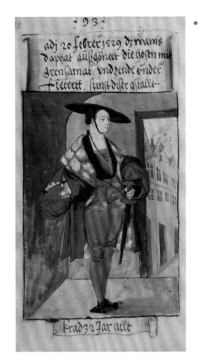

On 20 February, 1529: the doublet sewn with half silk, the hose lined with green velvet and taffeta, otherwise as shown.
Text below: Just 32 years old.

Clothing overview: This is a much more expensive set of clothes than those recorded in the previous image. The striking impression is created through the use of scarlet, the large amount of costly fur, and the significant amount of silk.

Headwear/hair: Matthäus is wearing a black bonnet with a very wide, flat brim with a strap looped under his chin. It is worn over a small black, intricate caul, which covers all of his hair.

Body garments: He has a knee-length dark gray gown, with a full lining of marten, and there is marten on the broad cape collar. It has very full, puffed sleeves, which are also fur lined and come to his mid-forearm.[115] The right sleeve shows that it has two long slits joined with pairs of black points tied in half bows. The gown is worn over a black half-silk doublet that is quilted all over with diagonal lines forming a diamond-shaped grid. It has a small grown-on collar at the back, but the fronts are cut away to form a v-shape, which reveals his shirt and placard. The doublet fronts are fastened only at the waist. The scarlet placard is trimmed along the top edge with a wide band of green velvet.

Linens: He has a shirt with a small neckband edged with a ruffle and possibly decorated with Italian shirring worked in white. It is heavily pleated.

Legs: His close-fitting red hose reveal the shape of his legs and suggest heavier thighs than in some of the earlier pictures. The hose are trimmed with two wide bands of green velvet, one of which is set just above the hips, and the other at the top of each thigh. In between there are a series of diagonal slashes through which green taffeta is visible. The hose have a large, round codpiece, which is also decorated with green velvet. He has narrow red garters that are tied above and below his knees, and the knot is positioned above his kneecap. The end of the garters are decorated with gold aglets or gilt fringe.

Footwear: He has a pair of black shoes. The vamps come up to his ankle, and they are decorated with vertical slashes on the black uppers. His red hose show through.

Jewelry: There is a round pendant with a dark stone in a gold and pearl setting on a black silk cord around his neck. He has a gold ring on the fourth finger of his left hand.

Weapons: His left hand rests on the gilt hilt of his short sword, which is in a black scabbard with a gilt chape. It hangs from a black girdle and hanger.

Gilding: The decoration on his garters, his ring, the pendant, and the hilt of his sword.

115. Compare with the depiction of the fur on the long gowns of the men holding civic office in *Die Monate Oktober, November, Dezember*, oil on canvas, 227.5 × 353 centimeters, Deutsches Historisches Museum, Berlin; illustrated in *Feste und Bräuche*, 33, 181.

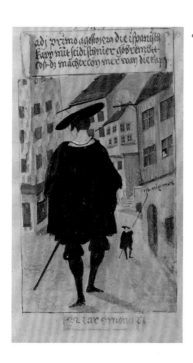

Image I 94 [recto]

First of August 1529. The Spanish cape trimmed with silk guards [Schnier], the making cost more than the cape.
Text below: 32 years, 5 months, 8 days.

Note: Schwarz records that payments for his tailor and other craftspeople exceeded the value of the fabric. Such an imbalance defined sumptuous luxury at the time.

Clothing overview: Matthäus is all in black again, and he makes another reference to Spanish fashions suggesting that they are becoming increasingly influential. His comment about the cost indicates that the embroidered guards on the gown were specially made for him.

Headwear/hair: He wears a black bonnet with a very wide brim worn fairly flat on his head. The bonnet extends down around the back of his head. This section is slashed at the back, has small earflaps, and only comes partway down the back of his head, providing a good view of the back of his hair. The back of his neck is clean shaven, and the three little twists of hair seen in the naked back view are no longer there.

Body garments: Seen from the back,[116] his Spanish cape has a low, square neck, and it sits quite widely on his shoulders, suggesting that whatever he has underneath (probably a doublet) has a similar style of neck. It is very full, and the fabric falls into gentle folds to just above his knees. He has thrown the right side of the cloak over his left shoulder, the end of which can be seen in the back view. The back view also makes it clear that the gown has a hood, which hangs down to the middle of his back. The gown is decorated with very wide black guards, which are embroidered with a couched geometric design. These are applied around the hem, down the fronts, and around the edge of the hood.

Linens: The white linen shirt has a fairly high neck, which is edged with a narrow ruffle. The neckband is quite wide, and there is a large amount of linen gathered into it.

Legs: He has black hose. The hose are paned at the knees, and the panes are formed into long loops. It is hard to tell from the small front view whether this is the only decoration on his hose.

Footwear: His black shoes have high cut quarters.

Jewelry: The black line on the back of his shirt is likely to be the cord that he has worn in a number of the other images. It probably has a piece of jewelry hanging from it.

Weapons: He is wearing his sword on his left hip in a black scabbard.

Other figures: The female figure at a first floor window is wearing a flat, bright red bonnet and has loose hair. She has a red gown with a low neckline, which is infilled with a white linen partlet.

Gilding: The half figure of a deer with antlers on the building to his right.

Image I 95 [verso]

In November 1529, during the English sweat, everything woolen except for the doublet, which was silk satin.
Text below: 32 years, 8 ½ months.

Note: The English sweat was an infectious disease, which spread in Augsburg from the beginning of November to the 6th December.

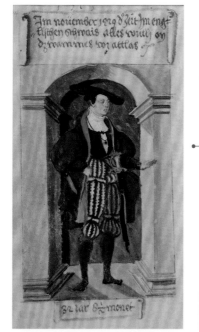

116. Compare with the woodcuts by Niklas Stör of a *Cobbler* and a *Tailor*, 1530s, shown from the back, Nuremburg, Germanisches Nationalmuseum.

Clothing overview: Matthäus's choice of wool clothing during a time of sickness probably reflects contemporary views about its health-giving properties (rather than suggesting a sense of economy, as he does on other occasions).[117]

Headwear/hair: He is wearing a black bonnet with a large, flat, slashed brim. The lower brim or turf is shaped around his head. It is decorated with short vertical slashes, and it has short earflaps. It is very similar to that in I 94. A little of his hair can be seen below the edge of his bonnet.

Body garments: He has selected a dark brown, wool gown, with a gray lining. The gown has an upright collar, and full, two-part, hanging sleeves. The upper part of the sleeves is very full and probably padded, while the lower, more fitted section is only secured to the upper with a pair of black points. On both sides, one point has been undone to allow his arms to pass through the slit in the sleeves. His black silk doublet has a very low neck, and the fronts are cut away to create a v-shaped gap, revealing a lot of the shirt. The doublet is fastened at the waist and at the neck. A pair of black points has been tied in a half bow to secure the top of the doublet. The doublet has full sleeves that are more fitted over his lower arm, and it is this section of the sleeves that is visible.

Linens: He wears a white linen shirt with a small neckband edged with a little ruffle. The very fine linen is gathered into the neckband. The low-cut doublet shows off the fine quality linen of the shirt to good effect.

Legs: His dark brown woolen hose match the gown. From his waist to just below his knees the hose are cut in vertical panes with jagged edges. The panes are joined with two horizontal bands at his hips and above his knees. They fit closely to his thighs down to the knee, where they gain some extra fullness. The lining for the left thigh is blue, with yellow for the right. He has a round, brown codpiece, slashed with yellow and blue. Blue ribbon garters are tied below the knees.

Footwear: The black shoes are wide at the front with a low-cut vamp, and the quarters come up quite high at the heel.

Jewelry: A black round pendant in a gilt frame on a black silk cord is hanging so that it is displayed against the white of his shirt in the gap created by the fronts of his doublet.

Weapons: It has bright steel and a gilt hilt on his sword in a black scabbard with bright steel chape and other fittings. It is worn from a black girdle and hanger.

Gilding: On the hilt of his sword, the frame of the brooch.

Image I 96 [recto]

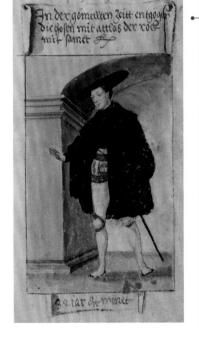

During the same period: hose with silk satin, the gown with velvet.
Text below: 32 years, 8 ½ months.

Clothing overview: The wool clothes in I 95 are offset by this much more sumptuous silk outfit, which he also wears during the period of the sweating sickness. It is telling that Matthäus depicts his clothes at this time, suggesting that either he still went about his daily life in spite of the sickness or that he bought these clothes just before the outbreak and had limited opportunities to be seen in them.

Headwear/hair: He has a black bonnet with a very wide, flat brim, worn flat on his head that is very similar to those in I 94 and I 95. His hair has grown a little and is fuller at the back.

Body garments: He is wearing a black, knee-length gown, which has a broad cape collar and full sleeves. The sleeves, quite unusually, are made in one piece, and they are long and wide. The gown has a pair of black velvet guards, one narrower than the other, which run round the collar, down the front of the gown, and around the hem. The sleeves have five of

117. See L. C. Arano, *The Medieval Health Handbook: Tacuinum Sanitatis* (New York: George Brazillier, 1976), 8–10.

these guards running lengthwise down the outside of the sleeve. The gown is worn over a plain black doublet, which comes to his natural waist. The doublet has a plain front, suggesting that it is side fastening. It has a high neck and small collar. Only the end of his right doublet sleeve can be seen, and it fits quite close to the wrist.

Linens: His shirt is not visible.

Legs: He is wearing tight bright yellow hose that are decorated with wide bands of red silk satin above and below his hips (compare with the hose in I 93). There are a series of short slashes with jagged edges over his hips, and the red taffeta underneath shows through. He has an ornate, round, yellow codpiece with two bands of red satin and slashes revealing the red lining. Narrow black garters are tied above and below his knees, with the knot positioned about the top of his kneecap.[118]

Footwear: His black shoes are wide at the front with low vamps and high quarters.

Weapons: His sword is in a black scabbard and it is worn suspended from a black girdle and hanger.

Gilding: None present.

Images I 97 and I 98 [verso]

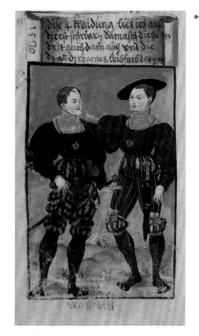

1530. These four garments I had made for the 20th February, 1530: the first black damask, the hose with flesh-colored half silk; the other and third also damask, and the hose with half silk [Zend], the hose woolen; the 4th the doublet flesh-colored half silk, the hose leather with yellow and golden taffeta [Zendl].

Text below: Aged 33 years.

Clothing overview: Matthäus has four new doublets and hose, ordered as sets, and presented to the viewer in two pairs. These two are similar enough to allow the viewer to consider the differences in the hose. Most notable is the style of the codpiece in I 98, which is different to those he has had to date.

Headwear/hair: He is bareheaded in I 97. He wears a black bonnet with a medium-sized brim in I 98, the edge of which has been wrapped with a narrow black, braided band. It is worn at a slight angle over his right ear. In both cases his hair is cut fairly short, but it is shaped around his ears.

Body garments: In each image, he has a doublet of similar cut with a fairly low, square neck at the front, while sitting quite high on his shoulders. The fronts have a suggestion of fullness in the body, possibly formed by pleating or quilting. The long sleeves are very full to the elbow and then more fitted below it. The neck at the front has a decorative edging. In I 97 the doublet is made from black damask, while in I 98 it is chestnut brown damask. In both cases it is a large pattern repeat indicating that these were expensive fabrics.

Linens: The shirts are similar with both having tall collars edged with a narrow ruffle. In I 97 the edge of the ruffle has been decorated with blackwork embroidery.

Legs: In I 97 his black hose are lined with body-colored half silk. The hose are slashed vertically at the hips and knees and diagonally on the thighs. The edges of the slashes have been jagged and between the slashes, there are star-shaped pinks. The hose have a round, black codpiece, also slashed to reveal the pink taffeta. Black garters are above and below the knee, and the ends of the garters are decorated with gold aglets or gilt fringe. In I 98 the hose are of dark brown wool, and they are slashed at the hips and the knees; underneath the slashes there is a yellow taffeta lining. The brown wool on his thighs has a narrow yellow

118. For garters tied in a similar style, see the male figure wearing very tight white hose in *Die Monate Oktober, November, Dezember*, oil on canvas, 227.5 × 353 centimeters, Deutsches Historisches Museum, Berlin; illustrated in *Feste und Bräuche*, 177.

vertical stripe. His codpiece, also striped, is in the form of a flap, which is secured with pairs of points; a black lace secured the front of his hose. Yellow garters are tied above and below his knees with the bows tied at the front.

Footwear: His black shoes have a low vamp and high quarters.

Accessories: He has a small, gray purse or bag hanging from his girdle in I 97. There is a suggestion of the pink (I 97) and black (I 98) points joining the hose to the doublets.

Jewelry: He wears the same heart-shaped gold pendant, decorated with his coat of arms. As usual it hangs from a black cord.

Weapons: He has a sword with a black scabbard in I 98 with a round black, gilt and bright steel pommel, while in I 99 the sword has a curved hilt and a short, wide blade. It is in a black scabbard with silver decoration and chape. In both cases, the sword hangs from a black girdle and hanger.

Gilding: The pendant, the garters.

Images I 99–I 100 [recto]

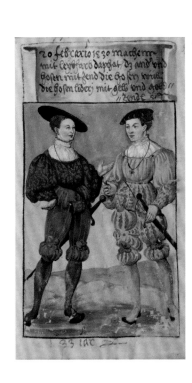

Clothing overview: The other two doublets and hose chosen by Matthäus provide more subtle variation on the figure-hugging clothes that he favors. The illustration also draws out the different effects that can be achieved by using wool or leather for his hose.

Headwear/hair: In I 99 Matthäus is wearing a similar bonnet with a wider, undecorated brim angled over his left ear to that in I 98. In I 100 he has a very different style of black bonnet. It is small, with no brim at the front but extends down over his hair at the sides and back. It is decorated, probably with lots of gilt thread embroidery, and it is worn flat on his head. His hair is short as in I 97–98.

Body garments: He has a dark violet damask doublet in I 99 and a doublet of flesh colored or pink half silk in I 100. The damask has a large pattern repeat, and it has been positioned carefully on the front of the doublet while the ogival motif is shown off well on his right sleeve. The fronts of both doublets are quilted, and they probably fasten at the side. The edge of the neck is pinked. The cut of I 99 is similar to that of the doublets in I 97–98, while I 100 has a wider neck than the other three examples. The lower sections of his sleeves are decorated with rows of pinks.

Linens: Both of his shirts have upright neckbands collars edged with narrow ruffles. In image I 99 the edge of the ruffle has been decorated with blackwork embroidery, whereas the shirt in I 100 is edged with a double ruffle.

Legs: In I 99 he is wearing woolen violet hose. The hose are slashed over the hips and over the knees, where extra fullness is allowed. The slashing reveals a green taffeta lining. The flap-shaped codpiece is slashed and tied in place with pairs of points with gold aglets. Violet garters are tied below his knees in a double bow. In I 100 the hose are of pink leather lined with high quality golden yellow taffeta. The hose are cut in four rows of vertical slashes, which have jagged edges. They are flush over the hip and then formed into loose rolls on his thighs and at the knees. The codpiece is slashed and secured with red points. Red garters are tied above and below his knees, with the double bow positioned over the kneecap.

Footwear: He wears black shoes with a small vamp and high quarters.

Accessories: There is a suggestion of black points joining the hose to the doublet in I 99 and dark pink/red points in I 100.

Jewelry: He is wearing the same heart-shaped gold set pendant as in I 97–98.

Weapons: He has a similar sword in both images with a black scabbard and a black girdle and hanger.

Gilding: The pendant, the aglets.

Image I 101 [verso]

This was my outfit [Rüstung] at the baths at Göppingen, when I suffered tertian fever on the first of May 1530.

Text below: Aged 33, 2 months, 8 days.

Clothing overview: He is dressed all in black as he travels to take the waters at Göppingen, and it is likely that his clothes are made from wool, even though he does not mention it. As usual Matthäus is wearing riding clothes for his journey.

Headwear/hair: He has a black bonnet with a medium-sized upturned brim and a pair of black ties under his chin. The brim is decorated with lots of black ostrich feathers, which have been gilded. His hair has grown a little longer.

Body garments: He is wearing a black, knee-length, riding coat. It has a round neck and fairly full, long sleeves, which are puffed at the top and more fitted on the forearm. The riding coat has a flat front, and it is probably side fastening along one shoulder and down the side of his chest. It is decorated with horizontal, applied narrow bands of black silk, which creates a striped effect. The skirts are heavily pleated, and there is probably an opening at the back, allowing the skirts to fall on either side of the horse's back and to cover his thighs.

Linens: His shirt is not visible.

Legs: He has black hose, which are slashed vertically at his knees to reveal a black lining below.

Footwear: He has a pair of black shoes, worn with bright steel rowel spurs with long necks.

Weapons: His sword has a black and bright steel hilt. It is in a black scabbard.

Horse/horse harness: He is riding a chestnut gelding/stallion with a full mane and tail. It is on the bit, and it has a high-stepping action. It has a black bridle with single reins and a curb bit. There are large gilt bosses on the bit, and there are also little gilt bosses where the chin strap meets the browband. There is also a black neck strap, crupper, and back strap, all of which have decorative edging. The most striking piece of his horse harness is the saddle, which might be covered with pale leather or possibly with velvet. The saddle has a high cantle, and the skirts of the saddle appear to be quilted to keep all of the padding in place. In addition, the saddle has a webbed girth, black stirrup leathers, and black stirrups.

Gilding: On the feathers on his bonnet, on the horse harness.

Images I 102 and I 103 [recto]

1530, to please King Ferdinand during the Imperial Diet, when Emperor Carolus (Charles V) was here. The hose made of leather, the doublet red-brown scarlet silk satin and yellow and golden yellow damask.

Text below: Aged 33 years, 4 months, and 10 days.

Note: The Augsburg Imperial Diet in 1530 was a meeting of the Holy Roman Emperor with German princes. It was a highly significant political and religious event. Emperor Charles V returned to the German lands after an absence of nine years, a period in which the country had been shaken by Protestantism and the Peasants' War (1525). Charles spoke no German, and most of the citizens of this relatively poor city were illiterate. The Habsburg entourage, moreover, was international, and stayed in Augsburg until the autumn. All this increased the importance of nonverbal, visual communication during the summer months of 1530. Sumptuary laws were suspended during Imperial Diets, as everyone was aware that many literate commentators were to report on the beauty of the city and its inhabitants. There was an elaborate entertainment program of dances, balls, and various kinds of games. Several German princes were awaiting a

ceremony in September, at which their privileges of vassalage would be renewed by the Emperor. Protestant princes and theologians were anxious to present their justification to Charles, a document that became famous as the "Augsburg Confession." Charles V pursued his own political agenda—to secure military support against the advancing Ottomans—and moreover ceremonially delegated political control over the German lands to his brother Ferdinand as future Emperor. Matthäus Schwarz was safe to assume that Ferdinand would appreciate his contribution to the display of beauty, gaiety, and innovation in the city. He had two outfits tailored explicitly "to please Ferdinand." Schwarz moreover aspired to a noble title and would have been aware of Ferdinand's future role in awarding it. Charles lodged in the Fugger houses, and together with Ferdinand, he negotiated exceptionally large loans. Schwarz thus would have been close to the emperor and his brother throughout their stay. Jenny Tiramani's reconstruction in this edition interprets the outfit on the left (see also Introduction I).

Clothing overview: These two outfits demonstrate the importance of looking the part at the Imperial Diet.

Headwear/hair: In both images he is wearing a flat black bonnet worn at contrasting angles. His hair has grown a little longer.

Body garments: In I 102 he has a short-waisted doublet with a low, wide neck, which sits on his shoulders, and it has very full sleeves. It is made from wide scarlet silk and yellow damask panes. These are joined at the neck, the waist, and at the midpoint—the latter with pairs of gold aglets. The full sleeves are made from scarlet and yellow panes, which are joined at several points with gold aglets. They are made in two sections, an upper full section and the lower more fitted section. In I 103 the doublet is of a similar shape and construction to I 102 but in a different color scheme, with the panes being dark pink silk and russet damask. The necks of both doublets have a pinked edge.

Linens: In both cases, Matthäus wears a white linen shirt with a tall neckband edged with a short ruffle, and large quantities of linen have been gathered into the neckband, creating a mass of very tiny pleats. The shirts probably fasten at the side, to go with the side-opening doublets.

Legs: In I 102 the hose are of yellow leather, slashed to create panes, making the red silk lining visible. The slashes run from waist to hip, then a row of horizontal slashes, and a second longer set that go down to below the knee. The edges of the slashes have been nicked, and the centers of the panes have a series of v-shaped pinks. The round, ball-shaped codpiece is slashed and turns slightly upward. Yellow garters have been tied around his knees, above and below the joint. In I 103 his yellow hose are cut in long panes, and each pane is decorated with six-pointed pinking, resulting in star-shaped cuts. The lining is pinky mauve, at the hips and knees, and bright red over the thighs. The codpiece is secured with points.[119] He has yellow cross garters, tied above and below the knee, with the knot of the bow being placed above the knee. They are tied with four puffs, in a rosette, right at the front of the knee, and the garters look very soft, possibly sarsenet. There is a whipped black lace securing the front of the hose on I 103, and two tiny points secure the top corners of his codpiece, which points down.

Footwear: His black shoes have a narrow vamp and high quarters.

Accessories: There is a small, red purse with black cords hanging from his girdle in I 102.

Jewelry: The pendant worn in I 102 is damaged, but it is probably the same heart-shaped piece in I 103. Both hang from a black cord.

Weapons: He carries black swords with different hilts, both in black scabbards, hanging from a black girdle and hanger.

Gilding: The aglets, sword hilts, and pendant.

119. Compare with drawing of codpiece of Cosimo I de'Medici, d. 1574; Arnold, *Patterns of Fashion*, 55.

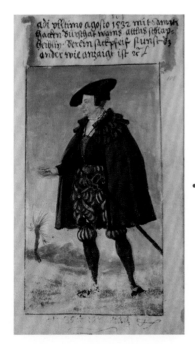

Image 104 [verso]

On 2nd September, 1530, the gown was made of marten fur at the back and black curled fur at the front, the hose with taffeta, the doublet of better quality taffeta [zendldort]. On mules, and otherwise as depicted.

Text below: 33 ½ years, 10 days.

Inside the image: The face is well captured.

Clothing overview: As autumn approaches Matthäus has a very opulent new fur-lined gown. The gown adds a sense of authority to his outfit, while his doublet and shirt provide him with opportunities for novelty.

Headwear/hair: There is a black bonnet with a medium-sized brim worn fairly flat on his head. The brim has a looped decorative edging. His hair is short and cut quite close to his head.

Body garments: His knee-length, gray-brown gown is lined with marten and edged with black curled fur (possibly lambskin). It has a small roll collar. The gown has hanging sleeves, the upper section of which is full and puffed, and the lower section is more fitted. The split in the sleeve can be joined with a pair of red points, which have been left undone. His doublet is made from black high quality taffeta. It does not appear to have a collar, and the fronts have been cut away so that they form a v-shape over Matthäus's chest. The right front has a series of buttons and the left front, a series of four loops. These appear to be purely decorative, with the doublet being fastened only at the waist. The sleeves are full at the top, but they become more fitted over the forearm. His white placard has been decorated along the top edge, which comes to a midpoint on his chest, with a wide band embroidered with polychrome silk and gold metal threads in a floral design. The placard is heavily pleated.

Linens: His white linen shirt is also pleated. It has a tall neckband edged with two narrow bands of blackwork embroidery and a small ruffle.

Legs: Matthäus wears tight-fitting dark yellow hose. They are slashed with short vertical cuts at the waist and the knees, revealing the bright blue taffeta lining, while also providing some fullness at the knees. The edges of the slashes are jagged. The ball-shaped codpiece has been slashed in a similar manner to reveal more of the blue taffeta. Dark gray garters are tied above and below his knees, with the knots positioned just above his kneecaps, and they are edged with gold aglets/gilt fringe.

Footwear: His black mules are wide at the front, and the vamps are cut with short vertical slashes over his toes.[120]

Accessories: There is a set of keys hanging from his girdle.

Jewelry: He is still wearing the gold heart-shaped pendant around his neck on a black silk cord.

Weapons: His sword sits on his left hip. It is in a black scabbard and hangs from a girdle and hanger.

Gilding: The pendant, the ends of his garters.

Image I 105 [recto]

Last day of August 1532, with velvet aglets, a doublet in a light fabric of wool and silk, silk satin bonnet, pearl-Sackpfeif, everything else as shown.

Text below: 35 ½ years, 8 days.

Note: On the hilt of the sword there appears to be a thread of pearls, which might be the *Sackpfeif.* (This literally translates as horn-pipe.)

120. A mule is a slip-on shoe that does not have quarters; Swann, "English and European Shoes," 22.

Clothing overview: Almost two years after the previous image and wearing a significant amount of black, Matthäus is dressing in a similar style to I 104, but as this is a late summer outfit, there is no fur lining in his gown. Indeed it is probably either unlined or has a very lightweight silk or half-silk lining.

Headwear/hair: His black bonnet has a medium-sized brim. It extended down over the side and back of his head and has ear flaps, which cover his ears. This back section is decorated with short rows of vertical slashes, forming a zigzag pattern. The bonnet covers most of his hair, but a little is visible at the back of his head and suggests it is still in the same, short style.

Body garments: He has a black knee-length gown. The collar is upright, and it is edged with a narrow slashed band. The cape is made from two rows of tabbed loops, the lower one longer than the upper one (compare with I 86). Each loop is either cut with an s-shaped slash or has an applied s-shaped piece of passementerie. The gown is decorated with a narrow black guard down the fronts, around the hem, and at the base of the collar. The gown is worn over a black doublet of a wool-silk mix, which comes to his natural waist. The sleeves are full, narrowing toward his wrists. The fronts of the doublet are cut back to form a v-shape over his chest, which reveals a scarlet placard. The placard comes to mid-chest height

Linens: His shirt has a small neckband that is edged with a small ruffle. The shirt is made from lots of fine linen that forms pleats over his chest.

Legs: His black hose, possibly of leather, are slashed with short, straight cuts from waist to hip, at the knees, and with diagonal lines in alternating directions down his thighs. The white lining shows through the cuts and accentuates the complex pattern. The hose probably have a codpiece, but it is obscured by the hilt of his sword. He has black garters tied above and below his knees, and the very full knot is positioned above his kneecap. The garters are edged with gilt, possibly aglets or fringe.

Footwear: He has black shoes and few details are visible because of the damage to the illustration.

Jewelry: He has a gold pendant with three pendant pearls worn on a black cord. On at the brim of his bonnet there is a small brooch with gold cord or chain.

Weapons: The hilt of his sword is very ornate. It is decorated with pearls and gilding. It has fancy black scabbard, and it hangs from a black girdle and hanger.

Gilding: His pendant, the decoration on his bonnet.

Image I 106 [verso]

8th May, 1535. Everything black was made of velvet, the yellow from half silk.
Text below: 36 years, 71 days.

Clothing overview: All in gray, this image, painted nine months after the last, provides an elegant view of Matthäus in his mid thirties. His comments imply that most of the outfit is made from wool.

Headwear/hair: He is bareheaded, and this reveals that his hair is cut very short again.

Body garments: He is dressed all in mid-gray, and the most important garment is his knee-length, gray wool gown. The gown is very full, and it has ornate, elbow-length sleeves, which are made from two sections. Pairs of black points join the upper and lower sections of the puffed sleeves, which are probably heavily padded to give them this shape. The gown is decorated with a series of applied z-shaped motifs made from black velvet, which are on the sleeves and around the hem. The deep, upright collar is also made from black velvet. The gown is worn over a gray doublet. Matthäus's comments suggest that this is stamped gray wool, but it might be gray damask that he has forgotten to record. It has a low neck and comes to his natural waistline. It is pleated, or possibly quilted, on the chest. The front

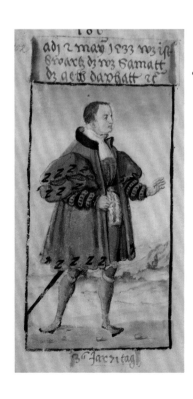

suggests that this doublet fastens at the side. In addition, it has very ornate sleeves that complement those of the gown. They are visible from the elbow to the wrist, and they are formed into a series of horizontal rolls, which are delineated with bands of black velvet. In addition, these horizontal rolls have been slashed with short, vertical cuts.

Linens: His shirt has a high neckband that is edged with a small, double ruffle.

Legs: His tight-fitting gray hose are worn with a short pair of trunk hose. These have been cut in panes that run from his waist to the top of his hips, where they are stitched together in a narrow band. The edges of the panes are cut in a decorative, crescent-shaped pattern. This pattern is accentuated by the contrasting golden-yellow half silk lining. Pale yellow taffeta garters are tied above and below the knee, with the small knot positioned just above the top of his kneecaps.

Footwear: His black shoes are wide at the front, with a narrow vamp and high quarters.

Weapons: He has a black sword in a black scabbard, which is worn with a black girdle and hanger.

Gilding: None present.

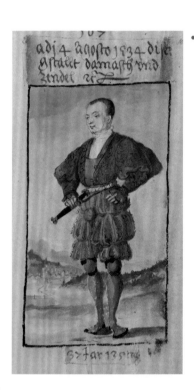

Image I 107 [recto]

On 4 August, 1534, in this manner, damask and taffeta.
Text below: 37 years, 135 days.

Clothing overview: A little over a year later, it is not surprising that Matthäus chose to record this bright scarlet doublet and hose. The color is reminiscent of the clothes he wears in I 86 for Anton Fugger's wedding, but there are many differences in terms of cut and fabric choices.

Headwear/hair: He is bareheaded, as in the previous illustration, and his hair is cut very short.

Body garments: Matthäus is wearing a short, waist-length, red silk damask doublet. It does not have a collar, and it is very short-waisted so there is a gap between the doublet and his hose. The fronts of the doublet are cut back to create a v-shape over his chest. The edges of both fronts are decorated with a wide band of red cord that has been couched in a geometric design. There are four false loops on the proper left front and four red silk buttons on the proper right front.[121] The sleeves are very full at the top, and this section is probably padded to help create this shape. Just below the elbow, the lower part of the sleeve is more fitted over his forearm to the wrist. The sleeves have deep cuffs that are cut in a series of long tabs that hang down over his fingers. Underneath the doublet Matthäus wears a plain red placard, which is possibly made of taffeta. It infills the gap in the front of the doublet and covers most of his chest.

Linens: He has a high-necked white linen shirt with a small stand collar. In addition, a small section of the shirt is visible in the gap between his doublet and hose.

Legs: His bright red hose are very full and puffy. They are cut in a series of vertical panes with jagged edges, which reveal a lot of the matching lining. They are cut in vertical slashes between waist and hip, upper thigh, and lower thigh, and they are divided by horizontal cuts. He has a spherical codpiece, which is slashed. The full, red taffeta lining can be seen through the slashes. He has black garters tied above and below the knee, and the small knot is positioned above his kneecap.

Footwear: His black shoes are wide at the front.[122]

121. Compare with the doublet in I 104.
122. For an example of a shoe with a slightly rounded wide toe, c. 1500–1530, from Jäfverts arkiv Nordiska museet, Stockholm, see J. Swann, *History of Footwear in Norway, Sweden and Finland* (Stockholm: The Royal Academy of Letters, History and Antiquities, 2001), 83, fig. 90.

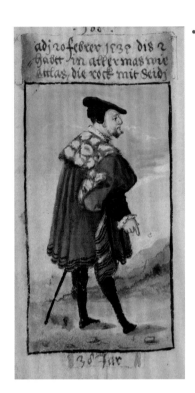

Accessories: Black points bridge the gap between his doublet and hose, keeping them together while revealing a little of his shirt.

Weapons: His right hand rests on a dagger in a black scabbard, which hangs from a black girdle. He has no sword. The hilt of the dagger, the mount at the mouth of the scabbard, and the chape are gilded bright steel.

Gilding: On his dagger.

Images I 108 and I 109

On 20 February, 1535, I wore these 2 clothing ensembles as shown. The doublets were silk satin, the gown had silk passementerie [Schnier]. That is when I began to grow a beard, in 1535.
Text below: 38 years old.

I 108 [verso]

Clothing overview: Matthäus presents the two new sets of clothes that he ordered in February 1535. They both include a striking gown and suggest a more formal style of presentation. He also makes a second, and this time successful, attempt at growing a beard at age thirty-seven.

Headwear/hair: He has a black bonnet with a small brim seen from the side. The brim is larger at the back, and the bonnet extends down around the back of his head. It has small ear flaps. The back section is slashed vertically, and in between these cuts, there are rows of short diagonal cuts. He has short hair, a hint of a moustache, and a carefully shaped beard.

Body garments: He wears a dark blue-gray, knee-length gown lined with marten fur. It has a deep but narrow cape collar, which is seen to good advantage in this side view. The fur has also been used to line the hanging sleeves, and it can be seen through the various splits. The gown is worn open. There is a lot of fabric in the back of the gown, which has been gathered and hangs in deep folds. The gown has three very narrow black guards, which have been applied around the hem and on either side of the openings of the hanging sleeves. Each guard is decorated with blocks of four very short vertical lengths of the same black passementerie. The sleeves are made in three sections: an upper full, puffed part, which is probably padded to give it this full shape, and two narrow parts that are only joined together along the seam (compare with I 109). Underneath he wears a black silk doublet, but only the sleeves are visible. These are fairly full, but they taper toward his wrists, and they are decorated with horizontal bands of black fabric, causing a striped and slightly puffed effect. In between the bands, the fabric has been slashed with short vertical cuts.

Linens: His shirt has a neckband edged with a double ruffle, which has a line of black embroidery worked along it. His shirt's wristbands have ruffles, which are also edged with black to match his neckband.

Legs: He is wearing black hose. There does not appear to be any slashing at his knees, and he is not wearing garters.

Footwear: His black shoes are quite wide in the toe, and they have high quarters.

Jewelry: He wears a plain gold ring on the fourth finger of his right hand.

Weapons: He has a sword in a black scabbard on his left hip.

Gilding: The ring.

I 109 [recto]

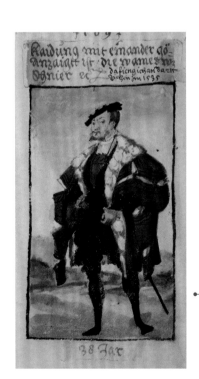

Clothing overview: Seen from the front view, his other set of clothes are very ornate and the more expensive of the two that he has ordered. The use of marten fur on both gowns stresses his wealth, status, and his maturity.

Headwear/hair: He has a very small black bonnet with a small yet highly decorative brim. It extends down a little at the back, and it is worn at a slight angle. He has fairly short hair, a little moustache, and a carefully shaped beard formed into points on either side of his jaw.

Body garments: He wears a brown knee-length gown with a deep turned-back cape collar, which is covered with fur, probably marten. The fur extends down the front of the gown, inside the sleeves, and may form a complete lining. The gown is worn open to reveal his doublet and hose. The hanging sleeves are made in three sections. The upper, puffed section is very full, and it is slashed to reveal the fur. The slashes are joined with pairs of black points tied in half bows. The two lower, narrow sections are also fur lined and joined together at a single point, hanging open. The gown is decorated with six alternating rows of black and gray passementerie on the sleeves and around the hem. Under the gown he wears a black silk doublet. The fronts have been cut back, forming a v-shape, which reveals his shirt and a scarlet placard. The doublet does not have a collar. The sleeves appear to be quite full, but they narrow toward the wrists. The scarlet placard has a low neck, and the neckband has a pinked edge; below this there are two rows of short diagonal slashes. The placard is held in place with red ties that go around his neck, which have decorative ends.

Linens: The very fine fabric of his shirt is pleated on his chest. The shirt has a neckband, which is edged with a small double ruffle. At his wrists there are small ruffles, which are formed into a pronounced s-shape.

Legs: He wears black hose, which are asymmetrical. On the left leg, the panes run from his waist to just above the knee and then form a puff over his knee. In contrast, on the right leg, the hose have been slashed between the waist and the hip and the upper thigh and the lower thigh, and they are formed into three loose rolls. The edges of the slashes on the right leg are cut in a decorative crescent pattern. On both legs the black lining shows through. The hose have a large, round, black codpiece. He has black garters tied above and below his knees. The ends of the garters are finished with black points with gold/gilt aglets or fringe.

Footwear: He wears black shoes with a low-cut vamp.

Jewelry: There is a plain gold ring on the fourth finger of his left hand.

Weapons: He has a sword in a black scabbard on his left hip and a dagger with an ornate scabbard on his right hip.

Gilding: The ring.

Image I 110 [verso]

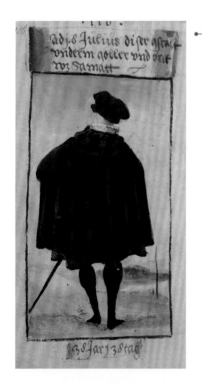

On 8th July in this manner, below the jerkin and bonnet were velvet.
Text below: 38 years, 138 days.

Clothing overview: A year later, the cloak Matthäus wears here contrasts with the fancy gowns in I 108–109. He is all in black, and is seen from the back.

Headwear/hair: He is wearing a large black velvet bonnet with a full, puffy crown and a fairly narrow, downturned brim. The edge of the crown and the top side of the brim are decorated with small puffs of black fabric, possibly velvet. He has not worn a bonnet of this type before. It is worn at a slight angle on his head and covers his hair completely.

Body garments: He is wearing a black knee-length cloak. The back view demonstrates the large amount of fabric that has been used to make the cloak, which hangs in deep folds from his shoulders. The right edge of the cloak has been thrown over his left shoulder, and it hangs down a little. The back view also shows off the very ornate collar, which is an important decorative feature. The collar is made from three elements. First, there is the upright section, which is edged with a black guard and decorated with diagonal slashes. Below this there are two rows of tabbed loops, the lower one longer than the upper one.[123] The cloak is edged with

123. Compare with I 105.

a narrow black velvet guard that is applied round the hem and probably down both fronts. Matthäus mentions a jerkin of velvet, but it is completely covered by the cloak.

Linens: The shirt has a tall neckband, which is edged with a ruffle, and there is a hint of some white decoration—possibly some Italian shirring.

Legs: He is wearing black hose, and there is no indication that he is wearing garters.

Footwear: His black shoes reveal few details. If they have high quarters, it is not possible to tell.

Weapons: He carries a sword on his left hip. It is in black scabbard.

Gilding: None present.

Image I 111 [recto]

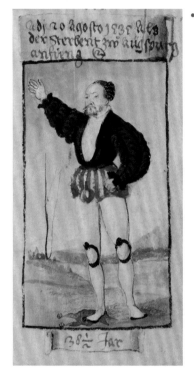

On the 20th August, 1535, when people in Augsburg began to die.
Text below: 38 ½ years old.

Note: Schwarz stands on a jester's cap. He refers to a plague epidemic, which began after the 4th July and lasted until March 1536.

Clothing overview: Another set of clothes that Matthäus links directly with a period of sickness in Augsburg. The open-fronted doublet and very short trunk hose are suited to the summer season, but he may not have had many opportunities to wear them in public if people's movements were curtailed because of the plague.

Headwear/hair: He is wearing a close-fitting black silk and gold thread caul that sits on the back of his head. In addition, his right foot is placed on a blue fool's cap with two horns, each one decorated with a gilt bell.[124] His hair, which looks to be starting to recede at the front but still quite full at the back, is tucked under the caul. His now pointed moustache has got longer, and he has a short, trimmed beard.

Body garments: Matthäus has a black doublet that comes to his natural waist, with no skirts. The fronts are cut away to reveal a large section of his shirt, and it only fastens at the waist. The sleeves of the doublet are different in terms of decoration, but both are quite full in shape, and they appear to be padded. The left sleeve had applied black bands forming vertical stripes, and in between these there are rows of diagonal slashes. On the right sleeve, the bands form horizontal stripes, and there are rows of vertical slashes between them. The cuffs of both sleeves are cut in wide tabs that extend over the back of his hand. These look to be square cut on the left cuff and curved on the right. Unusually for a low-fronted doublet of this style, it is worn without a placard.

Linens: Relatively little detail has been included in the depiction of the white linen shirt. It has a tall neckband edged with a little ruffle.

Legs: He is wearing a pair of close-fitting pale yellow hose, which provide a strong contrast with the black doublet. The yellow hose are worn with very short, bright blue, paned trunk hose. These trunk hose extend from the waist to the top of his thighs. The edges of the panes are cut with diagonal cuts to create a very decorative crescent effect. The round codpiece is made of the same blue, and it is slashed to reveal a yellow lining. Narrow black garters are tied above and below his knees, with the knot centered above the top of his kneecaps. The ends of the garters have gold aglets or a gilt fringe edging.

124. Compare with Albrecht Dürer, "Fool putting out his neighbour's fire instead of his own," woodcut from Sebastian Brant, "Das Narrenschyff," Basel, 1494, f. 18v (436b). Also see the fool wearing a blue and yellow horned cap with bells, in *Feste und Bräuche*, 72.

Footwear: His black shoes are wide at the toe, and the quarters come quite high up the heel.[125]

Jewelry: There are gold rings on the fourth and little fingers of his left hand.

Gilding: His rings, the decoration on his garters, and the caul.

Image I 112 [verso]

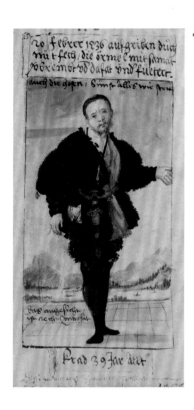

*20 February, 1536, roughed cloth [*aufgriben duch*] with Siberian squirrel fur, the sleeves trimmed with velvet and lined with half silk, like the hose. Otherwise everything as shown.*

Inside the image: The face is well captured.

Text below: Just 39 years old.

The marginal note records Narziss Renner's death.

Note: The image notes the illuminist Narziss Renner's death during the plague in the margins. Schwarz had closely worked together with Renner for over sixteen years and provided the illuminist with his main income (see Introduction I).

Clothing overview: Predominantly dressed in black, Matthäus is still very interested in his appearance at age thirty-nine.

Headwear/hair: He is wearing a small black caul edged with gilded thread and possibly with a gold thread tassel. The caul sits on the back of his head, and his hair is tucked underneath. He has a small beard, which has extended further along his jaw line, and a small moustache.

Body garments: He is wearing a mid-thigh-length gown that is made from a black wool fabric with a very distinctive textured surface. It is lined with pale gray Siberian squirrel fur, which provides a strong contrast. The gown has puffed sleeves that come to just below his elbows, where the material is drawn into a narrow band. The gown has a pocket slit in the lower right front, which is accentuated by the handkerchief that is hanging out of it. The gown is decorated with four narrow black guards applied around the hem. These might be made from black passementerie or very narrow bands of black velvet. Underneath he is wearing a black doublet, and just the lower section of the sleeves is visible. The sleeves are decorated with black applied bands forming horizontal stripes. Between the bands are rows of short vertical slashes. The proper right front of the doublet (or possibly of the gown) has three loops of black passementerie. The doublet is worn with a scarlet placard, which has a low neck.

Linens: He has a shirt with a narrow neckband that is edged with a small ruffle. The front of his shirt is gathered in small folds.

Legs: He is wearing black hose. They can only be seen from his mid-thigh downward. They are slashed above the knee, revealing the black lining. It is possible that the hose are cut in similar rolls at the hips and on the upper thigh. The edges of the slashes are cut, forming a decorative edging. Black garters are tied above and below his knees, with the ends of the garters finished with gold points or gilt fringe.

Footwear: His black shoes are wide at the front, and the vamps are cut low over his toes.

Accessories: There is a white linen handkerchief decorated with blackwork embroidery and a small frilled edge hanging out of his pocket.

Jewelry: He has a long thin gold pendant on a black cord or ribbon around his neck.

Weapons: He has a dagger in a black scabbard hanging from a green silk girdle (probably made from a length of lightweight silk, such as taffeta or sarsenet). The girdle is tied in a half bow, and the ends are decorated with gold aglets or gilt fringe.

Gilding: On the caul, the pendant, the dagger sheath, the ends of his girdle, and garters.

125. For a comparable example, see the shoes worn by the man in a wall painting of a fashionable couple, c. 1530, Åbo slott gatehouse (Turku), Finland, in Swann, *History of Footwear*, 85, fig. 93.

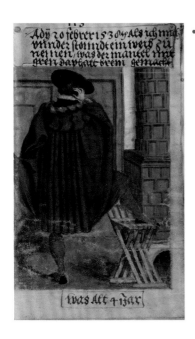

Image I 113 [recto]

20th February, 1538, when I decided to take a wife, the gown was made with green trims of half silk.

Text below: I was 41 years old.

Note: Schwarz continues after a two year break, and wedding plans prompt this image. From now on the text is not written in Schwarz's hand.

Clothing overview: After a two year gap, Matthäus offers another back view of his clothes to accompany his announcement that he has decided to marry. While the black gown is quite restrained, it is evidently worn over a striking pairing of a red and yellow striped doublet and red hose.

Headwear/hair: His fairly broad-brimmed black bonnet is worn at angle, and it is pulled down over his right ear. His hair is visible at the back, and it is longer and fuller than it has been for a while.

Body garments: He wears a dark knee-length gown, which is seen from the back. The right front has been thrown over his left shoulder, and some of the fabric hangs down in a loose fold. The back of the gown consists of a series of very deep pleats. It is decorated with a thick roll of twisted green and gray half silk around the low neck. Below this it has a deep cape collar, which is cut in a series of zigzag slashes. The gown is decorated with three very narrow guards of green passementerie along the hem and the lower edge of the cape collar. His other body garment or garments are only partially visible, and there are two likely possibilities. He may be wearing a black doublet with a small grown-on collar and contrasting sleeves. These are red and yellow with vertical stripes. Alternatively, he is wearing a red and yellow striped doublet with a low neck and full sleeves that narrow toward the wrists, and over this he wears a black sleeveless jerkin with a small collar. The second option is the most likely.

Linens: The tall neckband of the shirt is visible over the neck of the black doublet or jerkin. It is finished with a fairly deep ruffle, which is edged with blackwork embroidery.

Legs: He has scarlet hose, and there is no suggestion that they are worn with garters. They may be of the close-fitting type seen in I 93 or with full over-hose of the sort seen in I 107.

Footwear: He has black shoes, which are wide at the front. The vamp is quite low cut, while the quarters are quite high at the back of his heel. (See his left foot.)

Weapons: The scabbard of his sword is visible on left side of the picture, showing through the folds of his gown.[126]

Gilding: None present.

Page 110 [There is just text on this page.] [verso]

The year 1538. I threw away "The Course of the World," that is to say "The Rake's Life."

Note: Schwarz decides to marry and reevaluates his life and recordkeeping. He throws away the diary in which, as he notes in the prologue, he has described many of his clothes (see Introduction I).

126. Back view of a man wearing a gown, which is hitched up over his sword, see Albrecht Dürer, *Christ Carrying the Cross*, 1520, drawing, 21 × 28.5 centimeters, Uffizi, Florence; Wölfflin, 260, fig. 113.

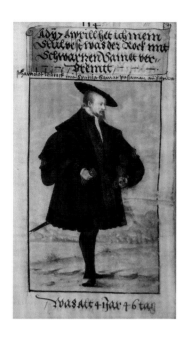

Image I 114[127] [recto]

On 7 April, I celebrated my engagement. The gown was trimmed with black velvet, the jerkin was sewn with Spanish velvet passementerie.

Below the image: Aged 41 years, 46 days.

Note: The engagement was a formal event administered by the priest.

Clothing overview: Matthäus wears very elegant and very expensive clothes to celebrate his engagement. While still very fashionable both in terms of style and in the use of Spanish materials, Matthäus has chosen clothes that reflect stylish, mature masculinity.

Headwear/hair: He wears a black bonnet with a wide brim at an angle on his head, dipping down slightly toward his left ear. The edge of the brim is decorated with closely spaced, small, black points tied in knots. Underneath, his hair is cut very short, and it works well with his very neatly trimmed stiletto beard and shaped moustache.

Body garments: Matthäus is wearing a very full, dark brown gown. It has a wide cape collar that extends right over his shoulders and overlaps onto the top of the sleeves. The two-part sleeves contain a lot of material, and he wears them properly. As a result, they are slightly pushed up to reveal the sleeves of his doublet. The two sections of the sleeves are joined with lots of pairs of black points that bridge the gap. The gown falls in heavy folds, which are evident on the skirts. It is decorated with a pair of black velvet guards, one wider than the other, down the fronts of the gown, around the collar, around the hem, and to edge both sections of the sleeves. The gown covers most of his sleeveless jerkin, which is of a new style that works very effectively with the gown. The tawny jerkin has a small grown-on collar, and the skirts extend as far as his mid-thigh. It is worn open to the middle of his chest and then done up. The front of the jerkin is decorated with bands of very ornate passementerie, and they form the focal point of his outfit. Finally he is wearing a black doublet, probably made from black satin. The cut of the jerkin suggests that the doublet is cut in a deep V at the front, and its fairly close-fitting sleeves can be seen where they show out of the gown's sleeves.

Linens: His shirt has a tall neckband, which is edged with a narrow ruffle. The cut of his jerkin shows off the fine linen of his shirt.

Legs: His plain black hose are only visible from the knees down.

Footwear: He has black shoes, which are wide at the front, and have quite narrow vamps.

Accessories: He is holding a pair of short, brown leather gloves in his right hand.

Weapons: His left hand rests on the hilt of his sword, which rests on his left hip. It is in a black scabbard.

Gilding: None present.

Image I 115 [verso]

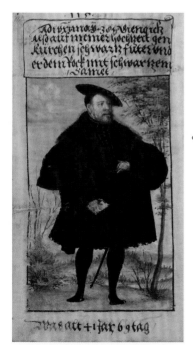

On the first of May 38, I went to my wedding in church like this: black lining below the gown with black velvet.

Text below: I was 41 years and 69 days old.

Clothing overview: His wedding clothes are much more subdued that those he wore for his engagement. Dressed all in black Matthäus provides a very good example of inconspicuous consumption, as he revels in the richness of the black fabrics and furs.

Headwear/hair: He is wearing a black bonnet with a fairly small flat brim. It is worn at a slight angle on his head, and the edge of the brim is wrapped diagonally with a narrow band of

127. In the Hannover manuscript, image no. 114, p. 102.

a shiny fabric, possibly a silk satin. His hair is shorter (cf. I 113), the ends of the moustache are longer, and his pointed beard has extended farther along his jaw line.

Body garments: He is wearing a knee-length black gown with a turned-back cape collar. The collar is covered with black fur, and the gown may have a full lining of the same black fur. The gown has hanging sleeves, which consist of a very full upper section and a narrow hanging section. The opening of the upper section is very wide, suggesting that the hanging section is just for show. The sleeves are decorated with wide guards of black velvet, and these also decorate the hem of the gown. Underneath he is wearing a black jerkin, which has a small, grown-on collar and long skirts that come to his mid-thigh. The jerkin has been left unbuttoned, but there is a row of small, black buttons on the proper right front, running from the collar to his waist. Below the jerkin there is a black doublet, which also has a small collar. It fastens down the center-front with round buttons, of which eleven are visible. The sleeves, which probably belong to the doublet, are visible as they emerge from the sleeves of the gown. They are quite full but become narrower toward the wrists.

Linens: A small hint of the ruffle edging the neckband of his shirt is visible above the collar of his doublet.

Legs: He is wearing black hose, which are plain from the knee down and probably plain above the knee too.

Footwear: His black shoes are wide at the front.

Accessories: He may hold a pair of brown leather gloves in his right hand, along with a bundle of letters.[128]

Jewelry: The second finger of both his right and left hands each has a gold ring.

Weapons: He wears a sword on his left hip, and it is in a black scabbard.

Gilding: None present.

Image I 116 [recto]

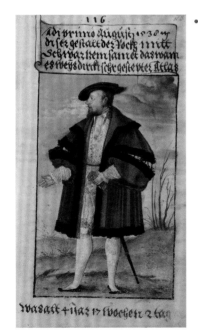

First of August 1538, in this manner: the gown with black velvet, the doublet white, Turkish quilted silk satin.

Text below: I was aged 41 years, 17 weeks, and 2 days.

Clothing overview: His first set of clothes as a married man, and the purple and white provides a marked contrast to his wedding clothes. Matthäus has not lost the wish to catch the viewer's attention, but now he does so though his use of color rather than clothes that are tight fitting or slashed in the latest style.

Headwear/hair: He has selected a black bonnet with a fairly modest brim, which is in two sections. The downturned front section overlaps the upturned back section. It is worn flat on his head. He has a neatly trimmed beard and moustache. His hair is quite short, and there is a suggestion that it is starting to go gray over his ears.

Body garments: Matthäus is wearing a knee-length gown of purple cloth, with a broad turned-back cape collar and very full sleeves. It is decorated with a broad, double, black velvet guard around the hem, down the center-front, around the edge of the cape collar, and on the sleeves. The gown's sleeves, which come to the mid-forearm, are made in two halves, with the join positioned halfway down the arm, and the two sections linked by pairs of black points. His doublet is of white Turkish silk, which has been quilted in a diagonal pattern. It is open down the front, revealing part of his shirt. It has a small collar, round white buttons, and fairly full sleeves that are fitted at the wrists.

128. The image is damaged, so the details are indistinct.

Linens: The white linen shirt is fairly plain with a narrow neckband, a narrow ruffle, and a front opening, which has been left undone. The sleeves end with narrow wristbands edged with a deep, s-shaped ruffle.

Legs: His white hose match the doublet. They are cut in panes, with the slashes running from waist to the hips and then down the thighs. The white lining shows through the slashes. The image is rather indistinct, but it is likely that the hose have a round, slashed codpiece. He has white garters, which are tied below and above the knees, with the knot positioned above the kneecap.

Footwear: His black shoes are wide at the front. They have narrow vamps and quite high quarters.

Accessories: He is holding a pair of gray gloves in his left hand.

Jewelry: There is a plain gold ring on the fourth finger of each hand.

Weapons: Matthäus has a sword on his left hip. It is in a black scabbard and hangs from a black girdle and hanger.

Gilding: The rings.

Image I 117[129] [verso]

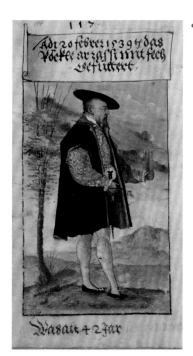

20 February, 1539: the short gown silk from Arras lined with Siberian squirrel fur.
Text below: Aged 42.

Clothing overview: Matthäus still favors bright yellow, and while he is seen from the side, it is quite likely that his gown, if seen from the front, shows off his legs, which he is evidently proud of.

Headwear/hair: Matthäus is wearing a black bonnet with a medium-sized brim, which is worn at a slight angle over his left ear. The edge of the brim has been decorated by wrapping it with a length of black passementerie or a thin strip of black satin (similar to his wedding bonnet). He has a trimmed beard and moustache and short hair.

Body garments: His black, knee-length, silk gown is lined with short, gray squirrel fur. It has no collar, but the edge of the gown rolls back, and by showing him in profile it is evident that the gown is shorter at the front than at the back. The gown has two-part hanging sleeves. The upper part of the sleeve is very short, and his arms pass through slits at shoulder height. The lower, narrow hanging section of the sleeve comes down to the hem of his gown. Underneath he is wearing a doublet that is made from dark yellow damask with a large pattern repeat. The doublet has a high neck and a grown-on collar, which has been left undone allowing the fabric to turn back a little. The doublet is fastened down the center-front. The sleeves are quite full, becoming narrower at the wrists. Rather unusually, he has a length of red fabric wrapped around his left sleeve.

Linens: His shirt has a tall neckband edged with a ruffle in an s-shape. It also has long cuffs that are edged with a little ruffle.

Legs: He is wearing bright yellow hose, which do not appear to be worn with garters.

Footwear: His black shoes are wide at the front. They have narrow vamps and quite high quarters.

Accessories: He holds a tall glass in his left hand and a sprig of a plant with green leaves in his right. There is a small, white, gathered pouch or purse at his waist, probably hanging from his belt.

Weapons: His short sword has a decorative hilt and an ornate black sheath with a decorative mouth and a chape. It hangs down in front of his body, probably from a black girdle and hanger.

Gilding: None present.

129. Omitted from Braunstein, *Un Banquier Mis a Nu.*

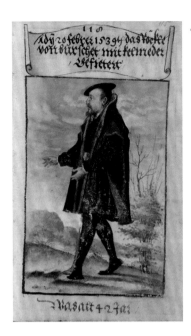

Image I 118[130] [recto]

20 February, 1539: the short gown from a mixture of wool and silk lined with the best marten fur.
Text below: Aged 42.

Clothing overview: Matthäus is wearing a new version of the gown (*das röckle*), which can be described as small because it contains the minimum amount of fabric so that it hangs straight down at the front and back.

Headwear/hair: He is wearing a small black bonnet with a very narrow brim, which is worn flat on his head. The brim is slashed at several points on the side. His hair is cut short, and his moustache and beard are neatly trimmed.

Body garments: Matthäus has selected a knee-length black gown made from a wool and silk mix (*Burschet*). The gown has a tall collar, which stands up at the back framing his face. It is lined with marten fur, and the fur extends down the front edges of the gown. It also lines the hanging sleeves and probably lines the whole gown. The gown has long, quite narrow, hanging sleeves, with a long vertical opening, which extends for most of the length of the sleeve. The end of the sleeve is narrow. The gown is decorated around the hem with two pairs of very narrow black horizontal guards. The gown is worn over a black damask doublet with a large pattern repeat. The doublet has quite full sleeves, on which the pattern of the damask is shown off to good effect. The doublet fastens down the center-front from mid-chest to the waist. It has a grown-on collar, which is left undone.

Linens: Just a glimpse of his shirt at the neck of his doublet and at the ends of his doublet's sleeves.

Legs: Below the knees he is wearing plain black hose with no signs of garters.

Footwear: The black shoes are wide at the front. They have narrow vamps and quite high quarters.

Accessories: A small white bag or purse hangs from his belt.

Jewelry: There is a gold ring on the fourth finger of his left hand.

Gilding: The ring.

Image I 119 [verso]

July 1539. This was how I rode to Nuremberg with cloth from Mechelen with a silk-satin doublet [goller].
Text below: Aged 42 years, 20 ⁵⁄₇ weeks.

Clothing overview: Matthäus has gone back to recording his riding clothes, and there are some subtle changes since the last time he depicted them.

Headwear/hair: He is wearing a dark brown bonnet worn at an angle toward his left ear. The fairly narrow, downturned brim has been decorated with a black and gold hatband. The hatband is possibly created by twisting together two lengths of different-colored fine silk or passementerie, and there is a large black tassel falling over his left eye. The bonnet is textured suggesting that it is made from fur or that it might be thrummed. The bonnet covers his hair. His moustache has become fuller, and his beard is longer.

Body garments: Matthäus is wearing a dark brown riding coat made from cloth. The coat fastens down the center-front, and it has a small black collar. The hanging sleeves are slit from the top to the end, and they are tied behind him to keep them out of the way as he rides. The coat is cut without a waist seam and it forms in gentle folds down the skirts. It looks to have a split up the center-back, making it possible for the skirts to fall on either side of the horse's

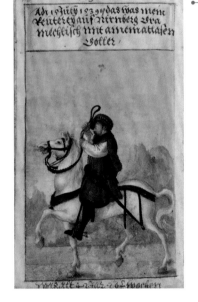

130. Omitted from Braunstein, *Un Banquier Mis a Nu*.

back and to cover his thighs to keep them warm. The coat is trimmed with three rows of black passementerie down the center-front, around the hem, and in four bands on the hanging sleeves. The riding coat covers a white doublet with quite full sleeves, which end at the wrist in a tight-fitting band.

Linens: There is a hint of the wrist ruffle at the end of his doublet sleeves.

Legs: He is wearing black hose, and there is a suggestion that he has black garters tied below the knee.

Footwear: It is likely that he is wearing black shoes, with black rowel spurs with long necks.

Weapons: He has a sword with an ornate black hilt in a black scabbard on his left hip. It is worn with a black girdle and hanger.

Horse/horse harness: He is riding a gray gelding/stallion with a long mane and tail, which does not look to appreciate how he is holding the reins. All of the harness is black and made as a set. The black bridle has a curb bit and broad braided reins, a wide neck strap with a fringed lower edge and tassel at the center of the chest, black saddle with a high cantle, black girth, stirrups and stirrup leathers, and a black crupper with the same fringed effect on the lower edge and two hanging straps.

Gilding: None present.

Image I 120 [recto]

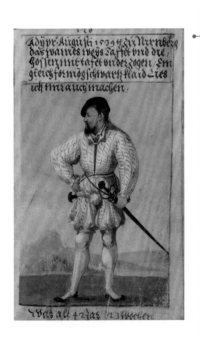

First of August 1539 at Nuremberg: the doublet white half silk and the hose lined with half silk. I also had an identical black outfit made.

Text below: Aged 42 and 23 weeks.

Clothing overview: Dressed all in white, Matthäus presents a striking figure in Nuremberg by wearing local fashions. By opting not to wear a gown, he shows that he is still favoring a style of doublet that he has worn for two decades, and this new style of hose show that he is still following fashionable styles closely.

Headwear/hair: His small black cap is worn at an angle, so that it comes down right over his right ear. In addition, it is worn over a black and gold caul with a band of gilt decoration around the edge and a small decorative pattern. The caul covers most of his hair, which is cut quite short. His beard and moustache show some signs of gray; they are quite carefully shaped, although the beard has got a little longer over the last few months.

Body garments: His white half silk doublet has a small collar that has been left open, allowing it to turn back slightly. The doublet is fastened with a button and loop below the collar, and there is another at the waist. The sleeves of the doublet are fairly full, but they draw in at the wrist. They have tabbed cuffs. The doublet is decorated all over with a series of vertical slashes, giving the suggestion of panes, which in turn have short diagonal slashes between them. A red placard infills the open front of the doublet and covers the shirt, extending from just below the open neck of his shirt to his waist. There is a suggestion that there are several rows of applied red passementerie just below the top edge.

Linens: The shirt is mostly covered, so just the neckband is visible. It is edged with a narrow ruffle and possibly a row of blackwork embroidery. It has been left undone.

Legs: He has matching white hose. The trunk hose have wide panes that are well spaced, revealing large amounts of the lining that is arranged in full folds. The top section of the trunk hose is fitted to his body, but they flare out between the hips and just above the knees, where the panes are attached to a tight band. The panes have been slashed with diagonal cuts, and the edges have been cut in a decorative pattern. The spherical codpiece is quite large. The trunk hose are worn with plain white hose.

Footwear: The quarters of his black shoes extend quite a long way up his heel, and they are fairly wide at the toe.

Weapons: He has a sword on his left hip with a decorative black hilt with a large pommel. It is in a black scabbard, which he is holding in his left hand. A dagger rests against his right hip. Sword and dagger each have their own black girdle and hanger.

Gilding: The hatband.

Image I 121 [verso]

20 February, 1540: a Spanish gown with 2 velvet stripes and small silk-ribbons.

Inside the image: These 2 portrayals [*angesicht*] well captured.

Text below: Aged 43.

Note: The first time since 1536 that Schwarz regards himself as well portrayed.

Clothing overview: His black clothes contrast with the previous set and present a more somber appearance. The Spanish cloak covers his other clothes and so is the most significant garment that Matthäus is wearing.

Headwear/hair: He is wearing a small black bonnet with a low crown and a narrow, downturned brim. It sits flat on his head. The bonnet has a black cord with a tassel tied around it, and it is positioned at the center-front. He has short hair, a neatly trimmed moustache, and a fuller beard.

Body garments: Matthäus is wearing a full, black, knee-length Spanish cloak. It could be made from a full circle because it contains a lot of fabric, which is probably a fine weave wool. The right front edge has been looped up and thrown over his left shoulder. The cloak is trimmed with a wide black velvet guard (which he describes as being a double guard of velvet with silk ribbon) around the hem and down the fronts. It is worn over a black doublet, a glimpse of which can be seen at his neck.

Linens: There is just a hint of his shirt at his neck. On his right wrist, it is possible to see the end of the ruffle of his right shirt sleeve.

Legs: He is wearing black hose. The black trunk hose have quite wide panes that are well spaced, revealing large amounts of the lightweight black lining, which is arranged in full folds.[131] The trunk hose have slashed knee bands. There are no garters.

Footwear: The quarters of his black shoes extend quite a long way up his heel, and they are fairly wide at the toe.

Weapons: The sword has an ornate hilt with a large pommel and quite a narrow blade. It is in a black scabbard and worn on his left hip.

Gilding: None present.

Image I 122 [recto]

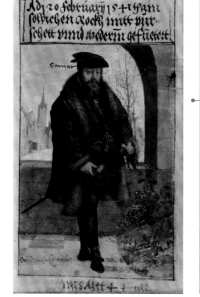

20 February, 1541: this gown lined with light wool and silk and marten fur.

Inside the image: Velvet; well captured.

Text below: Aged 44.

Note: The coat of arms has been added later. This is the period during which Schwarz received his award of nobility (*Adelsdiplom*) from Charles V.

131. See the yellow velvet and silk trunk hose of Moritz of Saxony, Niekamp and Jucker, *Das Prunkkleid des Kurfürsten Moritz von Sachsen*, 86, 136—37, figs. 68, 107–09.

Clothing overview: A year later, Matthäus is again dressed in black, but this is a much more sumptuous set of black clothes. These clothes stress his wealth and social standing through the use of rich fur in tandem with the use of velvet for accessories and trimmings.[132]

Headwear/hair: He wears a medium-sized black bonnet with a narrow brim, which is placed flat on his head. The bonnet is worn over a black velvet coif, which covers his hair.[133] He has a full moustache and his beard is a little longer than in the previous year.

Body garments: His knee-length black gown is made from a wool and silk mix (*Burschet*). The gown has a fur-covered rolled collar, and it is lined with a bright chestnut brown fur, which Matthäus identifies as marten. The gown has full-length, fairly fitted, fur-lined sleeves, the ends of which have been turned over forming a fur-covered cuff. This is one of the few occasions when he is shown wearing the sleeves of the gown rather than letting them hang down. The opening in the upper part of the sleeve is visible on the right sleeve. The gown is worn open to reveal what is probably a black jerkin. It has a small, grown-on collar. It opens down the center-front, and it has full skirts that come to his mid-thigh, covering the upper part of his hose. It is decorated down both of the fronts and around the hem with a black band. Underneath the jerkin there is a bright red garment, which is probably a doublet with a low neck that is decorated with several rows of black passementerie.

Linens: Very little of his shirt is showing, but there is a suggestion of an s-shaped ruffle above the neck of his doublet's collar. A little section of the shirt can be seen above the neck of his red doublet.

Legs: He is wearing black hose, with garters tied above and below his knees.

Footwear: His black shoes are more closely shaped to his foot at the front with fairly low-cut vamps at the toe. The quarters come up higher at the heel.

Accessories: He holds a pair of brown leather gloves in his left hand. His girdle is made from a length of black silk. Hanging from his girdle he has a bunch of four keys.

Weapons: He has a sword on his left hip with a black pommel and a dagger on his right. Both are in black scabbards, and the dagger scabbard has a gilt decorative mouth.

Coat of arms: This is similar to the coat of arms on the frontispiece but with a few significant differences. The helm has a gilt grill and a gold crown. The figure of a boy is also now wearing a crown.

Gilding: On the dagger, scabbard, and on the coat of arms.

Image I 123 [verso]

14th May, 1542, with young Conrat Rechlinger (and) Veit Witich. We vowed not to drink a half or a full glass for one year. A Frisian cloak with passementerie, a jerkin with silk from Arras, leather hose with half silk.

Text below: Aged 45 years, 12 weeks.

Note: Schwarz and his friends vow to abstain from customary male drinking rituals for one year (see Introduction I). Schwarz wears the same clothes as in the Amberger portrait in March 1542 and in Veit Konrad's book of clothes. Wittich and Rehlinger were Veit's godfathers. The text is written by a new scribe.

132. His clothes (but not his jewelry) compare quite favorably with those worn by Albrecht V a few years later; see Hans Mielich, Herzogs Albrecht V von Bayern, 1545, Bayerische Staatsgemäldesammlungen, Munich, in B. Borkopp-Restle, *Textile Schätze aus Renaissance und Barock* (Munich: Bayerisches Nationalmuseum, 2002), 22.
133. Compare with the coif worn by John Russell, 1st earl of Bedford, see Hans Holbein the Younger, *John Russell, 1st earl of Bedford*, pink prepared paper, black and colored chalks, 34.8 × 29.2 centimeters, Royal Library, RL 12239.

Clothing overview: The clothes are important because they are what Matthäus was wearing when he marks an oath to stop drinking, rather than necessarily being significant in their own right. Indeed, the clothes are designed to stress his ability to buy good quality clothes rather than being particularly fashionable.

Headwear/hair: He is wearing a small black bonnet flat on his head. It has a fairly full crown, which is slashed around the edge, and a narrow brim. He has short hair, a fairly full moustache, and a trimmed beard. He is graying at the temples, and there is a hint of gray in his beard.

Body garments: The black Friesian cloak or mantle is made of the characteristic pile fabric. It has a wide turned-back cape collar, and it comes to just above his knees. Matthäus is wearing it on his left shoulder, displaying his black jerkin made from black silk satin. The jerkin has a wide, turned-down collar, which is fastened. It has been left open at the front until being fastened at the waist. It has quite long skirts, which fall in deep folds and come to his mid-thigh. The sleeves of the jerkin are quite full at the top but narrow toward the wrist. The jerkin is decorated with bands of black passementerie. It is worn with a red placard with a low neck. The neck has been decorated with two horizontal rows of black passementerie.

Linens: Not much of his shirt is visible, but it has a narrow neckband edged with a small s-shaped ruffle and a pair of bandstrings that hang down from the neckband. Both bandstrings have a decorative tassel at the end.

Legs: His hose are black and mid-brown. The wide panes of his black leather trunk hose come to just above his knees, and in between it is possible to see a black half silk lining. They are worn with light brown hose.

Footwear: The black shoes are wide at the front. They have narrow vamps and quite high quarters.

Accessories: He has a small black bag, with a curved gilt metal frame, hanging from his girdle, which is made from a length of lightweight black silk.

Weapons: He has a dagger with a black hilt in a black scabbard with a decorative mount and chape. It hangs from his girdle with the hilt pointing toward his right hand.

Gilding: None present.

Image I 124 [recto]

The vow expired on the 14th of May. The doublet [was made] from light wool and silk, hose with half silk, all with passementerie borders.

Text below: 46 years, 12 weeks.

Clothing overview: His vow of abstinence over, Matthäus celebrates in a stylish pair of trunk hose and doublet.

Headwear/hair: He wears a small black and gold caul on his head with a decorative black and gold tassel at the center-front.[134] He has short hair, a trimmed moustache and a fuller beard.

Body garments: His black doublet is made from a wool/silk mix (*Burschet*). It has a high neck with a small grown-on collar, which is left undone and so turns back a little. The doublet has a row of small buttons and loops down the fronts, but it is fastened at the top and at the waist.[135] In between the doublet is left open, revealing his shirt. It is longer than some of his previous doublets, coming to his natural waistline. The sleeves are very full at the top and are probably padded at the top. They narrow a little over his forearms and the ends of the sleeves

134. Compare with the caul with a decorative band worn under a bonnet in Albrecht Dürer, *Ulrich Varnbühler*, 1522, woodcut, 43 × 32.3 centimeters, private collection, Wölfflin, 271, fig. 120.
135. For the silk- and thread-wrapped buttons found on the Mary Rose, see J. Gardiner, ed., *Before the Mast: Life and Death Aboard the Mary Rose* (Portsmouth: The Mary Rose Trust, 2005), 96–97.

are turned back forming a deep cuff. There are wide borders of black passementerie down both fronts

Linens: Not much of his shirt is visible, but it appears to have a narrow stand neckband edged with a small but very distinct s-shaped ruffle.

Legs: His black trunk hose come to just above his knees. The wide panes have been pinked, and in between the panes, the black lining hangs in full puffs. The panes are joined with a narrow band at the knee, which is pinked. The hose have a large codpiece with four puffs of the black silk lining pulled out. They are worn with black hose.

Footwear: His black shoes are very wide at the front but cut low over the toes, and the quarters are higher at the heel. They have a pair of small straps that fasten on the top of the foot.

Accessories: He has a tall *passglas* or *stangenglas* in his right hand held up in a toast. It is decorated with rows of five prunts arranged vertically from the base (or foot-ring) to halfway up. There is a pair of points with gold aglets on the right front of his doublet.

Jewelry: He is wearing a gold ring on the second joint of the fourth finger of his left hand.

Weapons: He has a sword with an ornate hilt in a black scabbard on his left hip, and a dagger, also in an ornate black scabbard, on his right side. Both hang from a black girdle and hanger.

Gilt: The aglets, the decoration on the dagger's sheath.

Image I 125 [verso]

27 December, 1543, at night, when Erdinger's house at St. Jakob burned down, it was very cold. I was a captain in charge of 18 people on the Perlach, the sleeves and rear in armor.

Text below: Aged 46 years, 44 weeks, 2 days.

Note: The square in front of the Augsburg town hall was called Perlach.

Clothing overview: Once again Matthäus is in armor, but on this occasion it is because he is undertaking his civic duty and helping to organize the efforts to put out a fire. His decision to wear armor for this activity suggests that the city authorities may have been concerned that the fire might result in looting of vacated properties.

Headwear/hair: He has his sallet or helmet on his head and the bevor or chin defense is in place, so very little of his face is visible.

Body garments: He is in half armor with his initials and monogram or cipher on his breastplate in gilding.[136] In addition he has pauldrons, vambraces, couters, and gauntlets. Underneath, he is wearing an arming doublet with mail gussets, which are visible on the underside of both arms.

Linens: His shirt is not visible.

Legs: He is wearing tassets together with a round codpiece that is slashed in the same style as those made of material and worn with his hose.[137] His mail skirt is visible at the back, covering the area from his waist to his mid-thigh. Underneath he has white hose, which are visible just below his knees.

Footwear: He has brown leather, knee-length boots. The top is turned over to reveal a black cuff. The boots have black soles.

Accessories: The arming points—red cord with gold aglets—which attach the vambraces and couters to his arming doublet, are visible on his left arm.

136. Compare with the very flamboyant parade armor made for Willhelm von Roggerndorf, by Colman Helmschmid, 1525, in Augsburg, Kunst Historischesmuseum, Vienna, No. A374.
137. For a later example, see breastplate and tassets, blacked and gilt iron, German, c. 1620, V&A M.866–1927.

Weapons: He holds a halberd in his right hand, his short sword (*a Katzbalger—cat-gutter*) in a plain black scabbard on his left hip.

Gilding: On the breastplate, the aglets.

Image I 126[138] [recto]

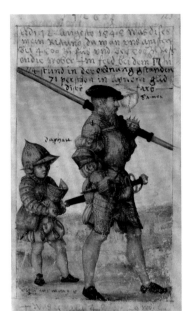

On 12 August, 1545, this was my armor when we were inspected, around 4,500 [men], except the weavers, on foot and 500 on horses, who stood in the field near the gallows in this order for ¼ hours, 71 people in one rank in this color.

Inside the image: Velvet; half silk; Vizli Memminger.

Text below: I was aged 48 years, 29 weeks.

Note: Citizens were required to appear dressed in yellow for the inspection of their armor and fitness, although Schwarz notes that the large group of weavers was not present. Detailed information on civic armor and civic uniforms from 1542 onward can be found in Paul Hector Mair's *Einspännigerbuch*, which is digitized.

Clothing overview: A year and a half later, Matthäus is in armor again but this time for very different reasons. He is taking part in another muster of troops, and on this occasion he is accompanied by his page, rather like he accompanied Contz von der Rosen in I 5.

Headwear/hair: Matthäus wears a flat black velvet bonnet, with a slashed narrow brim. It is worn flat on his head, and it is decorated with a large white ostrich feather, which hangs over the front. The vein of the feather is gilded. Vizli Memminger wears his master's sallet, which is rather large for him, and he carries the bevor. Matthäus's hair is now almost all gray and cut quite short, while his beard and moustache are fairly long but still neat.

Body garments: Matthäus wears some of the armor from the previous image but no mail. Seen from the side, he wears his breastplate, and probably the back plate, although this is not visible. In addition he has the pauldron, couter, and gauntlets. He is not wearing a vambrace on his upper or lower arm, so the sleeves of his arming doublet are visible. These sleeves consist of vertical yellow panes under which the violet half silk lining can be seen. Vizli's yellow doublet has a fitted body and sleeves, and it is decorated with applied bands of violet half silk.[139] These are applied to the sleeves, forming horizontal stripes, while on the body of the doublet, the stripes are vertical. In between the stripes, the fabric of the sleeves has been slashed with a series of small, diagonal cuts.

Linens: None are visible.

Legs: Matthäus wears tassets, which protect the front of his thighs and a steel codpiece. The narrow leather straps, which hold the tassets in place, can be seen over his trunk hose. Matthäus and Vizli both wear yellow trunk hose. The trunk hose have broad yellow panes, which are joined in a narrow band that comes to the mid-thigh. The full violet lining can be seen through the panes. The trunk hose are worn with matching yellow hose. They are not wearing garters.

Footwear: Both wear black ankle-height shoes with plain uppers and fairly naturally shaped toes.

Accessories: Vizli has a dark yellow bag, possibly made of leather, which hangs from a strap worn diagonally over his body.

138. In the Hannover manuscript, image no. 126, p. 112.
139. For a yellow doublet, with different sleeves, see the yellow satin doublet of Moritz of Saxony, Niekamp and Jucker, *Das Prunkkleid des Kurfürsten Moritz von Sachsen*, 126, figs. 99–100.

Weapons: Matthäus has his short broad bladed sword on his left hip, and his right hand rests on the hilt of his dagger. He carries a staff weapon in his left hand with it resting on his left shoulder. In contrast, Vizli has a dagger.

Gilding: None present (the gilding on the feather is represented with a yellow pigment).

Image I 127[140] [verso]

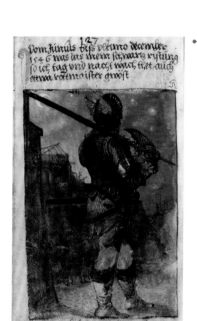

From June up to the final day of December 1546, this was my black armor, when I was on the watch day and night, and was Rott-master for some time [deleted] when Emperor Charles wanted to bag Augsburg [Augsburg wolt in den sack thon].

Text below: 49 to 50 years.

Note: Schwarz deleted part of this sentence after Augsburg's peace with Charles V. The image should be seen in relation to the memorable depictions of armored local patricians in Paul Hector Mair's *Geschlechterbuch* (now digitized), which was printed in 1550 and documents the extent to which armor signaled status aspirations and conveyed power.

Clothing overview: Matthäus wears armor while he serves in the city watch for six months from June to December 1546. While his armor is fashionable, it is a long way from his usual daily appearance.

Headwear/hair: Seen from the side view, the morion style helmet has a decorative central ridge or comb, and on either side there is one of a pair of gilt wings. It is possible to see a small amount of his moustache and beard.

Armor: He is wearing half armor, which consists of the chest plate, back plate, and arm defenses (the pauldron, couter, and vambrace). He also wears mail to protect the vulnerable areas along the back of his arms and around his armpits. The influence of fashion on the armor can be seen in the suggestion of tabs on the bottom edge of the back plate. He wears his gauntlets. The armor is made from blackened steel with some gilding on the arm defenses.

Linens: None visible.

Legs: He is wearing a mail skirt, which is secured around the waist to protect the groin. The fronts of his thighs are covered with tassets. The armor is worn over fitted light brown or yellow hose, which are slashed on the thighs, and the dark blue and purple lining can be seen between the slashes.

Footwear: He is wearing soft natural-colored leather boots, which come to his mid-calf with black turned-down tops and black soles.

Weapons: He is heavily armed with his short-bladed sword on his left hip, a halberd resting on his right shoulder, with his hand holding the point, and a dagger on his right hip. Both the sword and dagger are in black scabbards, and they are worn with black girdles and hangers.

Gilding: The wings of his helmet.

Image I 128 [recto]

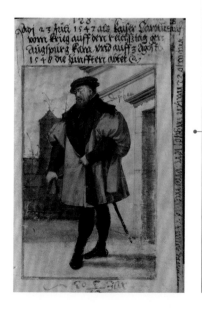

23 July, 1547, when Emperor Charles returned from the war to the Imperial Diet in Augsburg and abolished the guilds on the 3rd of August, 1548.

Inside the image: Half silk.

Text below: Aged 50 5/12 years.

140. In the Hannover manuscript, image no. 127, p. 113.

Note: Schwarz was likely to approve of this dramatic shift in local power toward patricians at the expense of craftspeople, who had supported the Reformation. He appears much aged, with thinning hair. The depiction of the head serves as model for the following images.

Clothing overview: This is a celebratory, dignified suit of clothes to mark Charles V's return to Augsburg. However, the richness of his clothing does not distract the viewer from observing that Matthäus looks much older.

Headwear/hair: He is wearing a black bonnet with a low crown and a narrow brim that downturns slightly. His hair is short and gray. He has a trimmed moustache, but his gray beard is quite long.

Body garments: Matthäus wears a full, knee-length gown of purple half silk with a wide, black cape collar. The gown is lined with black. It has long sleeves with a puffed elbow-length upper section and a lower, narrow hanging section. He holds the hanging section of his right sleeve in his right hand. Underneath he has a black doublet, which is fastened down the center-front with small black buttons. There are also what appear to be horizontal rows of black cord or passementerie on the front of the doublet. It has a high collar. Its sleeves, which are quite full, are visible where they pass through the slit in the sleeves of the gown, from the elbow to wrist.

Linens: There is just a hint of the s-shaped ruffle on the shirt neckband visible above the collar of the doublet.

Legs: He has black hose, which are visible from the knees down. The rest is concealed by the gown.

Footwear: His black shoes have uppers that come up to his ankle. They are slightly pointed at the toe and have a thick sole.

Weapons: He has a sword on his left hip in a black scabbard.

Gilding: None present.

Image I 129 [verso]

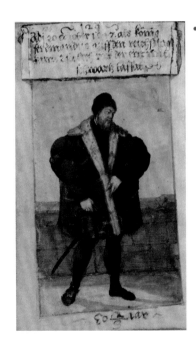

On October 20, 1547, when king Ferdinand came to the Imperial Diet, 2 such gowns, one with black half silk.

Text below: 50 ⅔ years.

Note: There is some text on a piece of paper glued over the writing, which has become indecipherable.

Clothing overview: This expensive set of clothes is very well suited to the Imperial Diet that Matthäus attends in October 1547. The use of the marten fur, in tandem with him ordering a second gown, which would allow Matthäus to vary his appearance during Ferdinand's visit, demonstrates his wealth and an understanding of an event of this type.

Headwear/hair: He is wearing a close-fitting, black cap that covers most of his hair. His moustache and beard have grown longer, and they are dark gray.

Body garments: Matthäus is wearing a black, knee-length gown with a light brown fur collar and lining. The gown has a wide, cape collar and hanging sleeves. They have a very full, puffed upper section and a fur-lined narrow, hanging lower section, which has a horizontal slit halfway down. His comments indicate that he orders a second gown at the same time that is in a similar style. The chief difference being that the other gown is lined and trimmed with black half silk. Not surprisingly, he opts to be painted in the more expensive of the two. The gown is worn with a black doublet, which has a high collar, and it is fastened down the front. The doublet's sleeves are visible from the elbow to the wrist, because he has put his arms through

the slit in the hanging sleeves of his gown. They are quite full at the elbow but become slimmer at the wrist.

Linens: Only a hint of the ruffle edging the neckband of his shirt shows at the neck of his doublet.

Legs: His black hose are only visible from the knees down. There do not appear to be any garters.

Footwear: He has black ankle shoes, and the toes are a more natural shape, forming a rounded point.

Accessories: He holds a pair of brown leather gloves in his right hand.

Jewelry: There is a gold ring, probably set with a gemstone, on the fourth finger of his left hand.

Weapons: He wears a sword in a black scabbard on his left hip.

Gilding: The ring.

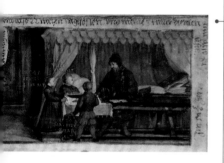

Image I 130[141] [recto, landscape]

On 19 December, 1547, in the morning at 5 o'clock, God's mightiness hit me [traff mich Gottes gewalt] while I was accounting, and so I remained indoors for 22 weeks, and my three children served me like this at the table.

Inside the image: 1539. Matheus, 8 years old. 1541. Veitli, 6 years old. Berbeli, 4 years old.

Text below: Aged 51 5/6.

Note: Uniquely for this period, Schwarz is represented after having suffered a stroke. He records that he was already working at five o'clock in the morning although these would be the shortest days of the year.

Clothing overview: This image represents a twenty-two month convalescence period, and it provides a rare glimpse of a bedroom. While it may not be a real interior, it does include the types of furnishings and textiles that Matthäus would have owned.

Headwear/hair: In this indoor scene, Matthäus wears a mustard-colored cap or hood. His sons, Mattheus and Veit (or Veitli),[142] are bareheaded, but his daughter, Barbell, wears a small cap, which covers the top of her head; the rest of her hair probably hangs down her back in a braid. Matthäus has grown a long beard during his period of illness.

Body garments: He wears a chestnut-colored nightgown over his other clothes (probably either a nightshirt or a doublet, shirt and hose). The nightgown has a roll collar, fairly full sleeves, and it is left partially open at the front to show a small amount of a black doublet. The nightgown was informal wear, worn at home to relax or, in this case, to recuperate, and so it is indicative of his poor health. In contrast, his children are dressed in fashionable clothes. Mattheus wears a gray doublet, while Veit, who is positioned behind the table, may either wear a doublet or, if he has not been breeched yet, a coat. Veit's garment, seen from the front, has a small black collar, fitted sleeves, and fastens down the center-front. Mattheus's doublet, seen from the back, has a gray collar, comes to his natural waist, and then has small skirts. Their sister Barbell wears a gray gown with a fitted bodice, fitted sleeves, and a pleated skirt with a black guard around the hem.

Linens: None are visible, but they would be worn.

Legs: Mattheus has bright red hose with slashed, puffed, upper stocks and red nether stocks.

Footwear: Matthäus has soft leather, knee-length boots, while his son Mattheus has black shoes.

141. In the Hannover manuscript, image no. 130, p. 116.

142. Veitli, the diminutive for Veit. This is the first glimpse we get of Veit, and it should be compared to him in II 9 in his own book.

Accessories: Matthäus's paralyzed left arm is supported by a wide black sling tied around his neck

Furnishings: Behind Matthäus there is a large bed with green bed hangings. The double upper valances are cut in scallops and are decorated with gold tassels, while the lower valances are plain.[143] The bed has four curtains, two of which have been pulled back, revealing the interior of the bed. There are white linen sheets and pillowberes or pillow cases. A plain white linen table cloth has been placed on the left end of the trestle table, where the family eats, while the rest of the table is left uncovered. The bed, with its associated textile hangings, linens, and mattresses, was usually the most expensive piece of furniture in a home.

Image I 131 [verso]

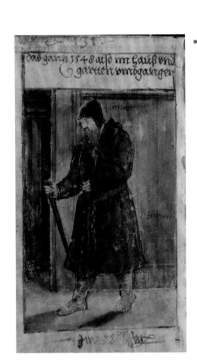

The whole of 1548 I walked around in the house and garden in this manner.
Inside the image: Velvet, Camlet.
Text below: In the 52nd year.

Clothing overview: Matthäus spends all of 1548 at home, and he is dressed in clothes suited to an invalid and for someone who spends his time indoors. The nightgown is intended to provide comfort and warmth, while still acknowledging that he can afford different types of clothes for different occasions. The fastenings on the gown and boots would suggest that he had help dressing.

Headwear/hair: He wears a fitted black velvet coif with a brown fur lining, which covers his ears and his hair.[144] He has a trimmed moustache, but his gray beard is less neat, and it has grown a lot longer during his convalescence.

Body garments: His nightgown is made from brown watered camlet, and it comes down to his mid-calf. The nightgown wraps over at the front, and it has fairly fitted sleeves. The nightgown is kept closed with a series of buttons and loops made from brown passementerie, which can be seen from the waist to the hem. They are probably also present on his chest, but these are concealed by the sling. It has a rather loose cut, and a belt of red and blue braided cord or fabric is looped around his waist. It might have a collar, but this part of the nightgown is covered by his sling.

Linens: A hint of his shirt is visible at the neck of his nightgown.

Legs: His hose, if he is wearing any, are not visible.

Footwear: Matthäus wears a pair of soft leather boots that may extend up to his knees. They have a rounded toe, and they fasten up the inside of his leg. They are done up with a series of buttons and loops. Indoor boots of this type were often fur lined for warmth, and they could be worn in bed.[145]

Accessories: He has a plain walking stick in his right hand,[146] and there is a black sling tied around his neck. It is supporting his left arm, which has been left weak as a consequence of the stroke.

Gilding: None present.

143. Compare with the depiction of the bed, with a single upper, scalloped valance decorated with tassels in Albrecht Dürer, *Life of the Virgin: The Birth of the Virgin*, 1504/05, woodcut, 29.7 × 21 centimeters, Metropolitan Museum of Art, New York; Wölfflin, 87, fig. 23.
144. A silk velvet coif of this type was found in the cabin of the Barber Surgeon on the *Mary Rose*, which sank in 1545; see Gardiner, *Before the Mast*, 35–36.
145. Compare with the pair of mid-calf length boots worn by Gustav Vasa in a portrait attributed to Willem Boy, c. 1557, Grh 467, Nationalmuseum, Stockholm; Swann, *History of Footwear*, 88–89.
146. Compare with the examples made for Henry VIII.

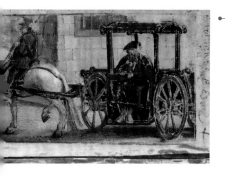

Image I 132[147] **[recto, landscape]**

In 1549 I started to drive to the office and likewise to the Margrave-baths [in Baden-Baden, U.R.] and rode [. . .] in such a cart.

Text below: In the 53rd year.

Clothing overview: During 1549 Matthäus continues to wear clothes suited to his convalescence. Warmth and comfort continue to be more important than fashion when he selects his clothes. His clothes also suggest his aging, and they form a contrast with the more fashionable and youthful clothes of the groom.

Headwear/hair: To mark his return to work and more active life, Matthäus wears a black bonnet again. His beard is quite long. In contrast, his groom has a much more flamboyant red bonnet with a shaped brim. It is trimmed with a large white ostrich feather.

Body garments: Matthäus is dressed in a long, ankle-length dark-colored gown. It has a small cape collar, and it wrapped over at the front. The sleeves are quite full, and the skirts fall in gentle folds. The gown appears to be worn over a black doublet. His groom wears a mid-thigh length, gray riding coat, with full, pleated skirts and narrow hanging sleeves, the lower part of which have been tied behind his back to keep them out of his way (compare with his riding coat in I 119). He has a girdle tied around his waist. Underneath he has a matching gray doublet with fitted sleeves.

Linens: None are visible.

Legs: The groom has mid-gray hose.

Footwear: Matthäus wears soft brown leather boots, which have a series of folds on the legs. The groom has gray shoes.

Accessories: Matthäus holds something on his lap—possibly a small bag or a pair of gloves. The groom carries a long riding whip in his right hand.

Horse/horse harness: A gray horse is pulling the cart, and the groom is riding pillion. The horse has a simple black harness, consisting of a black bridle with a curb bit, a black saddle, and crupper. The traces of the cart are attached the horse's black collar.

Cart: The cart is a small, covered black wagon with four wheels and space for one passenger. The side of the wagon is open to provide Matthäus with easy access. It has a small, curved cover to keep him dry or shade him from the sun.

Gilding: None present.

Image I 133 [verso]

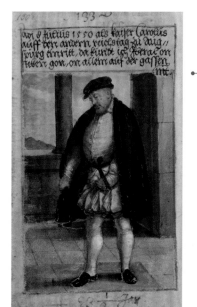

On 8 July, 1550, when Emperor Charles rode to the other Imperial Diet in Augsburg, I was able to walk everywhere without a stick, except for the alleyways.

Text below: 53 ⅓ years.

Clothing overview: By the summer of 1550, Matthäus has recovered sufficiently to return to his usual daily pattern and to fashionable clothes. This matching white doublet and hose reflect an awareness of current trends, including the peasecod belly on his doublet, the upturned codpiece, and the very full trunk hose.

Headwear/hair: His black bonnet, possibly made from black velvet has a fairly narrow brim and a full, puffy crown. It is worn flat on his head and pulled well down. His hair is quite gray, and it has been trimmed short, as has his moustache and beard.

147. In the Hannover manuscript, image no. 132, p. 118.

Body garments: He is wearing quite a simple black cloak with a suggestion of a small rolled collar. It comes down to his knees and if worn closed would cover his trunk hose. The cloak sits on both shoulders, making it easy to put on and take off, which is probably an important consideration as his left arm is still weak. Underneath the cloak he has a white doublet with a small turned-down collar. It is fastened down the center-front with pairs of white round buttons. There is some padding over the front, giving the doublet the fashionable peasecod belly in tandem with a fairly low waistline. The doublet has fitted sleeves and quite long skirts, which part around his codpiece.

Linens: His shirt is not visible.

Legs: The white trunk hose come to just above the knee. The broad panes are looped over and brought together in a plain, narrow band. The white lining shows through the panes. It is formed into full puffs. The hose have an upturned, quite large codpiece, and this is the first time he has worn a codpiece of this shape.

Footwear: The uppers of his black shoes come to his ankle, and the vamps are slashed vertically on the top of his foot.

Accessories: His left arm is supported in a sling, which is made from a loop tied in his girdle. The girdle is made from a length of lightweight black silk, which is tied around his waist.

Weapons: He has a dagger in a black scabbard with an ornate hilt hanging from his girdle. A sword, which would normally hang on his left hip, would be awkward with his arm in the sling.

Gilding: None present.

Image I 134 [recto]

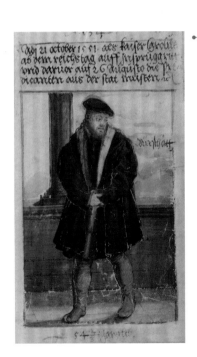

On October 21, 1551, when Emperor Charles rode from the Imperial Diet to Innsbruck, and before 26 August, when all the pastors had to leave the town.

Inside the image: A mix of light wool and silk.

Text below: 54 ⅔ years.

Note: The face resembles the portrayal of Schwarz on Hans Kels' medal (see Introduction). On 26 August, Protestant preachers who did not conform to the Interim were requested to leave Augsburg.

Clothing overview: As autumn approaches Matthäus has a new fur-lined gown that is comfortable, warm, and expensive. It has full-length sleeves, which suggest that he has more mobility in his arm, while also being easier for him to manage than the very complex sleeves that he had on some earlier gowns (e.g., I 108 and I 109).

Headwear/hair: He has a small black bonnet with a low crown and a narrow brim, which is worn flat on his head. His short hair is graying, and his moustache and full beard are quite neatly trimmed.

Body garments: Matthäus has a knee-length gown made from a black wool and silk mix (*Burschat*). It is decorated with a guard of pale brown fur, similar in color and style of depiction to the fur he identified as marten in I 93. The gown has fairly close-fitting sleeves, and the skirts of the gown fall in heavy folds. It is worn over a black doublet. The doublet has a high neck. It is fastened down the center-front, and it is decorated with horizontal bands of black passementerie down the front.

Linens: Very little of his shirt is on show, apart from a hint of the ruffle on the neckband.

Legs: His hose are not visible, but they are probably black, to match his doublet.

Footwear: He has soft brown leather boots that come up over his knees. The toe comes to a rounded point, and a very slight heel is evident on the right boot. The soft leather is slightly wrinkled at the ankle and knee.

Accessories: He no longer has a sling, but he supports his left arm with his other hand when necessary, as indicated here.

Jewelry: He wears a gold ring on the fourth finger of his right hand.

Gilding: None present.

Image I 135[148] [verso]

20 February, 1552. I began to let my hair grow again, which had not happened since 1528. The gown light wool and silk.

Text below: Just 55 years old.

Clothing overview: Four months later, Matthäus is wearing another rather subdued set of clothing with no color. He is not armed with a sword, and as in the last few images, the main emphasis is on warmth, comfort, and garments that are easy to wear. The gown or cloak with hanging sleeves also conceals his weak left arm.

Headwear/hair: He has a black bonnet with a full crown and a narrow brim. It is pulled well down, flat on his head. His hair is gray. Although his moustache and his beard are kept trimmed, he has grown his hair, and it is in a similar to the style of bob he favored when he was younger.

Body garments: He is wearing a knee-length plain black silk/wool mix cloth gown or cloak, which is worn on both shoulders. It has a turned-back collar that extends down the front of the garment. It covers his doublet, and he keeps his arms tucked inside his gown, possibly for warmth, and so the full-length hanging sleeves of the hang down at his sides.

Linens: Very little of his shirt is visible apart from the tiny ruffle edging the neckband.

Legs: He is wearing white hose, which are only visible from the knees down.

Footwear: His black shoes have rounded toes, the uppers come up to his ankle, and the soles are thick.

Gilding: None present.

Image I 136 [recto]

On 9 July, 1553, in camlet, fresh and healthy with God's grace, when Duke Moritz of Saxony was shot with three other princes, and Margrave Albrecht of Brandenburg ran away.

Inside the image: Camlet.

Text below: 56 years, 4 ½ months old.

Note: Moritz of Saxony died two days after the battle of Sievershausen, on 11 July, 1553.

Clothing overview: Matthäus celebrates his return to full health by the summer of 1553 with an expensive, elegant suit of clothes that acknowledge the fashionable cut for doublet and hose. Dressed in black and white again, this is probably as much a personal preference as any suggestion of adopting mourning for the recently murdered Moritz of Saxony.

Headwear/hair: He is bareheaded apart from a garland or wreath of red and white flowers worn at a slight angle. The wreath is made from either real flowers and leaves or silk flowers tied

148. Omitted from Braunstein, *Un Banquier Mis a Nu*.

together with gilt thread. His white hair covers his ears, and his moustache and beard are quite short. His hair is more obviously in a short bob again.

Body garments: His black camlet gown is heavily watered, and it falls in deep folds. The gown comes to just below his knees, and it has a broad turned-back collar. It has full, hanging sleeves. The upper section is very large, probably padded, and the puffed fabric gives him a sense of width at the shoulders. The narrow, lower sections of the sleeves hang straight down, and his arms pass through the slit. The gown is worn over a black high-necked camlet doublet with a small stand collar. The waistline is below the natural waistline, and there is some padding at the front to give it a slight peasecod shape. It is fastened with two rows of eight large, round black buttons. The doublet has very narrow skirts, and the fairly fitted sleeves narrow at the wrists.

Linens: The shirt is only visible at his wrists, where the wristband is decorated with a small pleated ruffle.

Legs: He is wearing white trunk hose. They have wide panes, which are drawn into a narrow band, which comes to just above his knees. In between the panes, the very full white lining spills out. The hose have a large, white, upturned codpiece, which has been slashed, and small puffs of white fabric have been pulled out through the slits. The trunk hose are worn with plain white hose.

Footwear: He has black ankle shoes. The vamps are slashed horizontally over the toes and vertically on the quarters.[149]

Accessories: He holds a small bunch of red and white flowers in his right hand. They are probably meant to be roses from the bush behind him.[150]

Weapons: He has a black girdle and hanger around his waist, and he has a dagger in a black scabbard hanging on his hip. The scabbard has a gilt and blued chape. He has not gone back to wearing a sword.

Gilding: On the wreath, on the scabbard for the dagger.

Image I 137 [verso]

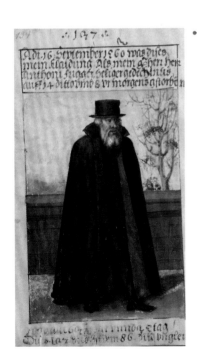

On 16th September, 1560, this was my clothing, when my gracious master, Herr *Anthoni Fugger in blessed memory died on the 14th at 8 o'clock in the morning.*
Text below: 63 ½ years and 25 days old. This 137th image is unlike the 86th image.

Note: Schwarz continued in this spirit on the next page and then erased it.

Clothing overview: Matthäus is dressed very formally, all in black, because he is in mourning for Anton Fugger. The style of the mourning differs to the four different styles he wore after his father's death in November 1519 (see I 37–40) and when Jakob Fugger died (I 77). His clothes should also be compared with those Veit wears as mourning for Anton Fugger (see II 37).

Headwear/hair: He wears a black hat flat on his head. It has a tall crown with a medium-width brim. His white hair, moustache, and beard have got longer, but they are neatly trimmed.

Body garments: He is dressed in a black wool full-length mourning gown, which is lined in a different shiny black fabric. It has an upturned tall collar, and the fronts of the gown turn back, revealing the lining from the collar down to floor level. His arms are covered by the gown. It is worn open at the front revealing his black doublet. Although the mourning gown was given to him as an employee of the Fugger company, he chose the other clothes that he is

149. Goubitz, *Stepping Through Time*, 277, fig. 6.
150. The symbolism of the rose in this context is hard to assess—symbol of the Virgin, Venus, and martyrs, it was also on the Schwarz coat of arms, so it may be a heraldic reference.

wearing. The doublet has a waist seam, at a natural level, and it is buttoned down the front from neck to waist with seven medium-sized, round black buttons. It is hard to tell whether the front of the doublet is padded in the fashionable peasecod style or not. The doublet has long skirts that come to his mid-thigh.

Linens: His shirt is not visible.

Legs: His matching black hose are plain, close-fitting, and visible from the mid-thigh down to his feet. There is a suggestion that the hose have an upturned black codpiece, which is visible through the skirts of his doublet. He may have narrow black garters tied just below his knees.

Footwear: His black shoes are a more natural shape at the toe, and the vamps look to be low cut over his toes.

Gilding: None present.

Page 135 [not illustrated]

On this 14th September, 1560, Herr Anthoni Fugger in blessed memory reached the age of 67 years, 3 months, 4 days [. . .] and I (myself) 63 years, 6 months, 25 days. So His Grace was older than me at that date, with a difference of 3 years, 8 months, 11 days. And this clothing is different in color than the 86th image in Anthoni's wedding. [. . .]

The Book of Clothes of Veit Konrad Schwarz, ca. 1561
Buchdeckel/Front cover [recto]

Veit's book is bigger than his father's book, measuring 23.5 × 16 centimeters. It is bound in brown leather with gilt stamped and tooled decoration.

Prologue and monogram

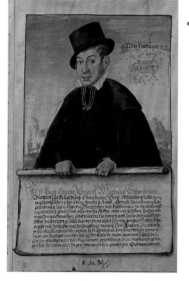

I, Veitt Conrad Swartz, legitimately born son of Matheus Schwartzen, citizen of Augsburg, in appearance as above, and aged just 19 years, 68 days, and 6 ½ hours, say that I have good reasons to hold that we Germans have always and ever behaved with dress like monkeys. Whatever we saw we had to copy in the manner of many nations, and at times we bastardized them, as we always governed ourselves strangely. My dear father's little book, which he calls his book of clothes, which he had made from anno 1520 from his birth onward—anno 1497 until now—provides me with much evidence for this. There one sees what fanciful dress was worn in cut and style at this time, which was highly regarded then. But it was a great difference to those that were shown to him by the old [people], which they wore 30, 40, or 50 years ago, so that this gave him cause to depict his own clothes, so that he or his descendants would see over 40, 50, or more years how this time reversed itself. So as the world becomes the more foolish the older it is and there is no end of new strange usages of dress until now, I started to have the clothes I have worn from my childhood onward depicted in this little book today, in their real colors and cuts. I have worn parts of a hose or other things more than once but have not had them depicted here more than once, so that one could see over 20, 30 years what has changed again since. And these clothes are the most noble, beautiful, and smart ones that I wore during this time, when I was in good repute. The others and bad ones I have left out because it would have taken me too much space. Otherwise a beautiful dress costs more during this time then 3 or 4 years ago. As one sees, I depicted several pranks for the youth at the beginning [of the book], everything that existed at the time to amuse young people. This I took from a little book of my dear father's own handwriting, which he called "The Children's Book," in which everything I did is described. What happened later I had depicted fresh from memory, because I knew for sure that these things happened like this. Nobody can bring me a part of dress that is too adventurous; for the stranger someone cuts hose, doublet, and shoes, the

more I like wearing it. Otherwise I have usually myself invented all cuts of hose, doublet, shoes, and bonnets and several times slashed the shoes myself, and you will see later what they looked like. This is enough of a prologue; each piece or painting will provide information. This is why I am not writing about it much. Date, Augsburg, the other day of January in the year 1561 at two o'clock in the afternoon, my age just as mentioned at the beginning; anyone who doesn't believe it shall recalculate.

Veitt Connratt Schwartz
Symbols of his initials and his father's lead motto, "Every why has its cause," written across.

Inside the image: My nativity.
I was born on October 30, 1541, in the morning between one and two o'clock, it was a Sunday.
1. House: Mars, Jupiter, 20°, Virgo, 23°, Virgo
2. House: Saturn, 1°, Scales
3. House: Mercury, Sun, 3°, Scorpion, 16°, Scorpion
4. House: Venus, 11°, Sagittarius
7. House: Moon, 25°, Pisces

Title page [verso]

Clothing overview: Veit Konrad Schwarz is depicted in a very similar style of frontispiece to that of his father in terms of it being a half-length portrait, but the clothes he has chosen are representative of his personal style. As a result he is dressed in black not red and with relatively little decoration on his clothes. While the black and lack of embellishment can be linked directly to Veit being in mourning, the overall impression of a more subdued style is also typical of his clothes as a whole. As such the two title pages emphasize some of the key changes in fashion for young men in Augsburg between 1520 and 1561. This picture should also be compared with II 37 where Veit is portrayed in the same garments but in a full-length view.

Headwear/hair: Veit wears a black hat with a high, straight-sided crown and a small flat brim. It is worn at a slight angle, dipping down over his right ear. His hair is cut short, and he is clean shaven.

Body garments: His black cloak is worn on both shoulders, as part of his mourning for Anton Fugger. It has a wide turned back cape collar, which is made from a contrasting fabric to the body of the cloak. In addition he has selected a black doublet, which fastens with a row of ten small self-colored buttons down the center-front. These are left undone for the last few inches, from the waist down. The doublet has fitted sleeves and a high collar that supports the neckband of his shirt. The top button of the collar has been left undone, allowing it to turn back slightly.

Linens: Although not much of his shirt is visible, this image provides the best depiction of the neckband of any in the book. The neckband suggests that this shirt is a high quality item. The ruffle is set in a clearly defined s-shape pattern, and the edges of the ruffle are decorated, possibly with whitework or cutwork. The wristbands appear to be finished with a tiny ruffle, but in this instance the artist has not included much detail. The shirt is front opening and it has been left undone at the front, allowing it to follow the curve of the doublet's collar. There are three pairs of bandstrings (the fine strings used to tie the shirt neckband), which have been left undone and hanging down to provide a strong point of contrast with his doublet. Each one ends with a small white knotted tassel.[151]

151. For later, very ornate examples of these "Leinenquasten," see B. Borkopp-Restle, *Textile Schätze aus Renaissance und Barock* (Munich: Bayerisches Nationalmuseum, 2002), 109–14, 162–63.

Jewelry: He has two gold rings on his left hand. The ring on his second finger consists of a gold band with an oval, red, cabochon stone, possibly a ruby, while the ring on his fourth finger consists of three interlocking plain gold bands.

Weapons: The black hilt of his sword, or possibly a dagger, is just visible behind his left hand.

Gilding: The rings on his left hand.

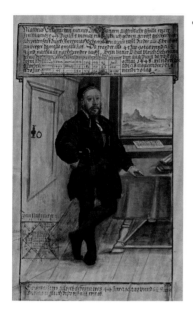

Image of his father [verso]

Matheus Schwartzen, my dear father's proper figure, as he looked in March 1542, that is 5 months after I had been born, copied by Jheremias Schemel from a panel that the old Christoff Amberger had painted then. There he was aged 43 years, 30 days, and 21 ½ hours according to this panel. His blessed father's name was Ulrich Schwartz of Augsburg, born there on November 28, 1519, 70 years old and 170 days. [Table to calculate his age in relation to astronomical and common hours.]

Inside the image: His nativity. Is born February 20, anno 1497 at 7 o'clock in the morning; it was a Monday.

House: Sun, 11°, Pisces, Saturn 11°, Pieces, Venus, 10°, Aries

7. House: Moon, 20°, Scales, Jupiter, 11°, Sagittarius, Mars, 15°, Sagittarius

12. House: Mercury, 4°, Pisces

Note: The panel by Amberger is in the Thyssen-Bornemisza collection in Madrid (see Introduction I).

Clothing overview: Veit records his parents separately, allowing the viewer to consider them as individuals. However, placing their pictures on facing pages and with them depicted turned slightly toward each other, also permits the viewer to see them as a married couple. Dressed in the style of the early 1540s, when Veit was born, Matthäus immediately presents a point of contrast to his son.[152] Matthäus is dressed in a black doublet and hose, but in this instance, it is an elegant choice rather than one linked to mourning.

Headwear/hair: Matthäus Schwarz is wearing a black caul, which is perhaps made from sprang (a yarn manipulation technique that produces a stretchy fabric). The caul is for indoor wear and so well suited to this domestic scene. It has a gold decorative edging, which is probably a metal thread cord and the remainder is possibly made from silk thread. The caul is worn on the back of his head, and it covers almost all of his hair. What can be seen of his hair indicates that it is cut short and it is graying at the temples. In addition, he has a neatly trimmed beard and moustache.

Body garments: The fabric of his black doublet has a high shine, suggesting it is made from satin. It has very full sleeves, which are probably padded and they narrow at his wrists. It has a small grown-on collar. The doublet, which comes to his waist, has been left unbuttoned at the front to reveal a red placard, which is worn across his chest. The placard has a low neck edged with a black band.

Linens: His white linen shirt provides a point of contrast with the black of his doublet. The shirt has a high neck, and the neckband is finished with a small s-shaped ruffle. The shirt has been left open at the front, and one white bandstring hangs down. It ends in a small white tassel.

Legs: He is wearing black hose. His trunk hose are close-fitting from the waist to the hip, and then they are cut in wide panes from his hip to his mid-thigh. Just above where the panes start, the trunk hose are decorated with a twisted band of black sarsenet. The panes are stitched into a narrow band around his thighs. In between the panes, the black lining shows

152. See I 23. Also compare with the half-length portrait, Christoph Amberger, *Matthäus Schwarz*, 1542, oil on canvas, 73.5 × 61 centimeters, Thyssen-Bornemisza Museum, Madrid.

through in generous folds. The hose have a codpiece, which is slashed and some of the black lining has been pulled through in puffs. The trunk hose are worn with plain black hose.

Footwear: His black shoes are fairly pointed at the front. The vamp is cut very low over his toes, but the quarters come up quite high around his heels.

Jewelry: Matthäus has a gold item on a black silk cord around his neck. It is seen side on and looks like a whistle, but it could also be a toothpick.[153] He has a thick gold ring on the fourth finger of his left hand.

Weapons: A length of lightweight silk, possibly sarsenet, is tied around his waist to form a belt for his dagger, which has a black hilt and a black scabbard with black chape.[154]

Accessories: Also attached to the belt is a small, round black purse with a silver mount.[155]

Furnishings: There is a green cover on the table (a similar cover can be seen in II 14). Green was considered to be a contemplative color and so was well suited for table covers in libraries and studies. In addition, there are two leather bound books on the table, one of which is placed on a book rest.

Gilding: His ring and the toothpick hanging around his neck.

Image of his mother [recto]

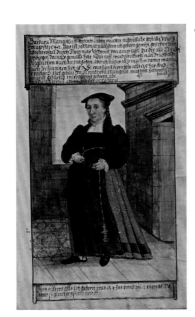

Barbara Mangoltltin, my dear mother's proper figure, as she looked like in August 1542, that is 10 months after I had been born, copied by Jeremias Schemel from a tableau that the old Christoph Amberger had painted. This tableau was only a half-size portrait, but I had it made in this way so that one would also see the length. She was otherwise just 35 years old. Her blessed father was called Annthoni Mangollt, born in Schwäbisch Gmünd, was born there in the year [. . .] and died in Augsburg on January 12, 1550.

Inside the image: Her nativity. Born on August 21, 1507, in the morning around ½ 5 o'clock; it was a Saturday.

House: Sun, 6°, Virgo, Saturn, 4°, Virgo, Mercury, 15°, Virgo

3. House: Jupiter, 15°, Scales

6. House: Moon, 19°, Aquarius

11. House: Mars, 21°, Cancer

12. House: Venus, 4°, Leo

Text below: When I was born, she was aged 34 years and around 2 months. There she looked like the above.

Note: This portrait is in a private collection and was last sold by Christie's in 2013 (see Introduction).

Clothing overview: This full-length view of Barbara is the first time that we see Matthäus's wife.[156] The inclusion of her picture makes it possible to see the differences to the clothing worn by Agnes (Matthäus's mother), and perhaps the most significant of these is that she does not wear the heavy veil.[157] However, there are also points of similarity, in particular the importance attached to the apron and the girdle.

153. See the miniature gold whistle pendant containing a range of small tools including a toothpick, English, c. 1520, private collection, Starkey, *European Court*, VII.18, 115.

154. Compare with 1.23.

155. For examples of contemporary purses and purse frames, see G. Egan, Material Culture in London in an Age of Transition: Tudor and Stuart Period Finds c.1450–c.1700 from Excavations at Riverside Sites in Southwark, MoLAS Monograph 19 (London: Museum of London, 2005), 58–61.

156. Also compare with the half-length portrait, Christoph Amberger, *Barbara Schwarz*, 1542, oil on canvas. Illustrated in Fink, *Die Schwarzschen Trachtenbücher*, 15, fig. 6, and listed as location unknown, but the portrait came up for auction on January 29, 2014, in the Christie's Renaissance Sale in New York.

157. See J. Zander-Seidel, "'Haubendämmerung': Frauenkopfbedeckungen zwischen Spätmittelalter und Früher Neuzeit," in *Fashion and Clothing in Late Medieval Europe*, ed. R. C. Schwinges and R. Schorta with K. Oschema (Riggisberg and Basel: Abegg-Stiftung and Schwabe Verlag, 2010) 37–43.

Headwear/hair: Barbara's small black cap is rather masculine in style. It has a small brim at the front, while at the side and back it fits closely around her head. Her long brown hair is arranged in a braid, or possibly two braids, that hang down her back.

Body garments: Her black bodice is sumptuous, and the very full sleeves are similar to those on her husband's doublet. The fabric is heavily pleated at the head of the sleeve and then gathered into a deep cuff at her wrist. The bodice has a fairly high, square neckline, with a small, grown-on collar at the back of her neck. The square neck and collar are outlined with a wide band of black scrolling and foliate embroidery. The bodice has a fairly high waistline. Her ankle-length skirt is made from a pale blue/gray fabric. It has a geometric pattern in gold. It falls in heavy folds at the back, suggesting the use of a lot of fabric. The hem of the skirt is decorated with two black-velvet guards, a narrow guard around the hem, and another wider guard several inches higher up. Over her gown she is wearing a nearly ankle-length apron of black damask. This choice of fabric suggests that the apron is intended to stress her position as being in charge of the household rather than indicating that she will be undertaking dirty tasks.

Linens: She will be wearing a linen smock under her gown. However, it is probably a linen partlet that infills the low square neck of her bodice. The partlet fastens down the center-front and the neckband has a small collar that is finished with a little s-shaped ruffle. At the end of her bodice sleeves, the cuffs of her smock are visible. These are deep, and they fall into large s-shaped folds.[158]

Footwear: She has black shoes and the toe is a fairly natural shape.

Jewelry: She wears a silver girdle around her waist, which hangs down the front of her gown. There is a large decorative tassel at the bottom of the hanging end of the girdle. The ornate shape of the tassel has been accentuated with gilding. In addition she has gold rings on both hands. She has a gold band with three stones (one red and two blue on either side) on the third finger of her left hand and two rings on the third finger of the right. Both are set with a single stone, one red and the other blue.

Gilding: The woven design on her skirt, on her girdle and her rings.

Images II 1–3 [verso]

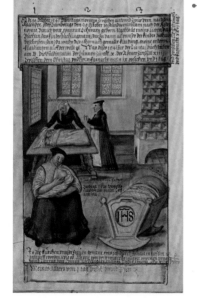

On October 30, 1541, on Sunday morning between one and two o'clock after the calendar or Saturday, October 29, 13 hours, 30 minutes in astronomical terms, I, Veit Conratt Schwartz, was born according to my dear father's book, called "The Children's Book," in which all our children's mischief is described. These clothes below were my first clothes in the world. This 1541st year the Sunday-letter was b, the golden number III, the sun-circle X, the Roman Zins-figure XIIII; there were IX weeks and XXVI days between Christmas and carnival.

Inside the image: Frantz Gerttnerin was my midwife; Barbara, Veit Vogel's wife, my wet nurse. I was breast-fed for ¾ of a year; I lay in a cradle for ½ year.

Text below: I was baptized by Johan Meuslin, in the church called Our Lady, as above, as Veit because of Veit Wittich, my cousin, and Conratt because of Conratt Rechlinger, my godparents [*meines godts wegen?*] in Augsburg. My age ranged from 1 day to ½ and ¾ of a year.

Note: The left wall shows a calendar. Veit Konrad explains after whom he was named at his baptism. His father had a horoscope cast at the time of his birth and noted data with occult meanings.

Clothing overview: These three images provide some very interesting glimpses of clothing and associated textiles for infants and the women who care for them.

158. Compare with the deep, folded, and embroidered cuffs in Hans Holbein the Younger, *Jane Seymour*, c. 1536, oil on panel, Kunsthistorisches Museum, Vienna, GG881.

II 1: Veit with his mother Barbara and the midwife, Frantz Gerttnerin.

Headwear/hair: Frantz Gerttnerin wears a white linen veil that covers her head and neck. In contrast, Barbara has a small black cap of the type that she wore before Veit's birth. Her hair is braided in a very long braid that hangs down her back.

Body garments: Frantz wears a black gown, which is probably made from wool. It has fitted sleeves, it is fairly loose in the bodice, with a high neckline, and it has quite a full skirt. Barbara wears a black, fitted, high-necked bodice. The sleeves are quite full at the sleeve head but are generally close-fitting. Her skirt is red, and it is heavily gathered at the back so that it falls in pronounced folds. It comes right to the ground, and it is decorated with a wide dark red guard several inches up from hem.

Linens: Barbara's white linen smock, or probably her partlet, is in the form of a small ruffle just visible above the collar of her bodice. She also has a full-length apron, which is the most significant symbol of her role as mother, with responsibility for the running of the household. In comparison to the more formal portrait in the previous image, this apron is intended to keep her clothes clean, and it could be laundered if it got dirty. The quantity of childbed linen displayed here stresses the cleanliness of the child and the wealth of a household that could afford to buy and maintain this amount of linen.

Jewelry: Frantz wears a girdle (possibly of silver or latten), and there is a suggestion that there are several items hanging from it, but these are obscured by the table. Rather surprisingly, Barbara is not shown wearing a girdle.

II 2: Veit being breast-fed by his wet nurse, Barbara Vogel.

Headwear/hair: Barbara Vogel wears a small black fitted bonnet. While similar in style to that worn in II 1, this bonnet is cut away at the front but comes down farther over her ears. Her hair is in a thick braid, which hangs down her back.

Body garments: She does not wear a bodice. Whether this level of informality in dress was associated with nursing women or whether she would have put her bodice back on after feeding Veit is uncertain. She is sitting on a fairly low chair with a back. Her skirt is full at the back, and it appears to be made from a heavyweight dark brown fabric, probably a thick woolen cloth. It is decorated close to the hem with a broad band or guard of red fabric.

Linens: A lot of Barbara Vogel's smock is visible. The body of the smock is gathered into the small neckband, which results in lots of very fine pleats. The smock is fastened at the front, but it appears to have a vertical opening from the collar to the waist, making it easy for Barbara to breast-feed Veit. The full sleeves have been pushed up to her elbows, but they were likely to have been full length, ending in a loose wristband. Veit is wrapped in a plain white linen cloth over his swaddling.[159]

Footwear: She has flat black shoes with slightly pointed toes and fairly plain uppers.

II 3: Veit in his cradle.

Headwear/hair: Only his head is visible, and Veit appears to be wearing a close-fitting white linen coif.[160] However, it may be the linen cloth has been wrapped around him as in II 2.

Body garments: While his body is not visible, the reference in the text to him spending half a year in his cradle suggests that Veit was swaddled.

159. For an overview of swaddling, see A. Buck, *Clothes and the Child: Handbook of Children's Dress in England, 1500–1900* (Wiltshire: Ruth Bean Publishers, 1996), 24–33.
160. For a later example (c. 1650–60) in the Blackborne Collection the Bowes Museum, Barnard Castle, see Arnold, *Patterns of Fashion 4*, 49, fig. 61.

Bed linens and cradle: The emphasis is placed on the substantial cradle with its own bedding; the addition of the IHS monogram on the end of the cradle indicates this is a godly household.

Gilding in 1–3: On the green cloth on the cradle.

Images II 4–6 [recto]

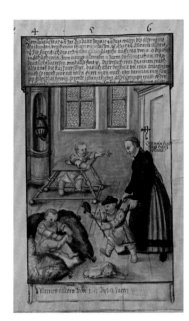

From August 1542 until the 44th year, these were my clothes and things that entertained me. In 1543, aged 1 ¼, I started to walk by myself for the first time on one day, from 2, 3 to [a distance of] 12 shoes wide. Item, aged two, I started to talk clearly and so on. The reason was that I was sat down in the walking chair, because I was full of mischief. If someone carried me, I did not like it; if someone led me or tried to be nice to me in some other way, I did not want it; so one let me drive about and fall in the walking chair, according to "The Children's Book," page 9.

Inside the image: My maid was called Anna.

Text below: My age was 1, 2 up to 3 years.

Clothing overview: Veit is presented in the clothes worn by a young boy prior to being breeched. He could be described as being in skirts or wearing a coat. These are also the clothes he wears indoors. There is a quite a lot of continuity between the images, but there are also some subtle changes to observe, which are noted below.

II 4: Veit learning to walk.

Headwear/hair: Veit is bareheaded and his hair is cut very short.

Body garments: He is wearing a fancy yellow tunic, which comes to his knees. The hem is cut in deep points. It has a round neck and elbow-length sleeves. A slightly darker color, thin band of passementerie has been applied around the hem, sleeve ends, neckline, and along the main seams.

Linens: Veit's white linen shirt comes to his knees. The neck is edged with a small ruffle. It has three-quarter-length sleeves that come to his mid-forearm and also end with a band and a ruffle.[161]

Legs: His legs are bare.

Footwear: He has pale brown shoes (probably made of leather), with a round toe. The quarters come up high around his heel, and there is a strap over the top of his foot to help keep them on.

Jewelry: Veit holds a gilt rattle in his left hand.[162] He has a small bracelet on his right wrist made from beads, possibly coral and gilt beads.

Accessories: He is standing inside a frame that provides him with support and a degree of mobility as he learns to walk.[163]

161. For two later examples (c.1560–80) of more ornate young boy's shirts, see the shirts embroidered with red silk, one with a low neckband and the other with a neck ruffle in the Museo del Tessuto, Prato, in Arnold, *Patterns of Fashion 4*, 18–19.
162. For another example of a rattle, see Hans Holbein the Younger, *Edward VI as a young boy*, c. 1538, oil on panel, Andrew W. Mellon Collection, National Gallery of Art, Washington, DC.
163. See Juan Pantoja de la Cruz, *The Infantes Don Felipe and Doña Ana*, 1607, oil on canvas, 118 × 124 centimeters, Kunsthistorisches Museum, Vienna; also see unknown artist, *Painting of a girl or a boy*, c. 1650–60, Norwich Castle Museum and Art Gallery, Norwich; Arnold, *Patterns of Fashion 4*, 44, fig. 44b.

II 5: Veit removing his hose.

Headwear/hair: Again Veit is bareheaded and his hair is kept short.

Body garments: He is wearing a similar tunic to that in II 4.

Linens: The shirt is of a similar style to that in II 4. Here is looks as though the ruffle at his neck and wrists is edged with black embroidery.

Legs: His legs are bare.

Footwear: He has a pair of short, footed hose (or possibly short, soft boots). The hose are fastened with buttons down the inside edge. (See the left hose resting on the cushion.)

Jewelry: Veit wears the same bracelet on his right wrist as in II 4.

Furnishings: Veit is sitting on a heap of cushions. The red and green examples have gilt tassels at each corner, which is fairly typical.

II 6: Veit with his maid, Anna.

Headwear/hair: Veit wears a small black cap edged with a padded roll to protect his head if he should fall. In contrast, Anna is bareheaded apart from a black fillet worn around her hair, which is arranged in two long braids.[164]

Body garments: Veit wears a knee-length coat. Although similar in terms of color and decoration to his body garment in II 4 and II 5, there is an important difference. The coat is side fastening, and it is fastened with pairs of points tied in half knots on the skirts. Anna has a black fitted bodice with a small collar. Her full-length sleeves have some fullness in the sleeve head, but they are fitted from the mid-arm down to the wrist. The dark gray skirt falls in deep folds, and it is decorated with a broad black guard around the hem. She has a full-length black apron.

Linens: Veit has a linen shirt with sleeves that come to his mid-forearm (similar to those in II 4 and II 5), while Anna has a white linen smock or partlet with a narrow ruffle around the neckband.

Legs: His legs are bare.

Footwear: He wears short hose that come to just below his knees. The hose have an integral sole, and there is a row of buttons down the outside, which ensure a good fit (also in II 5). Anna has black shoes with slightly pointed toes.

Jewelry: Veit still has the bracelet on his right wrist.

Accessories: Veit holds a short whip in his left hand and a hobbyhorse in the right. Anna has passed a rolled length of brown cloth under his arms and around his body. By standing behind him and holding the ends, she can guide him as he walks.

Gilding in 4–6: His rattle, the tassels on the cushions, the decoration on his coat, and his bracelet.

Images II 7–9 [verso]

From 1544 to 1546 [these were] my clothes and besides my pursuits as written in "The Children's Book." It was my pleasure to do something against people or to annoy them. Everything that had not seen daylight for 10 years had to be dragged out, and then it was torn apart, trodden on, and thrown out of the window. Item: I liked all insects when I came into the garden. I tied the ladybirds

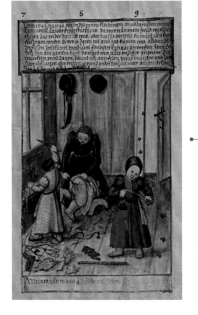

164. For a back view of a women with braids of this type, see Niklaus Manuel Deutsch, *Tochterlis*, c. 1519–20, 11.5 × 5.4 centimeters, inv. no. U.X.27, Öffentliche Kunstammlung Basel, Kupferstichkabinett.

and caterpillars to threads, and they had to fly to or circle around my hand, and I did other bad, naughty things, which I cannot narrate here in full.
Text below: Aged 4 to 5 years.

Note: Veit Konrad stands below the window surrounded by broken toys. He plays with insects, and three caterpillars can be seen on his long gray-blue coat.

Clothing overview: Veit is growing up, as indicated in the changes in his clothing and accessories, but he is still very much a young child who spends his time in a predominantly female environment.

II 7: Veit by the window.

Headwear/hair: Veit has his back to the viewer, providing a rare back view of his black bonnet. The bonnet has a narrow brim, a full crown, and it is pulled down well on the top of his head. It covers most of his hair but a little is visible, suggesting that his hair has grown longer over the course of the last months.

Body garments: Seen from the three-quarters back view Veit is wearing an ankle-length cream-colored, quilted, coat. The coat is drawn in at the waist, and it has full-length sleeves, which are full at the top, formed into a little puff, and then fitted on the lower arm.

Linens: None are apparent, but it is most likely that he is wearing a shirt under his coat.

Legs/footwear: Veit wears cream-colored hose or short hose. These may be footed hose with an applied sole, probably of leather. Or he may be wearing separate shoes, which are quite round at the toe, high over the toes, and fitted around the heel.

Accessories: Around his waist, there is a simple black belt with a white linen handkerchief hanging from it.

II 8: Veit being beaten.

Headwear/hair: Veit wears a black bonnet, similar to that in II 7, while Anna appears to be bareheaded. She has a very narrow black fillet around her head and her hair, which is parted in the middle and is probably braided.

Body garments: Not much of Veit's coat is visible, but the sleeves suggest that it is of a similar color to the coat depicted in the next image (II 9). Anna has a black bodice, possibly made from a fine wool or a wool mix. The bodice has a simple front, which is high at the neck, and sleeves with a little fullness at the top. It is worn with a rather striking red skirt. Over this she has a black apron.

Linens: Veit is wearing a shirt under his coat. It is quite a long, full garment, which probably comes to his mid-thigh or knees. It is visible because the maid has pulled up the coat to beat him. The ties at the neck of Anna's smock or partlet hang down and stand out against the black fabric of her bodice.

Footwear: As is probably the case in the previous image, Veit is wearing pale-colored short hose with integral soles.

Jewelry: Anna has a girdle around her waist. It is black and possibly made from leather, fabric-covered leather, or passementerie. It is decorated with decorative metal studs, both at her waist and where it hangs down at her left hip.

Accessories: Anna holds a switch. Two men's black hats, with narrow brims, tall crowns, and in one case a gilt hatband, hang on the wall behind Anna, along with a sword with a curved

blade in a black scabbard. These probably belong to Veit's father, Matthäus, and serve as a reminder of his future role as a man of the business world.

II 9: Veit playing with insects.

Headwear/hair: Veit wears a close-fitting black cap, which completely covers his hair.

Body garments: His ankle-length dark blue coat is probably made from wool. It is buttoned down the center-front, with six self-colored buttons, from the collar to the waist. It is slightly more adult in style than the coat in image II 7, and it is fairly fitted to the body with a natural waistline. The upper part of the sleeve has some additional fullness, but it is fitted from there down.

Linens: His shirt is evident under his coat at the neck and cuffs. The neckband and sleeve ends have been edged with a very narrow ruffle.

Legs/footwear: He still appears to be wearing the same style of short hose with integral soles.

Accessories: There is now a small black purse with metal purse fittings hanging from the right side of his plain black belt. A handkerchief hangs from the left side of the belt. Various toys lie broken on the floor, including his hobby horse. There is also a black strap with a buckle torn into several sections.

Gilding 7–9: The hatband.

Image II 10 [recto]

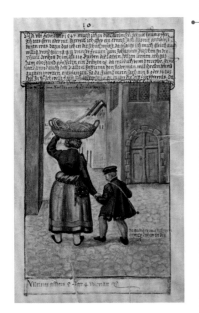

At the end of February 1547, I had to drag myself to the Latin School, whether I liked it or not. Because I came to see that this was serious and that there was no other choice than that I had to go to school, I showed myself quickly willing and went to Our Lady's at Johannes Busch's school. He then had 110 boys, who were to learn Latin. As I entered I gave everyone pretzels. Thus the teacher, his wife, and also the boys—in sum, everyone—received me with pleasant and kind words. Yes, I got on with my work well for 8 or 14 days; I did not want to miss any school. But after this period, one spoke strangely to me, so that I did not feel happy about school anymore, but I did not show this.

Inside the image: There he went with a heavy heart to school; Magdalena, our maidservant.
Text below: Aged 5 years, 4 months.

Note: The maid carries the basket with pretzels. Veit Konrad provides a rare glimpse of an early modern school boy's emotional experiences.

Clothing overview: Veit has been breeched, and so he has made the transition to more adult clothing. This is also the first time he is shown outside on his way to school. However, he is still in female company, and she holds his hand. Magdalena's clothes have much in common with those of Anna and Barbara Vogel.

Headwear/hair: Veit wears a black bonnet with a full crown and narrow brim, which is placed flat on his head. His hair is cut quite short and shaped around his ears. Magdalena does not appear to be wearing a cap, or if she is it, is concealed by the basket.[165] Her hair is braided, and the braids are coiled around the back of her head.

Body garments: He is dressed in a black gown that comes to his mid-thigh and has a small upright collar. It is quite full, and the material hangs in loose folds down his back. The gown has short puffed sleeves that come to his mid-upper arm, where the fabric is gathered into a narrow band. Underneath he is wearing a black doublet with fairly fitted sleeves. The maid Magdalena

165. For a woman carrying a basket in the same way, see October in *Feste und Bräuche*, 160.

wears a black bodice. This comes to her natural waist, and it looks to have a center-back seam. The sleeves are quite simple, with just a little fullness at the top. The bodice is worn with a light brown skirt, which comes to just above her ankles. This might be because the skirt is hitched up by her girdle, making walking easier in the street without getting the hem of her skirt dirty.[166] The skirt is decorated with a bright green wide guard close to the hem.

Linens: Both Veit and Magdalena have small ruffles edging the neckbands on their body linens. In addition, a small ruffle is evident at the end of Veit's doublet sleeves.

Legs: Veit is wearing black, gray, and dark yellow/brown hose. His trunk hose are made from narrow black panes that come to his knee, where they are looped up into a narrow band. In between the panes it is possible to see the mid-gray lining. The trunk hose are worn with a pair of dark yellow/brown hose. There is a suggestion of a seam running up the back of both his legs, indicating his hose are made from wool cloth. Magdalena has white hose, which are probably knee-length and secured with garters.

Footwear: Veit has black shoes. The vamp covers the top of his foot, and the quarters come up high around his heel. While similar at the front, Magdalena's footwear is very low at the heel, suggesting they might be mules.[167]

Accessories: Veit carries a large bag of red-brown leather. It hangs on his right hip from its strap, which rests on his left shoulder. The lower corner is decorated with a tassel. Magdalena has a black girdle, possibly leather or fabric-covered leather with gilt decoration, which she wears on her hips. Hanging from her girdle, she has a knife or dagger in a black scabbard with a chape,[168] a small black purse or pouch, and a large bunch of keys. The girdle, scabbard, and purse are decorated with gold or gilt studs. She balances a large basket on her head.

Gilding: The studs on Magdalena's girdle, the dagger's scabbard, and the decoration on her purse.

Image II 11 [verso]

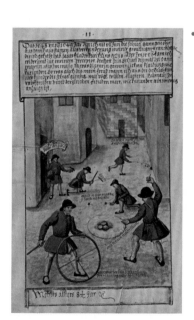

In 1548 and 1549 I did not go to school or out of the house much because I was prevented by my severe illnesses, which I had according to "The Children's Book," page 10. But in 1550 I returned to my teacher. This time he had his school at St Martin's. In May my usual dress was as below. This was my joy when I got out of school or behind the school: with birds, marbles, hoops, and other amusements, as shown partly below.

Inside the image: "Now, who can drive the hoop down the Maurberg?"; "Set me one, I shall set you a loss"; "12 out, and the three last not wide [?]";

"Quick, boys, who buys or gives one?"; "*Eggeti*!" [meaning unclear]; "There are 2 marbles, I just wanted to shoot one in."

Text below: Aged 8 ½.

Clothing overview: Veit is shown playing a number of different summer games, presenting six different views of one set of clothes. This can be compared with his father in I 11. They are engaged in some of the same activities, but Veit is shown doing more things, possibly suggesting a sense of competition with Matthäus.

Headwear/hair: His black hat has a quite high, domed crown and a fairly wide brim. The different views suggest that the brim was slightly turned up at the sides. The construction of the hat is most evident in the closest figure on the right, and it indicates that the hat is made from braided black straw.

166. Compare with the sketch of a woman walking by Holbein, which appears to show dress hooks being used to loop up the front of her skirt, while she holds the rest of the fabric; Hans Holbein the Younger, *An English lady walking*, c. 1540, Ashmolean Museum, Oxford.
167. A mule is a slip-on shoe that does not have quarters; Swan, "English and European shoes," 22.
168. See Egan, *Material Culture*, 14, 190–94.

Body garments: The bright red doublet has a fairly natural waistline and full skirts that come to just above his knees. It is buttoned down the front as far as the waist with six round, red buttons that run from the small grown-on collar to his waist. The sleeves are not too tight, so he has freedom of movement, and there is just a hint of fullness at the top.

Linens: Very little of Veit's shirt can be seen, suggesting that the neckband is edged with a narrow ruffle, as are the wristbands.

Legs: He is wearing pale-colored hose. These are only visibly from the knee down, except for the figure closest to the front on the left. Here the skirts of his doublet have parted, indicating that he probably has very modest trunk hose on, which would help to hold out the skirts of his doublet and give them a more stylish profile.

Footwear: His black shoes have quarters that are cut quite high at the back of the heel; they have a fairly rounded toe, and there is a narrow strap over the top of the foot.

Accessories: Veit has a black bag hanging from a strap worn across his body for his school books. Around his waist, he has a black belt, and from this hangs his pen case and inkwell on his left hip. Items like this were often provided with cases made from molded leather or *cuir bouilli*. He is shown with a range of toys, including a hoop and stick, marbles, and a top. In addition, he has a hawk on his left hand at the back on the far left and something in his left hand that could be a lure or some food.

Gilding: The central point of his hoop.

Image II 12 [recto]

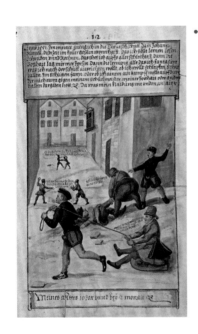

In 1551, I went to Johann Burtzell's German school during winter—at the time he lived in the Koller-alley—so that I should learn to read, write, and count. This I did in the worst possible manner, because I had my sense directed to bad things rather than to learning, as I fantasized what I wanted to get on with once school was finished: whether I wanted to pull someone through the snow, snow-ball, ride in the sleigh, or whether I wanted to dare someone to fight, who perhaps had told the schoolteacher or anyone else about my mischievousness. My dress was as shown below.

Inside the image: "Mine, turn the the sled around in a circle, but don't throw me down"; "I am going to pull you hard now"; "I am your master, even if you don't want it"; "Ey, you fool, you have done what the teacher has punished me for."

Text below: Aged 10 years and around 2 months.

Clothing overview: This composite image presents Veit engaged in a series of winter games, and he is depicted with several other boys of a similar age or slightly older. These will be identified in the notes below, as follows: the boy pulling Veit on a sled as boy 1, the boy on the right with his hand raised as boy 2, the boy lying on the ground as boy 3, and the boy with a snowball as boy 4. The clothing worn by boys 1 and 2 suggests that they are older than Veit and the other two boys. This illustration continues the theme of his education and recreation but is an innovation from Matthäus's book because of these winter activities.

Headwear/hair: Veit's hat has a tall, domed crown and a narrow brim. The brim is decorated with a twisted blue and gilt hatband that is knotted at the back. The hat is probably made from blocked felt or felted knitting, and it is decorated with thrums. Boy 1 wears a black bonnet, boys 2 and 3 both have black hats with moderate crowns, and boy 4 wears a hat similar to that worn by Veit but with a more pronounced brim that is pulled down at the back.

Body garments: Veit wears a doublet of similar style to that in II 11, with a natural waistline and skirts that come to just above the knee but this time in bright blue. Boys 1, 2, and 4 wear a more adult style doublet with very short skirts, while boy 3 wears a similar doublet to Veit's in pale tawny.

Linens: A hint of the decorative ruffle on the neckbands of the boys' shirts is evident in the illustrations of Veit and boys 1 and 2.

Legs: Veit has bright red hose, which are depicted in both side and back view. These are very evidently not worn with trunk hose, as indicated by the rear view of Veit bending over. Boy 1 wears fitted, short, red trunk hose that come to his mid-thigh with a fairly prominent, upturned codpiece in tandem with bright green hose. Boy 2 also appears to wear trunk hose, although much less detail is evident, and there is a suggestion of a codpiece. His dark brown trunk hose contrast with the tawny/dark yellow hose. Boy 3 looks to be wearing similar hose to Veit but in a mid-brown. Boy 4 has dark brown trunk hose with a codpiece and hose.

Footwear: Veit is wearing black shoes with a rounded toe, a strap across the top of his foot, and quarters that come up high around his heel. Boys 1 and 2 have ankle-height shoes, and while less detail is visible, this is also what boys 3 and 4 appear to wear.

Accessories: Veit has a black school bag with a gathered top that is carried from a strap going diagonally across his body. A few of his school books look to have fallen out onto the snow-covered ground. In the scene closest to the viewer, Veit is sitting on a simple wooden sled, while his companion, boy 1, pulls him along using a rope.

Gilding: On Veit's hatband.

Image II 13 [verso]

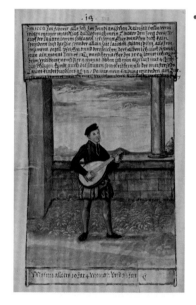

In February 1552, when I was lying in Indian Guajak [?]-wood because of my tonsils. My dear father let Jorg Strasser teach me to play the lute. I quickly learned, and even so had no special pleasure in it, but just to play the lute, string instruments, organ, pipes and so on, which is why I only learned for a month; afterward in 1554, I learned more with Melchior Neudsidler for 3 months. Then I felt pleasure to play with four voices and could tune the lute as well as the master himself, as written in "The Children's Book," page 12. This was my dress as below, a light wool-silk doublet with velvet trimming and hose with a half silk.

Text below: Aged 10 years, 4 months, and 13 years.

Clothing overview: While only two months has passed since the previous illustration, there is a marked change in Veit's appearance, and this is the first time he wears the shorter, more adult style of doublet. He is also shown playing the lute, which is an important musical accomplishment and represents the other skills that he acquires at the same time. At age ten, Veit is much younger than his father was when he learns to play (see I 66), but it may also reflect that his period of illness provided an opportunity to develop his musical education.

Headwear/hair: He has chosen a black bonnet with a small brim and fairly full crown, which is worn with a gentle slant toward his right ear.[169] Not much of his hair is visible, but it is still short and shaped around his ears.

Body garments: Veit is wearing a black doublet with a small collar. It fastens down the center-front, but as no buttons are depicted, it may fasten with hooks and loops. While the waist is covered by his lute, it has the more fashionable shorter waist than those he has been wearing to date and either no skirts or very short skirts. The doublet has fitted sleeves. The doublet is decorated with vertical stripes all over, and the stripes on the collar line up with those on the fronts of the doublet. The stripes are probably created with applied bands of black passementerie or narrow bands of black velvet.[170]

169. See, for example, the black velvet bonnet worn by Don Garzia de'Medici, Palazzo Pitti, Florence, Arnold, *Patterns of Fashion, c. 1560–1620*, 15, 56.

170. See the red satin doublet, c. 1560, with eight buttons with worked buttonholes; Arnold, *Patterns of Fashion, c. 1560–1620*, 70–71.

Linens: The ruffle on the neckband of his shirt is in a quite pronounced s-shape, while the small ruffle at his wrists is less well-defined. The neckband has one, or possibly two, pairs of bandstrings, which have been left undone and hanging down. They are tied together at the ends, which have small knotted tassels.

Legs: He is wearing mid-gray hose. The trunk hose have quite wide panes and underneath there is a matching gray silk lining. They are quite short, coming to his mid-thigh. This is the first time that he is shown with adult-style hose complete with codpiece. With youthful exuberance, he has chosen a rather large, upturned codpiece, which is decorated with large puffs of gray silk that have been pulled through the slashes.

Footwear: His black shoes have long vertical slashes on the toes. The width of the slashes makes it possible to see his gray hose underneath. The vamp covers the top of his foot, and the quarters come up around the ankle.

Accessories: He is playing a lute, possibly the lute seen hanging on the wall in II 14.[171]

Gilding: None present.

Image II 14 [recto]

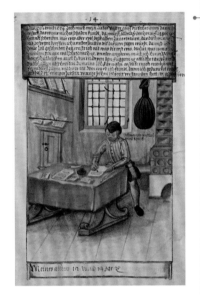

In 1553 and 1554 my dear father took me to the writing office because he saw that it could do me no harm. There I had to write all sorts of things regarding the Fuggers' affairs. I probably could be trusted, as the Lords did not need to worry that I would tell other people much about it. Because when I had written two lines, I did not know what the first one had been. It was a foreign language to me. Among other things, I had to copy several tariffs and accountancy matters for Master George Hulderich, also Master Marx, the Fugger. During this time I really thought that nobody unknown to me should address me with the familiar "Du" anymore, and I was hostile to anyone who did so. Because I imagined being much cleverer, even though I did not understand what was written.

Text below: Aged 12 and 13 years.

Inside the image: I meant it seriously [*ernstlich und spitzig*].

Note: Veit Konrad humorously remembers how he insisted on being addressed with the formal "Sie" when he first worked for the Fuggers.

Clothing overview: Here Veit is trying hard to look like an adult with clothes that are suitable in his father's place of work. This is one of the very rare occasions when he is shown with trunk hose where the panes and lining are different colors—indeed from this point on, he will almost exclusively be dressed in a single color (notable exceptions being the black with black and dark gray checks in II 22 and the black and brown in II 26).

Headwear/hair: In this indoor scene, Veit wears a small black cap or coif, which is close-fitting. It appears to be made from black satin or possibly velvet, and it covers most of his hair, which is kept short.

Body garments: His doublet in dark yellow with a natural waistline and short skirts that overlap the top of his hose. It fastens down the center-front with round buttons, six of which are visible. It has fitted sleeves, and while there is no obvious collar, it is likely that is does have one. Like the previous example, the doublet is striped.[172] This effect is probably created by couched lines of self-colored cord or applied lengths of a narrow braid.

Linens: The neckband of his shirt is edged with a narrow s-shaped ruffle, and there is a suggestion that it is embroidered with black silk. There is a hint of a small ruffle decorating the wristbands of his shirt sleeves.

171. For a mid-sixteenth century lute attributed to Hans Frei, Bologna, see Rangström, *Lions of Fashion*, 40–41, 300.
172. See also a plum-colored satin doublet with applied rows of cream-colored braid of a slightly later date, c. 1615–20, Hessisches Landesmuseum, Darmstadt; Arnold, *Patterns of Fashion, c. 1560–1620*, 26–27.

Legs: He is wearing parti-colored hose. His trunk hose have wide pale gray panes that are formed into one loop from waist to hip and a second, longer section from hip to mid-thigh, where they are joined together in a narrow band. In between the panes, the full back lining is visible, and it hangs down in folds between the panes. The trunk hose are worn with matching pale gray hose.

Footwear: His black shoes have plain vamps that cover the top of his foot. The toes are a fairly natural shape, and they come to a slight point.

Accessories: His lute is hanging on the wall, as a reminder of his other accomplishments, alongside evidence of his more academic pursuits—namely, the pen in his hand, a selection of other pens, a knife, and an ink well on the table, along with various documents. There are several books on the shelf.

Furnishing: The writing table is covered with a green cloth, probably green wool with a napped surface.

Gilding: None present.

Image II 15 [verso]

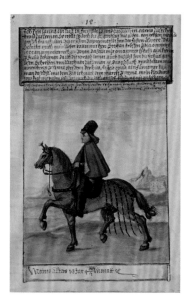

For a long time, I had wanted to move to foreign lands, to see and learn something. But the opportunity never arose because of my serious illnesses, until the Bolzano market during Lent 1550, when my father sent me to Bolzano on Wednesday, March 20, 1550, with Master Steffan Kröss. This said Master Kröß was to find me an Italian master, so that I would learn the language and go to school there to learn reading, writing, and counting. This happened, and I received a master for Verona or Berne whose name was Angelo Cosalo, a distinguished merchant there. With him I rode to the market in Verona. My dress was just as below. I did not allow myself to be taken in by Italian clothing. I was a Saxon horseman, had no weapon or shooting armor, but a broken dagger, as written in "The Children's Book," page 13, and my calendar, page 6.
Text below: Aged 13 years, 4 ⅔ months.

Clothing overview: Clothes for travel and riding are very important in Matthäus's book, and so it is not surprising that they feature in Veit's book too. The clothes he has selected for his journey to Bolzano, which would have involved going over the Brenner Pass, are well suited for travel in spring. It is telling that he wants to wear clothes he considers to be Saxon rather than Italian; he has a strong sense of his identity.

Headwear/hair: Veit is wearing a dark brown/black hat with a tall crown and a narrow, slightly upturned brim. The hat is probably knitted or felt, and it is covered with thrums.[173] It looks as though it is worn over another cap, which has a square, downturned brim at the front and extends at the back to cover the back of his head and neck and onto his shoulders. None of his hair is visible.

Body garments: He has a short mid-gray cloak, lined with a slightly paler green/gray.[174] It is quite full, suggesting that it is probably made from a half or three-quarter circle of fabric. It has a small collar, and it fastens at the base of this collar. Very little of the black doublet is visible under his cloak, apart from the small section of the front, which seen in profile suggests that it is slightly padded, and the end of his left sleeve.

Linens: Not visible.

Legs: Very little of his hose is visible between his boots and cloak.

173. For an extant example, see a hat with a tall crown, a felt base, and silk thrums, c. 1560–1600, Germanisches Nationalmuseum, Nuremberg. Also see the portrait attributed to Corneille de Lyon, *Portrait of an Unknown Man*, c. 1560, Louvre, Paris; Arnold, *Patterns of Fashion, c. 1560–1620*, 32, figs. 219–223.

174. Although it does not have a hood, it is similar to the semicircular wool cloak worn by a Spanish rider; see Abraham de Bruyn, *Eques Hisppanus*, 1577, engraving, British Library; Arnold, *Patterns of Fashion, c. 1560–1620*, 37, fig. 258.

Footwear: His long black leather boots come to the mid-thigh, and they are worn with black rowel spurs.[175]

Horse/horse harness: He is riding a chestnut gelding/stallion. The horse's forelock is tied in a decorative topknot, as is his tail. The harness is all black, probably leather, but it could be covered with a black textile. It is decorated extensively with gilt metal studs of the type supplied by a loriner. The horse has a bridle with brow band, chin strap, single reins, and a curb bit. The lead rein is left hanging. The saddle is padded and quilted, and it has a neck strap, a crupper, stirrups, stirrup leathers, and a series of long straps hang down from the crupper on either side of the horse's body.

Accessories: He is not wearing gloves for riding, which is surprising on a long-distance journey.

Gilding: None present.

Image II 16 [recto]

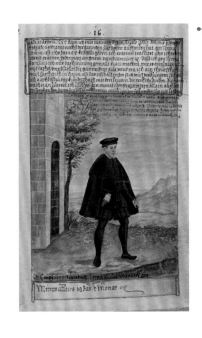

On April 11, 1555, I arrived in Verona with my master Angelo Cosalo, whom Master Steffan Kröß had found for me on March 29 in Bolzano. I had to pay him annually 25 scudi for boarding. I was well treated but did not understand just how nice and kind everyone was. Soon after I came to Verona, I had the dress made depicted below, as it is shown with a half silk, and impressed the whole town. And if I knew a German, I went to see him at home, so that I soon knew my way all over town. This way I soon got acquainted with people. The Italian boys, they now knew me all too well, and for a month or so I did not like to be found alone on the streets because boys pained me too much. I did not suffer it and slapped each of them once or twice in the face. Thus the lads grouped themselves together and wanted to get at me, as happened at times. Their talk was all the time: "The shitty German." I replied: "The magnates are fresh shit!" That was my best Italian according to my calendar.

Text below: On May 6 I started at the business school. Aged 13 and 5 months.

Note: German youths were commonly derided in North Italian cities, but this is an unusual account of the emotional responses that followed.

Clothing overview: This image is about him establishing a new identity in Verona, and he does this in part by having clothes made there in the local style, as well as learning to speak Italian, even if only to be insulting. He is dressed all in black, and this is reminiscent of how his father experimented with Italian fashions while living in Milan (I 21, I 22).

Headwear/hair: Veit has reverted to the style of black bonnet with the puffy crown and narrow brim that he was wearing in February 1552 (II 13). His hair is still short, leaving his ears visible.

Body garments: He wears a short black cloak with a deep cape collar, and it is worn on both shoulders. The cloak comes to his mid-thigh and so just covers his trunk hose. Underneath he is wearing either a black jerkin and black doublet or a black doublet; it is probably the former. The jerkin fastens down the center-front from the collar to the waist with seven, quite large, round black buttons. It does not appear to have a waist seam, and the skirts flare out very gently, coming to just below his hips. Very little of the black doublet is visible apart from the fitted sleeves, but it must also be quite fitted in the body.

Linens: His shirt has a small upright neckband that is finished with a narrow s-shaped ruffle. The bandstrings are tied and tucked inside. There is a very small section of his shirt sleeve showing from underneath his doublet sleeve.

175. These are similar to the rowel spurs worn in Vincenzo Foppa, *The Adoration of the Kings*, c. 1515, National Gallery London; illustrated in J. Clark, ed., *The Medieval Horse and its Equipment c. 1150–c. 1450* (London: HMSO, 1995), 146, fig. 105.

Legs: He is wearing black trunk hose with quite narrow panes that come to his mid-thigh. The panes are decorated down each long side, probably with a length of couched silk cord or braid and then either slashed with evenly spaced horizontal cuts or they have more of the same cord or braid applied in horizontal sections. Behind the panes there is a black lining. The hose probably have a black codpiece, but it is not visible. The trunk hose are worn with plain black hose.

Footwear: His black shoes have a slightly pointed toe, and the vamp covers the top of his foot. The uppers are probably made from either good quality leather or textile, and the vamps are slashed with three long vertical cuts over the toes and then with a series of short horizontal cuts arranged in staggered rows.

Accessories: He is holding a pair of plain brown leather gloves in his right hand, the first time that he is depicted with this accessory. He has a black girdle, made from a length of black silk tied around his waist in a half bow. The primary function of the girdle is to accentuate his waist because he does not seem to have anything hanging from it.

Gilding: None present.

Image II 17 [verso]

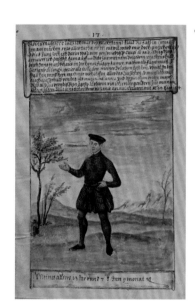

On May 28, 1555, I commissioned the following dress (the color is called "incarnate"): It was all made from a half silk fabric, and did not cost much, but looked good on me. On June 18 I went for my journey to Venice with it, on my hired horse. On the 19th I arrived there . . . also at my brother's Matheus Huldrich [Matthäus Ulrich] in the German foundation in the master Fugger's chamber. Afterward Signor Gerhardo di Longhi, frequently at the Golden Head, my brother's boarding master, showed me around everywhere in town. This helped me to see everything one could possibly see, also outside Venice, at Murano, Malamoca, and suchlike places. I thus stayed in Venice until the August 3, then I rode back to Berne to my old patron, as [related] in my letter to my father, signed with No.12.
Text below: Aged 13 and 7, 8, and 9 months.

Clothing overview: With this suit of doublet and hose, Veit is very keen to stress that the color and cut are his choice; at the age of thirteen he has full control over his wardrobe. He is equally pleased that such a pleasing outfit did not cost him a lot of money. Dressing all in one color presents a very striking effect, and this is the norm for his clothes from this point onward, but usually it is less flamboyant because he tends to favor black.[176]

Headwear/hair: He is wearing a black bonnet with a narrow brim and a full crown. It is flat on his head. His hair is cut short.

Body garments: His red doublet, which he describes as being incarnate is probably what the Italians would have called *morello*. This is a deep red or mulberry color that was often worn for civic dress.[177] It is made from a half silk, which has many of the virtues of a full silk but at a much more reasonable price. The doublet is lightly padded at the front, giving it a slight peasecod belly. It has very narrow skirts and the waistline is close to the natural level of his waist. The sleeves are tight and fitted, and there is a small grown-on collar. The doublet is decorated all over with a pattern of slashing or pinking. Pairs of short vertical cuts, alternating with pairs of short horizontal cuts, are arranged in offset rows to create a grid pattern on the doublet. It fastens down the center-front with eleven round red buttons, which are probably silk thread wrapped around a wooden core.[178]

176. For a comparable doublet and hose of crimson satin, c. 1562, compare with the doublet and paned trunk hose worn by Don Garzia de'Medici, Palazzo Pitti; Arnold, *Patterns of Fashion, c. 1560–1620*, 54–55.
177. J. Herald, *Renaissance Dress in Italy 1400–1500* (London: Bell and Hyman, 1981), 223.
178. For a later example of a suit decorated with slashing and pinking, see the satin suit of Sir Richard Cotton, 1618, Victoria and Albert Museum; Arnold, *Patterns of Fashion, c. 1560–1620*, 28–29.

Linens: His shirt has a small neckband that is edged with a ruffle and arranged in an s-shape. This is supported by the collar of his doublet and frames his face. Small wrist ruffles can be seen at the end of his doublet sleeves.

Legs: The suit has a pair of matching hose. The trunk hose have very wide panes that run from the waistband to the leg band, and they come to his mid-thigh. The panes are decorated with rows of three vertical slashes that are separated with diagonal slashes. The edges of the panes are cut to create a scalloped effect. The trunk hose are lined with a lightweight fabric, which is pulled into points between the panes. The hose have a very prominent, upturned codpiece. It is slashed, and puffs of the red lining have been pulled through the cuts and stitched in place to ensure they stick out. The trunk hose are worn with red hose.

Footwear: He has black shoes with slashed uppers. They are slashed in a style intended to match the pattern on his doublet. The design on the vamp is accentuated by his red hose showing through the cuts.

Accessories: He wears a black girdle and hanger, but at the moment he does not have the weapon that he aspires to attach to it. It is probably either black leather or leather covered with black velvet, and it has black buckles. It is possible that he has a pen case hanging from the girdle on his left hip.

Gilding: None present.

Image II 18 [recto]

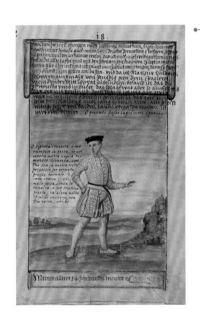

In December 1555 my Master Angolo Cosals wife and her daughter Honesta, as well as my Master's brother Bernardin's 5 daughters, almost all of whom were grown up and single, talked me into dressing myself in white for Christmas, everything from a half silk and with the cuts as below. They refused any color; in sum, I would have to wear white to please them; for they said white best suited a young fellow.

Text below: Aged 14 and 2 months.

Addition by Veit Konrad's brother:

And when I, Matheus Huldrich Schwartz, once walked from Venice to Berne to visit my brother Veitt Conrat, I found that Signora Honesta courted him. But the sheep was so simple-minded that he did not understand. But I am not certain what happened in my absence. But I am well aware that both parties shed a large number of tears both at the time of parting as well as long afterward. Oh how many steps tearful people waste!

> *Oh Lady Honesta,*
> *You turn my head around,*
> *And you against your wish*
> *remain honest.*
> *With God shall be your sheath!*
> *Pray to return it soon!*
> *In the meantime the tail grows.*
> *Ahimé! the feast*
> *without you, Honesta,*
> *makes me sad.*
> *Another turn*
> *and thousand turns again,*
> *Rest with God!*
> *Ahi, he!*

Note: This entry documents how women could pressurize young men to dress in ways that pleased them. Matthäus Ulrich later mocked his younger brother about his unfulfilled sexual desire as he has not recognized Lady Honesta's love in time during his stay in Italy (see Introduction I).

Clothing overview: These are the clothes he wears to celebrate Christmas in 1555 in Verona, and his comments indicate that he was also heavily influenced in his choice on this occasion by the women of the Cosalo family. The comments of his elder brother Matthäus who is depicted in I 130, suggest that the Cosalo were hoping he might marry their daughter. The white undoubtedly was intended to symbolize youth and innocence. However, while they may have dictated the choice of color, the style is consistent with what he was wearing already.

Headwear/hair: Veit is wearing the familiar style of black bonnet with a narrow brim worn flat on his head. His hair is cut short.

Body garments: His white half-silk doublet has a small collar, fitted sleeves, and very narrow skirts. It is buttoned down the front with a row of ten small round white buttons. It has a natural waistline and some padding to create a slight curve at the front over the belly. It is decorated with lots of short, closely spaced, slashes that are arranged in vertical rows in a chevron pattern. In between the slashes are small pinkings, which add to the decorative effect. This is a very ornate and impractical doublet, well suited to celebrate the Christmas period.

Linens: The only evidence of his shirt is the small s-shaped ruffle attached to the neckband, which is supported by the collar of his doublet.

Legs: He has matching white hose. The trunk hose come to just above the knee and they consist of very wide panes with a very full white lining underneath, which is pulled into points between the panes. The panes are decorated with rows of three diagonal slashes, which are separated from each other by horizontal slashes. The rows of diagonal slashes are made in alternate directions, creating a zigzag pattern. The codpiece is very prominent—the largest to date. It has slashes and puffs of white silk pulled through. The trunk hose are worn with white hose.

Footwear: The white shoes have a slightly pointed toe and heavily slashed vamp and quarters. The pattern of the slashing is similar to that used to decorate his doublet, suggesting that they were made specially to match.

Accessories: Around his waist there is a black girdle and hanger, as in II 17. It may be worn with a purse hanging on his left hip.

Gilding: None present.

Image II 19 [verso]

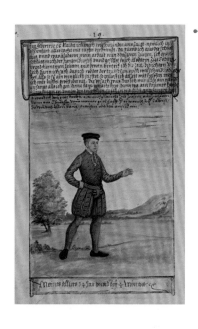

In February 1556 I dressed myself, as shown below, that is in ash-gray, all made from a half silk fabric and trimmed with the same. I finished with school and thus walking about became my work. I got rid of the young lads to associate myself with honorable and distinguished people. I spent my time with them until I went to Venice. Because I saw that I had neither the respect of the German, nor of the Italian boys; thus if someone caused misfortune, I always had to help carry it [the consequences], whether I had been part of it or not. The cause was that I had made a name for myself when I first came to Verona, because there were some bad dealings among the Germans, and although I had not started them, I for sure had taken part in them. But I thought it was time to stop because a German amongst my group of associates drowned in the Adige. This made all of us anxious, and we did not know what to do any more.

Text below: Aged 14 years and around 4 months.

Clothing overview: Two months later Veit stresses that he has chosen these clothes for himself. It is significant because he considers wearing this style (and color) of clothes marks the end of his schooling and his transition to a more adult world where the most important thing is being seen and admired as you walk the city streets.

Headwear/hair: Veit has selected a small, black bonnet with a narrow brim that is worn flat on his head. His hair is cut short.

Body garments: His doublet is made from ash-gray half silk. The doublet has a small collar, and it fastens down the center-front with ten small round gray buttons. It is close-fitting, but there is slight sense of a peasecod belly to the front of his doublet, and the doublet has very small skirts that rest on the top of his codpiece. The sleeves are also close-fitting and extend to just below the wrist. The doublet is decorated with short diagonal slashes, which are arranged in vertical rows, and they all slant in the same direction.

Linens: The neckband of his shirt is edged with a small ruffle, which is formed into s-shape folds. The two bandstrings are left hanging down. They end with small tassels or decorative knots and have been tied together at the ends to create a loop.

Legs: He is wearing matching ash-gray hose. The trunk hose come to just above the knee. They are made with quite wide panes, which are decorated with diagonal slashes, in the same style as the doublet. A lighter weight gray lining can be seen underneath the panes. The hose have quite a prominent codpiece, with two diagonal slashes and puffs of matching gray fabric pulled through on each side.[179] These are worn with plain gray hose. While in a similar style to those in II 19, they are rather less flamboyant.

Footwear: His black shoes have slashed uppers with long vertical slashes on the vamp and diagonal slashes on the quarters.

Accessories: Around his waist there is a black girdle and hanger.

Gilding: None present.

Image II 20 [recto]

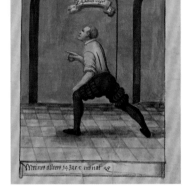

In March 1556 it was my joy to play the ball game. I hit it [the ball] with the Italians either in the cloister of the church, called Duomo, or in Piazza del Potesta. There my dress was as below in the cuts and colors. The hose were otherwise from Rassa [?].

Inside the image: O Mi Rebuco Zuge [?].

Text below: Aged 14 years and 5 months.

Clothing overview: In March 1556 Veit is dressed in the clothes of a teenage boy engaged in sport. When he refers to hitting the ball, he is probably playing *jeu de paume*, a forerunner of tennis that did not involve rackets, just a ball and a court, or in this case, a cloister, which evidently works just as well. He is living in Verona, and it looks as though he is being influenced by Italian ideas on the importance of sport and exercise.[180] The clothes he has selected allow for ease of movement, while his sweaty shirt could be laundered afterward.

Headwear/hair: Unusually Veit is bareheaded, but this is appropriate because he is engaged in vigorous physical exercise. Indeed, it is in keeping with the relative informality of the rest of his clothing.

Body garments: He is wearing a white sleeveless jerkin, with a round neck and no collar.[181] It comes to his waist and it has either no skirts or just the most narrow of skirts. The jerkin does not appear to have much shaping, but there is a long vertical slash down the center-back and a slightly shorter slash to the left of it, which will be echoed on the other side. This suggests that the jerkin might be made of soft leather.[182]

Linens: The neckband of his white linen shirt is edged with a narrow ruffle. His shirt has full-length sleeves that have been pushed up above his elbows.

Legs: He is wearing dark brown hose. They probably consist of a pair of trunk hose and hose. The trunk hose are very close-fitting over his buttocks. From the top of his thigh to just above his knee, the hose are cut in panes, and these panes have been formed into three horizontal bands.

179. Compare with Hannover brown trunk hose.
180. See S. Cavallo and T. Storey, *Healthy Living in Renaissance Italy* (Oxford: Oxford University Press, 2013).
181. Compare with the leather jerkin, probably for a young man, c. 1560 (Museum of London, 36.237). This example is made from dark leather decorated with pinking; see Arnold, *Patterns of Fashion, c. 1560–1620*, 19, 68–69.
182. For more examples of jerkins, see J. Arnold, "A study of three jerkins," *Costume* 5 (1971): 36–43.

Each band is decorated with rows of vertical cuts, and just above his knee, the hose end with a pinked band. The trunk hose are worn with plain brown hose, and there is a clear suggestion of a back seam, indicating that they are made from wool cloth or possibly leather. The side view provides a very good idea of how tight the hose are over his buttocks, while still allowing Veit to move very freely. As such it demonstrates the flexibility and elasticity of what the hose are made from. The hose probably have a codpiece, but it is not visible from this angle.

Footwear: His shoes have slashed black uppers. There are vertical slashes on the vamp and horizontal cuts higher up on the quarters, which come up quite high around his heels.

Accessories: He holds a small round ball in his right hand, which he is about to throw.

Gilding: None present.

Image II 21 [verso]

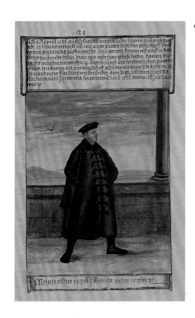

On April 8, 1556, in response to my dear father's letter from Augsburg on March 17, I moved from Verona to Venice on river called Adige, in good German company. We only arrived there on the 12th in the evening because we were unlucky and had to throw the anchor. Otherwise we were in excellent spirit. We did not leave the boat, so we cooked for ourselves. My clothes were as depicted below. I otherwise wore these clothes also in Verona during winter 1555/1556, when I was at home.
Text below: Aged 14 years, 5 months, and around 12 days.

Clothing overview: By late spring 1556, Veit has moved from Verona to Venice, and like his father he has adopted local styles. However, there are some notable differences between the long black gown worn by Matthäus in I 26 and the long black coat or cassock worn by Veit. This indicates the importance of Venice and Verona to the Fuggers' business and the importance placed on their representatives being sensitive to local fashions and customs.

Headwear/hair: Veit has a small black bonnet flat on the top of his head; it has a narrow continuous brim and a full crown. As usual, his hair is cut short.

Body garments: He is wearing a long black coat or cassock, which is probably made from wool cloth. It has a very loose cut with no waist seam, and it comes to his mid-calf. It is fastened down the front, from the neck to knee level, with decorative frogging made from applied black passementerie. It has hanging sleeves, and these appear to have been left hanging, or at least the right sleeve has. They also look to be decorated with applied horizontal bands of black passementerie. The coat has pocket slits at just below waist height, and it is likely that the pocket opening is incorporated into one of the long seams running down the front of the coat. He has his right hand in his right pocket, and it is likely that the left is in the other pocket. It has a turned-down wide collar, which looks to be a darker shade of black, suggesting it is made from a different fabric. Underneath he is wearing a black doublet, the fitted right sleeve of which we can see where it has passed through the slit in the hanging sleeve.

Linens: Just the very small ruffle on the neckband of his shirt is visible. The bandstrings are tied and tucked inside.

Legs: He is wearing black hose, but only the lower leg can be seen. These are of the usual type. He may well be wearing black trunk hose underneath the long coat or cassock.

Footwear: His shoes have plain black vamps that cover the top of his foot. They do not have quarters, suggesting they may be mules. They have thick soles.

Gilding: None present.

Image II 22 [recto]

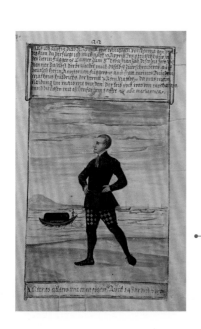

When I came from Verona to Venice on the 12th, as shown opposite, I presented myself in the German house, into the Lord Fugger's chamber, to Signor Sebastian Zäh on April 13, who at the time was His Grace's [Anton Fugger's] servant there. He needed me there for scribal work, on the

order of Lord Anntonien Fugger, in the place of my brother, Matheus Huldrich, who rode to Rome, Naples, etc. My clothes during May were as below: The jerkin was from Mochairaro-cotton and the hose with an ash-gray half silk, In the Macharonea manner.

Text below: My age, just as opposite, also 14 years and 7 months.

Clothing overview: The most striking things about these clothes are the use of checks and the very slim-fitting cut.

Headwear/hair: In this instance, Veit opting to appear bareheaded is more surprising than in II 20 because he is formally dressed. This provides a clear view of his short hair.

Body garments: He is wearing a tight-fitting black jerkin,[183] with a small grown-on collar and short fitted sleeves. The jerkin is buttoned down the center-front with eight, quite large, round black buttons running from the collar to the waist. The skirts of the jerkin come to his hips. The short slightly puffed sleeves appear to be paned, and they come to his mid-upper arm. The panes are slashed, and the sleeves end in a narrow band. The jerkin is made from a half silk, which Veit describes as *mochaiaro*. The latter was a mixed-fiber cloth with linen or cotton. It suggests he is buying local Italian fabrics.[184] Underneath the jerkin, he has a fitted, black doublet, the sleeves of which are visible from the middle of his upper arm to the wrist.[185]

Linens: Very little of his shirt is visible apart from the narrow ruffle on the neckband and the small wrist ruffles. The two pairs of long bandstrings have been left hanging down, and they end with small tassels.

Legs: He is wearing very tight-fitting hose that accentuate the shape of his legs. These consist of a very snug pair of over-hose with a pattern of diagonal checks of ash-gray and black. The waist is covered by the skirts of his jerkin, but the legs finish in a narrow band that has been pinked to create a scalloped effect. It is not possible to tell if the hose have a codpiece. They are worn with plain black hose.

Footwear: His shoes have black uppers that come to just below his ankle. They look to have a central, vertical slash on the vamp and then horizontal cuts on the quarters.

Accessories: He is still wearing the black girdle with all four hangers, which fasten together as there is no sword or dagger hanging from them.

Gilding: None present.

Image II 23 [verso]

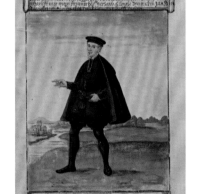

At Venice in May 1557, when I recovered from my great fever, which had kept me unwell [in bed?] from November 7, 1556, until March 21, 1557. So I did not want anything to upset or trouble me when my parents, siblings, God, or friends stirred something up, except when there was a cause for it. Thus I dressed, as is registered below, in black: a cape trimmed with silk satin, silk-satin sleeves on Macheier-cotton, trimmed with Macheier-cotton and slashed, and woolen stockings with silk-satin hose. My pious Lord, Signor Gerhardo di Longhi, gave me the golden toothpick; so I bought a turquoise and diamond-ring to go with it.

Text below: Aged 15 years and 7 months.

Note: This entry documents that colors could be chosen to bring about or protect their wearer from particular emotions. Black protected from emotional turmoil. Toothpicks were fashionable accessories for men at the time and worn as jewelry.

183. Veit uses the word *Leibrock*, which could translate as coat, but the garment depicted would have been described as a jerkin in English at this time.
184. For more on mixed fabrics in Venice, see L. Mola, *The Silk Industry of Renaissance Venice* (Baltimore and London: The Johns Hopkins University Press, 2000), 171–76.
185. He is dressed in a similar style to Maximilian II; see Antonio Mor, *Emperor Maximilian II*, 1550, oil on panel, Prado, Madrid; Arnold, *Patterns of Fashion, c. 1560–1620*, 18.

Clothing overview: Veit is still in Venice a year later, and his clothes are much more elegant than those he had worn previously. He is all in black, but this suit of clothes makes use of the different shades of black, surface textures of the fabrics, and a variety of decorative techniques. This is first time that he wears jewelry, and the gift from Signor Gerhardo di Longhi encourages him to buy jewelry for himself.

Headwear/hair: Veit has returned to a wearing a small black bonnet of the style seen in II 21, and his hair is still kept very short.

Body garments: He is wearing a short black cloak, which is worn on both shoulders, with a cape-style collar and with a black lining. The cloak is worn over a black jerkin and doublet. The jerkin is buttoned down the front with moderately sized round buttons of which seven are visible. The buttons appear to extend from the grown-on collar to the waist. The jerkin is closely fitting, with the hint of a peasecod belly and long skirts that come to mid-thigh. The skirts cover much of the upper part of his hose, and the bulk of the hose causes the skirts to flare out a little. The edges of the skirts are trimmed with a decorative cord or a braided border or guard. The jerkin is probably sleeveless, but it may have short sleeves like the example in II 22. Only the sleeves of the doublet are visible, and they are presented as being of a blacker, more lustrous fabric than the jerkin that has been decorated with a series of short, horizontal slashes.[186]

Linens: Very little of his shirt is visible apart from the narrow s-shaped ruffle on the neckband and the small wrist frills. The two pairs of long bandstrings have been left hanging down, and they end with small tassels.

Legs: He is wearing black hose. The trunk hose are made from fairly narrow panes that have been pinked. The panes have been formed into a series of horizontal bands, but only the lowest of these is visible under the skirt of his jerkin. The panes are stitched into tight bands. If there is a codpiece, it has not been accentuated. The trunk hose are worn with plain black hose.

Footwear: His black shoes have slashed vamps, which extend over his foot to just below his ankles. There are three long horizontal slashes on the toes and two rows of shorter vertical slashes on the top of his foot.

Jewelry: He is wearing a gold toothpick[187] on a black cord, possibly a loop manipulated cord. While he says that he has bought himself a ring, the painter has shown him with two gold rings worn on the fourth finger of his right hand. Both rings are set with gemstones, one with a blue stone, a turquoise, and the other a pale stone, which must be the diamond that he refers to.

Accessories: His black girdle appears to be made from a fine, lightweight, silk fabric tied around his waist in a half bow.

Gilding: On the toothpick and his rings.

Image II 24 [recto]

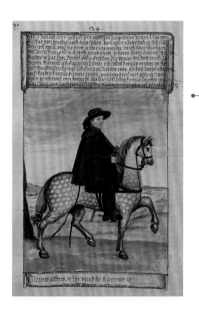

On June 7, 1557, I moved with my guide, Marx Fischer, from Venice to Augsburg, and arrived there on the 20th. I allowed myself enough time to thoroughly see every town I visited. This dapple-gray horse belongs to Lord Hanns Jakob Fugger. Lord Daniel Felix Baron of Spaur, he asked me to [come to] Brixen. Because I belonged to the Fuggers, I should ride there. Perhaps his Grace saw what kind of rider I was, as the horse would return without harm. I was well served by this,

186. Compare with the slightly later portrait of Charles IX of France wearing a black velvet jerkin with a narrow waist and full skirts over a white doublet with applied gold passementerie and matching, very full, trunk hose; see François Clouet, *Charles IX of France*, 1563, oil on canvas, 222 × 115 centimeters, Kunsthistorisches Museum, Vienna, N. GG 752.

187. For a slightly later example of a fancy toothpick, see the Pasfield jewel, c. 1600, in Scarisbrick, *Jewellery in Britain*, 146–47.

because my horse became sick, I let it run away by itself. My dress otherwise was fine and amusing, as is depicted below, in the Venetian manner.

Text below: Aged 15 years and around 8 months.

Note: Hans Jakob Fugger (1516–75) was a son of Raimund and nephew of Anton Fugger.

Clothing overview: Veit is dressed in his travel clothes for the fourteen day journey from Venice to Augsburg. The image allows him to show off his Venetian clothing and also to stress his riding skills. The importance of the latter was stressed by writers, such as Castiglione, and accentuated by the publication of *Gli Ordini di Cavalcare* (*The Rules of Riding*) seven years earlier in 1550 by Federico Grisone.[188] At fifteen, this is also the first time that he is depicted carrying a sword.

Headwear/hair: His black hat, with a medium-sized crown and a wide brim, is worn fairly flat on his head. It has a black hatband, the ends of which can be seen hanging down over the brim at the back. His hair is cut short.

Body garments: He is wearing a short black cloak that is fastened at the neck and comes to between hip and mid-thigh. It has a small cape collar, the edge of which is cut in a scallop pattern. The cloak is worn over black garments, probably a jerkin and doublet. The jerkin probably fastens down the center-front, and it has long skirts that hang down to his hips. Very little of the doublet is visible, apart from the fairly fitted sleeves. The slightly shiny look of the fabric suggests it might be made from satin or a half silk.

Linens: None visible.

Legs: He is probably wearing black hose, but they are concealed by the long boots.

Footwear: He looks to be wearing long black leather boots that come right up onto his thighs. There is a suggestion of the leather wrinkling a little at the back of his knees. He has a pair of black rowel spurs with long necks and black leathers.

Horse/horse harness: This very well-schooled dapple-gray horse belongs to Lord Hans Jakob Fugger. Its mane is brushed to the offside, and there is a knot in the tail. The carriage of the head is suggestive of a well-trained horse, responding to the bit, and it has an active, high-stepping gait. All the harness is black, and it is probably black leather, but it could be leather covered with black velvet. The bridle has brow band, nose band, check strap, single reins, a curb bit, and a leading rein. It has ornamental gilt bridle bosses (these are possibly gilt copper alloy). In addition there is a neck strap and a saddle with a deep knee roll, a double girth, stirrups, stirrup leathers, and a crupper.

Weapons: His sword has an ornate gilt hilt, and it is in a black scabbard. It rests on his left hip.

Gilding: The hilt of his sword and the bosses on the horse's bridle.

Image II 25 [verso]

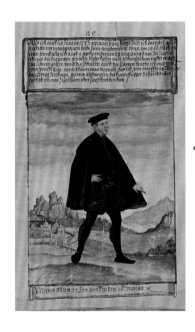

After I came to Augsburg, on the 20th of June, 1557, I once more traveled to the Margraven-bath on the 23rd, where I had also been in 1553. When I returned to Ausgburg on August 9, I had myself made the baggy hose as depicted below with an ash-gray half silk. I brought the leather jerkin and shoes, as well as the cape, with me from Venice. During this time I learned mathematics with Onoffrius Löffler's aunt, and went to master Fugger's writing office and saw whether I received anything to do or write.

Text below: Aged 15 years and in the 10th month.

188. The book, which was endorsed by Pope Julius III, was so popular that eight new editions were printed between 1550 and 1600; E. Hartley Edwards, *The Encyclopedia of the Horse* (London: Dorling Kindersley, 1994), 97.

Note: This entry documents the work of women as supplementary teachers for boys in towns, even to teach mathematics.

Clothing overview: A few weeks later he is dressed all in black but in a very different set of clothes from Venice. This also suggests that a variety of styles are being worn in Venice, and on this occasion Veit has chosen some that are relatively loose fitting.

Headwear/hair: He has a flat, black bonnet with a small brim that is worn fairly flat on his head. His hair is cut short.

Body garments: The black cloak comes to his mid-thigh and is worn on both shoulders. It has a small cape, which comes part way down his arms. It was probably made of wool, with black satin guards on the insides of both fronts and around the hem. It is worn over a black jerkin that fastens down the center-front with thirteen round gilt buttons. This is the only time he has gilt buttons in the course of the book, and they provide a strong point of visual contrast with the rest of his clothes. Both fronts of the jerkin have a long vertical slash, which extends from the middle of his chest to his waist. The jerkin is decorated with rows of short horizontal cuts separated with a row of diagonal cuts. The jerkin has short sleeves that end with a narrow band. It has a small grown-on collar. The edges of the cuts on the jerkin's front, the collar, center-front, and the short sleeves are edged with a narrow black braid or other type of passementerie. Underneath he has a doublet of black satin and only the fairly fitted sleeves show underneath the jerkin.

Linens: The ruffle on the shirt's neckband appears just above the doublet's collar, and small, matching wrist ruffles are evident.

Legs: He is wearing black and dark gray hose. The checked half-silk trunk hose come to his mid-thigh. They are different to those he usually selects because they are not paned, and as a result this accentuates that they are baggy, as he describes. The small diamond-checked pattern could be achieved by using a fabric with a standard check on the bias. The hose may have a little padding or at least a good lining/interlining to help them keep this full shape. The hose have a fairly prominent round but upturned codpiece made of the same checked material. The hose are plain black and are of black wool cloth cut on the bias.

Footwear: His black shoes have a slightly pointed toe, and the leather uppers come up high over the top of his foot. The vamps are slashed with horizontal and diagonal cuts, in a similar pattern to those on his doublet.

Accessories: He is wearing a wide black girdle and hanger, but it is hard to tell whether anything is attached to it.

Gilding: The gold buttons fastening his doublet.

Image II 26 [recto]

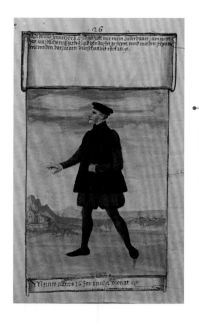

On January 1, 1558, my dear father gave me this clove-colored outfit from a half silk fabric for the New Year, quilted and with the cuts, as below; along with it [he gave me] a short gown of light wool and silk.

Below the image: Aged 16 years and 2 months.

Clothing overview: Veit's clothes on this occasion are a New Year's gift from his father, and this reflects that clothing is a popular gift for all ranks of society. New Year's Day is the usual time to exchange gifts (rather than Christmas Day). Matthäus has evidently made a good choice, or knew what his son would like, because Veit sounds happy with his present.

Headwear/hair: He has chosen a black bonnet with a small brim to celebrate the New Year. His hair is short.

Body garments: Veit is wearing a black sleeved half-silk jerkin. The jerkin comes to his hip, and it falls straight from his shoulder to hem with no waist seam. It has a fairly loose cut and flares out gently from his mid-chest to his hips. It has a small collar, which is done up. It fastens down the center-front with black buttons and loops set within horizontal bands of black passementerie. The small full sleeves, which come to his mid-upper arm, are gathered into a narrow band. The sleeve appears to be decorated with black passementerie. Underneath he has a mid-brown doublet, which he described as clove color (*neglfarbs*). It has close-fitting sleeves, which can be seen from the mid-upper arm to the wrist. He describes the doublet as being quilted, and this forms horizontal bands. Each individual band has a series of very short vertical cuts or pinks.

Linens: The ruffle on his shirt's neckband is formed into a distinctive s-shape. There are also small s-shaped ruffles on the wristbands of his shirt.

Legs: He is wearing mid-brown (or clove color) trunk hose with alternating wide and narrow panes coming to just above his knees. The wide panes are decorated with alternating diagonal slashes, while the narrow panes are left plain. The trunk hose are lined with a matching, lighter weight fabric. The trunk hose are worn with plain brown hose. The hose probably have a codpiece, but it is covered by the jerkin.

Footwear: He has black shoes with uppers that cover the top of his foot. The vamps are slightly pointed at the toe, and they are slashed, vertically on the toes and horizontally on the top of his foot.

Gilding: None present.

Image II 27 [verso]

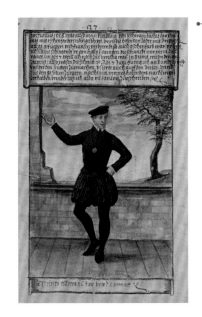

In June 1568, this was my dress: the doublet of black half silk, quilted with ash-gray silk, and the hose of leather lined with satin from Bruges and trimmed with passementerie [fransen], which were likewise ash-gray. I had a small striking watch hanging around the neck, which my dear father gave me in 1557, because I was still in Venice. In sum, as shown below, these were the cuts. On June 7 I started making acquaintances among people, and commonly went up to the Perlen [the Perlach square?] and to the companions [gesöllen], as recorded at length in my calendar, which is why I shall not write much about it here.

Text below: Aged 16 years and 8 months.

Clothing overview: Veit is dressed in a black doublet and hose, and without a cloak he looks very elegant for summer. The clothes accentuate his slim build.

Headwear/hair: He is wearing a black bonnet with a narrow brim of his familiar type. His hair is cut very short.

Body garments: Veit is dressed in a fitted black half-silk doublet with a small collar that fastens down the center-front with small round black buttons, eleven of which are visible. The doublet has a natural waistline, and there is some padding at the center-front. The doublet has very small skirts. It is decorated with applied gray silk passementerie, which has been couched down in vertical lines, creating a striped effect. In between the fabric has been slashed with short diagonal cuts in alternating directions.

Linens: His shirt is covered by his doublet, with the exception of the collar and wrist ruffles. The shirt's neckband is edged with an s-shaped ruffle, and on this occasion, the bandstrings are tucked inside the collar of his doublet. Small matching wrist ruffles extend beyond the end of his doublet sleeves.

Legs: He is wearing black trunk hose. These are also decorated with ash gray passementerie but in a different manner. The black leather panes are edged with a twisted

cord and then pinked with a series of short curving lines. Through these, the gray Bridges satin lining has been pulled through. Bridges satin is a union cloth, cheaper than a satin woven with a silk warp and weft. The hose have a fairly prominent, upturned codpiece, which is also decorated with slashes and pullings through.

Footwear: He is wearing black shoes.

Jewelry: He has a large round gold pendant containing a watch[189] with a patterned surface worn hanging from a black cord. The watch would be very useful for a young man in his line of business, but it is also an expensive present for a boy in his teens. It is interesting that he did not record the watch at the time he was given it but some months afterward.

Gilding: The watch around his neck.

Image II 28 [recto]

In July 1558, I started to swarm about and go for walks with good honorable fellows at night, as recorded in my calendar for this month. My clothes were as below: a black Saxon hat with feathers, a Saxon black woolen cloak lined with green fabric, and a Bohemian knife at the side. Otherwise on the following May 16, I, for the first time, carried a weapon during the night in Augsburg.

Text below: Aged 16 years and around 9 months, also 16 years and around 6 ½ months.

Clothing overview: Although it is the middle of the summer, Veit has selected a full-length cloak for going out in the evening. Compare it with I 60 when his father makes a first reference for clothes worn in the evening in March 1523 when he was aged twenty-six. At age sixteen, this is the first time that Veit mentions carrying a weapon. In contrast Veit's father records wearing a dagger in 1511 at the age of fourteen (I 12).

Headwear/hair: Veit is wearing his most flamboyant hat so far which he describes as being of Saxon style. It has a tall crown and a narrow brim and it is probably made from black felt. The lower section of the hat is wrapped with a wide band of gathered black fabric (the shine suggests a satin), while the upper part of the crown is thrummed. It looks to have a very narrow upturned brim, and it is decorated at the back with a large black ostrich feather (*födern*). This style of hat is very different to his usual style of bonnet, and it suggests that he selects different headwear according to the time of day.

Body garments: He is wrapped in a long, full, black cloak (mantle), which comes down to his mid-calf. It is made from a heavyweight wool cloth, and it has a tall, stand collar. The cloak is lined, as is evident where he has thrown the right front over his left shoulder. According to his own notes, the lining is green, but the artist has shown it as yellow. It is possible that the pigment has changed color slightly over time.

Linens: No linens are visible.

Legs: He is wearing black hose.

Footwear: On his matching black shoes, the vamps come up high over the top of his foot toward his ankle, while the quarters are still below the ankle bone.

Weapons: While he mentions a dagger or knife (*ain behamischen duseggen*), it is under the long cloak and not much is visible from the back view presented here. It has quite a wide, curved blade, as suggested by the size and shape of the black scabbard, which is decorated with a scrolling pattern. His decision to carry a weapon when going out at night reveals something about safety on the streets of Augsburg and also of male youth culture in the city.

Gilding: The moon and the stars.

189. For a slightly later French example of brass, gilt brass, and blued steel dating from c. 1600, see F230, Museum of the History of Science, Oxford, Starkey, *European Court*, XI.18, 153. Also compare with the example worn on a ribbon or cord around the neck of Lady Petre; Unknown artist, *Lady Petre holding a girdle prayer book*, 1567, private collection, Ingatestone – fig. 59; Scarisbrick, *Jewellery in Britain*, 147.

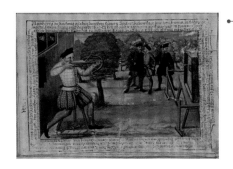

Image II 29 [verso, landscape]

In 1559, during the Imperial Diet, when master Annthoni Fugger lived in Lienhart Sultzer's house at the archway, his Grace helped us Fugger servants have a shooting match every Sunday or feasts in the garden, because they thought it would [be] best for us [to be] at home than outside. We agreed to this and had a fine order, as in the proper shooting hut, and this time the shooting masters were Frantz Knauß and Hanns Besch. On August 15, I also had a shooting match, as Jakob Wegman had pinned the wreath on me, with 20 shooting men. Lord Jakob, Earl of Montfort, as well as Balltasar, Earl of Trautson, the son-in-law of Lord Annthoni Fugger, kept us company. Master Annthoni Fugger, together with his daughters watched everyone, for I had attractive prices [?], [cloth] about an ells length and checkered, but in several colors. The best were 5 ells of fustian, won by Zimprecht Rieger, whom I decorated with the wreath. This thorn [doublet, codpiece?] was stiffened with bone, cost me 12 fl even without the armor. Otherwise my clothes were as shown below, leather hose with a half silk.
Text below: Aged 17 years and 10 months.

Clothing overview: A year later and Veit is practicing archery and taking part in archery competitions, just as his father did at a similar age. Here archery, as a military skill and a civic duty, is combined with it being competitive and having the opportunity to show off his skill in front of members of the Fugger family. Unlike his father, who shot a longbow, Veit uses the crossbow, a more fashionable and more modern weapon. Again he uses his book to stress both continuity and a sense of progression. The prizes provided by the Fuggers reflect some of the textiles that the company traded in.

Headwear/hair: Veit is wearing a flat, black bonnet, and the two women and three other men watching the archery also wear bonnets that are similar in terms of shape and color. As usual his hair is cut short, and he is clean shaven in comparison with the fairly full, but trimmed beards worn by the other older men present.

Body garments: Veit is wearing a pale cream doublet with fitted sleeves and narrow skirts. It has a small collar, fastens down the center-front with small, round buttons, eight of which are on show. It has a natural waistline, and there is a slight suggestion of padding over the belly. The doublet has been decorated with fine white cord couched to the fabric to create horizontal stripes. Each "stripe" is made up of three rows of cord. In between the stripes, the fabric has been cut in a series of short vertical cuts, arranged in evenly spaced vertical rows.

Linens: The neckband of his shirt is edged with a ruffle arranged in an s-shaped pattern. A small wrist ruffle is also visible.

Legs: He is wearing mid-brown and gray hose. The fairly wide mid-brown leather panes of his trunk hose are decorated with a chevron pattern of small cuts. In between the panes, the pale gray lining is visible. The trunk hose come to just above his knee, and they have a prominent, upturned codpiece. The codpiece has been slashed, and the gray fabric has been pulled through, creating two puffs on either side. The trunk hose are worn with plain gray hose.

Footwear: He is wearing black shoes with plain uppers.

Jewelry: Veit does not seem to be wearing jewelry apart from the gold ring on the little finger of his left hand, but the three male spectators are wearing long gold/gilt chains arranged in two or three loops, suggesting that they are older and wealthier than Veit.

Weapons: Veit is taking aim with his crossbow, which is inlaid with bone/ivory in a scrolling design.[190] One crossbow bolt can be seen in the target, and the crank for pulling the

190. For an example dating from the reign of Henry VIII, steel etched and gilt, pear wood inlaid, see 39-65tz, Glasgow Museums and Art Galleries, Starkey, *European Court*, XI.38, 166. For a slightly later and very ornate hunting crossbow, c. 1600, Germany, etched steel, wood, engraved antler, rope, V&A M.2744-1931; illustrated in A. Patterson, *Fashion and Armor in Renaissance Europe: Proud Looks and Brave Attire* (London: V&A Publishing, 2009), 101, fig. 96.

string back is at his feet, along with a case. He appears to be sitting on a three-legged stool. He is wearing a black girdle and hanger with silver buckle and fittings. There is a hint of the silver and black hilt of a dagger against his back.

Other figures: The two women to Veit's left are dressed in high necked black gowns, but very little detail has been included. They both have black bonnets decorated with gold aglets or small gold buttons. The ruffles on their smocks or partlets show above the collars of their gowns. The three men to his right are wearing, from left to right: (1) a short-sleeved black jerkin over a red doublet and matching red trunk hose, (2) a matching gray doublet and trunk hose, and (3) a black doublet and trunk hose.

Gilding: The chains worn by several of the other figures.

Image II 30 [recto]

On January 10, 1560, I first began to wear weapons during daytime. And as I was now invited to distinguished weddings, I was quick to practice my dancing with the pretty single women, as written in my calendar; the planet Venus fully tempted me to also flirt face-to-face [by looking directly into a woman's face], like a donkey [goes after] a bundle of hay. But I never let myself go too far out without a lantern, because I thought, I do not want to court someone to get a child. So it is useless that I fight for the virgins who are to be married, on reflection, as I am not yet marrying; so these same virgins would not wait for me either, and thus [I] would have had effort and work for nothing.

Inside the image: It is truly her. Ecce [Behold].

Text below: My age 18 years and around 2 ½ months.

Note: Veit Konrad stands on a shoe and overshoe (as his father on I 64); this symbolizes his lack of luck in finding love that will lead to a marriage.

Clothing overview: Veit continues to stress his move toward being an adult, and at the age of eighteen he starts to wear a sword during the day. This is several years later than his father (see I 12). He also notes that he is starting to go to the weddings of his friends and associates.

Headwear/hair: He is wearing a plain black bonnet with a low crown and almost no brim. It is worn flat on his head. His hair is cut short, and it is shaped around his ears.

Body garments: Veit is dressed in a black cloak similar to that in II 23. It is quite short, coming to his mid-thigh. There is a suggestion that it has a shoulder-length cape. The cloak is worn quite close together at the front but pushed back at waist level, so that it is held back by the hilt of his sword, revealing his trunk hose. His cloak is worn over another black body garment, which could either be a black doublet or a black jerkin and doublet. Whether it is a doublet or a jerkin, it fastens down the center-front, and it has a small collar which is done up.

Linens: The neckband of his shirt has been left open, and its s-shaped ruffle is supported by the collar of his doublet. The pair of bandstrings has been left undone, and they hang down. They have little decorative tassels.

Legs: He is wearing black hose. His trunk hose have wide panes that come to just above his knee. The panes are plain apart from the applied band of passementerie on each long side. In between the panes, there is a full black lining that falls in full folds. The trunk hose have a prominent, upturned codpiece that is slashed on both sides. Some of the black silk has been pulled though and formed into puffs, which are probably stitched in place. They are worn with plain black hose.

Footwear: He is wearing black shoes. The vamp comes up over the top of his foot, and the quarters are close-fitting around his ankles. They may have been slashed, or they may be decorated with applied bands of black passementerie. He looks to be standing on two mismatched shoes—a shoe with a pointed toe under his left foot and a short side-lacing boot under his right. This motif is used by Matthäus—see I 64 when his father was twenty-six—and may symbolize his dissatisfaction with his romantic situation.

Jewelry: He is wearing a pair of gold rings, possibly both plain gold bands, on the fourth finger of his left hand.

Weapons: He has a sword with a black hilt and in a black scabbard on his left hip. It is hanging from the black girdle and hanger. He has made the transition from only carrying weapons at night (a dagger) to carrying a rapier in the daytime. He now has the most important male accessory, which will assert his status, wealth, and age.

Accessories: He is holding a pair of brown leather gloves in his left hand.

Other figures: There are two very small indistinct figures, one dressed in red and the other in black, in first story windows who may represent the young women he considers courting.

Gilding: The ring on his finger.

Image II 31 [verso]

In March 1560 I got master Jörg Halbritter to make me a nail-colored dress: that is, a damask doublet and the hose trimmed with a half silk and pulled underneath, as is shown below. This is what I wore when I wanted to be dressed up, together with such a weapon, shoes, and the watch around the neck. The dress cost fl. 20 according to my book of expenses No. 1, page 5.

Text below: Aged 18 years and 5 months.

Note: This and the following outfit were both tailored by the same master tailor.

Clothing overview: Veit has chosen to depict his best clothes, a color coordinated doublet and hose in a rich brown. While he evidently considers black to be smart and appropriate for many occasions, he selects brown for his clothes for special occasions. This is the first time that Veit records the name of the tailor who makes his clothes, and he selects a master tailor for this set of clothes. The implication is that Jörg Halbritter is not Veit's usual tailor, if he has one. Veit also makes it clear that his accessories were as important as the clothes he wears in creating the desired look.

Headwear/hair: He has a black bonnet, with a flat crown and small brim, worn at a slight angle on his head. The bonnet is decorated with a narrow hatband of twisted black cord. His hair is cut short.

Body garments: Veit is wearing a mid-brown doublet made from imported Italian silk damask with a large pattern repeat. The doublet has a tall collar, a fairly natural waistline with a slight downward point at the center-front, and padding over the belly, creating a slight peasecod effect. The doublet has small skirts and fitted sleeves. It is fastened down the center-front with self-colored round buttons, ten of which are visible.

Linens: The neckband of Veit's shirt is done up, and it is supported by the collar of his doublet. It is edged with a neat ruffle in a tight s-shape. The two pairs of bandstrings hang down and end with small tassels.

Legs: His brown hose match the color of the doublet. The trunk hose have very wide panes. The panes are edged down both long side rows of pale brown cord and in between with horizontal rows, which have been couched in a zigzag pattern. Between the panes, the mid-brown lining is visible. The trunk hose are very full and are probably padded to achieve this

effect. The trunk hose come to his mid-thigh and an upturned, padded codpiece. The codpiece has three rows of couched cord in the same zigzag pattern. It has been slashed twice on both sides, and puffs of the mid-brown lining have been pulled out to form four little puffs. Below the trunk hose, his hose are plain brown.

Footwear: He is wearing black shoes with slashed uppers. The slashes are short, horizontal, and staggered to create a grid on the vamp.

Jewelry: He has a round gold/gilt watch worn on a black cord round his neck. It is the same one recorded two years earlier in II 27.

Weapons: His sword has a black hilt and it is in a black scabbard. It is worn with a black girdle and hanger, and he rests his left hand on the hilt.

Gilding: The pendant containing a watch worn around his neck.

Image II 32 [recto]

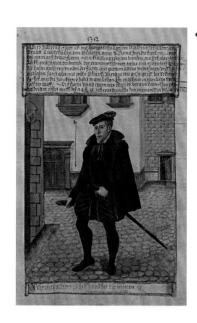

On July 17, 1560, I and Hanns Schaller led Mattheus Schaller's bride, Eva Scharerin, from Scharren to St. Anna into church; this was the first time that I led a bride. My dress was as below, a black woolen gown trimmed with velvet, the doublet black silk satin quilted with ash-color, the hose also as the [?] below, lined with good silk satin and with a half silk pulled through it. With the weapons, shoes, bonnet, everything as it is shown. The ribbon was pinned on me by the virgin Judit Mannlich, blessed Herrn Matheus Mannlich's daughter. [This hose and doublet] I had let Halbritter [the tailor] make half a year ago; it cost around 24 fl. I was up to all sorts of things then, as recorded in my calendar.
Text below: My age was 18 years and around 2 ½ months.

Clothing overview: These clothes that Veit wears for the wedding of Mattheus Schalleer and Eva Scharerin are some of the most ornate that he has worn so far. While they are not new for the wedding, he stresses that they are his best clothes, which he has not had the opportunity to wear; they were also made for him by Master Jörg Halbritter.

Headwear/hair: Veit is wearing a black bonnet with a narrow brim and fairly flat crown. It is worn at an angle on his head and pulled down over his right ear. Placed on the right side of the bonnet is a small round wreath made of red and gilt cord wrapped around to create alternating bands of color, which he notes was given to him by Judit Mannlich. His hair is cut very short.

Body garments: His mid-thigh-length black wool gown has a wide upright collar, which turns back a little to help frame his face. It is faced with black velvet, and the same black velvet is used to make two narrow guards, which decorate the fronts and hem of the gown. The gown has fitted sleeves. The upper section of each sleeve is made from wide panes, which are edged with black cord or braid and gathered together into a wide band. Below the sleeve is close-fitting, ending in a deep cuff. The gown is intended to be worn hanging open to reveal the clothes underneath. In this instance he has selected a black satin doublet, which he describes as quilted. The doublet buttons down the center-front and fastens with nine small round black buttons. It has a small collar and narrow skirts, which look to flare out a little over the top of his trunk hose. The fronts of the doublet are quilted with vertical lines of stitching. In between these lines, the satin has been pinked in horizontal and vertical lines.

Linens: The neckband of his shirt is edged with a medium-sized ruffle arranged in an s-shaped pattern, and it is supported by the collar of his doublet. The two pairs of bandstrings have been left untied, and they hang down onto the front of his doublet. They have been decorated with small tassels.

Legs: His black hose are ornate, and they go well with his rich doublet. The black trunk hose have very wide panes made of black satin. They are decorated with applied diagonal rows of black and gray braid. The long edges of the panes are trimmed with the same passementerie. The hose are lined with a mid-gray half silk. The trunk hose are very full, and they are probably

padded to help keep this shape. They come to his mid-thigh, and they have an upturned codpiece. This too is decorated with rows of the same striped gray and black passementerie. It is slashed, and puffs of the mid-gray lining are pulled through and probably stitched in place. They are worn with plain black hose.

Footwear: His black shoes have slightly pointed toes, and the vamps come low around his ankles. The vamps are cut with short pinks in pairs of diagonal lines that echo the style of decoration on his trunk hose.

Jewelry: He has a gold ring on the fourth finger of his left hand.

Accessories: Veit is holding a pair of fairly plain brown leather gloves in his right hand; while his left hand rests on the hilt of his sword.

Weapons: His sword has a black hilt, and it is in a black scabbard with a black chape. It hangs from a black girdle and hanger.

Other figures: There is a female figure standing at an open door in the background. She has a black bodice and a bright red skirt. She might be Judit Mannlich, who gave him the wreath.

Gilding: His ring and the wreath on his hat.

Image II 33 [verso]

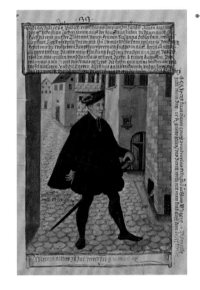

On July 23, 1560, I and Hanns Amman led the youngsters' round-dance at Signor Sebastian Zächen's dance at the merchants' chamber, and this was where his wedding also took place with the virtuous Lady Susanna Schlechtin Weiland Lienhart Egglhof's widow, Herrn *Ottmar Schlechtin's daughter. The wreath was pinned on me by the well-born virgin Veronica Fuggerin, Lord Anthonie Fugger's daughter. This was my dress then, as shown below. The doublet was woolen and quilted throughout, with 8 dozen small buttons, the hose trimmed with silk satin and quilted like the doublet. The shoes were slashed like the hose. This dress cost around 45 fl. according to a clear account and my book of outgoings No. 1, page 15. This time the* Batz *valued 15* Pfennig *of good coin. The bonnet no longer sat straight on the head.*

Inside the image: A diamond cost me 50 crowns.

Text below: My age 18 years and around 9 months.

Note: Veit Konrad was far more open than his father about the ever-increasing cost of his sophisticated apparel.

Clothing overview: A week later Veit is attending another wedding but this time he plays a more important role, and so he needs clothes for three days. For the first day he selects black as an example of inconspicuous consumption; evidently considered suitable for a wedding as indicated by his father wearing black for his own wedding. This is the first time that Veit mentions the specific cost of individual garments and accessories.

Headwear/hair: He is wearing the familiar style of black bonnet with a narrow brim, which is worn at a slight angle dipping over his right ear. It is decorated with a small round red and gilt wreath [*Den krantz*], which is probably made from twisted silk cord or lengths of a lightweight silk and cord. It is similar to the wreath that he wore at the wedding he attended the week before. His hair is still kept very short and he is clean shaven.

Body garments: Veit is wearing a knee-length semicircular black cloak made from wool cloth. It has a small cape that hangs down to his shoulders. It is faced down the front edges with black velvet guards. These are edged with a couched black cord, and they are slashed with a series of short diagonal cuts. On the right side, the cloak is decorated with three rows of a fine black cord or braid, which are couched close to the fronts and hem. It is worn on both shoulders, revealing the clothes underneath. In spite of what Veit describes, he looks to be wearing a black jerkin and a black doublet. The jerkin is probably made from wool cloth. It has

a high collar and fitted sleeves that come to his elbows. The fronts of the doublet fasten with small round black buttons, of which sixteen are visible. There are two long slashes, one on each of the proper left and right fronts which run from his mid-chest to the waist. Each slash is edged with more of the same buttons—seventeen of these can be seen around the slash on the proper right front and more are visible on the left sleeve. The jerkin has a fairly natural waistline and deep skirts, which come to his mid-thigh. It is decorated with extensive couched black cord or braid, forming bands of a chevron design on the collar, around each long slit, down each front, around the bands on the sleeves, and at the waist and the hem of the skirts. Only the lower sleeves of his doublet are visible. They have a suggestion of vertical stripes, formed either with lengths of applied cord or lines of quilting. In between, there are small vertical cuts forming chevron patterns.

Linens: The neckband of his shirt is edged with a medium-sized ruffle arranged in an s-shaped pattern and it is supported by the collar of his doublet. The two pairs of bandstrings have been left untied and they hang down onto the front of his doublet. They have been decorated with small tassels. The tiny wrist ruffles can be seen at the wrist of his doublet's sleeves.

Legs: He is wearing black hose. His black satin trunk hose have quite narrow panes, which have three lengths of black cord couched down either long side and down the middle. The edges of the panes are cut with small pinks to create a decorative effect. The panes are slashed with two rows of vertical cuts. There is no evidence that these trunk hose have a codpiece. They are worn with a pair of plain black hose.

Footwear: His black shoes have slightly pointed toes. The vamps are slashed with diagonal cuts on his toes and vertical lines on the quarters around his ankles.

Jewelry: He has two gold rings on the fourth finger of his left hand. His note in the text suggests that one is set with an expensive diamond that had cost 50 crowns while the other is a plain band.

Weapons: His sword has a black hilt, and it is carried in a black scabbard. It hangs from a black girdle and hanger, and he rests his left hand on the hilt.

Gilding: The rings on his finger and the gilt cord in the wreath on his bonnet.

Image II 34 [recto]

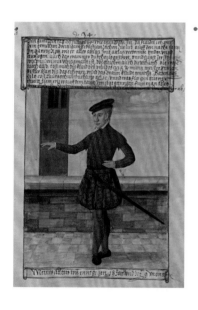

On this day, July 23, 1560, as is written here, I dressed all in red to please the said bridegroom Sebastian Zäch for the dancing at night, just like him. All silk satin, trimmed with silk satin, pulled under and through, also the doublet quilted throughout and otherwise slashed, as has been diligently depicted below; otherwise my shoes, they were just like this, and this dress cost me around and more than 33 fl. Rhenish coin. Master Simon Kistler has made this, the black and brown dress; these cost around fl 110 according to the book of outgoings book 15. And what good spirit there was and how it all went at the dance is recorded at length in the calendar of this month, which is why I break off here.
Text below: My age, as opposite, 18 years and around 9 months.

Clothing overview: The second day of the wedding, Veit is all in red like the bridegroom and the rest of his party.[191] This is the second time that he identifies the tailor who has made his clothes, but in doing so it highlights that he has selected a different master tailor—this time Simon Kistler—who makes all three sets of wedding clothes depicted in II 33, II 34, and II 35.

Headwear/hair: Veit is wearing the familiar black bonnet. There is a narrow hatband made from a twisted black cord. His hair is quite short.

191. There is a very similar style of suit (except not shown wearing canons) to that being worn in Battista Moroni, *The Gentleman in Pink*, 1560, oil on canvas, Palazzo Morosini, Bergamo. The unknown gentleman carries his feather-trimmed, black bonnet in his right hand. For a more luxurious example, see Steven van der Meulen, att., *Erik XIV of Sweden*, c. 1561, oil on panel, 58 × 31 centimeters, Nationalmuseum, Sweden, no. 909.

Body garments: He is wearing a bright red satin doublet with a smooth fitting body and padded peasecod belly. The waistline comes close to the natural level, and it has narrow skirts cut in one piece. The sleeves are close-fitting and with quite deep shoulder wings, which extend down over the upper arm.[192] The doublet has a deep, upright collar, which is buttoned up. It is fastened down the center-front with fifteen red round buttons. The doublet is decorated with narrow bands of diagonal slashes; the direction of the slashes alternates to form a zigzag pattern. In between the lines of slashes are long vertical lines, the quilting lines that Veit refers to.

Linens: His white linen shirt has a neckband edged with a narrow ruffle set in a deep s-shaped pattern. At the end of his doublet sleeves, there is a hint of the shirt sleeve, but it does not look to be a decorative ruffle.

Legs: He has a matching pair of bright red hose. The trunk hose are cut in quite narrow panes of red satin. Each pane has a narrow decorative edging down each long side and a pattern consisting of diagonal rows of geometric motifs. The panes are looped up and have a full, round profile, suggesting that they are padded to help them keep this shape. In between the panes the bright red lining is visible. The trunk hose have a quite prominent upturned codpiece, which is slashed and puffs of the lining pulled out. They are worn with hose of the same red, possibly cut from wool cloth, and there is a slight suggestion of wrinkling at the knee

Footwear: His black shoes have very ornate vamps, which come quite high on the front of his foot. The edge of the vamp is cut in a scalloped design, and over the top of his foot the vamp is decorated with a symmetrical design, combining pairs of diagonal lines and small pinks. The quarters are decorated with vertical cuts.

Jewelry: He has a pair of gold rings worn together on the index finger of his left hand, one of which is probably the diamond ring he mentions in the previous image.

Weapons: His sword is in a black scabbard with an ornate black hilt. It hangs from a black girdle and hangers on his left hip.

Gilding: The ring on his finger.

II 35 [verso]

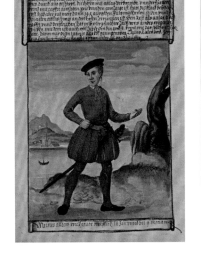

On July 24, 1560, at the aforementioned bridegroom Sebastian Zäch's after-wedding I was dressed in brown, like him. It was a silk-satin doublet, which was quilted throughout; the hose were trimmed with silk satin and with a pulled through half silk, as shown below. This dress cost around 32 fl, but I did not spend more than 14 fl for the making, silk and around 2 ells of silk satin, which vanished away on the hose. The rest, silk satin, cloth, a half silk, and such like, Zäch gave to me on behalf of his office, and I was well satisfied with this and would have done without these [?], for not everything went badly for me those days as recorded in my calendar. I was little Hans, a young man servant [knecht], jumped over all the dung-heaps.

Text below: My age as before, that is 18 years and around 9 months.

Clothing overview: For the after wedding, Veit is dressed in the same color as the bridegroom, as he had been the day before, suggesting the closeness of their friendship. This sequence of three images demonstrates the need for a sequence of clothes to attend these occasions to ensure an on-going display. For Veit, as a bachelor, it is all part of the process of presenting himself as eligible, even if rather young for marriage.

Headwear/hair: This black bonnet with a narrow, circular brim, and no obvious decoration, is worn at a slight angle. It has a narrow black cord acting as a hat band. His hair is cut very short.

192. For a similar shoulder wing, see the black velvet doublet worn by Svante Sture when he was murdered in Uppsala cathedral in 1567, in Arnold, *Patterns of Fashion, c. 1560–1620*, 57–58.

Body garments: Veit describes his clothes as brown, but the artist has recorded them as mid-gray. This silk-satin doublet is cut in a fairly simple shape, with some padding at the front giving a hint of a peasecod belly. It comes to a rather natural waistline, and has short skirts. The sleeves are fitted, and the doublet fastens down the center-front with twelve small round self-colored buttons, which extend up the short collar. While the cut might be quite simple, the doublet is covered in decoration. A grid of short vertical slashes arranged in offset lines is framed within horizontal lines, possibly lines of quilting, in tandem with rows of half circles creating a scale-like effect. The decoration accentuates the base of the collar.[193]

Linens: The style of the doublet means that not much of the shirt is visible. The neckband is supported by the collar of the doublet and so shows off well the deep ruffle that is set in a tight s-shaped pattern. In addition, the collar has three pairs of bandstrings, which are left undone so that they hang down, and each one ends with a little tassel. There is a hint of the shirt sleeves visible at the ends of his doublet sleeves.

Legs: He is wearing gray hose that complement his doublet. The trunk hose are made from quite wide panes, which extend from the waistband to a band mid-thigh. The panes have been decorated down either long side with bands of short diagonal slashes arranged to form an inverted v-shape. A slightly paler gray lining can be seen behind the panes. The trunk hose have a full shape, probably created with the inclusion of some padding. It has a quite prominent, upturned codpiece, which is slashed twice on either side and puffs of fabric have been pulled through. They are worn with plain hose, which are possibly cut from gray cloth.

Footwear: The black shoes have close-fitting uppers. The vamps and quarters are decorated with lots of slashes and pinks.[194]

Jewelry: He has the same pair of gold rings on the fourth finger of his left hand.

Weapons: He has a sword in a black scabbard resting on his left hip. It hangs from a black girdle and hanger.

Gilding: None present. Most of the gilding used for the rings on his fingers has been rubbed off.

II 36 [recto]

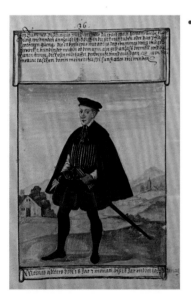

From summer until September this was my usual dress to walk the streets [literally: "to tread down the paving"], as shown below, when I walked to the accounts office. The cloak was with silk satin; the jerkin woven white and yellow, and in the middle over the sleeve, a yellow silk-satin trimming like a coxcomb; the hose trimmed with a half silk and pulled through; a velvet purse, in which I kept my keys; otherwise all as below.

Text below: My age ranged from 18 years, 7 months, to 18 years and around 10 ½ months.

Clothing overview: A subtly different style for late summer and early autumn 1560, and Veit implies that he wore these clothes for several months until the death of Anton Fugger (see II 37). Whether he discarded them after this point or they were just not his favorite clothes is hard to tell. The style of doublet is quite distinctive and different from those he has been wearing previously, suggesting that this was the fashion that season. He stresses that these are the clothes worn outdoors when he would be seen by the largest number of people.

193. Although slightly later in date, compare with the yellow satin doublet c. 1610–25 with a similar small collar, shirt skirts, fitted sleeves, close buttoning down the center-front, and slashed/pinked decoration, T. 4094, in Borkopp-Restle, *Textile Schätze*, 58–59.

194. For an equally ornate pair, but in this case embroidered with silk and metal thread rather than slashed, see a pair of shoes attributed to Erik XIV, second half of the sixteenth century, with embroidered leather uppers, Skokloster Castle, no. 11964, in Rangström, *Lions of Fashion*, 32, 297. Also see J. Swann, *History of Footwear in Norway, Sweden and Finland* (Stockholm: The Royal Academy of Letters, History and Antiquities, 2001), 90.

Headwear/hair: His black bonnet with narrow brim is worn at a slight angle over his left ear. It has a narrow hat band of twisted black cord, suggesting it is the same bonnet that he has been wearing recently.

Body garments: He wears a short black semicircular satin cloak, which comes to his mid-thigh. It is faced at the front with black satin that has been slashed in a series of staggered horizontal slashes, forming a grid pattern. On the outside, the cloak has been trimmed with four rows of black cord that have been couched close together around the hem forming a decorative band. There is a suggestion that the hem of the cloak has been slashed to form a subtle, tabbed effect. The cloak sits on both shoulders and does not seem to have any obvious means of fastening it at the neck. Under this he is wearing a black sleeveless jerkin, with a small collar. The body of the jerkin is slashed/cut in vertical panes, which run from mid-chest height to his waist. The jerkin comes to his natural waist and appears to have very small skirts. It fastens down the center-front with five round black buttons that run from the collar to the top of the slashes. The jerkin is either sleeveless or it may have short sleeves because there is a hint of black at the top of his right arm. Not much of the white doublet that he is wearing underneath the jerkin is visible. While he mentions a woven yellow/gilt pattern, only a little of this is visible on the sleeves, but it must have been very striking.

Linens: His shirt has a small ruffle on the neckband, and the linen is formed into deep, s-shaped folds. Three sets of bandstrings hang down, and they end in small tassels.

Legs: He is wearing black hose. His trunk hose are very full and they are made from wide panes that run from the waistband to the lower band, which comes to mid-thigh level. The panes have been decorated with a series of horizontal slashes, and they are edged with applied rows of dark gray passementerie. In between the panes, the mid-gray lining is visible. The trunk hose have a smooth, round shape and are padded to help keep the form. They also have a large codpiece that curves upward. It is slashed and small puffs of fabric have been pulled through. The trunk hose are worn with plain black hose.

Footwear: His black shoes come up to his ankle where the vamp turns over at the front.[195] The vamps are slashed with cuts placed on the diagonal, forming a chevron effect. The slashes of the quarters are vertical.

Accessories: He wears a dark gray leather glove on his left hand and holds the other in the same hand. A small black velvet purse with a silver purse frame hangs from his girdle.

Weapons: He has a sword with a black hilt in a black scabbard, which hangs from the black girdle with hangers.

Gilding: None present.

Image II 37 [verso]

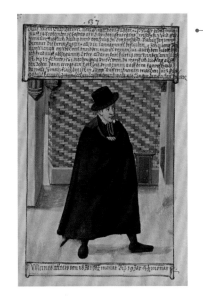

When my gracious Herr, Herr *Annthoni Fugger, in sacred memory passed away on September 14, 1560 (this was a Saturday, in the morning between 7 and 8 o'clock), in full conscience, patiently and devoted to God, servants of the Fuggers dressed in these long cloaks. I carried no weapons for one month and closed the cloaks in the front, I also wore the hat straight and very honorably, afterward fine and nifty as shown below, until February 17, 1561, at 2 o'clock in the afternoon, when I threw the mourning dress down on the ground, because there was a wedding dance at the dance house; there my dress, which I had made in a group with others to take a wife (the 39th image after this), wanted to show itself and no longer wanted to lie in a chest.*
Text below: Aged 18 years, 10 ½ months to 19 years, 3 ½ months.

Note: This entry accords activity to dress itself, as Veit's dress wants to be "seen" by others to break mourning rituals. The house in the background displays the Fugger family's coat of arms.

195. For similar slip on shoes, see the examples from a shipwreck c. 1590, in Swann, *History of Footwear*, 92, fig. 100.

Clothing overview: The death of Anton Fugger on September 14, 1560, has a profound impact on Veit's appearance, and here he is depicted wearing the full mourning cloak over his other clothes for the first stage of mourning for his employer. This should be compared with I 37 when Matthäus put on mourning for his father and I 137 when he too goes into mourning for Anton Fugger. Veit's youth probably partially explains his resistance to wearing full mourning, hence depicting himself a month after the strictest observances were dropped and allowing himself the flower and a sword.

Headwear/hair: His hat has a fairly tall crown with a flat top and a brim of moderate width. Rather than being worn flat on his head, it is at a slight angle over his right ear. It is very similar to that depicted in the frontispiece, and this is the only time he wears this style of hat, stressing its association with mourning by the 1560s.

Body garments: Veit is wearing a black, wool, ankle-length cloak, which is worn wrapped around his body and with the right side thrown over his shoulder, covering his other clothes. There is a suggestion of a hood or possibly a cape collar at the back. The cloak is worn over a black doublet with a small collar, which fastens down the center-front. In comparison to his other doublets, this appears to be plain, which is appropriate for mourning.

Linens: His shirt is much more noticeable because he is dressed in plain black, and very few details of his other garments are on display. The neckband of his shirt turns back over the collar of his doublet, and it is edged with a ruffle that is shaped into distinct s-shaped folds. His shirt has three pairs of bandstrings, all of which are left untied and hanging down.

Legs: His plain black hose can be seen on his feet and ankles.

Footwear: He is wearing black shoes and overshoes with thick soles.

Accessories: He has a red flower, possibly a red carnation,[196] which is either pinned to his doublet or he is holding it in his hand.

Weapons: He wears a sword in a black scabbard on his left hip, but just the tip is showing beneath his cloak

Gilding: None present.

Image II 38 [recto]

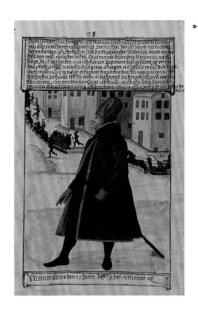

This winter, in 1560/61, there was a lot of terrific sleigh riding, as there had not been in many years, so much that I often lost control. This is why the town pipers, sleigh horses, and women's sleighs often had to suffer this month, as recorded in my calendar, without any need to relate it here. My dress was always a sable hat, a clove-colored woolen gown lined with fox fur and the left arm outside the sleeve, for I held my weapon in that hand. The gloves were plated metal, as depicted below. I kept myself on alert, in order to be ready if there was going to be a fight. I always rode [the sleigh] from 9 to 11 or 12 o'clock at night.

Inside the image: "Who passes through this street? Hui."

Text below: Aged 19 to 19 and 3 months.

Clothing overview: Although Veit records that he enjoys sleighing he does not depict himself driving his sleigh, as his father did; see I 44 (January 12, 1521), I 51 (February 20, 1522), I 57 (January 5, 1523), and I 58 (January 10, 1523). This may reflect that he is still in mourning. However, figures with sleighs can be seen in the background and show two types of sleigh: with a single horse and space for the driver and one passenger or with two horses, one of which is ridden pillion, with space for several passengers.

Headwear/hair: For his winter clothing in 1560/61, Veit opts for a fur hat made from sable (*ein zobline mutz*). The pelts are sewn together so they run vertically down the crown of the hat

196. A carnation was a symbol of betrothal, which does not seem appropriate at this point for Veit, but it may suggest a wish for romance.

Commentaries | 367

giving a striped effect. The hat has a tall crown and no brim. Instead it is shaped to fit snugly around his face, and it comes down over his ears and at the back his neck for extra warmth.

Body garments: His dark brown wool gown (*ein rock*) is fully lined with fox fur. It has a tall grown-on collar, which will help to keep his neck warm, and long sleeves that are fairly fitted but with some slight fullness at the top. His arm has been placed through the left sleeve so that he can grip the hilt of his sword. His other arm has not been put through the sleeve and is inside the gown. The gown is very loose, with no waist seam. It appears to fasten with a single button at the base of the collar. There may be a series of hooks and loops to close the front edge, but if there are he has left them undone. His need to hold his sword in his left hand suggests that, in a wish to keep the wearer warm, the gown has not been left open at the sides. Very little of his black doublet is visible, apart from the right sleeve, which appears to be quite fitted.

Linens: His shirt is not visible, but one would be worn.

Legs: He has black hose. The paned trunk hose are less flamboyant than many of the other pairs he has included in this book. They have quite narrow panes, which are not decorated and very little of the black lining shows through between them. If the trunk hose have a codpiece, it has not been depicted. The trunk hose are worn with plain black hose.

Footwear: His black shoes have plain uppers that come up to the ankle at the top, and the quarters are cut a little lower at the sides and back.

Accessories: As it is cold he is wearing light brown leather gloves.

Weapons: His left hand is through the sleeve in his gown so that he can grip the sword at the top of the scabbard. He does not appear to be wearing a girdle and hanger, so he has to hold the sword in his hand.

Gilding: None present.

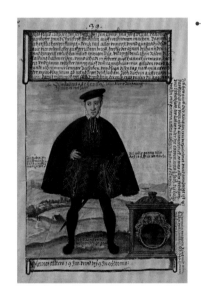

Image II 39 [verso]

This outfit I had made in January 1561 in the company of Jörg Ulstat, Melchior Hainhofer, and Christoff Böcklin to take a wife, so that whoever was going to marry first had to pay half of all costs and expenses, according to four properly executed letters, of which each of us had one. And because many forthright people [haimlich witzige leut] uselessly talked about these clothes in secret and because on February 17 I was invited to Hans Hörwart's wedding and dance at the dance house, I could not bear this any longer and took off my mourning dress on this day at 2 o'clock in the afternoon and dressed in these clothes, went to the dancing house, so that everyone would see me well, and I would have stood up to those saying anything to my face. I also wore this ring, as it is drawn and depicted. The dress has been well and diligently portrayed. It was all black and ash-gray, the silk satin below the cap was ¼ [?], the hose was lined with good silk satin and trimmed with passementerie.

Inside the image: This dress cost fl 85 kr 57 & 2 ½ according to a clear bill, which they well have to pay. A ruby for 60 fl of Rhenish coin and a diamond for 50 A. This sword, all of iron, cost 10 fl. Rhenish de bon marcha (well made). In sum, all together, dress, ring, and weapons, around fl 290. My signet ring with a ruby and diamond to be made by Master Mentel cost 24 fl Rhenish coin.

Text below: My age 19 years and 3 in 3 ½ months.

Note: The relation of the currencies is not clear, and thus the total sum cannot be checked, but this was clearly the most extravagant of Veit Konrad's commissions from local master tailors and goldsmiths.

Clothing overview: Veit takes off his mourning early in order to be able to attend his friend's wedding suitably dressed, and this suit of clothes makes clear the difference between

sophisticated, decorative black clothing that is appropriate for a festive occasion and simple, plain, matte black clothing to be worn for mourning.[197]

Headwear/hair: Veit is wearing the usual style of small black bonnet, which is worn at a slight angle over his right ear. It has a very narrow brim, and there is a twisted black cord tied at the base of the crown. His hair is kept short.

Body garments: He is wearing a black cloak that rests on his shoulders and comes to the mid-thigh. The outer fabric is left plain, but the inside of both fronts have been faced with black satin. The edge of the facing band has been cut with very short slashes, creating a decorative edging. The remainder has been slashed with short horizontal cuts, which have been placed between a chevron pattern created using lengths of black silk cord that has been couched down. The cloak is worn over a very ornate black doublet. It is decorated with applied passementerie. Two rows of the passementerie are stitched down vertically, creating a striped effect. In between the cord has been applied in diagonal lines forming an offset chevron pattern. The doublet has a deep collar, and it fastens down the center-front with small, round, black buttons. It has a natural waistline, and there is some padding to create a slight peasecod belly. The doublet has small skirts, which overlap the waistband of his hose.

Linens: His neckband has a slightly larger ruffle in an s-shaped pattern. It is supported by the collar of his doublet, and it is left open at the front. The two pairs of bandstrings have been left undone, and there are small tassels on the end.

Legs: Veit is wearing black hose. He has a very ornate pair of trunk hose, which have very wide panes. These are decorated with a chevron pattern probably created using applied cord or passementerie. Lightweight black silk has been used to line the trunk hose, and it is visible between the panes. The trunk hose have quite a prominent upturned codpiece that is decorated with passementerie and slashed. Puffs of the black lining have been pulled through the slits. The trunk hose are heavily padded, giving them this very full appearance. They are worn with plain black hose.

Footwear: His black shoes are decorated with lots of small pinks all over the vamp and quarters.

Jewelry: He has a ring on the little finger of his right hand, and it is illustrated in the inset detail. This ring is a symbol of his social status and of his being an adult.[198] It is set with his coat of arms, a diamond, and ruby, and there are cast naked figures on the shoulders of the ring. It is also enameled to accentuate the design and to make the point that nothing is left unembellished.

Weapons: A sword with a black hilt, in a black scabbard, is worn with a black girdle and hanger.

Gilding: The ring on his finger and in the detail.

Image II 40 [recto]

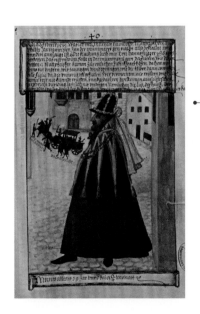

On February 23, 1561, I was dressed in this manner at the nightly mummery with Melchior Hainhofer, Matheus Hertz, and Philip Zanngmeister, as shown below. (Herr Hans Fugger lent me the clothing.) Everyone was forbidden to go to the mummery, so we drove to it, had 2 town pipers, and went to many assemblies of single women, where nobody disliked having us. We danced and jumped like calves, because there were belle figlie [beautiful girls] there, who did not displease us.

197. Compare with the clothes depicted in "Hispanici vestutus & habitus varii," from Hans Weigel and Jost Amman, *Habitus Praecipuorum Populorum*, 1577, Germanisches Nationalmuseum, Nuremberg; see Arnold, *Patterns of Fashion, c. 1560–1620*, 35.
198. See Scarisbrick, *Jewellery in Britain*, 148–51; also D. Scarisbrick, *Rings: Jewellery of Power, Love and Loyalty* (London: Thames and Hudson, 2013).

We thought we would conduct ourselves in a way that we would be unrecognized and thought we would extinguish the rhyme that says: four things cannot be hidden, namely love, a cough, fire, or water and pain. But it was all wrong from the beginning, as related in the calendar.

Inside the image: These 5 were our servants; the town pipers; silk satin.

Text below: Aged 19 years and around 3 ¾ months.

Note: Veit Konrad borrowed Hans Fugger's carnival costume, which underlines how closely the Schwarz family was connected to their patrons. Carnival took place on February 18. The 23rd was the first Sunday of Lent, hence the prohibition to appear masked. This entry further documents Veit Konrad's conflicted feelings about courtship before he was considered of a suitable age to marry.

Clothing overview: Veit wears this very colorful carnival costume on the first Sunday of Lent. It is a provocative, youthful gesture, where half the pleasure is wearing a disguise when he was forbidden to do so. However, by borrowing the clothes from Hans Fugger, it suggests that a degree of flouting the rules is permissible. He is in disguise with the mask and a costume that belonged to someone else, helping to conceal his identity. That said, they are not very covert because they take the town piper with them.

Headwear/hair: His hat has a very tall crown and a narrow brim. It could be made from blocked felt or possibly from velvet with a felt lining to help keep the shape. It is trimmed with white taffeta in ruched vertical bands down the crown and around the base of the crown. In addition, there is a hat band, which is tied in a bow at the back of the crown and then hangs down his back to his waist.

Body garments: He wears a bright red, all enveloping gown made of satin, according to a note on the image. The gown has a high collar and appears to fasten down the front, although this is not visible as he is shown in profile. Over the gown he has a blue and yellow "cape." The choice of blue and yellow, the Fugger's livery colors, fit with the reference to Hans Fugger having lent him the costume. It is decorated with a geometric design, which may have been created using appliqué or it might be painted. The cape is cut in deep points running from shoulders to his waist, and each one is finished with a large blue tassel.

Linens: His shirt is not visible, but he would be wearing one.

Legs: He is wearing red hose to match the gown. The fullness of the costume means that he could be wearing trunk hose underneath.

Footwear: His black shoes have pierced uppers. The quarters are slashed around his heels, while over his toes, the vamps are punched with lots of small round holes.

Accessories: He is wearing a mask or vizard with a moustache and beard. This will help to hide his identity (as he notes attendance is forbidden), and it also creates a sense of the character that he has gone as.[199]

Jewelry: The costume includes a gold/gilt chain worn double around his shoulders. The chain is substantial, being made from large links, and it hangs down to the middle of his chest. As this is part of a carnival costume, the chain is probably made from non-precious metals, but it is intended to replicate the chains worn by the wealthy and those in authority.

Other figures: In the background the covered wagon that Veit and his friends travel in, along with the five journeymen and the piper, can be seen. All of the figures in the wagon, along

199. Compare with the Daventry mask or vizard, a late sixteenth century mask found concealed in a wall of a house in Northamptonshire. The oval mask measures 195 × 170 millimeters, with openings for the eyes and mouth. It is made from three layers, namely an outer layer of black velvet, a middle layer of paper, and an inner layer of silk.

with four of the journeymen, are dressed in red, suggesting this color was very popular for carnival costumes and also helped individuals blend in and escape detection.

Gilding: The chain around his neck.

Image II 41 [verso, landscape]

On March 13, 1561, I was taught together with Jörg Ulstat, Connratt Mair, Victor Vöhlin, Christoff Stamler, David Sultzer, and others by the Cherrystone-Eater from Cologne, a vowed master of the Long Sword, an armorer, and citizen here at Augsburg, and the sword fighting was done in Hanns Behams', innkeeper, dance master outside Our Lady's Gate. We went to him for 2 hours every day.
Inside the image: This is meant to be me; this is meant to be Jorg Ulstatt; it is well portrayed; This pair of hose is full of hearts, lined with silk satin from Bruges, it first weighed 30 Augsburg pounds; it was filled with fabric and padded, so that it should be round.
Board on the wall: Oh God, lend me grace and art, That I may learn the free knightly art/duly and well, To use it before the Emperor, kings, and lords [*Herrn*]!
Text below: My age 19 years and around 4 ½ months.

Clothing overview: This indoor scene in spring 1561 reflects the impact of fencing manuals, such as Camillo Agrippa's *Trattato di Scientia d'Arme* (1553). First it records Veit learning to fence, and second it echoes how men fencing were depicted in these manuals (although in this case, it replicates the poses, rather than them being depicted nude, which is often the case in the handbooks).

Headwear/hair: Veit and Jörg are bareheaded, and their hair is cut very short. In contrast, the fencing master (the "Cherrystone-Eater") wears a black bonnet with a deep, pleated crown and a narrow brim. It is decorated with a small white ostrich feather.[200]

Body garments: Veit wears a black doublet and jerkin, both of which are worn open, revealing his shirt. The jerkin has small puffed sleeves. The body has a waistline, and the skirts flare out slightly. The jerkin is striped with applied bands of black passementerie, while Veit's doublet is plain black. Jörg is dressed in a black and white striped doublet under his black jerkin.[201] The striped effect was probably created by couching horizontal rows of black cord onto a white doublet or vice versa. The black jerkin has a very high stand collar; very short, puffed sleeves; and most of the body, skirts, and sleeves are made up from slashed panes. The fencing master's bright blue doublet has fitted sleeves, and it can be seen through the long vertical slashes in his black jerkin. The jerkin has a small stand collar and short puffed sleeves.

Linens: All three men wear white linen shirts. In each case the neckband is edged with a narrow ruffle. As the doublets worn by Veit and the fencing master have been left open, the fullness of their shirts is evident.

Legs: Veit notes that his trunk hose were padded with 30lb of material (possibly sawdust, bran, or horsehair) to give them their distinctive shape and profile. The trunk hose are made of broad panes. The panes have been pinked with a series of small heart-shaped cuts and the dark gray silk-satin lining shows through behind them and between the panes. In contrast, Jörg wears trunk hose with broad black panes with a decoration consisting of diagonal slashes or applied bands of passementerie over a black lining. They are worn with plain black hose.

200. As a point of comparison, see Anonymous, *Portrait of a fencing master*, 1562, Philadelphia Museum of Art, John G. Johnson Collection, 238. He is wearing a slim-fitting black jerkin over a mail shirt and a linen shirt—the small neck frill of the latter just visible. His hose have crimson canons decorated with applied gold cord worn with tight-fitting matching hose.
201. For a similar striped effect (although these stripes are on the diagonal not horizontal), see the black velvet doublet trimmed with golden yellow braid worn by Erik Sture, 1567, in Arnold, *Patterns of Fashion, c. 1560–1620*, 60–61.

Finally, the fencing master has bright blue trunk hose made from wide, undecorated panes with a matching blue lining underneath, a prominent codpiece and matching hose.

Footwear: All three men wear black shoes with pinked or slashed vamps.

Accessories: No gloves show, but by the late-sixteenth century, mail fencing gloves were in regular use. As George Silver noted in his fencing manual "this weapon must be used with a glove."[202]

Weapons: Each man is armed with a long sword (*döß langen schwertz*).

Gilding: None present.

202. Capwell, *The Noble Art of the Sword*, 129. For a pair of late-sixteenth-century Italian dueling gloves, see Royal Armories, Leeds, III.1440-1, illustrated in Capwell, *The Noble Art of the Sword*, 128.

Reconstructing a
Schwarz Outfit

Jenny Tiramani

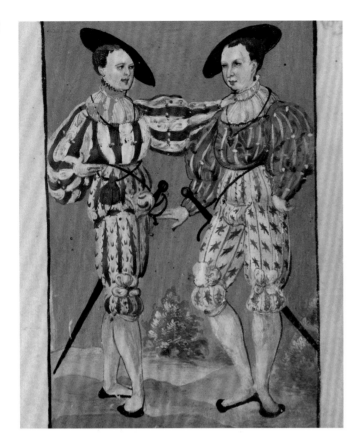

Figure 5.1. *Nos. I 102 and 103 from* The Book of Clothes

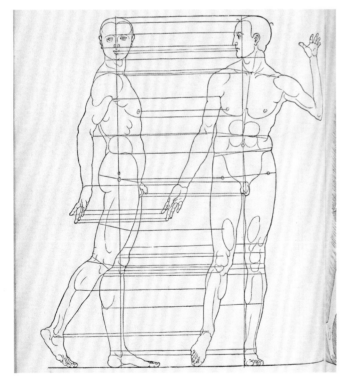

Figure 5.2. *Woodcut from Vier Bucher von Menschlicher, Albrecht Dürer, 1528, Nuremberg, RCIN 1150983, Royal Collection Trust/© Her Majesty Queen Elizabeth II, 2014.*

Introduction

To remake an outfit such as one depicted in the Schwarz manuscript is first and foremost an act of interpretation. It can never be a precise copy, as the clothes themselves no longer exist, and even if they did, without Schwarz himself to dress them in, it would not be possible to know exactly how they fitted him. The degree of authenticity achievable for this particular reconstruction was, as ever, defined by constraints of time and money. A list of the major purchases made and the costs of the work undertaken are therefore given, so that the reader may understand the context of the project more fully.

There are four elements that determine the nature of a piece of clothing: the materials, the cut or shape, the construction, and the context in which it is worn. Materials cost money, and naturally prepared, woven, or dyed yarn, textile, or leather usually costs considerably more than those produced by postindustrial methods. Priority was given to those aspects of the fabrics that were markedly different from modern equivalents, such as the use of natural dyes on the deerskin for the hose. Drafting a good pattern costs no more than a bad one. The degree of accuracy related to the drafting practice of a particular period depends partly on the number of surviving items available to study as references and partly on the understanding of the method, whether flat-drafted or draped on the body. Using the numerical system in place in Augsburg in 1530 was one factor that aided this process. This is recorded by P. Kelly in "The Universal Cambist and Commercial Instructor," London, 1835, as follows: "The Ell of Augsburg is of two kinds, the long Ell being 0,6095 Metres, or 24 English Inches, and the short Ell, 0,5923 Metres, or 23 ⅓ English Inches: hence, 36 of the long Ells = 24 English Yards, and 54 of the short Ells = 35 English Yards."

Outfits 102 and 103 are shown here at the miniature size that they were painted, and as such, the textile or construction details depicted are quite basic (Figure 5.1).

However, the caption given on the page is most helpful, stating that the hose are made of leather and the doublet is made in red silk satin and yellow silk damask, providing us with definite information about the main materials.

Many historical periods display an ideal body type, and in most of Europe around 1530, the desired male silhouette was for a high natural waist, sloping shoulders, and long narrow legs. This is clearly shown by Dürer in a woodcut of the naked male figure (Figure 5.2).

Schwarz may be shown with a slightly idealized silhouette in 102, but it is important to note that the clothes themselves create the illusion of the ideal body and are used to accentuate the desired shapes.

The wearer

It was considered of vital importance to make the clothes for a living person who resembled Matthäus Schwarz in certain respects. This enabled the new clothing to be fitted on him and the flat-pattern shapes to be explored and developed accordingly. It also meant that the model could be fully dressed, and the effect of the clothes on his posture and deportment could be observed (Figure 5.3).

Jack Brotchie was chosen for the following reasons: He had seven years experience as a professional model of contemporary fashion, both on the catwalk and for editorial work, and he had also worn sixteenth- and seventeenth-century reconstructed clothing for Shakespeare's Globe Education dressings since the age of fifteen. At the age of twenty-seven, when the Schwarz clothing was constructed in 2012, Jack was just five years younger than Schwarz was in 1530, and his physique was similar to that of Schwarz, as shown in the image, although his calf muscles are not so pronounced and his waist to waist through the crotch is possibly longer than Schwarz's by an inch or two. The measurements given here are those taken from Jack and used to draft the patterns. Their inclusion enables the reader to relate the size and proportions of the patterns to them.

JACK BROTCHIE MEASUREMENTS:

Height	5' 11"	Outside arm	24 ½"
Head circumference	23 ½"	Inside arm	21 ⅛"
High neck	14 ⅜"	Wrist	6 ⅜"
Base neck	15 ⅛"	Around thigh	21 ¾"
Chest	36"	Over knee	15"
Natural waist	29"	Under knee	13"
Hips	36 ⅝"	Around calf	13 ½"
Front nape to waist	13 ¾"	Above ankle	8 ½"
Back nape to waist	16"	Around ankle	10"
Across front	15 ½"	Outside leg to floor	46"
Across back	14 ½"	Inside leg to floor	35 ½"
Side neck to shoulder	6"	Side waist to knee	26 ¾"
Shoulder to front waist	16 ½"	Knee to ankle	19 ¼"
Shoulder to back waist	16 ¾"	Over arch of foot	10 ⅛"
Underarm to side waist	9 ¾"	Around toes	9 ⅛"
Waist to waist through crotch	35 ½"	Length of foot	10 ⅝"

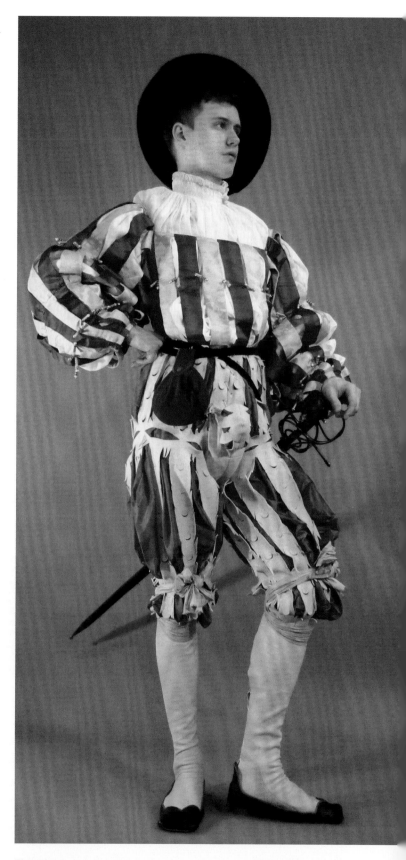

Figure 5.3. *Jack Brotchie wearing the reconstructed clothing based on 102.* © *Jenny Tiramani.*

The first step in the reconstruction of any historical clothing that survives only in a two-dimensional image is to imagine both the wearer and his clothes in three dimensions. This process is much like that of a detective, searching for clues in other places that support what can be seen and understood from the image itself. In some instances the other images of Schwarz from *The Book of Clothes* enlighten 102. In others, objects of a different nature help to build up the jigsaw puzzle, particularly sculptures and larger portraits of the period, such as that of Schwarz by Hans Maler (Figure 1.6; see page 7) painted only four years earlier, where every small detail of his fine linen shirt is clearly depicted. In the miniature (Figure 5.4), we can only see the front, so it was necessary to find both back and side views of similar outfits from the period in South Germany, where possible. The figure on the candlestick (Figures 5.5, 5.6, and 5.7) provides details of the back of the hose, neckline of the doublet, and the sword belt, though not identical to 102 in all respects. Although the overall impression of Schwarz in 102 is spectacular because of the use of vibrant reds and yellows, it is a relatively simple outfit, perhaps consisting of only three major body garments, described as follows:

Shirt

On his upper body he wears a high-necked white shirt next to the skin, and there can be little doubt that this was made of linen, the fabric chosen for shirts and smocks worn by men and women, respectively.

Doublet

Over the shirt he wears a doublet consisting of alternating panes of red silk satin and yellow silk damask. This appears to be worn without a placard across the stomach, whereas the curved painted lines around the front waist of 103 strongly suggest an open-fronted doublet worn with a separate matching paned placard. Due to the sketchy, small-scale nature of the paintings, there must always be the possibility of both doublets having the same shape and accessorized placard.

Another possibility not developed for this reconstruction is that the white linen seen between the panes of the doublet might be an extra layer stitched behind them and part of the doublet, known as "pullings out" rather than being the shirt seen through the gaps between panes. This is, however, unlikely given the vast amount of linen seen on both the shirts in 102 and 103, as well as on the high- and low-necked shirts such as those depicted in 68, 81, and 82.

Hose

From his waist down to the tips of his toes Schwarz is wearing one garment, known in the period simply as hose, but whether he has any underwear on beneath the hose is an unanswerable question. There are two possible garments he might have worn next to his skin below the waist, both of which would probably have been made of linen if they existed at all. The first is a pair of braies, or underpants. These were more common in previous centuries, when men's leg garments were not joined under the crotch by the gusset that developed into a codpiece, but rather consisted of two separate legs with only the linen shirt and/or braies between the legs. By 1530 when the legs of hose were conjoined, the shirt alone could serve as underwear in the crotch area, so the braies did not perform an essential function. The second garments that could have been worn under the leather hose were a pair of linen socks, perhaps to the height of the knees, to serve as the all important linen layer between the skin and the outer clothes. If the hose had been made from wool, there would have been more argument for him either wearing linen socks with them, or for the hose having a linen or fustian lining throughout, as wool wasn't generally worn next to the body. However, it seems to have been more acceptable for leather to be worn next to skin—it being the same organic substance—and certainly in the case of gloves this was usually the case. From the knee upward there is a layer of red fabric seen behind the slashes and pinks of the yellow leather hose. This was interpreted as red silk taffeta for the reconstruction, based on the hose of the previous four outfits; 97, 98, and 99 are described as having wool hose with taffeta underneath and 100 as having leather hose with taffeta underneath. Because it is highly unlikely for the taffeta to be the layer next to the body, there was probably a linen or fustian lining present in all these hose, but it may have only extended to under the knee, enclosing the taffeta but leaving the single leather layer for the lower leg and foot, to avoid bulk and give a smooth, tight-fitting silhouette. No extant examples are presently known with such half-linings, but there is a visual depiction of one in The Crucifixion Altarpiece by the Master of Aachen, 1490–95, The National Gallery, London, where a man is shown with the left leg of his hose split up the back seam and pulled up over his knee to reveal a bandage around his left ankle. The upper section of the hose is lined in white fabric, whereas the lower part of the hose is shown blue on both the inside and the outside.

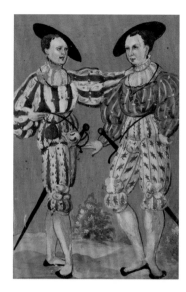

Figure 5.4. *Detail of 102 and 103 from* The Book of Clothes.

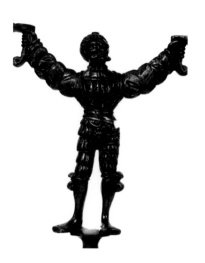

Figure 5.5. *Landsknecht candlestick, brass and bronze alloys, southern Germany, the figure c. 1520, H: 24.5 cm. Mus. No. M.2-1945. He wears a doublet with a separate placard across his chest. © The Trustees of the Victoria and Albert Museum, London.*

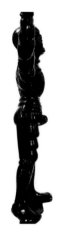

Figure 5.6. *Side view of Figure 5.5 showing the prominent codpiece projecting horizontally.*

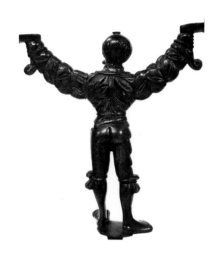

Figure 5.7. *The back of Figure 5.5, showing the un-slashed section across the buttocks and legs. The armholes are almost vertical, having very little curve to them.*

Garters

Almost certainly made of silk, these long straight lengths of silk fabric were tied at the knees to hold up the hose and stop them bagging or drooping. The way the garters are tied on 102 and 103 is called "cross-gartering," so-called because of the method of tying them, which had the effect of holding the knee section of the hose out in a puffed shape at the front and sides. There is a good side-back view of this on the man on the left of Figure 5.25, page 386. The halfway point of the silk was first placed under the knee at the front and the tails tightly pulled around the knee to the back, where the tails were crossed over each other forming a visual X, where they were sometimes twisted around each other first to hold firmly. Finally, the tails of silk were wound back to the front over the top of the knee and tied in a bow at the front. In contrast to this method, the garters on the candleholder figure were much shorter and tied under the knee only.

Shoes

Over the hose he has horn-toed leather shoes on his feet. These have very shallow toe boxes that measure about five inches across at their widest point. An extant pair of similar-shaped shoes in the Bayerisches Nationalmuseum, Munich (Figure 2.2; see page 33), have roundish pieces of thick leather stitched into the horns with linen thread, to act as pads against which

the wearer's toes could rest and to prevent them from slipping around in the cavities.

Bonnet

The bonnet is probably of knitted wool, fulled and brushed to a nap, although headwear of a similar shape was also being made from cut and sewn materials at the time. It is worth noting the sloping angle at which the bonnet on 102 is being worn on the side of the head, without an obvious method of securing it, either via pinning it to a coif worn beneath it or to longish hair. Neither is there a chin strap like that tied to the bonnet he wears in 101, where it would have been essential to stop it falling off while riding the horse.

Accessories

The outfit is completed by two belts worn across each other, one holding a bag, the other a sword and scabbard, and some kind of necklace that cannot be clearly understood from the sketchy rendering of it.

The reconstructed garments for 102 are presented on the following pages in the most probable order in which Schwarz got dressed.

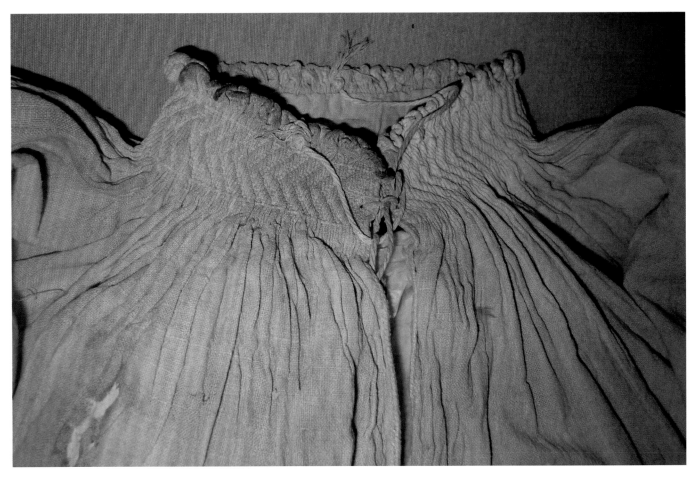

Figure 5.8. *Detail of a c. 1550 white linen shirt with all the linen of the sleeves and body gathered into the neck with staggered rows of running stitches that create a pattern of chevrons around the neck. A length of silk twist can be seen whipped to the edges of the neck frill and front opening. © Jenny Tiramani, with permission from the Church of San Domenico Maggiore.*

The shirt

Although some damage has occurred to the painting in the region of the shirt, obscuring the precise details, there is a definite curve to the profile of the shirt neck. This indicates that, as on the extant boy's burial shirt in Naples (Figure 5.8), there was no separate, flat neckband. Instead, the whole width of the sleeves and of the body pattern pieces was gathered into the neck and wrists, controlled and decorated by fine even gathering stitches; as such the shirt worn by Schwarz in 102 bears an important feature in the evolution of the ruff. The frilly edge at the top of the neck is simply the result of the large compressed volume of fabric held by the gathers from about 1490 onward; by the 1530s, it was used as a feature both as a gathered strip of fabric attached to a separate neckband and as it is seen here, as an integral feature of the rest of the shirt. This feature then grew and grew in width throughout the sixteenth century,

culminating in its separation from the shirt or smock, into an accessory known in its own right as a ruff.

The neck and wrist ends of the Naples shirt have elaborate patterns of chevrons created by multiple rows of counted-thread running stitches. These rows of stitches were positioned with great accuracy in staggered patterns so that when they were pulled up into the desired measurement for the wrist or neck, they formed intricate patterns. Many depictions of both the low- and high-necked shirts worn by Schwarz throughout the 1510s, 1520s and 1530s appear to employ this technique, sometimes with additional decorative smocking worked on the surface in white or gilt thread.

The wooden bust of a young man (Figure 5.9) is carved with a high-necked shirt that may have an even closer resemblance to that in 102. It has only a few rows of gathering at the top of the neck and at its base, with tight linen pleats left loose without

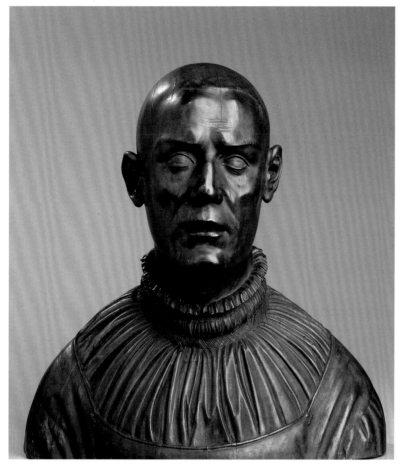

Figure 5.9. *Bust of a Young Man, Augsburger Meister, 1535–40, Bavarian National Museum © Bayerisches Nationalmuseum München. Photographer: Karl-Michael Vetters.*

Figure 5.10. *Detail of 102.*

stitches for the section in between. This results in the same curved profile as the shirt necks on 102 and 103 and was chosen for the reconstruction because of the constraints of time and budget, as well as for its likeness.

There are no distinct signs of either front or side neck openings on the shirts shown in 102 or 103 (Figures 5.10 & 5.11).

The decision to use a side fastening was made due to the fact that the seams between the front of the shirt and the sleeves occur exactly where an opening would be: a satisfying instance of form and function coming together. On both surviving garments and on images and sculptures of them, the majority of single side-openings on garments for the upper body are on the left-hand side, so that is where it was placed. The engraving of Jan van Leiden by Heinrich Aldegrever, 1536, in the Staatliche Graphische Sammlung, München (Inv. – Nr. 158165), records

Figure 5.11. *Detail of 103. Neither are they clear in the preceding shirts shown in 99 (Figure 5.13) and 100.*

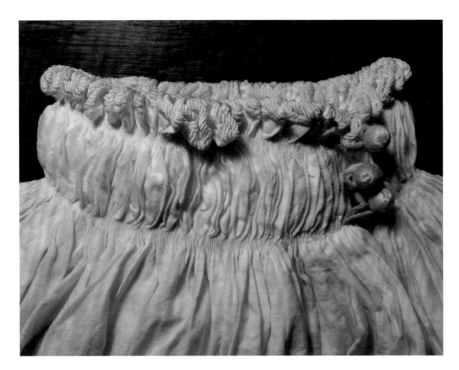

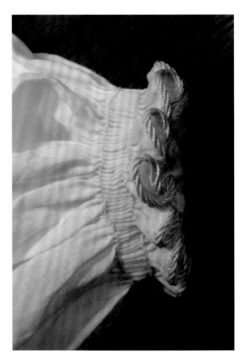

Figure 5.12. *The neck of the reconstructed linen shirt. The three buttons at the left-hand side of the front neck opening have wooden bases wrapped in silk threads and are held by loops of silk twist. © Jenny Tiramani.*

Figure 5.13. *The wrist end of the reconstructed linen shirt. A silk twist is whipstitched to the hemmed edge of the sleeve end, and the even pleats of the gathered section are held in place by a row of stitches connecting them. © Jenny Tiramani.*

such an opening in graphic detail, where the neck of the shirt is closed on the left by three buttons and loops and this was used as the reference for the reconstruction (Figure 5.12).

The length of the shirt was determined by the desire to have enough linen to tuck it between the legs but not too much volume to make the hose lumpy around the trunk when worn on top. The shirt reaches to just above the knee on Jack (Figure 5.14).

The sleeves are much longer than his arms, when not resting on his hands, and the extra length was necessary to fill out the large doublet sleeves. The huge shirtsleeves worn by Schwarz in 68, 81, and 82 (Figures 5.15 and 5.21) are similarly overlong.

> Linen supplied by Canetta, Genova, Italy, @ 30 per m.
> Shirt cut and fitted by Jenny Tiramani.
> Hand-stitched by Alice Gordon.
> Construction cost £ 800.00
> Materials cost £ 220.00
> Total cost £ 1020.00

Extant garments used as references

1. Woman's white linen smock, embroidered in polychrome silks c. 1600, V&A T.770.191.

2. Boy's white linen shirt, mid-sixteenth century, Church of San Domenico Maggiore, Naples.

Postproduction observations

1. The amount of linen in both the body and the sleeves on the shirt worn by Schwarz in 102 could have been more than that used for the reconstructed shirt if a finer weight of linen had been used, although this may not have filled out the sleeves of the doublet so effectively. The weight of linen for the reconstruction only allowed the amount used to be incorporated into the length of the neckline to fit Jack. Indeed the sleeves may have benefited from being slightly longer as well as wider.

2. Instead of the wrist ending in a small frill, resulting from the gathering of the sleeve width (Figure 5.13), the gathers could have been enclosed in a binding with a short wrist opening and a tie.

This would have resulted in a closer fit on the wrist, or when tied further up the arm to keep it out of the way if worn without a doublet, as seen in 82 (see Figure 5.15).

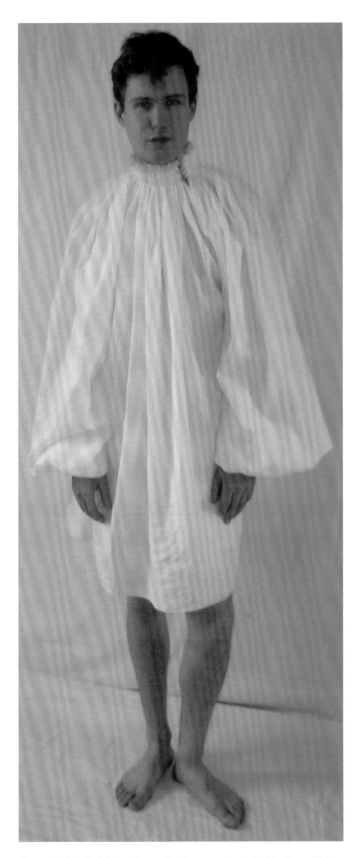

Figure 5.14. *Jack Brotchie wearing the reconstructed white linen shirt.*
© *Jenny Tiramani.*

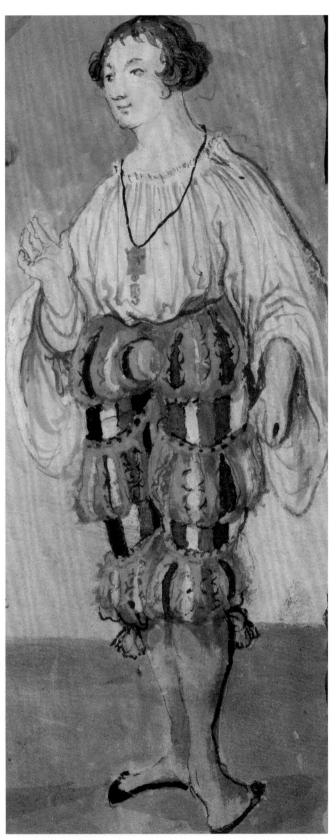

Figure 5.15. *Detail of 82 showing the linen shirt held around the forearm by a tie at the wrist end of the sleeve.*

Pattern of white linen shirt

Scale 1:8

The linen has an average
thread count of 74 weft x
82 warp per inch.

THE NECK SECTION BEHIND ALL THE GATHERING IS LINED
ON THE WS WITH A STRIP OF LINEN FROM J TO K.

CF

H1

J

BUTTONS

OPEN FROM
A1 TO NECK

FRONT NECK GATHERED INTO 4 ½"

A

PATTERN PIECES

1 Front body
2 Front body piecing
3 Left underarm gusset
4 Left sleeve
5 Back body
6 Back body piecing
7 Right sleeve
8 Right underarm gusset

B1

B

1

2

C1

C

KEY

CF Center front

WS wrong side or inside of
the garment

RS right side or outside of
the garment

SELVEDGE

SELVEDGE

CUT EDGE

SELVEDGE

F1

F

OPEN FROM
F1 TO HEM

OPEN FROM
F1 TO HEM

CF

DETAILS OF STITCHING & SEAMS
All stitching was worked by hand in 150 white linen thread

Selvedge / cut edge seam - the selvedge was felled to the ⅛" seam allowance of the cut edge. The seam allowance was then folded and
felled down on the WS.
Two selvedges - the selvedges were whipped together.
Hem - the cut edges at the bottom of the shirt, around the wrist openings and side-neck opening were turned and felled, ¹⁄₁₆" wide hems.
Hem & silk twist - a length of plied silk threads was whipped to the hemmed edges at the wrist openings and side-neck opening.
Gathering stitches at neck - two parallel rows of running stitches at the top of the neck and two rows at the base of neck.
Gathering stitches at wrist - four parallel rows of running stitches ⅛" apart with whipstitches on the RS holding every pleat to the next one.

Figures 5.16 to 5.20.
Shirt pattern © Jenny Tiramani.

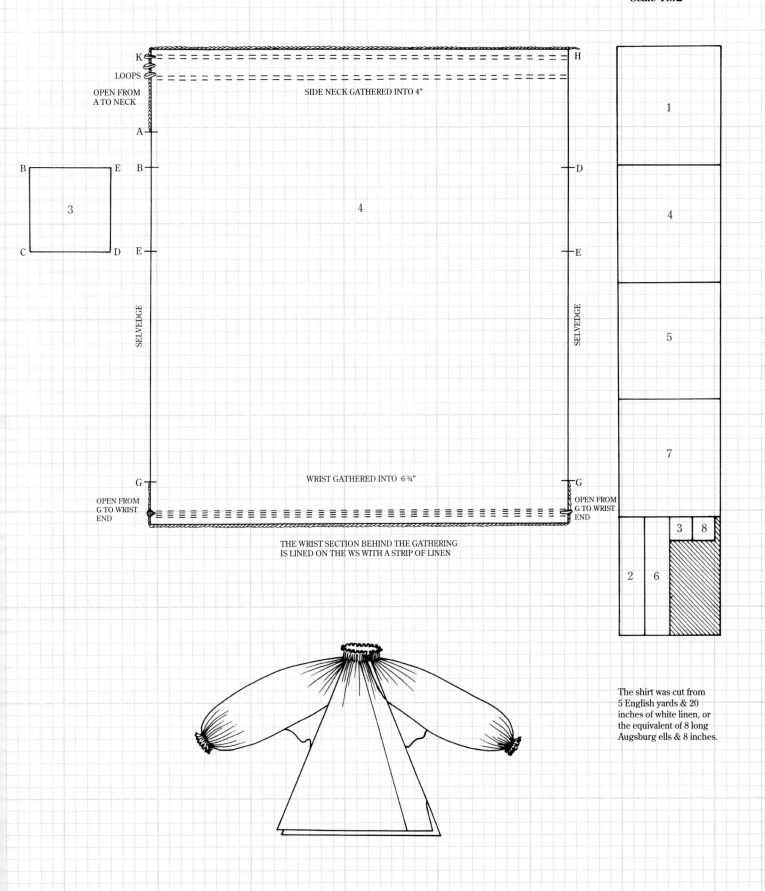

**Pattern layout
36" wide linen**

Scale 1:32

K

LOOPS

OPEN FROM
A TO NECK

A

SIDE NECK GATHERED INTO 4"

H

D

B · · E
3
C · · D

B

E

4

E

SELVEDGE

SELVEDGE

G

WRIST GATHERED INTO 6 ¾"

G

OPEN FROM
G TO WRIST
END

OPEN FROM
G TO WRIST
END

THE WRIST SECTION BEHIND THE GATHERING
IS LINED ON THE WS WITH A STRIP OF LINEN

1

4

5

7

2 6 3 8

The shirt was cut from
5 English yards & 20
inches of white linen, or
the equivalent of 8 long
Augsburg ells & 8 inches.

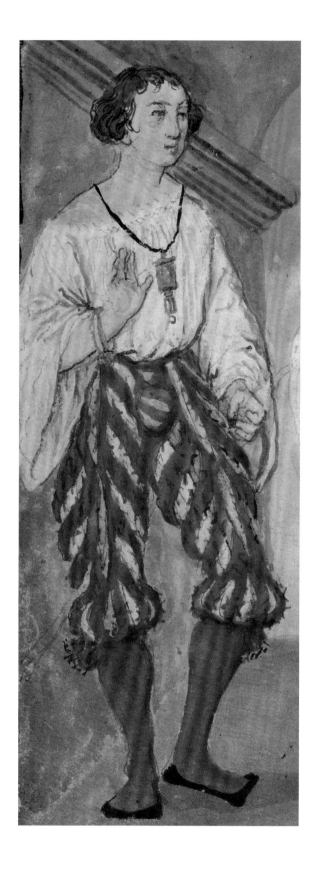

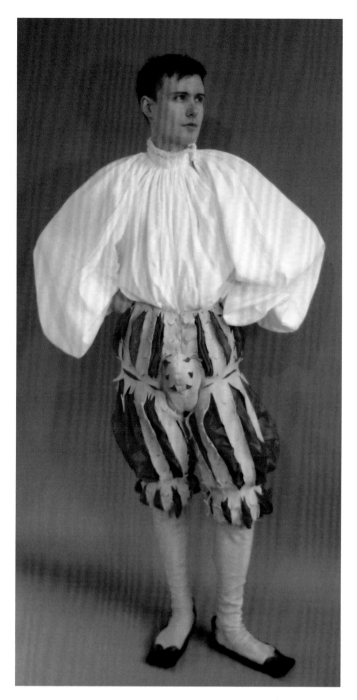

Figure 5.22. *Jack Brotchie wearing the reconstructed linen shirt and deerskin hose based on No. 102 from* The Book of Clothes. © *Jenny Tiramani.*

The hose

The hose worn by Schwarz in 102 are a development of the style of simple un-slashed hose worn by men of all classes at the end of the fifteenth century throughout Europe. In 102, as on many of the previously illustrated examples (including 91, 97, 98, 99, 100), the outer layer is cut with a knife to make the

Figure 5.21. *Matthäus Schwarz wearing a linen shirt with large sleeves and a pair of leather hose in No. 81 from* The Book of Clothes *or a layer of pullings out, as is the case in 102 (Figures 5.22 & 5.23).*

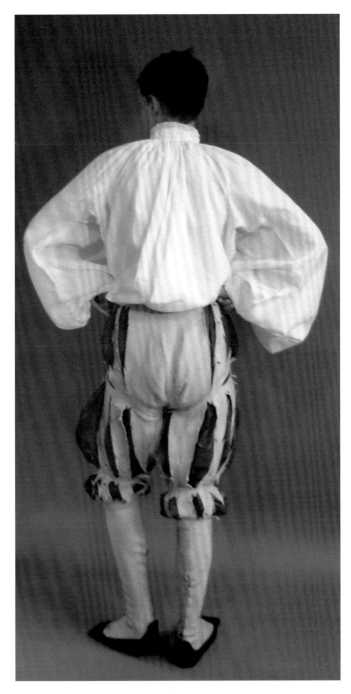

Figure 5.23. *Back view showing the hose section for the seat and back of the legs with no slashing or pinking; a practical choice for riding horses and creating less wear and friction when sitting down.* © Jenny Tiramani.

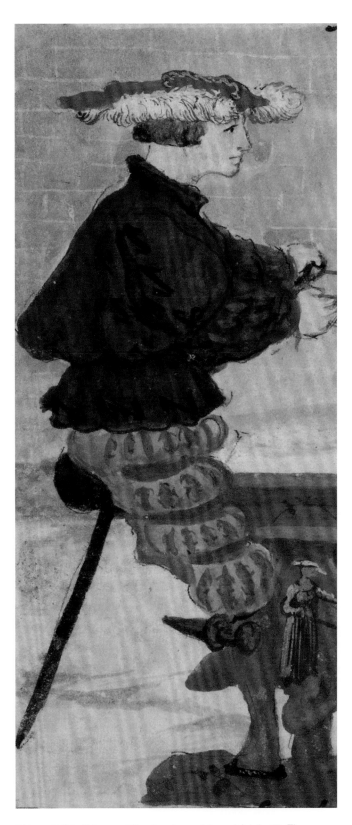

Figure 5.24. *Schwarz riding in a horse-driven sleigh in 57. The horizontal slashes of his hose stop before they reach the back.*

long slashes and punched, or pinked, with a chisel-like tool to make the small incisions. These slits often reveal either another pair of hose beneath, as in 81 and 82 (Figures 5.15 and 5.21), and probably even 57 (Figure 5.24), or a layer of fabric stitched inside as an interlining.

Both wool that has been fulled and leather are practical materials to use for such cuts, as they are inherently strong and will not fray. The hose worn by those men taking part in the Battle of Pavia (Figure 5.25) are almost certainly wool or leather.

They appear complex, fancy even, and therefore could be interpreted as laborious to make. This is not the case. As the pattern on the following pages shows, these hose were constructed from one single pattern piece of strong supple deerskin for each leg (plus a foot-piece), and all the puffed, slashed, and pinked shapes are merely slits in the leather, made swiftly and needing no finishing, hemming, or binding to keep them strong. It took only a couple of days to make the reconstructed hose from the soft flexible deerskin (Figure 5.26), including the insertion of the linen half-lining (Figure 5.27).

For 102 it is likely that two pinking tools were used—one for the semicircular shapes and one for the short crosses (Figure 5.28).

Similar-shaped cuts appear on both the doublet (diagonal crosses) and hose (semicircles) of Kunz von der Rosen (Figure 5.29).

By contrast, the hose worn by Moritz, Elector of Saxony, almost twenty years later consist of yellow leather under-hose from the waist to the toes, over which are silk velvet over-hose with silk satin pullings-out (Figure 5.30).

They would have taken far longer to make, having thirty-two pattern pieces for each leg, many of which are bound in silk strips and lined. The final pattern for the reconstructed hose was based on the older style of fitted hose, not the newer type of pattern that evolved in the first half of the sixteenth century (to which the velvet hose of Moritz conform) where the panes were cut straighter and going all around the leg in more of a tube shape that was gathered or pleated in around the knee.

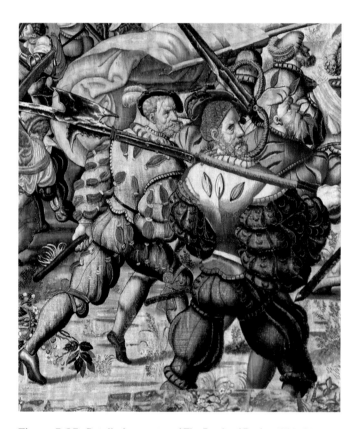

Figure 5.25. *Detail of a tapestry of The Battle of Pavia, 1528–31, Bruxelles workshops of Bernaert van Orley, Willem & Jan Dermoyen, showing the back of pinked and slashed hose. By permission of the Museo di Capodimonte, Naples.*

Deerskins supplied by Hagel's Tannery, Kalispell, Montana, USA @ US $80 per skin.
Deerskins dyed with Persian berries by Karl Robinson @ £95.00.
Red silk taffeta supplied by Hopkins, London, @ £20.00 per m.
Twill linen for the half-lining supplied by The Cloth House, Berwick Street, London @ £15.00 per m.
Hose cut and fitted by Jenny Tiramani.
Hand-stitched by Jenny Tiramani and Sarah Stammler.

Construction cost	£ 600.00
Materials cost	£ 300.00
Total cost	£ 900.00

Extant garments with patterns used as references

1. Yellow wool hose with yellow silk pullings-out, c. 1550, Bern Historisches Museum.
2. Yellow-dyed, alum-tawed leather hose with yellow silk velvet and satin trunks, worn with a yellow silk satin doublet, c. 1547, Dresdner Rüstkammer, Inv. Nr. i I.

Postproduction observations

The CB seam and the two seams that run up the back of each leg should probably be further apart, and the curve over the cheeks of the buttocks should probably be flatter.

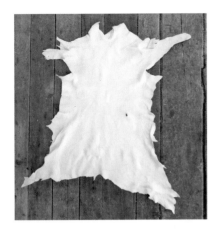

Figure 5.26. *An alum-tawed deerskin before it was dyed yellow with Persian berries. © Jenny Tiramani.*

Figure 5.27. *The inside of the codpiece and the trunk of the hose are lined in twill linen. The codpiece is stuffed with straw. © Jenny Tiramani.*

Figure 5.28. *Detail of the slashes and pinks cut into the yellow deerskin for the right leg of the hose. © Jenny Tiramani.*

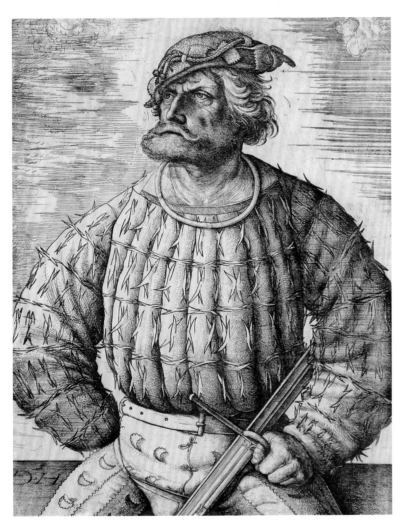

Figure 5.29. *Daniel Hopfer, Kunz von der Rosen, court jester at the court of Maximilian I, etching, probably a later copy, 1515–1600. Image from Los Angeles County Museum of Art.*

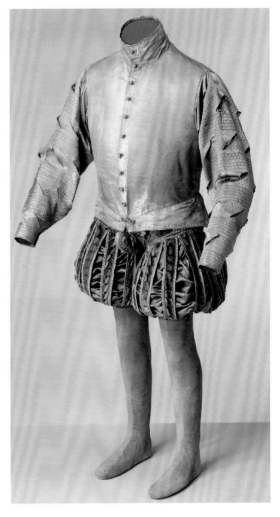

Figure 5.30. *Yellow-dyed, alum-tawed leather hose with yellow silk velvet and satin trunks, worn with a yellow silk satin doublet, c. 1547, the state costume of Elector Moritz of Saxony, c. 1547 © Abegg-Stiftung, CH-3132 Riggisberg, 2008; Photo: Christoph von Viràg.*

Pattern of yellow deerskin hose

Pattern layout on 3 deerskins

Pattern

Scale 1:8

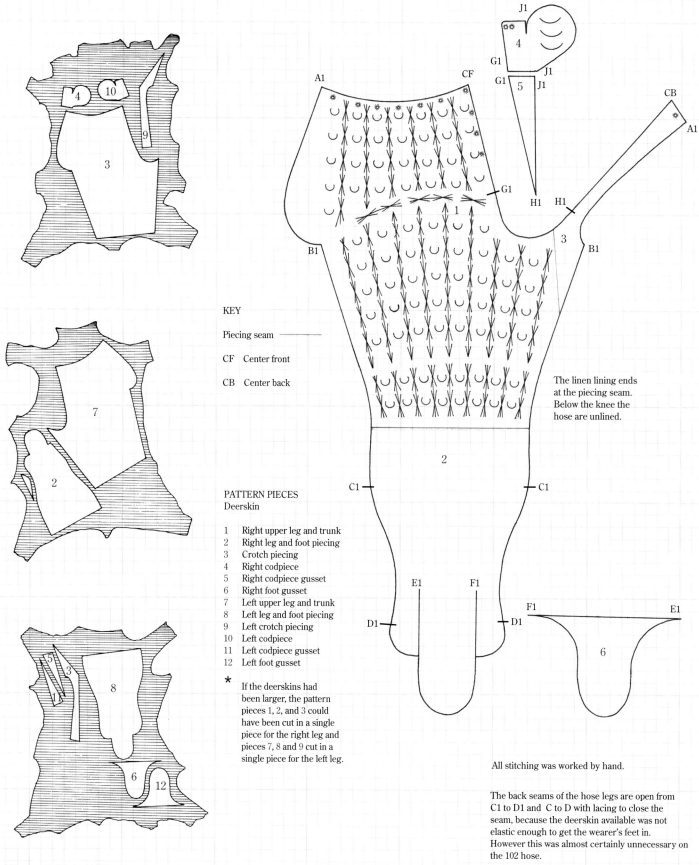

KEY

Piecing seam ————

CF Center front

CB Center back

PATTERN PIECES
Deerskin

1 Right upper leg and trunk
2 Right leg and foot piecing
3 Crotch piecing
4 Right codpiece
5 Right codpiece gusset
6 Right foot gusset
7 Left upper leg and trunk
8 Left leg and foot piecing
9 Left crotch piecing
10 Left codpiece
11 Left codpiece gusset
12 Left foot gusset

* If the deerskins had
 been larger, the pattern
 pieces 1, 2, and 3 could
 have been cut in a single
 piece for the right leg and
 pieces 7, 8 and 9 cut in a
 single piece for the left leg.

The linen lining ends
at the piecing seam.
Below the knee the
hose are unlined.

All stitching was worked by hand.

The back seams of the hose legs are open from
C1 to D1 and C to D with lacing to close the
seam, because the deerskin available was not
elastic enough to get the wearer's feet in.
However this was almost certainly unnecessary on
the 102 hose.

Figures 5.31 to 5.37.
Hose pattern © Jenny Tiramani.

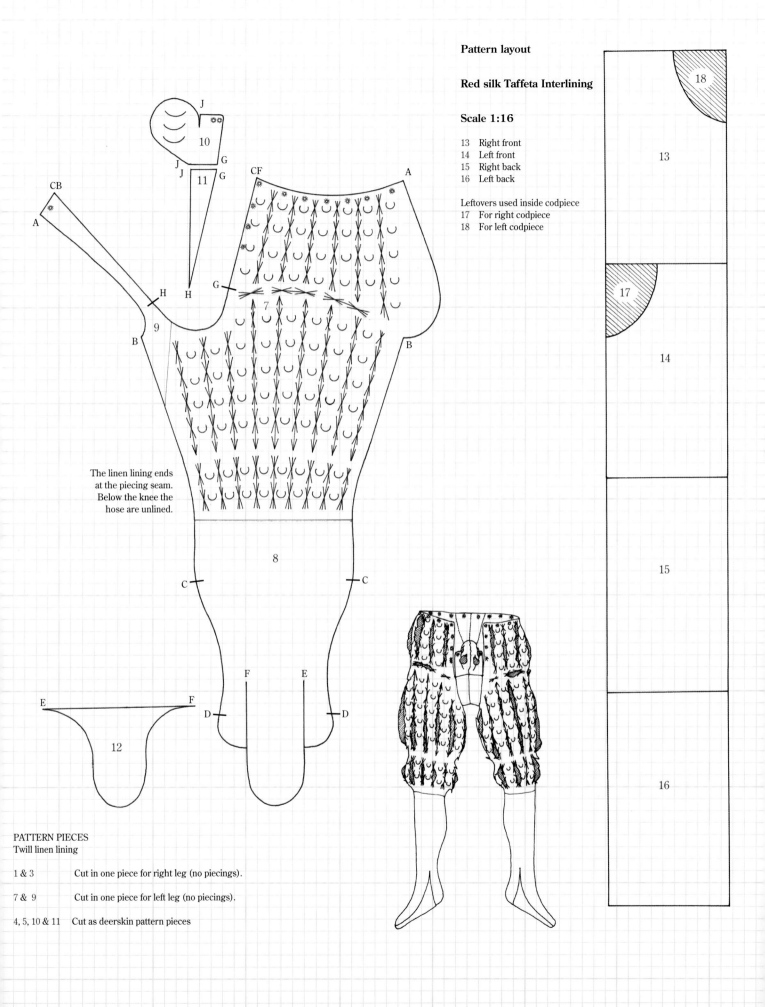

Pattern layout

Red silk Taffeta Interlining

Scale 1:16

13 Right front
14 Left front
15 Right back
16 Left back

Leftovers used inside codpiece
17 For right codpiece
18 For left codpiece

The linen lining ends
at the piecing seam.
Below the knee the
hose are unlined.

PATTERN PIECES
Twill linen lining

1 & 3 Cut in one piece for right leg (no piecings).

7 & 9 Cut in one piece for left leg (no piecings).

4, 5, 10 & 11 Cut as deerskin pattern pieces

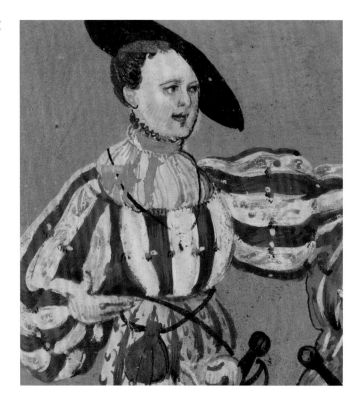

Figure 5.38.

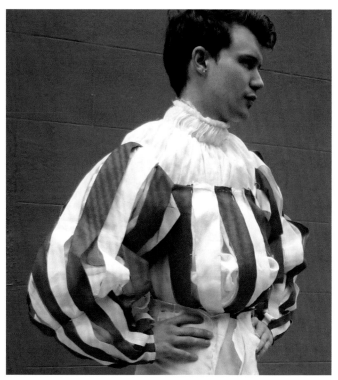

Figure 5.39. *Jack Brotchie wearing linen toiles of the doublet and hose over the unfinished white linen shirt at an early trial fitting. © Jenny Tiramani.*

The doublet

The exact number of panes on the doublet in 102 had to be estimated from the ones in the view given (Figure 5.38) and would have to be increased or decreased in width on a larger or smaller person to maintain the same number.

The reconstructed doublet (Figure 5.40) has forty-eight separate panes in total, and each pane has four layers—192 separate pieces of fabric in all, as every pane consists of four layers. The outer layers are of the silk satin or damask, and each one of these was cut with a seam allowance of about ⅜ inch, folded around and felled to the two layers of linen interlining that had been previously been pad-stitched together to give them some substance and shape, especially those for the front of the body. Finally a red or yellow silk taffeta lining was felled to the back edge of each pane with the seam allowance of about ⅜ inch folded in all around.

The choice of fabrics for the two different silks was made to achieve the best hues without jeopardizing their textures. A chemically dyed, shop-bought, red silk satin was chosen because the most important feature of a satin weave, described as "Atlas" by Schwarz, is its high-gloss sheen, as this can be compromised by immersion in water to dye it. Good red silks are also much easier to find than yellows, which are not so fashionable today. Silk damasks with large-scale motifs are difficult to source, so

a special order was made. It was also a priority to harmonize the yellow used for the silk with that used for the hose, so both were naturally dyed with Persian berries; the silk was immersed in water, whereas the dye was applied to the deerskins with a cloth. There was some loss to the shine of the satin parts of the damask weave, but it was deemed acceptable.

The challenge of construction for this garment was to achieve the extended bulbous shape of the front, so easily achievable on metal breastplates of the period. At the toile fitting, using cheap fabrics to mock-up the doublet, this shape was successfully achieved, and the shirt held out a single layer of loomstate linen without difficulty.

However, when the aglets (Figure 5.39) were attached to the finished doublet, the front panes drooped slightly, and a small kink in them occurred across the chest where the aglets joined the panes together. This droop was caused more by the heaviness of the pewter than by the fact that the panes were joined together.

Red silk satin supplied by The Berwick Street Cloth Shop, Berwick Street, London, @ £40.00 per m.
Ivory silk damask supplied by Hopkins, London, @ £60.00 per m. (Figure 5.43)
Ivory silk damask dyed yellow with Persian berries by Karl Robinson @ £100.00.

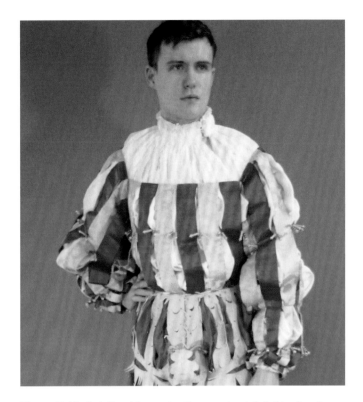

Figure 5.40. *Jack Brotchie wearing the reconstructed clothing based on 102. © Jenny Tiramani.*

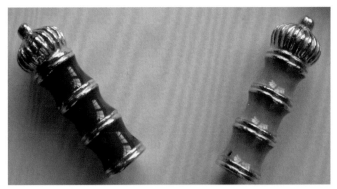

Figure 5.41. *Two of the gilded, with enamel, pewter aglets used on the reconstructed doublet to join the panes together. © Martin Adams.*

Figure 5.42. *Detail of Francois I by Jean Clouet, c. 1535, The Louvre. He wears a paned doublet in black and ivory with black aglets positioned on the ivory panes and ivory ones on the black. Photo © RMN-Grand Palais (musée du Louvre)/Hervé Lewandowski.*

Red silk taffeta supplied by Hopkins @ £20.00 per m.
Twill linen for the half-lining supplied by The Cloth House, Berwick Street, London, @ £15.00 per m.
A total of 138 gilded pewter aglets, with enamel, supplied by Martin Adams @£3.00 each.
Doublet cut and fitted by Jenny Tiramani.
Hand-stitched by Jenny Tiramani, Natasha Freeman, and Sarah Stammler.

Construction cost	£ 2200.00
Materials cost	£ 550.00
Total cost	£ 2750.00

Postproduction observations

The panes could have been constructed in several other ways being utilized by European tailors at the time. Quilting was used to support the shape of doublets from the fourteenth century, and it would have been possible to create the curved shapes of the panes by working layers of linen and silk in the hand, perhaps with a layer of cotton or wool padding between them. Aglets made of a lighter material than pewter would have also helped keep the shape at the front of the doublet.

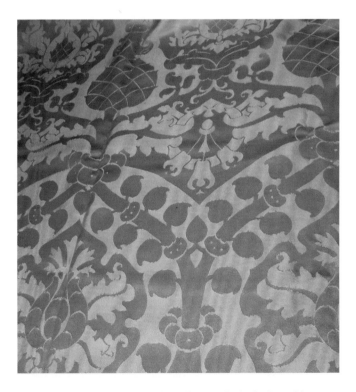

Figure 5.43. *A view of the silk damask naturally dyed yellow with Persian berries. The parts of the patterns that look darker are those with a satin weave and the lighter parts with a twill weave. © Jenny Tiramani.*

Pattern of paned silk doublet

Scale 1:8

All stitching was worked by hand.

There is an eyelet hole, made with a bodkin, at the waistline in the center of each pane on the body, to lace the doublet to the hose. The holes are whipstitched in silk buttonhole twist.

All red silk satin pattern pieces are also cut in a layer of natural linen interlining, a layer of natural holland linen interlining and a layer of red silk taffeta lining.

All yellow silk damask pattern pieces are also cut in a layer of natural linen interlining, a layer of natural holland linen interlining and a layer of yellow silk taffeta lining.

On the sleeves the panes are connected by wired aglets at every balance mark, from F1 to F1 and F to F around the arms, and all around the armholes and wrists.

On the body the panes are connected by wired aglets at every balance mark from A1 to A on the front, A to A1 on the back, around the waistline and neckline.

The doublet has an opening on the left front from J/B to H/G and there are brass hooks and eyes at J/B , K/L and H/G.

On the body there are seams from A1 to E1 and from A to E.

PATTERN PIECES

1 - 12	Lower right sleeve panes
13 - 24	Upper right sleeve panes
25 - 32	Back body panes
33 - 40	Front body panes
41 - 52	Upper left sleeve panes
53 - 64	Lower left sleeve panes

KEY

● Red silk satin pane

○ Yellow silk damask pane

Figures 5.44 to 5.50.
Doublet pattern © Jenny Tiramani.

A F

41 53

42 54

43 55

C 44 56

C 45 57

46 58

47 59

B 48 60

B 49 61

50 62

51 63

52 64

A F

There are small gathers in the elbow ends of all the upper-arm panes to reduce their width from 2" to 1 ½" before stitching them to the lower arm panes, all the way round the arm.

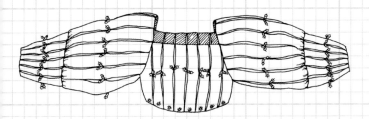

The panes are whipstitched together all around the waistline, the neckline and around wrists, with silk buttonhole twist.

The sleeve panes are whipstitched to the body from B1 to C1 on the right sleeve and B to C on the left sleeve.

Pattern layout

Red silk satin panes

Scale 1:16

Pattern layout

Yellow silk damask panes

Scale 1:16

Figure 5.51. *The topside of the reconstructed bonnet, before the silk ribbon points were attached. © Jenny Tiramani.*

Figure 5.53. *The topside of a red knitted bonnet, c. 1550. © Bern Historisches Museum.*

Figure 5.55. *Detail of 103 showing the spiral lacing of the hose at the front and top corners of the codpiece flap tied to the hose with points.*

Figure 5.52. *The underside of the reconstructed bonnet, before the silk ribbon points were attached. © Jenny Tiramani.*

Figure 5.54. *The underside of a red knitted bonnet, c. 1550. There are small silk ribbons all around the brim. © Bern Historisches Museum.*

Figure 5.56. *Detail of the reconstructed hose showing the single silk point laced in a spiral pattern up the front opening and the codpiece partially tied onto the fronts of the hose with silk taffeta points. © Jenny Tiramani.*

The bonnet

The bonnet was knitted by Rachel Frost on five 2mm needles with a natural mid-brown merino wool yarn, overdyed in the fleece with logwood and an iron mordant for a good black (Figures 5.51 and 5.52).

After knitting, the bonnet was fulled, by repeat immersion in hot soapy water and prolonged agitation in the form of kneading, beating with a mallet, and rolling. The bonnet was knit at a slightly larger size than desired when finished, to allow for shrinkage during the fulling process. The nap was then raised with a metal brush and the surface sheared to produce a uniform height of pile. The bonnet was then stiffened with

shellac and a silk point was threaded through the two sides of the split brim to tie them together.

The crown of the bonnet has similar proportions to the example in Bern Historisches Museum (Figures 5.53 and 5.54), but the brim is ¾ inch wider at 4 ½ inches, to achieve a similar proportion to that worn by Schwarz in 102.

We were concerned that it would prove impossible to keep the bonnet on Jack's head at such a steep angle with such a small crown and nothing to attach it to. However, it transpired that it stayed in place as long as he retained an upright posture and moved his head in a self-aware manner.

Extant garment used as reference

Red wool knitted bonnet, c. 1550, Bern Historisches Museum. The brim of this bonnet is 3 ½ inches wide, and the outer edge has a diameter of 12 ⅝ inches. The crown has an internal diameter of 5 ½ inches and an external diameter of 7 inches.

The fastenings

Lacing was the predominant method of fastening on outfits such as 102 and was used to attach the doublet to the hose and to close the front opening of the hose. The top corners of the codpiece flap were tied to the hose with woven silk ribbon points. Although these are not clearly visible in 102, the hose laces are depicted in 103 (Figure 5.55).

All these laces and ties have brass aglets at their ends to help thread them through the eyelet holes (Figure 5.56).

The jerkin, doublet, and hose shown in 107 are worn with a gap between them at the waist, revealing the linen shirt worn underneath (Figure 5.57). The spiral lacing at the waist, with a continuous lace that connects the doublet and hose, is easily seen here and the same method was used on the reconstruction of 102.

Although it was universal practice to join the doublet to the hose with lacing at this time, this is not visible in 102 or on Jack's doublet and hose or in 103 or many other images of Schwarz at this period, because in most cases the lace is pulled tightly so that the edges of the doublet and hose meet and it is concealed. The only other fastenings used on the reconstruction are three brass wire hooks and eyes that connect the left-front opening of the doublet. Again, there is no visible means of fastening or an opening in 102. Alternatively, the original doublet may have had a lace or laces to close it on the left side, at the front, or even at both the left and the right fronts. All these variations on fastening a doublet existed around 1530 and may be observed in portraits and on sculptures.

General observations

This exercise in reconstructing the 1530 outfit worn by Matthäus Schwarz in 102 has resulted in some fascinating and sometimes surprising discoveries.

Despite the apparent similarity of the doublet and hose in 102, it took only a couple of days to make the reconstructed hose, whereas it took more than two weeks to make the doublet because so much sewing was involved. Pinking and slashing was a spectacular but very cost effective decorative technique, and like other methods of embellishing garments, it had a structural consequence as well, affecting the handle and flexibility of the surface. Making cuts or constructing a garment from a series of panes as on the doublet and hose of 102 increased flexibility and aided movement. By contrast, the much more expensive application of embroidery, especially when carried out in metal threads, added firmness and weight to the ground fabric onto which it was applied. Embroidered garments were rarely seen on Schwarz, with the exception of his linens, but they may have been worn by the Emperor Charles V and his brother Ferdinand on their visit to Augsburg in 1530, for whom Schwarz wore this outfit in an effort to please.

Figure 5.57. *Detail of 107 showing the continuous spiral lacing connecting the doublet and hose all around the waist. This is the method used for the reconstruction of 102.*

Figure 5.58. *Sarah Stammler making one of the eyelet holes in a yellow silk damask pane at the waist of the doublet, to tie it to the hose. On the left of the image a finished eyelet hole is visible, whipped around the edge with silk buttonhole twist. © Jenny Tiramani.*

Another striking result of making these clothes was that they gave Jack the fashionable silhouette of 1530. Because of the puffed curves created by the voluminous folds of linen on his shoulders, he appears to have broad sloping shoulders, a high waist, and long legs (Figure 5.59).

However, when wearing the Commes des Garcons suit he adopts the fashionable silhouette of 2012, consisting of narrow square shoulders and a longer body (Figure 5.60).

The theory that there is such a thing as a "modern body" and that it is impossible to obtain historical silhouettes on people today is not borne out by the result of this reconstruction or by many other such experiments in reconstruction conducted by myself and colleagues. The clothes themselves shape the body and can give it the illusion of breadth, of height, of substance, or of fragility.

By its very nature, a reconstruction like this one cannot be entirely conclusive: instead it should be viewed as an experiment or a conversation with history. Unlike purely theoretical speculation of any kind, such as a written article or an illustrated lecture that can discuss various possibilities, reconstructed garments themselves require firm decisions to be made for fabrication; these decisions are informed by trials and mock-ups, but even after this process, it is only when the final garments are made that any flaws can be seen. Several other versions exploring some of the points that have been raised throughout this short exposition of the present reconstruction of 102 might shed further light on its true nature, although they would always be governed by whatever materials were available to the makers and by the ever present constraints of time and money.

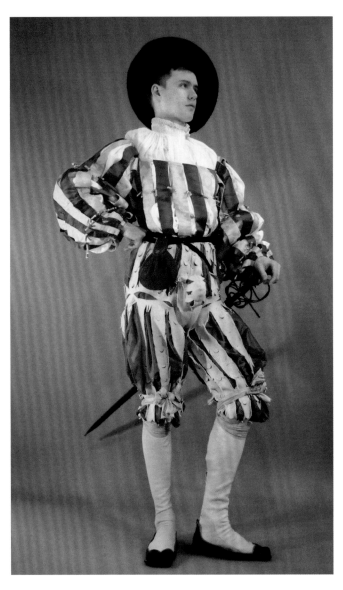

Figure 5.59. *Jack Brotchie wearing the reconstructed clothing based on 102. © Jenny Tiramani.*

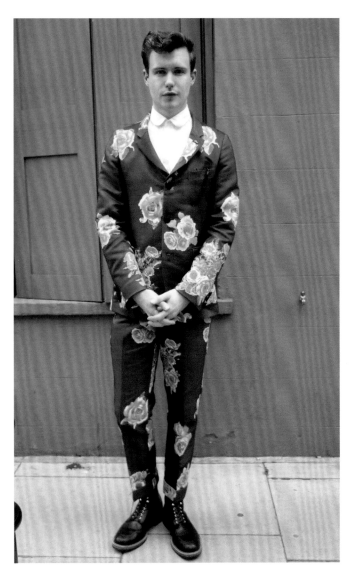

Figure 5.60. *Jack Brotchie wearing a suit from the AW2012 Commes des Garcons Homme Plus collection, a shirt by Fumito Ganryu, and boots by Junya Watanabe. © Jenny Tiramani.*

Glossary of Textile and Clothing Terms and Terms for Accessories

The glossary focuses on the textile and clothing terms used in the text written by Matthäus and Veit Konrad Schwarz. The English term is given first, and where possible, this will be the sixteenth-century English term. This is followed by the sixteenth-century German term, and where appropriate, the modern German word, and finally by a definition. A few additional terms have been included that have been used in the commentaries but that do not appear in the translation/transcription; as such, these may be unfamiliar to the reader. These terms are marked with an asterisk.

aglet (*hacken*)—an ornamental metal tag that could be attached to the ends of points, making it easier to insert them into lacing holes, or used in pairs with no visible tie ends; they could be used as a fastening or as a decorative trimming

armor/*die Rüstung* (*mein ristung, die ristung*), black armor (*mein schwartz ristung*)—plate armor to cover and protect the body, sometimes worn in conjunction with mail

ashgray/*Aschefarbe* (*aschenfarb, eschenfarb*)—a color, a mid-gray shade

bandstrings, shirt ties (*Leinenquaste*)—little linen ties on shirt collars; some could be very ornate in their construction

bases/*gesäß* (*gses*)—skirts of mail to be worn with/under plate armor

beard (*der bart*)—facial hair, on the chin, neck, and cheeks; sometimes seen in tandem with a moustache (hair grown on the upper lip)

bells (*schellen*)—two main types of bell were used as dress accessories or accessories for a horse harness: the rumbler bell (a closed sphere with a loose pea inside) and the clapper bell (an open bell with a fixed clapper)

black/*schwarz* (*Schwarz*)—a color, often achieved by combination or over dyeing; a color associated with Spain and with mourning

blue/*blau* (*bla*)—a color, covering a range of blue shades from light to dark, probably dyed with woad or woad and indigo in combination

bonnet/bonnet (1) *dar Barett* (*biret, barett, Das barett*); *ein bernisch biret ein groser brauner Niderlender*; Genoese bonnet (*Jenueser birett*); (2) *die Mütze*, sable bonnet (*ein zobline mutz*);

(3) *ein scheirn* Netherlandish beret (*ein niderlendisch scherin*) [similar to the modern word for shaved]—a small, close-fitting head covering, often of soft material, with a brim

boots/*der Stiefel* (*in stifeln*)—footwear extending over the ankles and often to the knee; they could pull-on or be fastened with laces or buckles

*breeched, breeching—the point when a boy stopped wearing a coat with skirts and started to wear a doublet and hose, usually between the ages of five and seven

bridges satin, Brussels or Bruges satin (*brikisch atlas, briggisch atlas, briggischem atlas*)—a union cloth with a silk warp and woolen weft

brim (*die uberstilm*), a folded brim (*stilm gantz*)—the projecting edge or border of a bonnet or hat

brown/*braun* (*braun, praun*)—a color

buttons/*der Knopf*, little buttons (*knepflen*)—a small, often round or spherical item used to fasten and decorate clothing; it could be made from silk or wool threads worked over a wooden core, cast precious and semi-precious metals, bone, etc.

camlet/*Kamelott* (*Kamelott, schamelot, zambalot*)—a warp-faced plain weave fabric with a pronounced weft rib; made of silk, wool, mohair, camel hair, or a combination of two of these; it could incorporate metal thread and could be figured, watered, or waved

caul (*erstaln haubn*)—a small head covering, usually worn indoors, probably made of silk or metal threads from a range of techniques, including sprang

chain/*die Halskette, die Kette* (*ein guldi kötti*)—a type of jewelry worn around the neck, in a variety of lengths, often with a pendant hanging from the chain

cloak (1) (*Die cappen, der cappen, der kapp, die kapp*); Frisian cloak (*Capo friso*); Spanish cloak (*spanisch kappen, die spanisch kapp*) and (2) (*der mantel, den mantl*); little cloak (*das mentelin*); long cloak (*in langmentl*); Saxon cloak (*ein sexischen mantl*)—a loose outer-body garment, which could vary in length from hip length to ankle length, and which could be made with or without a collar and with or without sleeves

cloth/*das Tuch* (*tuech*), Alpine cloth (*Das tuch barpianisch*), cloth from Mechelen (*gra mechlisch*)—a piece of fabric; a woolen, woven fabric

clothes/*Kleider*, clothing/*Kleidung* (*klaidung, klaid, klaidet*); Italian clothing (*die italienisch kleidung*)—collective term for garments worn on the body

coat, riding coat (1) *Leibrock* (*Das leibröcklin, der leybrock, leibrock*); (2) *Sayon*[1] Riding coat (*sayon*), Lombard riding coat (*lombardisch sayon*); (3) *reitrock, Wappenrock, waffenrock*—a coat or gown for riding that might have quite fitted sleeves, long or short skirts; if it had long skirts, these might be very full or they could be split at the back

*codpiece—an appendage, the shape of which changed during the late fifteenth and sixteenth centuries, which was attached to the front of men's hose by points to conceal the front opening

color (*die farben, diser farb*)—one of the most significant means of decorating clothes and often regulated by sumptuary legislation

cord/*die schnur* (*schnier, Die schnuer*) small silk cord (*seidenschnierlein*)—a type of passementerie, a string formed of several threads twisted together

crimson (*rot-cermexin*)—a color, probably achieved by dyeing with either kermes or cochineal, depending on the date

curled fur (*kröpfin*)—probably a tightly curled lambskin

damask/*der Damast* (*Damast, damaschg, damasti*)—a monochrome, figured textile with a reversible pattern created by using contrasting faces of the weave, usually a satin; the ground was usually of satin (warp-faced) and the pattern in sateen (weft-faced); it could be made from silk, linen, or wool

dapple-gray/apfelgrau (*apflgrau*)—a color for a horse

diamond/*der Diamant* (*deemantrung, ain diamante, ain diemant*)—a precious stone, cut

doublet/*das Wams, Männerswams* (*das Wammes, wameser*)—the main garment for the upper body for men and boys once they were breeched, usually made with sleeves, attached to the hose by a lacing band

ell (*Ein elen, 5 ellen*)—a unit of measurement for cloth; the long Augsburg ell was 0.6095 meters or 24 inches, and the short ell was 0.5923 meters or 23½ inches

embroidered/*ausgenäht*[2] (*ausgnöt, ausgnett*)—decorated with embroidery or needlework

embroidery/*die Stickerei* (*göstickt*), also *niederlendisch arbait*—decorative technique involving needlework often found on shirts and other linens

feathers/*die Feder* (*födern*)—the basic feather structure consists of a central tapering rod supporting a fringe on either side

fitch/*fitch* (*fech*)—fur of a polecat (*Mustela putorius*), which has a dark brown coat with paler, creamy-yellow fur on the belly

flesh color/*fleischfarben* (*fleischfarb*)—a red-brown color, probably achieved by dyeing with madder

fox/*der Fuchs* (*fux*)—a red-furred quadruped red fox (*vulpes vulpes*) with a bushy tail

French style or manner/*französisch*—the use of the term acknowledges an awareness of a distinct French fashion or aspects of this style

fustian/*Barchent* (*Barchant*)—a plain weave cloth of linen and cotton

German style/*Deutsch* (*auf theutsch*)—the use of the term acknowledges an awareness of a distinct German fashion or aspects of this style

glove/*der Handschuh* (*der Handschuhe, die hendschuech*)—there were two main types of gloves: those with a separate thumb, the next three fingers all together (i.e., the index, middle, and ring fingers), and the little finger being separate (sometimes referred to as split mittens) or those with four individual fingers and a separate thumb

gold, golden/*das gold, golden* (*guldi, gulden*)—either cast from gold or gilded

gold color, gold, yellow/*goldfarb*—a color, probably achieved by dyeing with weld

gown/*der Rock* (*disem rockh*), a short gown (*das röckle, röcklin*); a lined gown (*ein gfieterter rock*)—for men, a long, loose, outer

1. Jutta Zander-Seidel, *Textiler Hausrat: Kleidung und Haustextilien in Nürnberg von 1500—1650* (Munich: Deutscher Kunstverlag, 1990) 433. In her list of "Historische Begriffe," she gives *Sayon* as the old term for *Leibrock*.

2. Zander-Seidel, *Textiler Hausrat*, 433. In her list of "Historische Begriffe," she gives *ausgenäht* as the old term for *bestickt*.

garment, often with sleeves and for women, their chief body garment

green/*grün* (*Grün, grin, grenfarb, grienem*)—a green color probably achieved using a woad-weld combination

gray/*grau* (*grau, gra*)—a color

guards, borders/(*getteer, guldi getteer, brem, zaum*)—decorative bands of material applied as borders or along seams; they could be embroidered or plain

hair/*das Haar* (*das har*), long hair (*ein langs har*)—hair, both on the face and the head, was a very important symbol of early modern masculinity

half silk/*Halbseiden, taffat, daffat* (*der daphat, daphett, taffeta*)—a mixed fiber textile that is half silk and half another fiber, probably wool

hat/*der Hut* (*den huet*), a Saxon hat (*ein sexischen huet*)—a head covering with a crown and brim

horse/*das Pferd* (*das phert, ein zelter*), the black horse (*der Rappe*)—a marker of social status and essential for much private travel as well as transporting goods overland

hose/*der Hosen, die Männerhose* (*der Hosen, ein Paar Hosen, barhosen, bar hosen*)—for men, the chief garment covering the lower body (also see trunk hose) and for women, a stocking, which usually came to the knee

incarnate (*incarnad*)—a color, literally flesh color, and this bright red was probably achieved using madder or madder in combination with other red dyes

jerkin/*das goller*—a short upper garment usually worn over the doublet, often sleeveless but it could have long sleeves

leather/*das Leder* (*löder, lideri, liderin*), Prussian leather (*preisisch löder*), leather hose/*lederhosen* (*gesäßhose, ain liderin gseß*)—material made from skin, usually animal skins, that have been preserved by tanning or a similar process such as tawing

lined/*gefuettert* (*gefietert, gefuttert, gfieterter, futer, göfietert*)—a garment that has a lining for added warmth; the lining might also contribute to the visual appearance of the garment especially if it was a contrasting color or weave to the outer fabric

linen/*das Leinen* (*das brustduch leynin*)—a fabric made from hemp that could be bleached white or left in its natural gray/green state

lining/*futtertuch* (*futerduch*)—the material used to line garments, usually of a lighter weight than the main fabric but not always; winter fur linings could add real substance to a gown

liver color/*leberfarbe* (*Leberfarb, leybfarb*)—a dark red/brown color

marten/*der Marder* (*mederi, merderin, kelmeder*)—fur of the marten or pine marten (*martes martes*), a member of the mustelid family; their fur ranges in color from light to dark brown, and the winter coat was especially prized for being thick and silky

mixed fibers and linen/*Macheier*[3] (*Mochairaro, Macheier*)—a union cloth combining linen with another fiber, including cotton.

mourning/*die Wehklage* (*die klag, mein klag*)—dark or black clothes and accessories worn to mark the death of an individual, usually a family member; the long mourning cloak (*gugl*) was a full-length mourning gown with a hood that could be pulled down to cover the face of the wearer

mules/*Schlappen, Pantoffel* (*bantofl*)—soled shoes with no quarters worn as an indoor shoe but also as an overshoe outdoors to protect other footwear

nightgown (*ein nachtkleid*)—a loose, lined gown worn indoors for warmth

over-hose (*Überzügen*)—fancy hose, often coming to the knee but they could be shorter, which were worn over another pair of very tight fitting hose.

passementerie/*Posamenten* (*Posamenterie*), passementerie borders (*passamanporten*), Spanish velvet passementerie (*spanisch samat-pasaman*), velvet passementerie (*samat-pasaman*); also fringe, tassel/*die Franse* (*fransen, frantzen*), silk tassels (*seidin fransen*)—ornamental braids or trimmings; the term could also include buttons

pearl/*die Perle* (*perlen, berlin*)—precious stone/gemstone made from calcium carbonate; they are iridescent and nacreous

3. Zander-Seidel, *Textiler Hausrat*, 78.

pinked/*zerschnitten* (*zerschniten, den schnitten, schnitz, die schnitt, zerschnitten*)—a decorative technique consisting of small, decorative cuts often made with a special tool

pins/*die Nadel* (*stöfft*)—consisting of a long shank with a sharp point at one end and a round head at the other; made from copper alloy and iron, used to fasten garments and secure accessories

placard, chest cloth/*brustduch* (*Ein gfalten brustduch, brusttuch, das brustduch leynin*)—a stomacher or covering to infill the front of a low cut doublet

pleats/*falten* (*falten*)—a fold or series of folds made in fabric and often stitched in place

points (*Wolfsangeln*)—ties of silk cord or leather with aglets at the ends to join doublet and hose or to create decorative effects

pulled out, tuffed out (*ausgöneet, auszogen, ausgezogen*)—pullings out could either be small puffs of fabric stitched behind slits or the lining behind panes

purse, bag, pouch (*die Tasche*)—a small bag, wallet or detachable outside pocket worn hanging from the belt or girdle with either a drawstring closure or a flap

*quarters—the back or rear part of the shoe upper with either a pair of side seams or a center-back seam

quilted, quilting (*gestepter, gesteppt, gestöppet*)—a technique that usually involves two layers of fabric with a layer of padding (such as feathers, down, wool, cotton waste or silk waste) in between; layers are often secured with lines of stitching

red/*Rot* (*Rot, rott*)—a color, often achieved by dyeing with madder

red-brown/*rot-braun*, (*rot-braun cermexin*)—a color, probably achieved by dyeing with madder

relined/*underfuetert*—when a lining has been replaced or put back in again, such as with fur linings that were taken out for the summer and put back for the winter

ring/*der Ring*, a diamond ring (*ein deemantrung*)—a piece of jewelry worn on the fingers

roll, padded roll/*wülschen* (*Wülsten*)—depicted as being part of the decoration on doublet sleeves and on hose (usually on the thighs)

ruby/*der Rubin*—a gemstone made from corundum that range in color from dark red to pale pink

rust color/*nagelfarbe* (*neglfarbs*)—a color, probably achieved by dyeing with madder

satin (*Atlas, atlasen, atlaß*), Turkish satin (*dirckischer atlas*), good satin (*guetem atlas, gueten atlas*)—a shiny fabric where the warp threads float over four or seven wefts

scarlet (*cermexin, rot-cermexin, scharlach*)—a color, probably achieved by dyeing with either kermes or cochineal, depending on the date

school bag (*der Schulsack*)—a bag for carrying books and paper; the pen case and ink well often attached to the outside of the bag

shirt/*das Hemd* (*das Hemd, das hemet*), Franconian shirt (*ein altfrenckisch guldi hemet*)—an undergarment worn next to the skin, usually made from linen, with a neckband and long sleeves ending in a wristband

shoes/*die Schuhe* (*die schuech*)—footwear that comes no higher than the ankle

shot or changeable/*gewirckht*[4]—a fabric where the warp and weft are different colors so creating a changeable or iridescent color effect as the textile moves

signet ring/*der Wappenring* (*mein wappenring*)—a ring with the wearer's initials, monogram, badge, or coat of arms on the bezel

silk/*die Seide* (*seidin, seidi*), silk from Arras (*arrassi, seidi arras*)—textiles made from the fibers produced by the silkworm (*Bombyx mori*); they were highly prized because of their soft handle, lustrous appearance, and the ability to dye easily in a wide range of colors

slashed/*aufgeschnitten*—garments or parts of garments that have been decorated with a series of cuts, which could be vertical, horizontal, or diagonal

sleeves/*die ärmel* (*ermeln, die örmel, in erbl*)—covering for the arms, which can either be made separately and attached to the garment with points or be an integral part of the construction of a garment, such as a doublet

4. Zander-Seidel, *Textiler Hausrat*, 433. In her list of "Historische Begriffe," she gives *gewässert* as the old term for *moiriert*.

sleigh or sled/*schlitten* (*disen schliten*), sled track (*schlittenpan*)—a horse drawn carriage on runners used to transport people over snow and ice

*sole—the part of the shoe in contact with the ground

Spanish, Spanish style/*Spanisch* (*auf hispanisch*)—the use of the term acknowledges an awareness of a distinct Spanish fashion or aspects of this style

spear/*der Speer* (*ein spies*)—a thrusting weapon with a long wooden shaft and a sharp, pointed head usually made of metal

*sprang—similar to netting, sprang is an elastic textile that is produced by the manipulation of a set of warp threads

*spurs—the two main types of spurs include prick spurs and rowel spurs; the basic components include the body of the spur (the main part of the spur, including the neck, which carries the goad), the sides of the spur or the terminals, the attachments that secure the spur leathers, and the crest (when the spur sides join and form a point, which can often be decorated)

*squirrel—fur of the European red squirrel (*Sciurus vulgaris*); the color of the squirrel's coat varies with the time of year and the climate, such as the thick, gray, winter squirrel furs, the best of which were imported from Scandinavia and Russia

stripe, stripes/*der Streifen* (*die strich*), small stripes (*keder*)—narrow bands of alternating colors

summer clothing/*summer klaidung* (*ein summerklaidung*)—thinner, lighter weight clothing, often without a lining, so better suited to warmer weather

swaddling (*der fetschen*)—narrow bands of fabric, often linen, used to wrap newborn babies and infants

taffeta (*Zindel, statzendl*)—a lightweight, tabby weave silk, often used as a lining

*thrum—a decorative technique that created a shaggy effect by adding threads

toothpick/*der Zahnstocker* (*den zanstirer*)—a small implement to help with personal hygiene

trimmed/*verbrämt* (*brembt, gebremt, göbrembt, verbrembt*)—decorated or ornamented using a range of techniques

trunk hose, breeches (*gseß, atlassin gseß*)—a specific form of hose, often made of a series of panes, joined at the waist and the leg band, which probably had a codpiece

turquoise/*der Türkis* (*dirkees*)—a blue-green precious stone from a hydrous sulfate of copper and aluminum; its name derives from a sixteenth-century old French word for Turkish

underlaid/*underzogen* (*unterzoge*)—a fabric that was placed under another that had been pinked and slashed, usually of a contrasting color and weight to the top fabric

*uppers—the element of the shoe that covers the top of the foot apart from the sole

*vamp—the front part of the shoe upper

velvet/*Samt* (*samati, samettini*)—a fabric with a short pile formed by placing the supplementary pile warp over rods introduced during the weaving process; the pile could be cut in one height, cut in different heights (velvet upon velvet), left uncut, or a combination of these; velvets could have a solid cut pile or they could have cut pile on a voided satin ground; the latter could be polychrome and could incorporate metal thread

Venetian style/*venezianisch* (*venetianisch*)—the use of the term acknowledges an awareness of a distinct Venetian fashion or aspects of this style

white/*Weis* (*weis, weys, weiß*)—often achieved by bleaching the fibers, but much wool was naturally off-white

wool, woolen/*die Wolle, Wollgewebe* (*wullin*), fine wool from Perpignan (*barbia*), very fine (*superfin*)—cloth woven from proteinaceous fibers, usually from sheep but could also include mohair from goats and cashmere from camels

wool and silk fabric/*Burschat* (*burschatin, Burschat, burschatines, burschattins, buschatt, purschett*)—a union cloth that combined silk and wool

wreath, garland/*der Kränze*—decorative garland made from fresh or silk flowers, leaves, etc.

yellow/*gelb* (*Gelb, gar*)—a color, probably achieved by dyeing with weld

Acknowledgments

Ulinka Rublack wishes to thank, above all, Prof. Dr. Jochen Luckhardt, the director of the Herzog Anton Ulrich-Museum in Brunswick, for his kind cooperation, as well as Prof. Dr. Thomas Döring for his support and for organizing a two-day symposium on the *Trachtenbücher*, which allowed us to closely study these manuscripts and discuss them with experts: Philippe Braunstein, Christoph Emmendörfer, Stefan Hanss, Christian Heitzmann, Kurt Löcher, Katharina Mähler, Gabriele Mentges, Christoph Metzger, Michael Roth, Heike Schlie, and Ruth Slenczka. Their comments helped to sharpen the introduction, and I am most grateful for their advice. Stefan Hanss deserves special thanks for the assistance he offered whenever needed and for discussing questions relating to the introduction with me after the symposium. The project to edit the *Trachtenbücher* for the first time in full color was a dream that could not have been realized without Anna Wright from Bloomsbury, whose enthusiasm and vision sustained it right from the start and throughout the past three years. I am also most grateful for the detailed and constructive feedback from those who reviewed the project and final edition for Bloomsbury, as well as for the assistance provided by Hannah Crump and Ariadne Goodwin and, last not least, the production team's extremely patient and excellent work. Special thanks must also go to Cambridge University, the Cambridge History Faculty, and St. John's College for funding the reconstruction of a Schwarz outfit and thus supporting new ways of doing research into past mentalities and skills. Jack Brotchie could not have been a more perfect model, and it is a pleasure to acknowledge my gratitude for his cheerful patience and interesting conversations. Further funding for the publication was generously granted by the Pasold Fund and St John's College, and I wish to sincerely thank Chris Dobson, Giorgio Riello, Lyndal Roper and Evelyn Welch for their concern and support. I finally wish to thank Maria Hayward and Jenny Tiramani for the true privilege of being able to work with them, which I have relished throughout the project.

UR

Index